BURTON HOLMES

TRAVELOGUES

The Greatest Traveler of His Time, 1892–1952

Edited by Genoa Caldwell

**Directed and produced by
Benedikt Taschen**

TASCHEN

HONGKONG KÖLN LONDON LOS ANGELES MADRID PARIS TOKYO

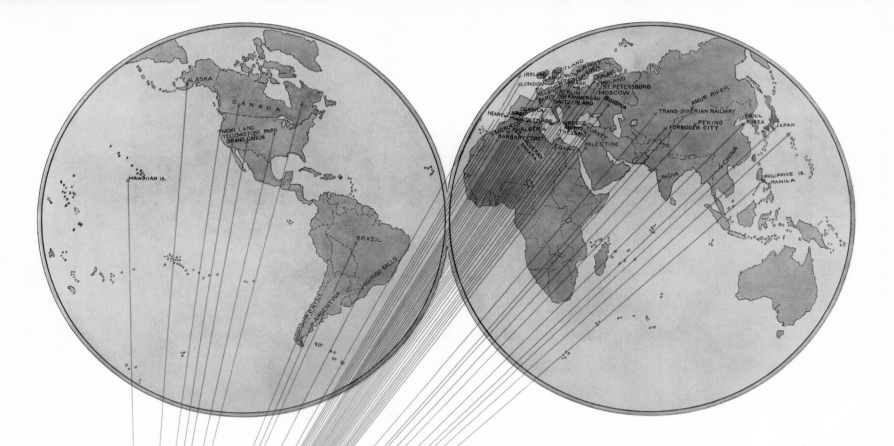

BURTON HOLMES

Acknowledged the World's Greatest
Traveler and Travel Entertainer

At the age of thirteen Mr. Holmes accompanied his parents on his first trip to foreign lands. So alluring did the journey prove that he became fired with an ambition to make travel his life work, and a few years later he found himself enjoying a full realization of this ambition. In 1893 he made his first professional appearance, since which time he has traveled more than a million miles in quest of the picturesque and the unusual, ever anxious to convey honestly and truthfully, whether by word or by camera, a true-to-life picture of his journeyings.

Mr. Holmes' matchless gift of portraying accurately each country he visits, investing it with its true local atmosphere, and the breath and kindliness of his view in depicting the national customs and the life of each individual nation place the seal of authority on the BURTON HOLMES TRAVELOGUES. To-day he is recognized as the world's foremost travel lecturer, welcomed and acclaimed by heads of nations and municipalities, vying with one another in doing him honor and in paying just tribute to his great work.

Hundreds of thousands who have been denied the pleasure and privilege of extended travel are able to speak intelligently and entertainingly of remote corners of the world because of access to Mr. Holmes' illuminating and fascinating descriptions. His travelogue pen-pictures rival in detail and fidelity-to-facts the productions of his matchless camera. No other traveler in the wide world possesses the detailed knowledge, the rich material and the genius for conveying these possessions to you as does Burton Holmes.

CONTENTS

**LEFT ADVERTISEMENT FOR TWELVE-VOLUME *TRAVELOGUES*
SERIES, PUBLISHED BY THE TRAVELOGUE BUREAU, 1919**
Burton Holmes, the peer of all travelers, stands ready to
escort you, wherever your fancy dictates, to whatever land
you may choose; swinging wide the portals that you may enter
and see each land in its proper setting and true local color.

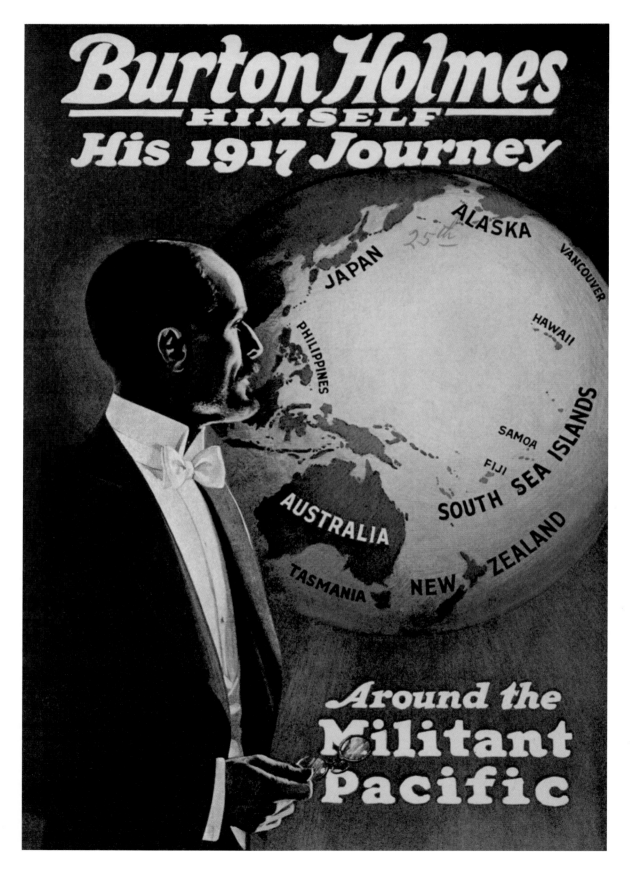

The dean of travelogues, one of the most widely known men of our time, sets forth on his final journey. Burton Holmes, eighty-eight years old, a man whose name was synonymous with the word travelogue. He invented it trying to escape the word lecture. He wanted a term to suggest entertainment rather than something educational or documentary.

The most popular platform figure of that day formally passed his mantle on to young Burton Holmes, who was born in Chicago in 1870. BH, as he was known to his associates and close friends, started out with black and white lantern slides, then slides hand-colored by inspired miniature painters such as Augusta Heyder of Newark, New Jersey.

His predecessor, John L. Stoddard, had been so successful that when he retired he bought a handsome castle in the Italian Alps at Cortina. Burton Holmes then came along and made many changes in the travel talk technique, for years using a combination of super-bly colored slides alternating with motion pictures. He was the first to do it. His audiences preferred to have him take them places where they themselves had been, to see again the chateaux of France, the hill cities of Italy, the castles in Spain, and so on.

Burton Holmes had many imitators, but none ever achieved any-thing like the success that was his. The greatest traveler of our time, perhaps of all time, one of the finest men I ever knew. Surely few men ever lived who had as many friends as Burton Holmes.

—Eulogy broadcast by Lowell Thomas,
 on the day Burton Holmes died, July 22, 1958

LEFT **LECTURE PROGRAM COVER FOR THE 1917 SEASON**

TO TRAVEL IS TO POSSESS THE WORLD

These words I have set down in many an autograph collector's book.

They are, I think, true words. I know that through travel I have possessed the world more completely, more satisfyingly than if I had acquired the whole earth by purchase or by conquest. There is no implication of selfishness in the kind of possession of which I speak. Whoever possesses the world through travel takes naught from any man. No one is the poorer because you have made the whole world yours.

You have gained everything, but you are no monopolist. The wealth is there for all to share. It is not yours alone. You may invite all men and women to travel with you in imagination and they too may feel that they, like you, are rich in vivid mental pictures of places worth going to, of people worth knowing, of things that are world-famous.

I have tried to convey to others with the spoken word the enthusiasm for travel that has been mine. I have done my best to make my hearers SEE the things that have thrilled me in the course of my more than sixty years of travel.

Now I am asked to do this without the aid of pictures glowing on a screen, without the help of the spoken words which can be made to mean as much by a shading of a tone or the stress of an inflection. Now I am at work with nothing but a sheet of paper and a pen to help me re-create the atmosphere of "otherwhere," to help me make real to those who have not seen, the things which I have seen and can still see so vividly with the mind's eye.

Word pictures are hard to paint. We are told that "words are the only things that last forever." Therefore words should be the most durable pigments with which to paint pictures of the things that have seemed worthwhile, the things that have become one's property, in the sense in which travel endows one with a title deed to the entire world.

One great advantage of possessing the world through travel is that one may enjoy all the satisfactions of possession without the responsibilities of ownership. Now, in days when our most valuable assets become or threaten to become our most crushing liabilities, it is good to contemplate property which cannot depreciate but must increase in value, property which cannot be taxed by federal government, or state or city authorities, property which calls for no repairs or alterations.

Everything from real estate to diamond tiaras has had its vaunted worth reduced to pitiful and sometimes complete inconsequence. Stocks, bonds, and all manner of gilt-edged, beautifully engraved certificates of value, to secure which we have slaved and saved and denied ourselves the joys of travel, may sink in worth to such a point that it will seem absurd to pay the rental charges of a safe deposit box.

The only things I own which are still worth what they have cost me are my travel memories, the mind-pictures of places which I have been hoarding like a happy miser for more than half a century.

I have done my best to convey with "word pictures" the things I have seen and can still see. I have been aided by all the increasing wonders and beauties of photography. I still recall with pleasure my first camera, a heavy clumsy box with six double holders for 4x5 glass plates purchased in 1883 with my life savings of $10.00.

In the past I have reproached myself for my extravagance, for my lack of foresight, for my disregard of proper provision for the future. My wise friends saved and economized, went without things they wanted, denied themselves the costlier pleasures of the table, the bouquet of vintage wines and the, to me, supreme joy of going places and seeing things.

And now where are we? We, they and I, are all at the same dead-end of life's highway. They are weighted down by all the leaden burdens of their golden hopes gone wrong. They have their memories but these are memories of wise, dull and frugal days of piling up of hard-earned dollars in safe places where those dollars would increase and multiply and be there to console for all the pleasures that their owners had denied themselves and all the fun that they had missed.

I, too, have nothing but my memories but I would not exchange my memories for theirs. I have a secret treasure upon which I can draw at will. I can bring forth, on the darkest day, bright diamonds of remembered joys, diamonds whose many facets reflect some happy dream come true, a small ambition gratified, a long-sought sensation, caught and savored to the full, a little journey made, an expedition carried to success, several circumnavigations of the globe accomplished.

Yes, it has been a good life. And it is good to rest, with nearly all of one's dreams realized. Dreams of going, seeing and doing most of the things that seemed worthwhile—good to know that I have, in my own way, possessed the world.

—Burton Holmes, 1953

BURTON HOLMES: THE BEAUTIFUL WAY AROUND THE WORLD

*"When you talk about comebacks
you don't need to include Burton Holmes, because
he never had to come back. He never was out."*

MILWAUKEE JOURNAL

When it opened to the public in 1891 New York's Carnegie Hall was the largest concert hall of its kind and the most luxurious of its day—2804 seats on five enormously tall levels, a lavish mahogany stage, with state-of-the-art acoustics unmatched anywhere in the world. Russian composer Peter Ilyich Tchaikovsky launched his triumphant tour of the United States by conducting the New York Symphony Society's Orchestra in a performance of his *Marche Solennelle* on opening night, and ever since then the stage has been graced by world leaders and luminaries from the worlds of classical music and jazz. Over the 60 years Burton Holmes presented his *Travelogues* around the United States, Carnegie Hall was a mainstay of his circuit; so much so that the hall, lacking a movie screen, accepted Holmes's offer to have one permanently installed so he could present his tales year after year.

From the day he purchased his first camera in 1883 until shortly before his death in 1958 (at age 88), Burton Holmes is believed to have seen and chronicled more of this earth over a longer period of time than anyone before or since. Often with close friends, and always with his two inseparable companions—a motion-picture camera and a still camera—he traveled to nearly every country in the world.

A brisk, immaculate man with a Vandyke beard, erect bearing and precise speech, Holmes's lectures remained a premier form of entertainment for six decades, playing to full houses in evening dress at the nation's finest theaters and auditoriums. Even when the public began flocking to feature films, Holmes's *Travelogues* remained largely unaffected, filling to capacity with ticket prices reaching $1.50, compared to the average movie price of a dime. In all, Holmes presented 8000 lectures between 1892 and 1952; each new season was an important winter social ritual for five generations of Americans.

Holmes always referred to himself as a performer rather than a lecturer—and perform he did, sometimes six shows a week, sometimes in a different city each night of the week. Summers he traveled abroad, photographing, filming and gathering material for his lectures; in the winter he would tour the United States with the *Travelogues*. Regular stops included Carnegie Hall, Symphony Hall in Boston and Orchestra Hall in Chicago—all top-tier venues where he played to the "opera-going" public. The lectures were carefully crafted verbal narratives, and he developed a style of delivery that allowed even those in the farthest rows to hear every word, since microphones were far in the future.

As a storyteller, Holmes had a smooth, elegant style of delivery that enchanted his public. But as a man, Burton Holmes was highly enigmatic. He enjoyed living well, but wasn't much interested in money. He loved comfort, yet traveled to the most remote parts of the globe. He appeared pompous, yet had a tremendously self-deprecating sense of humor.

In the course of his long and productive career, Holmes crossed the Atlantic thirty times, the Pacific twenty, went around the world six times, shot half a million feet of film and earned over five million dollars. It is said that *The Burton Holmes Travelogues* remain, with the exception of America's symphony orchestras, the longest-running show in history.

"YOU HAD TO DO IT ALL YOURSELF AND KNOW WHAT YOU WERE DOING"

Burton Holmes was born in January 1870, the only child of a wealthy and cosmopolitan couple, Ira Holmes and Virginia Burton Holmes. Virginia's father, Stiles Burton, was one of the "old settlers" of the promising young city of Chicago, Illinois.

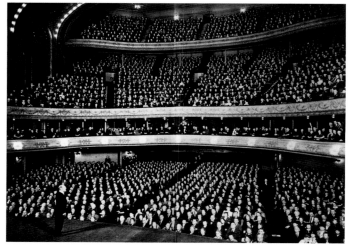

ABOVE BURTON HOLMES ON STAGE, CHICAGO, 1937
Orchestra Hall, Chicago, 2801 seats, filled to capacity with cash customers for Burton Holmes and one of his famous *Travelogues*. This shows one of his twenty-five Chicago Orchestra Hall appearances. Similar "scenes" greeted the world traveler throughout the country every season.

His grandson would inherit the wanderlust that had sent Stiles Burton across the ocean to Bordeaux as a young man in 1833. During a three-year stint in France, he had not only learned the French language but had acquired a keen taste for French wines and luxury goods; when he returned to America he returned with a full supply of imported foodstuffs. Chicago was still in its infancy, maturing from a village outpost around Fort Dearborn to a city in its own right, and the hardy pioneers fell hard for those new luxuries. That was the start of the Burton fortune—sizable, but fleeting—which at

its peak was worth several million dollars in Chicago real estate.

When Ira Holmes married Stiles and Ann Burton's daughter, their social standing in a now-booming Chicago afforded them friendships with leading icons of business: Marshall Field, of department store fame; George Pullman, originator of the sleeper railroad car; and a client who turned out to invent Listerine mouthwash, among others. The Holmes fortunes, however, fluctuated wildly. Burton's father was a brilliant man and a born gambler, playing always for the highest stakes—in business, in real estate speculation or on the Board of Trade. Once he pyramided a tiny capital of $250 into more than $800,000, on paper. In reaching for a million he lost it all, and with it the major portion of his wife's interest in the Burton fortune.

Young Burton saw vividly how tenuous were fortunes created of money, and came to an early conclusion that the world of finance wasn't for him. A born showman, he took instead to magic, and by the age of five had perfected a routine of tricks. The budding young magician's card tricks delighted family and friends, among them future U.S. President William McKinley, who lived with his wife in the same hotel in which the Holmes family resided: the Clifton House on Wabash Avenue. In later years, as a schoolboy, Burton and his friend George Ellery Hale (the future astronomer) modeled their own "Theatre Magique" show after that of Herman the Great, the leading magician of the time.

It was at the age of nine, however, that the boy caught a true glimpse of the man he would become. Grandmother Burton took him up the boulevard, a mere block from his new home on Michigan Avenue, to see an illustrated travel lecture on the renowned Oberammergau Passion Play given by the most popular lecturer of the day, John L. Stoddard. While Stoddard was not the originator of illustrated lectures, he was the first to give such presentations on a large scale as an artist, a scholar and man of letters, and he regularly drew crowds in the thousands. Holmes was enchanted and a career in magic suddenly paled in comparison to living such a life of adventure.

"Silly idea," said Grandmother Burton. "Mr. Stoddard is a highly educated and very cultivated man. No one has ever done what he is doing. No one can ever hold the public as he does." But the dream persisted, and for ten seasons Holmes considered himself to be Stoddard's appreciative admirer.

On the charge of lacking a "proper" education, Grandmother Burton turned out to be right. At the age of sixteen Holmes walked out of the old Harvard School for Boys; he had a fairly good record but had simply lost interest. Travel was the only education for him, and he would later say that his only diplomas were ticket stubs and paperwork from the Pullman Company, the French Line, the Cunard Line and Thomas Cook.

In 1883 the Illinois Industrial Exposition opened in Chicago. Thirteen-year-old Burton spent the entire summer combing every exhibit from every country until he knew them all by heart. The Expo also brought him into contact with his first camera, and he invested his life savings in a $10 outfit "for the amateur." It was a heavy and cumbersome box, fitted with a simple, fixed-aperture lens and supplied with six double plate-holders for 4-by-5-inch glass plates. Exposures of up to several seconds were required even in bright sunlight and a litany of darkroom supplies were also acquired: trays, chemicals, red lantern and glass graduates. It was time to "make" a picture. He and a friend took a streetcar to a park and Burton made his first photograph, of a tramp sleeping on an old park bench.

Holmes later commented on his first years learning the art: "There was for me the fascination of magic in photography. There were then few amateur photographers. The layman knew nothing of darkroom mysteries. The word *Kodak* had not yet been coined. You could not press the button and let someone else do the rest. You had to do it all yourself and know what you were doing."

"THROUGH EUROPE WITH A KODAK"

In 1886 Grandmother Burton was planning an abbreviated grand tour, and since Burton had already left school she invited him and his mother along. The fires of the young man's imagination were already well stoked by childhood stories of Ann and Stiles Burton's travels to France, Egypt and Russia in the 1860s, but this was his first legitimate adventure. The three sailed across the Atlantic on the flagship of the Cunard Line, the *Etruria*, then the largest, fastest, finest ship afloat and the pride of the British mercantile marine.

It was his first trip to Europe—pure excitement restrained only by the fact that Grandmother Burton insisted on maintaining a strict schedule, which put a damper on his photography schedule. Edinburgh, London, Hamburg, Paris—all celebrated cities he knew from books were now real and waiting for his camera—especially Paris, which left a heightened impression on the young man. It was here that he first encountered his beloved Café de la Paix. He took a seat at the corner sidewalk table, which, according to Parisians, rests on the very spot where the axis of the universe impinges upon Paris. Holmes couldn't have agreed more, and visited that table every time he returned to the city.

Four years later he returned again to Europe for a longer grand tour with the same traveling companions, and

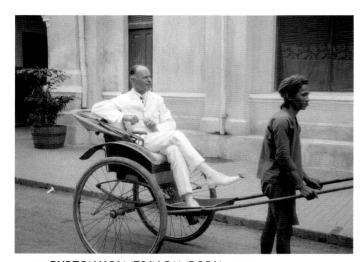

BURTON HOLMES IN CAMBODIA, 1925

Holmes relished the world's varied forms of transportation, as evident in his description of this photo: "The rikishas in Cambodia are an improvement over the old carts of remembered journeys to Asia. The chair seats are comfortable, the springy movement delightful, and the automatic stride of the rickisha driver inspires confidence as he bears me safely around this ancient place."

again a camera (by now, a Kodak, introduced by George Eastman in 1888) went along as a first-class cabin passenger. Holmes was now twenty years old and already a proficient photographer with an eye for composition. It was during this trip that Holmes had the thrill of his young life. At the Passion Play in Oberammergau, Germany, he had the good luck to be seated next to John L. Stoddard, king of the lantern lecture circuit. During the fifteen acts of the Passion Play, the sage and

his disciple would form a friendship to be renewed again on other tours.

By now Holmes was the secretary of the Chicago Camera Club, which he had joined after purchasing his first camera, and like all members was expected to show lantern slides made from his travel negatives. He prepared a show of unique Kodak negatives for the monthly meeting. Members had been accustomed to a terse "This is the Milan Cathedral"—long pause—"This is the Grand Canal"—another pause, and so on. But Burton had another idea.

He found a double dissolving stereopticon that would fade the pictures one into another without any shock of change. To "take the edge off the silence" and keep the show moving, he spread his comments evenly over the entire sequence of slides so his narration was perfectly timed to the pacing of projected images. The novel flow of the show pleased the club, and one bright member suggested that since it sounded almost like a Stoddard lecture, it might please a larger public. This stroke and a nudge was all Burton Holmes needed.

Funds were borrowed for studio equipment, a hall was hired and advertising cards were displayed in shop windows announcing a lecture on "Through Europe with a Kodak," by a member of the Chicago Camera Club. Thus, Holmes's first lecture was discreetly anonymous.

The public lecture was a success, luring 350 American dollars into the club's treasury. The thought of that $350 lingered in Holmes's mind, but he spent the next year at various odd jobs—collecting rents, selling real estate, selling photo supplies—with the occasional travel interlude.

THE MAGIC LANTERN

In 1892, aching with wanderlust, Burton Holmes borrowed the necessary funds from his family and set out on a five-month tour of Japan. Upon boarding the ship, Holmes discovered that Stoddard was a fellow passenger. They renewed their friendship and Holmes was surprised to learn that Stoddard actually disliked Japan, and was simply stopping there on his way to an extended tour of Asia. He invited his budding young rival along; Holmes, surprisingly, declined.

This decision was fortuitous. At Yokohama, Holmes was the first ashore, where he registered for a room at the Grand Hotel. In those days Japan was still tradition-bound, brimming with the charm of ancient times and not much influenced by Western culture. From the moment he arrived there, Holmes experienced a sense of déjà vu; he felt he had lived in this exotic country before. He deliberately avoided the port cities, populated by Westerners living as they did at home, and focused his efforts on the interior—areas where Occidentals rarely traveled. This first trip deep into the Orient garnered photographs of a culture and people rarely seen by outsiders. He fell under the spell of Japan—the kinship was so strong that he adopted the kimono dress at home in America—and despite some disillusionment with the place in later years, the charm never was broken.

While delighted with the photographs resulting from the Japan trip, he felt they needed something more. In Yokohama, Holmes became acquainted with two local watercolor artists, surnames Tamamura and Enami, whom he engaged to hand-color his own glass lantern slides. Soon Holmes was commissioning work from Chicago-based artist Katherine Gordon Breed, whom he credited in early programs as developing "The Breed 'Nature Process'" of artistic color work, and, by 1901, also artist Helen E. Stevenson. The colorists were so

proficient that they were able to tint each individual slide using single-hair ermine brushes, with results nearly as accurate as modern color film. Holmes had an incredible memory for the colors he saw and was able to communicate remarkably precise hues and shadings to the artists. From that time on, all the lantern slides included in his lectures would be in color.

The Financial Panic of 1893 had almost wiped out what was left of the family fortune by the time he returned from his first "Oriental" journey. The question of making a living hung ever more in the balance, and rather than return to a dreary job in a photo shop Holmes decided to risk it all and invest instead in a one-man show. He said of his daring new venture: "The vast public which had made Stoddard so successful for a generation was still out there. Why not try for those easy-chair travelers as my own audience. I had no money, no manager—but I boldly leased the Recital Hall for a course of four lectures. My brother became my manager—on my expectations."

On November 15 and 22, 1893, at the age of twenty-three, Holmes presented his first bona-fide, paying public travel lectures: "Japan—the Country" at eleven o'clock in the morning and "Japan—the Cities" at eight o'clock those evenings. For months he had painstakingly prepared the tinted slides and his scripts, two 12,000-word discourses, suiting paragraph to picture and picture to paragraph.

His mother's personal list of social contacts, her "visiting" list, furnished most of the 2000 names and addresses to which his first lecture announcements were sent, plus selected addresses from *The Blue Book*. To his surprise, advance ticket sales were brisk—elegant cash customers would drive up to Holmes's home in Brougham or Victoria carriages to select their seats. He kept a cashbox in the parlor and became his own box office man. The balance sheet of the short "season" showed at $700 profit. *The Burton Holmes Lectures* were launched at last. Holmes recalled in his 1953 autobiography, *The World Is Mine*:

"It required some skill for the smooth running of the equipment and the timely projection of the colored slides, and that could make or break the lecture. But an experienced operator and the stereopticon could be rented from the McIntosh Battery and Optical Company. Then someone who had occasion earlier to use their equipment advised me to demand that the operator sent should be Oscar. 'He's the only one that has any sense.' So I demanded and got Oscar; and thus began my happy, life-time association with Oscar Bennett Depue.

"Oscar set up his outfit and we had a dress rehearsal. I insisted on dispensing with signals. No clickers, no pounding on the stage with a pointer, no flash of light from a little lamp nor tinkle of bell to mar my show and warn the public that it was time to change the picture on the screen. I wanted the show to move smoothly, to create the illusion of travel, not to be just an exhibition of lantern slides. I wanted the talk to lead up to and introduce each picture, which must come on at just the right moment. The picture must not be seen until the audience had been prepared for it and was expecting it. Nor must the picture be delayed even a second, nor must it linger longer than was necessary for the telling of its illustrative story.

"To achieve this, very careful scoring of the text was necessary. Certain words or brief phrases in the body of a sentence were underlined. These were the cues for changing the slides, underlined phrases on a cue sheet, which the operator could scan from time to time and hearing the magic words, would know that it was time to 'turn the chromo' in the magic lantern."

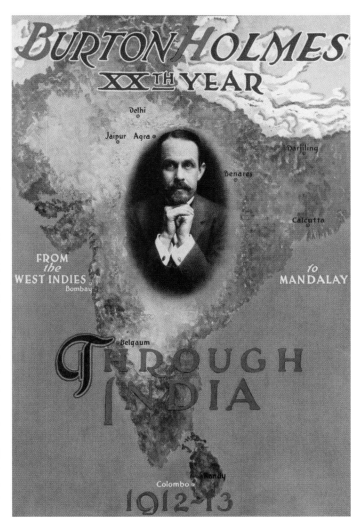

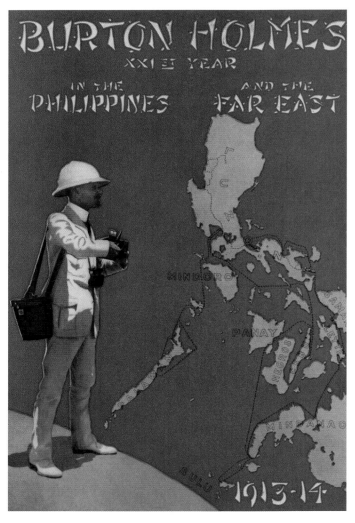

LEFT **LECTURE PROGRAM COVER FOR THE 1913-14
SEASON**
"As with mail carriers, neither snow nor rain nor heat,
nor gloom of night stays Burton Holmes from the swift
completion of his lecture tours..."
—*Burton (Massachusetts) Herald*

After playing to full, appreciative houses and making a profit, Holmes felt he was on his way. Never mind that it was in front of a very supportive and well-heeled hometown crowd. An attempt to take Milwaukee by storm with the same Japanese lectures failed and he was once again broke. Still, he had now decided on this form of lecturing as the ideal way to finance his trips. It wasn't that he wanted to lecture; it was that he wanted to travel. What better way to see the world without actually working?

It was a fine idea except for one difficulty: John L. Stoddard. Stoddard had dominated the lantern lecture circuit for nearly two decades. Holmes felt he needed new programs to compete with Stoddard, or at least to coexist with him. An excursion to Morocco was financed, again with borrowed money, and a striking show assembled, but to little avail. Audience loyalty was still with the old master.

Then the impossible happened: In 1897 Stoddard announced he was retiring to a villa in Italy—no explanation, no fanfare, he just retired and the market was open. He urged the theater and hall managers to look favorably upon the talented newcomer. Although all was not smooth sailing, the travel lecture circuit now belonged to Burton Holmes, and he filled the void with a vengeance.

"A MODERN MIRACLE ...
THE ILLUSION OF LIFE ITSELF"

While an obvious talent in his own right, Holmes's success was further secured by his close working friendship with the ingenious Depue, whose facility with the new medium of moving pictures gave Holmes a distinct advantage over Stoddard. With the introduction of film into his lectures, Holmes and Depue became motion-picture pioneers. In 1897, using a movie camera called a Chronophotographe, devised by Georges Demeny and manufactured by Gaumont of Paris, the pair made one of the first-ever motion pictures about travel subjects. Certainly, filmmakers like the Lumiere brothers had already broken ground with their scenes from the streets of Paris, but Holmes was one of the first to take a camera on the road to far-flung locations. In the case of countries like Korea, Japan, China and the Philippines, he was responsible for the first footage ever shot on their shores.

In those early years, the making of motion pictures depended solely on the ingenuity and ability of the cameraman. Together they worked tirelessly, innovating, inventing and initiating film techniques. Holmes intuitively "overcranked" the motion-picture camera to avoid the quick, jerky motion usually seen in old films, and once the two used a peephole in a closet door and a kerosene lantern to print motion-picture film.

The foreword of the *Burton Holmes Lectures* advertising booklet prepared for the crucial season of 1897–1898 read:

"In addition to the lantern slides in color there will be presented for the first time in connection with a course of travel lectures, a series of pictures to which a modern miracle has added the illusion of life itself—the reproduction of recorded motion. Mr. Holmes has secured the most perfect

BURTON HOLMES AT HOME IN A KIMONO EDITING SLIDES, HOLLYWOOD, CALIFORNIA, CA. 1930

"I found on returning home from that early trip to Japan, that it was not only pleasant but economical to wear Japanese dress when at work indoors. One morning, manuscript in hand, memorizing a lecture, pacing up and down my studio where many golden Buddhas gazed down upon me, my wife suddenly interrupted my dramatic rehearsal by introducing an Irish maid who had applied for a position. She never came back to take the job. We later learned that she had expressed herself to the agency in no uncertain terms: 'Niver on earth would I wurruk in such a flat with haythen idols all over the place and a man wandering around in a kimony.'"

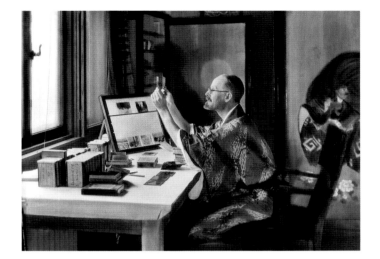

instrument yet invented for the projection of Motion Pictures. A different series will be shown at every performance after the conclusion of the lecture. The scenes will not be related to the subject of the lecture but will be varied in character."

The motion-picture scenes taken by Holmes and Depue were miscellaneous in character, absurdly so. A typical show ended in the projection of brief action scenes of the Omaha fire brigade, followed by a police parade in Chicago and Neapolitans consuming spaghetti, each reel running twenty-five seconds. The show's climax was always the first travel picture ever filmed: "St. Peter's Cathedral in Rome," the sole action of which was limited to the slow migration of a herd of goats. Holmes often wondered why this was the biggest hit of the program and always brought a laugh, until a member of the audience pointed out to him that halfway across the piazza one of the goats halted to take care of pressing business.

Holmes and Depue returned to Italy in 1897, filming and photographing the Grand Canal, the Doge's Palace and the feeding of the pigeons at St. Mark's Square in Venice. They continued on to Paris, where they filmed everyday life, from monuments to vegetable wagons. The novelty of his earliest "moving pictures" introduced a new magic to the old-fashioned lantern slide show, and the Stoddard public responded warmly. It took years for real success, but eventually Holmes absorbed Stoddard's audiences and won scores of lecture series subscribers throughout the nation.

But the attempt to fill the Stoddard dates in Eastern cities called for cash and courage, and Holmes had very little of the former. A sanguine friend of his however, Louis Francis Brown, had plenty of both and together with Depue they formed the Burton Holmes Lectures, Incorporated. Brown's up-front investment of $50,000 was considered to match

the existing tangible assets of glass lantern slides, lecture manuscripts and a few hundred feet of film. Brown would also begin a twenty-seven-year career as Holmes's manager, a role in which he was responsible for bookings and promotion. In time the two men were responsible for coining the term *travelogue* to advertise the show. The name was a hit, instantly associated with Holmes's unique presentation, and reminding ticket buyers that this was no staid lecture.

Holmes also decided early in his career to do as Stoddard had done in another regard and publish a series of travelogue books that would be both educational and entertaining to the general public. From 1900 on, he enjoyed great success with the elaborately illustrated books, which included photos and writings from his earlier lectures. The *Burton Holmes Travelogues* were published and reprinted over several decades in ten- and twelve-volume sets and he offered several additional supplemental volumes over the years. More than 40,000 sets were sold in his lifetime, and inspired other books later in his life.

"WHEN YOU LOVE YOUR WORK, EVERY DAY IS A VACATION"

If giving the lectures sounded like a fun and easy way to turn a profit, taking the trips and bringing home the product posed countless logistical challenges. A model of Victorian good manners, Holmes rarely mentioned suffering from fever or other maladies while on any of the three-month summer trips to more exotic locales; he never dwelled on the hazards or inconveniences of uncertain transport by stagecoach, horse-drawn carriage, train, riverboat, wagon, rickshaw, donkey, camel or even human bearer.

Certainly, there were advantages to a lifestyle that afforded him dinners with kings and personal tours by foreign diplomats, but Holmes was also scrutinized and even threatened by hostile chiefs and tribesmen; he experienced the bodily effects of strange foods, not to mention adjusting to hunger, thirst, searing heat, rain, muck, mud, insects and the wearying dust that blew onto and into the delicate camera mechanisms.

Although he claimed to be a devout coward, his actions over a half-century would suggest otherwise. He was shot at in Morocco for being an "infidel dog" and stood knee-deep in falling volcanic ash in Naples in order to photograph the eruption of Mt. Vesuvius. He filmed footage of German air raids from Paris rooftops in World War I, as well as documented front-line action during the thick of battle. Holmes would always claim that he left the dangerous forms of travel to men like Richard Halliburton and Lowell Thomas. But the record shows that as a life-long member of the Explorers Club he did, at times, live dangerously. Yet his travel companions commented time after time that Holmes always remained calmly good-tempered at the end of the day as at the beginning. He loved to say, laughingly, "When you love your work, every day is a vacation."

Imagine the logistics of planning faraway trips to unknown lands in a time before air travel: handling the professional equipment—delicate cameras, lenses, developing tanks, drying racks, large stocks of film—plus trunk after trunk of personal luggage to provide for the party's minimal comfort; then to face getting everything transferred to the local hotel upon arrival by any variety of conveyances available.

Immediately upon return to the United States, Holmes began the process of editing photographs, making the glass lantern slides, selecting film shorts, writing the lecture, and

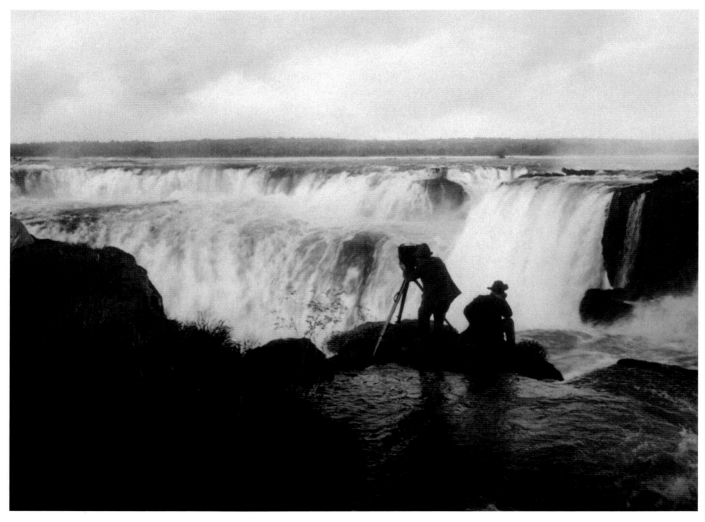

finally putting the lecture and the pictures together in a seamless whole.

Certain standards remained consistent over the years the *Travelogues* toured. Each show was two hours in length. In his early years the glass lantern slides were projected as Holmes delivered the lecture, then short twenty-five-second 60mm film reels were shown at the conclusion of the show. In 1902 Holmes switched to 35mm black-and-white film for slightly longer (but still short) movies, which he alternated with the slides. Occasionally, Holmes had the motion picture stock dyed amber, blue, green or pink, which, when alternated with the hand-colored slides, practically left audiences believing they had seen natural color images on screen. The *Burton Holmes Travelogues* followed this format until the 1940s, when the shows featured only motion pictures.

Changes in partners and staff also occurred over time. Louis Francis Brown died in 1925, and new managers entered the business, including William W. Westcott beginning in the late '20s, Walter T. Everest and Horner-Moyer Inc. in the '40s.

Oscar Depue continued to work with Holmes as his projectionist in key cities until 1916 when he became

LEFT **BURTON HOLMES AND CAMERAMAN OSCAR DEPUE AT THE IGUASSÚ FALLS, ARGENTINA, 1911**
"Each night, after a hard day of picture-making, the indefatigable Depue, would work with his developing machine, his tanks, bottles, and chemicals, set out in the moonlight on a tiny island in the stream nearest to the shanty where we lodged. After developing, we used the clean, flowing water for washing the film, then dried the long strips of negatives on a portable rack set up at the edge of the falls."

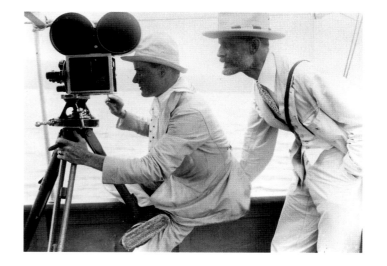

BURTON HOLMES AND CAMERAMAN H. T. COWLING AT LAKE BEIVA, JAPAN, 1917
Burton Holmes and cameraman, Herford T. Cowling, filmed fresh impressions of Japan for the upcoming season of lectures. Though Holmes had already traveled to Japan six times by now, the photos were absolutely new, because Japan itself was changing rapidly.

president of Burton Holmes Films, Inc. in Chicago. He also spent more time on his own career in later years, becoming known for his Depue Multiple Sound and Picture Printer equipment (a motion-picture printing machine) and other inventions that raised the standards of an infant American film industry. Other cameramen would become Holmes's traveling companions, including Van Wormer Walsh and, most notably, the widely respected Andre de la Varre, with whom he began to collaborate in 1924, and later Thayer Soule. Among the memorable journeys Holmes shared with de la Varre was a trek to Ethiopia for the coronation of King Haile Selassie, the first time anyone had been invited to photograph or film such an event in North Africa—where they had the pleasure of riding as "stowaways" on the special train of His Royal Highness the Duke of Gloucester.

Colorists Katherine Gordon Breed and Helen Stevenson were eventually replaced by Grace Nichols and Mildred Petry. As stated in the booklet *Burton Holmes and the Travelogue, A Life Story as Told to Lothrop Stoddard* (1939): "So richly colorful is the impression produced by their brilliant lantern-slides that audiences do not miss the color in the motion-pictures, which although in black and white, are always alive with action. Strangely enough, many who attended the lectures have for years insisted that Burton Holmes has *always* had movies in natural color—even before they were invented."

"THE MOST METICULOUS PRONOUNCER OF FOREIGN WORDS IN THE NATION"

By 1910, Holmes's career had flourished sufficiently to warrant a move from Chicago to New York City. He loved the roaring metropolis, and regarded it as the most interesting and significant city in the world. Manhattan offered everything he needed or wanted at that time and a few surprises as well. He had many East Coast friends, colleagues and, of course, his Carnegie Hall audiences, assuring him a warm welcome. To top it all off, the great ocean liners were practically berthed in his backyard when he decided to settle on Manhattan's Upper West Side. Finally, in 1920, he purchased a duplex apartment overlooking Central Park at 2 West 67th Street. He called his new home Nirvana as a reference to the peace evinced by his collection of Buddhas—one hundred in all, large and small. These Buddhas had been following him home ever since the first one crept into his trunk on his 1892 visit to Yokohama.

Before Holmes met his future wife, Margaret Oliver, he had only been associated with one romance worthy of the gossip columns. It was widely speculated that he was engaged to fabulously wealthy actress-cum-decorator Elsie de Wolfe. Once, while visiting Denver, a reporter asked Holmes if they were to be married. Homes replied, curtly, "No." That afternoon a banner headline declared "BURTON HOLMES REFUSES TO MARRY ELSIE DE WOLFE!"

Shortly afterward, during a photographic excursion, Holmes met Margaret Oliver, a still photographer in her own right. Born deaf, Margaret was an expert lip reader. She was socially at ease, a cultivated, well-traveled young woman. A courtship followed and on March 21, 1914, after a moonlit proposal on a steamer's deck, Holmes married Margaret in New York's St. Stephen's Episcopal Church. He took her to prosaic Atlantic City for the first few days of their honeymoon, before embarking on a long trip motoring through the British Isles. Always an adventure, their trip was cut short by the onset of World War I, and the two returned home on a second-class refugee ship to Montreal.

Holmes always said he was extremely fortunate to have married the *right* woman, and Margaret shared his world for nearly forty years. Not only did she accompany him on many future trips, she also helped in the real work of picture making, preparing the stills for the lantern slides, and later in the organizing, indexing and filing of thousands of black-and-white negatives taken over the years.

In 1927 the couple decided to split their time in America between New York and Hollywood. Holmes loved the atmosphere of hopeful make-believe prevalent there and, after renting for a few years, he and Margaret purchased a home he named Topside in the hills high above Hollywood. They filled their home with memorabilia and art objects gathered from the four corners of the world and it became another showplace.

The 1930s were a golden time in star-studded Hollywood. Holmes fit right in; he was a star himself. He produced dozens of travel shorts for Metro-Goldwyn-Mayer in those years, and narrated them personally in four languages, a fact noted by fans and press alike. The *Chicago Daily Tribune* once commented, "The most meticulous pronouncer of foreign words in the nation is Burton Holmes, who makes a hobby of languages." His film *The Real Hollywood* was popular with audiences and included his friends Douglas Fairbanks and wife, Mary Pickford, Dolores Del Rio, Jean Harlow, Pola Negri and Laura La Plante, all of whom were regulars in Topside's social calendar.

"YOUTH SEEMED TO BE FOR ME, EVERLASTING"

Over his lifetime Holmes was presented with countless awards, among them the Cavaliere Crown of Italy, Comendador of the Order of Isabel la Catolica, the Golden Honor

"He has transformed the travel lecture into an art, of which he is the greatest living master."

CHICAGO DAILY TRIBUNE

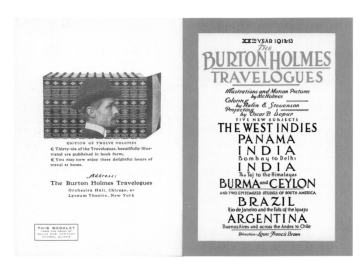

Cross of the Austrian Republic, the Grand Star of Ethiopia and a star on the Hollywood Walk of Fame. But it wasn't for the glory—or the money—that Holmes chose his way of life.

Holmes traveled for pure reasons: He wanted to see the world, and he was open to what he would see. He loved his life and the cycle of traveling to new and different places every summer and talking about the experiences to his loyal audiences every winter. Yet he wasn't blind to the dangers around him. He felt even in the 1920s that Japan was moving in a potentially dangerous political direction and, as early as 1934, Holmes feared the Nazification of Germany was putting that country on the road to future conflict.

By 1936 it was becoming increasingly difficult to stay ahead of the audience—advances in travel made trips to another continent more accessible, and motion pictures had evolved from a novelty to a sophisticated form of entertain-

ment. Holmes had spent a summer broadcasting live from the Century of Progress Exposition in Chicago (1933) for NBC and his films on travel and life in Hollywood enjoyed a significant following, but the burgeoning medium of television was on the horizon, and times were changing.

During the years of World War II, Holmes kept his journeys to the United States, taking train tours and motoring jaunts through the states to savor their particular beauties. Holmes commented, in his autobiography, "Without respite the years rolled on. Without repose, which was something I never felt the need of, the decades passed. I had not time to age. Youth seemed to be for me, everlasting... As long as there were countries that I did not know, I could see no reason for retiring." Each season found the elegant and polished Holmes back at Carnegie Hall in New York, Orchestra Hall in Chicago, the Academy of Music in Philadelphia or the National Theater in Washington, D. C., delivering his lectures before sell-out audiences.

Burton Holmes and his crew remained "on the road," making motion pictures of places, close and far away. Holmes did eventually retire from the public platform and legitimate stage in 1952, and died peacefully at home in Hollywood on July 22, 1958. His *Travelogues* had always been presented with that special warmth of true friendship, of sympathy and understanding, and despite competition from television and motion pictures, audiences still put on their finery and lined up every winter to allow the distinguished gentleman with the white goatee and tuxedo to take them out of themselves and into another place.

Genoa Caldwell, Archivist
The Burton Holmes Historical Collection

LEFT **INTERIOR PAGES, "THROUGH INDIA" LECTURE PROGRAM FOR 1912–13 SEASON**
This season included Holmes's most popular lecture to date, on the construction of the Panama Canal, among other exotic offerings.

RIGHT **JAPANESE CHILDREN READING A BOOKLET ABOUT THE *TRAVELOGUES*, CA. 1940**
"To the traveler, the children of Japan were always a delight with their polite manner, their respect for others—seeing a group of children together was always a joyful, lovely sight."

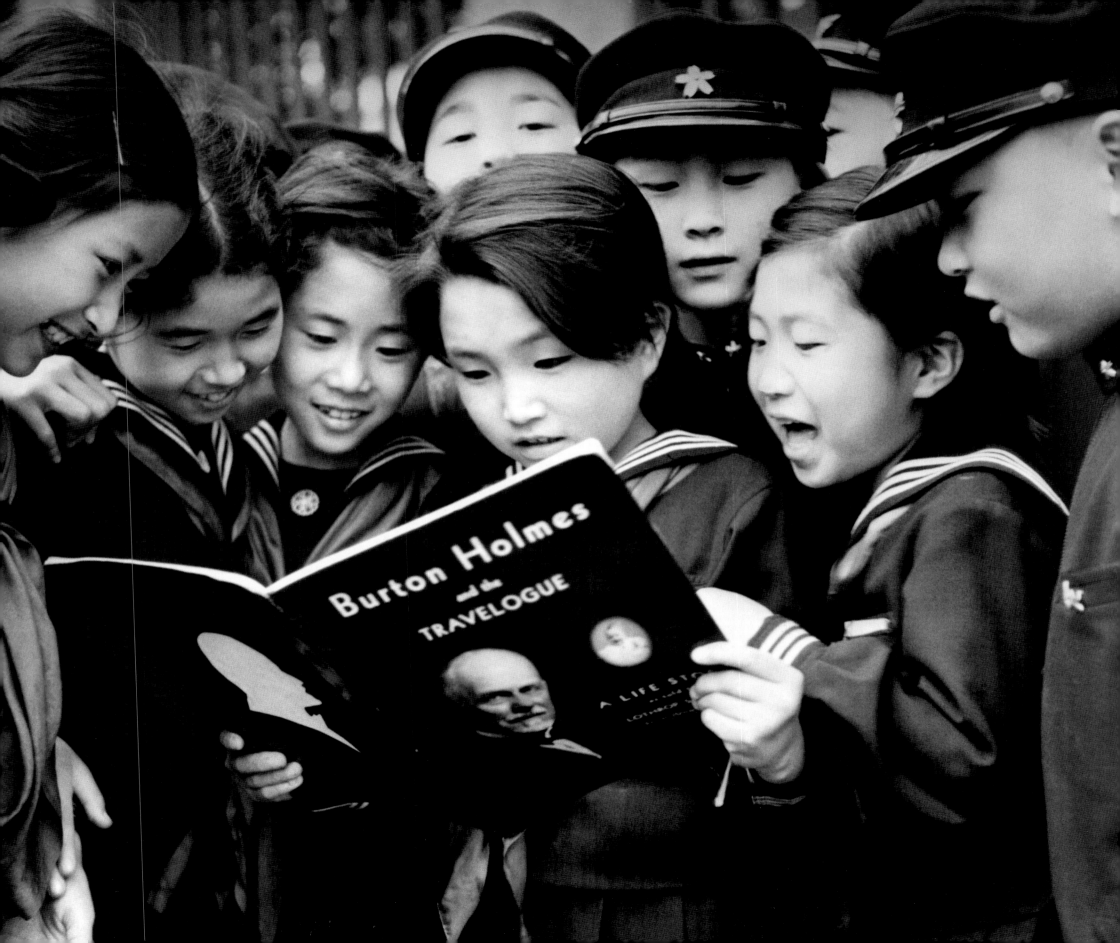

EDITORIAL NOTE:

Unless otherwise indicated, the descriptive text in each chapter has been culled—and, in some cases, condensed—from the various writings of Burton Holmes, from 1892 until his death in 1958. While many of his descriptions come across as modern, we have retained the sometimes archaic punctuation and unorthodox spellings he employed. Among the sources, which are listed in the bibliography of this volume, are articles, programs, letters, lectures, and his multi-volume *Travelogues* series (published first in 1901, and then in updated editions over the years), as well as other books. Editor's notes are set in italics.

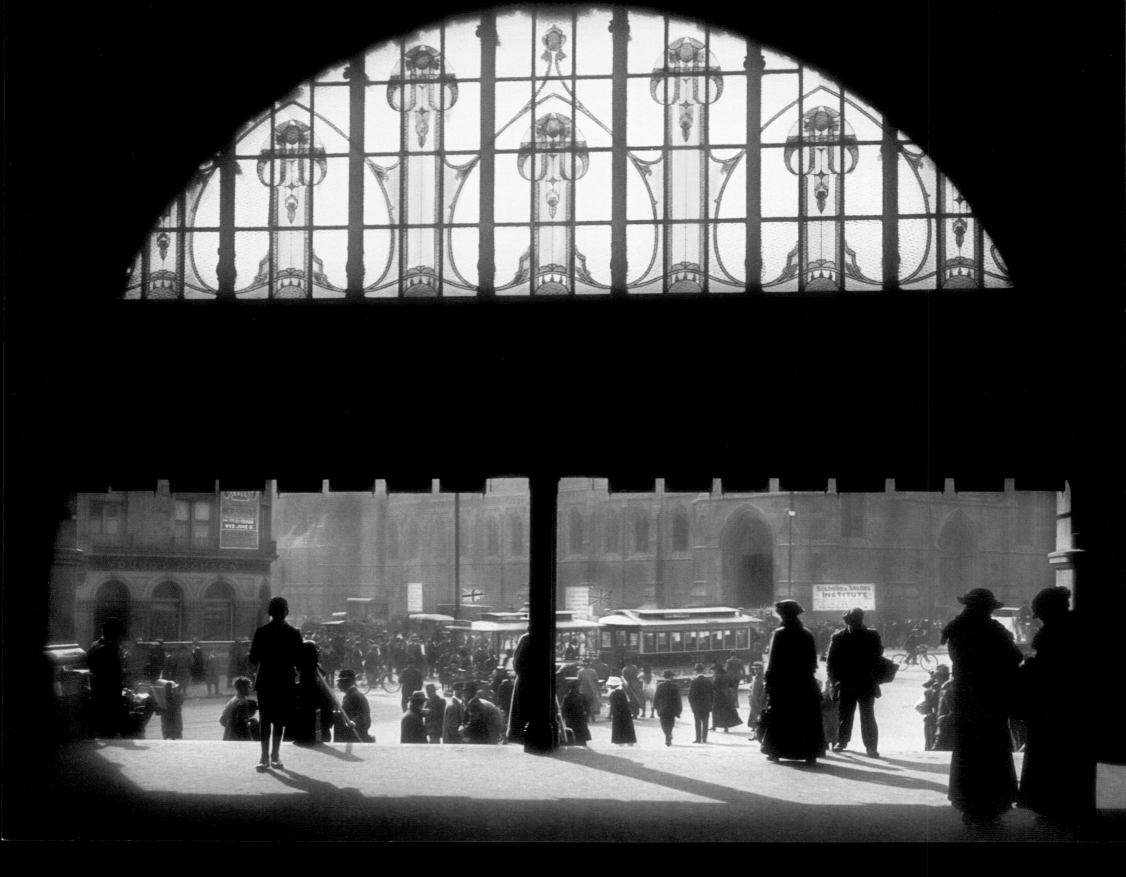

AUSTRALIA
A COUNTRY THAT COVERS A CONTINENT

Australia is the only country in all the world that covers an entire continent; it is an ancient continent that is the flattest, driest continent on the earth. It has mountains, a high desert plateau and a beautiful coastline; it is a land rich in interest and varied in character. We are making only a short visit to Australia this year because of the turmoil of war and the uncertainty of travel in such times. But I take with me the desire to return to spend a longer period exploring Australia's vastness, and in the future present a fuller picture of its uniqueness and uncommon beauty to our American audiences.

The building with a central heating plant is almost unknown in Australia. The shivering visitor has the option of paying for a fire that won't burn or an electric heater which merely looks hot and does not heat. Keeping warm in Australia is a purely personal obligation, something to be attended to at your own expense, something that is no concern of the hotel proprietor nor of the owner of a building.

I went one evening to a concert in the grandiose town hall of Sydney; as I entered the huge concert auditorium, I thought that the entire audience was smoking. It was not. It was merely breathing! What I thought was smoke puffed from a thousand lips was merely the breath made visible by the low temperature. Nobody seemed to mind—ladies in evening dress snuggled into their heavy wraps—men kept their ulsters on—I turned my collar up and wished that I had brought a steamer rug. I began to understand why the Russian pianist pounded the piano so hard; he, too, was trying to keep warm.

As with so many former colonies, the governing hand of the white man now holds the aboriginal race in close subjection to his will. The coming of the white man with his ships and guns and gospels was the beginning of the end of the isolated Australian aborigine. *[1917]*

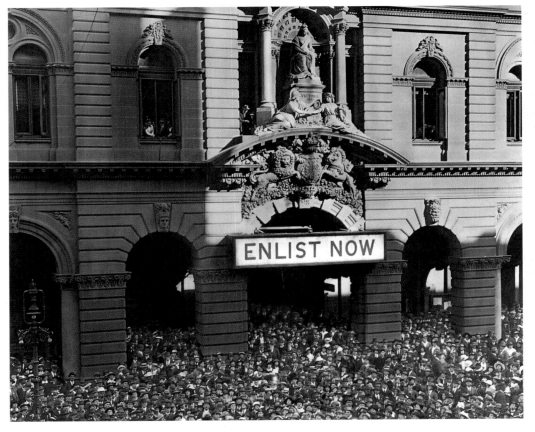

LEFT **FLINDERS STREET RAILWAY STATION, MELBOURNE, 1917**
Melbourne's Flinders Street Railway Station is a grand baroque terminal, its portal crowned by an elegant Art Nouveau archway of stained glass.

RIGHT **RECRUITMENT RALLY, WORLD WAR I, SYDNEY, 1917**
The civic center of Sydney is in Martin Place, a short wide street upon which front the finest buildings of the city. If anything happens in Sydney, it is sure to be in Martin Place. The enlistment campaign found here its logical headquarters in the heart of the city with its downtown recruitment centre. Every day at noon, vast crowds were harangued with soul-stirring appeals to enlist in the army and help save the Empire.

BELOW **YE OLDE CHINA SHOPPE, SYDNEY, 1917**

RIGHT **PORT PHILLIP BAY, MELBOURNE, 1917**
A misty morning sunrise silhouettes a simple horse and cart
against the modern buildings of cosmopolitan Melbourne.

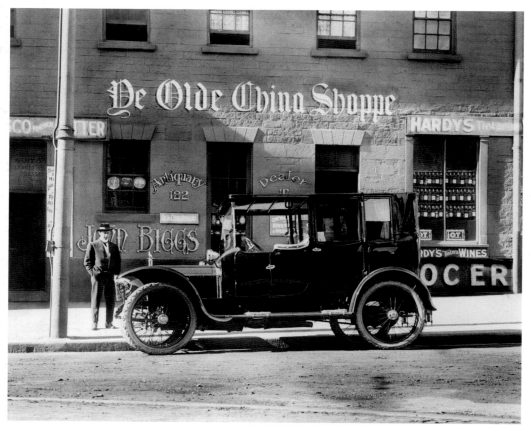

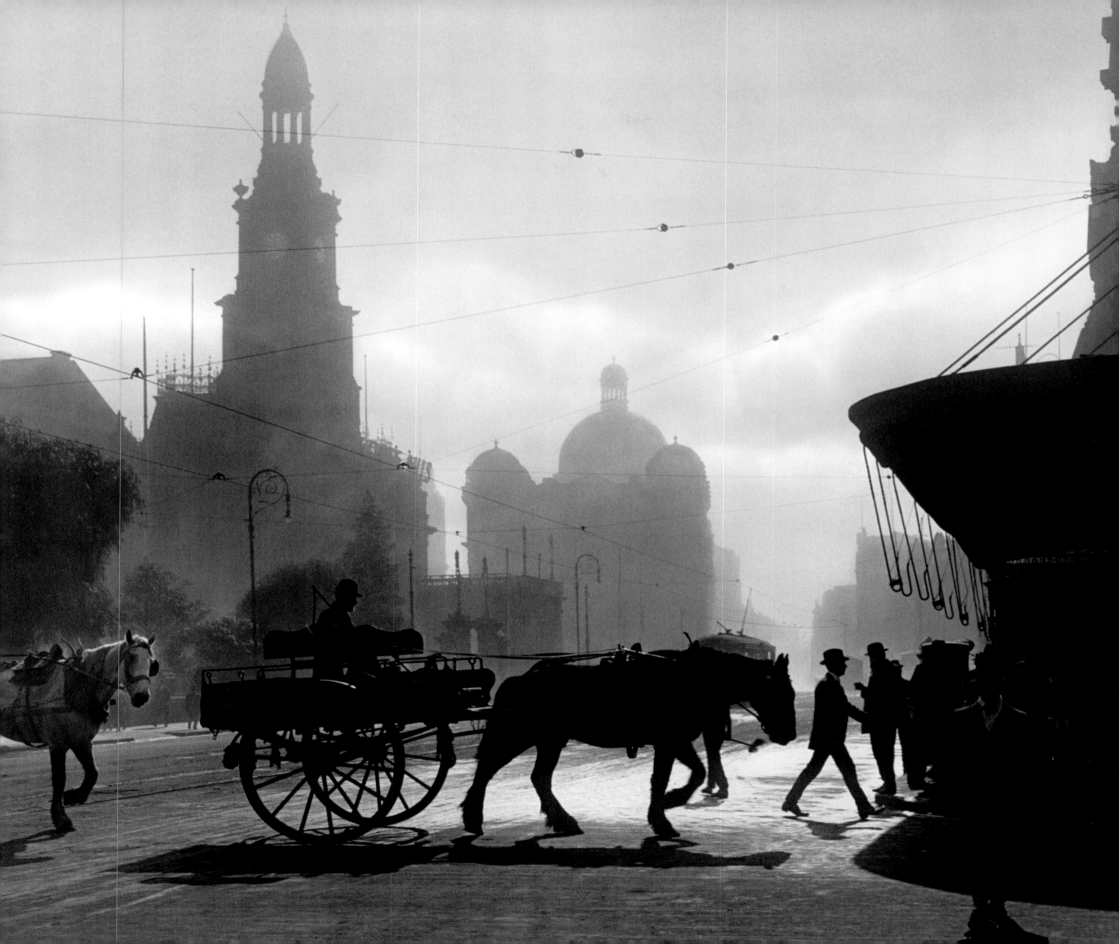

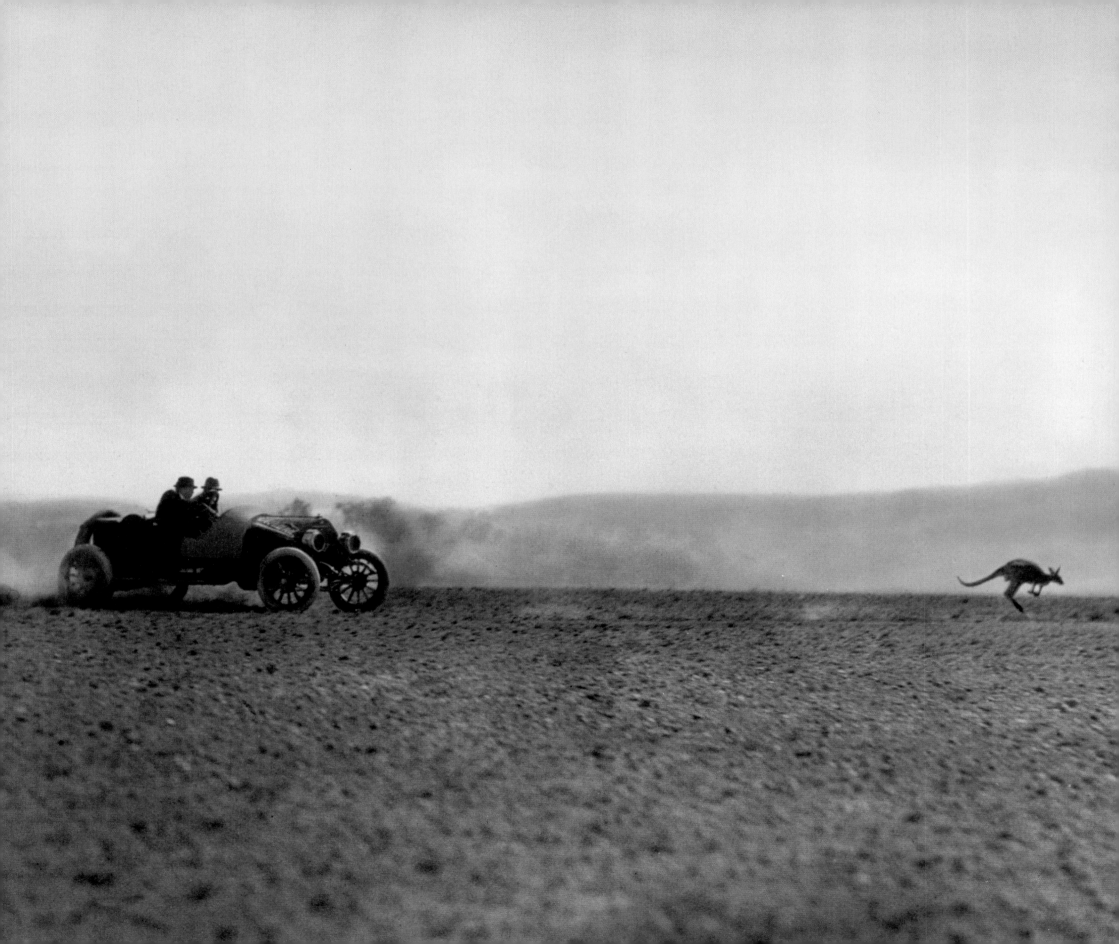

AUSTRALIAN OUTBACK, KANGAROO-CHASING, 1917
I asked where I could see the kangaroo in its native state.
Nothing is easier, I found, if you do not mind a rail journey
and a rough ride in a motorcar through the bush and out
upon the inland plains of South Australia, where the adven-
turous sportsmen of Adelaide go now and then to hunt the
wild marsupial from motorcars. The proposition promises
excitement—and the promise is usually fulfilled.

MUSIC TO THE EARS

Austria is a country of incredible natural beauty; deep valleys and cold Alpine streams abound, tall mountain ranges tower above the gentle hills of vineyards, forest and fields. Vienna, its capital city, was once the glittering center of the Austro-Hungarian Empire, and is, historically, one of central Europe's great cities. Music, art and literature have been the cultural hallmarks of the city, where the arts have flourished for centuries.

While visiting Vienna, I discovered my grandmother Burton liked horse racing. She suggested we attend one of the season's favorite highlights, the Vienna Derby, at the venerable racetrack, Freudenau, in the Prater. That memorable day spent watching the gallop horse races, mingling with others on a day's outing and brushing sleeves with the Viennese elite while dining—plus the study of the impressive architecture of the racetrack itself—added immeasurably to my education. *[1890]*

The Grand Opera House is a superb edifice on the Ringstrasse, a great boulevard built by Emperor Franz Joseph, which yields in splendor only to its Paris rival. In fact, if one has never seen the latter, the Austrian temple of music will seem unsurpassed in the sumptuous decorations of its staircase, portico and foyer; while the auditorium, which has a seating capacity for two thousand five hundred, is decorated far more pleasantly and with less ostentatious gilding than that of Paris.

Late-comers to a performance in this opera house are not allowed to disturb the audience already assembled. No one is permitted to take his seat during the overture; and in Wagner's operas, where there is no intermission between the overture and the first act, those who come late are not allowed to go to their seats until the curtain falls. *[1907]*

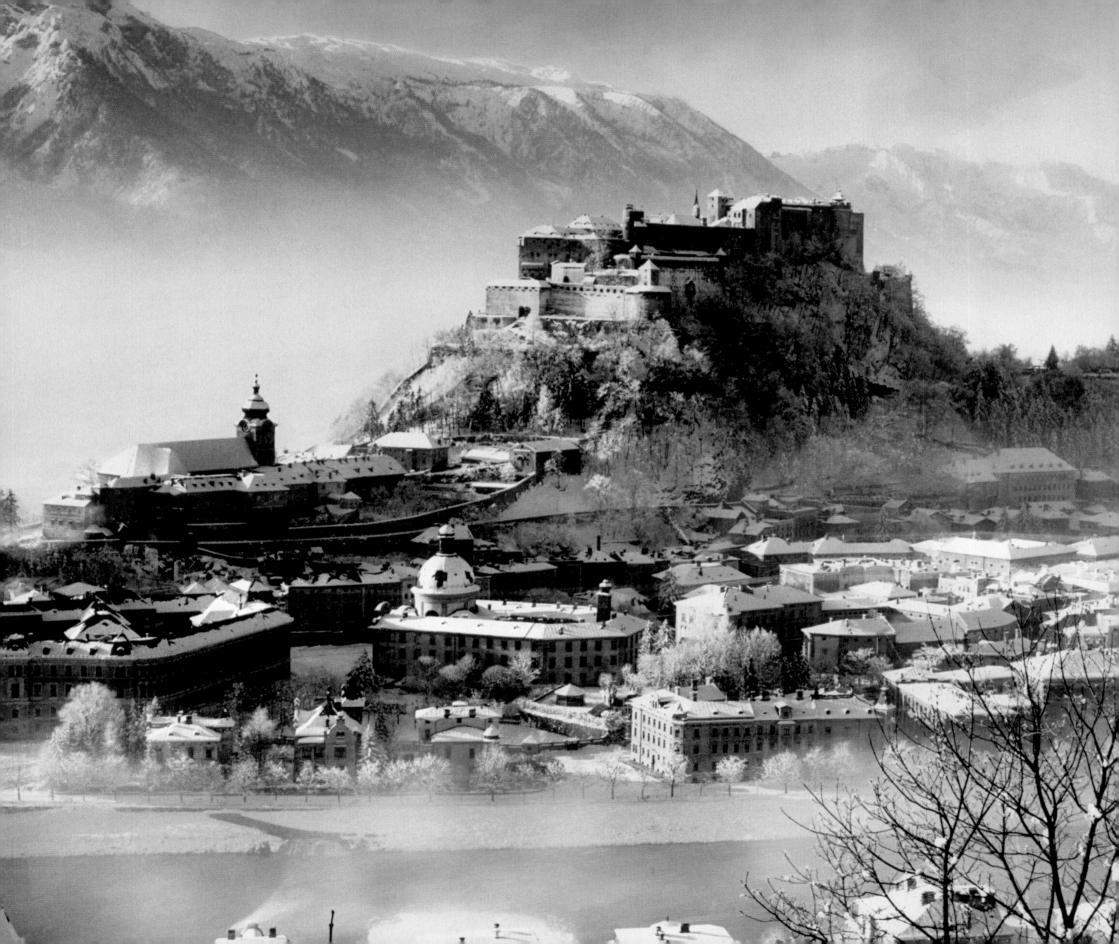

LEFT SALZBURG, 1907

Salzburg is without question the chief showplace of Austria, the most attractive of the Austrian cities, the one most visited by lovers of the picturesque. Born in Salzburg in 1756, Mozart is the chief celebrity of the city and they keep his memory fresh by means of monuments and tablets and all manner of reminders.

BELOW THE IRON CROSS, AUSTRIAN ALPS, 1907

We climbed in the misty darkness that preceded dawn, and found ourselves at sunrise on the ridge, where the fog suddenly forsook us, unveiling all the awful isolation of the ghostly crest on which we stood. We reached the *Kleinglockner*, then scrambled down and crossed that awful place between the peaks; and scaled the white, ice-crested pinnacle of the *Großglockner* and stood at last beside the iron cross atop that peak. There is just room for the cross—a tall cross, two-thirds of which is now buried in the snow that is heaped five feet deep on the apex of the mountain. And there we stood looking out upon a sea of vapors not less than a full hundred square miles in extent. The whole world had been overwhelmed, submerged and blotted out, save for the rocky tip of the greater Alpine peaks, which now and then thrust themselves above the surface, like the heads of drowning giants struggling in a rush tide.

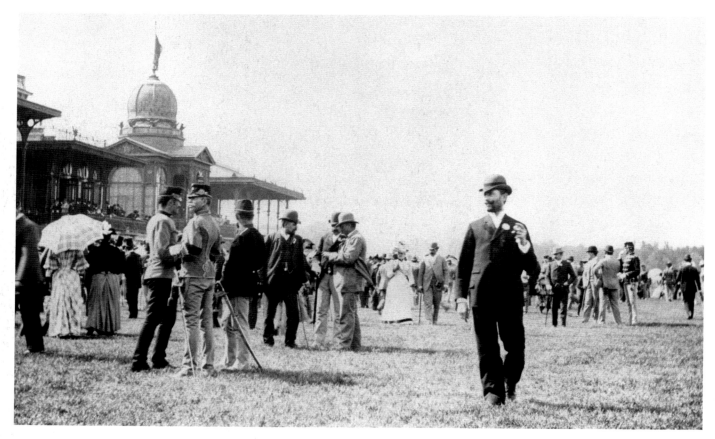

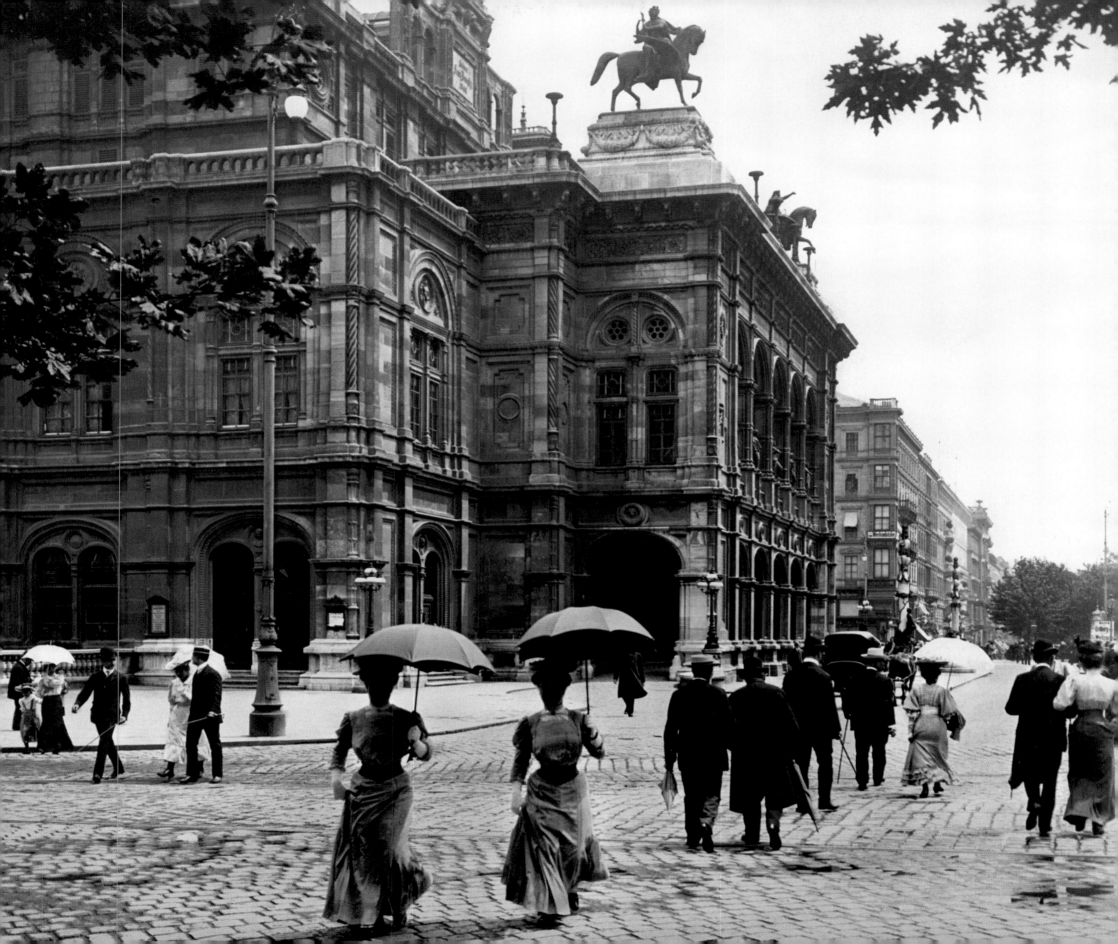

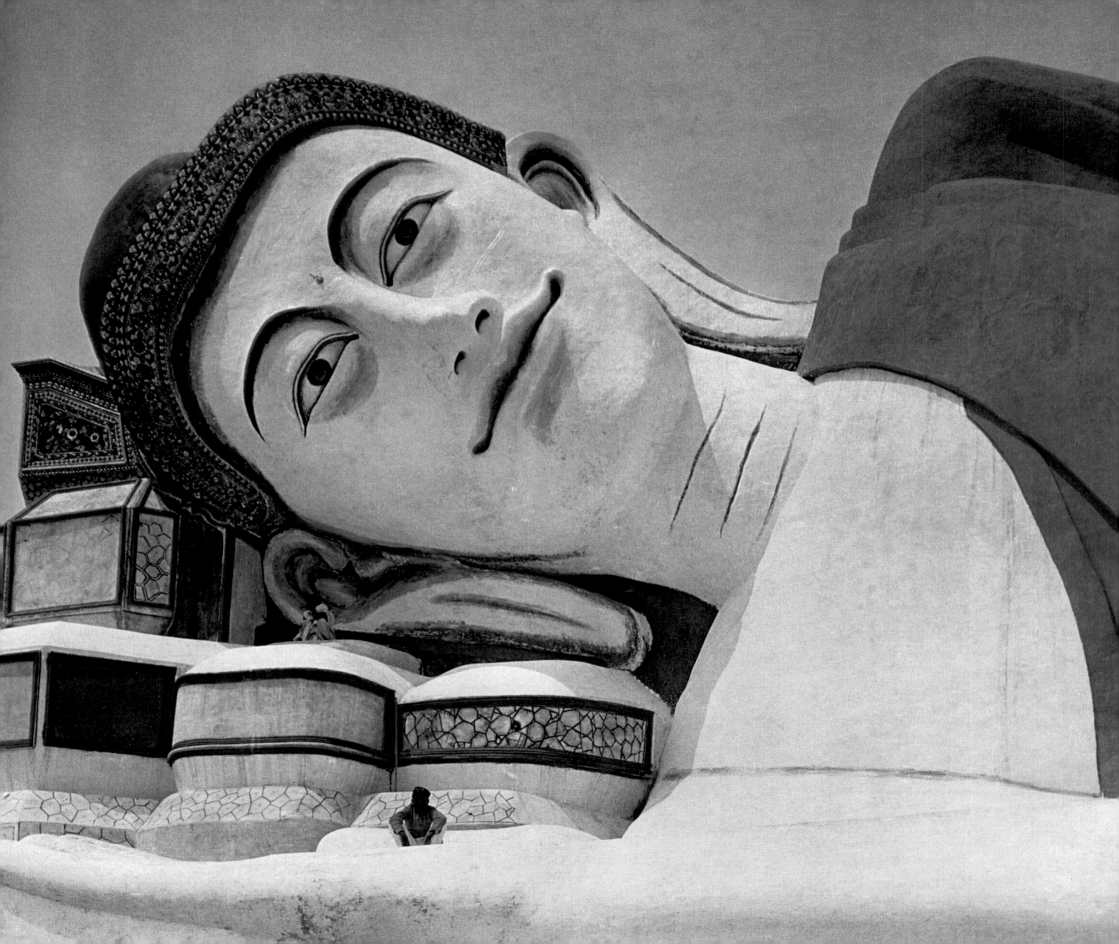

GOLDEN TEMPLES

Beautiful Burma! The loveliest land of England's Oriental Empire. The land is Buddhist, the people gentle, cheerful, and in contrast to the religion-obsessed races of the Indian peninsula, delightfully human, approachable, congenial. To the traveler stunned by the overwhelming splendors and oppressed by the equally overwhelming squalor of India itself, a little ramble in this land of lightheartedness, among peoples of a gentler faith and even quainter customs, serves as a delightful "after cure."

The usual mode of travel on the China Sea is by small steamer. Our fellow-travelers on the ship are not the least interesting feature of the trip; young and old, bareheaded, fezzed or turbaned, packed in by hundreds, they still maintain a certain poise and dignity peculiar to the Oriental, even under the most adverse conditions. *[1925]*

An immense festival of much pomp and splendor took place in Rangoon while we were visiting the city. We had never witnessed so opulent a celebration, which spread out over several acres. The largest structure was a gloriously ornate golden pavilion, sort of a stage-like platform filled with officials, dignitaries, and military personages. On all sides, as far as you could see, were large crowds with parasols, a variety of elaborate temples and multi-layered stupas, as well as a huge paper elephant float pulled by too many men to count. The whole wonderfully exotic scene stunned me into unaccustomed silence, and I never asked anyone what we were celebrating. *[1912]*

LEFT **SHWETHALYAUNG BUDDHA, THE RECLINING BUDDHA, BAGO, 1912**
The magnificent, boldly painted statue of the Reclining Buddha at Bago is said by the Burmese to be relaxing, not sleeping, for his eyes remain open. The enormous stone Buddha, built in 994 AD, rises six stories and is said to be one of the most life-like of all the Buddhas.

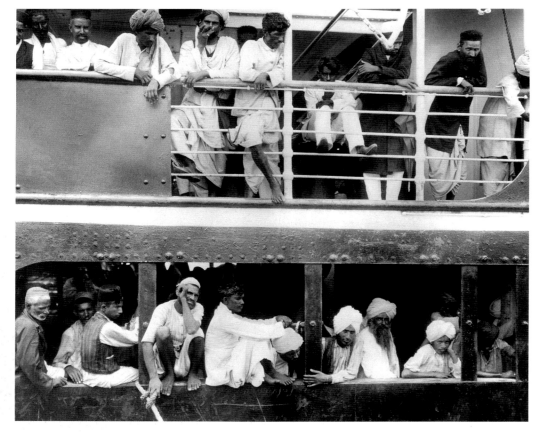

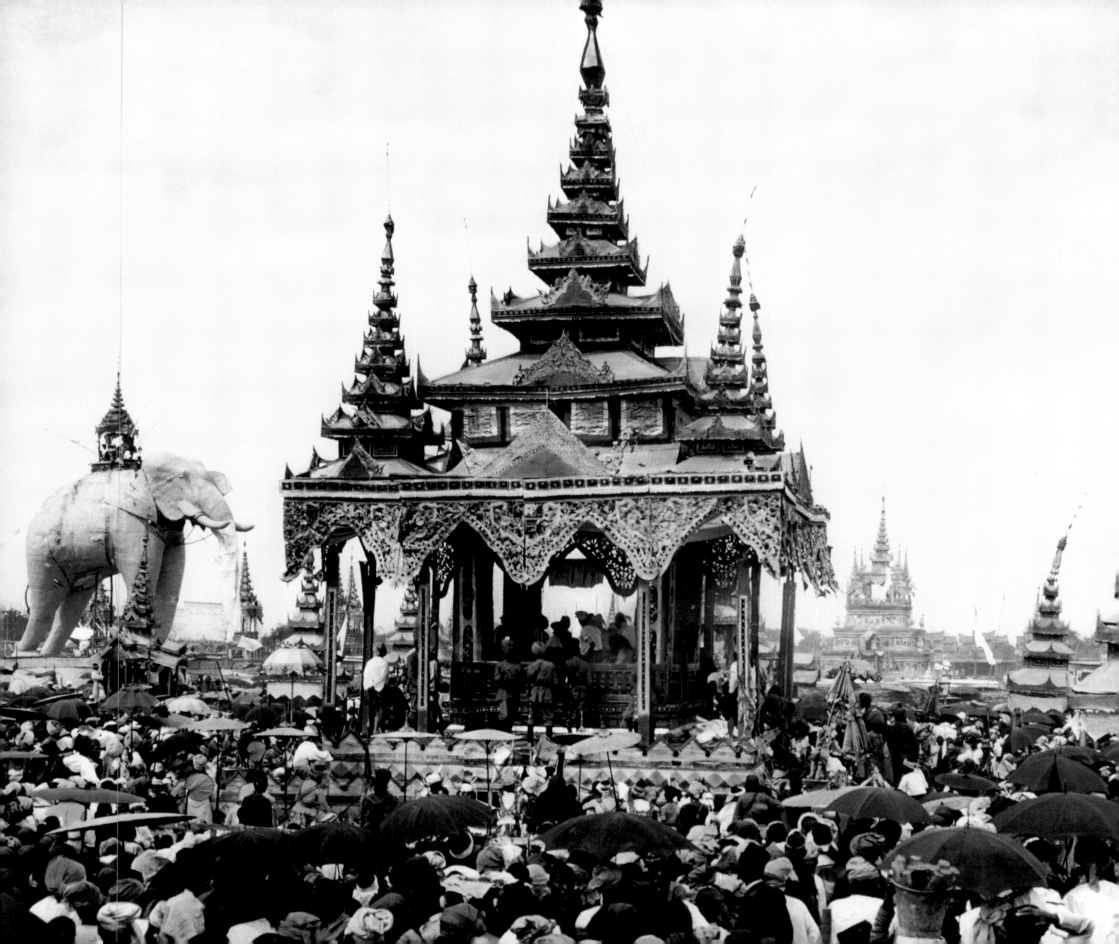

LEGACY OF THE KHMER KINGS

Cambodia tells the tale of wonder and ancient history, of lost kingdoms and ancient Khmer peoples, of a disappearing yesterday—now transforming the people and landscape—and preparing them for the stress of an undreamed of tomorrow.

The amazing Angkor Wat, the crowning creation of the Golden Age of the Khmers. This apotheosis of a forgotten art dates from the early twelfth century. It was not quite completed when the mighty Empire mysteriously fell, the population ebbed away, the jungle crept in and reclaimed the site, and the glories of Angkor began their slumber of six centuries here in the silent tropic wilderness.

There is a troupe of ballet dancers at Angkor Wat, poor village girls, well-trained in the one great surviving art of Old Cambodia, the Lakhon or the Classic Dance. Their teachers are two old women who were once royal dancers in the harem of the King. These village girls evoke for me the remote ceremonies of the vanished past. Thus did they greet and offer tribute to the ancient, half-forgotten gods, for in their dance I saw repeatedly that classic gesture of a gracefully uplifted but uncanny hand, the finger and thumb poised according to the canons of a classic art, and offering of lotus blossoms in a gesture of pride, humility, and adoration to the gods of a great people. [1925]

RIGHT ANGKOR WAT, ANGKOR, 1925

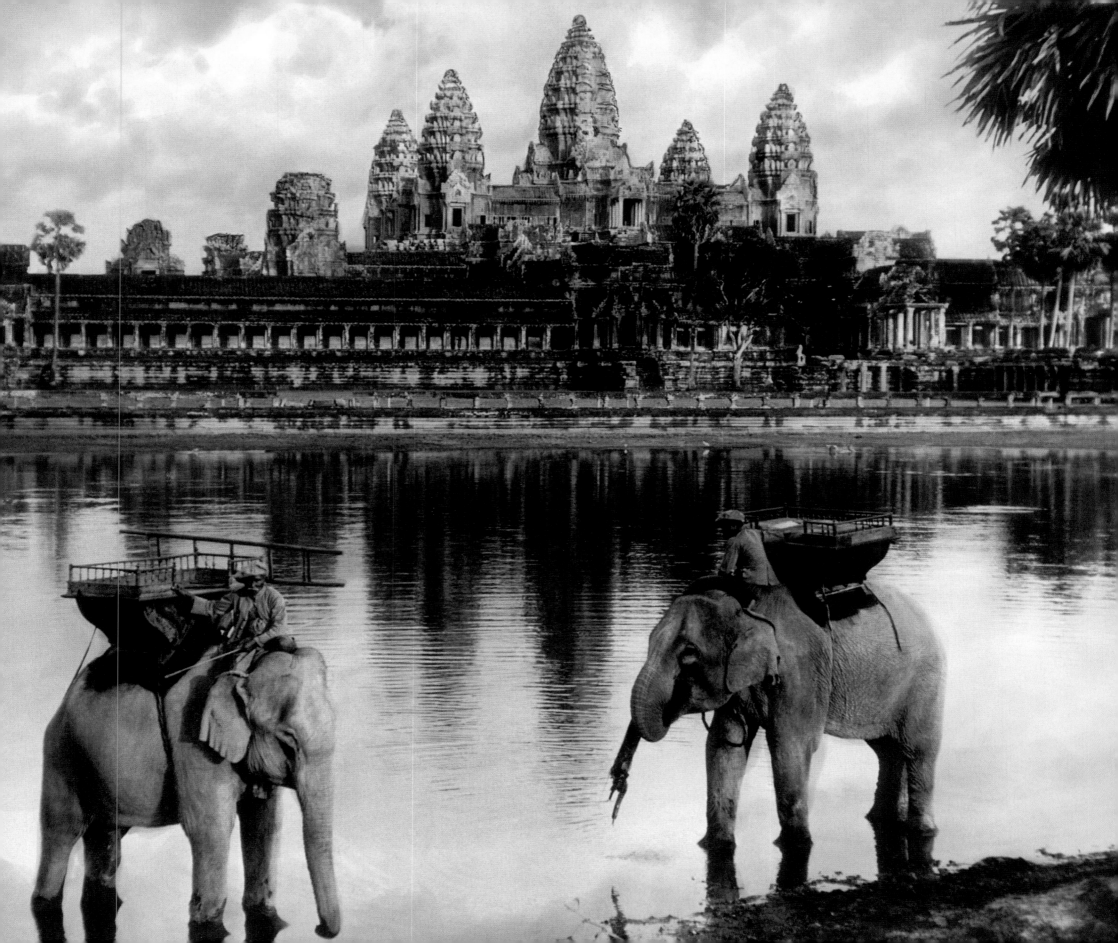

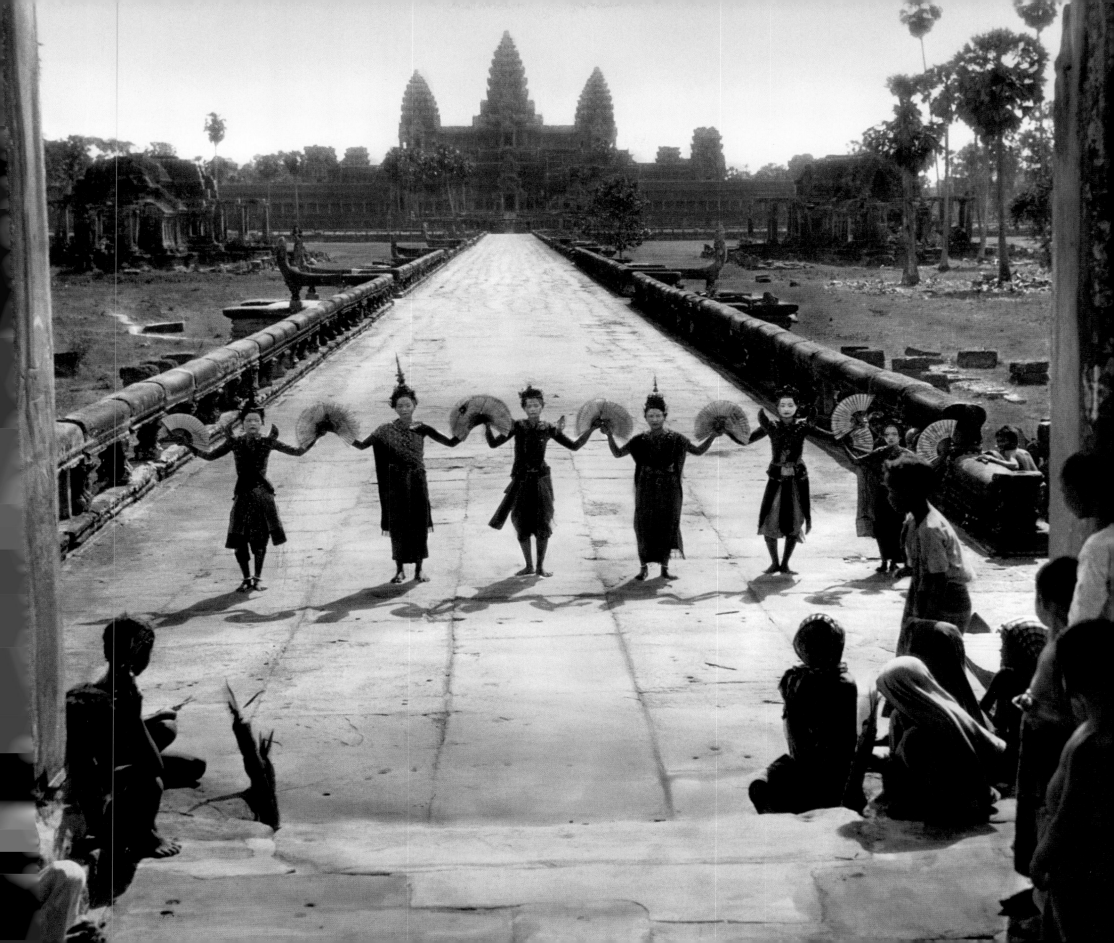

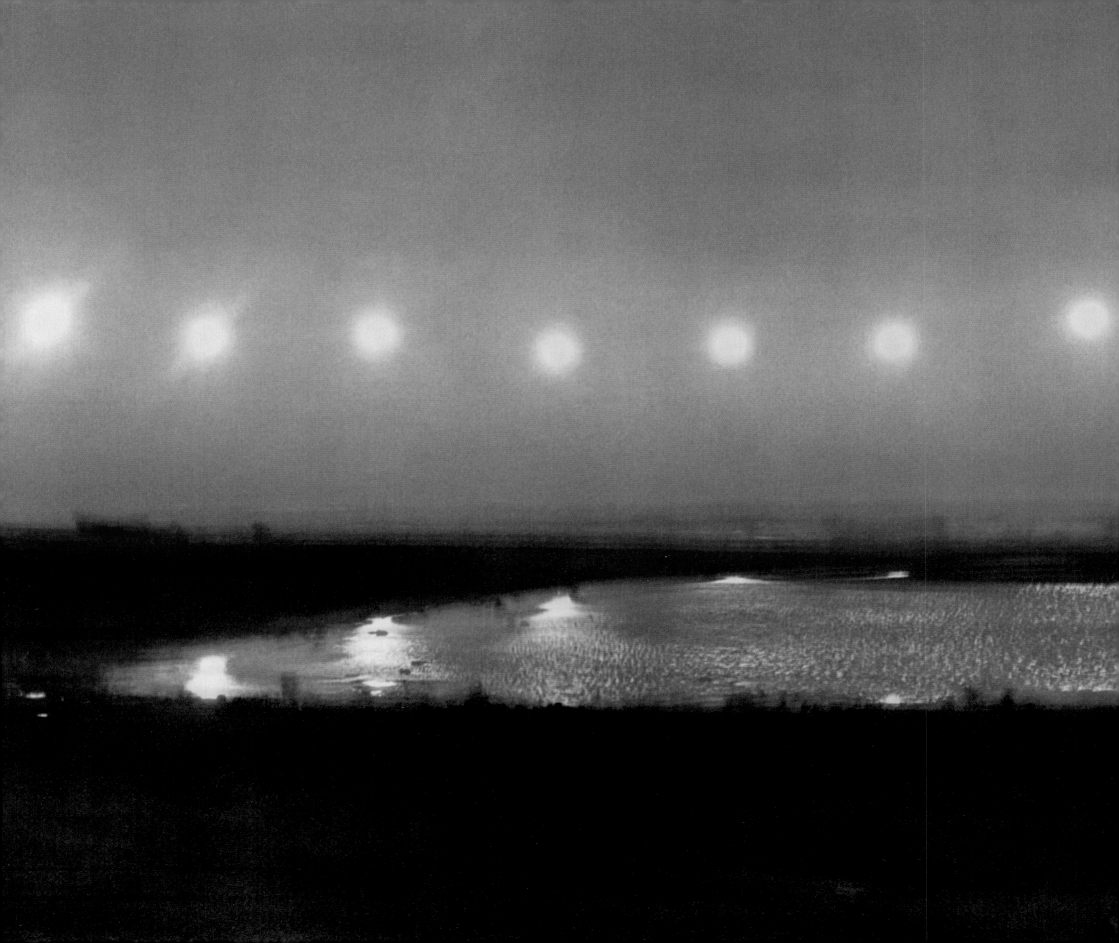

GOLD RUSH IN THE KLONDIKE

The whole history of humanity's quest for gold has been epitomized in the last several years by the sensational series of events that followed the finding of gold in 1896 in the far northwest corner of the continent. Within a few short years, a vast, almost unknown and unpeopled region has become one of the most discussed, most variously peopled, and most rapidly progressive regions in the world.

Alaska and the Klondike as they are today are among the most amazing facts of our new century: yesterday a wilderness with heroes fighting epic battles with the elements; today a land of towns and cities with happy homes and thriving business enterprises. Where in the world is there a region which within 2000 days has been rushed from lonely desolation into the dignity of an established commonwealth? *[1903]*

LEFT **THE PATH OF THE MIDNIGHT SUN, THE ARCTIC, 1903**
Here near the summit of the world, the sun does not appear to sink right down to the horizon as in the old familiar sunsets we have so often watched. Instead, it glides from left to right along the horizon, in a downward trend so slight that for an hour it seems to hover just a little bit above the line between the waters and the sky. Still there is a lowest point in the low downward arc described by the slow-moving sun. That point is due north, and as we gaze along the ship's compass, we see the sun will reach that point soon. Gazing northward from the mouth of that vast Arctic inlet many a thrilled and happy traveler has beheld in all its midnight glory the golden sun setting and—without disappearing—rising again to begin another daily course around the Arctic horizon.

ABOVE **ON THE PACIFIC OCEAN, LEAVING VANCOUVER, BC, 1913**
There are two ocean pathways across the wide Pacific. One begins at the Golden Gate and the other at the Strait of San Juan de Fuca. We chose the northern route because it is the shortest and the coolest, because the ships are wonderfully fine, because the railway ride through the Canadian Rockies is a magnificent experience with which to initiate a summer journey.
Our ship, the Empress of China, sister to the Empresses of India and Japan, when we first see her at the Vancouver wharf from the windows of our approaching train appears as small as a yacht, for we have come from the depths of the Fraser where mountains were piled all around us. But she seems big enough when once we are on board, for there are few ships afloat that offer roomier accommodations than the Canadian Pacific Empresses. There is not time to dwell upon the voyage itself, but I must at least confess that I have never more thoroughly enjoyed a voyage at sea. Conditions of weather, service, and accommodations I have never seen surpassed; and as for speed, well, we traveled all too swiftly across this fascinating summer sea.

When crossing Canada in 1916 and in the private car of the President of the Canadian Pacific, Lord Shaughnessy, it was thought advisable by the sponsors of our picturing tour of the Dominion that Mrs. Holmes and I should be entertained by the Royal Governor-General in Ottawa. "It will be well," they said, "for you to meet the Duke and Duchess and the Princess formally; then when you arrive at Banff out in the Rockies, where they will be in residence for the summer, you will be privileged to be received informally—and that's more fun."

So, formally, we drove up to Government House in Ottawa—in a battered Ford taxi, Model T. It was the only car at the Ottawa station when our train pulled in. I had been told that a motor would be in readiness to take us to Government House. "This is the car," the taxi man insisted. "I have taken many important visitors up to his Royal Highness's in this very car; this isn't England, you know."

But once within the mansion it was England and England with a vengeance. A lady secretary and an aide-de-camp received us and introduced us to a dozen other guests, among them political folk from the Province of Quebec. When all the expected guests were assembled, a door at the far end of the long room was opened and in marched Duke, Duchess and Princess. After a word of greeting for each invitee, the Duke asks briskly, "Well, shall we lunch?" We find our places at the long table. I am at the left of our hostess, who was born Princess Louise of Prussia, but who as wife of the uncle of King George of England, had just come from a farewell ceremony in honor of Canadian troops leaving that very day for France to fight the Germans.

I had been warned not to ask questions and not to introduce any topics for conversation. Royalty must have the first word and the last. This rather cramps the style of the free-born citizen of the U.S.A. I tried to do my best and not say the wrong thing. The table service was extremely expeditious. Before I had my second sip of soup, the plate was gone.

BELOW **THE DAWSON CITY FIRE DEPARTMENT, 1903**
Talk about readiness; here stands Dawson City's lone fireman and his rolling stock, in front of his hastily-built fire headquarters in a hastily-built wooden town.

RIGHT **THRIVING GOLD RUSH TOWN DAWSON CITY, 1903**
Though Dawson was a busy place, I found a large leisure class. Its members sit or stand there all day idle, nor do they seek that any man should hire them. They bestir themselves only when the sun begins to bleach the sidewalk, transferring themselves with an air of injured dignity to a shady stretch of sidewalk just around the corner.

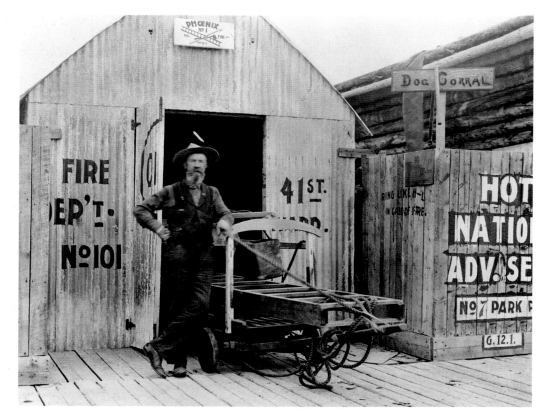

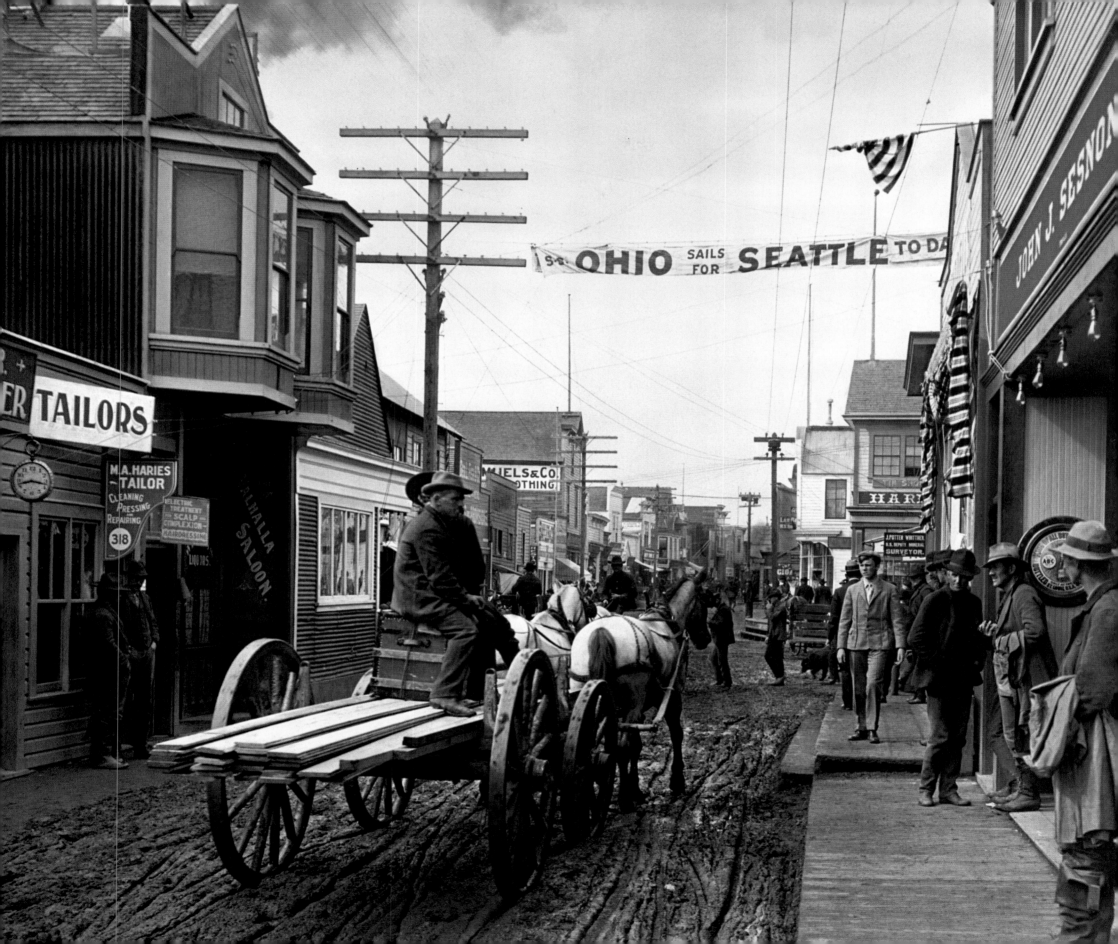

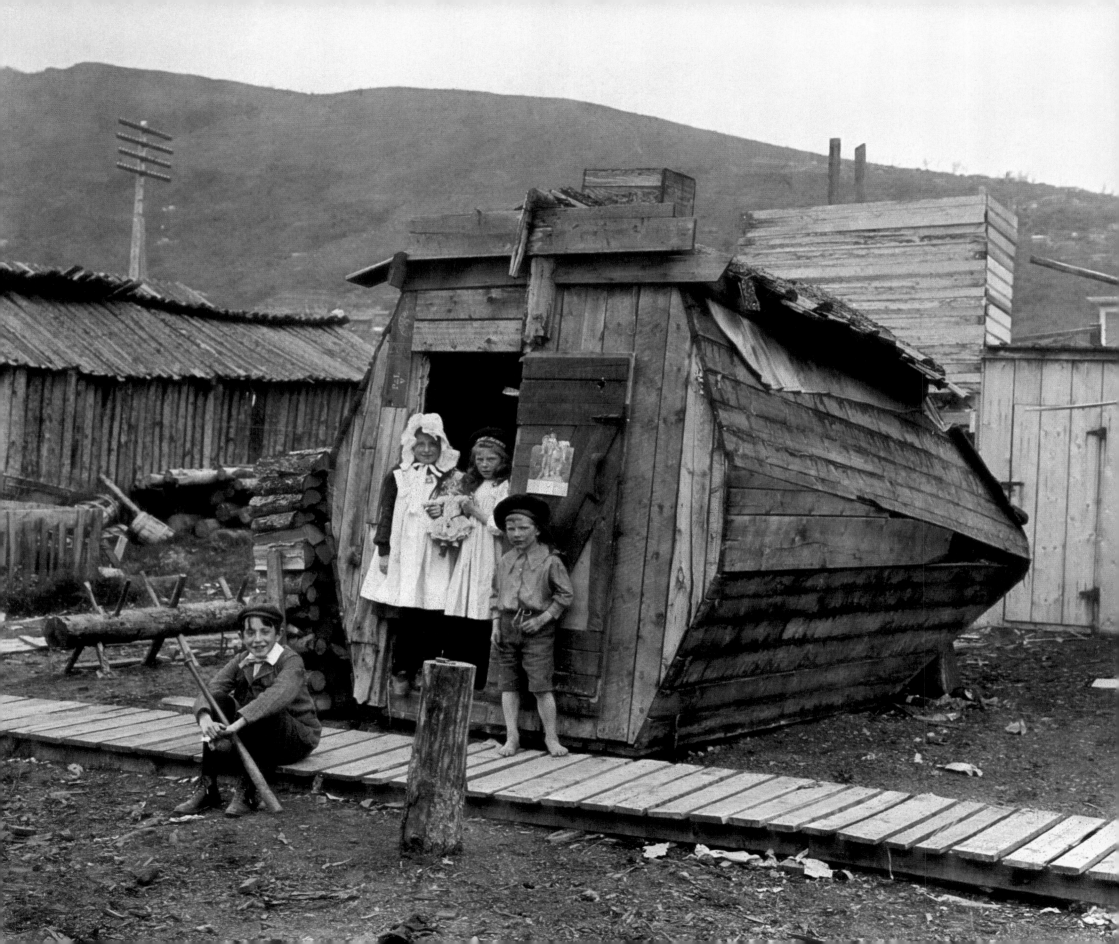

My chop vanished before I had done very much to it. My ice, from which I turned to say something to the Duchess, was not there when I was free to savor it. I began to suspect that our hosts had had their own simple and hearty British luncheon in their private dining room before the daily invasion of official guests had arrived. Royal appetites at any rate did not appear ravenous, but mine was a good appetite and the royal fare delicious—to judge from the brief samplings permitted me. Then came the traditional port wine—delicious port. I sipped it lovingly but lightly and again, growing careless, turned to the Duchess to express my appreciation of good port. I was hoping to console myself for all the good things that had eluded me by drinking up the dregs of that brimming glass of rich and tawny wine from Portugal. Alas, the butler had suffered no diminution of celerity in serving and unserving. The next and last I saw of my almost untasted port was as it trembled on the tray of that retreating butler on his way to the distant pantry door. Next time I feast with royal folk I shall have a square meal and a few drinks before I go to the official table; or better still, I shall carry with me some sort of clamp with which to fix my plate to the table while conversing.

I have frequently and boastfully poured this story of my only meal with royal folk into the ears of social queens who have entertained me in the course of my lecture tours.

Lunching a second time at the home of one of them, a charming lady of St. Louis, I was surprised to find a gaily beribboned packet at my place. "A gift for you," said my hostess. "But this is not my birthday," I protested. "Never mind, this is something you may need next time you are entertained by the great ones of the earth; I hope it works." It was a silver-plated clamp just big enough to clamp a soup plate to a table! [1916/1953]

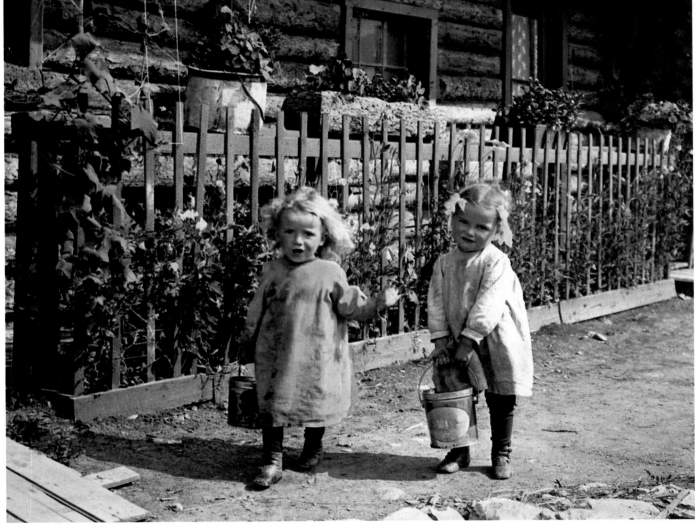

LEFT **CHILDREN IN FRONT OF THEIR WOODEN PLAYHOUSE, DAWSON CITY, 1903**
These children had the luck to have an ambitious father who built the local saloon and several other buildings. To keep the youngsters occupied while he worked, he used left-over lumber to create a cozy and dry children's playhouse right on the boardwalk.

RIGHT **LITTLE GIRLS WITH BUCKETS, DAWSON CITY, 1903**

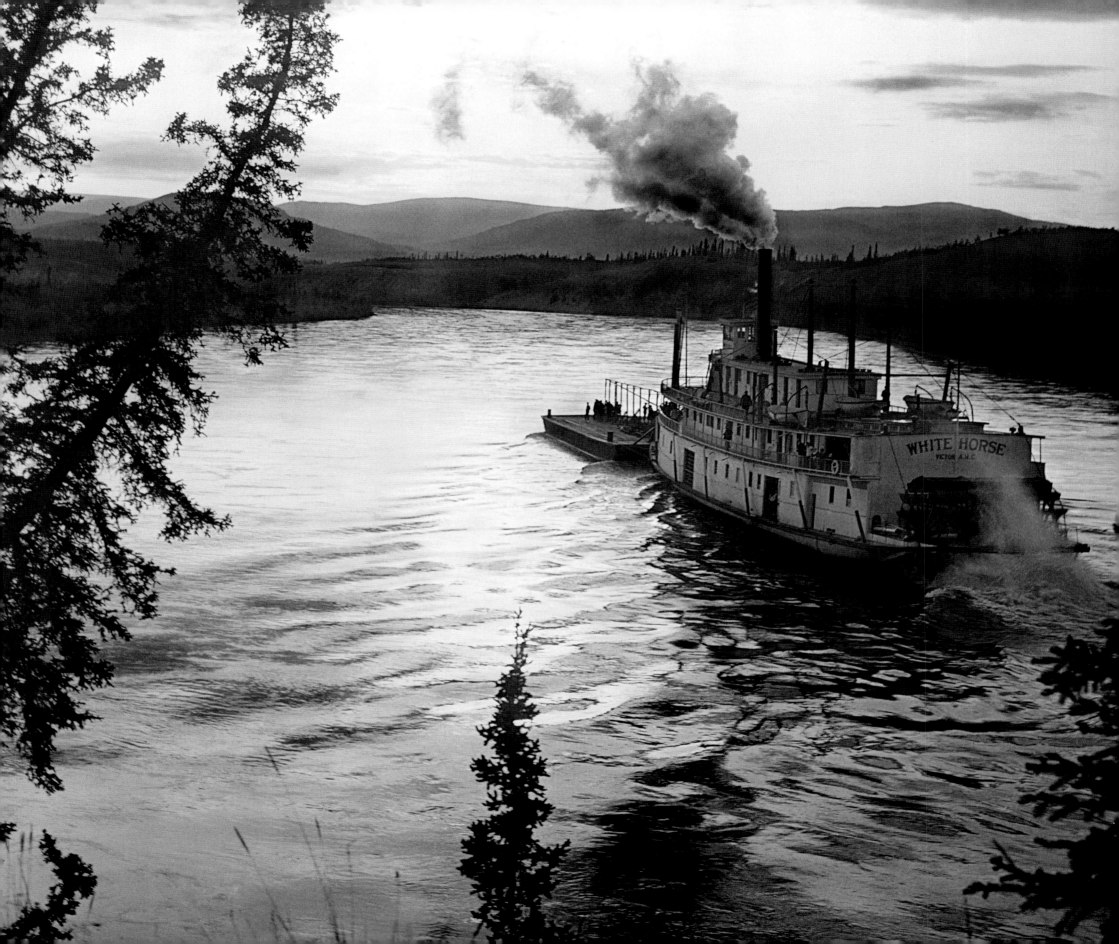

THE SS *WHITE HORSE*, YUKON RIVER, 1903

From White Horse down to Dawson I had for highway the great rapid-flowing river and for conveyance the comfortable Yukon steamers that ply all summer up and down the stream. Our voyage was made in two days and two short nights. We suffered some delay when we went to the assistance of another steamer in distress, taking her passengers and possessions on board. The other steamer was carrying miners to the scene of a strike, and her pilot dropped asleep and struck a rocky cliff head, and the steamer refused to budge. Her hull was damaged and her decks strewn with bits of rock she had gutted from the cliff. The miners, in the excitement, true to the spirit of the prospector, picked up and pocketed these quartz samples.

THE YUKON RIVER, 1903

The Yukon River proved to be as menacing as it looked at first glance; the swift current racing toward unknown dangers—jutting rocks and furious rapids, the foaming waters, churning, whirling, the turbulence of which no photograph can picture.

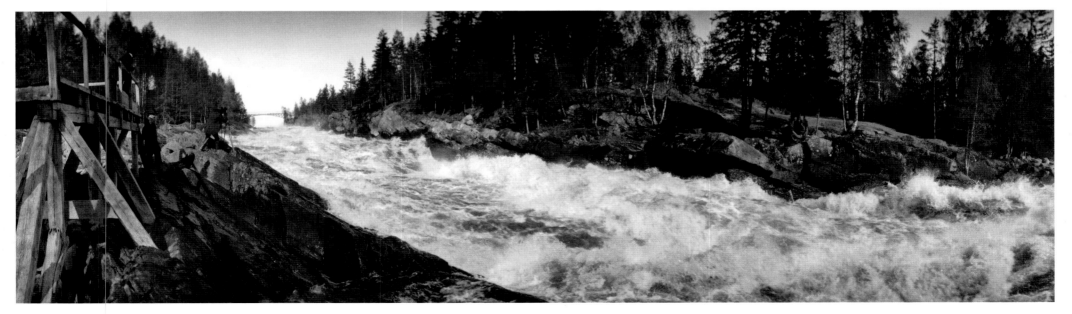

RIGHT **LAKE LOUISE, BANFF, BRITISH COLUMBIA, 1916**
Lake Louise is the loveliest lake in Canada, if not in all the world. No picture can fully satisfy the eye that has once looked upon Louise. Tears of delight come into many eyes at first sight of this overwhelming beauty; I have seen such tears, even if I did not shed them.
Nature sets this spectacle of beauty here before us and the response it wakens in our souls proves that we are each one of us possessed of the artistic instinct, that if we will but yield to it, a love of beauty can and will control, console and bless our earthly love.

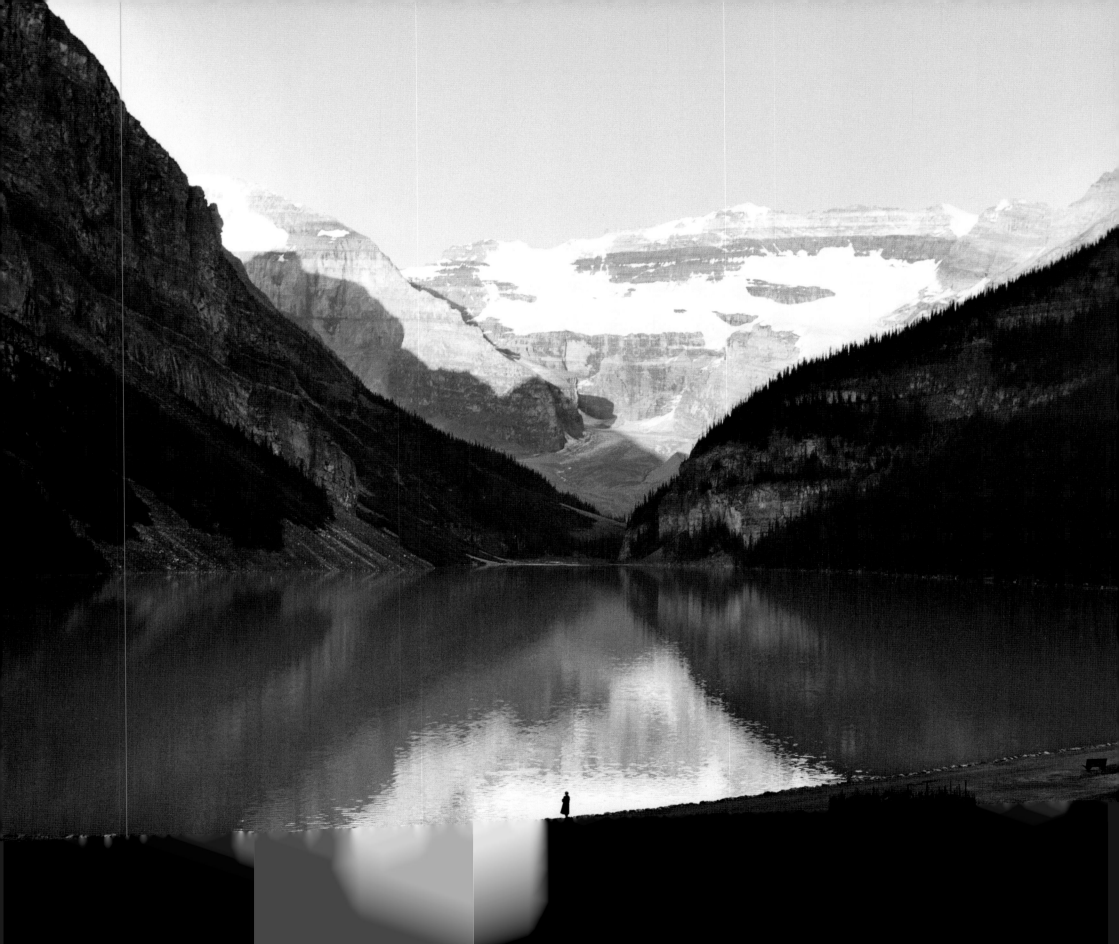

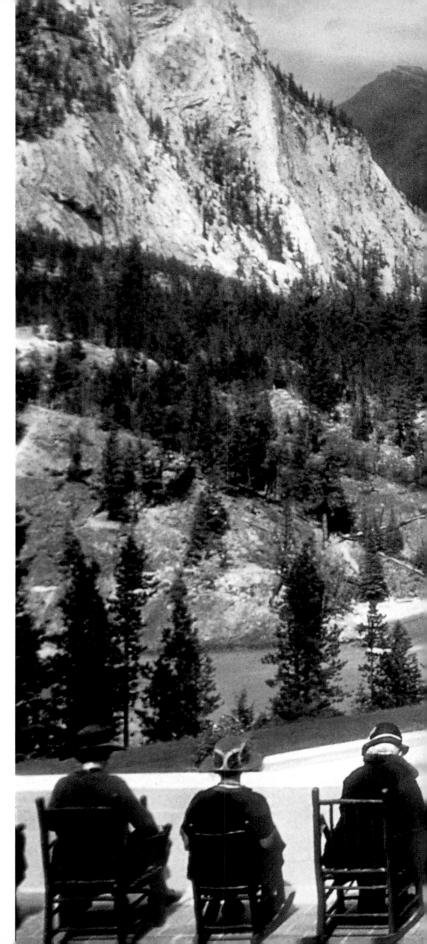

RIGHT **TOURISTS AT THE BANFF SPRINGS HOTEL, 1916**
As a rule a big hotel in a beautiful mountain region is the one blot on the landscape, but here at Banff the architect has handled his design supremely well. He has made his hotel the keynote of a superb situation, not only an admirable but a necessary feature of the view. Without the hotel itself, the scenery of Banff would lack something that seems essential: a focal point, a central rallying point for the eye.

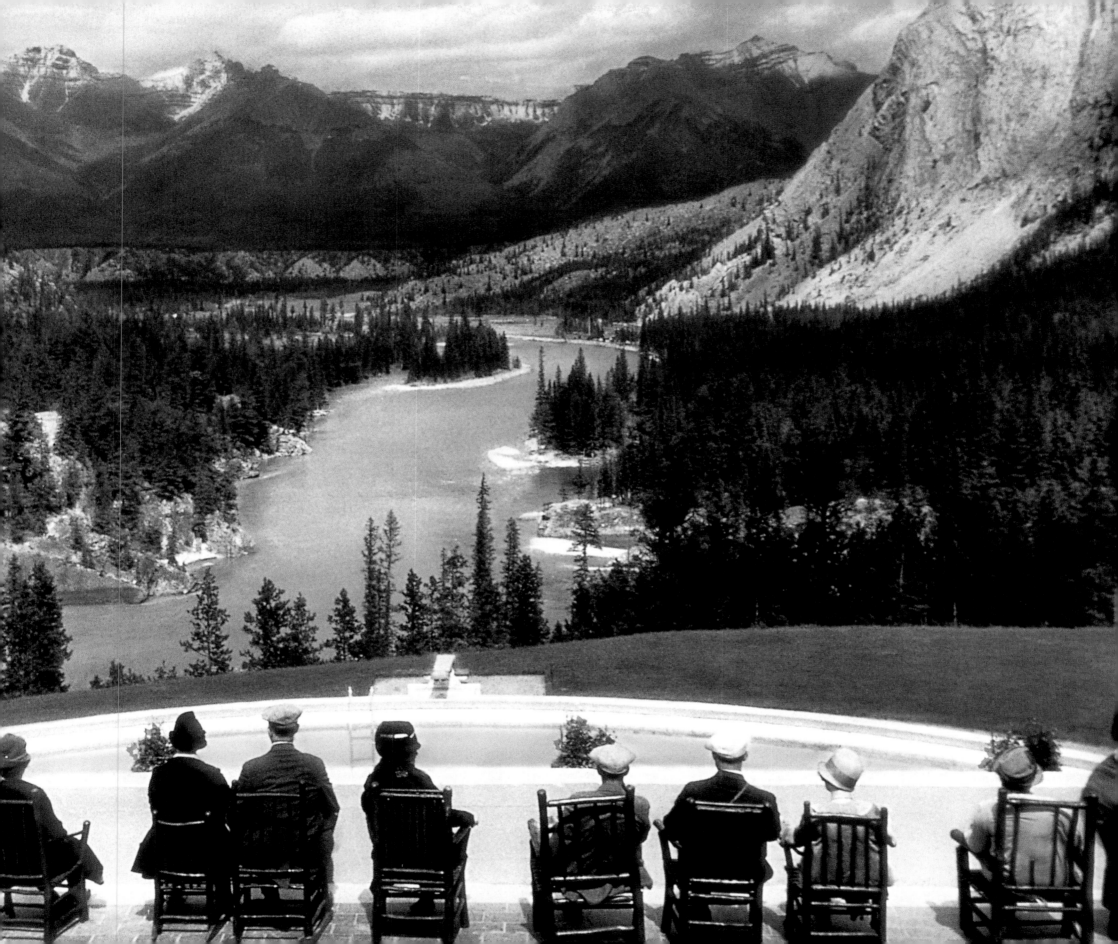

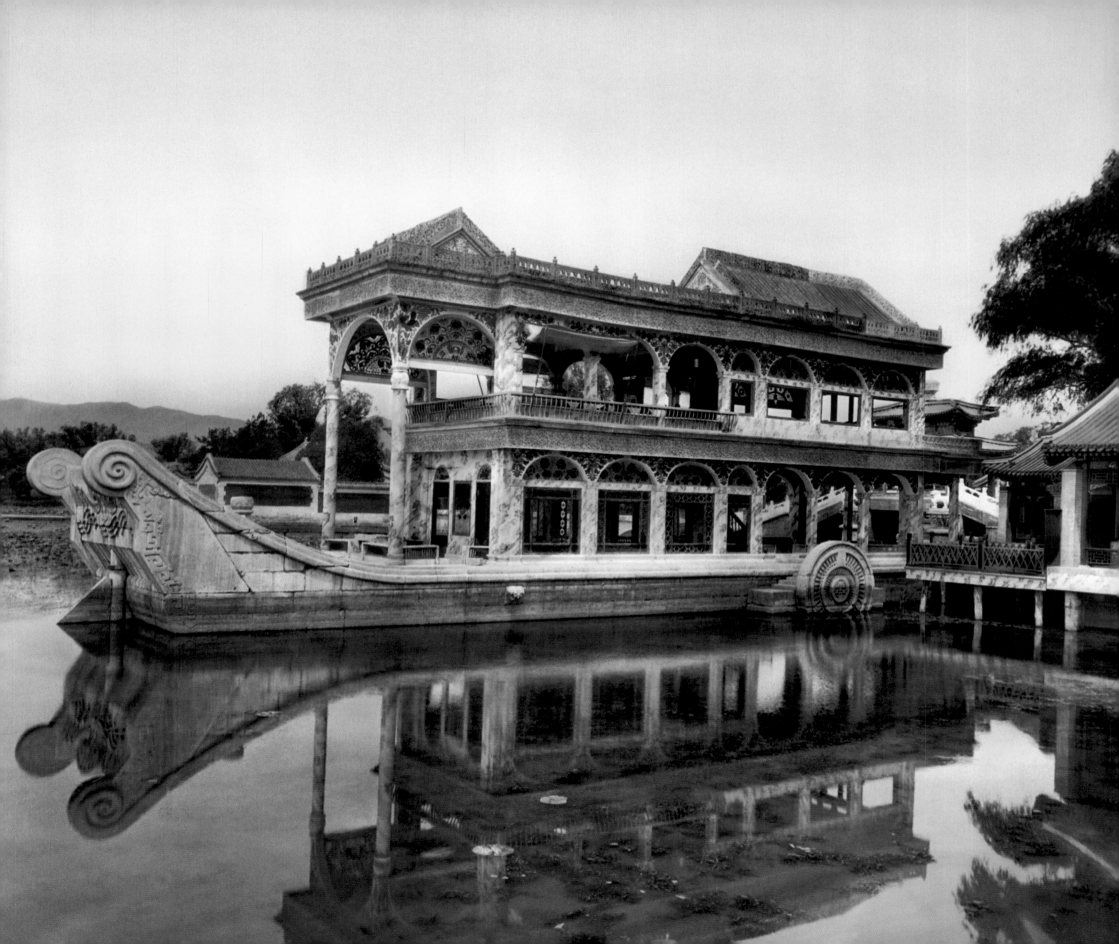

OPENING THE FORBIDDEN CITY

China is a colossal puzzle. The outside world has tried in vain to solve it, by means of force, railways and Christianity. To force, China opposes weakness, and weakness is victorious; to railways, she opposes unquenchable superstition, and superstition conquers; and to Christianity, she opposes the weight of accumulated tradition, and thus far tradition has prevailed. The tide of Progress is sweeping the nations of the West out upon the oceans in this new century. But China, moored to the rocks of immutability, resists the modern current, despite the efforts of all Christendom to cut the cables of conservatism that bind her to the past. *[1913]*

Far more interesting to the traveler of 1901 was the China of the Imperial yesterday, the China of old-time art and ancient mystery of quaint costume and quainter customs—the China that revered Confucius and feared that most masterful woman of her generation, the indomitable Empress Dowager.

Peking is not only the capital of China, but it is one of the important capitals of the world, so absolutely unique that the traveler will consider it one of the world's great spectacles. It is a city in three parts, the Imperial Palace lying deep within the confines of the Forbidden City, which in itself is surrounded by the Tatar City, and, outside of all, the Chinese City.

The once invisible Peking—the Peking of the privileged and semi-sacred few—was now available to my cameras. Peking, capital of the Celestial Empire—half hidden in a haze of incandescent dust—dominated by sixteen towering city gates—shut in by miles of jealous walls now breached and tunneled for the invading locomotive. Here the troops of many nations quarter in her sacred places—her innermost "Forbidden City" becomes the playground of the curious— the palaces of the "Son of Heaven" are profaned and despoiled—her population cowed and embittered, regarding with mute defiance the exodus of the avengers and the rebuilding of the fortress-like legations—this is the Peking of the year of Our Lord 1901 in the aftermath of the Boxer Rebellion.

The story of the Boxer outbreak, of the siege of the legations, of the relief-expeditions, and of the capture and occupation of Peking by the international forces, has been already told a hundred times from a hundred points of view.

LEFT **MARBLE BARGE, THE SUMMER PALACE, PEKING, 1901**

Quaintness, beauty, and wonder are everywhere combined; witness the curious Imperial barge of marble, graceful in outline, and marvelous because it seems to float as lightly as a craft of wood upon the lovely artificial lake. Above, are grouped pagodas, temples, shrines, and summer houses. Below, their tinted forms are mirrored in the blue; and just astern of the white marble marvel is a bridge with curving roofs of tile, unique in form, rich in color, and exquisite in workmanship.

The junk, we are told, was the peace-offering of a corrupt naval official, who, discovered in diverting appropriations for the building of ships into his private pocket, built for the forgiving Emperor an everlasting ship on board of which the Son of Heaven could forget his cares, and, incidentally, the roguery of his officials.

RIGHT **ROOFTOPS OF THE SUMMER PALACE, PEKING, 1901**

But if the common countryside appears to us beautifully curious, what words may be used to describe the object of our outing, the Summer Palace of the Emperor of China: "Oriental," "beautiful," "curious," "impossible," carry not half enough of meaning to reveal the wondrously strange charm of the world-famous site.

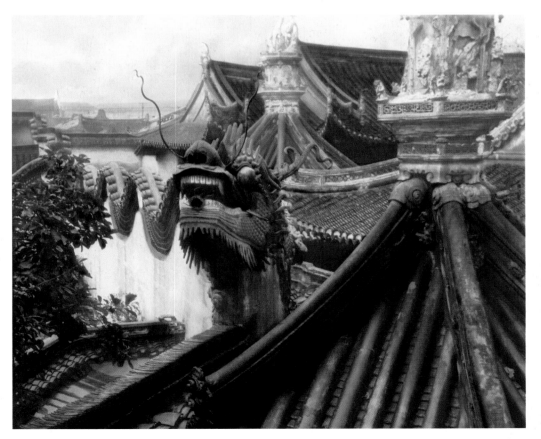

I merely wish to look upon the scene made memorable by these events and other scenes that are significant because they throw a little light upon the problem of the East—the mystery of China.

The city, now in ruins, is policed by foreign troops. Its ramparts have been razed; smooth boulevards have been created where useless city-walls once stood. The ants look on in wonder or complaint, and those who toil in transport choose the new unobstructed road made by the "foreign devil"; but never would they have made it for themselves. Left to themselves they will in time obliterate all traces of this foreign occupation, and forget the days when European patrols marched through their streets, hindering the progress of the creaking wheelbarrows, the swinging baskets, and the green sedan-chairs of pompous mandarins.

Viewed from the massive towers of the City Gates, from the broad ramparts or from the once prohibited and semi-sacred artificial hills in the Imperial City, Peking reveals itself to the amazed onlooker as a splendid wall-girt metropolis, perfectly preserved, fabulously elegant, incredibly artistic, unutterably superb.

Peking is paradoxical. It is one of the ugliest cities in the world—it is one of the most beautiful. It is hideous, squalid, abject, and it is as the same time lovely, magnificent, and glorious. Well may we call the Chinese "ants," and their cities "ant-hills." The heel of Europe may crush and scatter the heaps raised by these busy toilers, and grind out a million busy lives. It avails nothing. Other millions of toilers recommence the task, and build again—instinctively as ants—another city after their own fashion.

Now that the mysterious enclosure which was the heart of Peking has been laid open to the gaze of the world, it is with something of awe and involuntary reverence that the traveler enters the once sacred and forbidden place. Much of the grandeur has passed with the vandalism of the unthinking soldier and many treasures have been lost to the world. But there still remains enough to delight and amaze the traveler who sees the vast Imperial palace in the center of the city, which became known as the Forbidden City because only the Emperor's family and closest advisors could enter it. [1901]

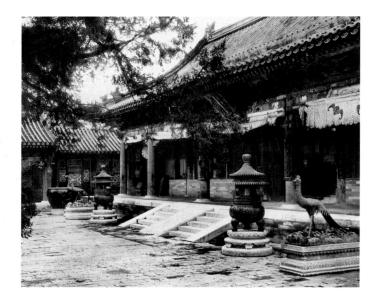

LEFT **ABODE OF THE "SON OF HEAVEN,"**
THE FORBIDDEN CITY, PEKING, 1901
When the conquerors first entered the Forbidden City, they found it polluted with the dirt of a decade and cursed by the mal-administration of the corrupt palace officials. Only the gilded great thrones of the Son of Heaven stand forth almost untarnished amid this dilapidation. We are led through many high-walled alley-ways and many yellow-tiled gates to the private dwellings of the Emperor and of the Empress Dowager. They consist each of a suite of buildings glass-walled and transparent as aquariums, surrounded on all sides by stone-paved courts and covered galleries and corridors. Bronze phoenixes and dragons, and gilded water-jars and finely chiseled incense-burners give to these courts the air of a museum.

RIGHT **A THRONE ROOM, THE FORBIDDEN CITY, PEKING, 1901**
In one of the three throne rooms rises a screen of golden lacquer, so exquisitely dainty in design and execution that it appears to be a bas-relief of lace woven in threads of gold. But lest a wrong impression be conveyed, remember that all these splendid things are old—not with the mellow oldness of time, but with the hopeless oldness of neglect. Photography is always kind to things that have lost their freshness, from professional beauties to Imperial thrones, and these soiled and dingy halls appear in pictures as splendid as when they were first built, three hundred years ago. But in reality, they are in a sad condition, the rich soft carpets are soiled and torn, covered with a layer of dust and grime; wild birds nest amid the rafters and on our entrance fill the dim fantastic void above us with their frightened flutterings. Everything tells of a long period of gross neglect and abandonment.

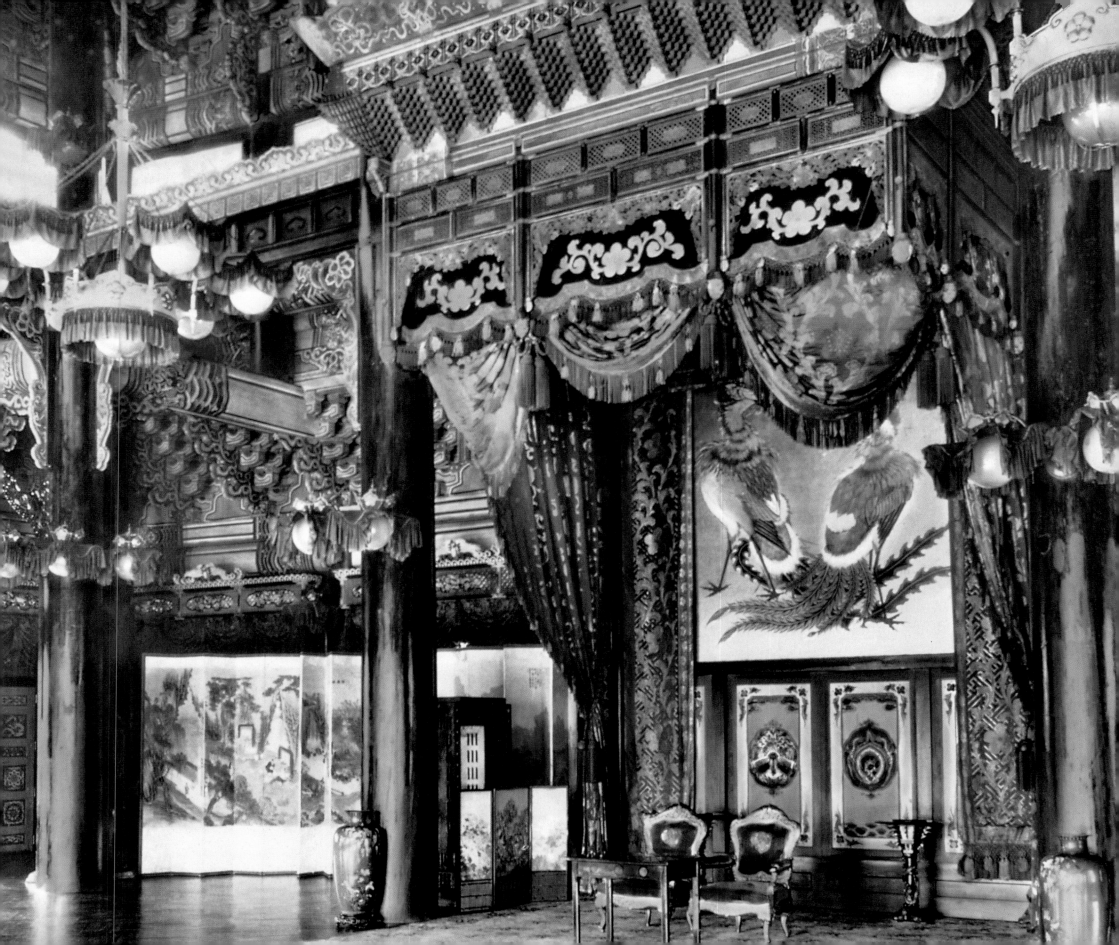

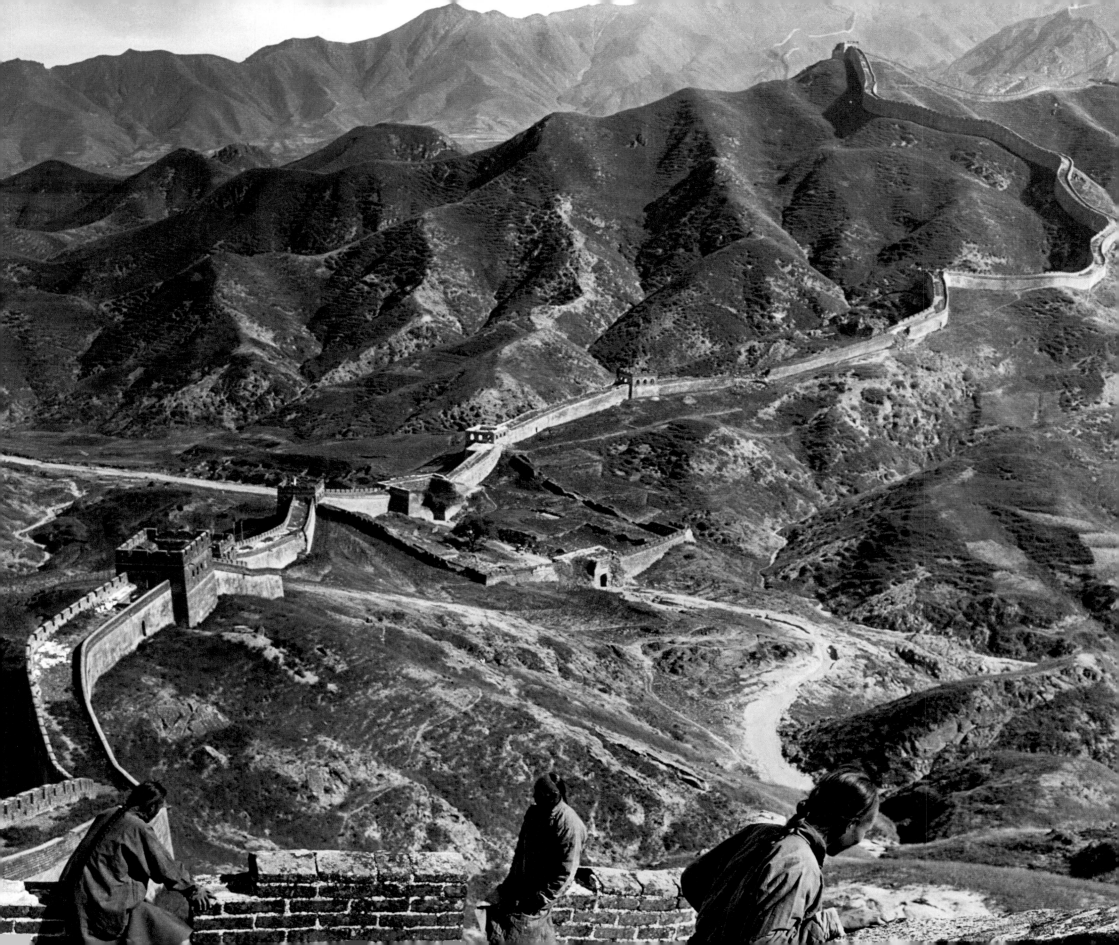

LEFT **THE GREAT WALL OF CHINA, 1901**

The Great Wall was begun seventeen hundred years before Columbus discovered America, before any of the great nations of Europe had come into existence. It is a mute reminder of the splendid civilization the Chinese must have had in the long ago days, when our own ancestors were living in huts and sleeping on straw.

BELOW **THE PANORAMIC VIEW FROM ATOP A PAGODA, THE SUMMER PALACE, 1901**

We set out to climb the famous Hill of Ten Thousand Ages, covered like the Palatine at Rome with palaces and temples. But how unlike the Roman piles are these unheard-of-architectural forms! How fascinatingly foreign to the art we inherit are the designs, the coloring, the noble ensemble, and the naïve details. Confused by the multiplicity of stairways, terraced courts, and winding paths. I cannot see how best to reach the height that is our goal. Breathless with admiration and with exertion, we climb the countless steps that lead up through this architectural wonderland, until we reach the topmost floor of the pagoda. There, what little breath remains is taken from us as our gaze leaps out across the lake and lights upon the dainty little island linked by a dainty bridge to the green fertile shore. The beauty of the scene surprises us. We pictured China as an ugly land—a land of graceless shapes and of forbidding aspect. But where could we find hills richer in pleasing lines, greener in summer verdure, than the heights that rear themselves there in the west to shelter Peking from the cruel winds of the adjacent Gobi Desert.

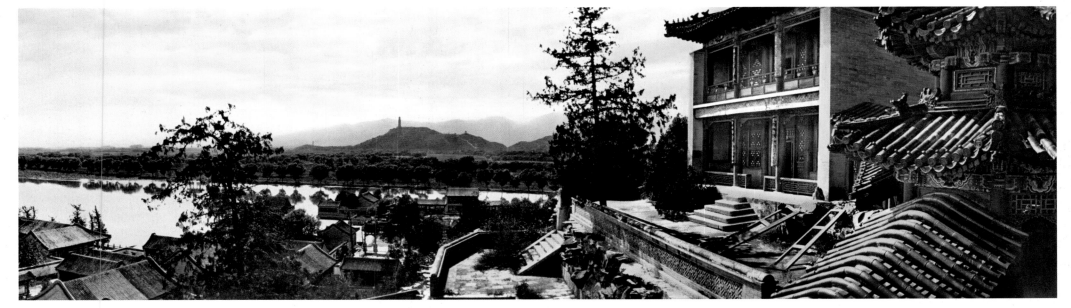

BELOW MARBLE BRIDGE, THE SUMMER PALACE, 1913
The famous curving Bridge, called by the ugly name of the "camelback." It deserves a fairer name, for it is the loveliest bridge in all the world. Its marble arch is unspeakably beautiful; it satisfies the eye as completely as any of the architectural creations of the past. Even the Taj Mahal and the Parthenon are not more perfect of their kind, more true to the traditions of the arts from which they sprung, and of which they are the highest, noblest products.

From every point of view, the lines of this choice creation of Chinese genius combine to form a Chinese ideograph that should read "perfection." Let us not forget there are perfect things in China. But we also realize, sadly, that beautiful creations like the Marble Bridge return to nature when untended and ignored.

RIGHT A DISTANT JUNK AT SUNSET, 1913
A scene of quiet timelessness: the drifting clouds across mountain faces, the reflections in the water, and the classic junk in the distance.

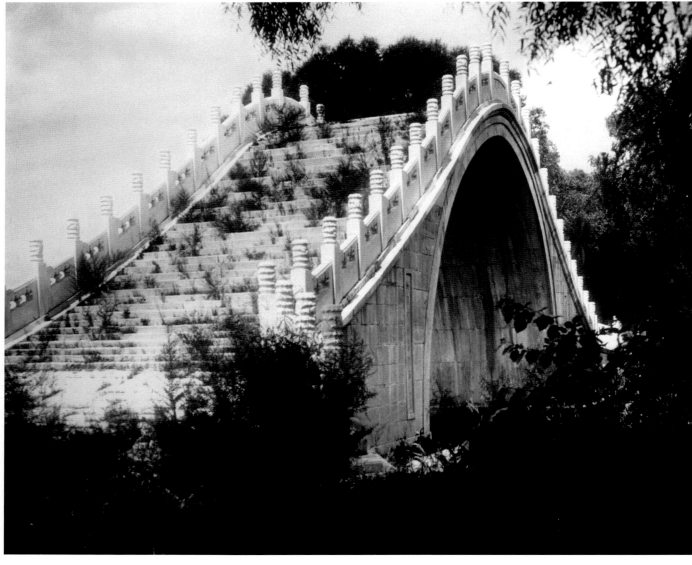

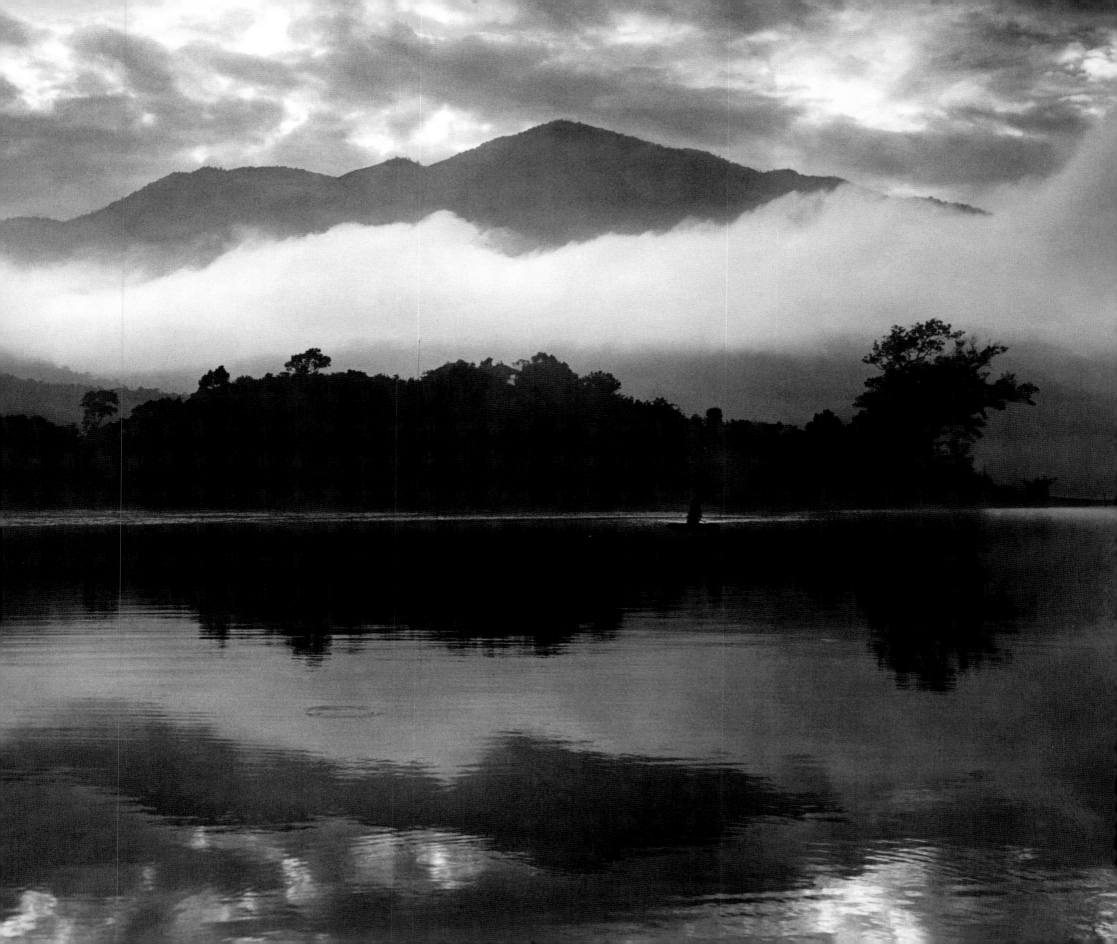

A MANCHU FAMILY BOARDING A PEKING CART, 1901

Only Peking natives know how to enter into and enjoy the Peking cart. Foreigners find it impossible to get aboard without instruction or example, such as that furnished us by a lady of the Manchu clan. She gracefully glides in, stepping up, turning, sitting, and then sliding backwards on the inclined floor to a position just above the springless axle. She sits there, tailor fashion, her children on either side— her lord and master taking up his position where one shaft joins the body of the cart, while the driver perches on the other shaft, whence he can prod the mule at his ease and dangle his feet in the dust cloud raised by the yellow wheels.

A SEDAN CHAIR, PEKING, 1901

Suddenly a glare of scarlet flashes in the crowd—it is a bridal-chair, borne swiftly toward the house of some expectant bridegroom, by carriers in festal garb; or, again it is the somber green of an official chair, the equipage of one of the few princes left in Peking to parley and make peace with the intruders.

A PAILOW NEAR THE CHIEN-MEN GATE, PEKING, 1901

Impression-gathering in the Peking streets is a delightful occupation. I cannot conceive of anybody being bored in Peking. For him who has eyes to see and ears to hear and a nose to smell there is, in the language of the continuous-vaudeville advertisements, "something doing every minute." The common, continuous passing throng is in itself enough to hold the attention for hours at a time; and to vary its marvelous monotony of brown body, blue trousers, and upheld paper fan, there are the vehicles, of many sorts— the low carts laden high with military supplies, drawn by small ponies, driven by half-nude teamsters; the familiar, but ever-astonishing passenger-cart, with its blue arched roof, its taut-stretched awning, shielding mule and driver, and its yellow wheels, tired with corrugated metal and thus equipped for the eternal task of filing deep grooves in the Peking pavement for other wheels to deepen.

All these wheeled things go by as we stand watching near one of those strange street arches known as "*pailows*," memorial structures erected in honor of some great or good personage of whom we never heard.

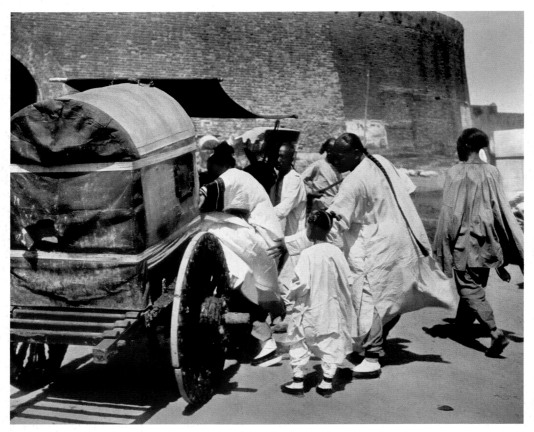

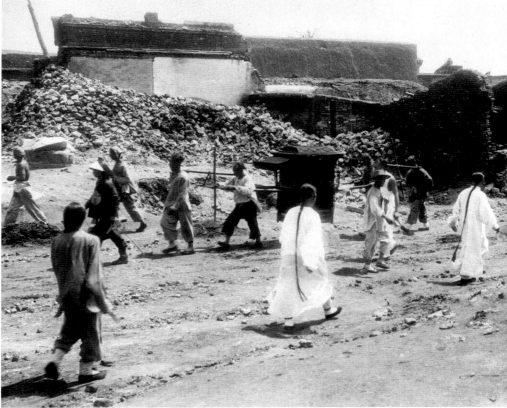

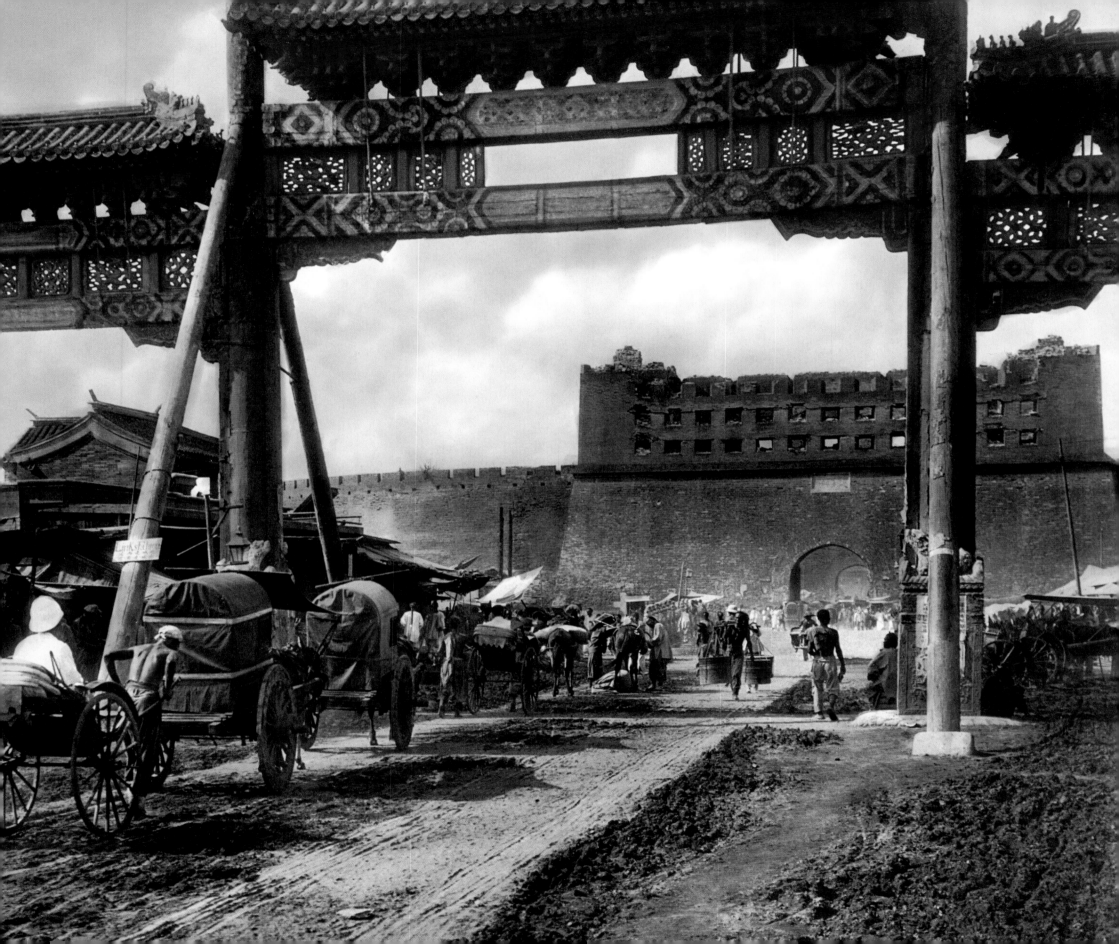

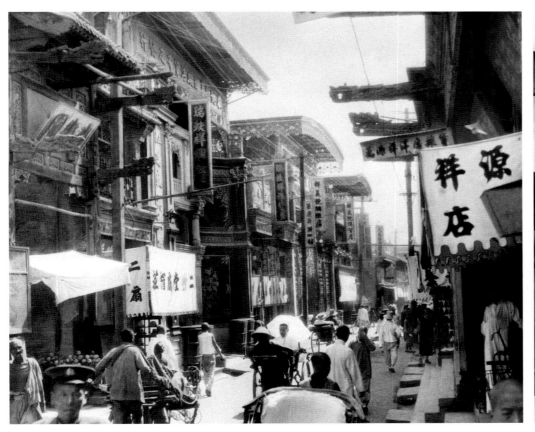

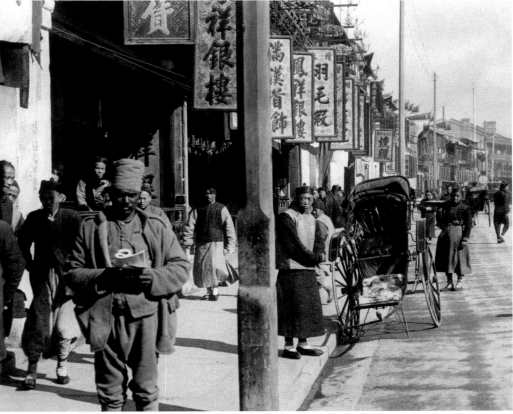

LEFT **A YOUNG CHILD WITH THE SAMPANS,
PEARL RIVER, CANTON, 1901**

Canton is about ninety miles from Hongkong, and is a night's ride by steamer or about five hours' ride by rail from that point. Nothing I have seen in foreign ports has prepared me for the arrival at Canton. At first glance the city repels, and at the same time fascinates. Our approach is the signal for squadrons of sampans to form in line of battle. Each craft is crowded with half-naked natives gesticulating wildly in their efforts to attract the attention of the Chinese passengers whom they are eager to serve either as porters or as boatmen.

The water life of Canton is one of its most peculiar features, as thousands of boats floating on the rivers and creeks provide homes for countless multitudes. Yet a small child still finds some small object to play with and enjoy at the edge of his family's sampan crowded in with hundreds of other similar life-giving boats.

ABOVE,
LEFT
AND
RIGHT **THE BUND, SHANGHAI, 1922**

Three days by steamship from Hongkong is the city of Shanghai. The foreign settlement is thoroughly distinct from the native town, and is practically European in its architecture and manner of life. Here are the famous Mandarin Gardens and the Tea Houses pictured on the blue china plates of our great-grandmothers.

Shanghai is the great commercial port of central China, situated on a river that empties into the estuary of the Yangtze-Kiang. The region here is a flat mud plain, the city is as flat and ugly and bustling as are many of the cities of our own western plains. Indeed, except in a few minor ways, a man from Chicago or Detroit or Omaha feels quite at home in Shanghai.

PAGES
64–65 **WATERFRONT ACTIVITY, SHANGHAI, 1913**

The year is 1913, and the tale is of an awakening. There is today, a new China—a republican China without pig-tails, but with straw hats and tan shoes—without a Son of Heaven, but with a president, a parliament and politicians.

The frenzied activity of the port of Shanghai never ceases. We receive again that impression of unending toil—which is to me the first, the last, and the most enduring impression that I brought from China—a toil that knows no beginning, for it begins before the toilers have begun to think; toil that never ceases, for without it there would be an end to life; toil that racks muscles, tears flesh, fixes on every brow of bronze a crown of pearls of sweat; toil that would be heroic were it not utterly unconscious of itself.

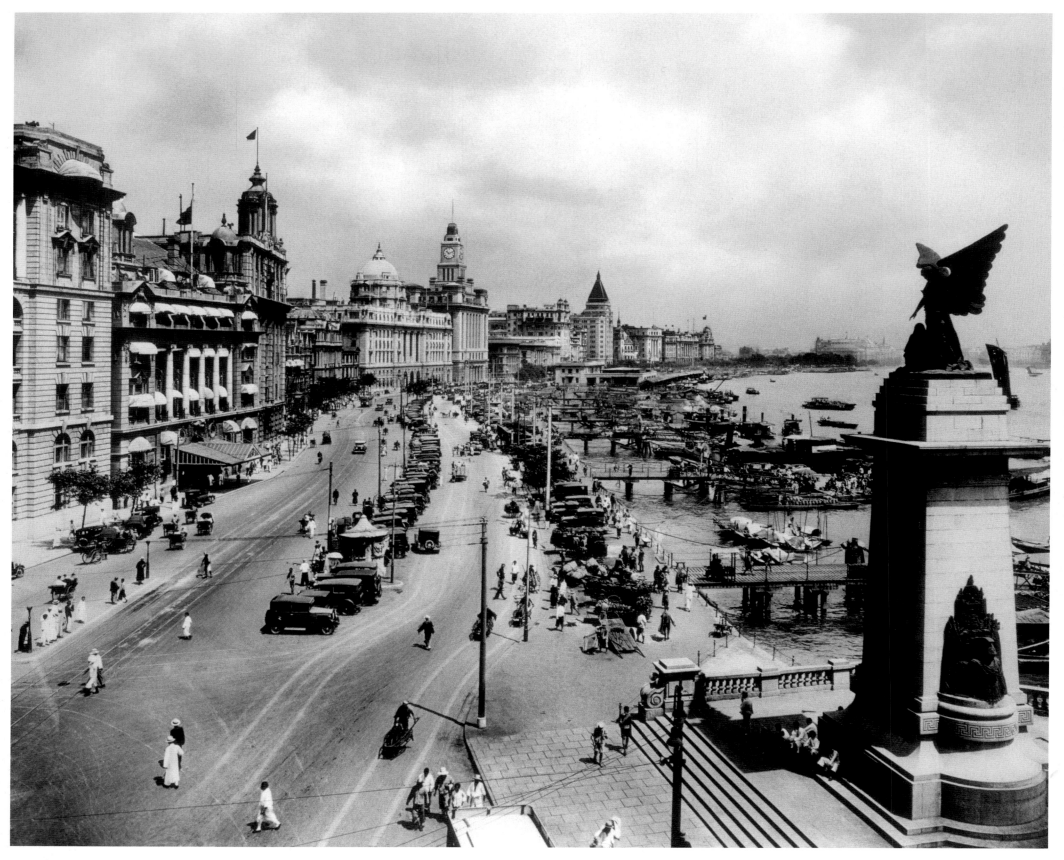

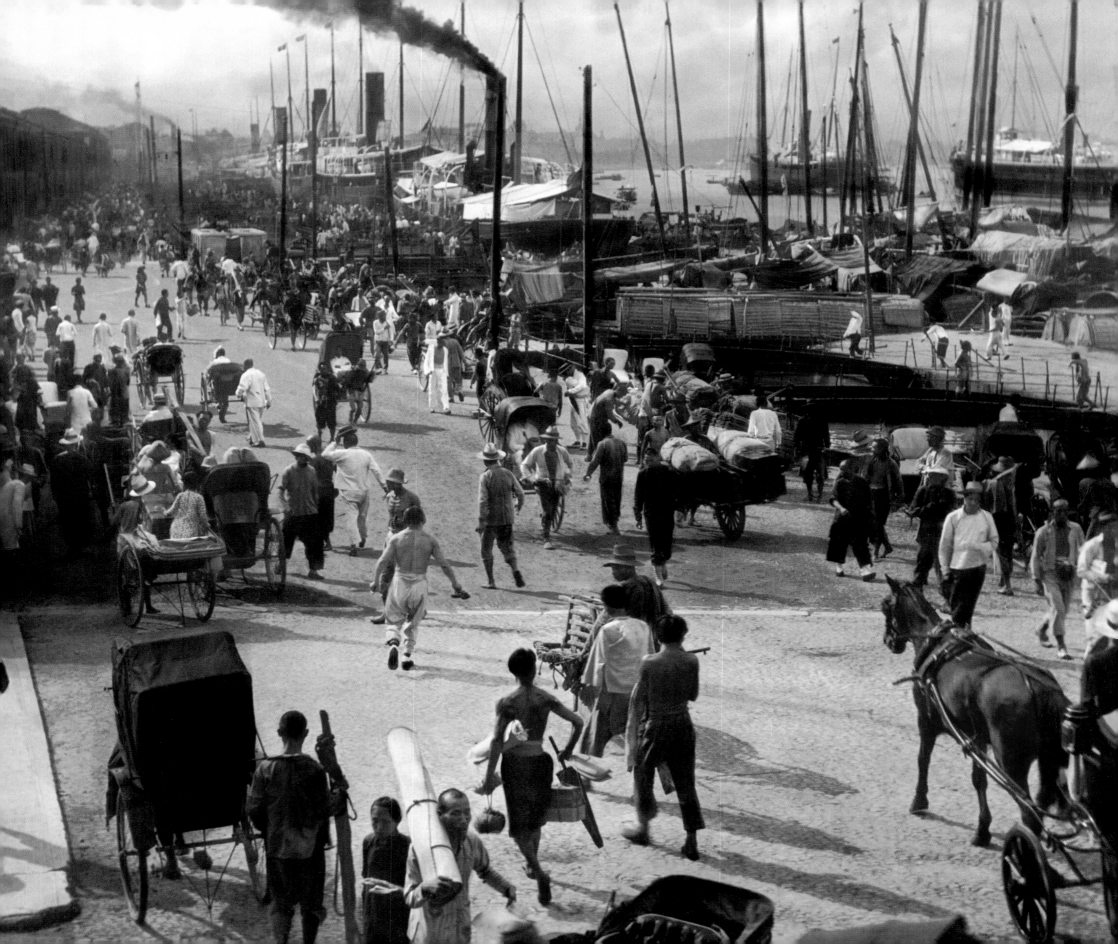

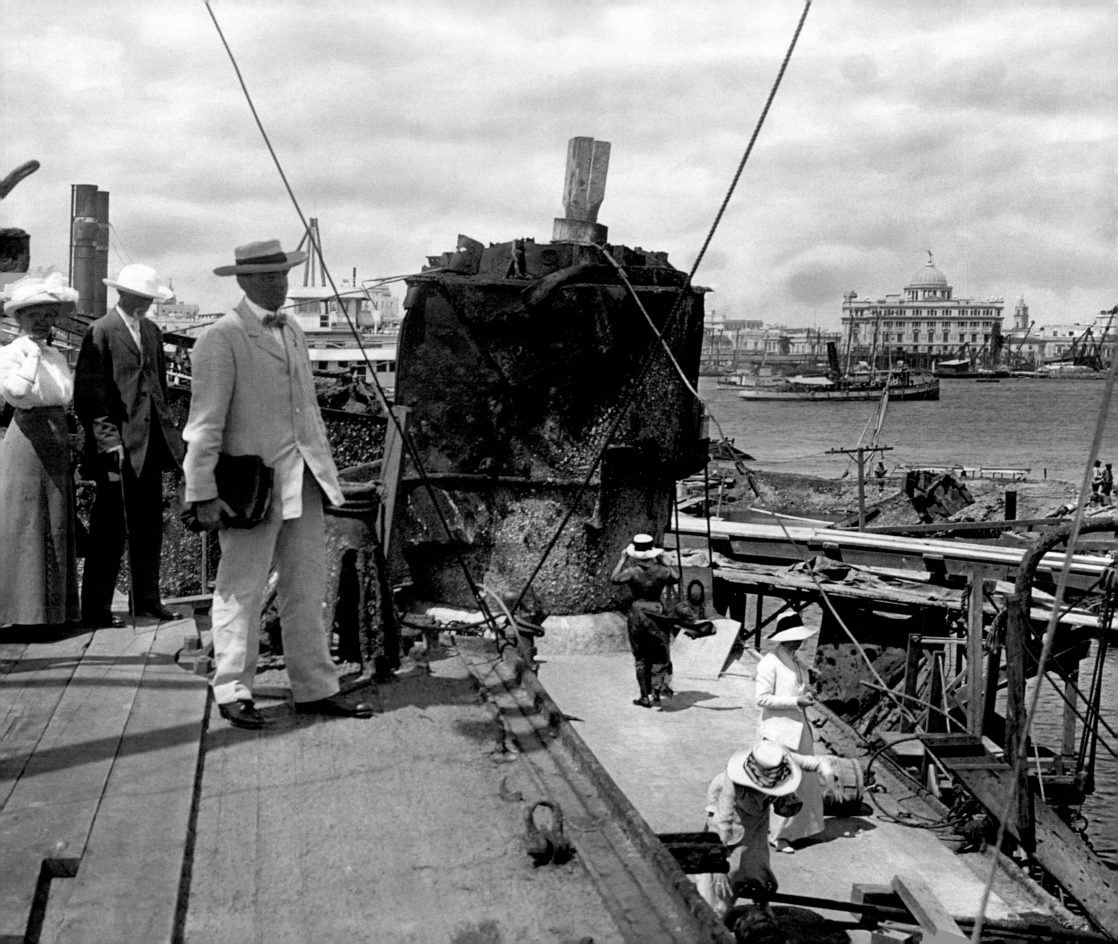

CUBA
RAISING THE *MAINE*

We chanced to reach Havana just before the second sinking of the *Maine*, the formal burial of the battered hulk which had just been raised, after being submerged for many years. She has been literally cut in two by the explosion of her magazines, caused by the explosion of a mine placed by wretches, still unknown, beneath the forward portion of her hull.

The work of lifting the old *Maine* has lasted eighteen months, but finally she floats again, triumphantly, to unfurl new flags above the scene of her assassination. All this labor, time, and money has been spent in order that Uncle Sam may give his brave old ship, at last, a decent burial.

More than two hundred and sixty victims perished when the *Maine* went down. The bodies of some were not recovered until the *Maine* was raised, thirteen years after the

catastrophe. All rest now in our National Cemetery, near Washington, with the main mast of the *Maine* standing as their monument above their graves. So vanishes for all time the gallant ship whose tragic fate so materially changed the destinies of our United States. [1912]

In 1898, the American battleship USS Maine mysteriously exploded and sank in the shallow waters of Havana harbor. While never proven, the United States believed Spain was to blame, and the incident served as a catalyst for the Spanish-America War, whose rallying cry was "Remember the Maine, to hell with Spain."

When it was constructed four years earlier, the vessel was the first Navy ship built entirely with materials manufactured in the United States. A symbol of American modernity and increasing might, President McKinley had sent it to

Havana as part of a greater plan to put pressure on the Spanish government to grant independence to a Cuba on the verge of rebellion. The Maine was given a friendly reception and allowed to dock for three weeks before the sudden, devastating explosion. The ensuing war was a short one—less than four months—with the U.S. decimating Spain's Atlantic and Pacific fleets and defeating Spanish forces in Cuba and Puerto Rico, guaranteeing the two islands independence.

After several years, the sunken hulk became a navigational hazard in Havana harbor and the U.S. Congress was petitioned to raise funds to raise the Maine and give its victims a proper burial.

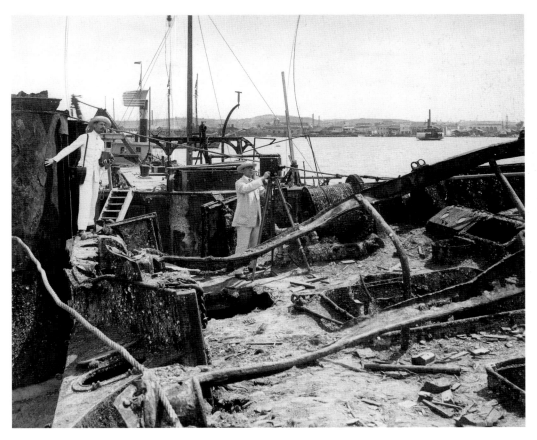

LEFT **U.S. OFFICIAL ON BOARD THE USS *MAINE*, HAVANA HARBOR, 1912**

RIGHT **BURTON HOLMES ON THE DECK OF THE RAISED USS *MAINE*, HAVANA HARBOR, 1912**

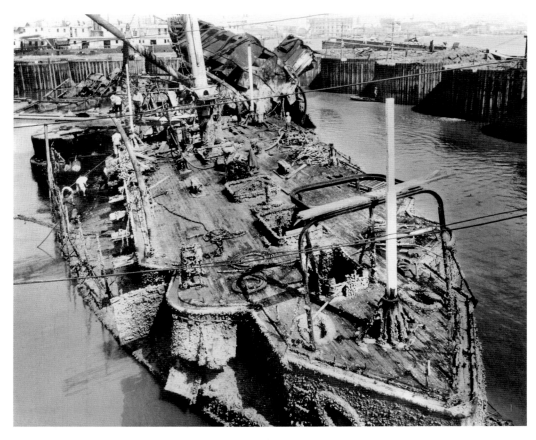

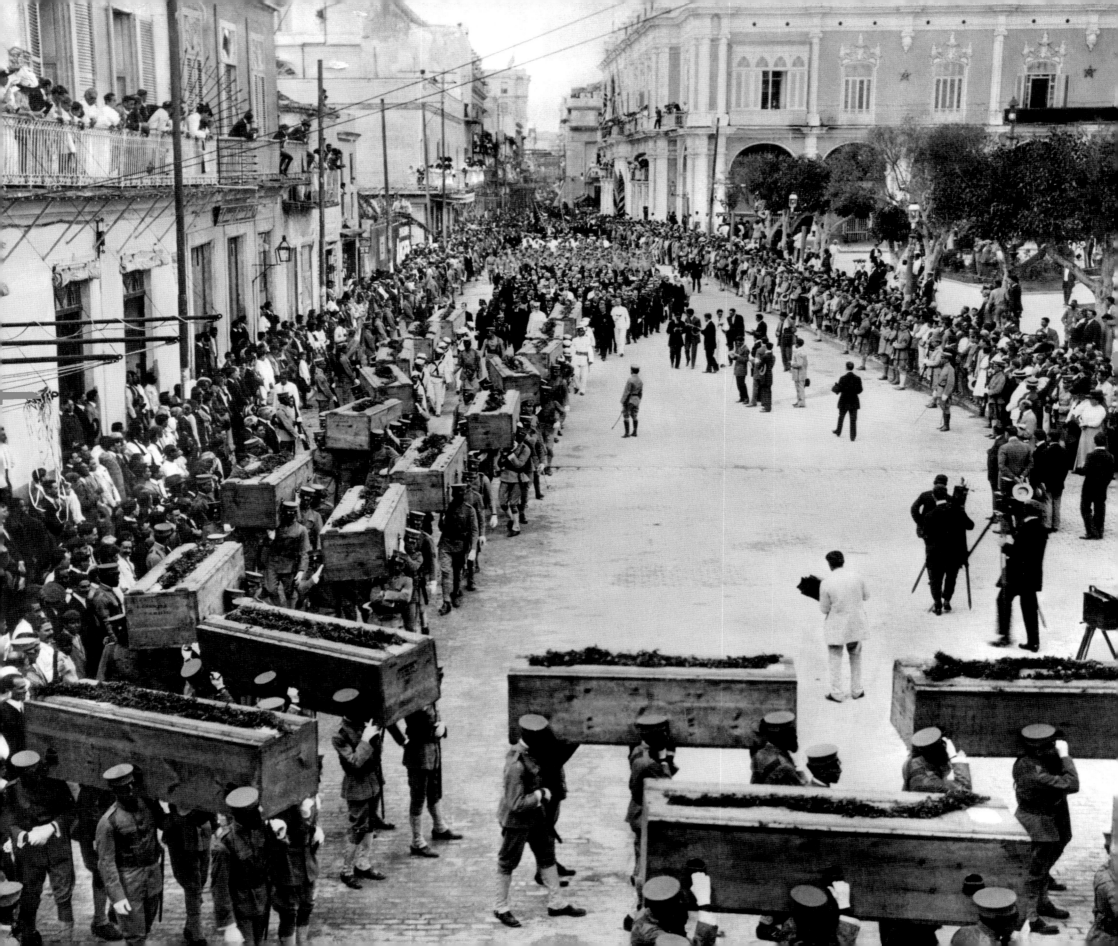

THROUGH HAMLET'S COUNTRY IN A MOTOR-CAR

Denmark is one of the most admirable countries in Europe. It is one of the smallest states of Europe, smaller even than Switzerland, but still occupying more space on the map than Belgium or Holland. There is, however, practically no waste land. With a population of almost two and a half millions of educated, enterprising citizens—few extremely rich and few extremely poor—King Christian's justly governed little realm seems the very home of contentment. The new Copenhagen of to-day, a city of four hundred thousand, is more or less familiar to the world of travel, but the lesser cities, the villages and the delightful country districts, are rarely visited by foreigners. The lecture not only deals with the attractions of the Capital, but also tells the story of an excursion into Jutland, to Aarhus and the famous Horse Fair

at Randers, and of an automobile tour of Zealand, touching at Hamlet's castle of Elsinore, at the Chateau of Frederiksborg and at Roskilde where the Danish Kings are buried; thence southward to the end of the island whence a ferry transfers to the little isle of Möen, the first motor-car that ever invaded that peaceful out-of-the-way corner of the prosperous and peaceful home-land of the Danes.

Among the motion pictures there are interesting scenes of city and village life, including a parade of superb prize horses and bulls at the Randers Fair, impressions of automobile runs along the country roads and an interpolated picture of especial interest to chauffeurs, showing all the prominent contestants in the great Paris-Berlin auto-race, passing the control station at the Belgian Frontier.

We find the Danish metropolis surprisingly attractive. We are amazed at many things—the broad fine avenues, the modern buildings. We are delighted by the excellence of the hotel, from the windows of which we look out upon the public park and the new City Hall, a structure recently completed. Electric streetcars of twentieth-century design, noiseless and far more elegant than those in many of our cities, glide across the square with a supple ease. There is a feeling of up-to-dateness about nearly everything. *[1902]*

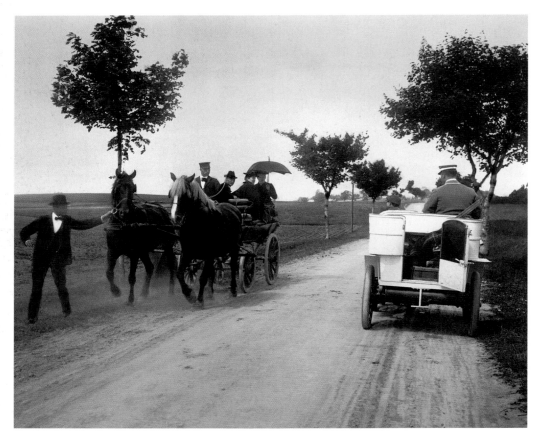

LEFT **FIRST MOTOR-CAR SEEN SOUTH OF COPENHAGEN, 1902**

There were few motor-cars in Denmark in 1902. Ours was a French automobile of a very rakish cut, complete with a tall, handsome military chauffeur, both belonging to a colonel in the Danish army who placed them at our disposal for a tour. But wonderful as it was to us, I may as well confess that it would excite only ridicule to-day, for it was a mere six horse-power voiturette, capable of twenty-five miles an hour on the level roads, but rather weak and puffy when it came to climbing hills.

RIGHT **CAR TROUBLE, SOUTH OF COPENHAGEN, 1902**

We enthusiastically hit the road, passing trees, fields and horse carts, tasting the sweet delights of speed. When suddenly, bang! pss-s-ss! Oh, the horror of that sound, the hiss of that elastic serpent coiled around the front wheel, that flabby rubber viper that will not hold its breath long enough for us to cover half a kilometer. Thanks to the only auto repair shop in town and thanks to his good aid and that of his willing men, things are soon put to rights and we do have a good day, one of the best days I can remember, unless it be the day that followed, and the day that followed that.

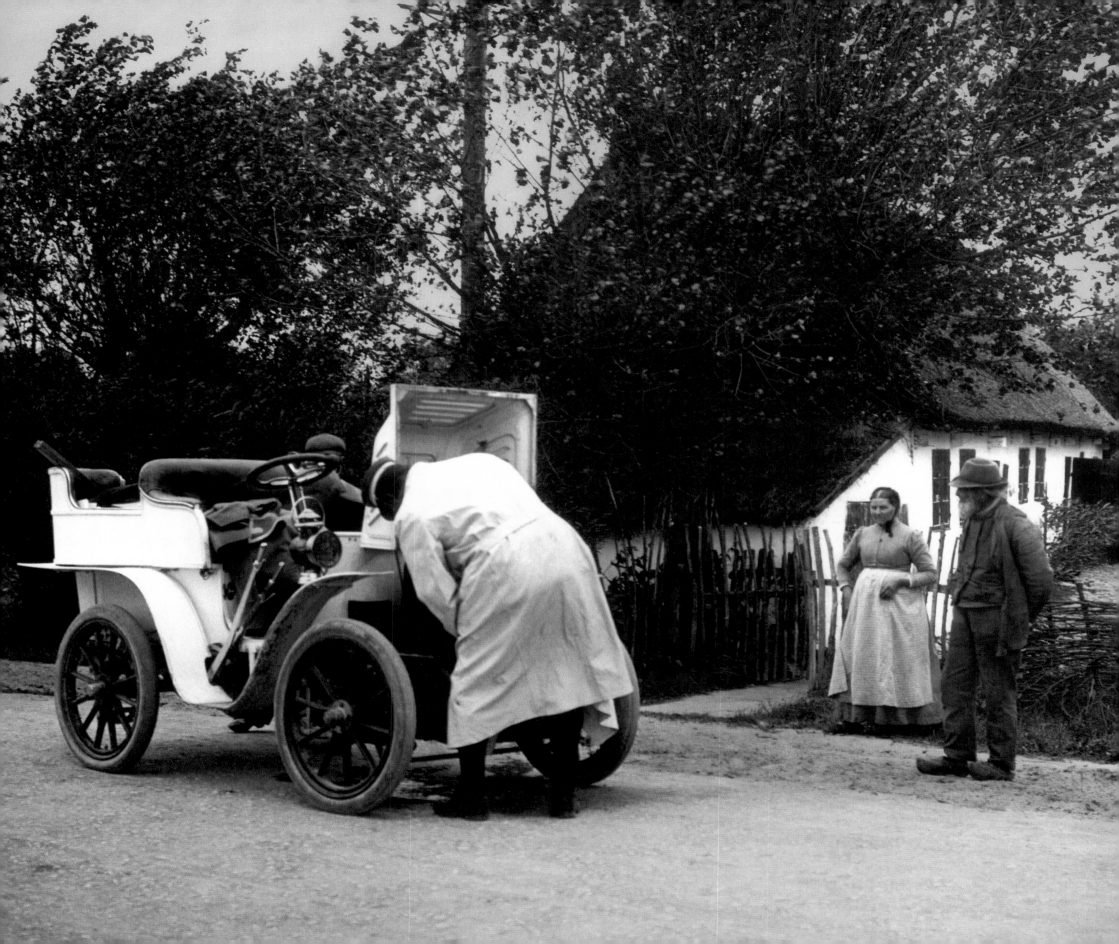

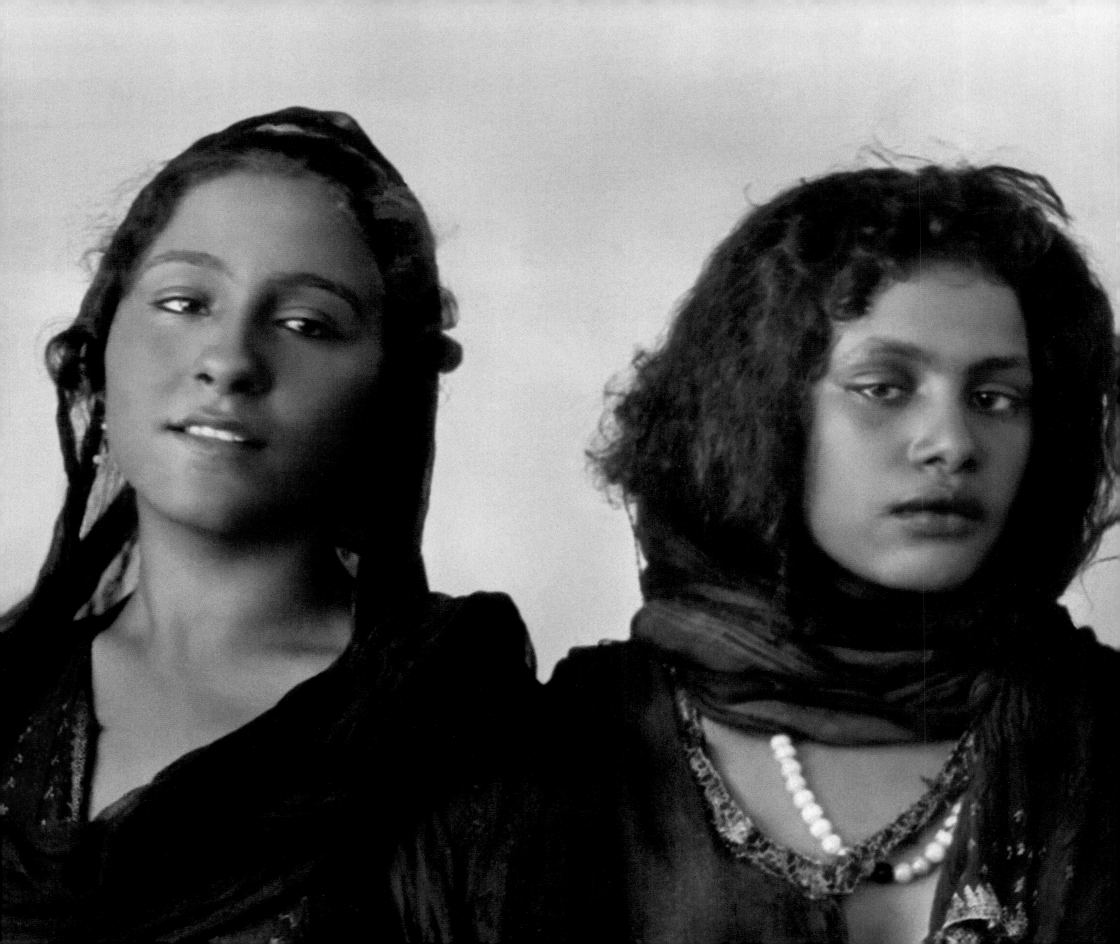

EGYPT
MOTHER OF THE WORLD

To go to Egypt is to go back to the beginning of human history. Beyond Egypt lies primeval mystery. The earliest pyramid marks the frontier between the unknown and the known, and in the wilderness of centuries that rolls between the pyramid and the oldest works of man in other lands, the only conspicuous milestones are the other pyramids, and the other Egyptian monuments that rise along the Nile. For more than a score of centuries the world was Egypt, and Egypt was the world.

A voyage up the Nile is like a thousand-mile mirage come true. In a mirage we seem to see wonderful things that we know to be impossible. Along the Nile we actually behold the things that seem to be impossible because they are so wonderful. A mirage is only an optical illusion of wonders and beauty in the desert, but the river Nile has created a wonderful and beautiful reality, and that reality is Egypt, the ancient land that was the mother country of antiquity.

The valley of the Nile was the cradle of our civilization. In the sands of Northeastern Africa the seeds of human greatness brought forth the earliest fruits of promise for our race. In Egypt, man first rose above the level of the brute; there, first, he began to cultivate the soil, to build cities, to establish governments, to write his story and to commemorate his deeds in monuments of stone. In Egypt, Art, Letters, and History were born. For us, "the heir of all ages," it is an inspiring privilege to visit this land of beginnings, this birth land of the genius of the human race.

The Egypt of today is worthy of its magnificent traditions. The grandeur and the greatness of the past still are there, palpable in forms colossal, indestructible, and overpowering. And it is this Egypt of the fathomless past, this Egypt that was the mother of the world that we know, that has called to us—children of the New World—across the centuries and across the seas, and we come obediently and gladly, for we owe her much in duty and respect—much more in admiration and in wonder.

We who would read understandingly the world-book of travel must sooner or later not only read but study the great first chapter—the Genesis of history—the pages writ in hieroglyphs on the old papyrus manuscript that tells the Tale of Egypt.

The traveler must perforce visit Egypt backwards; he must begin with the picturesque Moslem Egypt of today and work his way slowly back into the far more significant and far more picturesque Pharaonic Egypt of unnumbered yesterdays.

LEFT **EGYPTIAN WOMEN, CAIRO, 1906**
Behold, The Eternal Feminine!

RIGHT **TEMPLE DOORWAY, ABU SIMBEL, 1906**
This was one of those great moments that come so rarely to the traveler, one of those thrills that are the chief rewards of travel, one of those instances longest remembered and less frequently recalled. It came at sunrise one morning late in February. Our guide stood in the great portal gazing outside toward the Nile beyond, which rose the eastern hills outlined against the glow of the coming day. The sun leaps in sudden glory above the crest and sends its first rays straight as an arrow into this holy place.

England is now governing Egypt—both directly and through her masterly control of the native organizations, political and military. His Highness the Khedive Abbas II Hilmi, born in 1874, has been the nominal ruler since the death of his father. He owes allegiance to the Sultan of Turkey; his nation pays tribute to the "Sick Man of Europe" who, by the way, now seems to be getting well; but as the guide-book politely puts it, "the Khedive's independence of action is controlled by the British plenipotentiary."

England holds the keys of Egypt's gates and the keys of Egypt's treasury. The native may protest, and the modern Egyptian is a vigorous protestor, but the fact remains that Egypt belongs to England by virtue of the perpetual fiction of a temporary occupation. Egypt, before England came, was a land of lawlessness and pauperism. Alexandria, once the greatest city of a classic age, had shrunk to the estate of a poor fishing village of five thousand souls. Today Egypt is right and prosperous and Alexandria a thriving and attractive city of more than three hundred and fifty thousand souls.

There are two routes from Alexandria to Cairo—we go by rail, first along the banks of the canal and then across the wide, fertile reaches of rich delta land, past teeming towns of unromantic aspect, past miserable mud villages, over superb steel bridges, spanning the many spreading branches of the Nile, and at last, after one hundred and thirty miles of this new sort of monotony, our train thunders through a dilapidated suburb and rolls into the central station of the metropolis of Egypt. Metropolitan it well may be called, for Cairo has a population of nearly eight hundred thousand and is growing larger every day. It is the largest city in all Africa. It is the capital of a now rich and prosperous nation numbering ten million souls, and it becomes, every winter, the Mecca of those cosmopolitan pilgrims of pleasure whose other sacred places are the Riviera, Palm Beach, Paris, London, and New York. Day after day, we watch train after train roll into this Cairo station bringing the pleasure seekers and money-spenders of the world to Egypt's Capital. It is worthwhile to come to Egypt if only to indulge in the social joys of "the Cairo season." [1906]

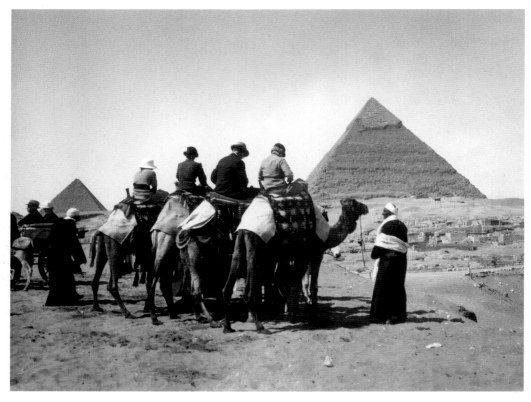

LEFT **TOURISTS ON CAMELS AT THE PYRAMIDS, GIZA, 1906**
Who looks upon the pyramids for the first time keeps silent: they represent terrestrial Eternity, they almost paralyze imagination, because they alone of all the works of man bid fair to conquer Time. But what are the Pyramids? They are simply tombs—the burial vaults of kings who reigned about 2000 years before the days of Rameses or nearly 50 centuries ago.
Never to be forgotten is the moment when we first behold the outlines of those solid shapes, gigantic and triangular that stand for all the glory and the dignity of the Egypt of the past. We murmur, "The Pyramids," that is all that should be said: "Pyramids!" All history is breathed in that one word. This is the story of our race from today back to the dim beginnings.

RIGHT **SUNSET, GIZA, 1906**

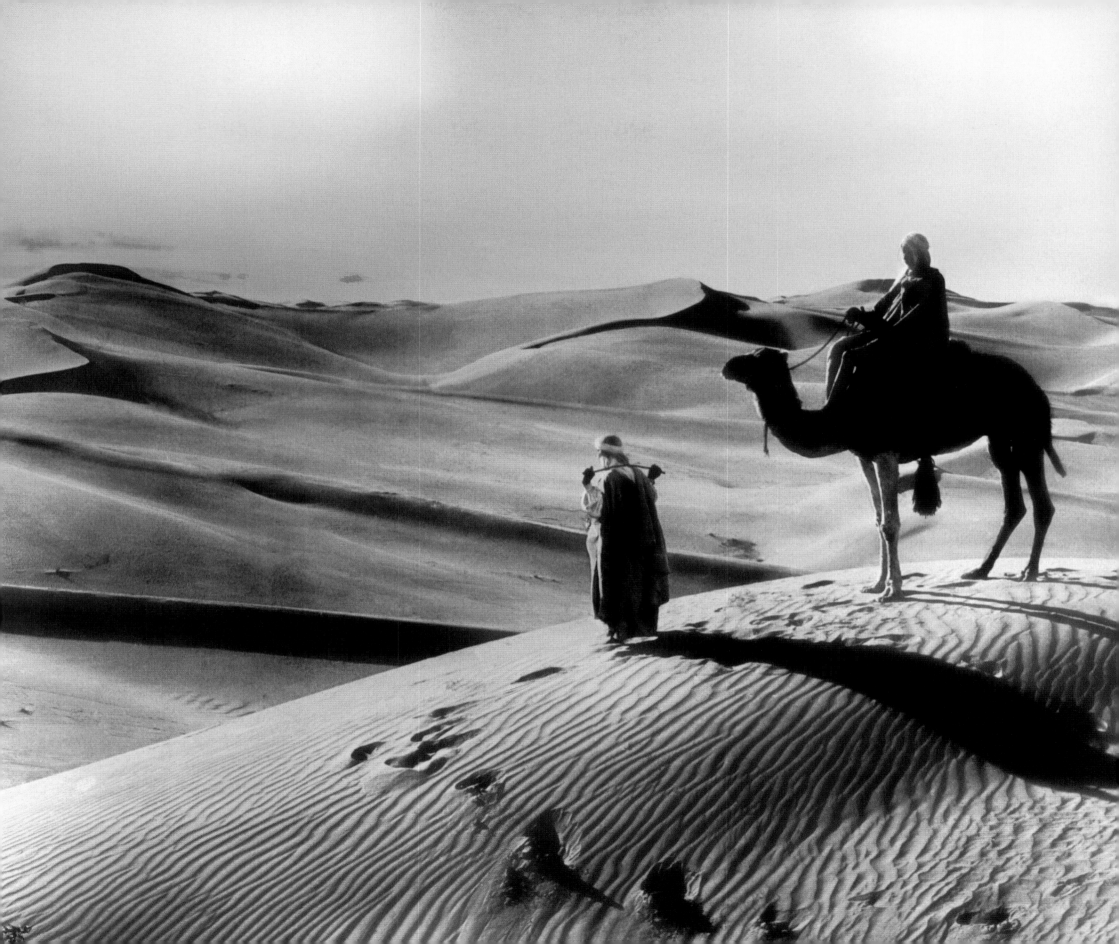

PALMS AND THE PYRAMIDS, GIZA, 1906
Man made, but man cannot destroy, the Pyramids. The
Pyramids are destined to perish only with the world.
"All Things fear Time, but time fears the Pyramids."

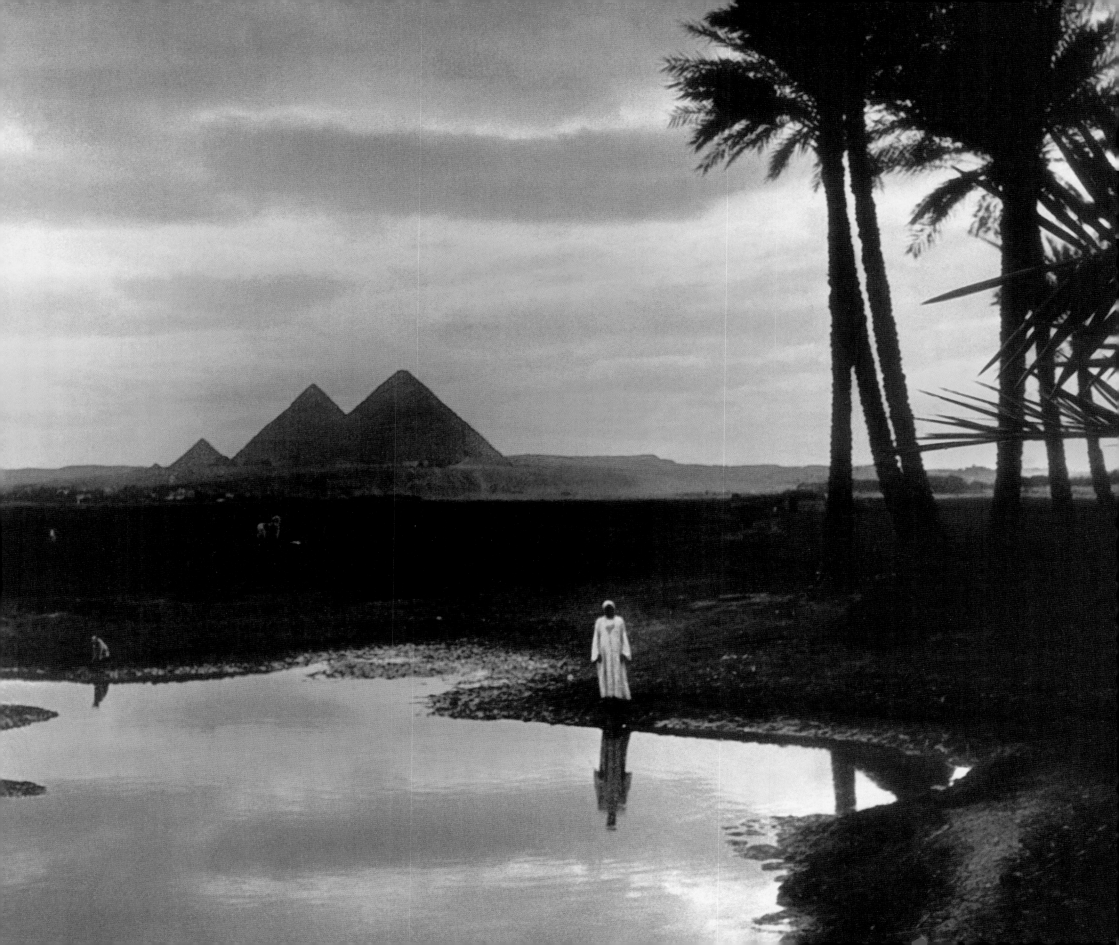

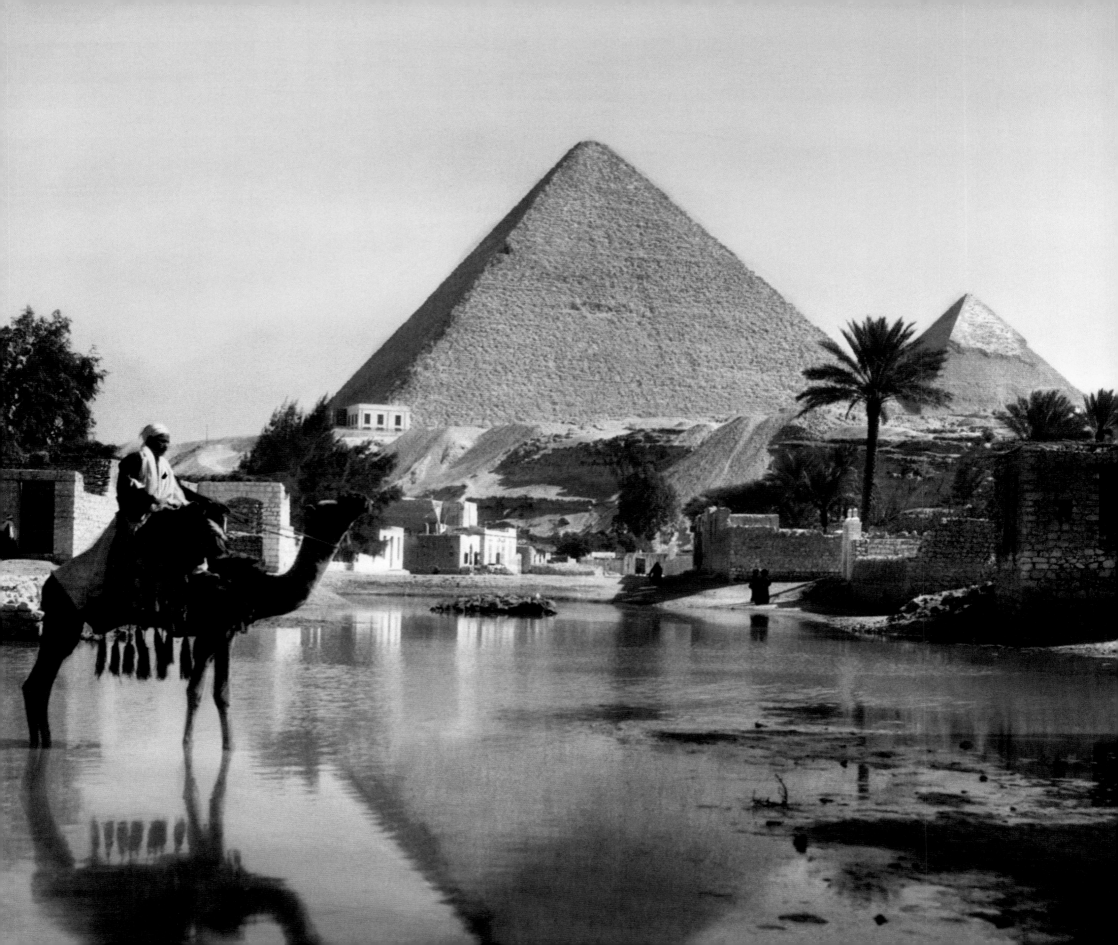

LEFT **MAN ON A CAMEL, THE PYRAMIDS, GIZA, 1906**
You cannot conceive of the intensity of the Great Pyramid
until you have been boosted up and then been hauled
down the northern slope of this stone mountain made
with hands—this Matterhorn of masonry, this one sur-
viving wonder of the Seven Wonders of the World.

BELOW **THE SPHINX, GIZA, 1906**
Who does not know this face and form; who need be
told the name of the huge thing, speechless but eloquent.
Today, battered and broken by the attacks of Time and Man,
this personification of mystery is flat-faced and featureless,
its head the stony semblance of a human skull; but I feel
sure that once this mutilated mask was beautiful.
We do not know by whom this thing was made or when.

We do know that it was cut from a ridge of natural rock,
with patches of masonry added here and there to carry out
the gigantic conception of the unknown sculptor. Here we
should close our eyes and try to picture all these things as
they were in those remote days when the Sphinx was per-
fect, when the pyramids were intact and immaculate and
loomed in all their geometric beauty as the dominating fea-
tures of the grandest cemetery the world has ever seen.

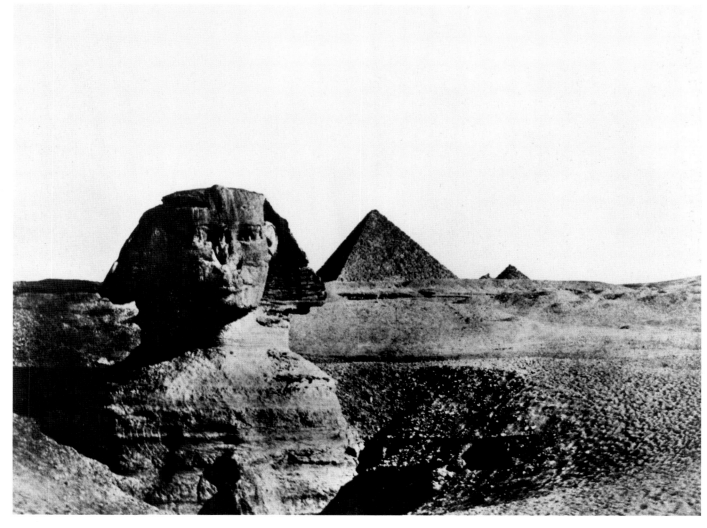

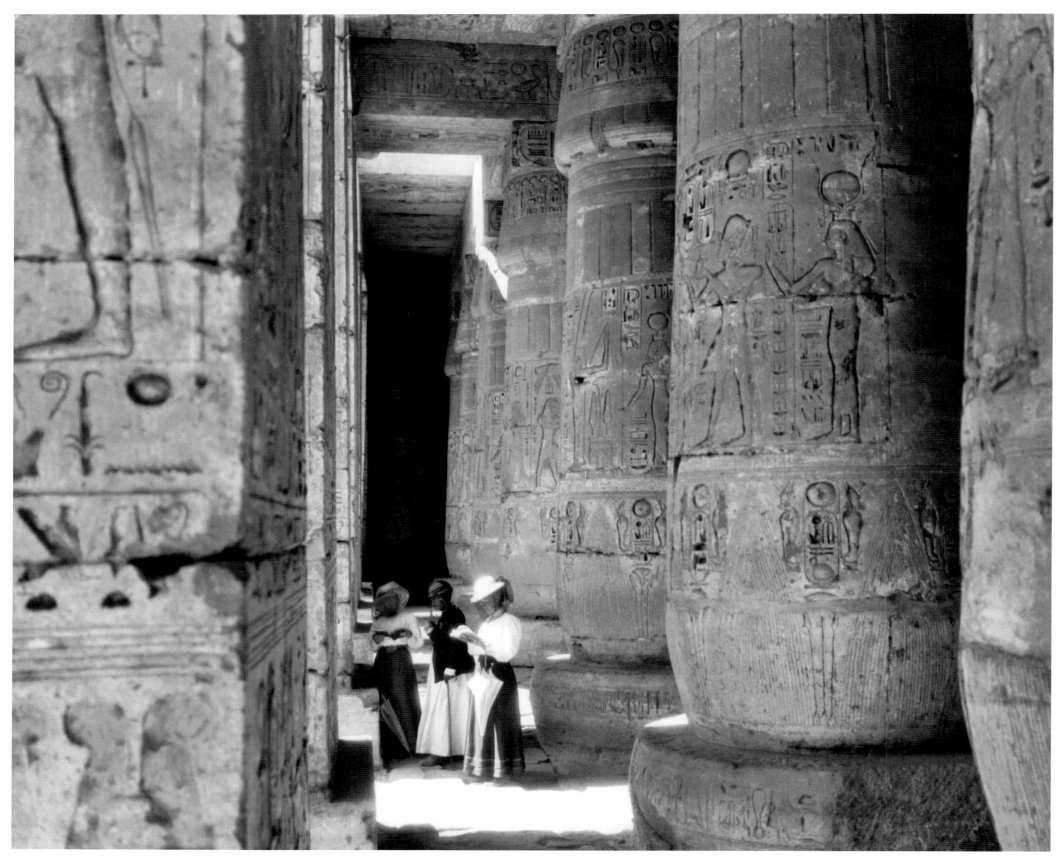

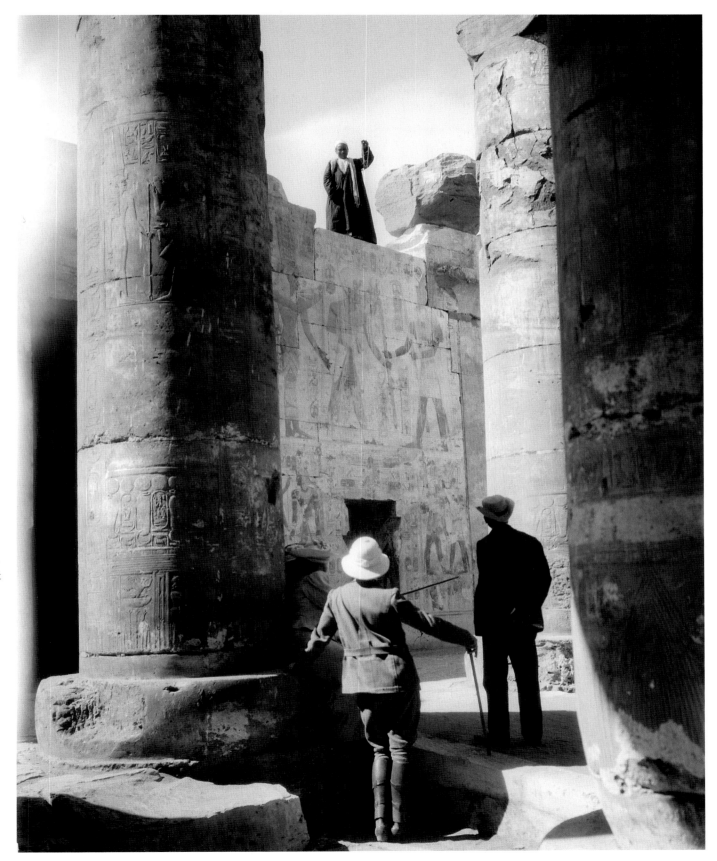

LEFT **TOURISTS IN THE TEMPLE OF HATHOR, DENDERA, 1906**

The Temple of Hathor at Dendera is one of the most satisfying sights in Egypt, at least to the casual traveler who, when he goes to much expense, trouble, and fatigue to see a sight, demands a sight that he can see with his ordinary eyes, not one upon which he must turn the eyes of erudition or imagination to make it look like anything worthwhile. These ancient pillars are eminently seeable. The sight "jumps to the eye," as the Frenchman would say. The interior looms in stony dignity and with a certain heavy architectural grace.

RIGHT **THE TEMPLES AT ABYDOS, 1906**

If we would make progress up the Nile as travelers we must be aware of taking with us too much excess baggage in the form of true erudition but even though it will be a dangerous thing we must take it with as little knowledge else we shall be blind to the meaning of things we have come to see today.

We should know, therefore, that when we dismount from the little donkeys that have carried us for more than eight picturesque miles from a modern mud village that seemed to be melting into the Nile to ancient temples that seem to be fretting away under the influence of the sand-laden winds of the desert, that we have reached the site of one of the oldest cities Egypt ever knew—Abydos, one of the holiest places in all of Egypt.

A TOURIST BOAT ON THE NILE, 1906

In Egypt, the hawkers hawk more kinds of petty and unusually useless merchandise than you would believe. I was actually offered a live parrot; then came such diverse articles as inlaid chairs, pistachio nuts, red fezzes, a monkey head, post-cards, shimmering shawls and incredibly...a mummied crocodile.

FELUCCAS ON THE NILE, 1906

We never tire of the sailing boats that wing their silent way like butterflies along the golden pathway of the Nile. We like them best when they are coming toward us, or slipping straight away up or down the placid stream. The full face of a Nile felucca is always *distingué* and beautiful, but the profile is distinctly disappointing. Thus it all depends on the point of view: head-on, the boats are fairy craft, graceful as gorgeous insects on the wing; on the quarter they have already lost their magical perfection of proportion; and when at last we overtake one and view it as it glides along abeam, the splendid argosy has become an ordinary scow, and the glorious, full-winged butterfly has grown as scrawny and as awkward as a humble sand-fly.

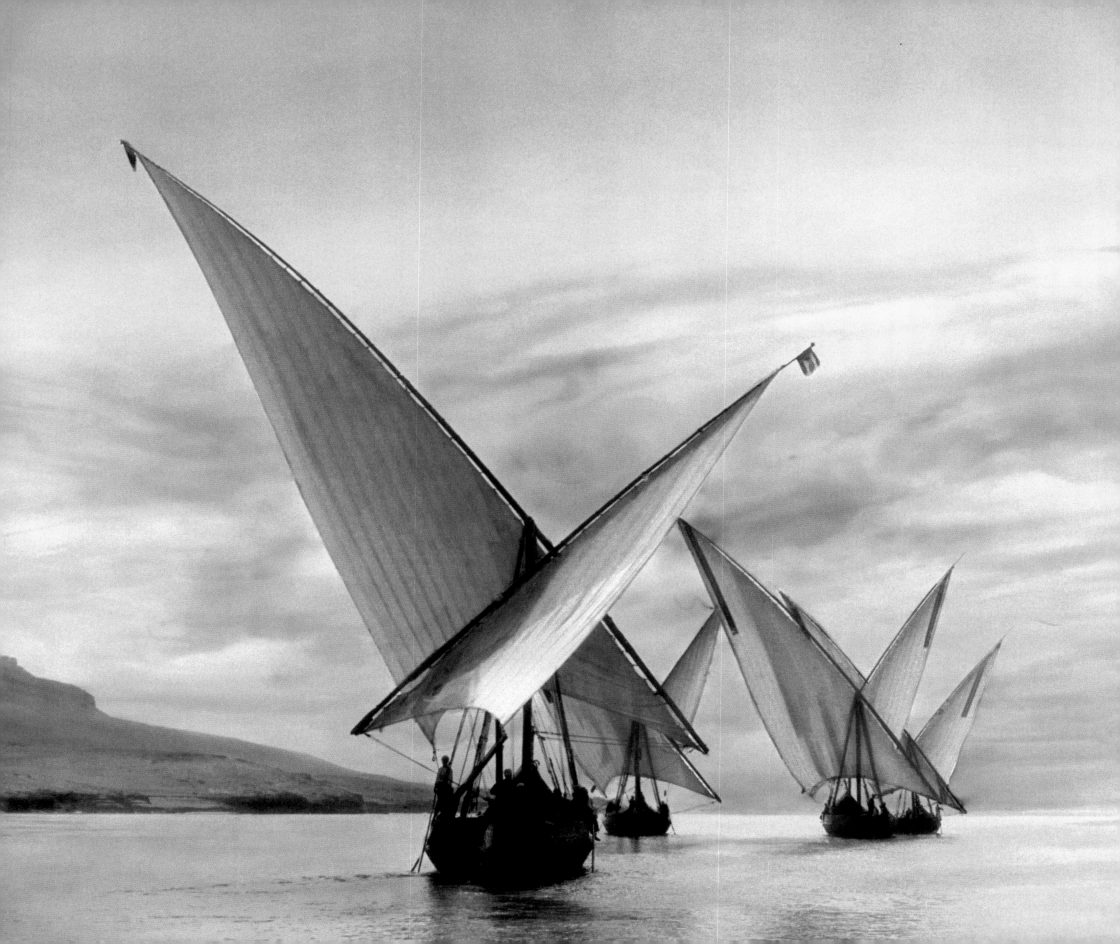

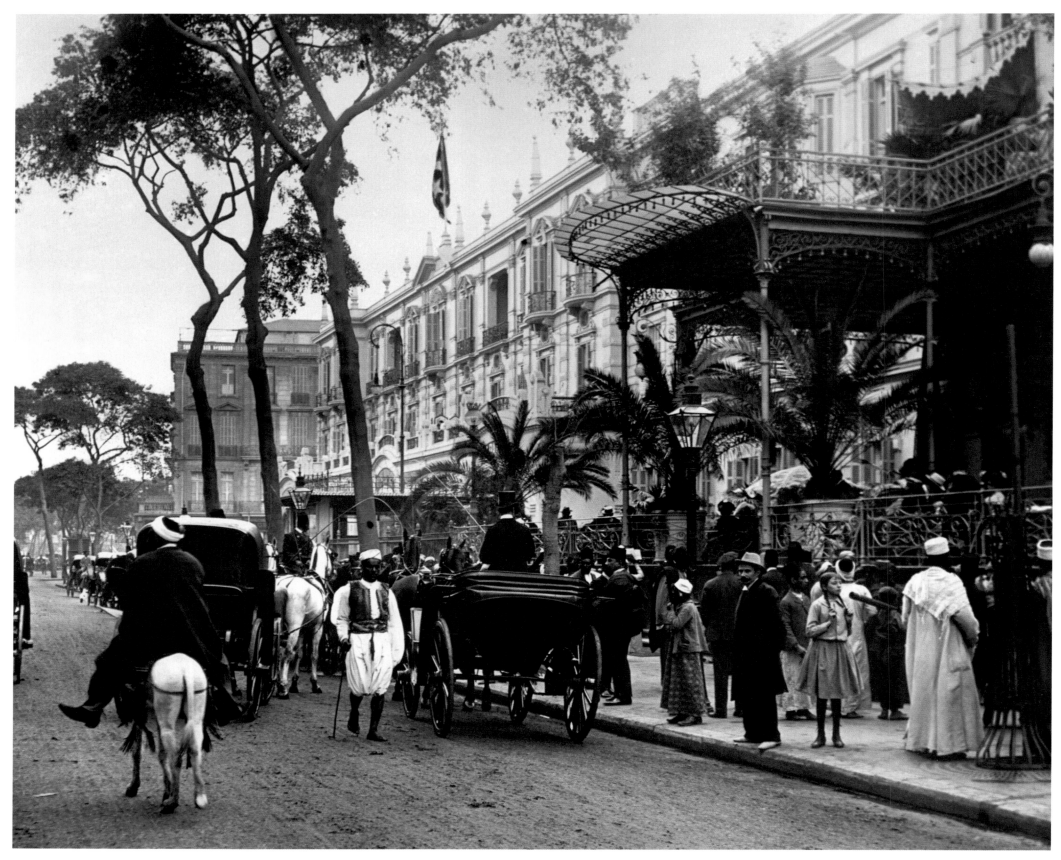

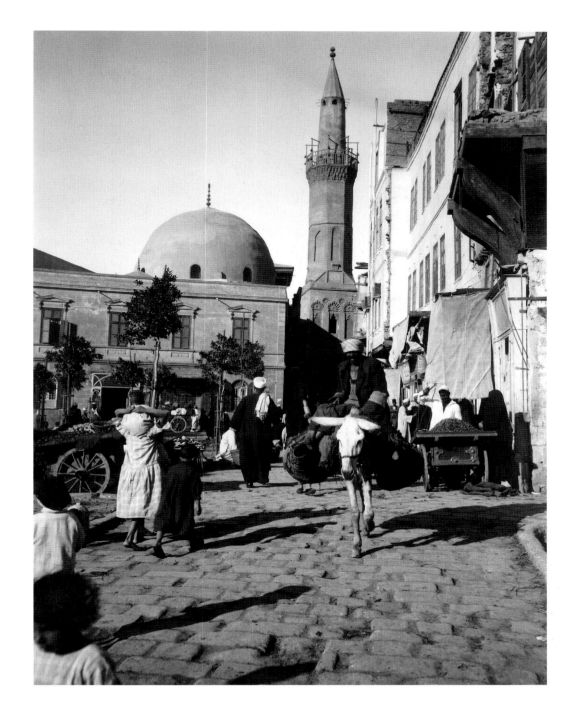

LEFT **SHEPHEARD'S HOTEL, CAIRO, 1906**

We drive directly to Shepheard's Hotel, the original cara-
vansary for Christians in this Moslem city. There are now
many other big hotels, some bigger, even more luxurious,
but Shepheard's remains the heart and center of the for-
eign life of Cairo. The terrace of this hotel is one of the
famous meeting places for world wanderers, half-way
halting place in their race around the world.
Not to know Shepheard's terrace is a social crime. The
traveler who has not trod the tile pavement of this terrace
is little better than a stay-at-home. And the woman of fash-
ion who has not sipped tea at the tables on the terrace
dares not look five o'clock in the face.

RIGHT **CAIRO, 1906**

The real streets of Cairo are not found in the neighbor-
hood of the hotel. Let us plunge into the maze of the
bazaars reeking with color before we can feel that we are
in the real streets of the real Cairo. Everywhere there is a
strong appeal to eye and ear—and nose. We are in a world
of novel sights and sounds and smells. Tall minarets attract
our gaze on high, loud crying merchants calling down to the
front of some dark, deep-set shop, one of the many thou-
sands of similar tracts of contagion set for tourists in these
interminable bazaars.

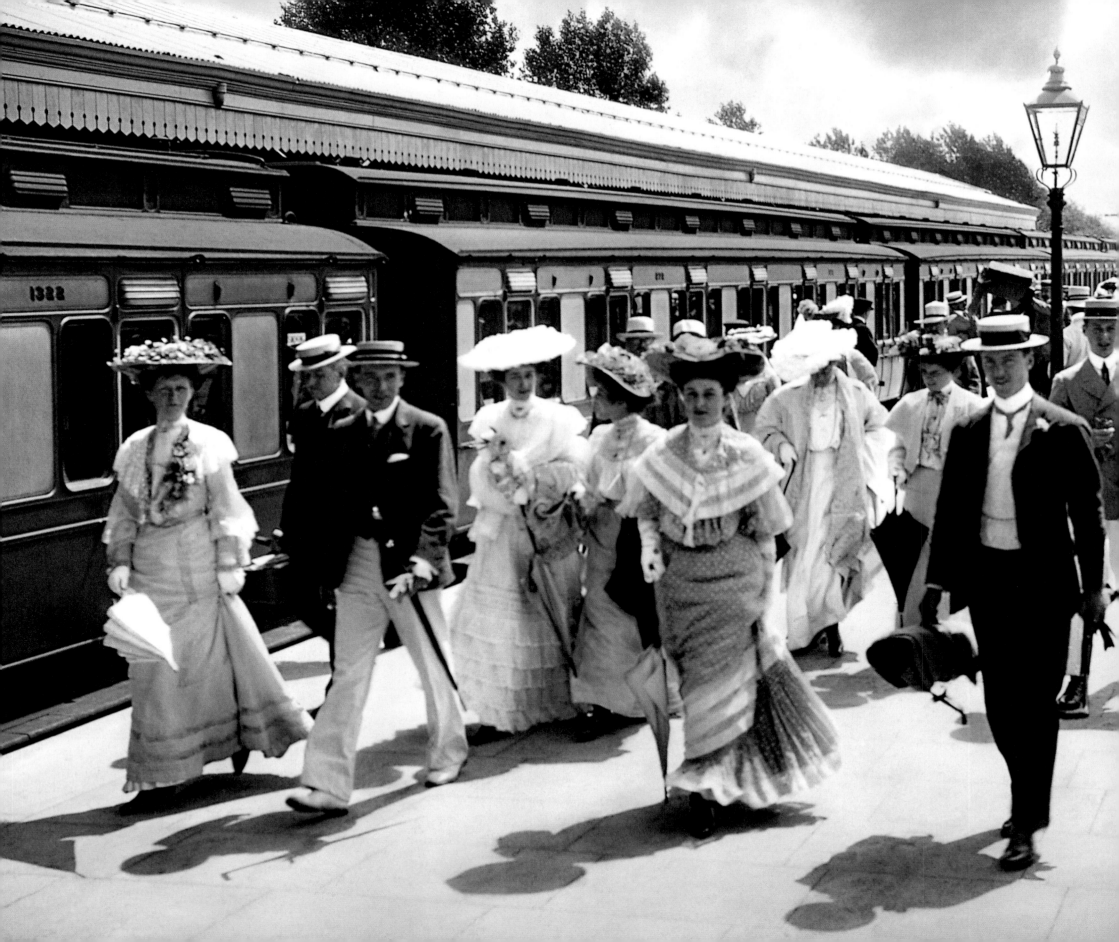

ENGLAND
BUILDING AN EMPIRE

In consideration of the British Isles—the little archipelago that has mothered the most masterful of modern races—the English-speaking, peace-loving, fair-fighting, and unconquerable race that has extended its dominion around theworld and, through its American kindred, has created in the United States the richest and most powerful of modern nations.

England is not Great Britain. England is not the British Empire, but England is and must remain the heart and soul of the world-wide federation of free peoples who speak her language, cherish her ideals, and give her loyal, respectful, self-respecting, and intelligent allegiance. There is something thoroughbred about England, something that men of other nations are impelled to admire and respect even though they may resent and pretend to ridicule it. Nowhere in the world is there a land so rich in gentlemen.

The country itself is as well-groomed in appearance as the English gentleman. You may search Kipling's Orient from Bombay to Mandalay and fail to find a "greener, cleaner land" than England. There is no monotony in the feat of beauty that is spread before the traveler in the south of England. The exquisitely finished aspect of the country, the absence of industrial scars, the picturesqueness of the old-time towns and villages make touring a delight. And yet strong indeed must be the traveler's "wanderlust" to keep him on the move in England when there are so many charming places that invite him to lay aside his pilgrim staff, and settle down to spend the season.

To know London is to love London. Though to the newcomer a city seemingly inhospitable, London becomes in time, to a greater or less degree, according to the worthiness and merit of its guest, a place of such delightful and interesting experiences that a sojourn there must ever remain a gracious and ennobling memory. [1904]

London is the most important place on earth. It is not only the most populous, it is the greatest of great cities. No other city is the center of so many world-wide interests. Toward no other city do so many human beings look for inspiration, for commands and for reward. To the Americans, London means more than any other foreign city; we are related to its life: it is the Mother City, *the metropolis*, not of England only, but of the entire English-speaking world.

LEFT **ARRIVING AT THE HENLEY-ON-THAMES RAILWAY STATION FOR THE ROYAL REGATTA, 1897**
Summer in England is a season of delight, and going to Henley is one of the most delightful doings of the season. The Henley Royal Regatta is an important fixture in the sporting calendar and a Society event of the highest order.

London is not one city; it is about 30 towns and villages that have become cities and grown into one another without losing their respective identities. Each is governed by its own mayor and its own alderman, each sends its own representative to Parliament, each has its own town hall, its own town business center, its own parks and pleasure-grounds and its own parishes. Of all these united cities, the oldest and most famous is the one that is called "The City." It is the financial and commercial heart and center of the modern world, and in the midst of it stands England's greatest bank—the Bank of England. The metropolis of the world's greatest empire is no mere creation of today—London has had a continuous existence for about two thousand years.

In London dwells a population of over seven million. The citizens of London outnumber the sum total of the subjects of three important European kingdoms; add all the Norwegians in Norway, and all the Danes in Denmark, to all the Greeks in Greece, and you will not have quite enough people to fill the places of the living Londoners to-day.

There is no other city in the world that offers so much old-time charm, combined with so much that is best in modern life—old London, dreaming calmly, undisturbed by modern London's roar—new London, with its pulsing enterprise, guided, controlled and made delightfully likable by the spirit of the old. Besides the London of grand old architectural piles, historic sites, aristocratic squares and teeming city lanes there is the London of relaxation and recess from sightseeing and from care—there is the London of suburban palace parks, like Hampton Court—of river junkets, by steamer down to Greenwich, or in punt, canoe, or skiff along the shady reaches of the princely Thames—there is the London of popular festivities at Crystal Palace, Hampstead Heath, or Epsom Downs on that great day when all the world goes out to see the Derby run; and most fascinating of all, the Henley Regatta with its wealth of beauty, color and animation. [1914]

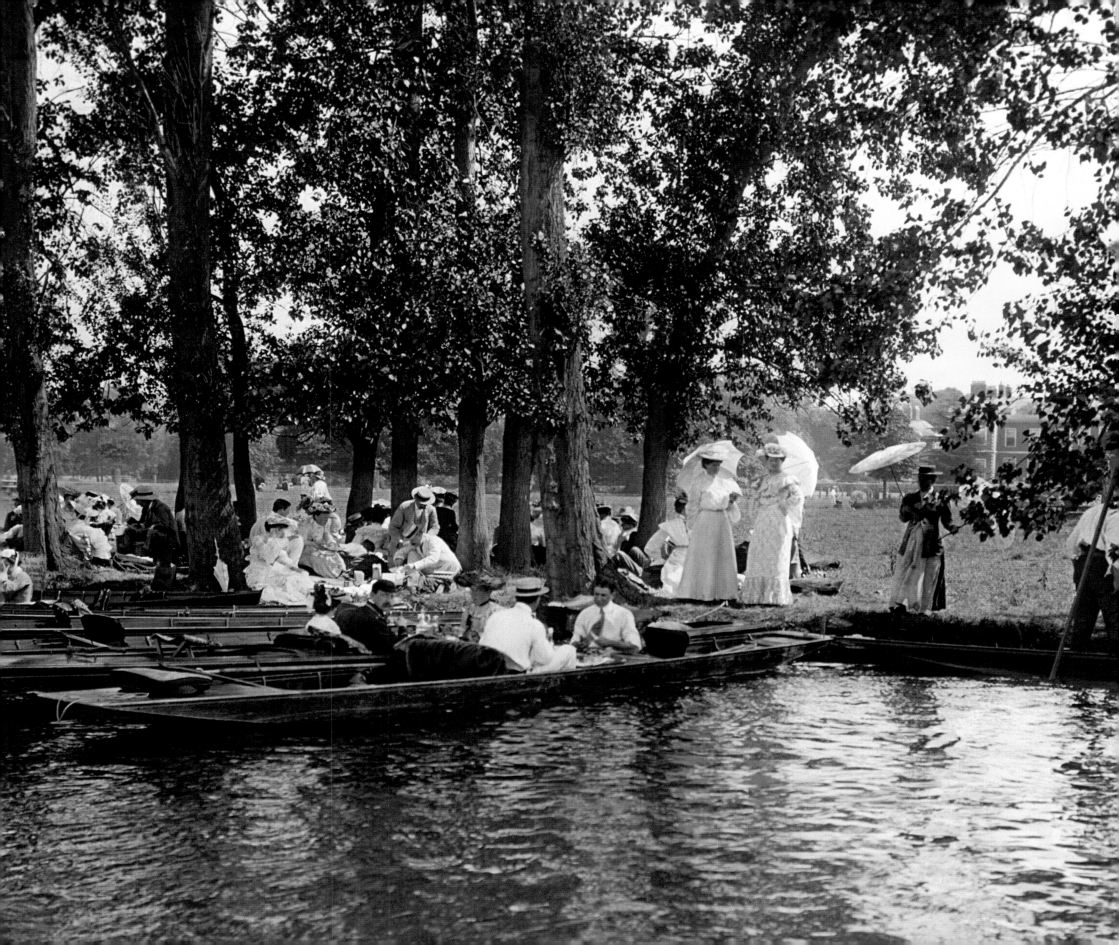

BELOW OXFORD STREET, 1897

In the 1890s, Oxford Street, in the heart of London, was
a street of small, single shops; those of booksellers, shoe-
makers and goldsmiths always bustling with activity. The
words "carriage trade" work very well to describe the quality
of goods and custom service available on this mile-long
shopping street.

**RIGHT THE CRYSTAL PALACE, SYDENHAM HILL,
SOUTH LONDON, 1897**

A popular resort for London's multitudes is at Sydenham,
eight miles from London, where the famous Crystal Palace
looms grandly. The great glass house is more than sixteen
hundred feet in length, its nave one hundred and seventy-
five feet high. The glass and iron that enter into its construc-
tion were first used in the building of the first great
Industrial Exposition held in Hyde Park in 1851.
This Crystal Palace commemorates the opening of the
epoch of those colossal industrial shows that we now call
World's Fairs. The Crystal Palace is, in a sense, a permanent
World's Fair offering us in its beautiful Courts of Art and
History splendid retrospective glimpses back along the
past of many civilizations, offering at the same time, in its
galleries and concert halls, much that is new and beautiful
in art and music, while in its gardens and arenas we may
witness from time to time thrilling spectacles of strong
appeal to all sorts and conditions of men.
*Over the following years the Crystal Palace played a vari-
ety of roles, as the site of England's first major television
station (1934) and sporting events ranging from soccer to
motorcycle racing. Destroyed by a spectacular fire in 1936,
the park grounds surrounding the Palace remain.*

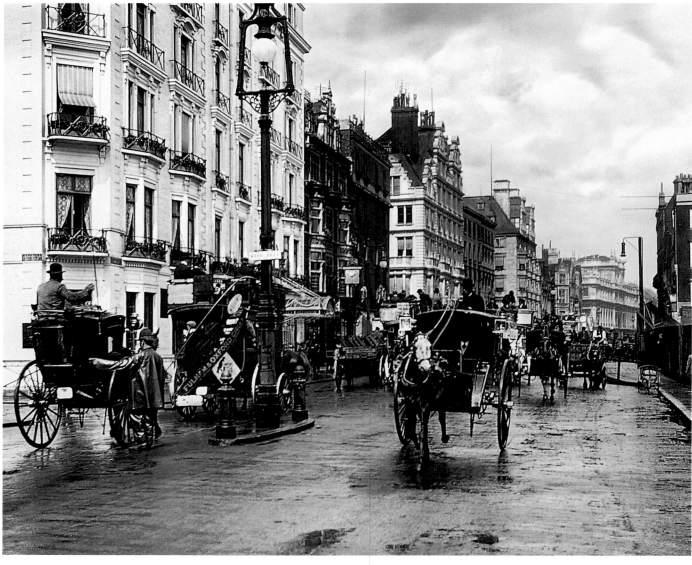

90 ENGLAND

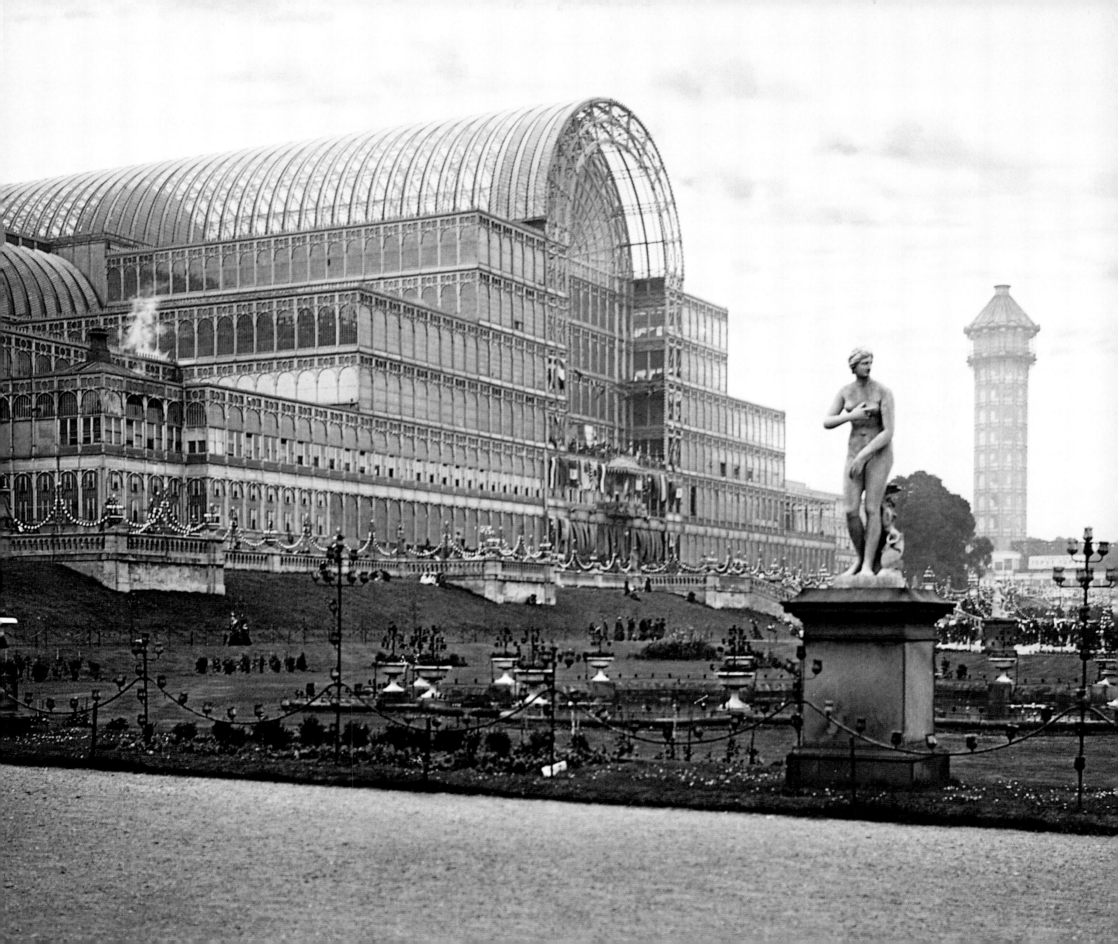

BELOW **TROOPING THE COLOUR, LONDON, 1897**

Perhaps the most impressive military parade in the world takes place once a year, on May 24, the birthday of Queen Victoria. On that day, a splendid scene unfolds with the "Trooping the Colour" which starts precisely at 11 A.M. The military display is both magnificent and satisfying. The space is comparatively small, and the massing of the Brigade of Guards is wonderfully effective—far more than it would be on a larger field. The annual ceremony honors the tradition of the Colors, meaning the flag, being the rallying point for a regiment, a symbol the soldiers must recognize and respond to on the field of battle.

The parade, which starts and finishes at Buckingham Palace, still takes place every year, but now on Queen Elizabeth II's official birthday, June 17.

RIGHT **THE TOWER OF LONDON AND TOWER BRIDGE, LONDON, 1897**

Far more conspicuous and imposing in appearance is the new Tower Bridge, which looks more like a tower than the Tower of London whence it takes its name. London's famous Tower is undeniably untower-like and squat. Its history, however, is the history of London for the last ten hundred years. Until the time of Queen Elizabeth it was a royal residence, and for many long years thereafter it remained a prison and a fortress.

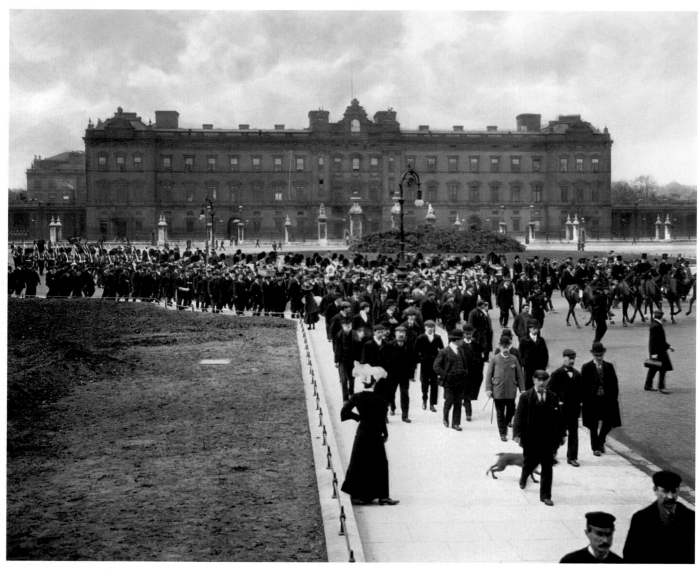

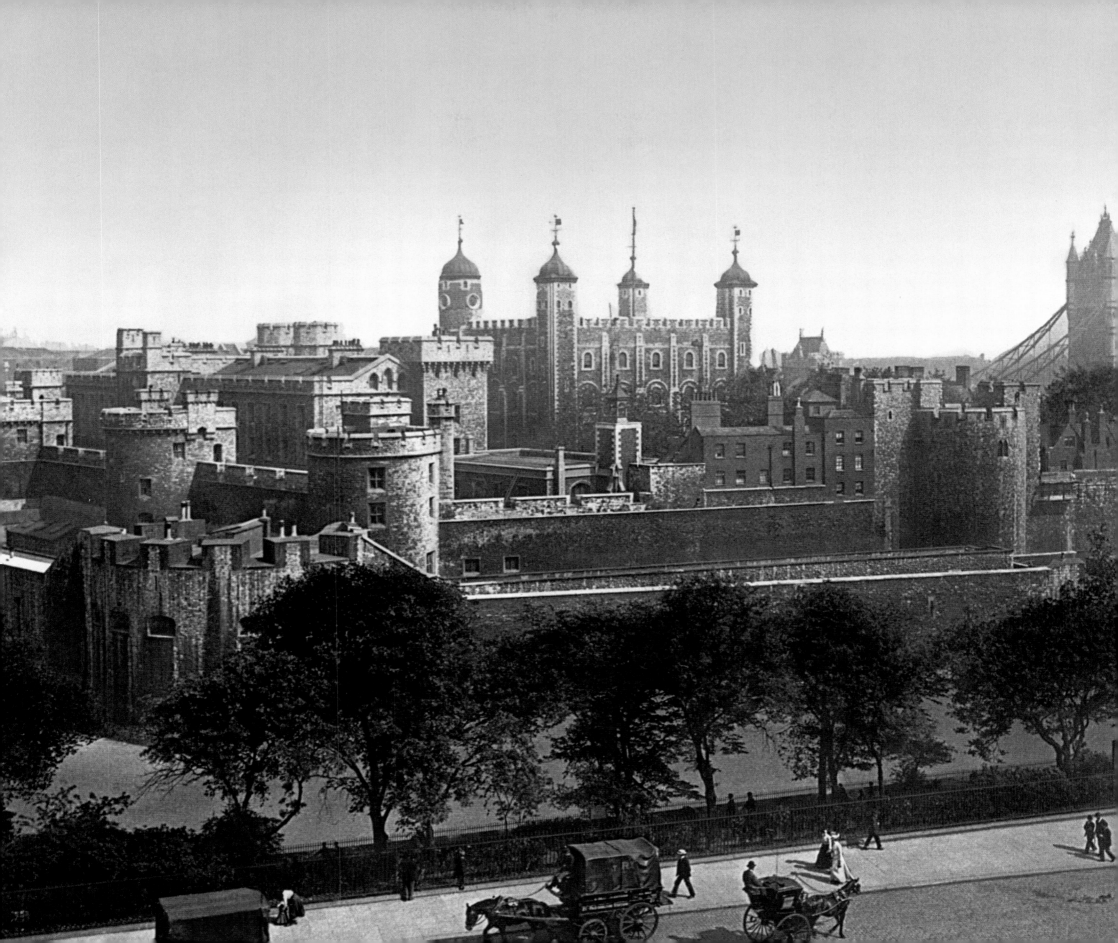

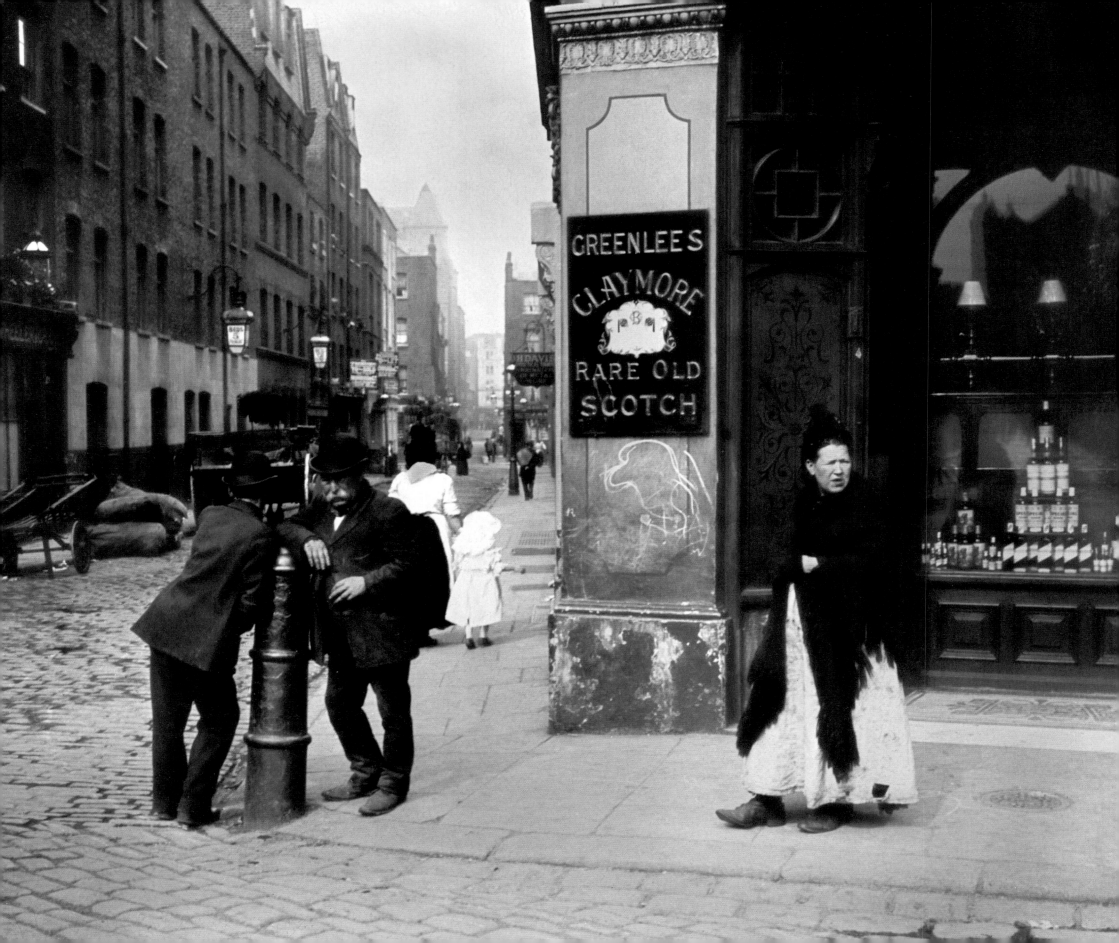

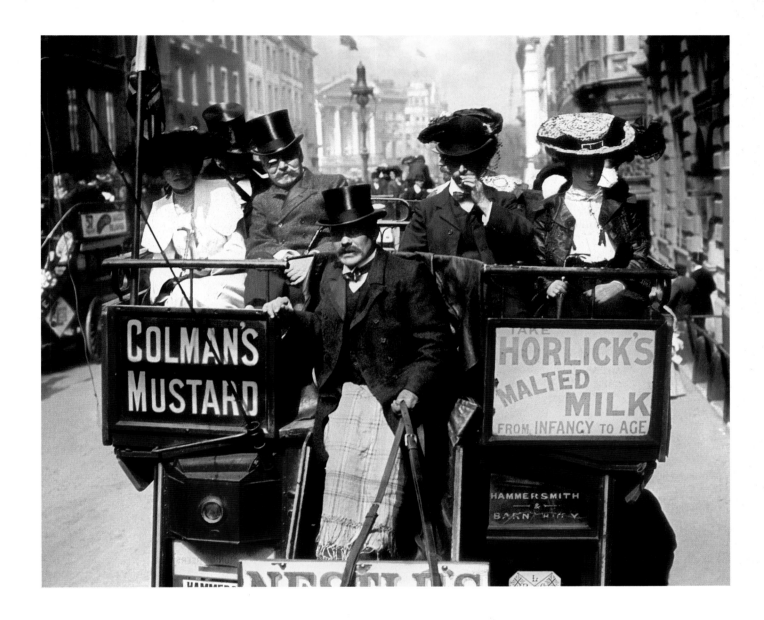

OUTSIDE AN EAST END PUB, LONDON, 1895
Those living in the East End of London live on the very
verge of the abyss surrounded by it on all sides. I have
noticed them coming out of pubs, leaning against lamp
posts for support or slouching along, usually in the middle
in the street, so broken in spirit that they dare not ask again
for the penny that has been so often refused. I have aston-
ished them by offering a greeting and an unexpected six-
pence. They would look up a little dazed and say, "Oh, good
God, guv'ner—thank you!"

HORSE-DRAWN BUS TRAFFIC, LONDON, 1897

VICTORIAN STREET SCENE, LONDON, 1897
My first impression of London was a huge, noisy city of
horse-drawn omnibuses, hansoms, private broughams,
and wagons, and it seemed to me that everyone was either
cracking a whip or shouting.
An omnibus journey was a slow procession, with many halts
and every opportunity for the exchange of pleasantries and
even making a new acquaintance. A traveler becomes part
of the busy street life of London.

A TRAFFIC JAM, WESTMINSTER BRIDGE, LONDON, 1897
When in London one should take at least one hansom, if
only to admire the marvelous skill of London cab drivers
in winding through the throngs of vehicles and pedestrians
which surge through the narrow streets and on the bridges.
It is probably the peculiar position from which a hansom
cabby looks upon the hubs of his own and his neighbors'
wheels that enables him to estimate to almost a hair's
breadth the space required for him to pass; but nothing I
have ever seen in any other portion of the world can equal
the ability thus displayed.

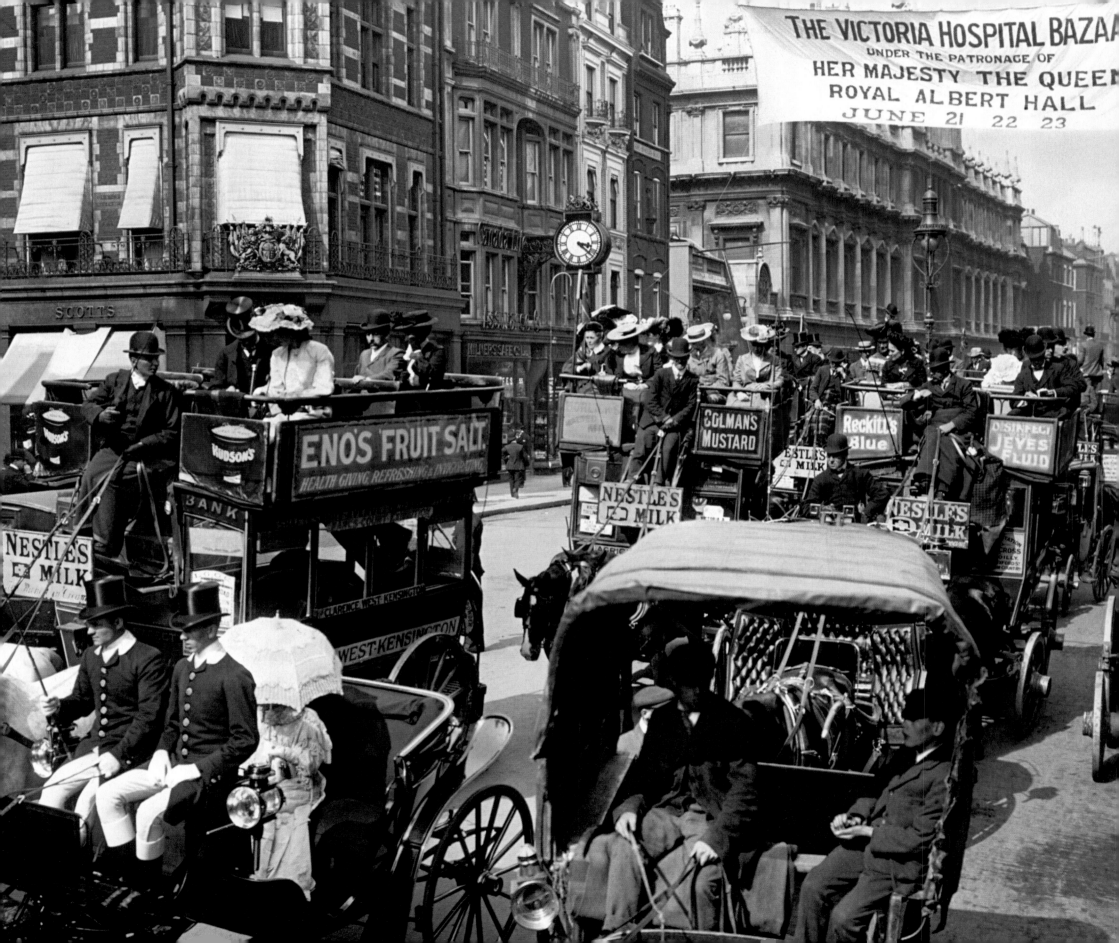

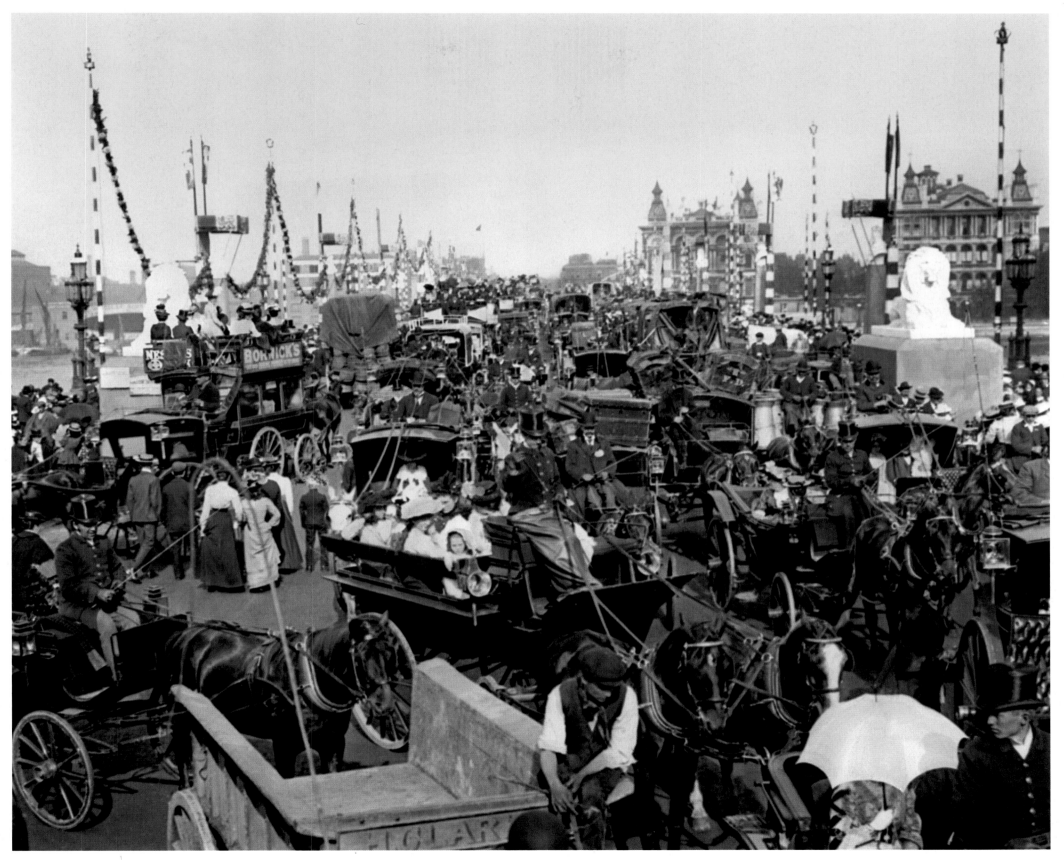

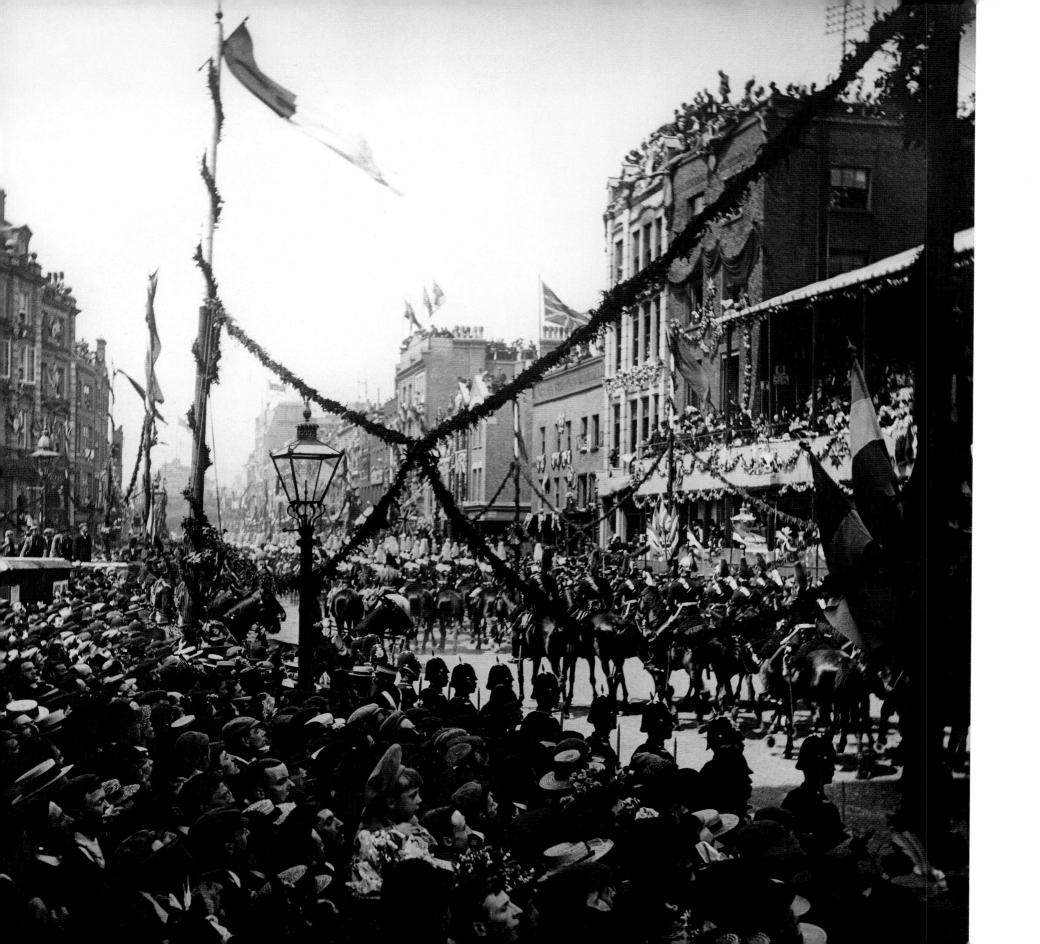

LEFT **QUEEN VICTORIA'S DIAMOND JUBILEE PROCESSION, LONDON, 1897**

After another continental tour, we reached London in time for the Diamond Jubilee of Queen Victoria. The Queen, having emerged from her long seclusion, was a highly respected figure and endless throngs of her loyal subjects lined the parade route from Buckingham Palace to St. Paul's Cathedral. We managed to secure a favorable position from which to photograph the procession. After several chilly hours of waiting, the sun broke out, just as the parade came into view. The regal Queen rode in an open landau, drawn by eight white horses; in my lens I sighted a tiny, white-haired woman dressed in black, the only spots of color, the cream-colored feathers in her bonnet and her white parasol. Excited shouts from the crowd of "It's the Queen!" greeted her long-awaited appearance in public.

RIGHT ABOVE **ARMISTICE PARADE, LONDON, 1918**

At 11 A.M., November 11, 1918, the guns of war stopped—at the eleventh hour of the eleventh day of the eleventh month. The bells of London rang out, and the lights went back on, as the British people rejoiced and celebrated the laying down of arms. World War I did not result in victory for the combatants; both sides simply agreed to stop the slaughter. The war to end all wars did not achieve that; what it did was lessen the idea that war is a glamorous endeavor.

RIGHT BELOW **EAST END WOMEN, LONDON, 1897**

I spent many hours wandering about the different London towns, but the streets and people that affected me the most were those in the East End. Here we find poverty, unemployment, and inadequate housing in the midst of London's wealth and commerce. But there's always a bright spot in the day and I enjoyed seeing the happiness of these two women in companionable conversation outside their front doors.

BUS ADVERTISEMENT FOR BURTON HOLMES'S TRAVELOGUES, LONDON, 1904

With some trepidation, I made my debut stage appearance in London in 1904, where I was kindly received with marked cordiality by a most discriminating public.

In announcing Holmes's entertainments in Great Britain, the word lecture (which Burton suggested seldom denotes anything entertaining) was replaced by travelogue. The newly invented word was happily suggestive of the traveler's tales with which Holmes delighted his audiences.

ABOVE RIGHT **PICCADILLY CIRCUS, LONDON, 1919**

We come to Piccadilly Circus to watch the world go by—the commonplace world of which we are a part, but a world which becomes wonderful the moment we are content to step aside and for a space become merely spectators of its every-day doings.

The passings and repassings of the myriad buses, motor-buses, hansoms and four-wheelers; the ceaseless crossings and intercrossings of the human millions is one of most impressive things in London, one difficult to picture, for in a picture we do not feel the endlessness of the procession.

RIGHT **FLEET STREET, LONDON, 1919**

Toward the wealthy West End we now make our way, pausing to gaze up from the crowded streets at St. Paul's noble dome that seems to float there in the air, high above the throngs that pass through Fleet Street, London's "Newspaper Row," the heart of the English Press.

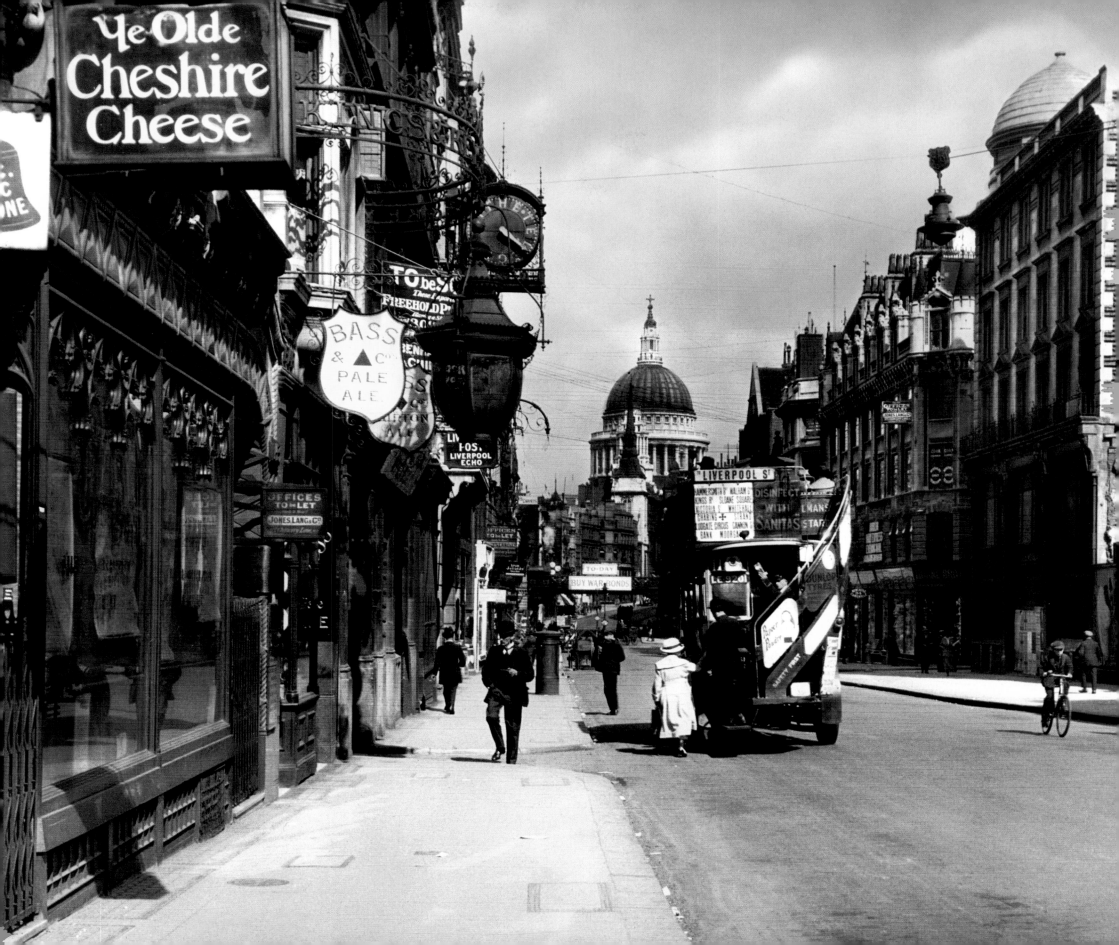

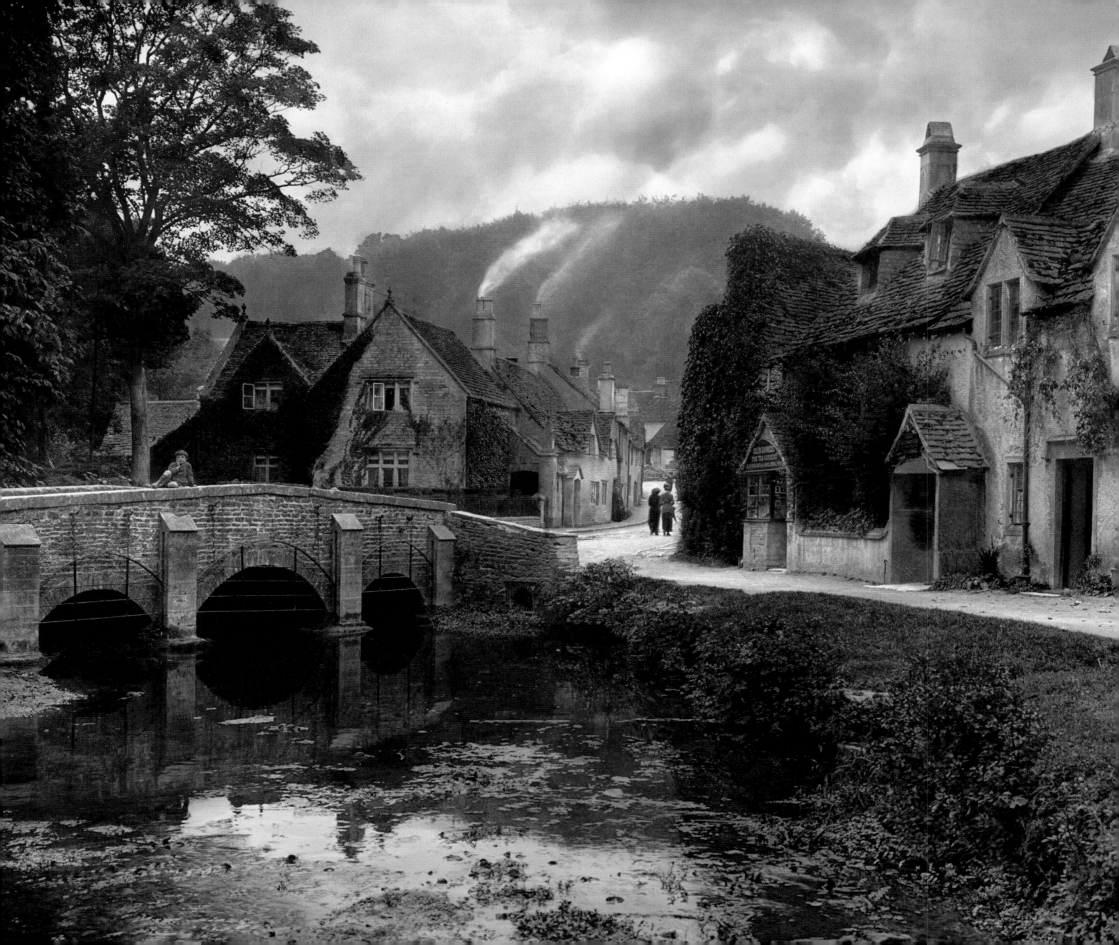

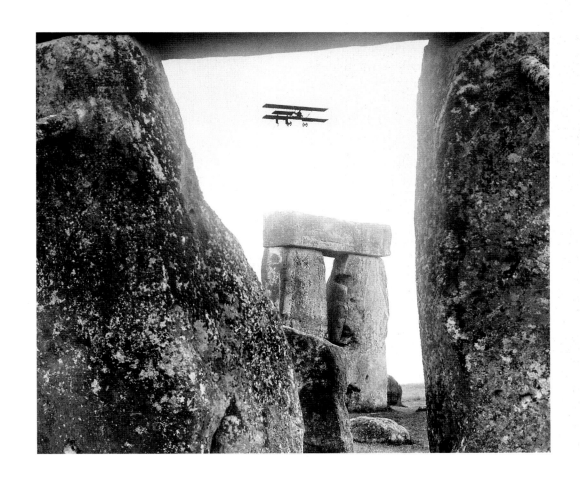

CASTLE COMBE, WILTSHIRE, 1914

As we travel through this land, that of England which is so old and at the same time so new—at least to me. Strange to say it is only after a quarter of a century of travel up and around and down our interesting earth, that I now find myself for the first time tasting the joys, seeing the sights, and marveling with the surprised enthusiasm of one who has discovered something new, at the beauty of delightful rural England.

As we traverse its deep cut lanes and peer through garden gates at impossibly charming cottages, we begin to understand why Englishmen are always talking about the delights of a country week-end.

STONEHENGE, WILTSHIRE, 1914

No man knows for what purpose these great stones were erected on the low hill that looms above the wide and wind-swept Salisbury Plain. The arrangement and orientation of the mighty blocks suggest that the mysterious temple was a colossal prehistoric sun-dial and calendar stone, erected with careful regard to the direction of the sun's appearance on the morning of the summer solstice. The cyclopean masses of Stonehenge must have been reared, by unknown men employing means to us unknown, more than thirty-six centuries ago—or, that we may better sense the remoteness of the date, let us say four hundred years before Ramses the Great set up his obelisks and the mighty monoliths of his colossal temples in the Egypt of the Pharaohs.

It is with a thrill of wonder that we look through one of the titanic trilithons—which opens like a portal of the fathomless past—and see, framed there against the blue of the heavens, British military aviators cleaving the ancient sky of Britain with man-made wings of modern air-craft. Their flight turns our thoughts from the unfathomed past, hopefully toward the unfathomed future of our race.

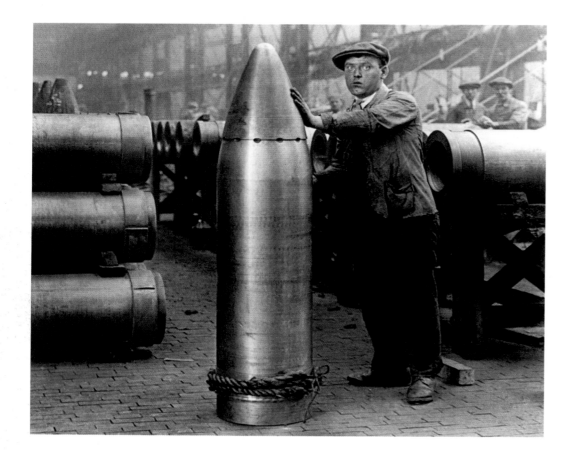

LEFT **A WORKER IN A MUNITIONS FACTORY, 1918**
The economic consequences of the war were felt quickly, as factories hired armies of workers to meet the new demand for munitions, chemicals and other goods.

RIGHT **AMERICAN SOLDIERS AT SUNSET, 1918**
I give my admiration to the men who, without counting cost or asking any reason why, answer a country's call to arms and do their duty as their courage and their nature makes them see it. Nobly they bore themselves, splendid in their dauntlessness, undismayed in defeat, magnanimous in victory. *The original glass lantern slide of this photograph was labeled "England," but current research indicates it could be wartime France.*

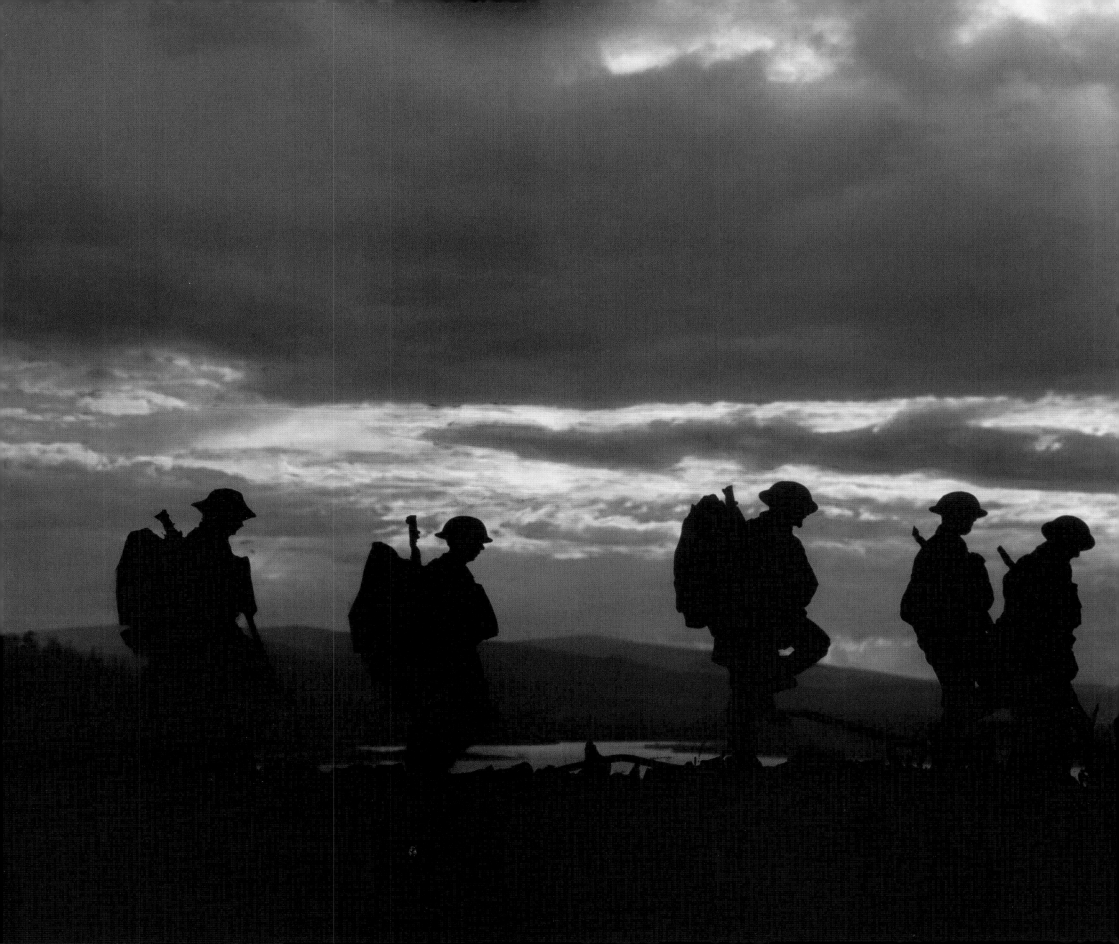

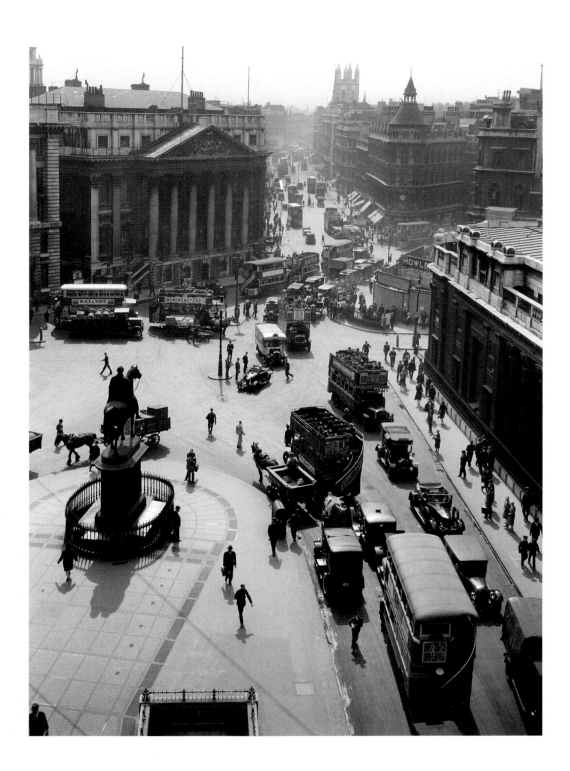

LEFT **MANSION HOUSE, LONDON, 1921**
London is splendidly unbeautiful; its architecture for
the most part grandly ungraceful; its walls covered with
a cleanly grime.

RIGHT **CONSTRUCTION AND CONGESTION, LONDON, 1929**
To get the "feel" of London's streets we should traverse
them day after day, viewing them from the outside seat of
many buses. The London bus is one of London's elevating
joys; it elevates one from the dead level of the streets, gives
one a point of view at once commanding, comprehensive,
and extremely cheap.
The shop-girl on a penny bus may literally look down on the
Lady in her smart Victoria. But both buses of the people and
the broughams of the swells are indiscriminately halted at
every intersecting street by the all-powerful and always po-
lite policemen. The hand that wears the glove of the police-
men rules the road, and rules it well.

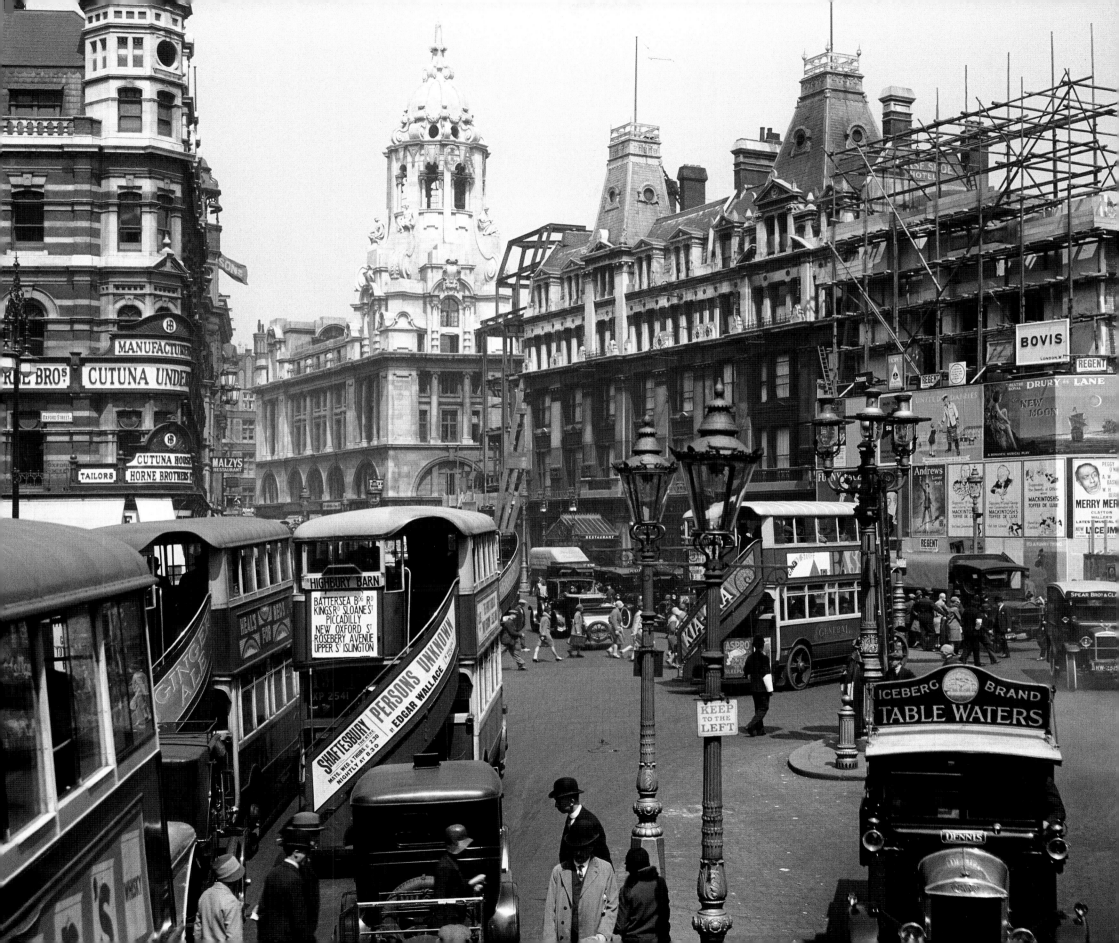

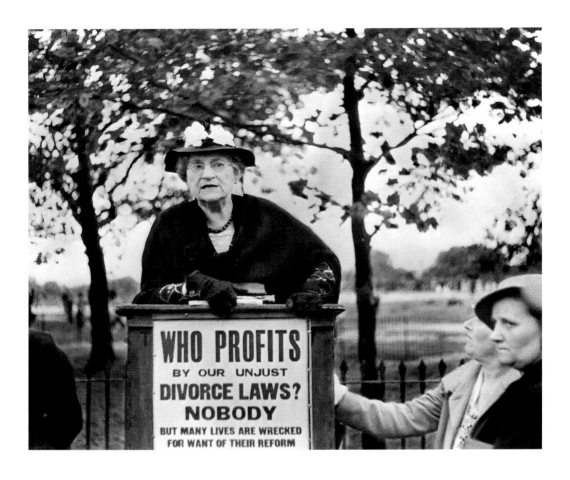

ABOVE **SPEAKERS' CORNER, HYDE PARK, LONDON, 1921**
The Park can be filled instantly to overflowing by an irresistible inrush of humanity from the congested regions roundabout. This happens now and then as the result of some slight socialistic agitation of that encircling human sea. Wave after wave of decently dressed earnest men rolls in from the surrounding streets, settles into a calm sea of faces upturned toward the orator, who is thundering a condemnation of the existing order of things.
I listened in amazement to the most outspoken abuse of the government, yet not a protest came from any of the bobbies within earshot. The working-men listened attentively, and applauded with discrimination and when the show was over, picked up their banners and marched off as they came, in orderly well-ordered ranks, obeying every behest of the polite but firm policemen.
In 1921, women were in the forefront of several major issues, such as Divorce Law reform. All a serious reform advocate had to do was stand on a box and deliver a speech. The crowd encouraged many women speakers with their applause and cheers that day.

RIGHT **CROWD AT EPSOM DOWNS RACECOURSE, SURREY, 1921**
They're off! The sport of kings has always attracted commoners as well as crowned heads. The British passion for sport has always gone hand in hand with a passion for gambling. The racetrack and gambling had a draw for American travelers as well: you could go to the races while traveling, something the tourist might not be able to do at home, that is, without censure.

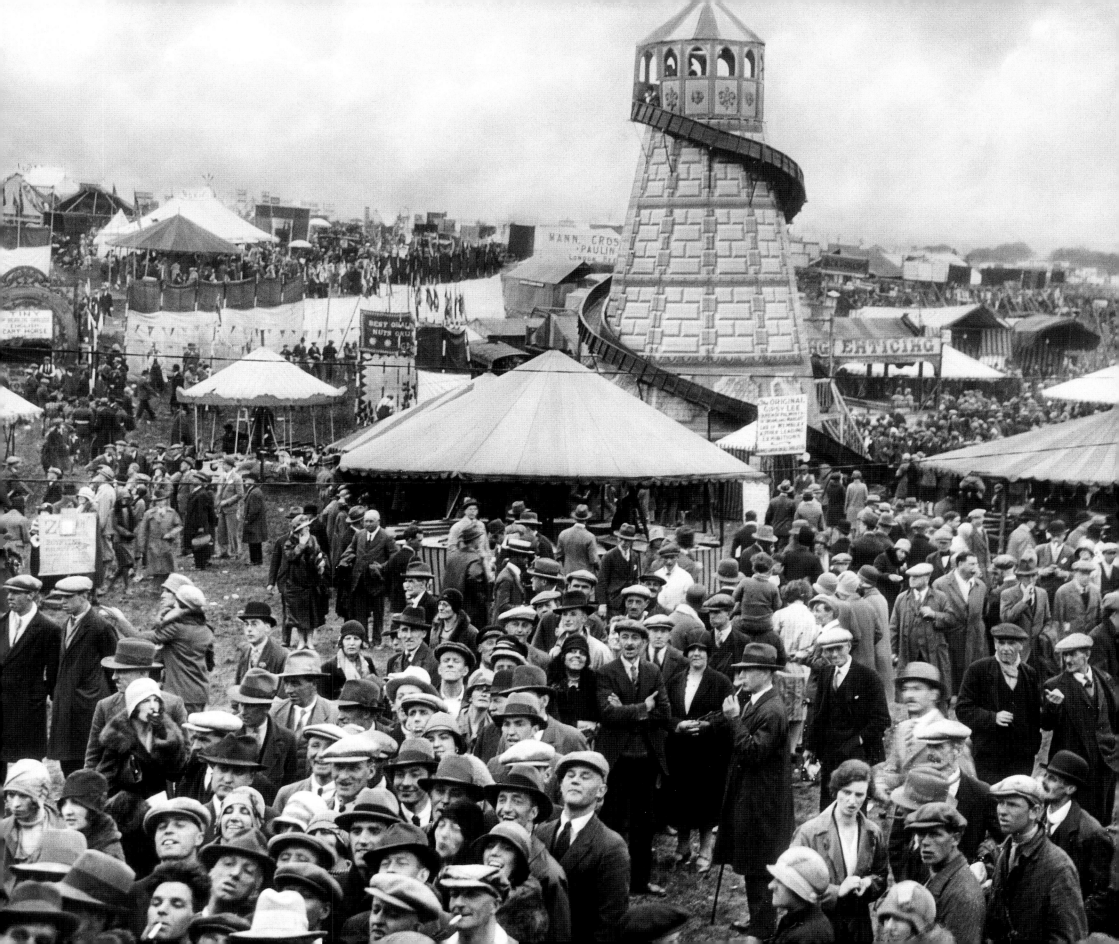

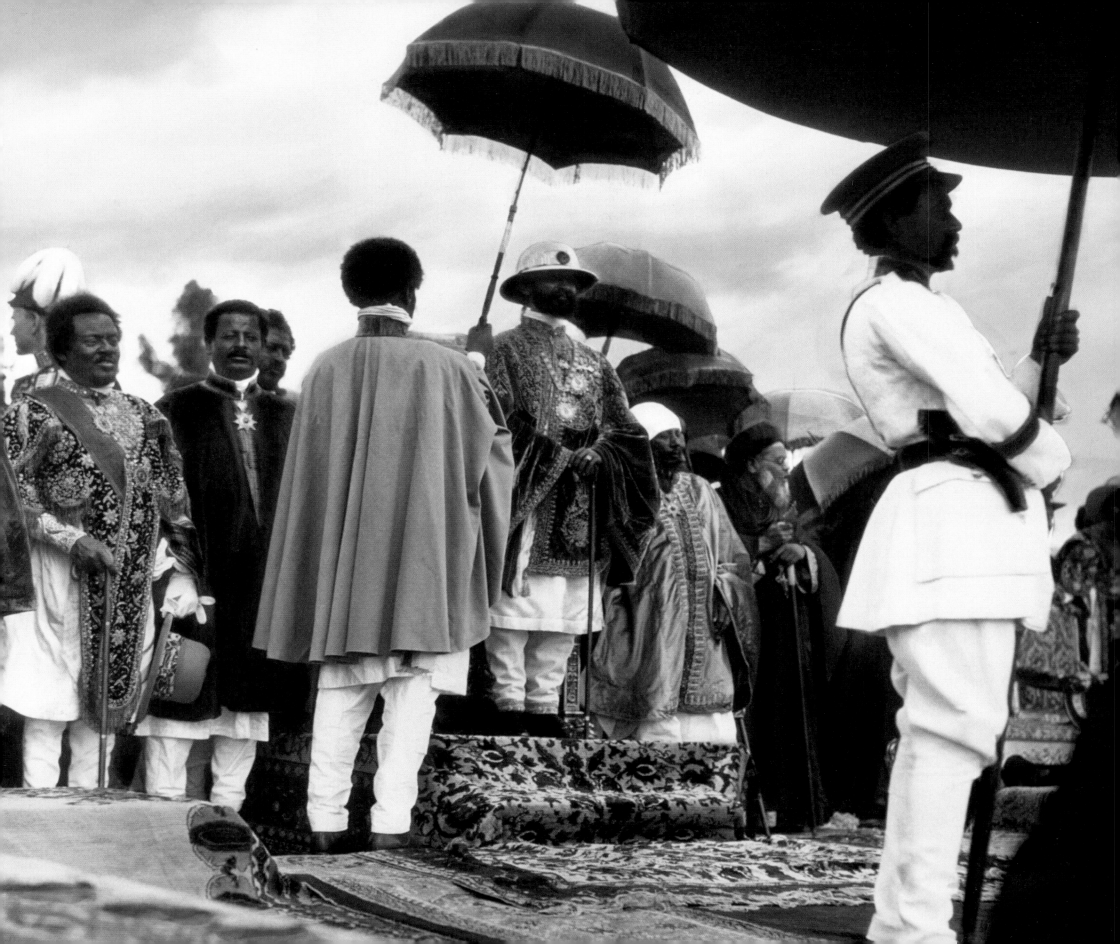

ETHIOPIA
A TIME OF IMPERIAL SPLENDOR

In the fervent hope that his public will welcome a glimpse of one of the least familiar countries of the Christian world, Burton Holmes has made a marvelous journey to the glorious highlands of Abyssinia. It was his privilege to accompany the American Special Ambassador sent by President Hoover to represent the United States at the recent Coronation of the Negus Ras Tafari Maconene, "King of Kings" and Emperor of Ethiopia. Splendor extraordinary and superlative interest characterize this amazing experience. [From the Burton Holmes program "Travels of Today," 1930-1931]

To my great surprise and delight, I received a Royal invitation to witness and film the coronation of Ras Tafari, to Emperor of Abyssinia. To reach this magnificent spectacle and opportunity for both movie and still cameras, Andre de la Varre, our cameraman, Mrs. Holmes and myself sailed from Marseilles late in October, landing ten days later at Djibouti in French Somaliland.

To reach Ethiopia we had to go from Djibouti to Addis Ababa as stowaways on the special train belonging to H. R. H. the Duke of Gloucester, and his brilliant suite of generals and admirals. Addis Ababa was 500 miles inland—and upland. At various stations along the line, we saw a guard of honor, composed of tribesmen gathered from miles around. The men, dressed in white and carrying muskets, were drawn up in single file, parallel to the railway in a line that extended for many miles.

"The Ethiopia that is NOT in the News Reels" would be a fitting title for this lecture. The story of the war has been told in the daily press. Pictures of agonizing Abyssinia have been shown on many screens. These pictures portray a peaceful, happy country—a semi-barbarous nation rejoicing in new-found contact with the outside world. Events and celebrations of astounding colorfulness and splendor, in vivid contrast to what is now transpiring in that unhappy land. [1930]

When Ras Tafari was crowned Emperor of Ethiopia on November 2, 1930, at age 38, he took the new name Haile Selassie I, which means Power of the Trinity, and the titles, Lord of Lords and The Conquering Lion of the Tribe of Judah.

LEFT **IN THE ROYAL ENCLOSURE, CORONATION OF HAILE SELASSIE, ADDIS ABABA, 1930**
I was the only photographer allowed to take pictures in the Imperial Enclosure. This I accomplished by a gentle ruse: suitably attired in high hat, tails, a pair of impeccable spats, and an aristocratic air—I ventured forth. Since I looked the part of a gentleman, no one challenged my right to be there, diffidently juggling my tripod in the stifling 104° heat.

RIGHT **ENTRYWAY TO THE CORONATION CEREMONY SITE, ADDIS ABABA, 1930**
The entryway to the ceremony was crowded with white-clad Abyssinians. The chieftains among the royalty and foreign dignitaries wore satin capes, carried intricately carved leather shields, and for such occasions as a coronation, wore crowns circled by a band of lion mane. These figures presented an impressive and unforgettable sight.

The coronation was set for 6 A.M., which called for an uncomfortably early start. The order was for full dress, and the tail coats and white shirt fronts looked decidedly amusing at that early morning hour. The service with the elaborate ritual of Coptic Christianity was impressive, but very, very long. It was midday, the heat stifling, when the final benediction was given, and the new Emperor and Empress were doubtless as weary as were their many guests.

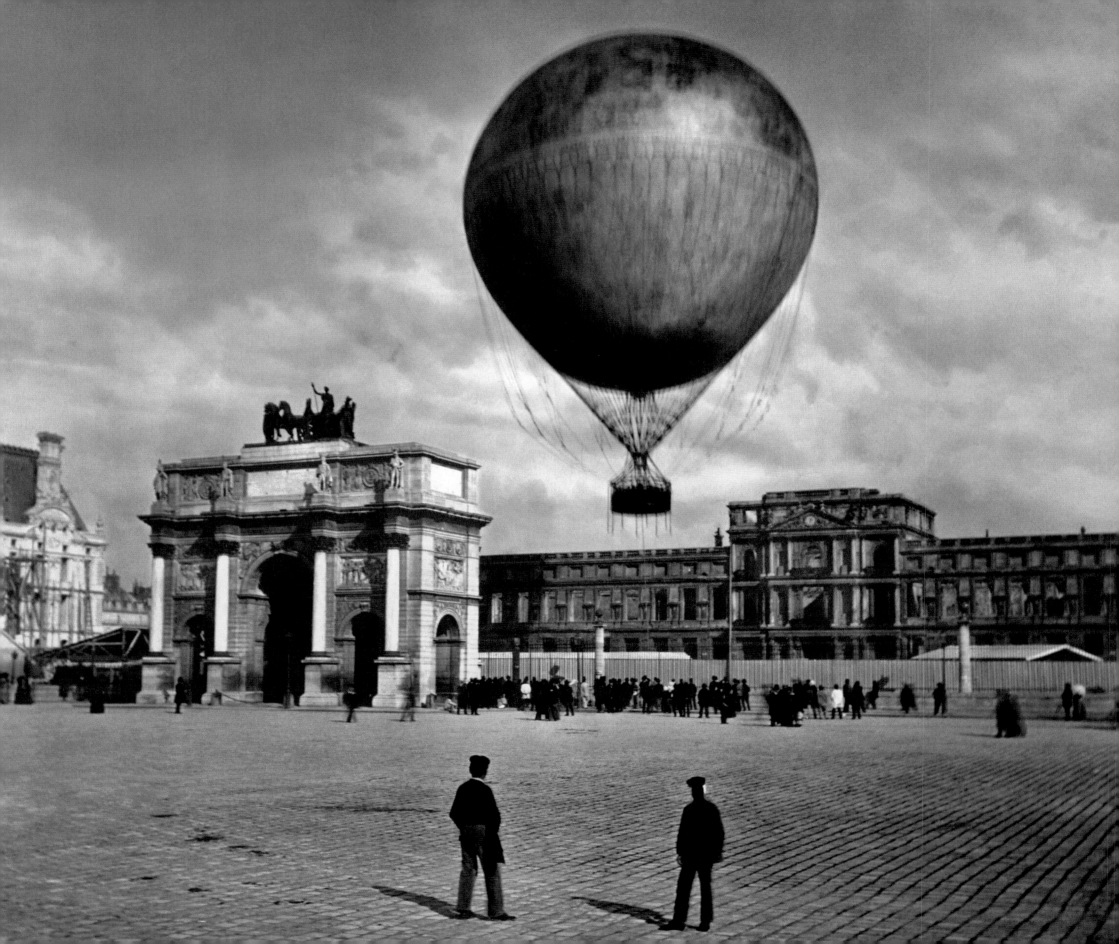

FRANCE

OOH! LA, LA!

Of all European capitals perhaps Paris is the one best known to Americans. Everyone has heard the saying that "good Americans when they die go to Paris," but fewer have heard the flippant remarks of one of our younger wits that "the bad ones get there while they are alive!"

Good Americans—and bad—adore Paris. Paris becomes to them a sweetheart. London, a little repellent at first sight in its dingy, unlovely dignity, becomes in time a friend. One loves Paris. One admires London. I remember vividly all the incidents of my first visit to Paris. Of the London of that year, I have only a foggy souvenir. *[1953]*

Who can resist the city's charm? I confess that I cannot. To me it is a pleasure simply to be in Paris. With every recurring visit, I find that I gaze on it with a sense of novelty, and interest and a pleasure for which I can find no expression in words. I, too, exclaim, "Paris, Paris, Paris!" The very name has been one to conjure with, whether we think of it as a mere sound on the lips and in the ear, or as a magical written or printed word for the eye.

Whoever celebrates the famous things of Paris cannot but repeat what has been said a thousand times in praise of her museums and her monuments, her treasures of art, her incomparable avenues, and her splendid decorative spaces. There is no place in all the world like it. No city fascinates like the City by the Seine. None of the world's great capitals is so truly the capital of the great world. Whoever you may be, whatever things attract you, you will be at home in Paris; you will find there the very thing you seek. In a word, Paris is everything to everybody; but above all, Paris is Paris, and whichever sight of Paris pleases you, I hope you may find a little of your Paris here. *[1908]*

I'd like to relate a story first told to me many years ago by my late manager, Louis Francis Brown, and later used many times effectively in my introductions to lectures on Paris. As it invariably seems new even to the sophisticated audiences of to-day, I'll risk re-telling. It is about a dear old British clergyman, vicar of a country parish, who all his life had dreamed of seeing Paris. Eventually in his seventy-second year, in failing health but still mentally alert, he found it possible to realize his dream of visiting the gay French capital. On his return, friends and parishioners gave him a reception of welcome. "And how, dear Vicar, did you enjoy your

LEFT **HENRI GIFFARD'S CAPTIVE STEAM BALLOON, TUILERIES PALACE, PARIS, 1878**
This photograph shows Henri Giffard's captive balloon at the Tuileries—the main attraction at the Paris Exposition Universelle of 1878. The enormous hydrogen balloon had a capacity of 880,000 square feet (25,000 cubic meters) and was capable of taking 52 passengers at a time on a tethered ascent to 1,600 feet (500 meters). The Tuileries had burned in 1871 and was eventually demolished in 1883. While Holmes could not have taken this photograph, he is thought to have had the photo painted and to have included it in at least one of his many Travelogue shows on Paris.

RIGHT **THE BOIS DE BOULOGNE, PARIS, 1895**
The huge park on the western side of the city, with its forested areas, lovely lakes, meandering walkways and bridle paths and two racecourses, has been a favorite pleasure ground since the 17th century. In the 1890s, particularly on a beautiful Sunday afternoon, the "bois" was a very fashionable place for promenades, for enjoying the cascading fountains, and for watching the novel balloon ascensions.

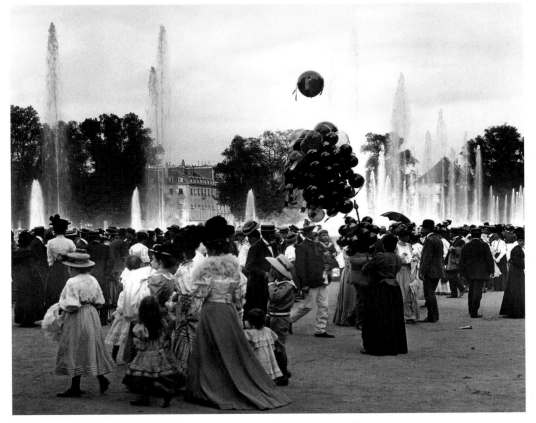

stay in the wicked city of Paris?" was the first and most frequent question. "Oh very thoroughly indeed, very thoroughly. But I must confess that my pleasure was marred from time to time, oh very slightly married, by a vague regret—mind you, a very vague regret—that I had never been in Paris *before* I gave my soul to God."

But the charm of Paris did not make me overlook certain shortcomings of her civilization. I was shocked to find that in our hotel, which was one of the better class, there was not even gas light in the sleeping rooms. At night as we walked up stairs (there was an *ascenseur* but it worked only for the aged or infirm) we were handed neat little candle-sticks, each with a lighted candle and a box of matches. And for each candle we were charged a price that yielded a handsome profit to the management. Electric lights were then almost unknown, but

gaslight displays in the public rooms, in shops and on the streets were sometimes brilliant—brilliant for those dark days or rather, nights. *[1953]*

In 1900 Paris the capital was rearing the gorgeous modern palaces of the Exposition Universelle, which was to mark the close of the glorious and never-to-be-forgotten nineteenth century. The Exposition Universelle captured the attention of the entire modern world. The French had transformed a muddy wasteland into a vision of green lawns, flowers, and thousands of exhibits from nearly every nation on earth. While the wonders of the present were displayed, the main idea was to show mankind's future. Visitors saw a moving pavement, wireless telegraphy, the first escalator, and the most powerful telescope ever built. *[1900]*

The Paris Expo was part of a grand tradition of international fairs, beginning with the 1851 Great Exhibition held in London's Hyde Park and carrying on to include such highlights as the New York World's Fair in 1939. The Paris Expo was the first major international arena for the display of motion pictures and introduced the world of decorative arts to the Art Nouveau style. Many of Paris's most famous buildings were constructed for the Exposition, including the Grand Palais and the Petit Palais, the Gare de Lyon, the Gare d'Orsay, and the Pont Alexandre III, as well as Eliel Saarinen's Finnish pavilion. The Paris Metro opened to the public the same year, 1900.

LEFT **DUFAYEL DEPARTMENT STORE, PARIS, 1895**
The city's most elaborate department store—built between 1880–1895 by architect Guillaume Rives and sculptor Jules Dalou—provided a variety of goods for sale on credit and also projected early films. At the age of two Jean Renoir saw his first movie here.

RIGHT **THE EIFFEL TOWER, PARIS, 1895**
But of all the monuments of Paris not one so completely dominates the city as the Eiffel Tower—that inverted exclamation point—nearly a thousand feet in height. From the top of the tower Paris looks like a model city of tiny toy houses, tiny green trees marking the squares and parks and boulevards, a narrow glittering ribbon marking the curving course of the River Seine. Here and there looms some slightly larger plaything—a toy Arch of Triomphe or a toy opera-house. We feel a childish desire to reach down and pick up bits of that pretty, silent, toy-like Paris to take home with us as souvenirs.

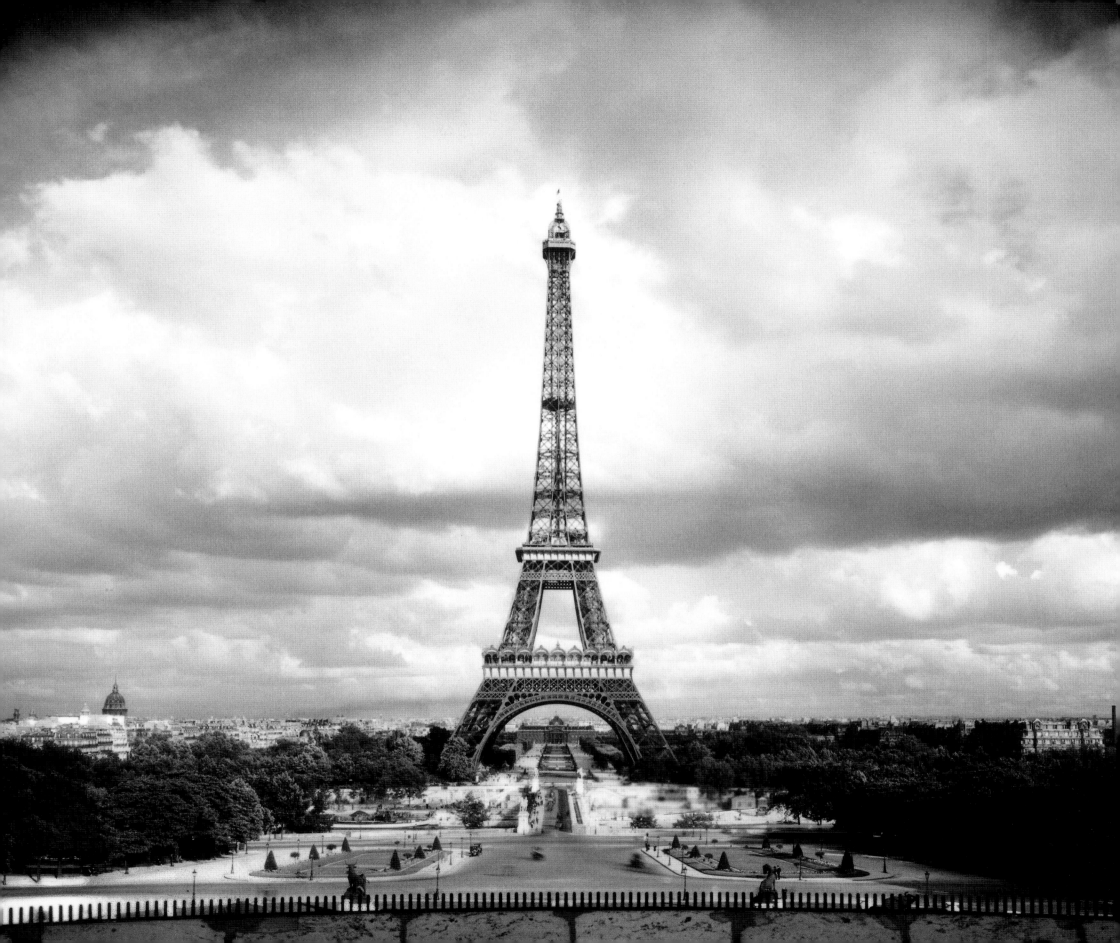

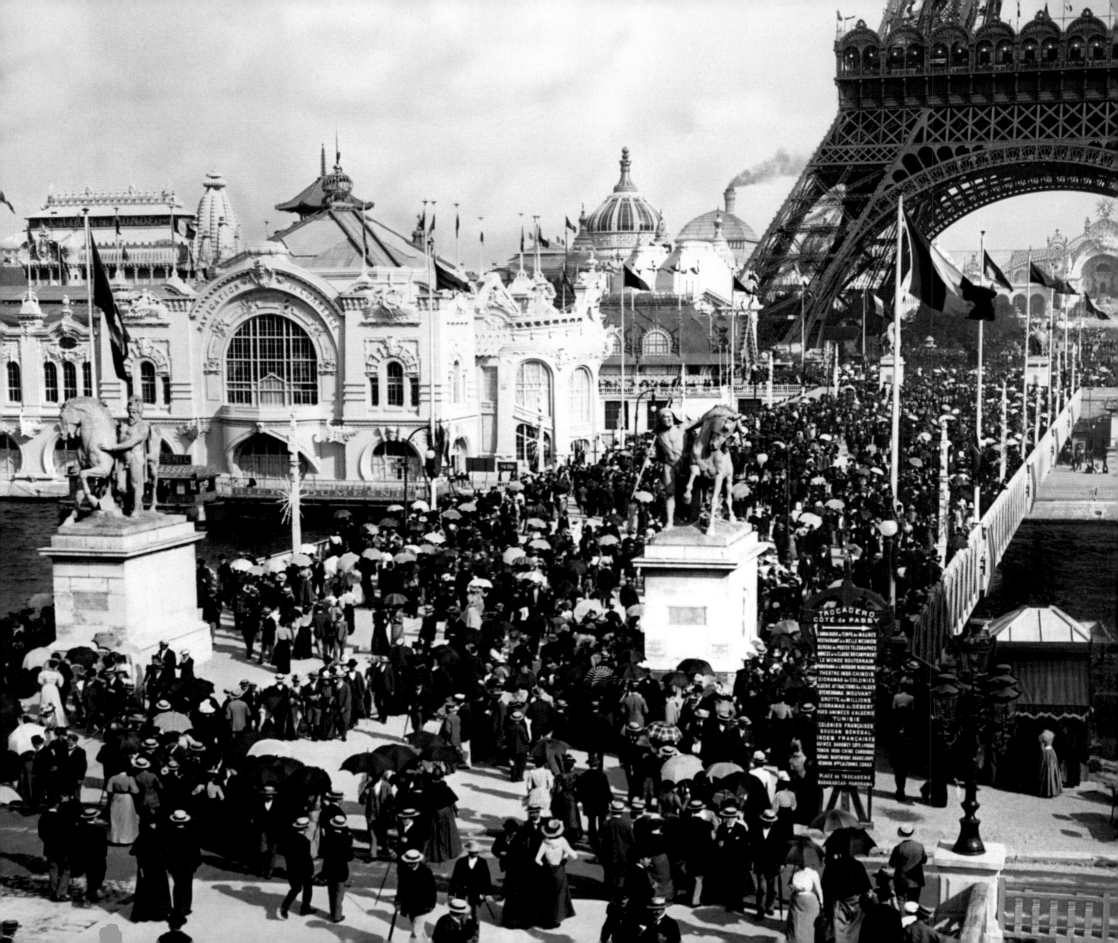

BELOW LEFT **THE PONT NEUF, PARIS, 1895**

The most famous of the many bridges under which we pass is the old Pont Neuf—the "new bridge" that is really older than many of the others. It was finished in 1604; it was to old Paris what the boulevard near the Café de la Paix is to the Paris of to-day: it was the center of life and gaiety, the place where everyone was sure to pass.

The Pont Neuf is a double bridge traversing the narrow west end of the island called the Île de la Cité and spanning both branches of the Seine. Below it, extending westward like the low prow of a ship of stone—the decks of which are deep covered with cargo of verdure. It is one of my favorite little corners of quiet Paris, "a peaceful, pretty garden," this Jardin of Henri IV.

BELOW RIGHT **SCHOOLGIRLS' OUTING, PARIS, 1895**

After lingering in the Louvre for a long while, we leave to find a café for some afternoon refreshment, and witness a pretty parade of innocence. Like a sweet passing vision of the days that were, a procession of little girls flit swiftly by.

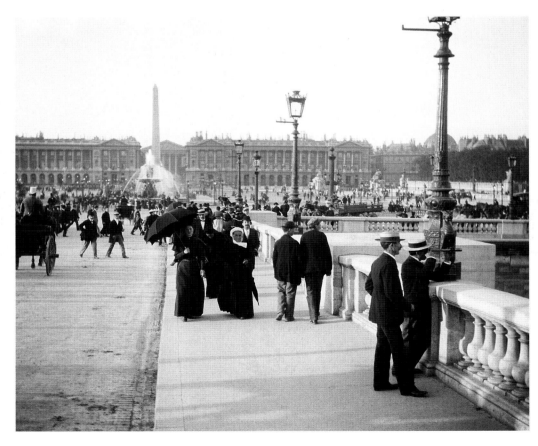

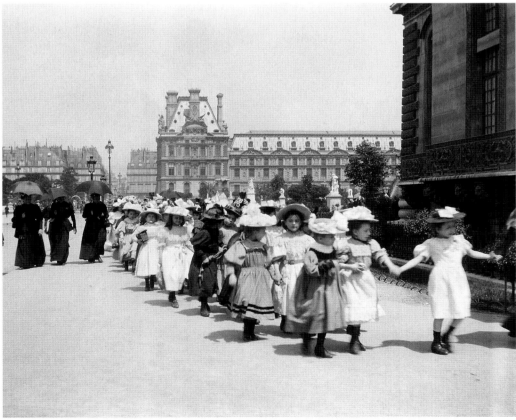

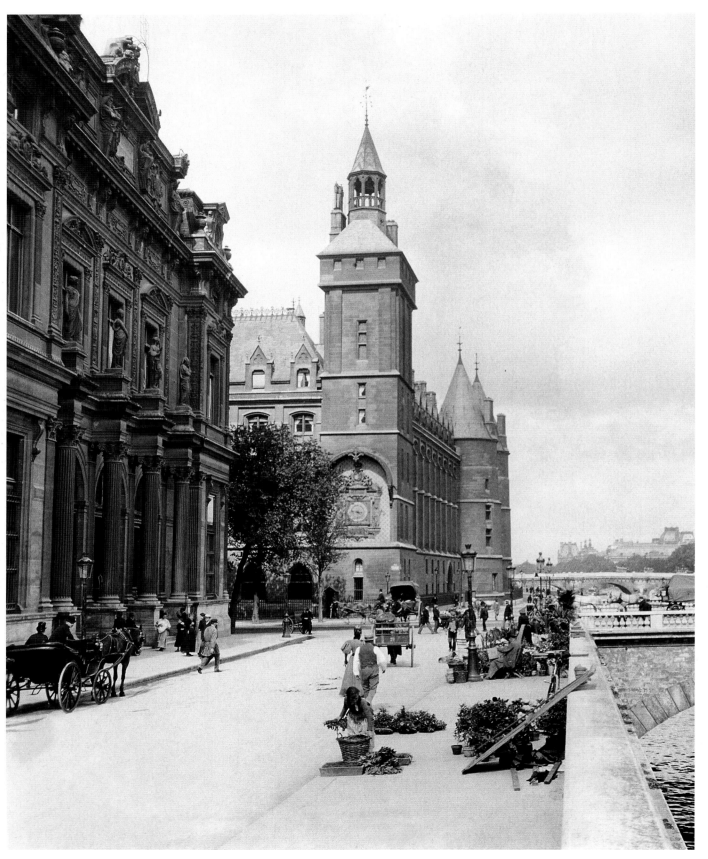

LEFT **THE CONCIERGERIE, PARIS, 1895**
The pepper pot towers of the Conciergerie remain a powerful symbol of medieval Paris; site of the jail where Queen Marie-Antoinette was imprisoned before her execution. It's true that for the traveler, the grandest and most splendid spectacles of Paris are all free. For nothing, we may enjoy vistas of magnificence and antiquity, if we but care to look.

RIGHT **MONTMARTRE SQUARE, PARIS, 1895**
You will say at first that no such quaint old square exists today in Paris; but the artist himself will take you to it, the place where artists dwell. You may take your camera, the camera will take a picture of that quaint old square showing it as it appears to-day and every day, to anyone who takes the trouble to find it—by first losing himself in a labyrinth of twisting streets.

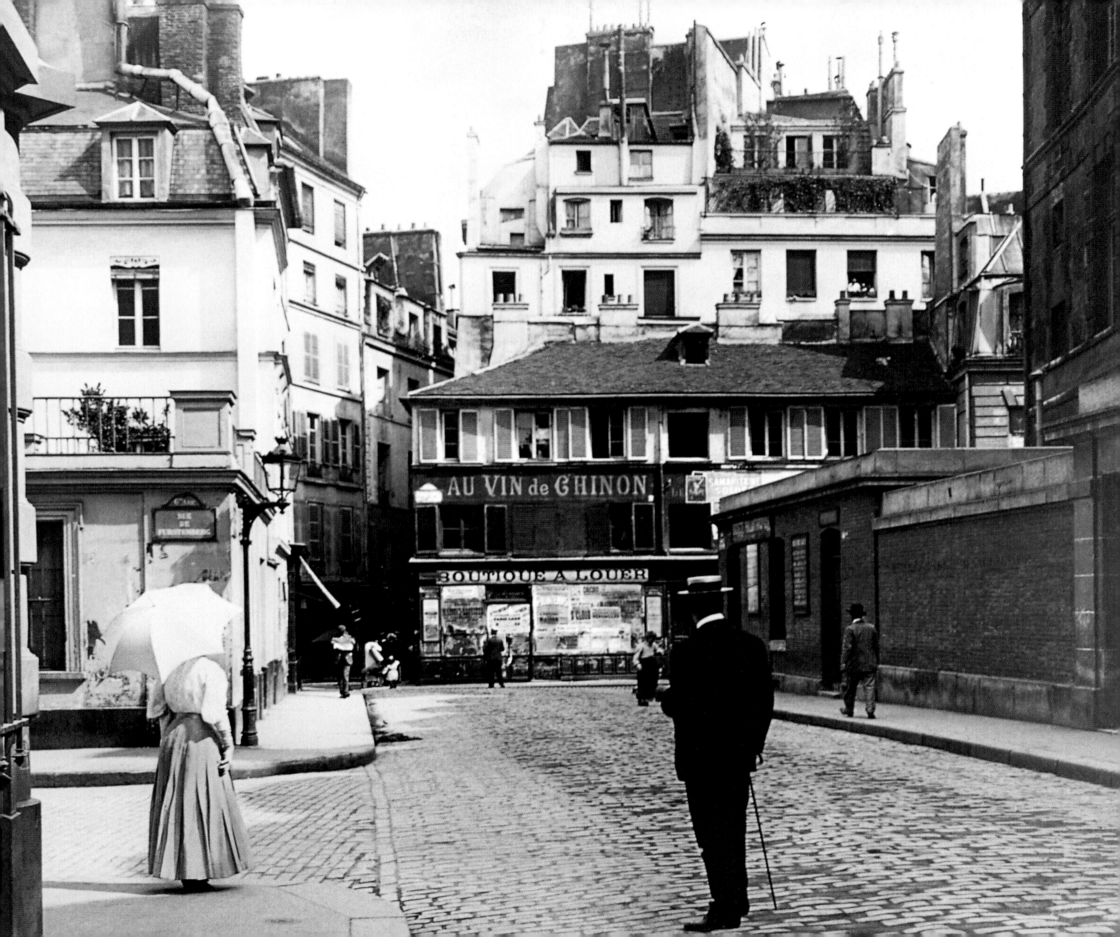

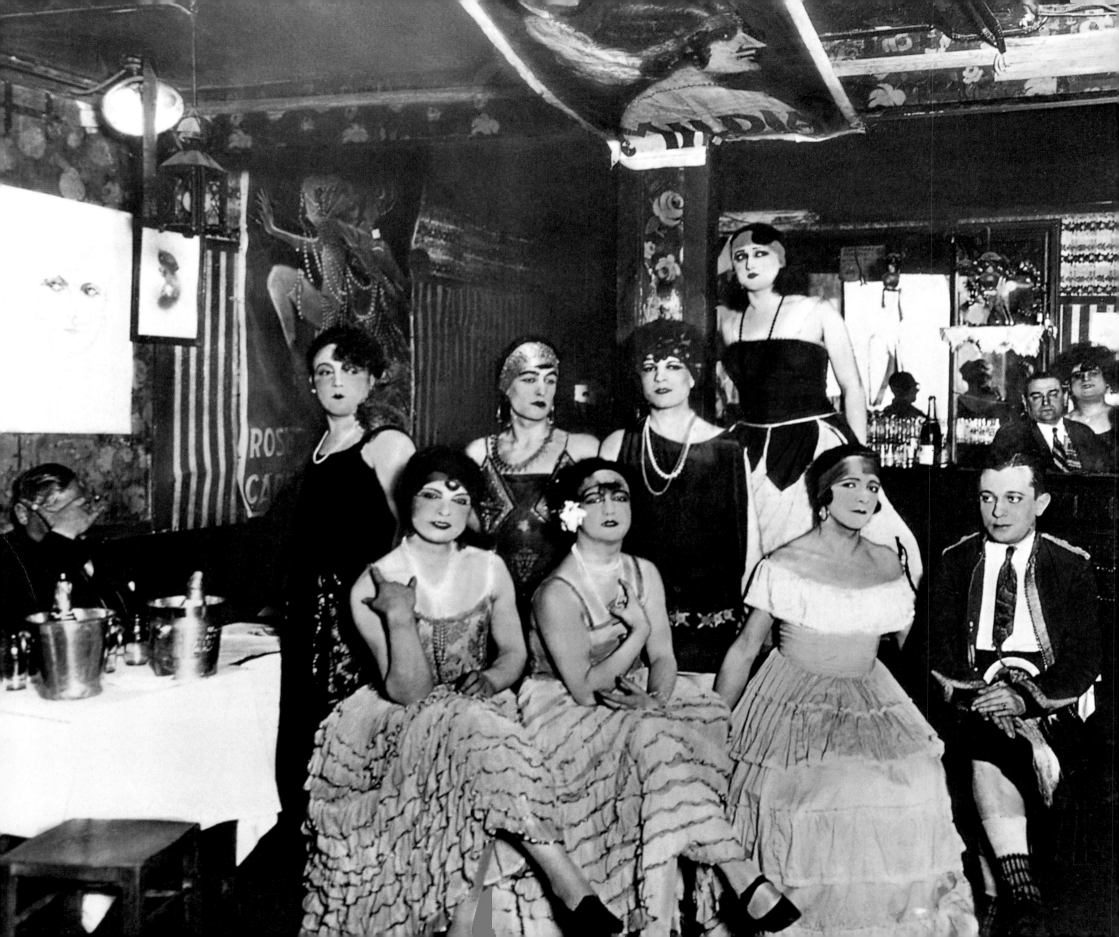

LEFT A BAR IN MONTMARTRE, PARIS, 1927

The life of Paris is a continuous performance. Parisians express themselves artistically and culturally, in their Cafés, restaurants, night-clubs and theatres, making Paris, the city itself, dear to all its people and travelers from near and far.

BELOW A SHOWGIRL, POSSIBLY AT THE FOLIES BERGÈRES, PARIS, 1927

This photograph was likely given to Holmes to be colored and used in his shows by its photographer Alfred Cheney Johnston, who specialized in showgirls. Holmes's duplex on 67th Street in New York was across the street from Johnston's residence in the Hotel des Artistes, and they were likely to have been friends in the '20s.

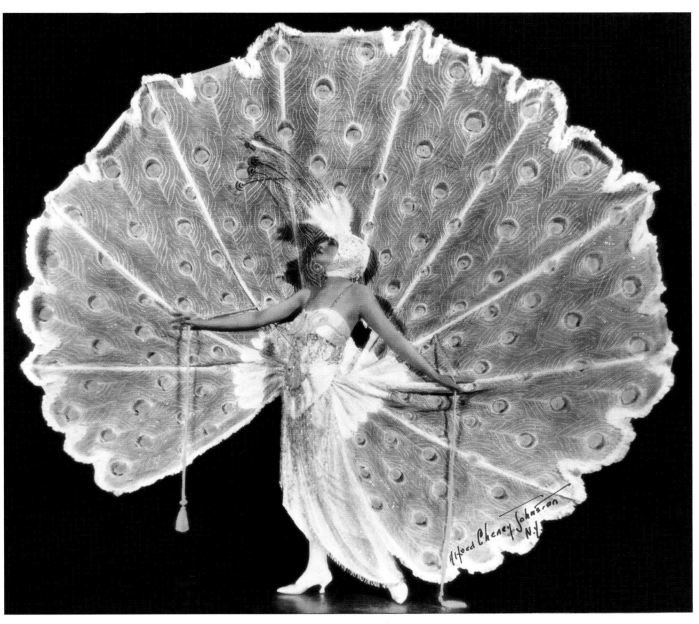

STREET SCENE, JARDIN DE PARIS, 1895

The cabman of Paris is the traveler's best friend and his worst enemy at any season. But summertime is not the season to visit Paris, if one cares to see the rank and fashion of the Capital. The gorgeous pageant of well-appointed traps that may be witnessed here in early May or June has been succeeded by an endless river of cabs filled with delighted strangers doing *Paris* to their heart's content.

Only a few years after this photo was taken, Moulin Rouge nightclub star Jane Avril debuted her solo performance at the Jardin de Paris, one of the major café-concerts on the Champs-Élysées. The Cancan was a sensation, and her association with it immortalized by Henri de Toulouse-Lautrec's portrait of her for an advertisement announcing the show.

FILM STILL, SIDEWALK TERRACE OF THE CAFÉ DE LA PAIX, PARIS, 1897

Holmes shot his first motion picture here, his favorite spot in Paris. Holmes remembers the first day of his first trip to Paris the year prior:

I went out alone for my first day in Paris. I wanted to find all the places I had read about for myself. And what a memorable day it was. First to the Café de la Paix, to sit at a sidewalk table, at the very corner table which, according to Parisians, marks the central spot of civilization. What I ordered, I cannot say; probably, my favorite predilection, a chocolate ice cream. Then from a bus-top I surveyed the boulevards, miles and miles of boulevards—recognizing all the sights from my Baedeker. I covered Paris in one long day. My French—high school French, was pretty bad but it sufficed. I was sixteen. The Springtime of Life in Paris!

TWO WOMEN, PARIS, 1910

I am tempted some day to prepare a travelogue and call it "Quiet Paris." It would make a very charming lecture. Nobody would come to hear it—but I should feel that I had paid a little of the debt that I owe Paris, by attempting to correct that almost universal misapprehension that Paris is all vanity and rush and restlessness. That the characteristic expression of Paris is a lustful leer and the chief amusement of Parisians, debauchery, so it may seem, especially to the American who pays his annual toll to the vice of Paris; but there is a "quiet Paris" full of serenity and calm. The peaceful Paris is not a special quarter; it is made up of many and various fragments scattered far and wide.

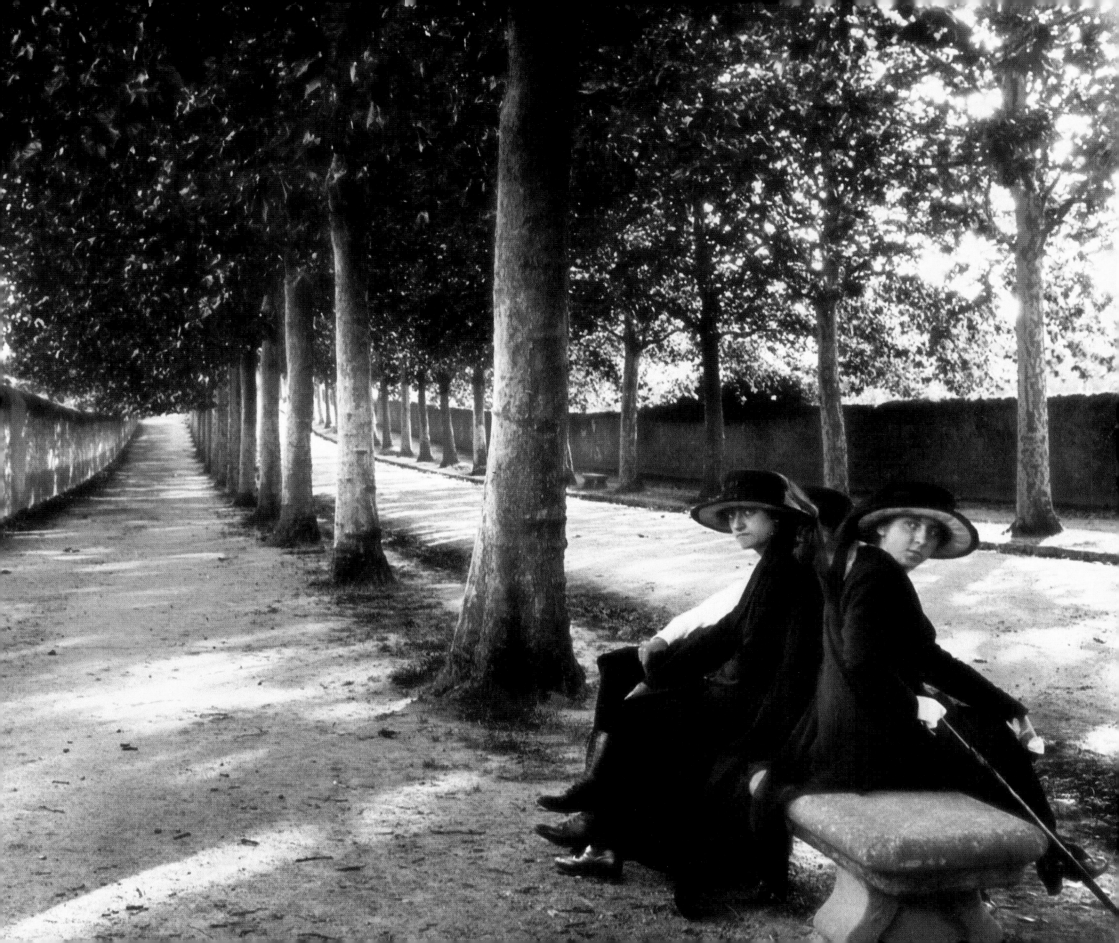

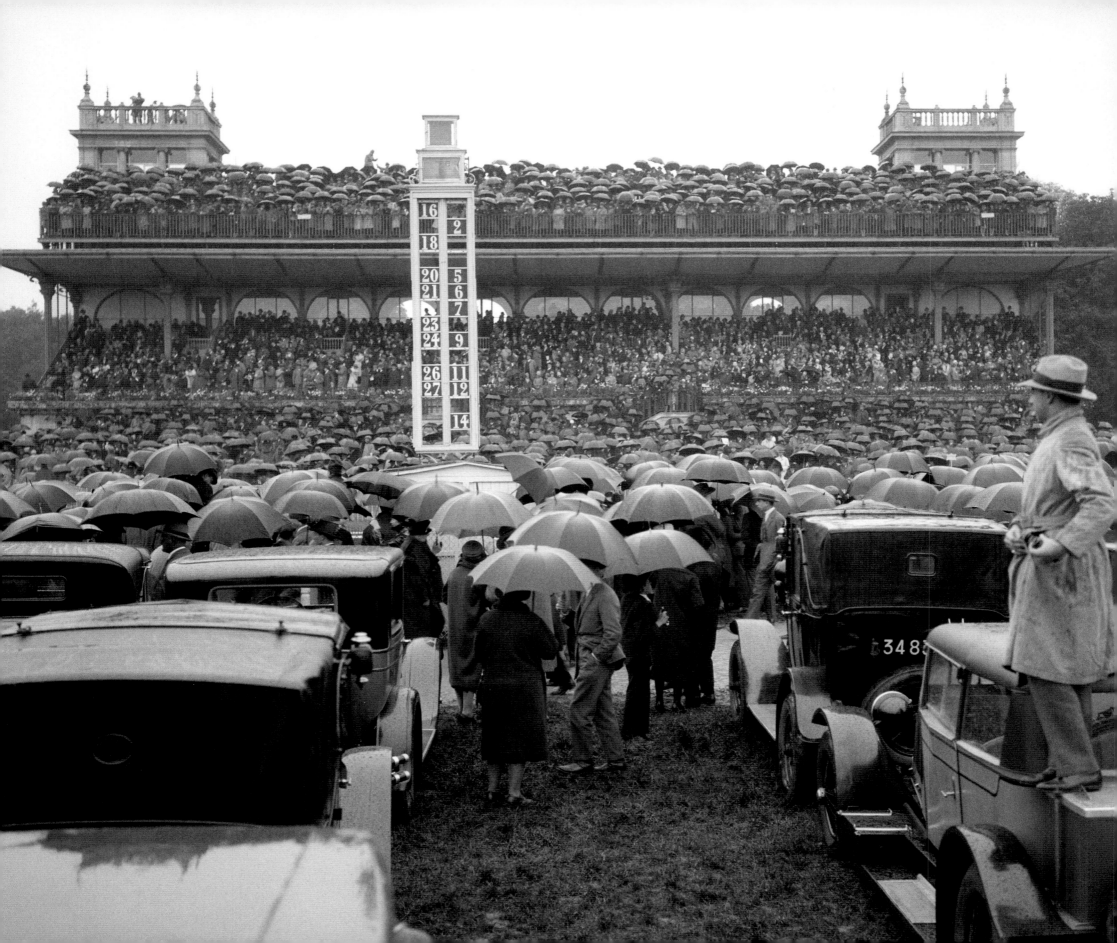

LEFT **LONGCHAMPS RACECOURSE, PARIS, 1935**
Horse racing fans flock to Longchamps during the racing season, as they have done for decades; not even a rainy, chilly day can dampen their enthusiasm for the sport.

BELOW **LONGCHAMPS RACECOURSE, PARIS, 1895**
Famed Longchamps Racecourse located in the heart of Paris' leafy Bois de Boulogne makes it easy for residents of the fashionable west side of Paris to go to the races. However, horses are not the only subject of interest for the spectators at Longchamps. *Mannequins* with parasols from the finest dressmaking salons parade out in full force during the racing season. All feminine Paris studies the *mannequins* on parade at Longchamps, greedily—and on their verdict does a new style catch on or fail.

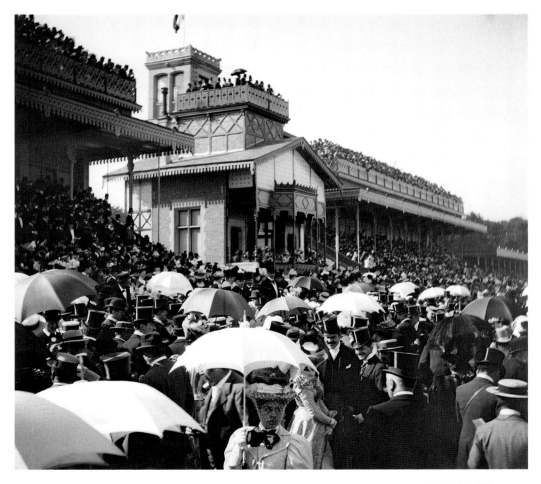

LEFT **THE ESPLANADE AND LES INVALIDES,
EXPOSITION UNIVERSELLE, PARIS, 1900**
The sparkling new buildings of White City of the Esplanade
frame Napoleon's Tomb, for under the bright, golden dome
beneath sleeps the world-famous man who was born in
Corsica, conquered Europe, died in St. Helena, and, ac-
cording to his dying wish, he lies buried on the banks of Seine
in the midst of the French people whom he loved so well.

RIGHT **A DRESSMAKING SALON, PARIS, 1900**
It is lots of fun to go out shopping with Americans in Paris,
especially with someone who really means to order several
gowns. The fashionable dressmaking establishments make it
pleasant to the men who traipse along; the women of course
find pleasure in looking at the frocks; the men find even more
in looking at the pretty living models or *mannequins* upon
whose shapely forms the new frocks are displayed. These
stately show-girls sweep into the salonwith the air of un-
crowned Empresses, oblivious to the humble would-be
purchasers of the finery, which usually becomes the poor
but pretty *mannequin* much better than it does the purse-
proud customer.

JOSEPHINE BAKER, NIGHTCLUB, PARIS, 1927

The artist-life in Paris is a subject rich in interest; a subject I'd like to cover one day. Suffice it now to take a hasty peek into one of the racier night-clubs, where a comely performer from America, Miss Josephine Baker, has created a sensation among the Parisians, and in fact, creates a new sensation with her sensuous, sometimes comical dances with every new performance.

Josephine Baker is pictured here with her "husband" Count Giuseppe "Pepito" di Abatino. Not only was the "marriage" a publicity stunt—he managed her and was her lover, but they never actually married—he was not really a count.

POLA NEGRI AT THE CAFÉ DE LA PAIX, PARIS, 1927

I must urgently recommend that you spend your first leisure hour in Paris at the corner table of the *terrasse* of the Café de la Paix. It is a fact known and proved, that if you want to find a friend in Paris you have only to sit at this corner long enough; a friend will appear in time. No stranger can sit here for an hour without seeing someone whom he knows or used to know. On this day, I see the beautiful actress, Pola Negri, a close friend from home, taking tea at the corner table I have so often mentioned to her.

Holmes was friend to many an actor, and the silent film star was no exception. Considered a rival to Gloria Swanson, Negri was at various times engaged to Rudolph Valentino and Charlie Chaplin, among others. When she signed up with Paramount Studios in 1923 they promoted her as a vamp, with advertising slogans like "the woman who pays and makes men pay." This photo was taken after she returned to Europe shortly after Valentino's untimely funeral, where she fainted to very dramatic effect—an act thought by many to be a cry for attention, and the beginning of the end of her career.

It was not easy for civilians to get permits to go abroad in 1918; it was harder still to get permits to carry cameras. But after weeks of effort we wangled the necessary permits and permission to sail on the old White Star Liner *Lapland* in late May, when the Germans were within a few miles of Paris.

The Atlantic crossing was not the kind I had been accustomed to. No cheering crowds, no reporters, no unauthorized persons allowed to pass beyond the wire fence along the waterfront. We kissed our wives good-bye—and I, for one, kissed myself good-bye at the same spot, I definitely expected never to return alive.

I had been led to believe that we were to travel on an inoffensive merchant ship with less than a hundred passengers. Once out in the open spaces of the Atlantic, suddenly up from between decks came a roaring, cheering khaki-colored flood of doughboys, twenty-two hundred of them. We were in a convoy. There were more than twenty-three thousand soldiers of the American Expeditionary Force crossing the ocean with us in a convoy. We were fair game for German U-boats—I wanted to go home!

But it was too late; I had to keep my place among the heroes. I kissed myself good-bye a second time and decided to make the best of it. Rumors of U-boats added to our anxieties. Every morning my first act on reaching the deck was to take inventory of our twelve fellow-transports.

Several foggy days ensued without incident. When finally the broad Irish channel stretched before us southward, we were nearly at our destination. All hands were on deck—all life belts left below or tossed aside. Overhead small British dirigibles cruised like flying porpoises in welcoming curves. British planes zoomed past saluting us. The pilots and observers waved to the Irish nurses massed in uniform on the hurricane deck. A flotilla of destroyers frisked to and fro like playful baby whales or circled round our ships. It was a happy, triumphant moment. We had crossed the North Atlantic. We

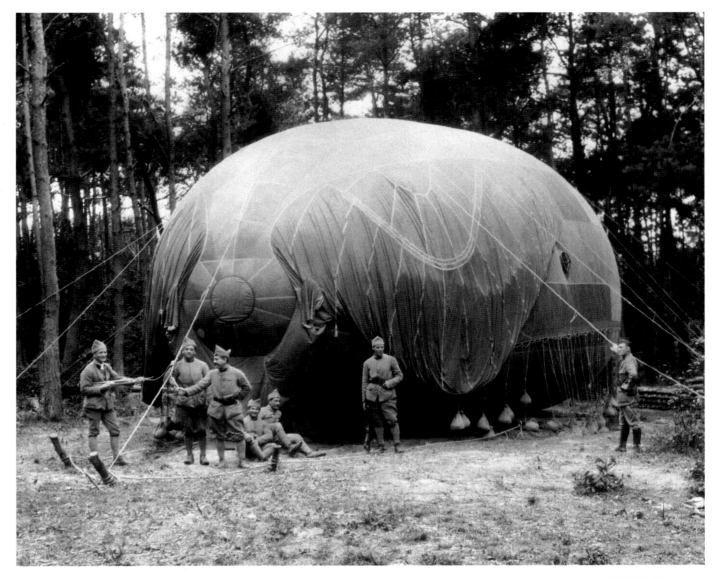

LEFT **FRENCH DIRIGIBLE, CA. 1907**

RIGHT **CAPTIVE BALLOON, WORLD WAR I, 1918**

had foiled the U-boats of the enemy. We were among friends. Liverpool was waiting to welcome thirteen liners crammed with heroes. We were all heroes—or at least felt that way about ourselves.

We had not yet seen the war face to face as were soon to see it on the Continent. A few nights later, our little group embarked at Southhampton on a nameless, lightless, soundless steamer with a few silent, anxious passengers and crossed the submarine infested waters of the Channel to a "port in France." It was the port of Le Havre to which we had come so often and so joyously in happier times on the great French liners from New York.

The news that greeted us was bad. The Kaiser's legions were at the gates of Paris. Big Bertha was dropping her huge shells in Paris every fifteen minutes. From our windows at the Grand Hotel we saw that night the flash of guns along the Chateau Thierry front only about forty miles away.

The next day we found that the Yanks had turned the tide at Chateau Thierry, that the enemy retreat was on—and that the beginning of the end of the Great War was already predictable. The U.S. authorities let us go to Chateau Thierry, not in our big car, but in a battered Ford. Under conduct of British officers, I was taken to Calais and even to Dunkerque. Then they escorted me to ruined cities near the front and to

Vimy Ridge, where shells were falling as I trudged through miles of trenches to the observation post whence I could look down on the German lines which were soon to break and crumble and fall back.

I did not stay to celebrate the victory in Paris. I was ordered south to Bordeaux to sail for New York on an old French liner that would be convoyed across the Atlantic by a warship. As it turned out we sailed away without protection into as bad a bit of weather as I have ever encountered. The two guns on the deck were swept overboard the second day out, just wiped away by giant waves. The food was awful and—not wanted. The ship was dirty, the crew and stewards were

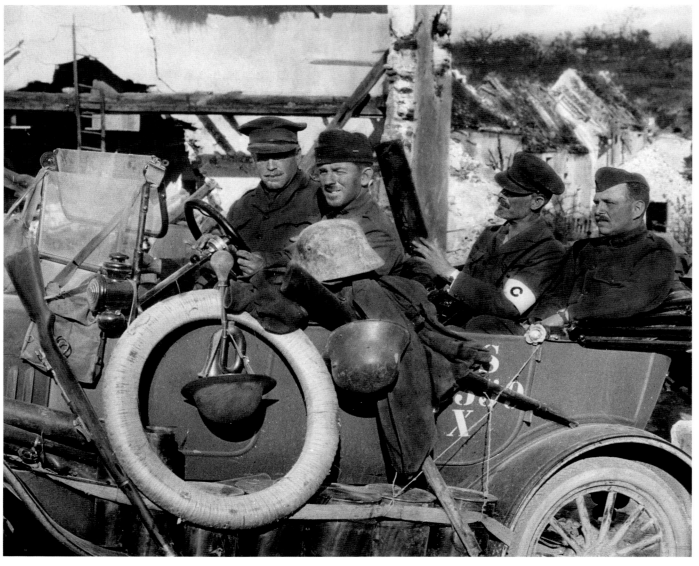

LEFT **BURTON HOLMES AND AMERICAN OFFICERS AT THE FRONT, 1918**
We were outfitted with khaki-colored correspondent uniforms and on the sleeve of each tunic was a white brassard on which appeared a large red "C," the symbol of the war correspondent, second class as it were; the real correspondents of great dailies wore a green brassard. "Correspondents for what?" people would ask. We represented no newspaper, no periodical. So we would say, "We represent the *Travelogues*"—and let it go at that. This always left our questioners guessing. We tried to suit our bearing to our military make-up. I fear that the effort was not entirely successful. But when seated in the car bearing the insignia of the Ministry of Munitions, or collecting petrol for the drive to the front, we presented a sufficient military aspect.

RIGHT **FLYING JENNYS, WORLD WAR I TRAINING AIRPLANE, 1918**
A whole generation of American and British war pilots learned to fly in the Curtiss biplane, JN-4, affectionately named the "Jenny."

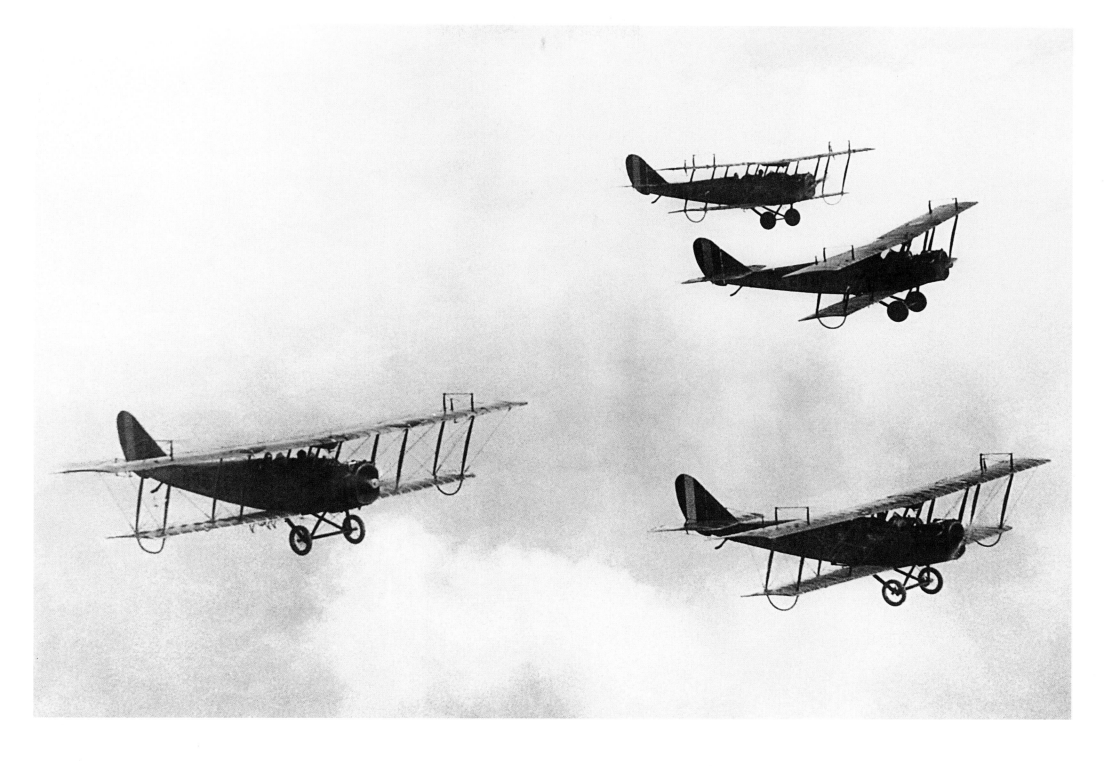

BELOW **U.S. FORCES LAUNDRIES, SERVICE OF SUPPLIES, CHAUMONT, 1918**

War is dirtier than you ever imagined. With each passing day, the laundry hills turned into mountains, sometimes stopping a foot from the ceilings of the huge storage units built to house this necessity of survival. The unending toil required the labor of hundreds of willing workers; to collect, disinfect, launder, sort, mend, fold, recycle and deliver—endless mounds of the clean laundry and uniforms needed by the fighting men.

RIGHT **ON THE WAY TO THE FRONT, 1918**

No unofficial touring is allowed in war-time France. We have our "carnet d'essence"—our little booklet authorizing us to draw essence, or gasoline, from any French or Yankee supply station anywhere in France. To get essence from a French depot is a task that taxes time and temper, so complex the formalities, so slow the service, so antiquated the methods of supply. But when you strike a Yankee depot—show your card—sign your slip—grab your gas and on your way!

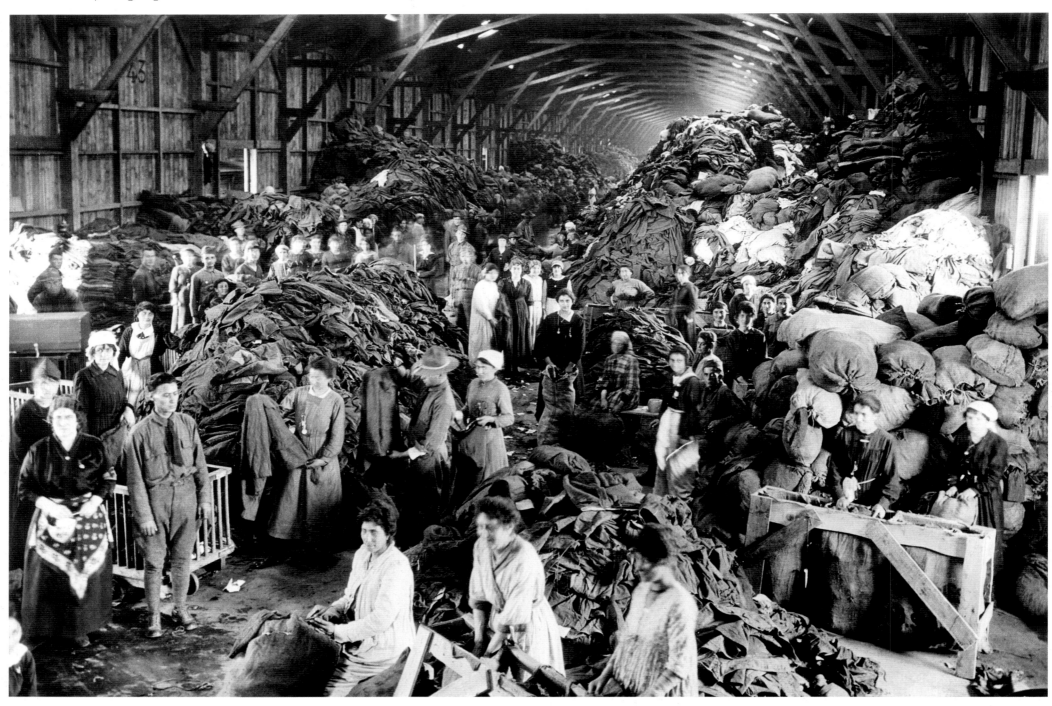

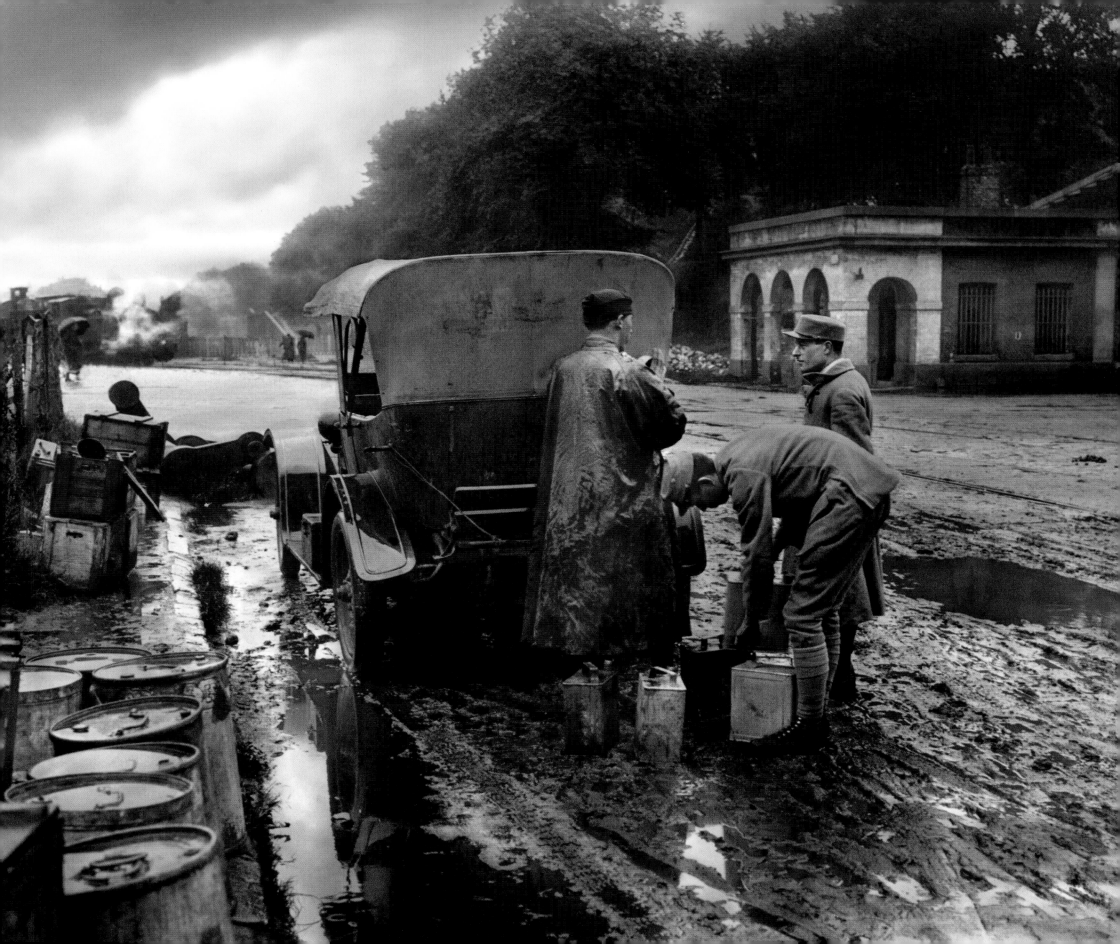

grouchy, our pace was as much up and down as it was westward. But we were going home, and after long slow days of storm and discomfort we came at last to little old New York, which had never looked so wonderful and so beautiful to me before. My precious filmed pictures of the war as I had seen it—and recorded it—were safely with me and I began the making up of my most dramatic programs of "The Yanks in England" and the other four travelogues about the Yanks in Paris, in France, at the Front, and in Italy. Meantime the expected victory was won. The triumph of the Allies was complete. *[1953]*

BELOW LEFT **CHILDREN PLAYING IN THE WRECKAGE OF A GERMAN TANK, METZ, 1918**

BELOW RIGHT **TOPPLED STATUE OF KING FREDERICK WILLIAM III, METZ, 1918**
In Metz, we found the children of Lorraine waving once more the dear forbidden flag of France and crying "Vive la France!" It is difficult to visualize in a picture a state of mind and heart such as we find in this land of Teuton speech and Gallic sympathies, but something of the atmosphere can be seen in the crowds around the empty memorials pedestals. On this one stood King Frederick William III. How much Metz loved him is indicated by what Metz did to his monument in 1918.

RIGHT **U.S. SOLDIERS, ARMISTICE DAY PARADE, RUE ROYALE, PARIS, 1918**
Because of historic rivalries, old wars and lost battles, France was drunk with their victory over the Kaiser's Germany. French statesmen and generals became heroes to the people because of the victories in the Marne and at Verdun. But some historians see the true victors in the American army under the leadership of President Woodrow Wilson; for they believe the American forces were the crucial factor in the defeat of the exhausted German forces.

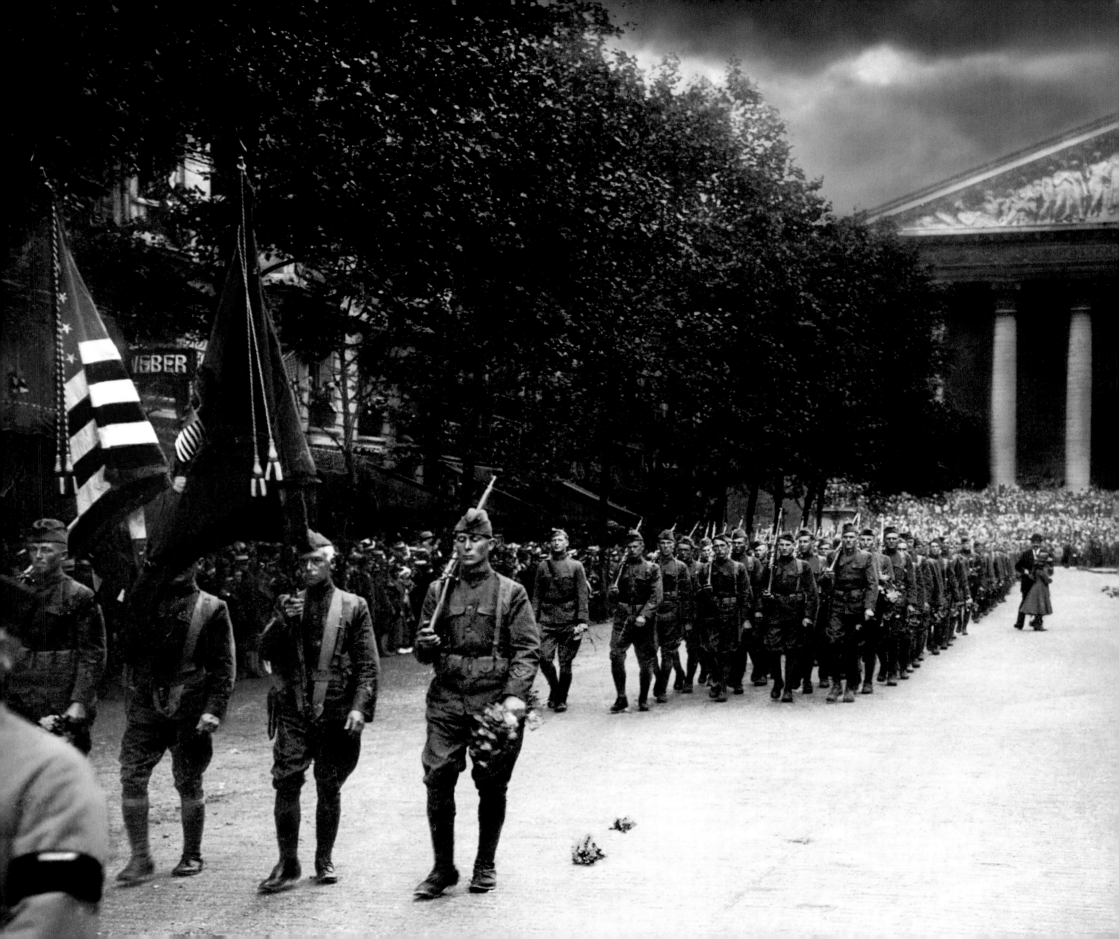

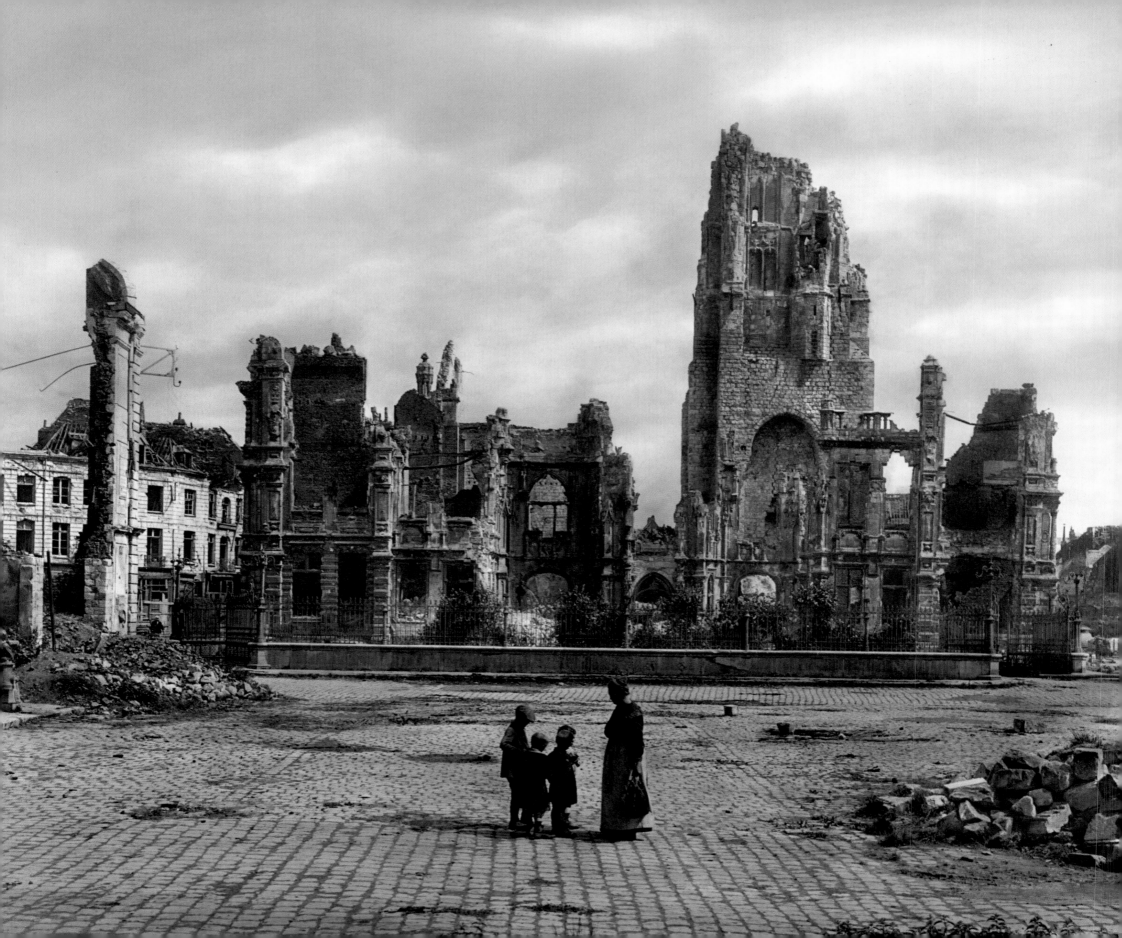

LEFT **ROUEN AFTER THE WAR, 1919**

Sad as is the violated countryside, beaten to barrenness by the tempest of war, sadder still is the appearance of the cities, devastated by the same man-made storm. The city of Rouen suffered significant damage by German bombing; people's lives were ravaged by the violence, house after house ripped apart, we see appalling ruins everywhere.

In the summer of 1919, Burton Holmes and his crew devoted themselves to a survey of the battlefields and picturing the aftermath of the war in Belgium, France, redeemed Alsace-Lorraine and the occupied Rhineland.

BELOW LEFT **BATTLEFIELD DEBRIS, 1919**

Piles of rusting, discarded gun carriages, artillery and weaponry covered the battlefields.

BELOW RIGHT **CAPTURED BRITISH TANK, 1918**

This was a British tank. The Germans captured it—painted their cross upon it and sent it back against this labyrinth of trenches. It climbed triumphantly like this, only to fall a second later upon the helpless bodies of the French de-

fenders—a well-placed shell—a direct hit—struck it a fatal blow. "Killed in action" would be a fitting epitaph for this gigantic fighting brute of living steel.

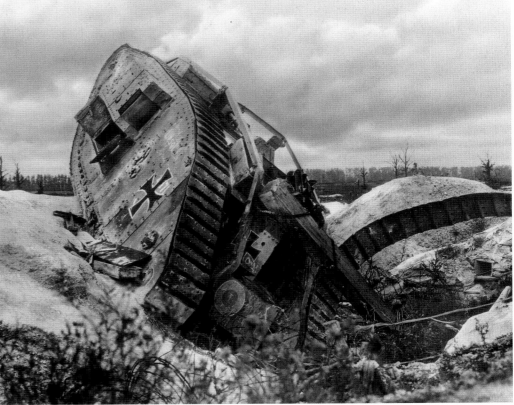

RIGHT **A LAST GOOD-BYE, WORLD WAR I, PARIS, 1918**
No man in the prime of his life knew what war was like. A generation of young men rushed to join up, to bear arms; imagining it would be an affair of great marches and great battles, confident the conflict would be over within months.

BELOW **CLOWNING FOR THE CAMERA, PARIS, 1918**
When Uncle Sam plunged into the great struggle in 1918, we decided to don our khaki correspondent uniforms and joined our fighting men in Europe—armed only with our cameras.

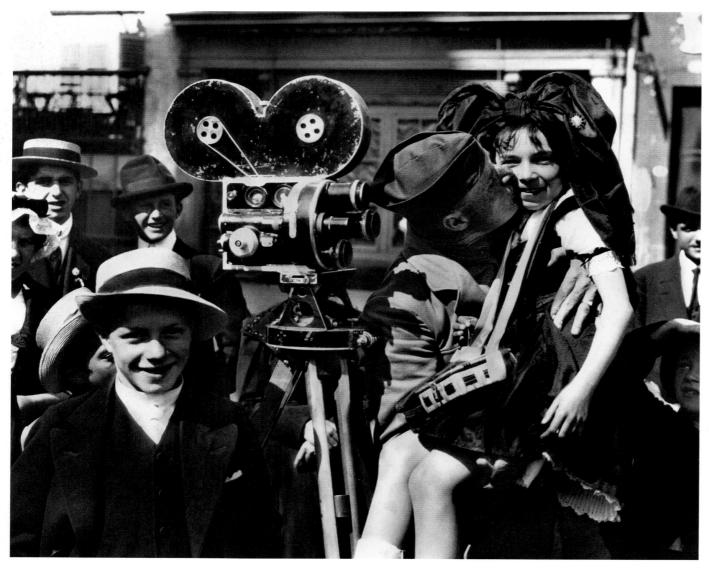

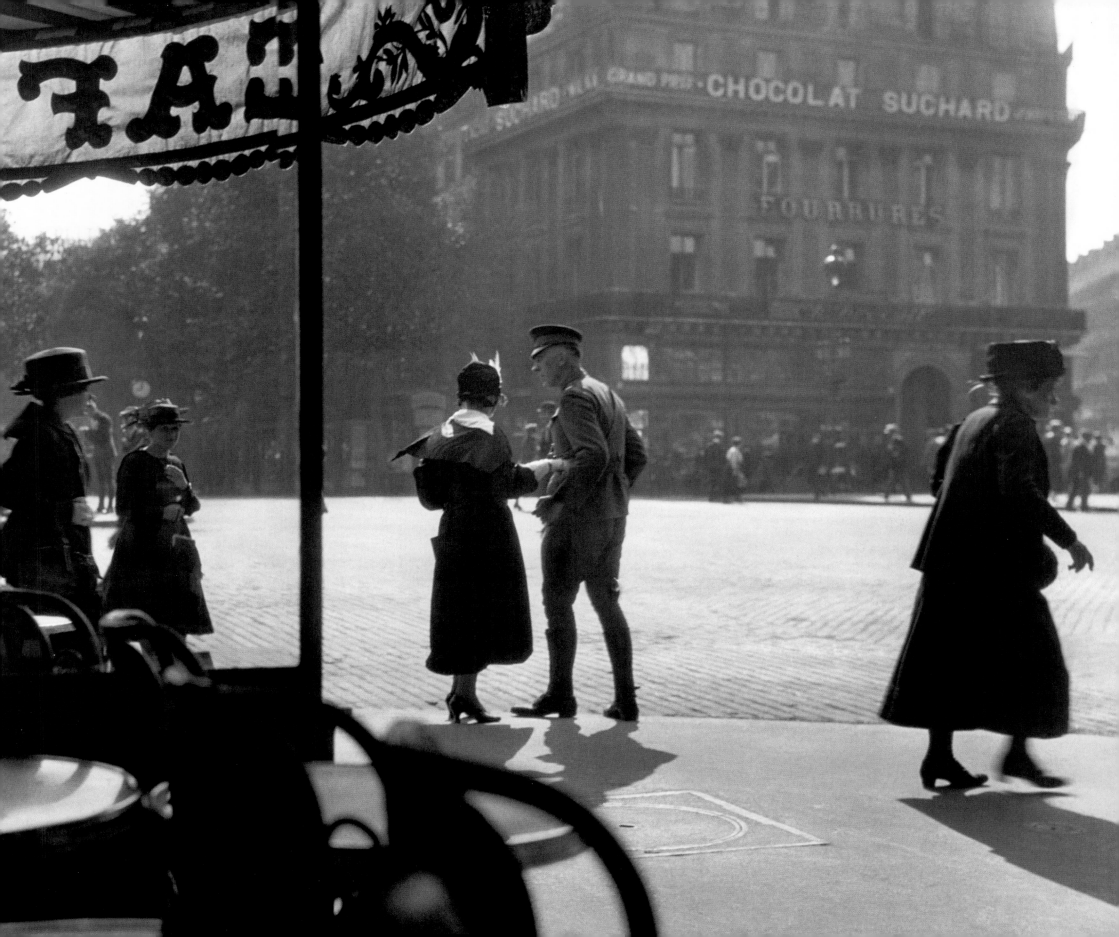

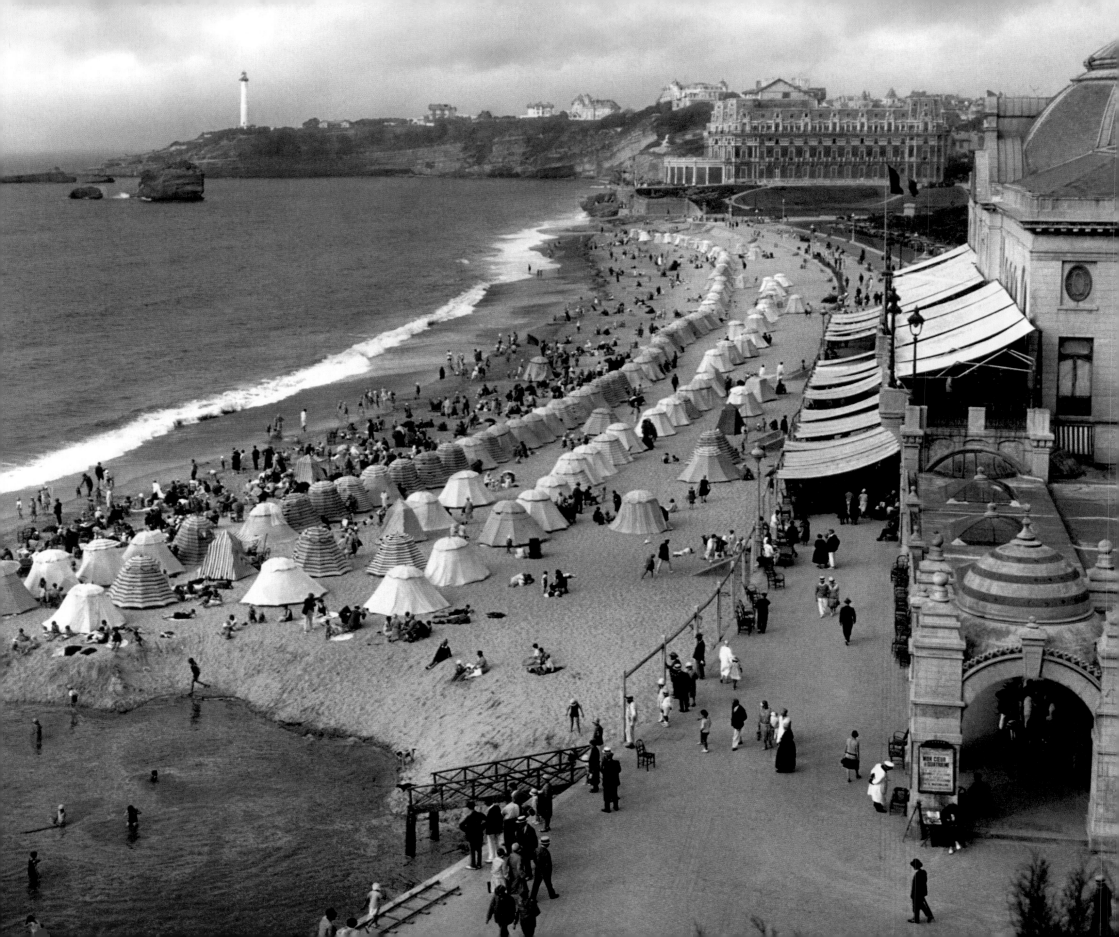

LEFT BIARRITZ, 1927

The late Royal, Edward VII, set the fashion and his royal patronage made Biarritz famous. Biarritz had blossomed into one of the liveliest watering-places of Europe. In time, fashionable Americans found out about Biarritz, the seaside resort that prides itself upon its exclusiveness. Biarritz is at its best in summer-time, when the sun shines brightest, when sea bathing is delightful, your companions brilliant, your food delicious, and your life—pleasurable bliss.

BELOW CABANAS ON THE BEACH, NICE, 1927

Nice, or "Nizza la Bella," as the Italians called it when it was their own, caters to thousands of strangers in the November to May season. A busy city on its own account, the tourists' capital in winter adds another population of like proportions. For sophisticated Europeans, the other reason for the great popularity of Nice is that it is within a half-hour's ride of that restricted little metropolis of Monte Carlo, home of the world-famous Casino.

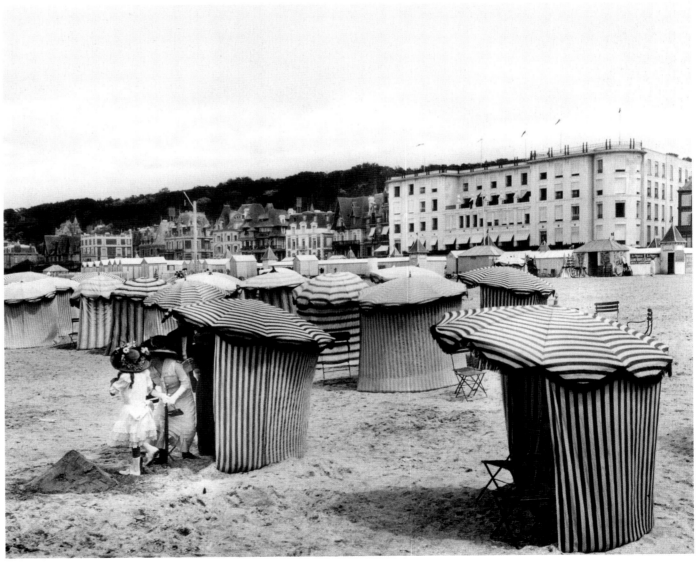

In the changing Old World, one corner remains delightfully unchanged. The ancient provinces of northwestern France retain to-day the characteristic and the charm of a world that used to be. For the traveler, weary of the gay routine of Paris and the gorgeous frivolities of the Riviera, a journey into the France of Yesterday will come as a novel and refreshing experience. The beauty of Normandy and the quaintness of Brittany are proverbial. The homes of the world-conquering Normans and of the sea-conquering Bretons must be visited if we would understand why Normandy and Brittany are still the most interesting diversions of the very varied land that we call France. There quiet charm still dwells and the Past is still alive.

One of the Wonders of France—one of the most impressive reminders of her great past—is the island of Mont Saint Michel with its little town and its colossal and ecclesiastical structures, piled on its rocky summit in astounding but well-ordered confusion. The marvelous Abbey was the creation of not one period but several successive centuries. Each of the co-related buildings reflects the spirit of the age in which it was conceived. The very stones of Mont Saint Michel are eloquent with the story of eventful centuries. It is a colossal object-lesson in French history and in architecture—another proof that Paris is *not* all of France.

About a hundred years ago, when the beach was even less secure than it is to-day, a ship was stranded on it, and being forsaken by the tide, it sank so quickly into the yielding mass that the tips of its mast were lost to view in twenty-four hours.

With a good guide I ventured to make the tour around the island at low tide. I found that it was not safe to stand too long in admiration of the rock, for constant walking is the price of remaining on the surface. In places the walking was decidedly wet, and I found the guide indispensable. He would carry me on his back over the dampest places, and then return to rescue the camera. The legs of the tripod would meantime have settled into the sand at a depth of two or three feet. *[1935]*

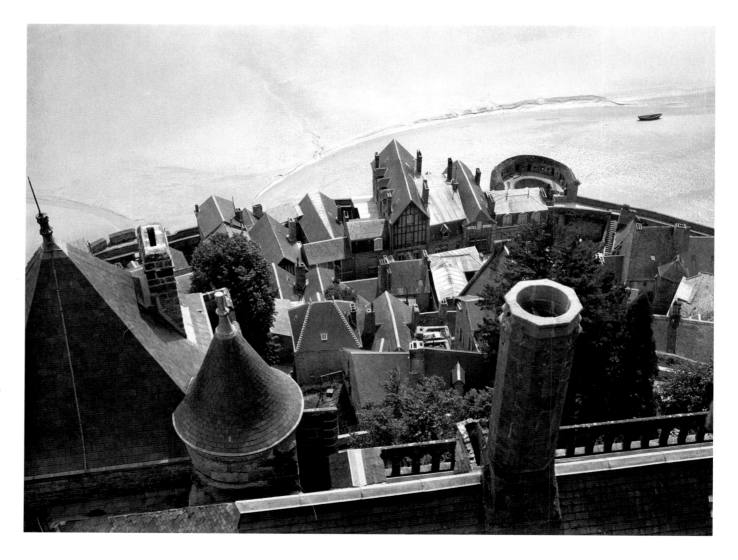

RIGHT **VIEW FROM ABOVE OF MONT ST. MICHEL, BRITTANY, 1935**

From the hotel terrace one could almost drop into the street below. We seem to be living at one and the same time upon a mountain-top, on shipboard, and among the clouds in a balloon. In fact, we are upon a mountain, the sea is round about us, and at times the clouds and mists of Brittany.

Far below we see the village, and beyond, the great plain of shifting sand which within an hour will become a glittering expanse of sea. At night this ascent to our abode is a fantastic experience, for every guest of the Hotel Poulard is furnished with a lighted paper lantern, and when these flickering lights are slowly moving skyward, the scene suggests an evening picture in Japan.

FAR RIGHT **MONT ST. MICHEL, BRITTANY, 1935**

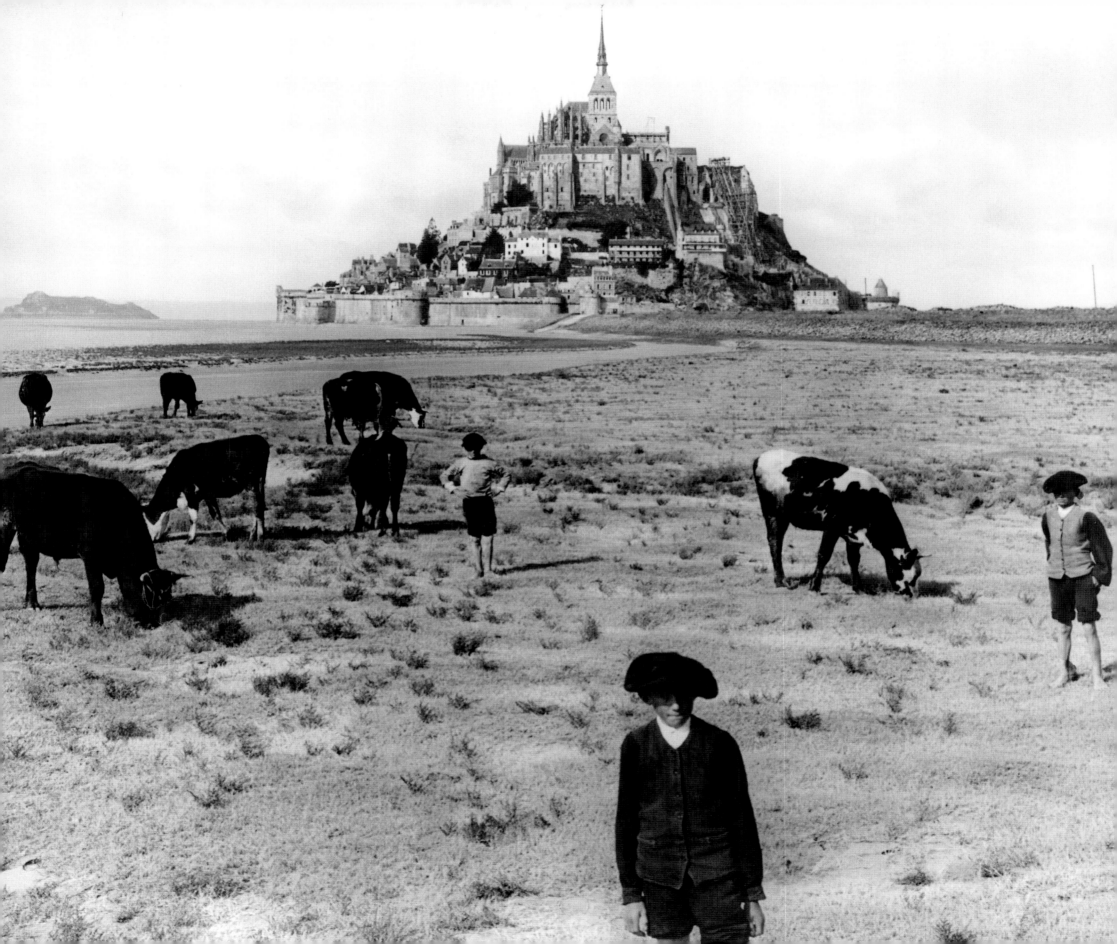

GERMANY
BEYOND BAVARIA

We go abroad, not to acquire a disdain for the life and the ideals of an older world, a world which naturally is in some ways wiser, a world which has been enjoying leisure while we have been so feverishly busy building up our wonderful New World. Germany has not been idle these past forty years; the ship that carries us across the sea, one of the many ships belonging to the most important steamship company in all the world to-day—a German company—is evidence that Germany has not only been hard at work but has in fact done a thousand times better than the United States in developing her commerce on the seas. German ships carry a large share of the mails of England and the United States. German ships serve as transports for the ever-increasing army of American tourists that annually invades England and the Continent. The world now looks almost with awe upon the German laborer.

German industry has flung a crushing hammer into the factories of France and England; and the French and the English working-men are still wondering what hit them. It will be our turn next, unless we learn to be less wasteful and to live within our means. The growth of German industries in the last quarter-century has been phenomenal; suffice it to say that since the Franco-Prussian War, United Germany has advanced from a real, all-pervading poverty to a prosperity that astonishes even the men who have guided the nation on its rapid and triumphant way.

We feel the prosperity in the very atmosphere as we walk the streets of Hamburg, now the greatest seaport of the Continent. The shopping streets of Berlin might be mistaken for streets in an American city. The buildings, the shop-fronts, and show-windows offer little that is unfamiliar; and the shoppers, though not so smart in appearance as those of Fifth Avenue, would pass as New Yorkers. Berlin is a "city of contrasts; American, yet helmed with steel; an ultra-modern setting, where tradition remains all powerful." Yet the traveler feels the unseen presence of something fine and beautiful. It is cleanliness that pleads most eloquently for Berlin. The art of municipal housekeeping is practiced in perfection. Berlin is the best kept great city in the world. There are no "back yards" in Berlin; balconies filled with flowers ornament the buildings, out-door cafés give glimpses of cheerful sociability, and the traveler is confirmed in his impression that Berlin is a "city beautiful." I have gone so far as to suggest from the platform that it would be a wise outlay for the public funds of any city in America to pay the expenses of its Mayor and Board of Aldermen for a sight-seeing journey to Berlin and back. One of my kindly critics in reviewing the lecture asked, "Why back?" so I do not insist upon the return of the official tourists

LEFT **UNTER DEN LINDEN, BERLIN, 1890**
Even though it is raining heavily, Grandmother Burton, Mother and I stroll Unter den Linden, down the first and most famous avenue that is both the Prussian capital and the metropolis of the German-speaking world. Unter den Linden is a broad, calm river of luxury and leisure. It is the nearest approach in Berlin to a Parisian Boulevard. As we make our return to our hotel, we stop to watch a review of the Kaiser's troops marching through the streets of Berlin.

RIGHT **VICTORIA CAFÉ, UNTER DEN LINDEN, BERLIN, 1907**
The focal point of Berlin life is where the Friedrich Strasse crosses the broader, finer and more famous avenue called the Unter den Linden. Our picture of this famous urban cross-roads is taken from the balcony of the almost equally famous Café Bauer, taken in spite of the protest of the waiter and without the consent of the proprietor, for on asking his permission to make pictures from the balcony on which we sat as patrons of his establishment, the crafty but short-sighted individual refused, saying that pictures taken from his balcony always showed and advertised, not so much his own establishment, the Café Bauer, but rather the rival establishment, the Victoria Café across the way! To temper our disappointment—not realizing that while he "verboted" we were taking both the verboten snap-shots and the verboten motion pictures—he assured us that the outlook from the Victoria was much more effective, including as it did the façade of the Café Bauer.
The word verboten is a fetish worshiped by the commoner. A clever Frenchman has said that the Prussian lives in discipline like a fish in water.
While the picture shown in this book appears to have been taken at street-level, other Holmes photographs taken from the rival café's balcony are believed to have been shot the same day and are published in his 1914 Travelogues.

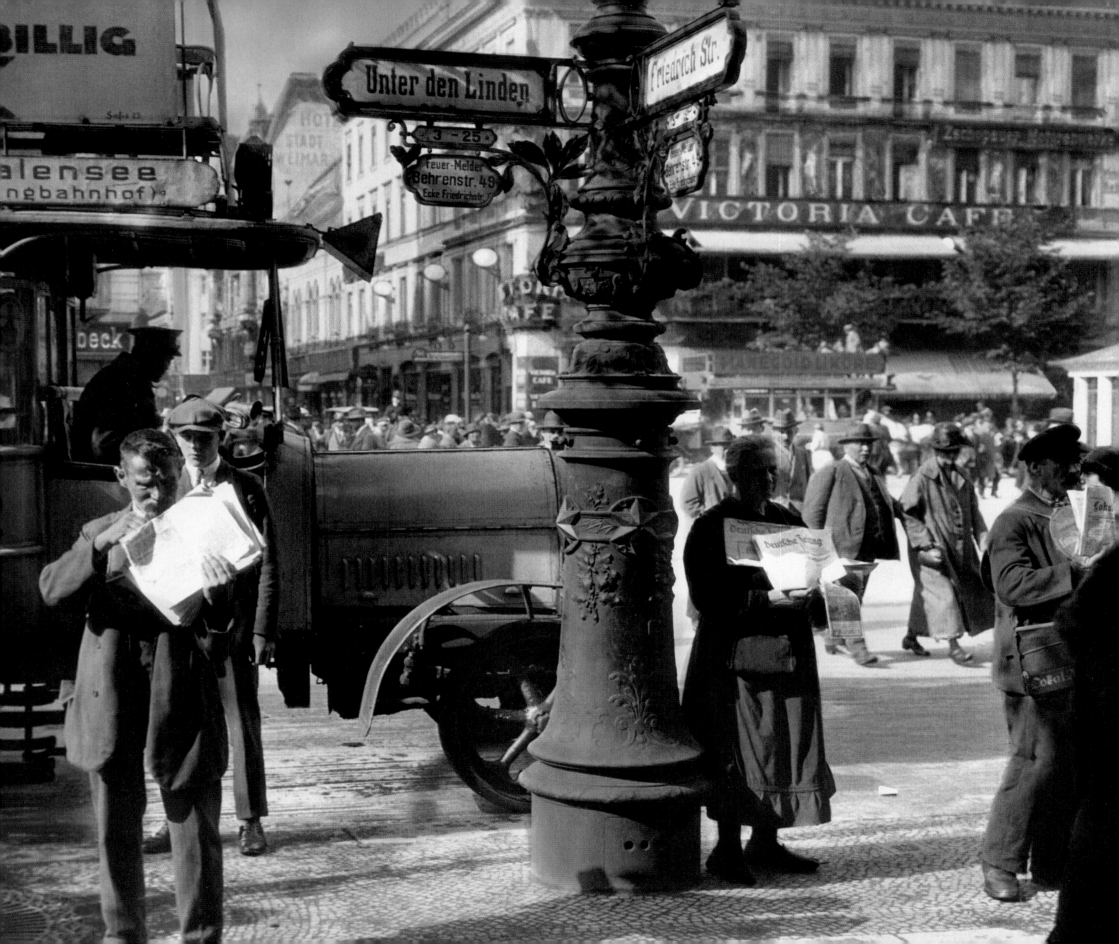

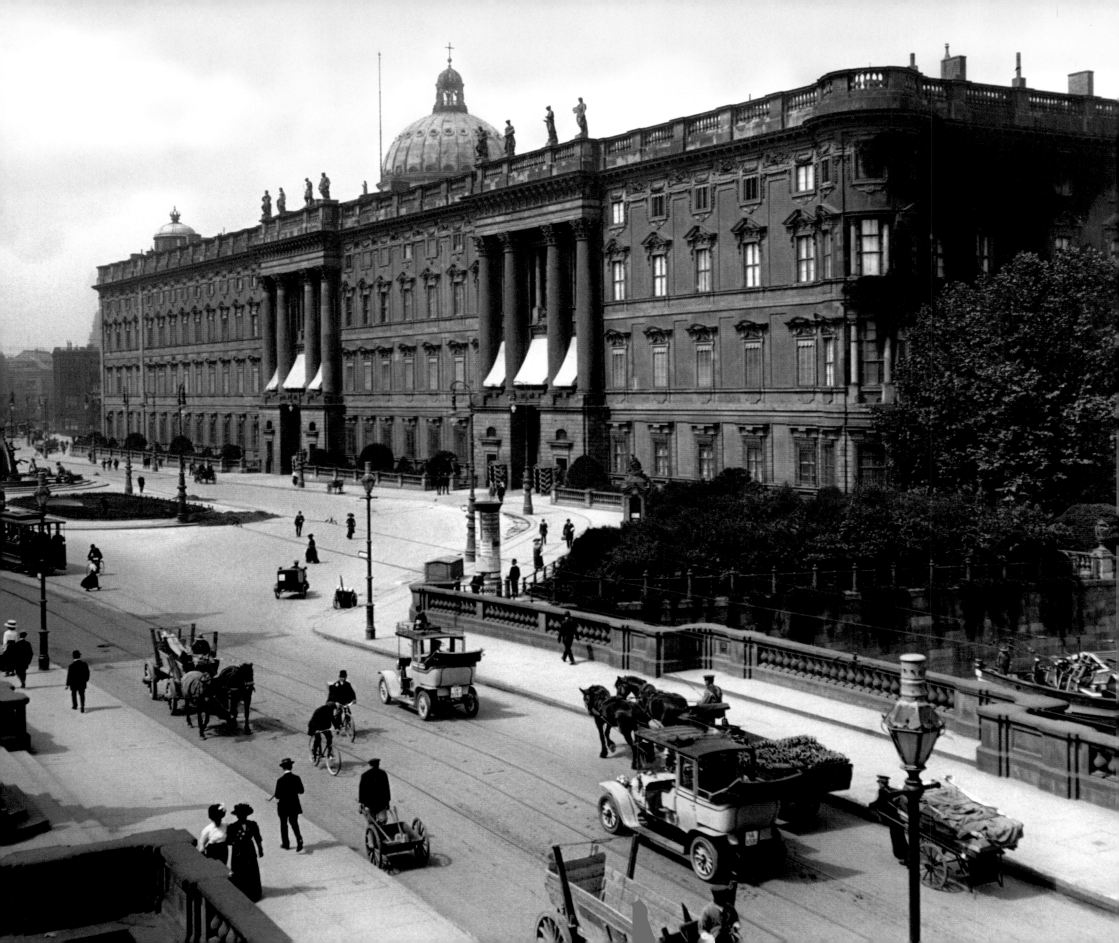

THE ROYAL PALACE, BERLIN, 1907

The Royal Palace dates from several different periods and contains about seven hundred rooms. To describe the interior would be to repeat the descriptions of nearly any other royal palace of the Continent. To visit in detail the homes of kings and emperors, to tramp through suite after suite of gorgeous apartments, is to learn to value the simple comforts and to appreciate the conveniences of your own little home or apartment. Splendor, magnificence, costliness, yes; but empty splendor, formal magnificence, cold, cheerless costliness; nothing cozy; nothing *intîme*; nothing homelike, livable, congenial—nothing really artistic, because the ostentatious can never be artistic in the full sense of the word.

BERLIN MOTOR-BUS, 1907

The street-car system of Berlin is wonderfully complete and covers all portions of the city. The fare is ten pfennigs, or two cents. A tip of five pfennigs is generally given to the conductor, who will then pay some attention to the passenger and notify him of his arrival at the street where he wishes to leave the car.

The tide of Berlin traffic rushes with as great speed but with less noise than that of our American cities. The motor-bus and taxicab are much in evidence—but the horse-drawn bus with its low body and small wheels still zigzags along like an old-style horse-car off the rails.

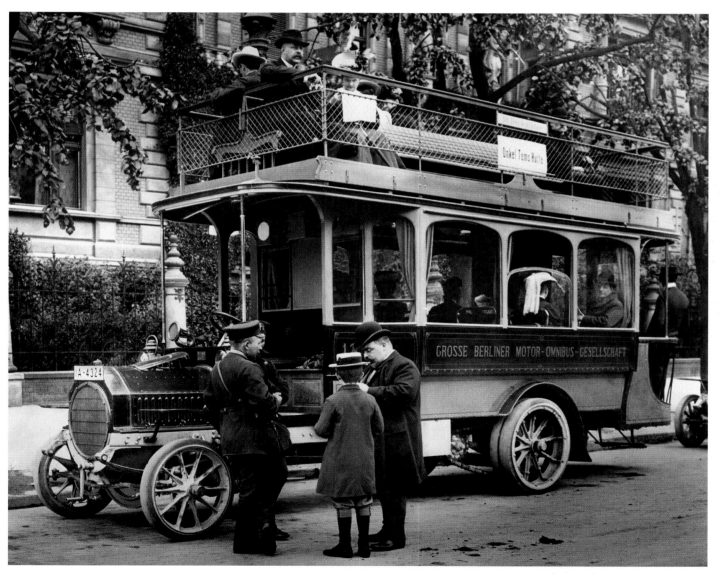

unless they have taken honestly to heart the splendid object lesson offered by Berlin.

Old Berlin was not laid on a grandly spacious plan, but the old crowded section of the city represents but a small portion of the metropolis of to-day. The vaster part of Berlin is brand-new, and in the making of it the people have profited by all the lessons of the past. Space, light, and air, easy communication, convenience, and beauty, have been regarded as more important than the question of mere cost. "What is it worth?" the German asks rather than "What will it cost?"

From the position of a poverty-stricken and war-ravaged agricultural nation, Germany has advanced to that of a rich, peace-preserving industrial nation whose little label *"Made in Germany"* has made its triumphant way around the world upsetting the economic equilibrium of many a manufacturing community. All this amazing progress along the paths of peace has been made to the sound of military music,

but at the same time the rattle of the loom has been heard above the clank of the saber, the racket of the steel riveters above the roar of rifle practice, and the mental processes of the German master minds in chemistry and in all the scientific industries have done more for Germany than all the maneuvers of her army or the strategic cruises of her fleets.

Has Germany succeeded because of her preparedness for war, or has she succeeded in spite of it? Her military pre-eminence and her increasing naval prominence cost her people dear, for in addition to the enormous expenditures made by the government for the equipment and maintenance of her great army and navy there must be added to the enormous total made up of the modest sums provided by devoted families for the support of the young men during their period of service in the ranks or on the seas.

But is all that crushing military burden necessary? This is the question asked by the "plain people," the taxpayers, as

they stand in the presence of the great War Giant they have bred and reared and which they now have to feed and clothe and keep supplied with powder and with steel. Is this monstrous thing of blood and discipline—this German army—worth what it costs the people in gold, in labor, and in sacrifice? This is the question Humanity is asking. The War Lord has his answer ready. His people may find yet another. Let us hope that the answer will not be one that will shake the foundations of civilization, that the guiding hand of him who sits upon the German throne and the sturdy common sense of those who call him Kaiser may so wisely control this unparalleled incarnation of military power—this army of the Fatherland—that it may never, like the monster made by Frankenstein, become a thing that even its creator cannot master. [1907]

LEFT **BARRACKS OF THE KAISER'S TROOPS, BERLIN, 1907**
The German people support their soldiers and their sailors not only indirectly through taxation, but directly by sending from time to time the little sums that make life possible for a self-respecting wearer of the Kaiser's uniform.

RIGHT **KAISER WILHELM II, 1907**
To-day there are nearly three million people living in Berlin. Of these one man stands out as the most conspicuous, pervading personality of living Germany—the Kaiser. He is everywhere, interested in all things, active in all things, himself in all things. He has an insatiable appetite for information; as a giver of advice he is indefatigable. We see him in photographs or in person questioning his admirals on the bridges of his warships, directing his staff officers at military maneuvers or reviewing troops. We see him as an equestrian in the Tiergarten, as a pedestrian in Unter den Linden or as the helmeted war-lord in the imperial car, motoring like a hurricane from Mars across the Platz. Berlin without the Kaiser would seem to lack one-half of its three million population.

BELOW **MAD LUDWIG'S BAVARIAN CASTLE, NEUSCHWANSTEIN, 1919**

Commanding a spectacular panoramic view of the Bavarian landscape, surrounded by dark forests and heavenly mists, stands Mad King Ludwig's sparkling fairy-tale castle, Neuschwanstein. Ludwig II drew up the plans himself, with the help of an ambitious stage designer, who agreed with the King that a huge fantasy castle built in the medieval style, which also paid homage to Wagner's operas, was an inspired idea.

RIGHT **THE BLACK FOREST, 1919**

After all these years of traveling the world, I retain vivid mental pictures of places worth going to, and of seeing things that are world-famous. So many wonderful moments come easily to mind, but one of the best I recall is a flash of illuminating beauty taken deep in the Black Forest of Bavaria. The Germans must be descendants of the old forest tribes— even the city-dwellers are tree lovers; all who can afford it have gardens with as many trees in them as possible; those who cannot afford a real garden devise a little imitation garden on a balcony or in one of the loggias so frequently found in the facades of the newer apartment buildings. Hundreds, in fact thousands, of tired citizens literally take to the woods after business hours; and on Sundays and holidays, thousands—nay, hundreds of thousands—of city-dwellers take to the taller timber of the farther reaches of the forest to spend their hours of leisure in the lap of Nature, breathing the perfume of the pines.

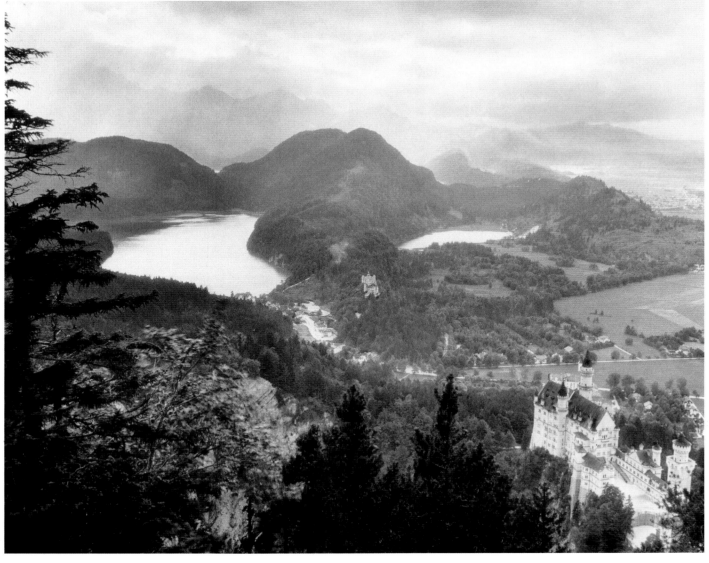

LEFT **ST. BARTHOLOMEW'S CHURCH AND MOUNT WATZMANN ON KÖNIGSSEE, BERCHTESGADEN, BAVARIA, 1923**

The fabled Mount Watzman and lake at its base, Königssee, widely considered to be among the most pristine examples of natural beauty in Germany, have been favorites of landscape painters since the early 1800s. In the 1920s the town of Berchtesgaden fell under Nazi control, and nearby Obersalzberg would become known as the site of the Berghof, Hitler's mountain retreat. Overlooking the house at the peak of Kehlstein mountain, stands the Kehlsteinhaus ("Eagles Nest"), which was given to Hitler by the Nazi Party on the occasion of his fiftieth birthday.

BELOW **THE TOWN OF COCHEM, ON THE RIVER MOSEL, 1919**
Along the Rhine and Mosel there are ancient walled towns and picturesque villages. The steep hillsides are covered with woods, and ruined castles stand guard on high rocks overlooking the rivers.

LEFT **HITLER YOUTH RALLY, BERLIN, 1938**
Just as in Japan and Italy, ambitious German leaders are using the schools to debauch the rising generation, to instill the poison of the "Master Race" complex, and to awaken and strengthen in the young these dormant, brutal instincts that are, alas, innate. Loyalty to the Fuehrer, Duce, or "Son of Heaven" has become the religion of the moment. To die for The Leader is the highest duty. Millions of deluded men have been privileged to fulfill that duty.

BELOW **LITTLE GIRLS WAITING WITH FLOWERS, BERLIN, 1938**

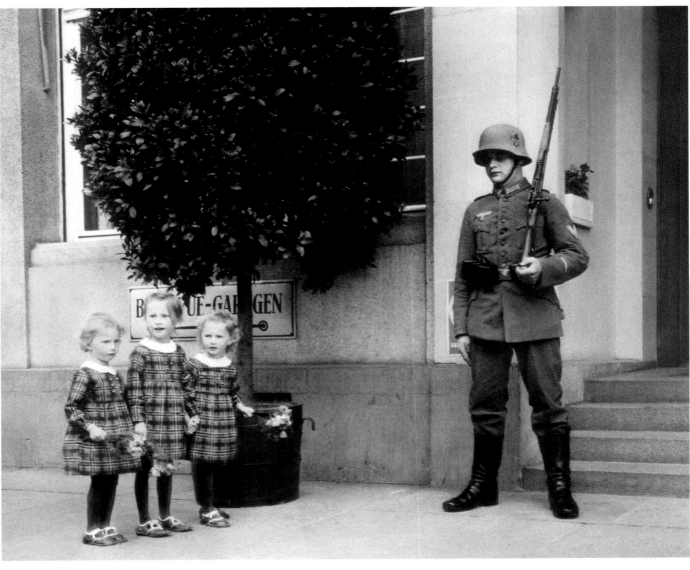

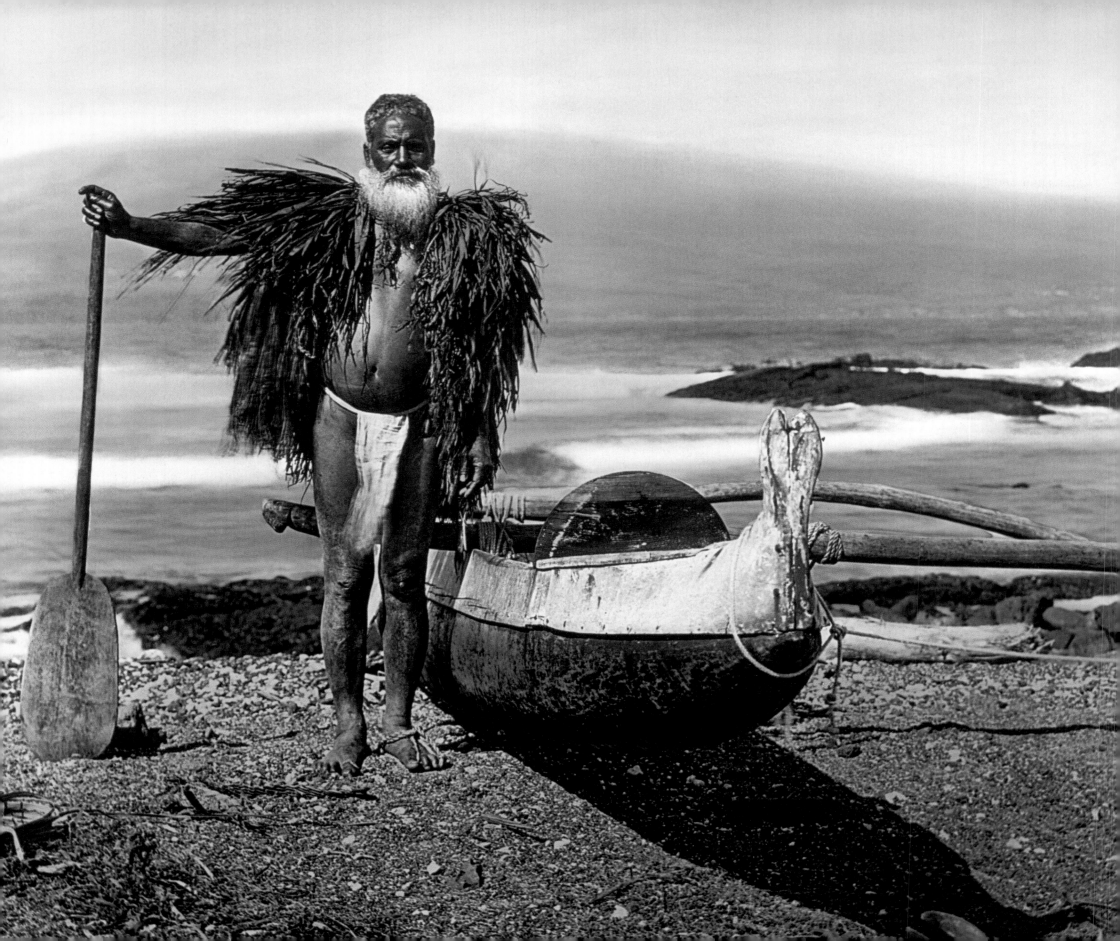

HAWAII
PEARL OF THE PACIFIC

It is an unparalleled experience for the American traveler—who leaves his own shores and sails across the seas to a distant, independent country to find, soon after arriving at his destination, that the expanding confines of his native land have followed, overtaken and enveloped him—to see the Stars and Stripes flung out by eager alien hands, to wave forever against a tropic sky; to be a witness of the most charming, peaceful conquest that the world has ever known. *[1898]*

The City of Honolulu, on the island of Oahu, is the port through which the traveler enters Hawaiian territory. It is a delightful city with environs of singular charm. The lavish foliage of the tropics is here found, for the setting of Honolulu is in the semi-tropical surrounds of a land where "it is always afternoon." The people are noted for their courtesies and hospitalities, which multiply in geometrical progression the longer one stays. *[1913]*

Two borrowed phrases here insist on repetition, for "overhead there rolls a sea of smashed rainbows," and "here and there are drifting patches of iridescent vapors like itinerant stained-glass windows from some great cathedral." And as the sunset fires flow from the west like liquid gold, we tremble when we think how far this flood of golden light has journeyed over trackless oceans to touch and glorify these tiny dots of earth in the midst of the greatest ocean on our globe. We catch our breath and the thought of all the leagues of barren waters that stretch away to north and south and east and west; of the everlasting surrounding deep that washes both the shores of Asia and America and rolls its mighty volume from continent to continent and pole to pole. As we stand on this Hawaiian shore, so far from our own land, a stranger passes, asks us if we have heard the news brought by the latest steamer from America. At his words "Annexation is an accomplished fact," we fix our feet more firmly on this lava shore, for we, who a moment since were as strangers in a strange land are now at home—Hawaii has become part of the United States. *[1898]*

Concerned that Hawaii might become part of an expanding European nation's empire, the United States offered Hawaii a treaty of friendship in 1849, and annexed the islands in 1898. Hawaii and Alaska did not achieve statehood until 1959.

LEFT NATIVE WITH CANOE, 1898
As we walk about the island, we cannot but fear that the leisure-loving native is doomed. He flourished like the vegetation of his island so long as he was left to grow his taro, pick his mango, and idly repose. There was no necessity for labor. Then the white man came with his doctrine of activity, whereupon for the first time the curse of Cain descended on this happy land. The islander did not resist; one by one he simply laid him down to die; he will revenge himself by disappearing from the earth where he no longer feels at home.

RIGHT PALM TREES AT SUNSET, 1898
We look in admiration at the tall palm trees, the most charming feature of the Hawaiian landscape. To me they look to be always angry, always contending with the tradewinds or defying one another. Travelers have compared them to a grove of damaged umbrellas, or feather dusters struck by lightning.

**THE HONGWANJI MISSION,
JAPANESE BUDDHIST SCHOOL, CA. 1913**

*In 1899, several Buddhist priests came to Hawaii from Japan
to open schools for the education of Japanese children on
the island.*
Waikiki is as well a paradise for the mixed Asiatic popula-
tion, and here young China and Japan are seen in all their
sweet simplicity. Mark Twain has told us of seeing here
"certain smoke-dried children, clothed in nothing but sun-
shine—a very neat-fitting and picturesque apparel indeed."

CELESTIAL CONTEMPLATION, 1898

*This photograph, along with several others by Professor
Henshaw, was given to Holmes for his shows. It ran with
the above caption in the 1914 edition of his Travelogues
volumes.*

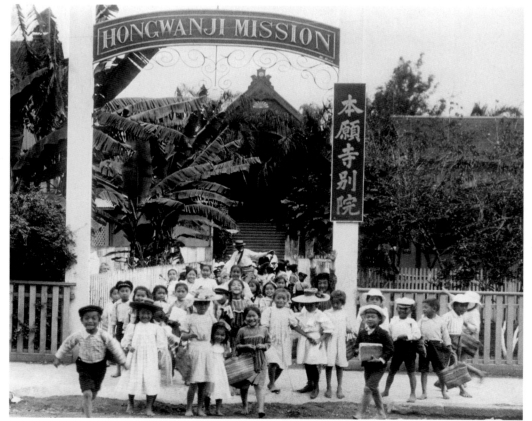

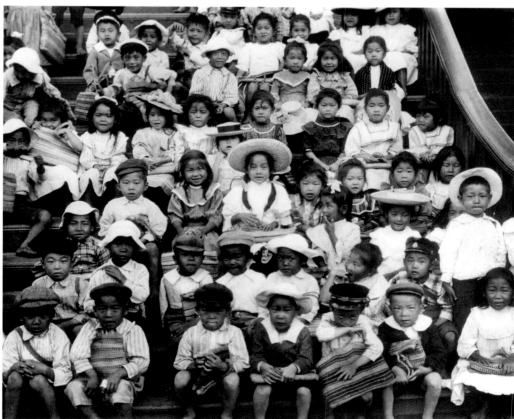

THE LAST DAYS OF WINDMILLS

Holland *and the* Dutch: Touching busy Amsterdam and Rotterdam, quiet Haarlem and The Hague, fashionable Scheveningen and "Imperial" Doorn, Alkamar on Cheese Days, Volendam when the sun is shining and Marken when the kiddies are in holiday attire.

No country in Europe has more of what we call "local color" than this little Kingdom of the Netherlands. The Holland with which we are familiar is a picturesque combination of windmills, dikes and tulip beds, of dogs harnessed to carts, boys in baggy trousers, of babies dressed like grandmothers and pretty little knitting girls in lace caps.

We are to see the sturdy inhabitants in their various avocations; to study their art and architecture and be made to feel that we actually know these wonderful people, who for eighty years struggled with Spain, were over-run by Napoleon, accomplished such wonders in land reclamation, produced the foremost scholars in Europe and a host of great painters, and founded the greatest city in America which they called "New Amsterdam."

I will say I am inspired by the achievements of these people of the Netherlands in civilization, in war, in letters and in art—praising the courage of their heroes, the wisdom of their statesmen, the genius of their painters, and the industry and patience of the plain folk. *[1926]*

In spite of many trips to Europe in the three prior decades, Holmes did not lecture on Holland until 1926.

LEFT **SCHEVENINGEN, WATERING-PLACE OF THE HAGUE, 1926**
Here at Scheveningen the wives of local fisherman appear on Sunday, on this fashionable promenade, dressed and coifed just as their mothers were a hundred years ago. No short skirts for the fisher maidens—no cloche hats to spoil the quaint and pretty coifs that so well set off their calm and honest faces. They live in Scheveningen and yet they seem to be in no way touched by this modernizing flood of changing fashions which has even brought the Charleston to these classic sands.

RIGHT **THEATER SHOWING SHIRLEY TEMPLE MOVIE, AMSTERDAM, 1939**
Hollywood's little moppet, Shirley Temple, brings her brand of sunshine and spunk to places far and wide.

WIND-POWERED SAWMILL, ROTTERDAM, 1926
We always think of Holland as a place of wooden shoes
and windmills. Well, the wooden shoes, the *klompen*, will
undoubtedly be worn for many years to come—but the wind-
mills of Holland, alas for art and artists, are doomed to dis-
appear. There are still many of them standing but very few
in use. Those, like this one in Rotterdam, now used as saw-
mills, will persist.

AERIAL VIEW OF POLDERS, 1926
The vast majority of windmills used merely for pumping
water from the low polders up to the high canals are
being rapidly supplanted by the far more effective gaso-
line pumps of today.

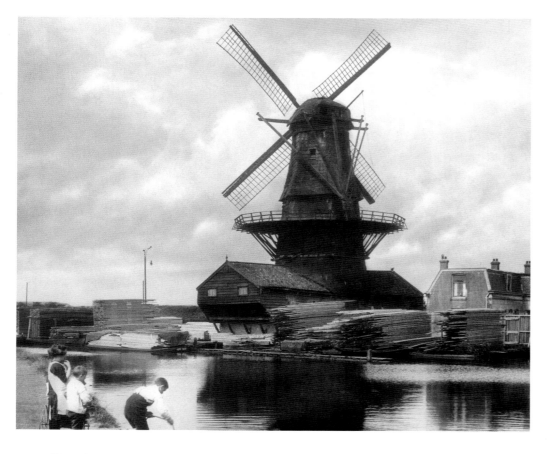

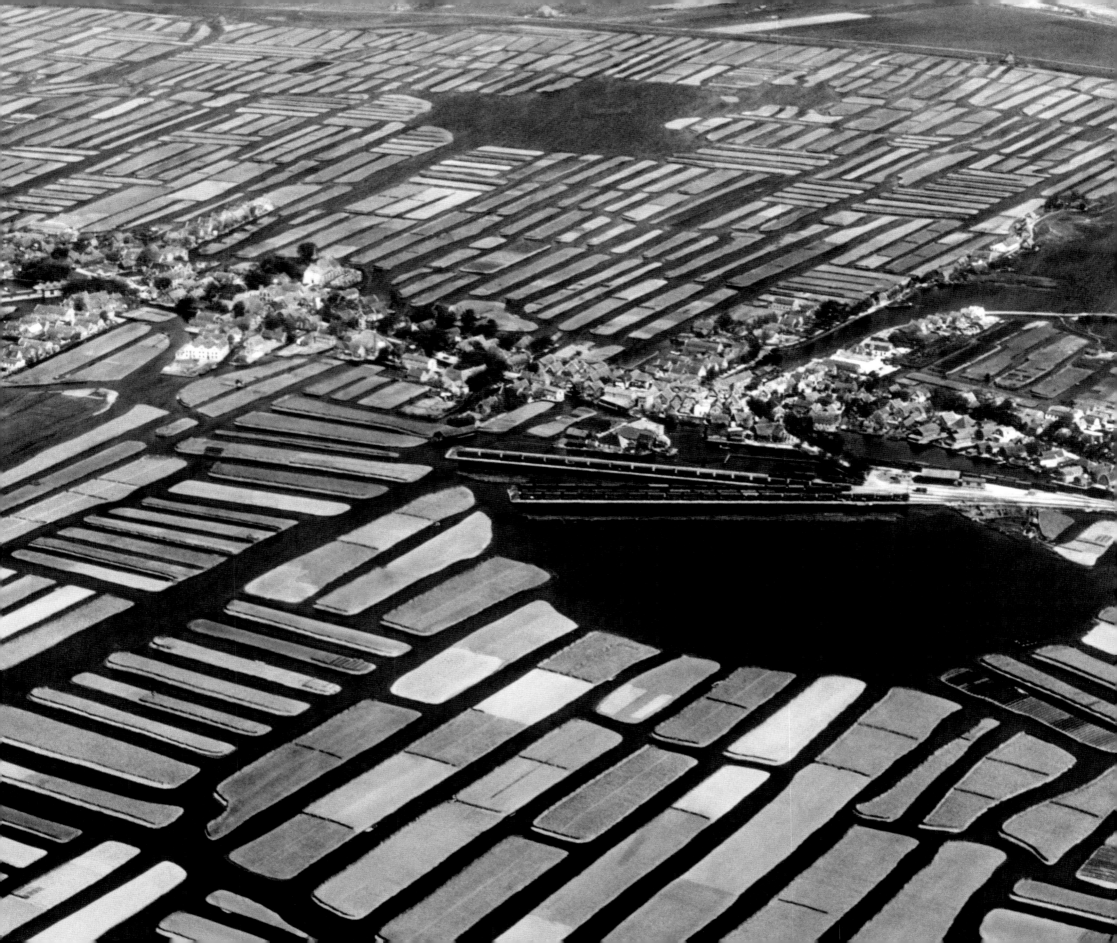

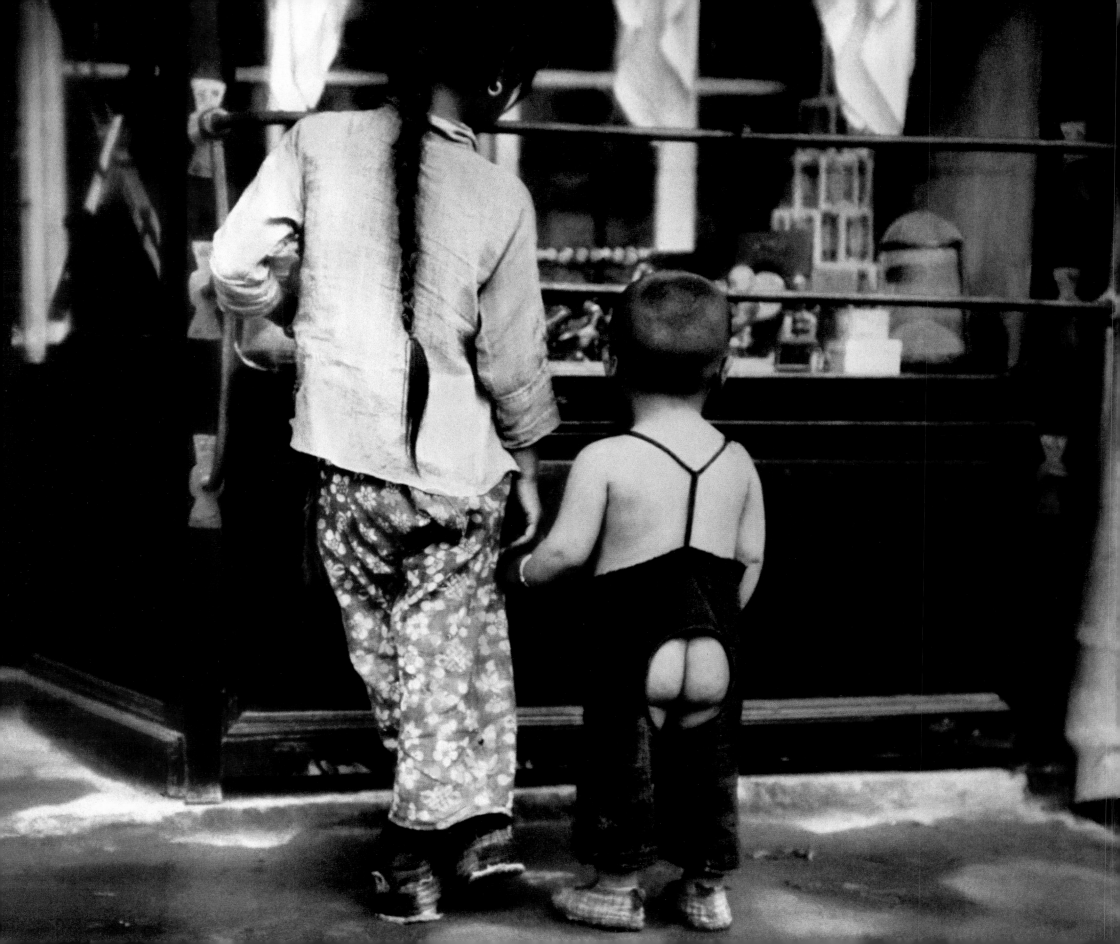

THE WORLD'S EMPORIUM

As the mists drift aside for a moment, we enter the narrow channel between the mainland and the island of Hongkong, clusters of huts scarcely distinguishable from the earth and the rock behind them are the only evidences of human presence, and we are vaguely surprised at this apparent desolation; we almost expected to see teeming millions crowded to the very edge of China, struggling to retain a foothold on its sacred shore.

We were in the busiest harbor in the Eastern Seas, the meeting-place of ships from every corner of the world. So broad is the anchorage that there is no crowding; the countless mighty ships swing freely with the tide, each in its watery orbit, each with its nebula of satellites.

We are surprised to find the harbor of Hongkong so beautiful. Hongkong is a free port; the pleasure of arrival is not marred by official molestations. We are permitted to arrive without committing perjury or breaking our fingernails upon the refractory catches of our trunks. We follow the splendid stone quay to the right along the waterfront, all this is comparatively new; the waterfront familiar to the traveler of ten years ago is now two blocks from the shore: the grey structures far to the left with three tiers of arcaded balconies formally mark the harbor edges of Hongkong. Despite the many examples of European architecture, we know we are in an Oriental country, and we realize that we have scented a new land. The discovery of a new smell is always an event in the life of a traveler. Every foreign land worth visiting has its peculiar, its unmistakable aroma. Delightfully we sniff the heavy atmosphere in an attempt to analyze the new-found perfume; in it we detect an *oldness* that is not antiquity, a raciness that is not of decay, a touch of aromatic wood, and a suspicion of incense from long ago and far away, all this saturated with the steam of perspiring population—such is the smell of Hongkong. It gives us a keen sense of remoteness, not altogether grateful to a traveler who finds himself alone in Hongkong. *[1899]*

As was often the custom in his time, Holmes spelled Hongkong as one word rather than two. The island was occupied by the United Kingdom in 1841, and remained a colony until it was handed over to the People's Republic of China in 1997.

LEFT **MOTHER AND CHILD WINDOW-SHOPPING, 1901**
The clothes I saw in Hongkong were all rather somber in color, and very severe in effect. The children, to be sure, wear gay colors and patterns, and in the summer hardly bother with clothes at all, or those that are worn are well-ventilated.

TYPHOON IN HONGKONG HARBOR, 1906 (PHOTOGRAPHS TAKEN 10 MINUTES APART)

These pictures were taken during the terrible typhoon of September 18,1906, which came without the usual warning. As a rule our observatory in Manila warns Hongkong in time for the shipping to prepare for the big blow. The liners get up steam and get out extra lines and anchors; the little junks and native craft seek refuge in the special inner typhoon harbor.

But this storm came from the landward direction, unannounced. In two hours time the storm took an enormous number of lives, no one will ever know the exact number. By 9:30 A.M. the blackness of despair had fallen on the souls of all the living who clung to craft remaining afloat. The wind is driving a heavy wall of rain across the harbor at the rate of 150 miles an hour. So dense is the downpour that it hides many of the sinking ships. Junks are hammering themselves to pieces here on the stone wharf. Ten minutes later, one junk has succeeded in its suicidal effort and the waves are washing over the wharf. Meantime, a big river steamer had battered holes in herself and gone down. Ocean liners in the harbor dragged their anchors and collided or else rammed themselves into wrecks along the Kowloon shore. By 10:00 the typhoon had eaten about all there was in sight. A typhoon usually blows for ten to eleven hours. This one did its work in less than two. By noon the sun was shining, and by 2:00 P.M. the stillness of death had fallen upon the waters. There are remnants of the pier through which a launch had battered her way, followed by a flotilla of junks on their dash toward the stone wharf where they were utterly annihilated.

Fifty percent of the native shipping in these waters was completely wiped out and an estimate of eight to ten thousand men, women, and children did not resume, that afternoon, their fight for existence amid the crowded competition of this, the greatest sea port in the world.

JUNK ON THE CHINA SEA, 1901

To me, there is more beauty in one of these slow, cumbersome out-of-date ships, with its crimped sails, than in the trimmest sloop that ever came from the genius of the best of modern designers.

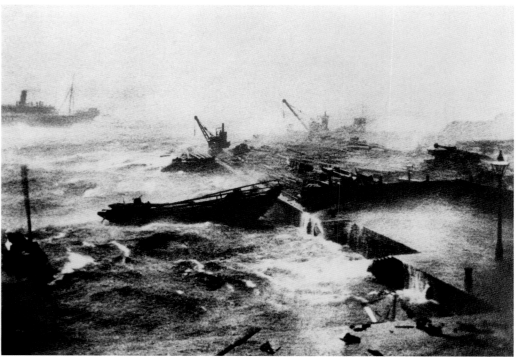

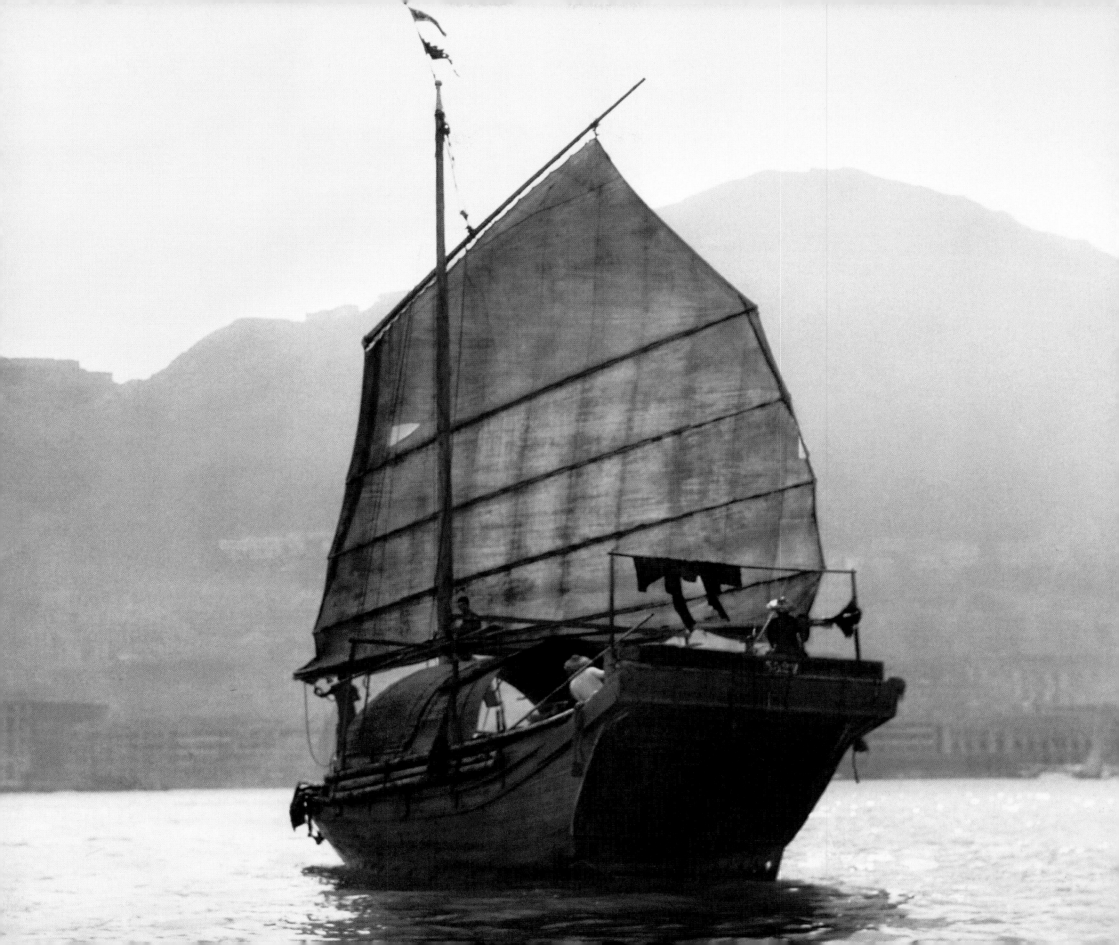

INDIA
SIGHTS OF SUPREME BEAUTY

India, for the travel-lecturer, is the richest, most alluring subject in the world. For twenty years I have been trying in vain to find time to visit India during the comparatively comfortable "cold weather" of the winter season. Resolved at least to see if not to *do* India, in 1912 I braved the not exaggerated terrors of a real Indian Summer. The amazing land of British India filled our screen with its splendor, squalor and beauty.

I lived to tell the tale, and returned with wonderful material to share with my audiences. Three of the greatest sights in the world are revealed: the most beautiful of architectural creations—the Taj Mahal; the most amazing of religious spectacles—Benares; and the highest of the earth's mountain ranges—the Himalayas. In addition to these sights of supreme beauty and interest, were glimpses of Indian life, high and low; suggestions of the grandiose existence of the Great

Moguls in their fortress-palaces at Agra and at Fatehpur-Sikri, and of today's Anglo-Indian life in Calcutta and at Darjiling [sic] on the green slopes of those towering "hills" whence the eternal snows of Kinchinjunga and Everest are sometimes seen. *[1912]*

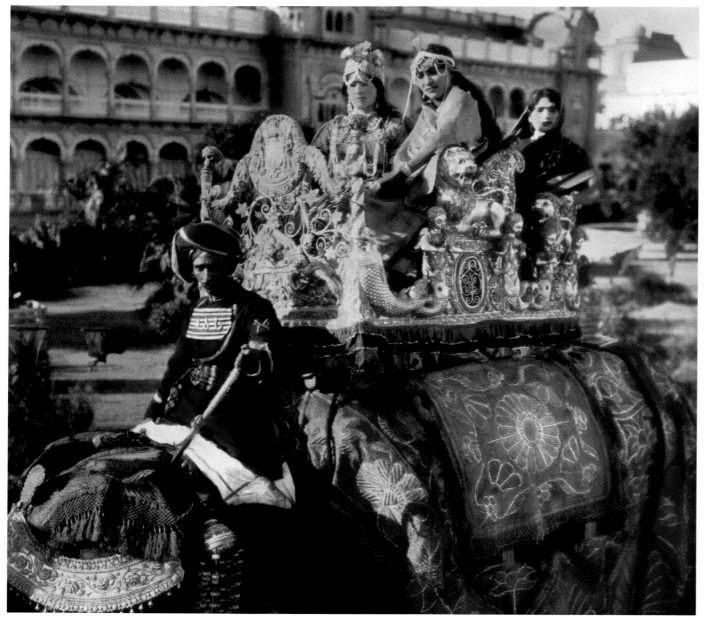

LEFT **RELIGIOUS PROCESSION, WOMEN RIDING ON AN ELEPHANT, DELHI, 1912**
India is the land of festivals. Every month, somewhere in the country, a festival is being celebrated. The major festivals are linked to particular temples, like the great Elephant parades. These processions feature scores of beautifully decorated elephants, driven by mahouts in princely attire, women riding in ornate, gilded chair-platforms balanced on the elephant's back, richly adorned in colorful embroidered costumes, layers of golden jewelry, some women wear lengths of precious pearls upon their heads.

RIGHT **WOMEN AT A FESTIVAL, DELHI, 1912**

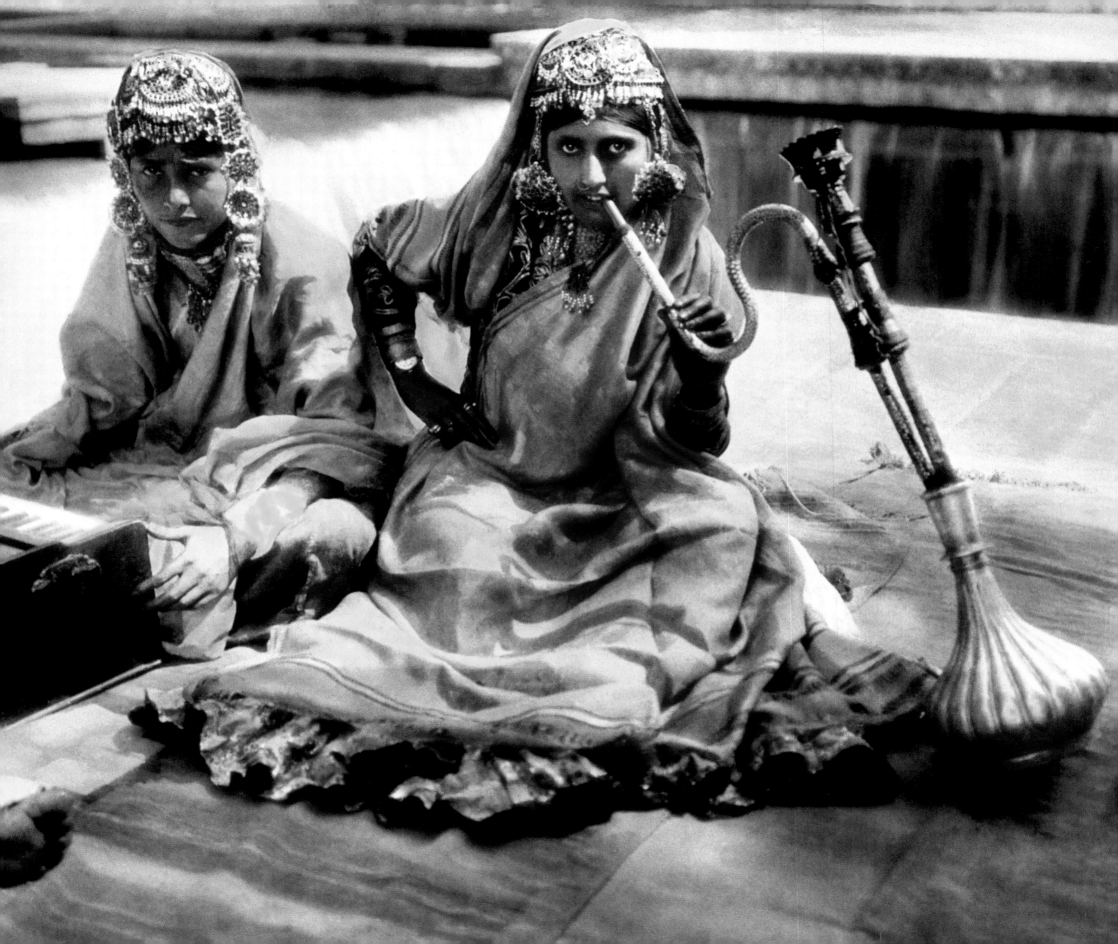

GANGES BATHERS, BENARES, 1912
The Ganges is one of the world's most amazing sights—this riverfront of the holy city at the hour when the population and the pilgrims come to perform their ancient rites, as they have been performed here almost without change for at least three thousand years.

THE BANKS OF THE GANGES, BENARES, 1912
I was not totally prepared for the most amazing and repellent sight in the world as I approached the old Hindu city of Benares on the banks of the all-holy river called the Ganges. To LIVE in Benares is to every pious Hindu a high and holy privilege. To DIE in Benares on the shore of this most sacred river is to gain instant entrance into the Paradise of Siva. To BATHE in the turgid waters of the Ganges is to wash away all trace of carnal sin. To PERFORM here the many, long-enduring, complex, and mysterious religious rites practiced by the Brahmin is to cleanse the soul of all impurities and to prepare it to return perfected into the all-embracing one-ness of the infinite essence where alone dwells perfect peace.

But this rosy road to ultimate peace and joy appears to those of us not numbered among the elect as a most distressing highroad to the hereafter, frequented by the tumultuous mob of frenzied seekers after salvation.

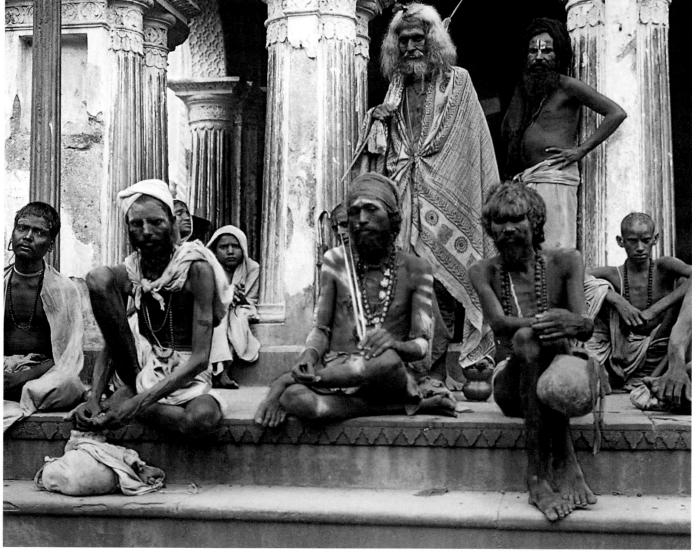

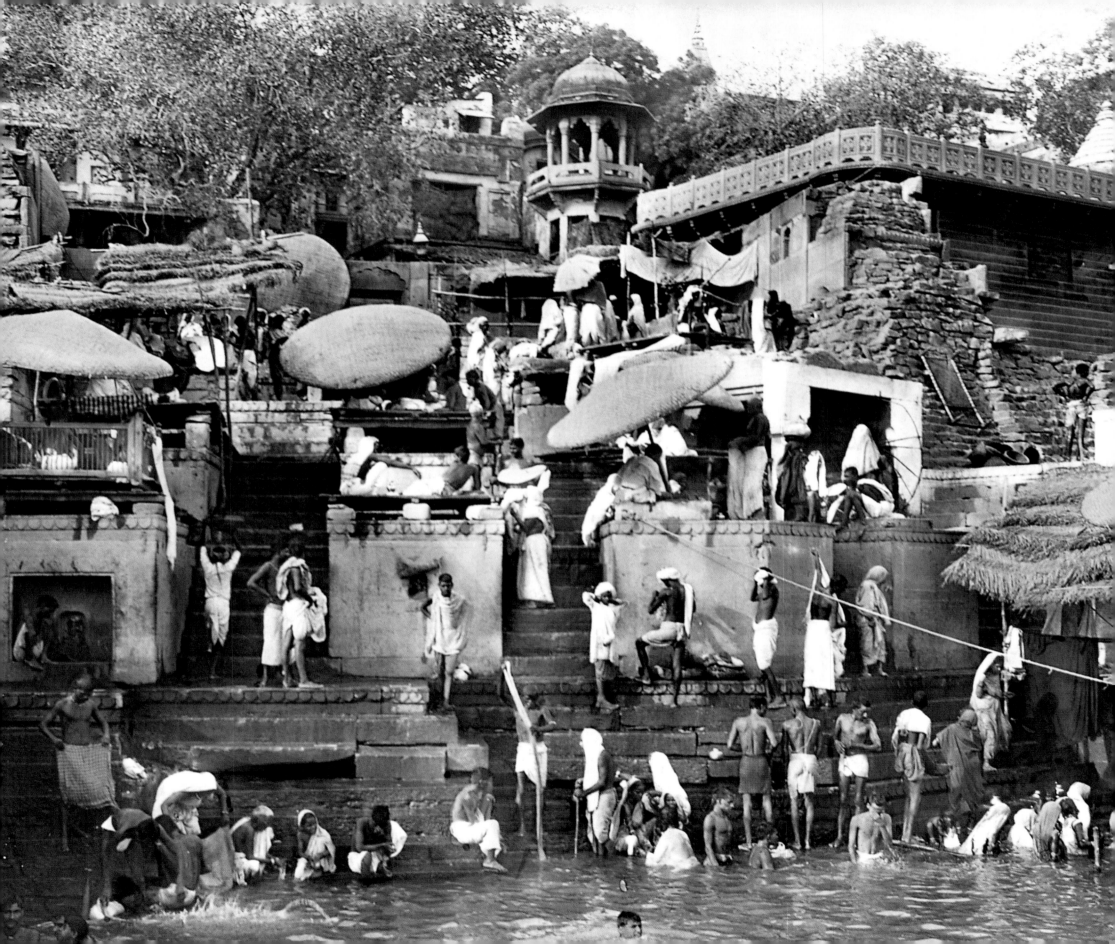

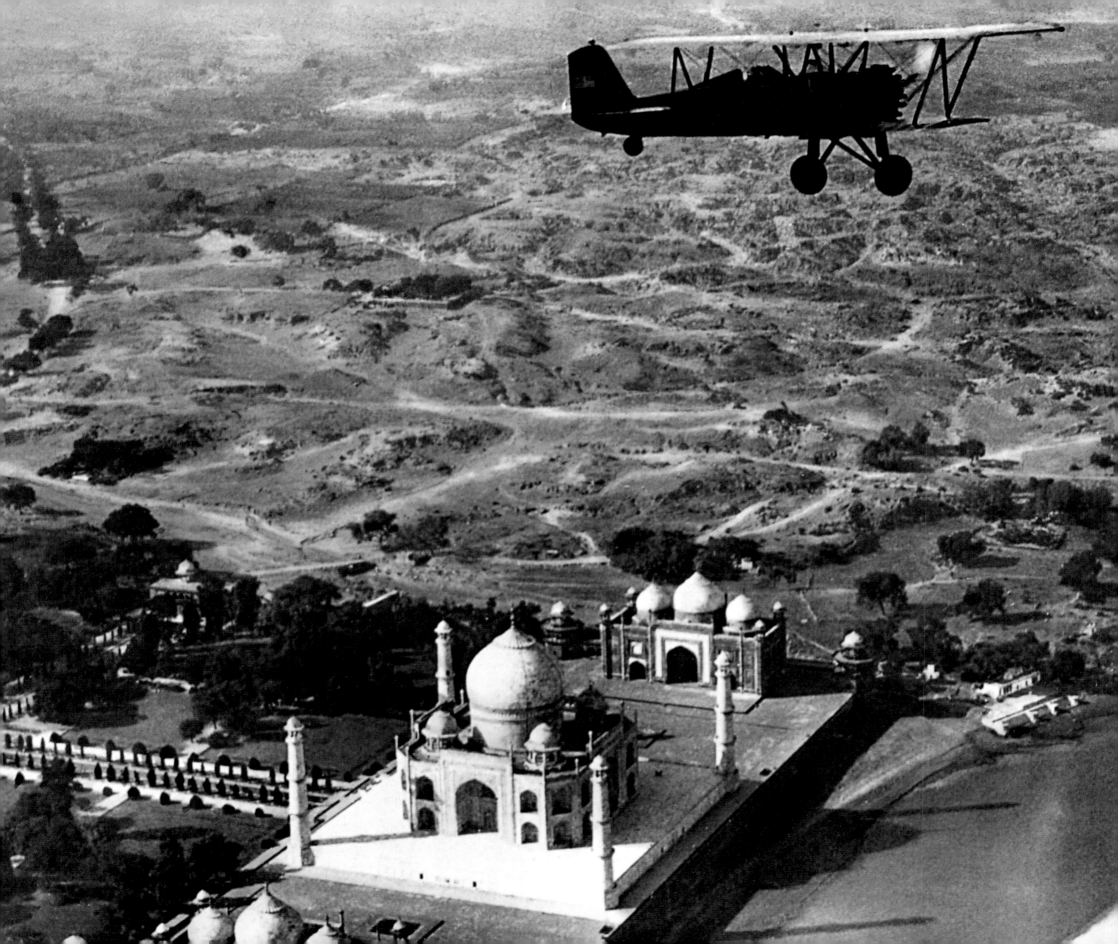

LEFT AIRPLANE FLYING OVER THE TAJ MAHAL, AGRA, LATE 1930

From every point of view the Taj Mahal is perfect in both symmetry and beauty. With other buildings we must occupy a certain point of view to see them at their best. But this miraculous creation is always and from every point of view perfectly balanced—correctly composed. We cannot throw it out of line or of proportion by standing at unfavorable points of view. There are no wrong spots at which to stand, no angles adverse to a satisfying survey of the Taj. Perfect within, perfect without, perfect in line and color and design, and better than all else, perfect in motive and sentiment; for the one was grateful love, the other was life-long affection. *Labeled in the archive as a photo from Holmes's trip to India (1912), the plane in the photo appears to actually be a civilianized version of an Air Force plane from the early 1930. As Holmes did not return to India a second time, the photograph must have been given to him for use in a show.*

BELOW THE TAJ MAHAL, AGRA, 1912

The Taj Mahal, the Oriental pendant to the Grecian Parthenon, as flawless in design as the world-famous masterpiece of the Greek Age of glory, but far more beautiful, and unlike the Parthenon, not a ruin, but intact in its surpassing beauty, unmarred by war's disasters, pure as when the last conscientious toiler took away his tools, leaving behind him the most beautiful building on the face of our revolving globe.

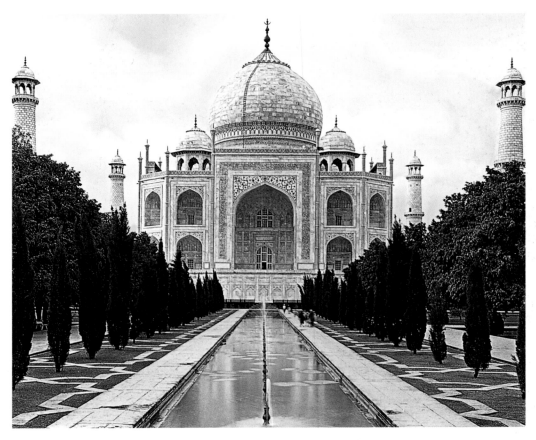

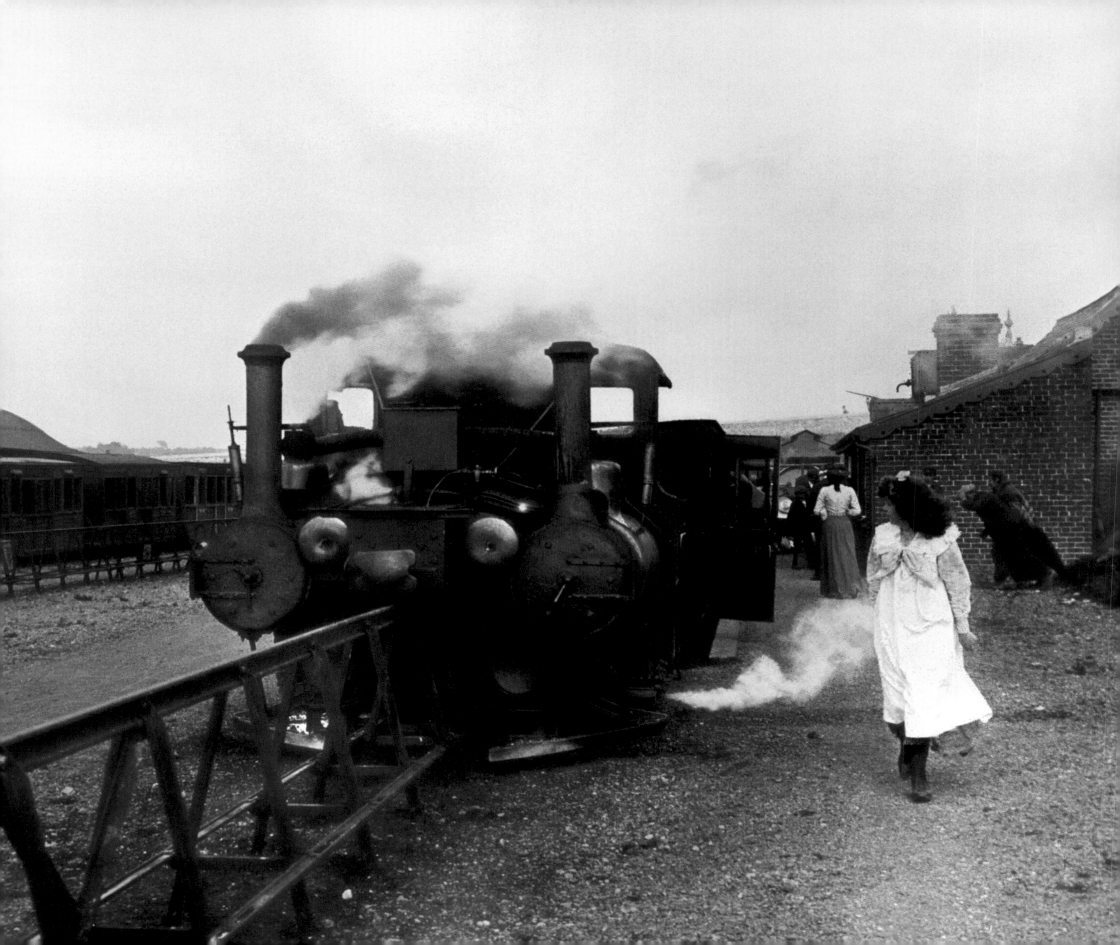

IRELAND
A NOBLE LAND

Ireland is rich—rich in many things that richer nations lack. Ireland is rich in beauty—rich in pride of a race, in devotion to religion, and in a fearless hopefulness that the worst fortunes cannot kill. Its beauty is expressed in sincere, kindly smiles of welcome, and in the noble lines of the Irish landscape—for Irish scenery is not merely pretty; it has about it a certain nobility suggestive of the classic scenery of Greece.

In Ireland, the traveler will find all the elements for a picture-story, altogether picturesque and pleasing to the eye—as Ireland herself is pleasing to the eye of anyone who looks upon her with a just appreciation of her fortunes and misfortunes, her not-forgotten sufferings, her honest aspirations, and her unnumbered and enduring charms.

To one who does not know the beautiful green island whence have come our many Irish fellow-citizens, their love and admiration for their native isle may appear strange. Why should they love a country where their fathers suffered? What affection do they owe to poor old Ireland, always pictured to us as a distressful country as a land of poverty and woe?

Yet go to Ireland—look upon her beauty, realize her wealth of possibilities, feel the cheering warmth of Irish welcome, treat your eyes to Irish smiles, your ears to Irish wit; let the simple sincerity of Irish life reveal to you the unsuspected depths of Irish character and you will understand why Irishmen love Ireland, and you, too, will often turn with loving and regretful glances toward the beautiful, unhappy island that lies so near to England—and yet so far away, if distance is measured by mutual understanding. [1914]

We luxuriated in the soft green world of Ireland during many weeks of appreciative wandering and observation throughout the length and breadth of the land; from the lakes of the south to the cliffs of the north; from the luxurious villas and castles of the eastern riviera to the fishers' cottages of Achill Island. [1936]

LEFT **BALLYBUNNION RAILWAY, COUNTY KERRY, 1914**
We have a train to catch—and such a train! The queerest, most absurd, most utterly outlandish train that we have ever seen. Its name is appropriately outlandish; it is the "Ballybunnion Mono-rail Express." It runs from a station on the ordinary line to Ballybunnion about 10 miles away on the Atlantic Coast.
The speed of this peculiar railway, though not surpassing 7 miles per hour, nevertheless exceeds that of the only competing conveyances in the form of tiny two-wheeled carts drawn by donkeys, driven by dignified old dames.

RIGHT **ROCK OF CASHEL, COUNTY TIPPERARY, 1936**
Among the holy sights in Ireland none is dearer to the pious patriot than the great Rock of Cashel in County Tipperary. A holy place it has been for a thousand years and more, in spite of the tradition concerning the infernal origin of the rock itself. Ask any old-time Tipperary man how it came there, and he will tell you how long years ago the devil took a big bite out of the crest of a neighboring range of mountains, and how finding the mouthful very dry and tough, he spat it upon the floor of Ireland's fairest valley.
In proof of this they show you this isolated Rock of Cashel, and the great gap in the skyline of a mountain several miles away. The buildings on the rock are in many ways remarkable. There is a beautiful cathedral, beautifully ruined, a castle admirably falling to decay, and a little Norman church, known as King Cormac's Chapel. There is, of course, an Irish tower, round as a rod and wonderfully well-preserved, and there are Irish crosses, one so old and worn it is nearly formless.

SUNSHINE AND SONG

I have often been asked, "What is your favorite country?" My answer always is: "I have two favorite foreign countries—one in the Orient—Japan, and one in Europe—Italy." Why do I like them best? Above all because they are so good to look at; because the history of each goes back to the dawn of their respective civilizations; because the roots of their culture and their art are deep-set in the rich soil of the centuries. Because both are volcanic lands—and volcanic lands are always beautiful with the beauty that at times invites the jealous anger of the Gods.

Although no two lands could be more unlike than are Japan and Italy, no two people more dissimilar than are the Japanese and the Italians, both have for most of us an irresistible appeal. The secret of the charm of both Japan and Italy lies in the fact that the beauty sought for and found by more artistic earlier generations has left its everlasting mark upon both lands which, despite the disturbing hand of progress, still offer to the eye pictures of enduring ancient dignity and loveliness unrivalled elsewhere in this changing modern world.

I pity a blind man most in Italy, yet even he might find life less of a burden there than in other lands. There he would hear music, the real music that comes from the soul of a people. Italians need not be musicians to be musical, they do not look on singing as an art, merely another way of telling you their sorrows and their joys. [1924]

Venice is still victorious over Time. Despite her age, the City of the Sea is fascinating still. She has successfully defied a dozen centuries, she may well defy as many more. All other cities in the world resemble one another. Venice remains unique. She is the City of Romance—the only place on earth to-day where Poetry conquers Prose. [1897]

LEFT **THE BLUE GROTTO, CAPRI, 1924**
"But is the Blue Grotto really blue?" everyone wants to know. My answer is this picture. The blueness is, of course, a luminous illusion. The rocks are not blue—and the water, if you pick it up, is colorless, but the sunshine of the Italian day filtering through that crystal liquid takes on this tone of beautiful unearthly azure for which the Blue Grotto or "La Grotta Azzura" of Capri is world-famous.
There is no escaping this bath of beauty. We feel that we are being dyed; that when we come out into the open day again we shall be blue of skin, with azure eyes and tresses of cerulean hue. The magic of the grotto transfigures everything.

RIGHT **GONDOLAS, VENICE, 1924**
Here is a fragment of what you see in the sunlight of a summer's day—the Venice that delights with her color, the Venice of bobbing gondolas, arching bridges, and cool, narrow calles—the Venice of light and life, of sea and sky.

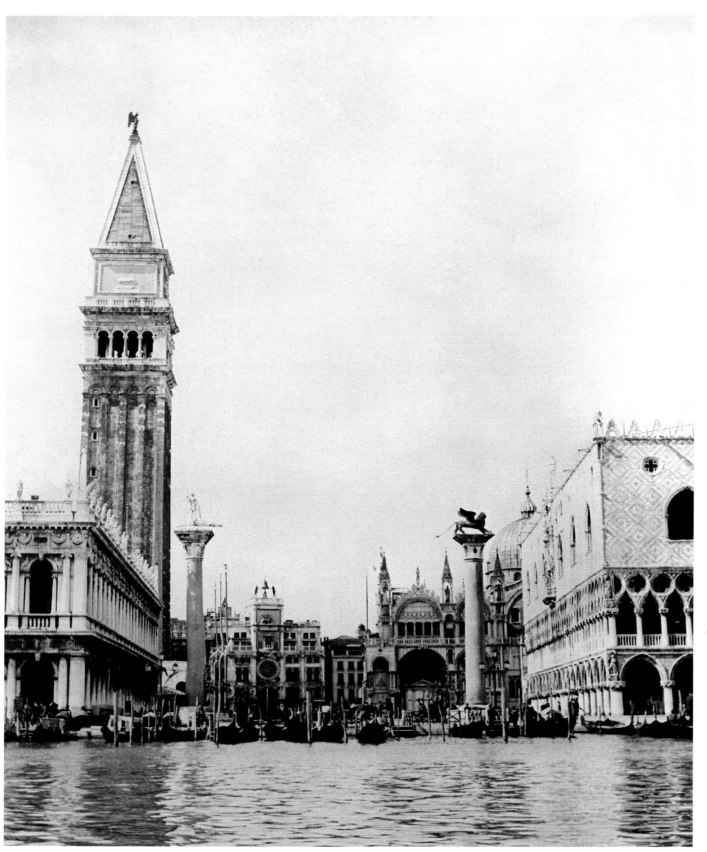

LEFT **ST. MARK'S, SQUARE, THE CAMPANILE, VENICE, 1897**
My first morning in Venice! How my heart warms when I remember my first hours in Venice—my first ride in a gondola. Dazed and delighted then suddenly, I am in the Piazza San Marco, standing mute in that grand piazza of the doges, with its white pavement blazing in the sun, framed on three sides by marble palaces. I had always thought of the great Campanile as the noblest campanile on the globe, and indeed, it was, until I saw that jewel—the most sacred, the Church of San Marco. Venice must be seen; seen and felt a hundred times over.

RIGHT **THE RIALTO BRIDGE, VENICE, 1897**
The Rialto Bridge remains a relic of Venice in her glory, for its huge arch is entirely of marble, and has a length of over a hundred and fifty feet. Its cost exceeded half a million dollars; and the foundations, which for three hundred and twenty years have faithfully supported it, are twelve thousand trunks of elm trees, each ten feet in length.
Wave before it, for an instant, the magic wand of fancy and we can picture to ourselves how it must have looked when on this Rivo-Alto, or "High Bank," which gives the bridge its name. Venetian ladies saw outspread before them the treasures of the Orient; when at this point the laws of the Republic were proclaimed; when merchants congregated here as to a vast Exchange; and when, on this same bridge, the forms of Shylock and Othello may have stood out in sharp relief against the sky.

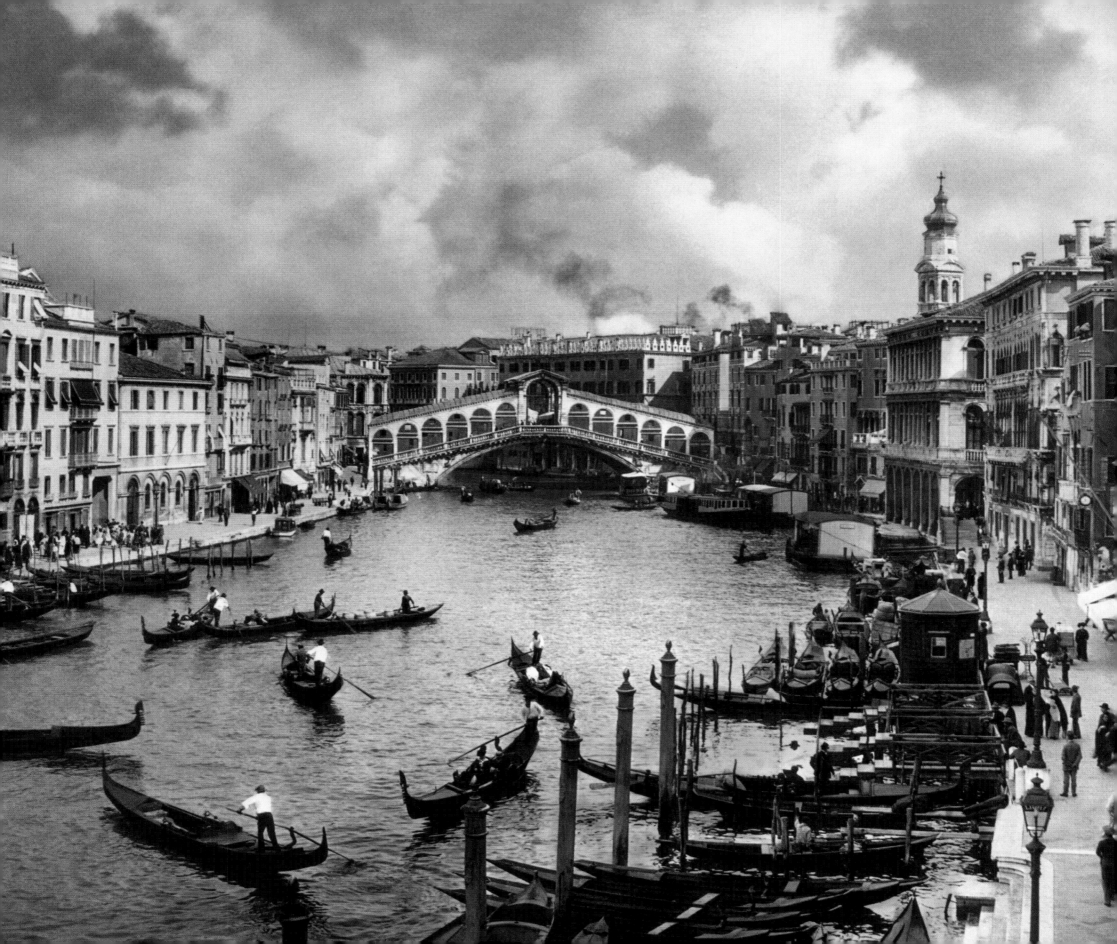

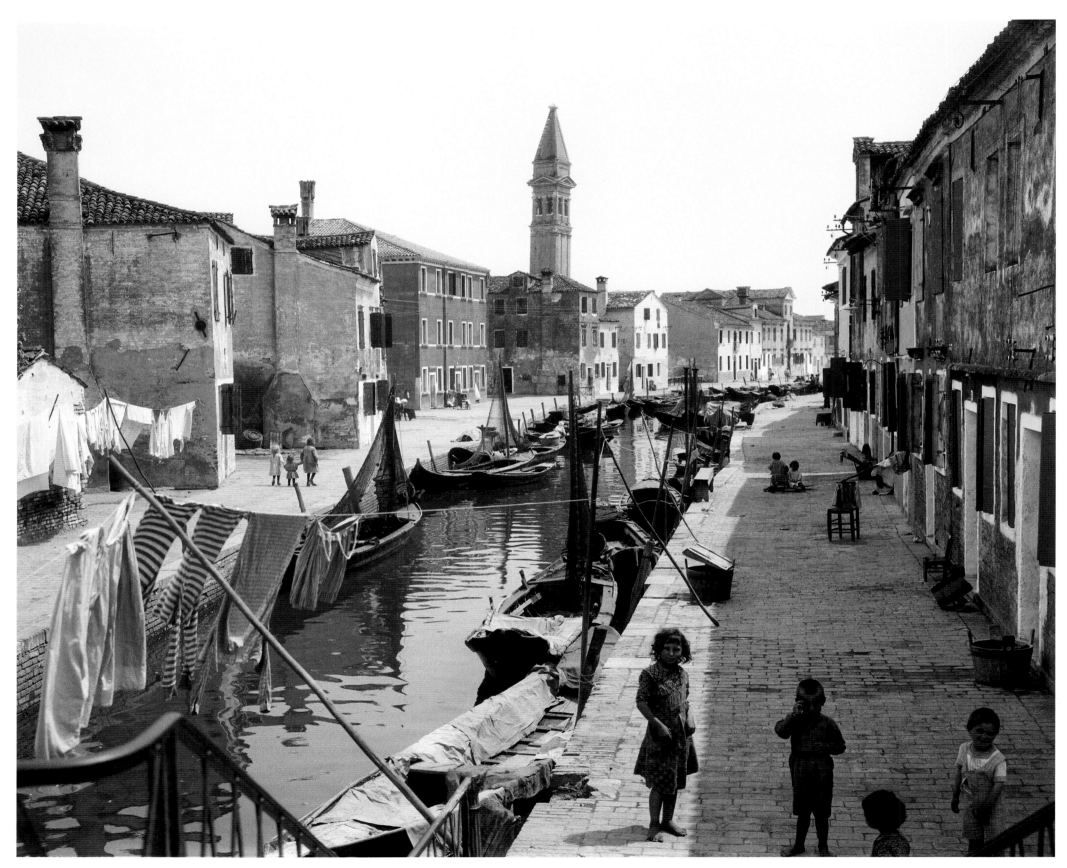

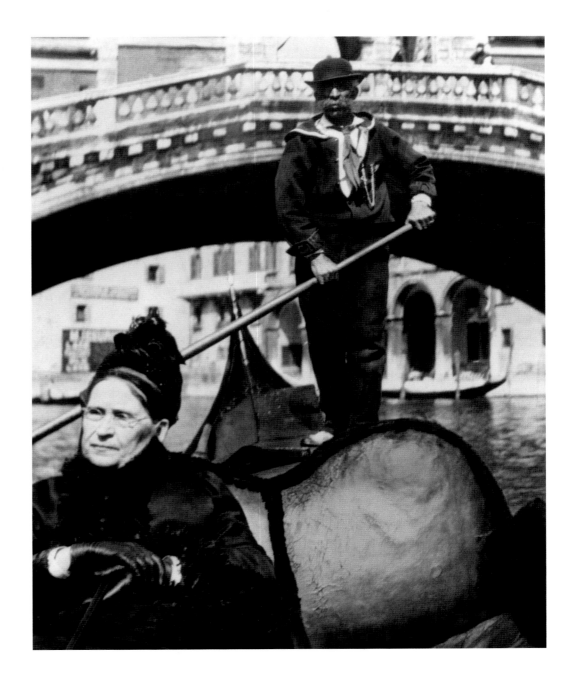

LEFT **THE FISHERMAN'S ISLAND, BURANO, 1924**
Everybody lives out of doors here; everybody lives on the
water on this fisherman's island near Venice. While the men
spend their days fishing, the women live each day in a sim-
ple way; they chat, they fret, mend nets, wash clothes, cook
and watch their children play in the sun, just as they have
done for centuries.

RIGHT **GRANDMOTHER BURTON IN VENICE, 1890**
My grandmother, Ann Burton, taught me to travel with
joy and expectation, to learn from my experiences, and
to accept other cultures completely. Granny may have
looked grim, but her soul shone like a thousand suns. Her
own travels had taken her, along with her husband and my
grandfather, wine importer Stiles Burton, to Russia, Europe
and points east and west in the 1860s.
Grandmother gave me my first two Grand Tours of Europe,
at sixteen and again at twenty. In 1906, after I began to
travel for my dinners, I took her on her dream trip, a tour
up the Nile. At 86 years old, Granny had a grand old time.
She played a most important part in my existence for she
virtually set my course in life, and I owe her, and believe I
gave her, my deepest devotion.

On certain portions of our globe there has been set the seal of beauty. The Bay of Naples bears that seal. Nature has done for that famed region all that the eye of the beholder can demand. I had been to Naples many times, and nearly died of disappointment every time. Not disappointed in her beauty, but because I had not time to see the still more lovely places roundabout. Therefore, it was with a keen sense of satisfaction that one April evening, Oscar and I sailed into Naples harbor with the thought that we could stay in Southern Italy almost as long as we might want to stay for I had given up on the idea of a tour around the world; first, because I had stayed too long in Egypt; secondly, because a leisurely sojourn in Italy looked far more attractive than what would have been to me a race through India and Ceylon at the hottest season of the year.

There is no mountain in the world that has so terrible a reputation as Vesuvius. The Alps, the Andes, the Rockies, the Himalayas are from four to seven times as high, but they are all dead mountains—Vesuvius is alive. Vesuvius rises outside the most populous city in all Italy.

Chance made us eye-witnesses of the last Vesuvian eruption, which began on April 8, 1906. We entered the harbor of Naples on the very eve of the most terrific outburst that had occurred in modern times. It was too late for us to land, and we retired to our cabins, utterly unconscious of the impending tragedy—saying as we bade one another good night, "How well Vesuvius looks tonight. We must go up tomorrow to the crater by Cook's railway." We did not know that while we slept that night in harbor, Cook's railway would be swallowed by the crater, and that part of the cone itself would cave in and be blown out again in atoms, rising in a dusty cloud to a height of several thousand feet before it settled down on the surround region. But we found some of that pulverized cone scattered all over town, like dirty, grayish talcum powder, as we drove next morning from the landing place to our hotel.

We found the hotel crowded with visitors. That Sunday morning, April 8th, we secured the only vacant room; by Wednesday, April 11th, my companions and myself and one other guest had the hotel all to ourselves. The others had all fled as fast as they could get away. By Wednesday the entire railway system of the south was at a standstill, the lines blocked or buried by the cinder-storms. The streets of Naples were alive with the pitiful processions of the terror-stricken populace—women with streaming hair loaded with grayish ashes, and small boys with the dirt of Naples powdered over with the same gray volcanic powder, paraded through every street, carrying crucifixes, candles, and the image of a saint or a Madonna.

It must be understood that on the fatal night of the 7th and the morning of the 8th of April conditions were such that no pictures could be taken. We could not even see what was then going on. The first catastrophe of which we had definite confirmation was the over-whelming of the village of Bosco-trecase, near Pompeii, by a stream of lava. This happened between two and four o'clock, in the darkness that preceded dawn. We reached the place twelve hours later. We found a sea of black stuff, like huge chunks of charcoal, lying ten to twenty feet deep over an area of many acres, with here and there a housetop rising from the mass.

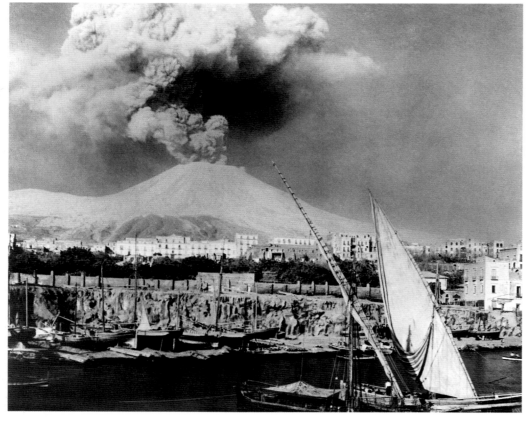

THE ERUPTION OF MT. VESUVIUS, APRIL 1906

LEFT, RIGHT, AND P 186

We knew that behind and above all this destruction Vesuvius was waking to new activity; and worse, we knew that the wind was now toward Naples, and that there would be no end of our petty tortures even there. Then we began to wonder if something worse might not be coming.
It was not until Monday morning, twenty-fours hours after we had landed, that Vesuvius was seen at all from Naples. All day Sunday a grimy haze hid everything; but Monday morning the wind changed, and the smoke that had turned all the world to a gray nothingness retired—took shape in the distance, and finally resolved itself into that terrible Vesuvian pigna, that awful, dreaded shape described by Pliny, eighteen hundred years ago, as being like a huge umbrella pine—a tree with a trunk of rising smoke and spreading branches all of curling smoke, a tree six thousand feet in height and rooted in a burning crater that is itself four thousand feet above the sea.

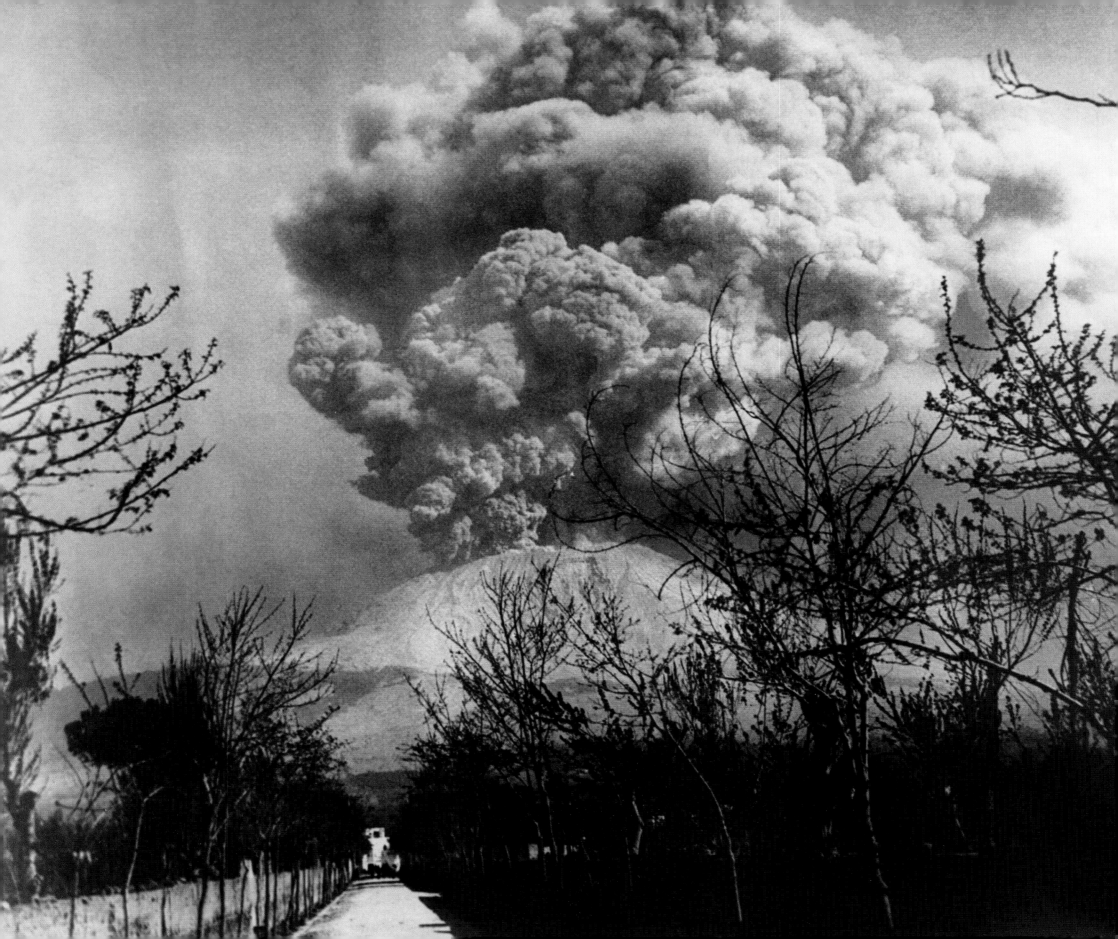

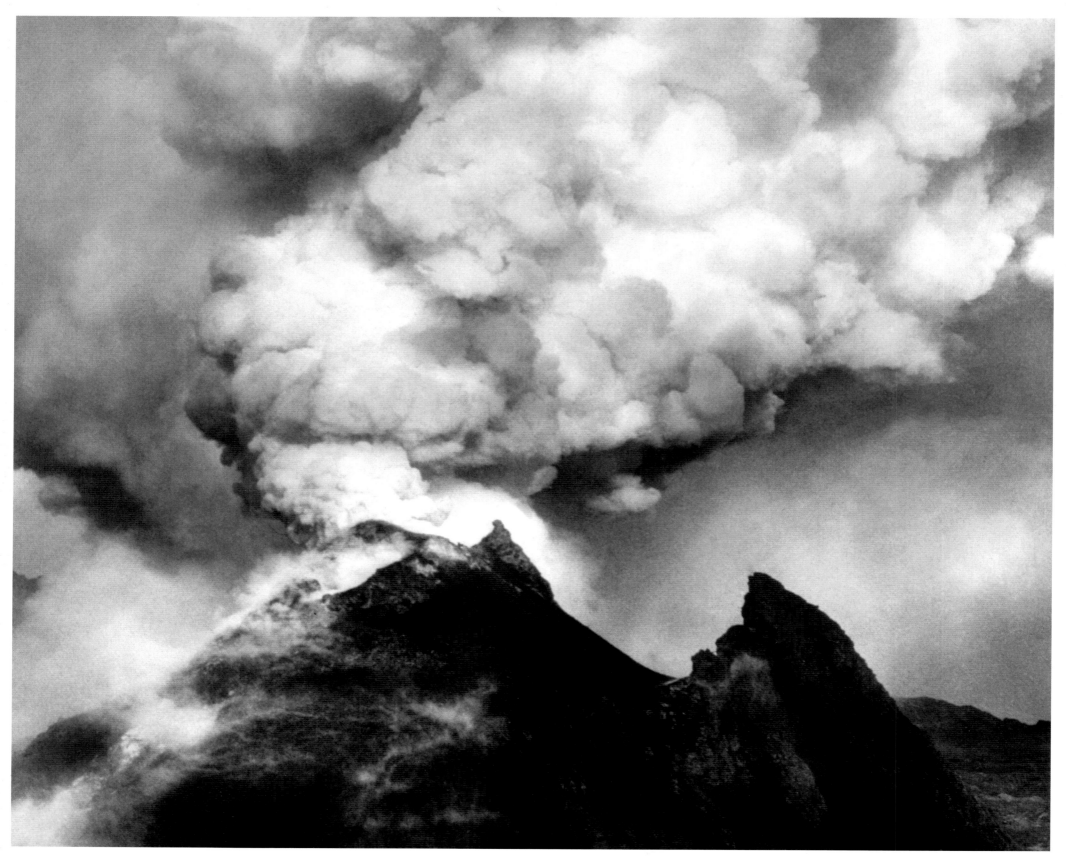

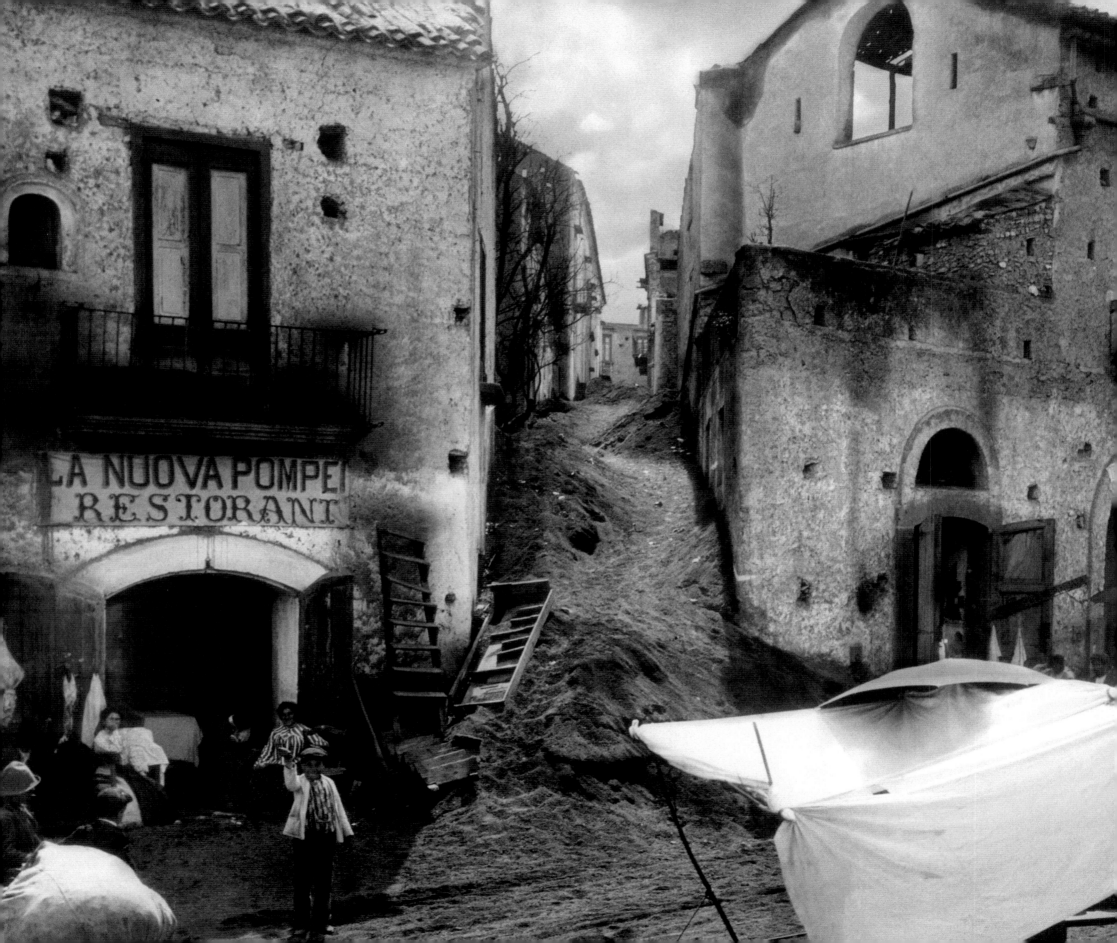

P 187 ASH-FILLED SKY, OUTSIDE NAPLES, APRIL 1906
A terrible obscurity fills the sky and follows the woman like a black wall of solid stuff, reaching up from the pale earth up to a heaven that is black and ominous. Blacker and blacker grows the air, until it is as black as night with an almost opaque blackness—a blackness we can positively feel.

LEFT VILLAGE RESTAURANT, OUTSIDE NAPLES, APRIL 1906
Some streets had been completely overwhelmed, not by lava, but by falling ash, and by cinders—big, gritty cinders, deep floods of cinders.
Holmes caught a touch of irony in the name of the corner restaurant, "La Nuova Pompei Restorant," or "The New Pompeii Restaurant."

BELOW LEFT FRIGHTENED VILLAGERS, NAPLES, APRIL 1906
Refugees in horse-carts clog the ash-filled streets trudging along, not knowing where to go, having no money and no homes, thinking of nothing save their dull desire to get beyond the reach of that awful rain of cinders which has already crushed their house, killed their neighbors, and is now pursuing them as if bent on destroying every inhabitant of this once happy region known as the Campagna Felice, or the Happy Country.
Many villagers fled, some took refuge in the church. They thought the house of God would stand even if all else failed. They put too much trust in their poor old church; roof, cinders, ceiling, all crashed down upon that congregation; and out of the two hundred who were praying there, less than sixty lived to tell how the rest perished.

BELOW RIGHT REFUGEES FLEEING THROUGH ASH-FILLED STREETS, TORRE DEL GRECO, APRIL 1906
We thought of the last days of Pompeii—of the downpour, first of ashes, then of pumice-stone, then of cinders, then of boiling mud. The main street of the town of Torre del Greco was filled with ash-piles for many weeks thereafter, the ash-piles in the streets growing higher every day as more and more ashes are shoveled off the housetops and as channels are opened so that vehicles can pass. Even the roads in the open country between the towns are nearly knee-deep in a flood of powdery stuff that rises in big puffs, like puffs of smoke, wherever it is touched by the foot of man or struck by a horse or a hoof.

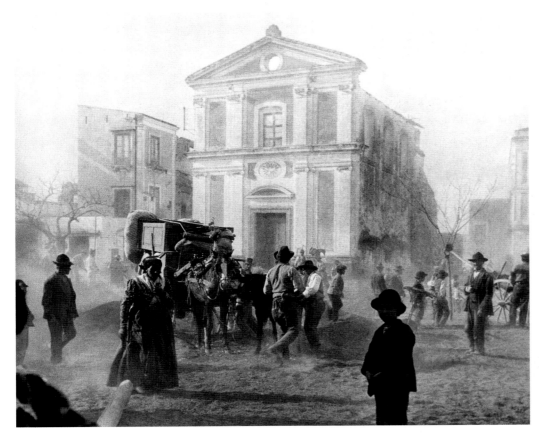

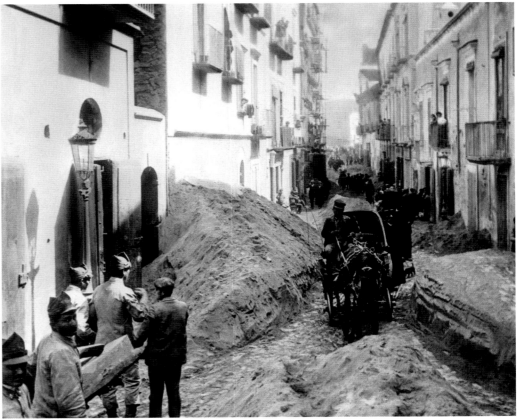

Night has come on and we are fifteen miles from Naples, to which we must return for food, rest, and above all, plates and films, for we must use on every subject a dozen plates in order to be sure of getting one good picture under these conditions, the like of which we have never met before.

Never shall I forget our return drive to Naples. At first fatigue was all that bothered us; then night came suddenly, and with it a strange smothering sensation, noticeable chiefly in the eyes, as if our eyes were being smothered; then they began to itch; then we began to rub them, then we kept them closed until the driver said, "Please take the reins a moment while I clean my eyes—I cannot see." No more could we, unless we cleaned our smarting eyes every two minutes.

By this time the air was thick with flying ashes—powdery and bitter as pulverized quinine. It was like driving through a blackish blizzard of heavy, clinging, penetrating, dirty, dried-up snow. The stuff got in our noses, and in our mouths, and ears; every jolt shook it in showers from our hats and shoulders, and it took the three of us to steer the blinded horse along the now almost deserted street that curves for fifteen miles around the bay toward distant Naples. We could see nothing save a dim gas-lamp here and there quickly extinguished, so far as concerned us, by a sudden swirling of ashy clouds.

There were several false alarms warning of new volcanic activity, only to find that the vapory display is due to the rain that had fallen while we slept. Vesuvius has not waked. The treacherous, terrible volcano sleeps in its old half-troubled slumber, to sleep a harmless sleep perhaps for centuries—perhaps, who knows, to wake again in awful and destructive majesty before another day has passed. *[1906]*

Burton Holmes and Oscar Depue spent an ash-laden fortnight of rough experiences while working their way around the erupting Mt. Vesuvius. With both still and motion-picture cameras, they recorded the historic volcano's grandest modern show.

LEFT **ST. PETER'S SQUARE, ROME, 1890**
What spot on earth can surpass, or even be compared with that of St. Peter's in the perfect lustre of its setting. The glorious traditions echoed in the architecture of the past captured my heart. Rome fed my beauty-hungry eyes and spread images upon my photographic plates.
Holmes took this photo of his grandmother Ann Burton and mother, Virginia Burton Holmes, in St. Peter's Square, on their second grand tour.

RIGHT **ST. PETER'S SQUARE, ROME, 1924**
The timeless beauty of St. Peter's Square in the summer of 1924 had not diminished in power and the significance of religious tradition since our first visit to this holy place in 1890.

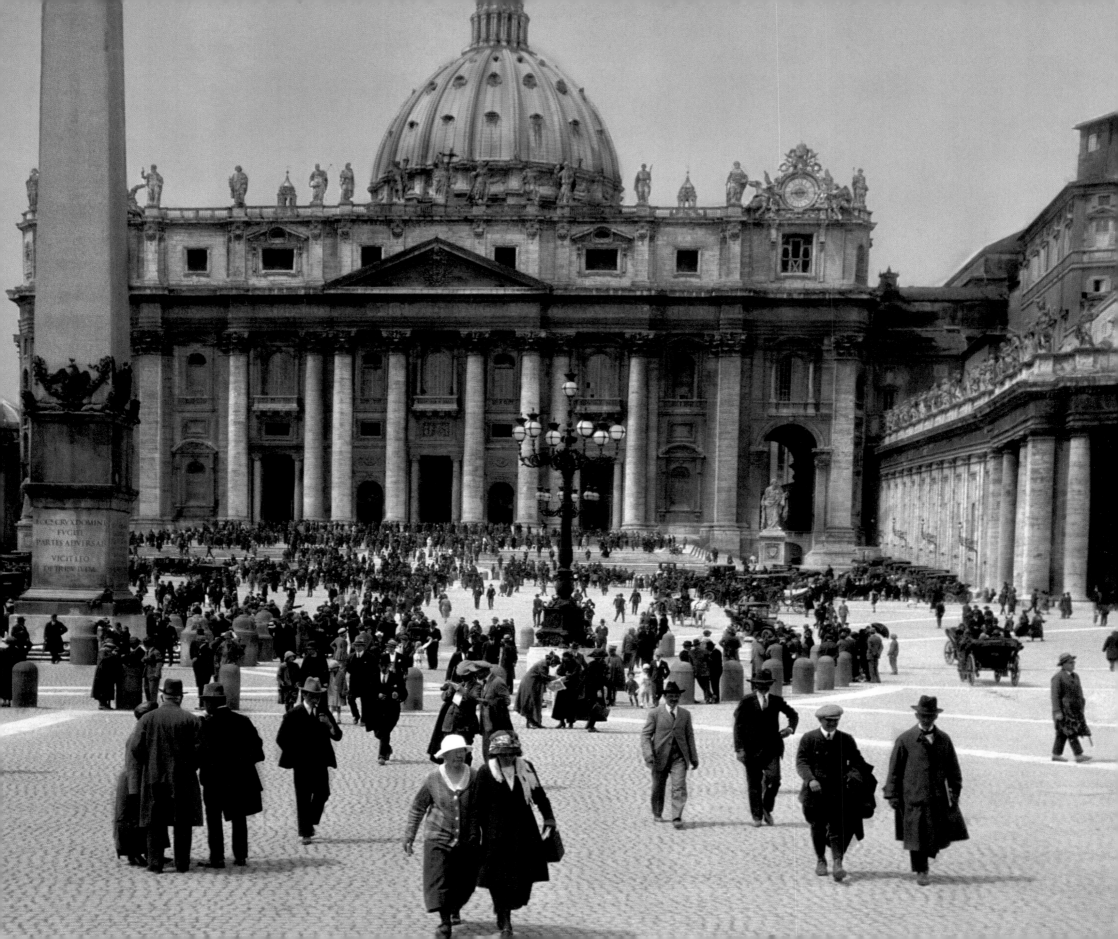

UNDER THE ARCHES, NAPLES, 1924
Gaze where you will, and natural beauty smiles back at you, everywhere save in the dark streets of the towns, yet even there, in the wide archways, full of sun and shadow, tinged with deep rose and violet, physical beauty smiles at you with the glorious eyes of Italy.

DUOMO SQUARE, SANTA MARIA DEL FIORE, FLORENCE, 1924
The spacious Duomo Square is a favorite meeting-place for Florentine men as there is always some activity going on: a game of cards, or chess, or an opportunity to participate in a stimulating, and sometimes contentious, political debate among old friends.

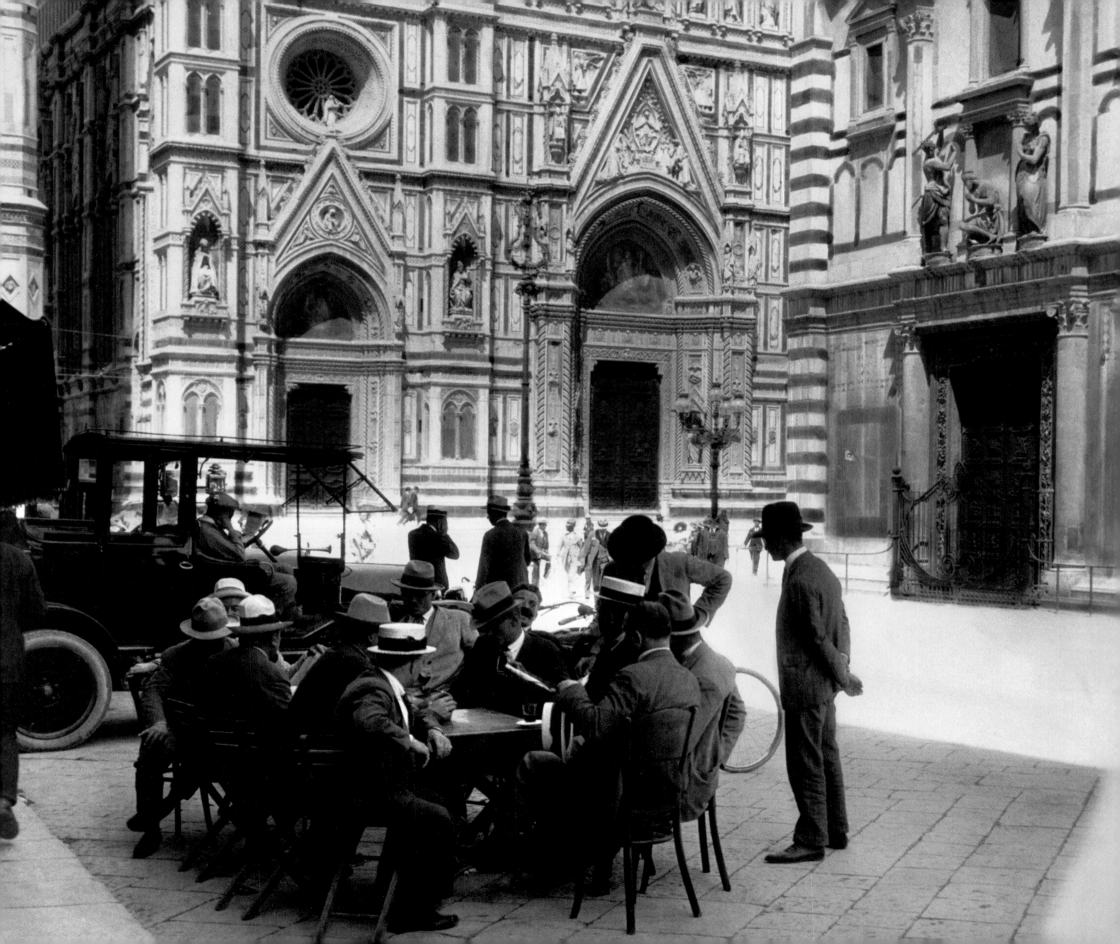

LEFT **AN ITALIAN FAMILY, BURANO, 1924**
In the small houses of the fishing village of Burano, a family
of five or six will live, work, cook, eat and sleep in one little
low-ceiled room. By day the door is open, the women sit
outside and toil with needles and children nibble broken
bits of bread. By night, the door is shut tight and five or six
people sleep the solid slumber of the weary.

CHAIR-RENT WOMAN, PUBLIC PARK, 1924

Romans love their parks. And in order to sit comfortably for more than a few minutes, a canvas chair can be rented from the official chair-rent woman for a few cents. All of Rome seems to be outdoors to-day, enjoying an unseasonably mild day. Men sit in rows talking and gesticulating as Romans do; and nearby young girls sit demurely with their hands in their laps. Every free piece of ground is occupied, or so it seems.

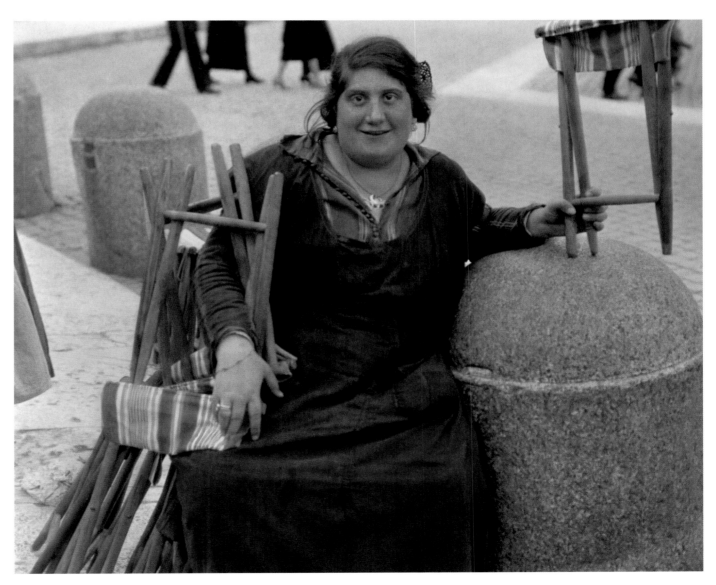

Immortal Rome is not a subject to be lightly undertaken by the travel-talker. He who would speak of Rome should have at his command phrases worthy of so sacred and glorious a theme.

He who would picture Rome before the eyes of a traveled and cultured public should be an artist able to interpret, through the medium of photography, the living glory and the undying charm of the Eternal City. He who would compress within the limits of a single lecture all that the thoughtful visitor should see and know of Rome, should exercise a selective judgment of the utmost accuracy. It is no wonder that Rome has remained so long a city unrevealed and uncelebrated on the popular lecture platform.

The traveler who knows his Rome "within the walls" knows only half of Rome's immortal story. Beyond the gates, north, south, east, west, lie regions rich in the romance of ancient and of medieval Rome, reflecting the glamour of the heroic past and glowing with the enchanting beauty which is the perennial attribute of Italy.

From the peopled heights of Tivoli to the deserted streets of Ostia—the Roman seaport abandoned even by the sea; from the smiling gardens of Frascati's sunny slopes to the grim underworld of the Roman plain, where catacomb and columbarium entomb the generations of dead centuries; from the Alban Mountains where the Lake of Nemi still guards its Imperial mysteries, to the sea-like sweep of the Campagna, traversed by the silent Appian Way and guarded by the arches of the classic aqueducts, everything is significant, everything evokes some world-famous name, some portentous date, some drama of earth-wide celebrity. To visit Rome and not explore the history-laden areas that lie outside the walls is to miss much of the meaning of the Eternal City. [1904]

RIGHT **THE DUOMO, MILAN, 1924**
Many afternoon hours can be profitably spent studying the incredible façade of the Cathedral of Milan; it is that inspiring. One of the largest cathedrals in the world, this Gothic marvel is virtually covered with carvings, roof pinnacles, high rose marble spires, and a profusion of belfries and statues—at once colossal and Heavenly.

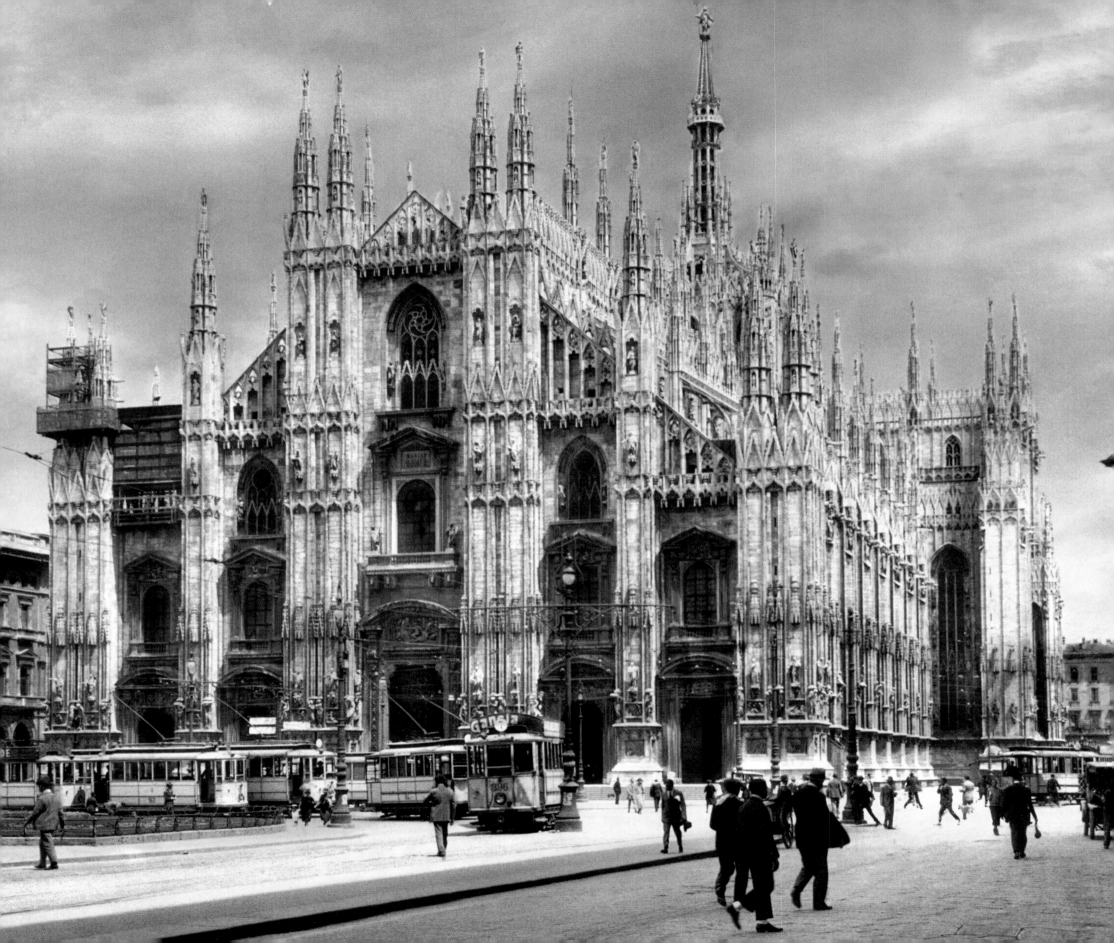

JAPAN
DAI NIPPON

There is a Japanese adage which tell us that "once seeing is better than a hundred times telling about." This applies so aptly to Japan itself that it were presumptuous to attempt to give in two brief *tellings* any idea of the fascinations of the Land of the Rising Sun. But with the aid of pictures that reveal a little of the beauty of the land, it may be that these "tellings" about the country and the cities of Dai Nippon are at least better than no tale at all.

Modestly the Japanese called their country Dai Nippon. "Dai" means "great." Men of other races smiled tolerantly at this bombastic title for a land which on the map of the wide round earth appeared so tiny and to the eye of the traveler so charming—so "cute" as lady tourists always labeled it.

Japan is blessed with natural beauty in its mountains and valleys, its trees and flowers, its rivers and seas, and the thousands of religious structures were almost invariably placed amidst these fascinating scenes. The result is an indefinable artistry that pervades the entire Empire.

I fell in love with the alluring Old Japan when I was twenty-two and very susceptible to the charm of things that were different. The Old Japan that I first knew was inconceivably picturesque, strangely and curiously beautiful. There were no ugly areas, no unfinished raw edges anywhere visible. All things Japanese were bound together into a satisfying mellow unity, marred only by the then few foreign things introduced by our utilitarian missionaries of western progress—railways, telegraph poles, modern post offices and official buildings, which were sordid-looking copies of our least admirable structures. These innovations were, at the time of my first visit, few and inconspicuous.

Other richer journeys may await me, but none will have, for me, the same peculiar charm, nor in remembrance give the same enthusiastic thrill; for the Japan that I have tried to show you and tell you of, is the Japan that fascinated me when I was twenty-two.

It was late in August 1892, that my good friend Alfred Goodrich and I set out on the first long journey that was to fix the pattern of my life. We boarded a Canadian Pacific sleeping car in Chicago, bound for Vancouver. A merry crowd of friends came to see us off. In the midst of this I observed two gentlemen, sitting quietly nearby. One was a little man; the other, tall, dark and handsome with familiar, flashing eyes. In him I recognized, to my amazement, John L. Stoddard. He, too, was bound for Vancouver to sail for Yokohama on the *Empress of Japan*. Fate had again flung us together, this time

RIGHT **MOUNT FUJI IN WINTER, 1892**
This mountain, which is volcanic in character, is the sacred mountain of Japan, 12,365 feet high. It is now almost two centuries since Fuji's volcanic crater emitted its last fiery breath, and since that time, it has slumbered peacefully, to all appearances wrapped in eternal sleep. The Japanese speak of their sacred mountain, more commonly and lovingly, as Fuji San.
Fortune favors us this day, and Fuji San stands there, revealed in her most somber wintry aspect. Even on near approach it seems intangible, as if it were but an illusion built of violet mist and flecked with slender drifts of cloud. In winter Fuji shrouds herself in a white mantle that sometimes trails its icy hem in the green valleys round about. Then, gazing skyward, I see the majestic white snow-cap, riding on the vapors at an amazingly great altitude. My guide stands with bowed head before the sight to make his peace with the spirits of the mountain.

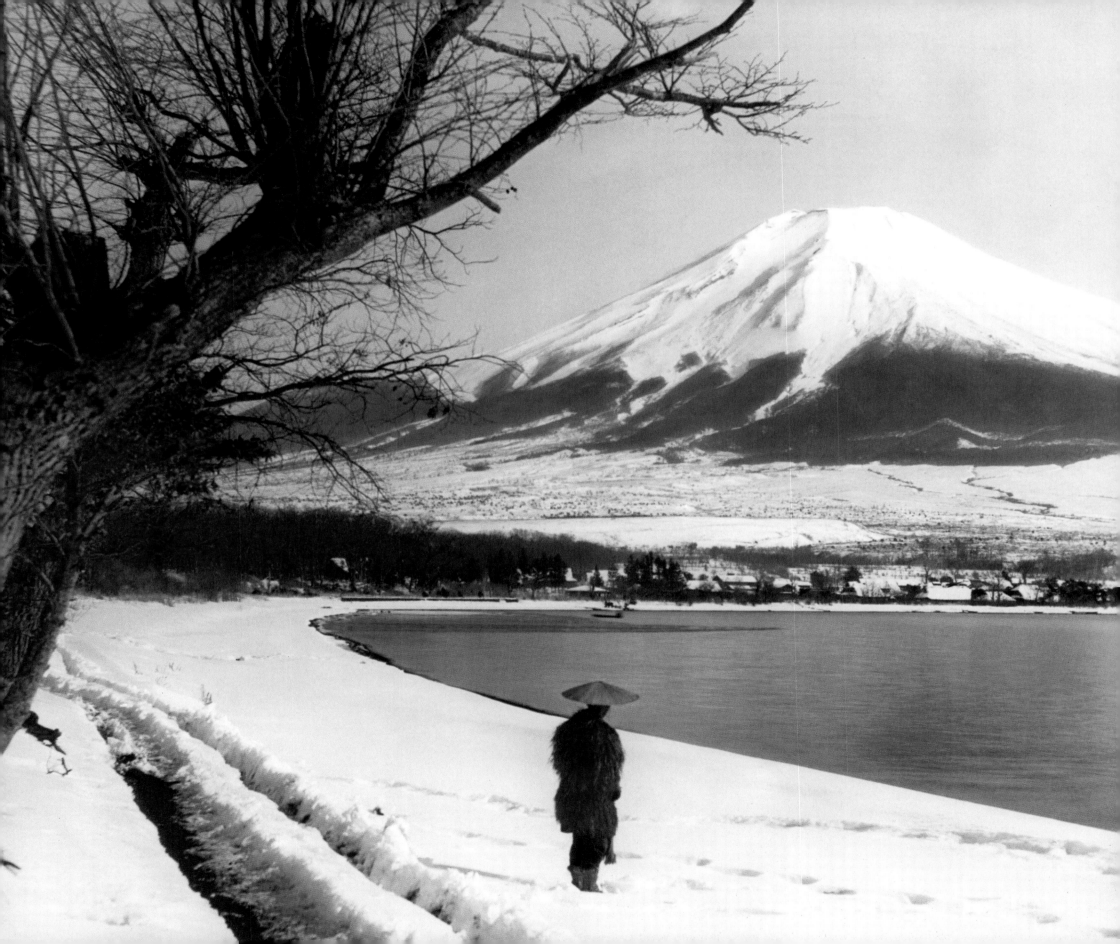

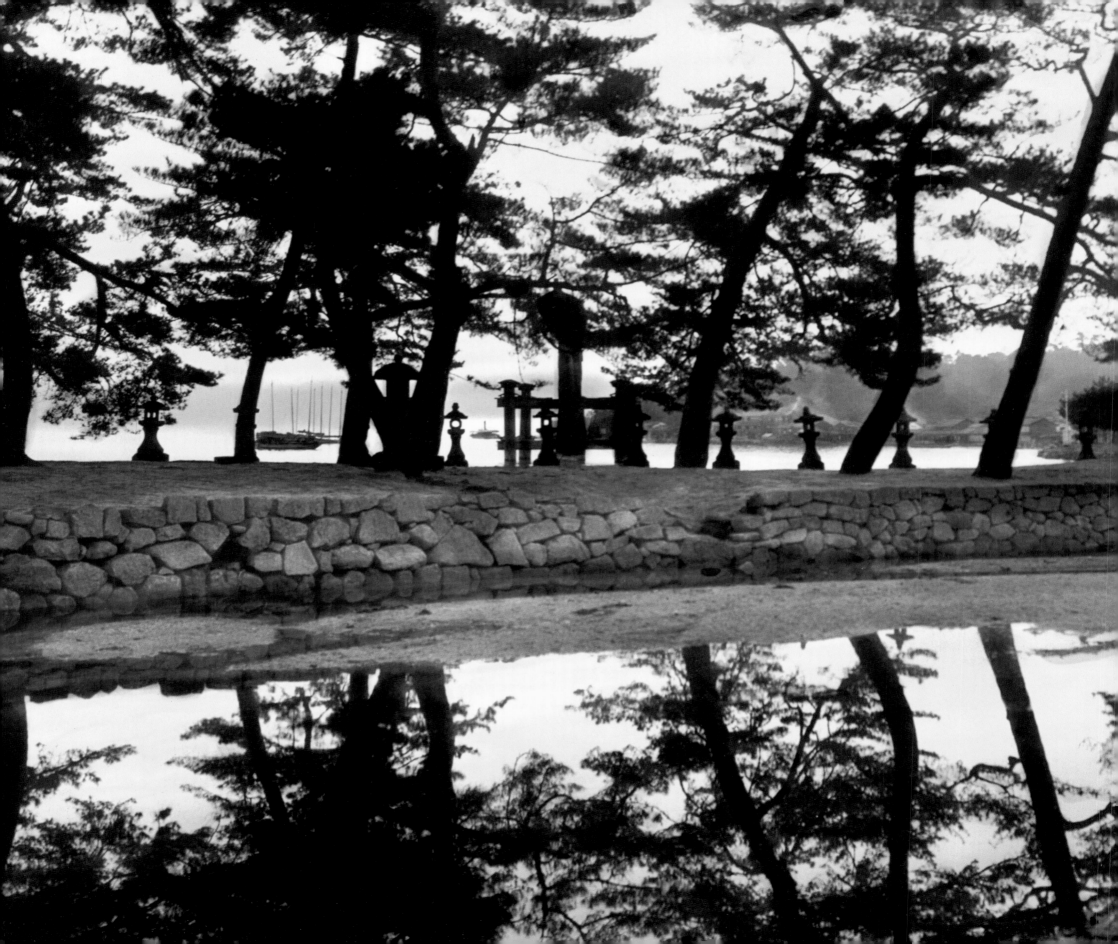

for a long companionship lasting nearly half way round the world—the world which he was then to circumnavigate for the first and only time.

That first voyage from Vancouver to Japan was a rough one. There are, according to mariners, twelve graduated wind velocities, from perfect calm to resistless hurricane force. Well, for four days in mid-Pacific, just south of the Aleutian Islands, we enjoyed a "Number Eleven" gale, just short of the worst that could have happened. The old *Empress of Japan*—six thousand tons—then queen of that ocean, was a mere yacht as compared with the great Canadian Pacific liner bearing the same name which took her place in later years. Stoddard wrote of that storm, which tossed trunks around his cabin and dropped them upside down with casters in the air, and he mentions "one awful day when the entire nourishment in our cabin consisted of one grape—and my companion ate the grape!" Pacific Ocean! Who gave the biggest of earth's ponds that silly name?

We were whipped into Tokyo Bay by the tail of a typhoon and landed at Yokohama, in a torrential downpour. I, in my eagerness to see the Japan of my dreams, was among the first group of drenched passengers to be put ashore by the precarious little launch of the Grand Hotel. Luggage and companions were to follow when the storm abated. Drippingly I emerged from the customs shed to be confronted by my first jinrikisha. Japanese thrill number one. A smiling half nude *kurumaya* helped me into his man-size baby carriage, raised the protecting hood, hung an oil paper apron from my shoulders and then asked, *"Dochira?"* My Berlitz Japanese was equal to the occasion. To his query of "Whither?" I replied, *"Ni-jiu ban Bund,"* which meant number twenty on the waterfront, the address of the world famous Grand Hotel of Yokohama, which ranked with Shepheard's in Cairo as one of the two most celebrate Oriental hostelries.

Greeted at the desk by the urbane manager, Louis Eppinger, I registered, my hand trembling with excitement, emotion and the chill of my stormy landing. I registered very shakily for self, companion and for Stoddard and his companion too. From the first moment, despite the gloomy aspect of everything that morning, Japan fascinated me. I liked the smell of it, that peculiar, strange aroma of things Japanese. I was, of course, only on the threshold, the Europeanized, Occidentalized edge of the real Japan. Later on I was to be greeted by and even become accustomed to, aromas of less delectable nature, but for the moment let that pass.

LEFT **THE TORII GATE (FROM SIDE) AND LANTERNS AT ITSUKUSHIMA SHRINE, ISLAND OF MIYAJIMA, 1922**
We do not wonder that the Japanese have sanctified the island, for we know that to the Japanese everything that is beautiful or strange is also holy. Even to us Miyajima appears as a glorious out-of-door cathedral, with pinnacles of rock for spires, maple-decked valleys for its aisles and chapels, great trees for pillars, the beauties of all nature for adornment, and for a dome, the eternal vault of blue.

RIGHT **THE HOT SPRINGS, ISLAND OF HOKKAIDO, 1908**
The region of Noboribetsu is famous for its hot springs. This region combines the color beauty of the Japanese Yellowstone Park with the terror of a Japanese Vesuvius. Most people who go to Noboribetsu go not to see the sights but to bathe for their health. The water is led down a valley, and it cascades from wooden spouts into the bathing-place. Of course it cools off a little on the way, but even so it is terribly hot. People with rheumatism or other troubles stand, or lie, under the spouts where the water will fall on their aching joints and back. The cure is almost as painful as the disease!

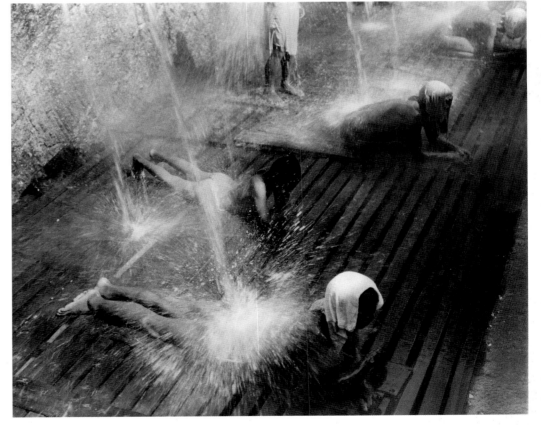

RIGHT **MOUNT FUJI, 1908**
Through the great trees, I behold far, far away, the match-
less cone—snow-draped and spotless—of Japan's holiest
mountain: Fuji-no-yama. There are moments when the
sacred mountain is transfigured by the glory of the sky.
At sunset she stands forth in gorgeous purple against a
golden background—at sunrise a pink halo hovers turban-
like around her head, and as the dawn advances, a pinkish
veil unfolds and falls upon her snowy shoulders. Then grad-
ually the morning colors fade, the violet mist rises from the
valleys and, on the summit, fearfully far above us the snow
gleams white and pure in the light of a noonday sun. But
even brighter is the gleaming of the snow crown of the
mountain mirrored in the surrounding lakes. A submarine
Fuji is evoked by every lake or placid stream, and often-
times the unreal inverted vision is more beautiful than the
reality, unreal as that reality may seem.

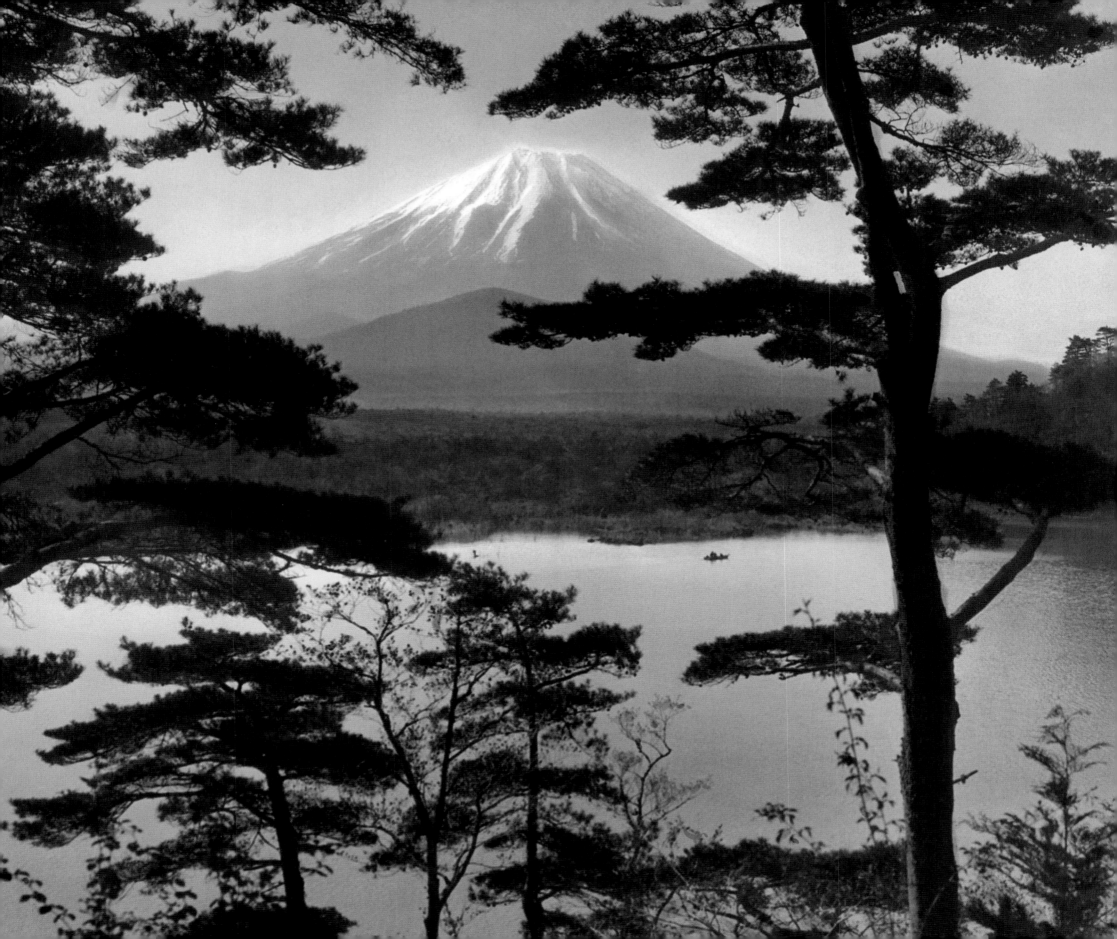

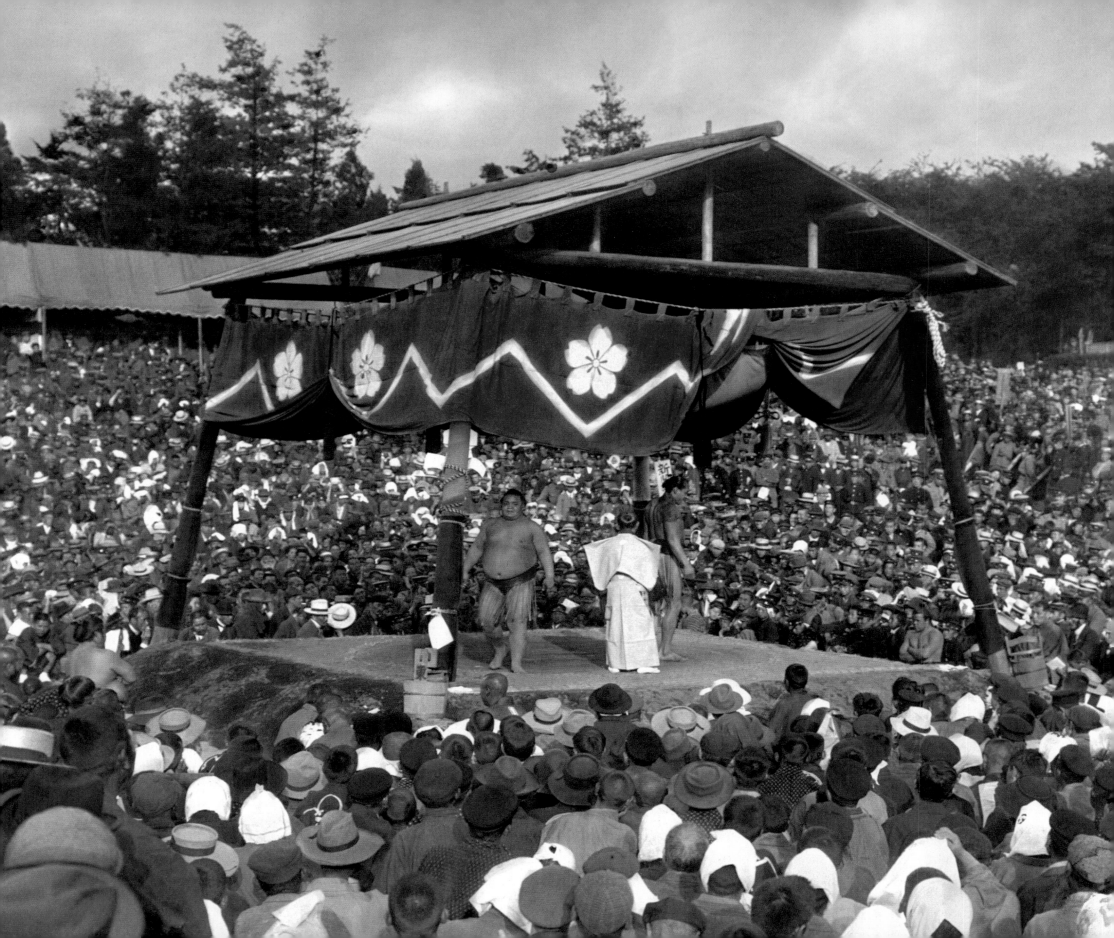

A SUMO WRESTING TOURNAMENT, KYOTO, 1908

LEFT

The wrestlers of Japan are all big men. They are called Sumo, or Sumo-tori, and while they form a class apart, they are full-blooded Japanese, phenomenal sons of ordinary people. Because a career in the ring offers such rich rewards, parents of burly offspring usually dedicate their big boy babies to this sport and give them over at a tender age to be trained in this ancient and profitable art.
I have witnessed several of these colossal tournaments. But it is at a minor tournament in a small town that we may observe the Sumo in action at close range. They wear queues, tightly curled, like the bull-fighters of Spain and for the formal introduction ceremony, richly embroidered aprons presented to them by admirers. The umpire wears the old-time formal Kami-shimo dress, corresponding to our

frock coat for state occasions. He carries a curious fan with which he makes his signal to contestants. In former days he wore a short sword, to be prepared to commit hara-kiri in case he should disgrace himself by rendering a wrong decision! In other words, he was ready for the cry of "Kill the umpire," and ready to beat the public to the execution.
In spite of their great weight, the men are supple. Their flesh has been hardened by batting at wooden posts, until it is like tempered metal. The famous Sumo-Taiho once challenged anyone to kick him in the stomach. The challenge was accepted by an American football champion, who for the test was allowed to wear his walking boots. The wrestler braced himself, and as the kick was delivered shot his great stomach forward and sent the ball player flying as if projected by a catapult.

THE AINU, HOKKAIDO ISLAND, 1892

BELOW

I have come to Hokkaido to see the homes of a strange race, supposed to be the remnant of the aboriginal population of ancient Japan, a rapidly disappearing race called by the curious name of Ainu. The Ainu people have a striking physical vigor and display a cheery kindliness. The dress of the women is very like that of the men, dark blue with bold patterns applied in red and white. As soon as our visiting group arrived, the feast, the liquid feast began. Never had I seen such dignified dissipation.

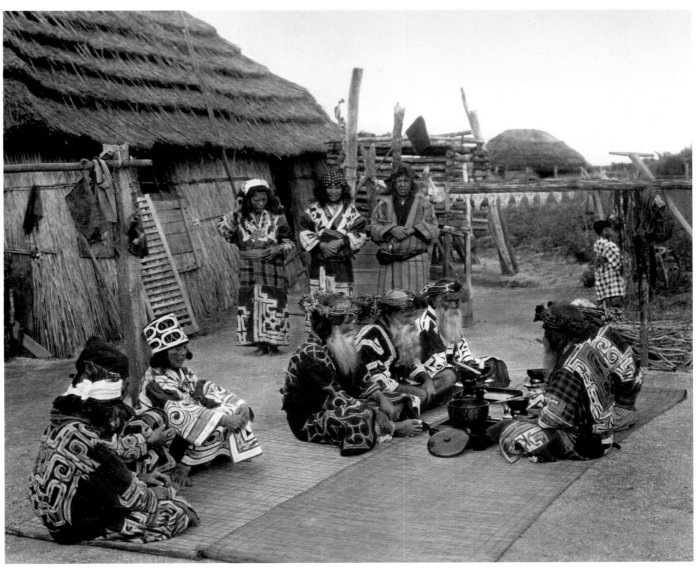

I liked Japan from the moment I set foot on her storm-swept shore. I doubt if I have ever been happier than during the four months I spent in the as yet unspoiled *Japanese* Japan of 1892. I seemed to be living in a strange new world that I had known intimately in some previous life on earth. Japanese customs, dress, food, manner of life seemed perfectly familiar to me. I could use chopsticks (I hate the word; the Japanese have a name for them, *hashi)* gracefully and effectively at my second Japanese meal. I liked the funny, pretty food. I sat on the floor with ease and slept on *futon* with pleasure. I adopted the comfortable kimono and ever since have worn it when not compelled by custom to get into the ugly garb of what we are pleased to call "civilization." Japan seemed to me more truly civilized than any country I had ever seen.

Now that Japan has adopted western civilization with all its implications I find it hard to love her as I did when she was still true to her ancient self, to her traditions of courtesy and love of beauty, and in matters artistic, true to her innate and exquisite good taste.

Strangely enough, Stoddard did not like Japan. He toured the country dutifully, saw the sights, reported on them elegantly and eloquently in his lectures of the following winter, but the charm of Japan never laid hold on him. He had asked me to join his little party and go on around the world. I was delighted, cabled home for permission and for money, but by the time both were forthcoming I had decided that six weeks in Japan was not enough, that China and India and all the rest might wait. I had found my land of predilection and I had to go deeper into it and satisfy myself that it was really all that it seemed to me to be. And there was always the haunting thought that I had lived and loved and learned "the way of the Buddha" in some remote but vividly present long ago.

I lingered on in fair Japan after my friends had left and saw the snows of early winter blanch the impossibly quaint vistas of both town and country. It was like living in a land of exquisite old Japanese prints done by the masters of the art of Ukiyo-ye, on a scale of reality but with all the delicacy, beauty of line and harmony of color that the old artists drew from their carved wood blocks and fixed on exquisite paper. All that I saw seemed part of a past life. I felt at home, happily at home in old Japan. I hated to tear myself away.

On one cold January morning I boarded a white Empress liner for the homeward voyage. I carried with me fond regrets—and two dozen of the most perfect chocolate éclairs ever produced, *chef d'oeuvres* of a French pastry shop of Yokohama. These were to cheer my gastronomic soul at dessert on shipboard so long as they might last. Alas, éclairs do *not* last. We ran into terrific weather, I dared not leave my bunk for several days, and when I did—again, alas—the éclairs had lost their patience and were no longer edible. Never invite chocolate éclairs to make a winter sea voyage with you. You may not get around to them in time. *[1953]*

LEFT **ROPES MADE FROM HUMAN HAIR, HIGASHI HONGWANJI TEMPLE, KYOTO, 1908**
The Higashi Hongwanji rises, not with the aid of government or prince, as did the ancient shrines, but owes its being to the common people and the peasants, who, by gifts of money and material, of time and labor, have rendered possible this mighty undertaking.
Those who had nothing to give yet gave something; witness the gigantic coils of rope, indeed the strangest offering of all, and the most pathetic, for they are made of human hair. Yes, poor peasant women, destitute of all save their wealth of raven hair, sacrificed even their crowning glory, and braiding their jet black tresses into mighty ropes, sent them to be employed in hauling timber for the construction of the temple. One of these cables is three hundred and sixty feet in length and nearly three inches in diameter. And now, the work is accomplished, these coils of human hair remain as a memorial of the faith of unknown thousands of pious, gentle souls who have not hesitated to make sacrifice, at the call of duty, even of their good looks. And yet we have been told that Buddhism is a dying faith!

RIGHT **LONG-TAILED ROOSTERS, TOKYO, CA. 1932**

**HOMES AND SHOPS UP THE GRANITE STEPS,
TOKYO, CA. 1932**

In Japan most things worth seeing—temples, tea-houses, views and cemeteries—are high in the air and accessible only by means of those everlasting and exhausting giant granite steps.

**KUJIRAYA STORE OR "WHALE SHOP," ACROSS FROM
THE KAJIBASHI BRIDGE, TOKYO, CA. 1932**

TOKYO STREET SCENE, CA. 1932

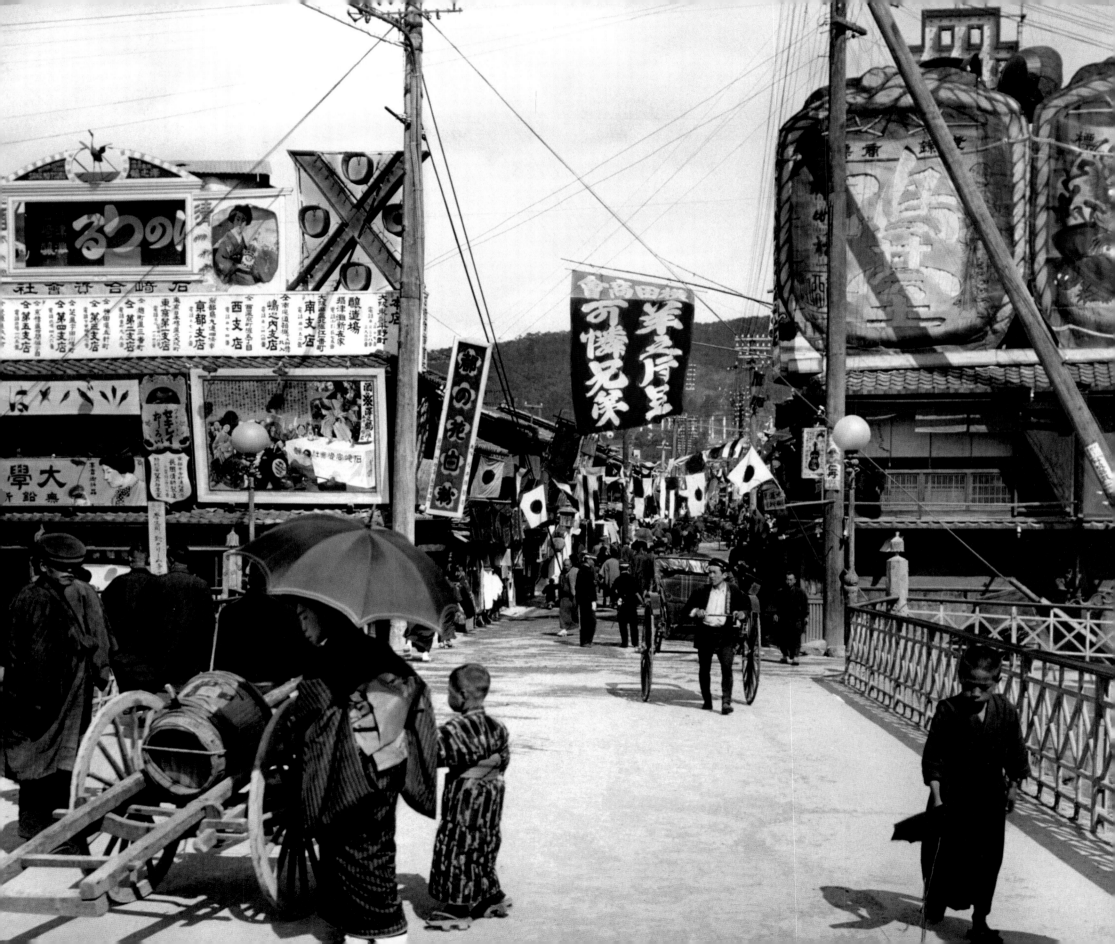

LEFT **THE IMPERIAL HOTEL, DESIGNED**
BY FRANK LLOYD WRIGHT, TOKYO, 1922
The foreign visitor is usually taken to the Imperial Hotel.
Where should American and European travelers lodge
if not in that magnificent establishment, where all the com-
forts of the Occident are provided, thanks to a thoughtful
government which is determined that the stranger shall
not find the greatest city of Japan deficient in hotel-
accommodations of the most modern type? If you seek
nothing but comfort and convenience, by all means go to
the Imperial Hotel.
If, like me, you want to feel that you are really in Japan,
pass by this splendid pile and follow me toward a remote
and thoroughly Japanese quarter of Tokyo where there
are no reminders of the modern lands across the sea.
The Imperial Hotel was demolished in 1968.

BELOW **YOUNG AMERICAN TOURISTS, YOKOHAMA, 1892**
I met these American women, brimming over with enthusi-
asm, in my Yokohama lodgings. Curious and independent
travelers, who like me, wanted to get away from the ordi-
nary and explore a wider diversity of experience, then un-
known in Chicago or Philadelphia. To us, Japan seemed like
a paradise—a fairyland—yet more truly civilized and hos-
pitable than any country we had visited.

BELOW LEFT CAB-STAND, YOKOHAMA, JAPAN, 1892

We have arrived in a land of novelty, for there before us is a cab-stand unlike any we have ever seen. The horses and drivers are combined in one being, and long lines of these smiling centaurs gaze silently our way, politely asking the honor of our patronage. I disguise my delight, and carelessly nod to one of the little fellows who runs back to his baby-cart, steps between the shafts, and dashes up to where I stand. With the sensation of supreme bliss, I mount this rolling rocking chair and say "Grand Hotel." As I am whirled past banks and steamship-offices and consulates and clubs, I did my best to look at home and to create the impression that I was cradled in a "jinrikisha," for that is what my vehicle is called by foreigners; but the Japanese say "kuruma," and call the little man who furnishes the motive-power a "kurumaya." Call it as you please, but your first ride in a rikisha is one of the things in life never to be forgotten. You feel like an overgrown baby being wheeled about by a male nurse who has lost his senses and broken into a run, as if pursued by unseen demons.

BELOW RIGHT THE GINZA DISTRICT, TOKYO, 1932

To the casual visitor the Japan of to-day seems a land of railways, telephones, and modern commerce in tea and silk; and this is to a certain extent true, especially if he confines himself to Yokohama, Kobe, and other open treaty ports. Even Tokyo, the capital, is already touched by the marring hand of foreign innovation, for there the traveler finds tramcars and ugly public buildings in red brick, designed according to the Japanese idea of European architecture. The civilization of the Japanese differs widely from our own; it is a *civilization*, ancient, admirable, and artistic, fitting the needs of this people far better than the manners and customs of our newer, cruder Occident, which they are now—alas—so hastily and in many respects ill-advisedly adopting.

RIGHT STREET SCENE, TOKYO, 1922

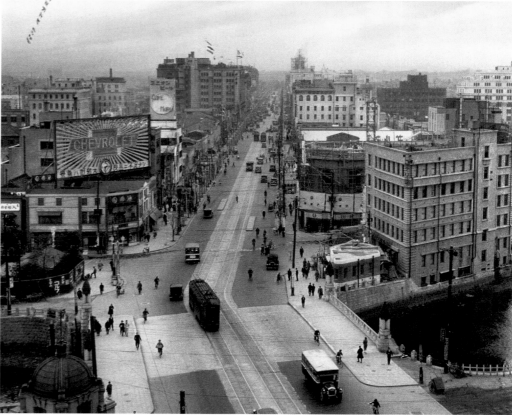

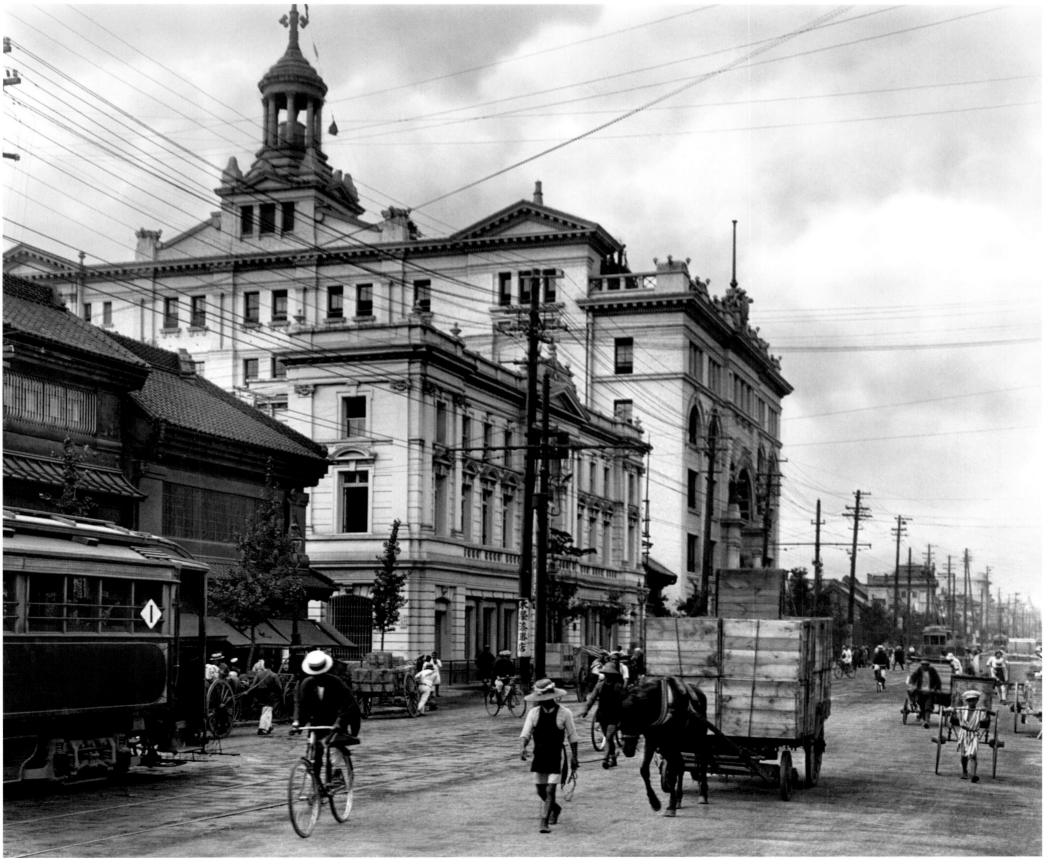

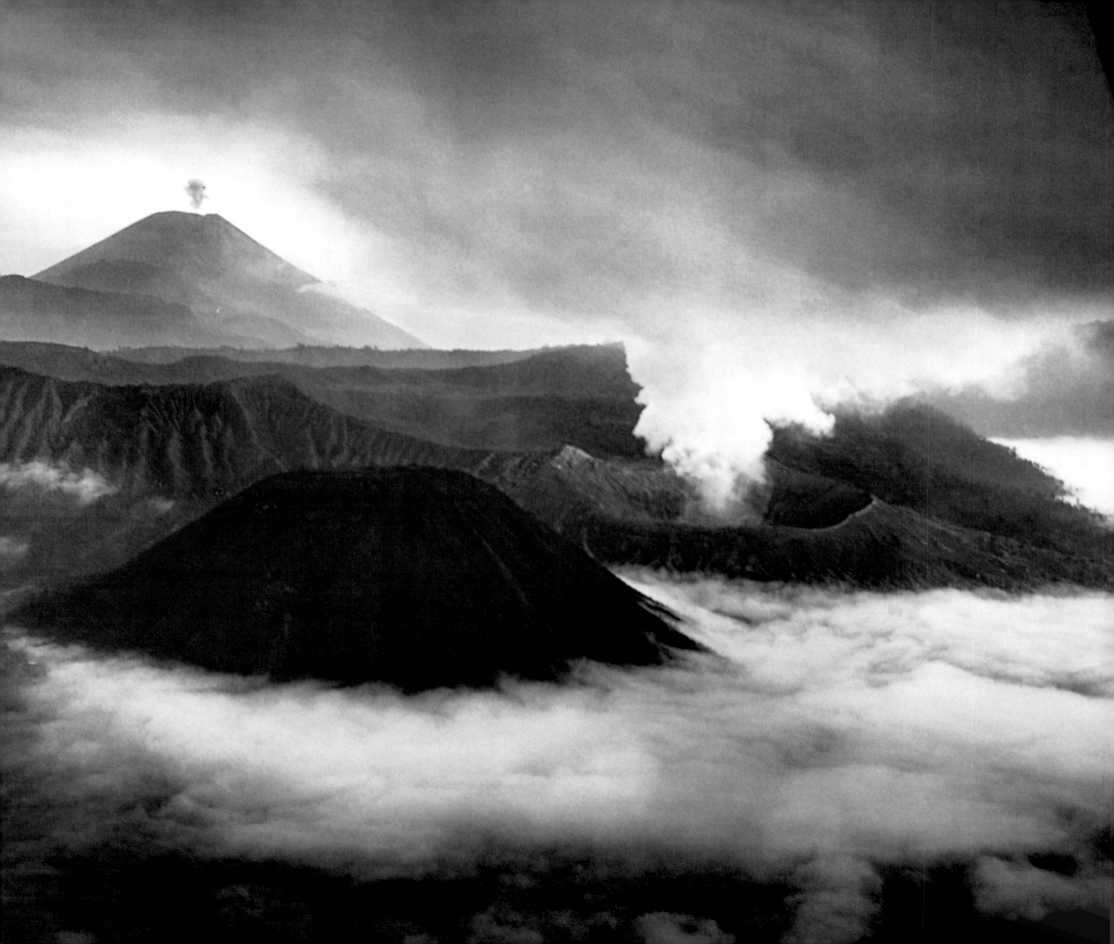

TREASURE ISLAND OF THE ORIENT

The romance of travel is still to be enjoyed in the tropical empire of Netherlands India. Beautiful Java with its teeming millions of gentle, sarong-clad brown folk, is one of the pleasantest, most quaintly picturesque countries in the world. Sumatra is as yet an almost undiscovered playground for the tourist. Other islands with their varied and peculiar cultures, customs and costumes, await our astonished inspection. Nowhere in the Far East will the traveler find regions richer in fantastic sights and possibilities than in this alluring equatorial archipelago. [1942]

Nobody knows anything about Java. But I found out a little about that far-off, lovely tropic island and it is a land of surprises. In Java, a few thousand Dutchmen pacifically rule more than thirty million Javanese. In Java there are scenes of quaintness, grandeur and beauty that will become world-famous. Java is for the traveler a new land, an open door to a fascinating East Indian Wonderland.

The costume of the Javanese girl is exquisitely simple and supremely comfortable—a quaintly colored sarong of complex design folded around her form. No shoes upon her feet, but in her ears a pair of barbarous earrings, brutally bulky, thrust through the lobes which are pierced to receive the peg-like stems, a full half-inch in diameter. Thus dame fashion grips the maid of Java only by the ear.

We watch the passing of a spectacular religious procession of Javanese men, women and children carrying tall yellow parasols, multi-colored banners and colorful fans. Other women carry offerings in round baskets on their heads, while the procession makes their way to the local temple grounds. [1932]

LEFT **VOLCANIC ACTIVITY, 1932**
There are many active volcanoes in Java, some very dangerous. Yet people live their whole lives in the shadow of these unpredictable mouths of death. Even from a distance, the smoking craters seem unreal, as if but an illusion built of vapory mist flecked with slender drifts of clouds.

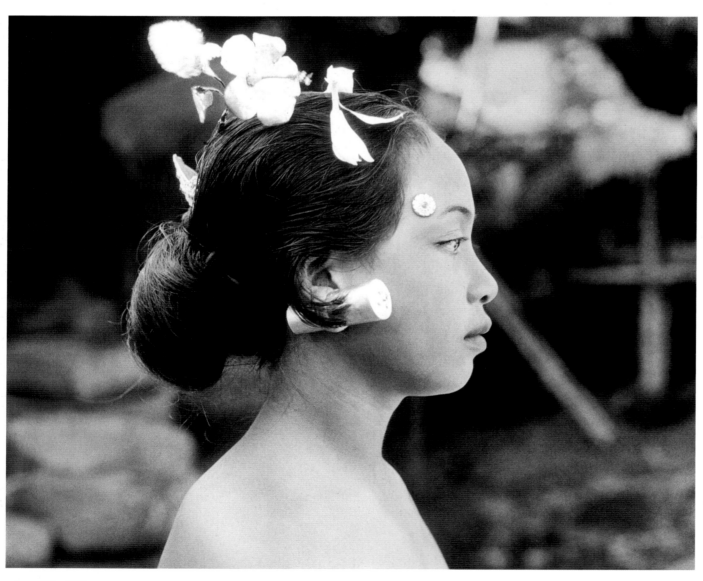

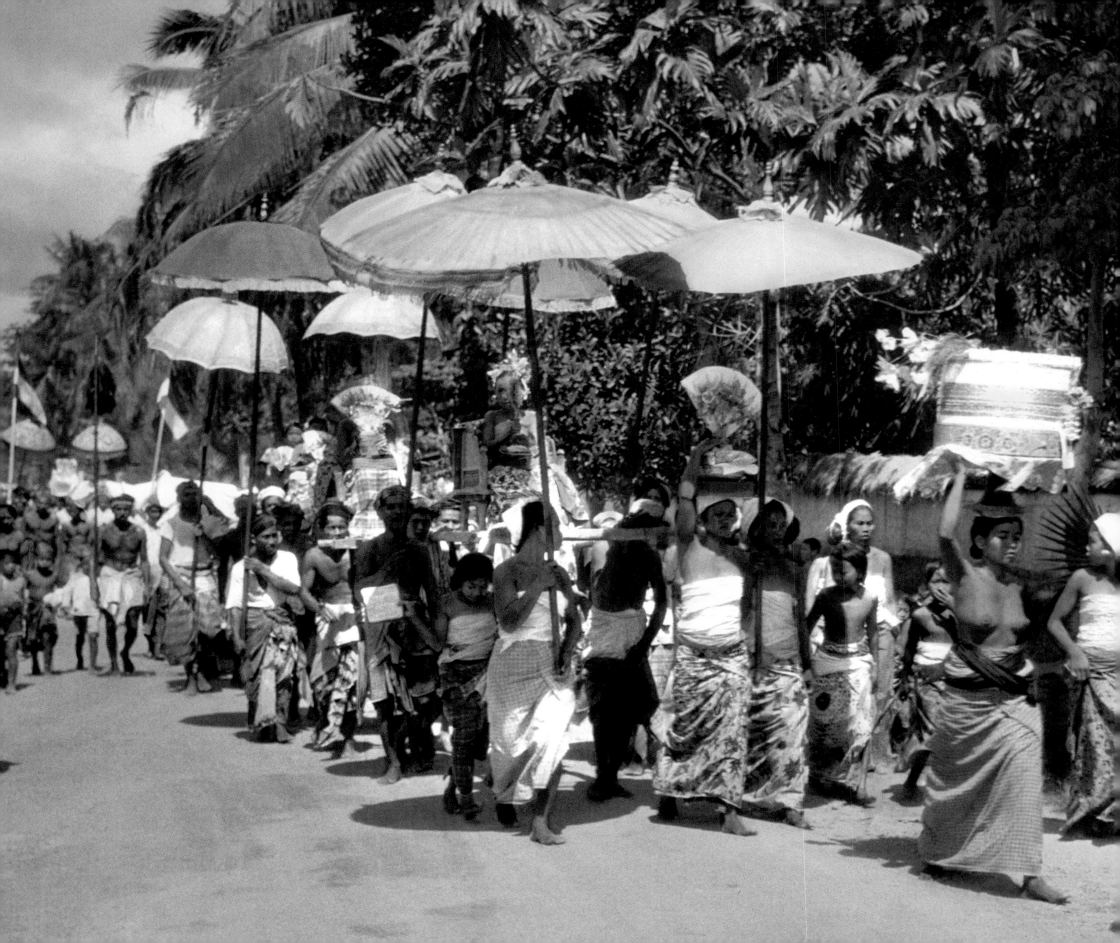

LEFT **A YOUNG BOY SITTING ON A TURTLE, 1932**

BELOW **MAKING NEW FRIENDS, 1932**

THE HERMIT KINGDOM

The year is 1899, and a visit to the Korean capital is one of the choicest tidbits on the menu of modern travel. The city of Seoul is the quaintest I have ever seen. These are the sensations we enjoyed while dashing along the streets of Seoul on one of those swift trolleys, first toward the East Gate from the straw-roofed suburbs—the gate looming bigger and bigger, until at last we curve through a courtyard, and plunge into the tunnel-like arch from which we emerge to skim straight away up the main street of Seoul, scaring horses, and spreading dismay among the white-robed denizens of the Korean capital.

There is much contrast in the streets of Seoul, for some are as wide as the boulevards of Paris, others as narrow as the alleys of Canton. The passing show is always interesting; the passers-by, so queerly clad, so curiously mannered. There is so much of interest to see within a few miles of the walls of Seoul to yield us generous dividends upon our very small preliminary investment.

A word as to the pronunciation of the name of the capital of Korea will not be amiss. It is variously mis-spoken. English travelers offend the ear with "Sowl." The French say "Sayoull." Americans, when cornered, compromise on "Sool," but usually refer to "that big city in Korea." The people call their capital city "Soul," the sound being precisely that of the English word *soul* dissyllabified [sic].

In all the world there is no queerer nor more curious country than Korea. A survey of Korean customs is as amusing as a comedy. Korean history has been a tragedy. In Korea both comedy and tragedy are extravagantly picturesque. [1899]

The old native name of Korea, "Cho-sen," means the "Country of the Morning Calm," or "Land of Morning Freshness."

RIGHT **MILITARY OFFICER ON PALANQUIN, OUTSIDE SEOUL, 1899**
High-ranking officers of the Korean military dress in such elaborate costumes that they have to be wheeled to battle areas on palanquins.

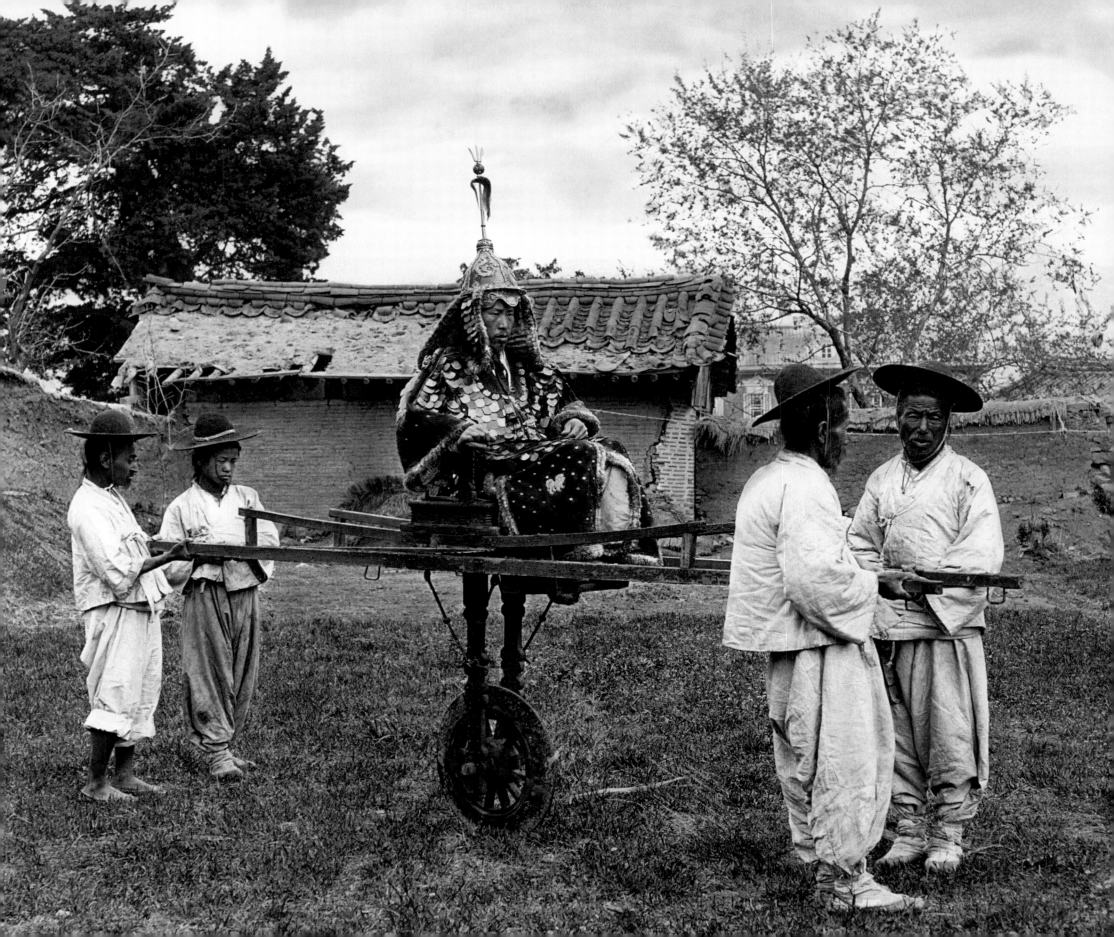

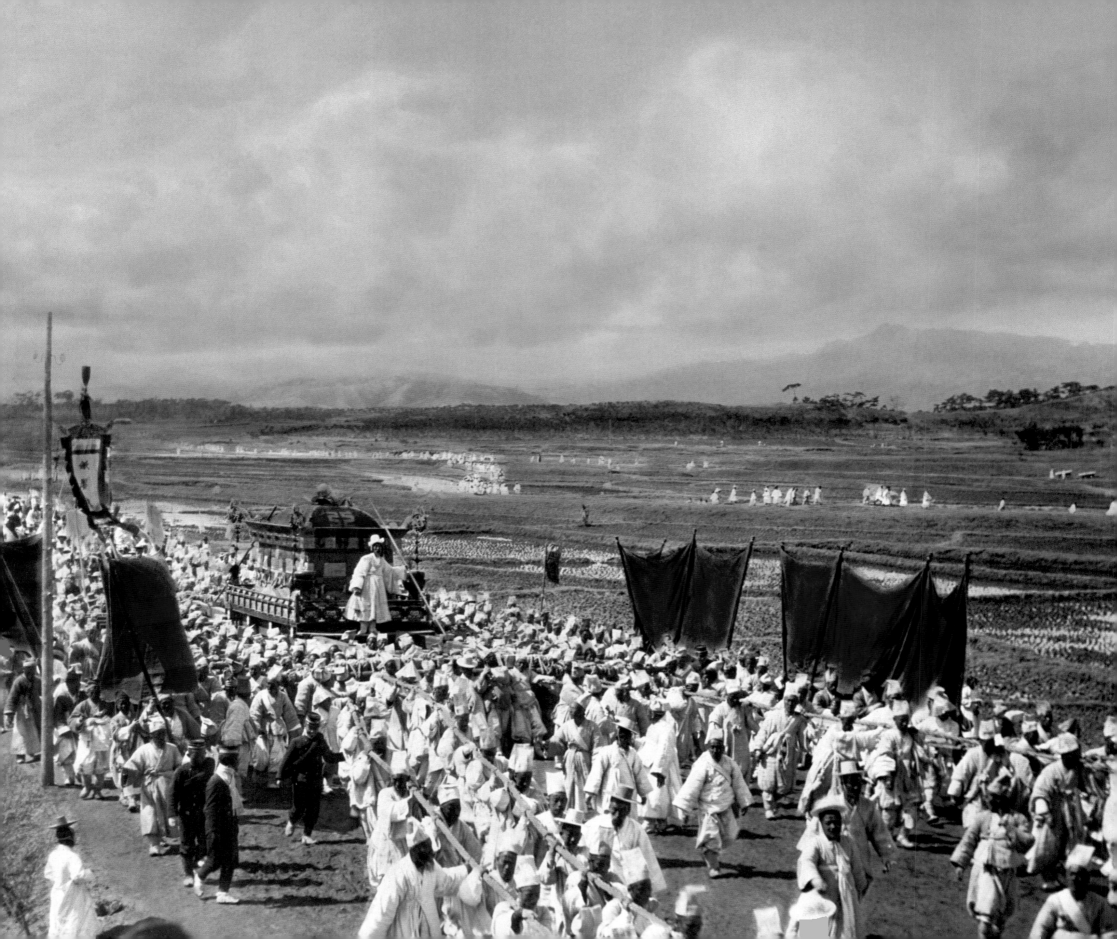

**PROCESSION TO ANCESTRAL TOMBS
NEAR SEOUL, 1903**

One of the most amazing things in all Korea is a highway leading out from Seoul to the new ancestral tombs some seventeen miles distant—a unique and splendid highway, in a practically roadless land. It was made merely because old Queen Min's remains must be escorted to the final resting place in the new necropolis by a great procession forty feet wide, along this seventeen-mile long road.

During the Japanese occupation, the Queen was all-powerful within the Palace, while the Japanese reformers controlled the administration. But in 1895, with the connivance of the Mikado's forces, a mob was permitted to break into the palace. The King took refuge in the corner room of the Queen's private pavilion and she was killed there before his eyes. Her body was carried to the ancient grove of pines, drenched with petroleum, and burned on the spot marked by a simple shrine. The remains were utterly consumed save for a finger, which was found later on caught in a casement of the room where she had struggled with her murderers.

Finally, on this auspicious day, the little finger of the Queen—all that remained of the poor lady—was transferred with great pomp to the sacred enclosure and buried with due ceremony in the conventional mound, above which an unconventional roof of a modern corrugated-iron was erected.

WOMEN ON THE STREET, THE WEST GATE, SEOUL, 1899

We see comparatively few women on the streets. Most of them are shrouded in coats of brilliant green, which are not put on like coats, but merely thrown over the head and clutched under the chin, concealing the faces as do the veils of Moorish women. The sleeves which dangle free and empty have white cuffs, while long red ribbons add a dash of brilliancy to this striking costume.

The coat, however, is not supposed to be the woman's own; despite its use by married women in general, the fiction has it that it is the fighting costume of the husband, which the faithful wife wears in time of peace—never daring to get comfortably into it in the ordinary way for fear that in case of sudden alarm there might be some delay in throwing it upon her valiant spouse as he rushes forth to battle. The red ribbons are supposed to have been stained with the blood of enemies wiped from a dripping sword.

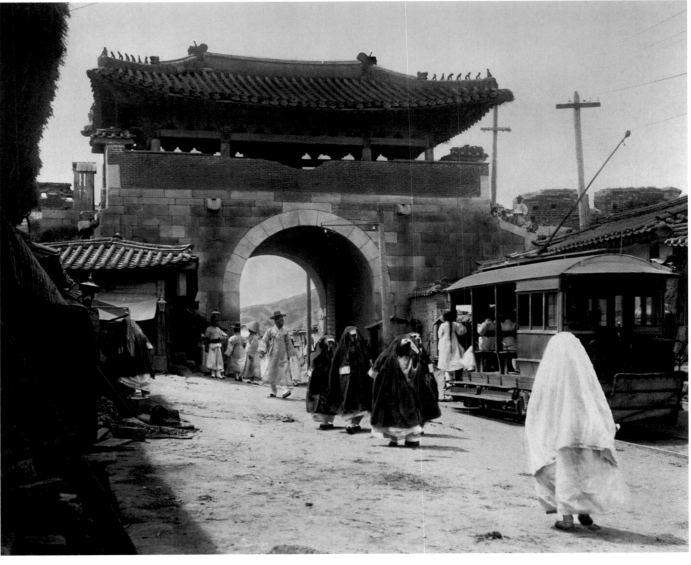

MEN WITH TOPKNOTS, SEOUL, 1901

Strong are the bonds that bind the Koreans to customs of the past. No man may wear the horsehair hat until he has acquired a top-knot, and no man may do his hair up in a top-knot until he has announced his intention to wed.

ANCIENT DOORWAY, SEOUL, 1901

A bachelor remains in the estimation of his fellows a mere unsophisticated boy, and is treated as a boy and like a boy must go bareheaded, his hair parted in the middle and plaited down his back. This coiffure gives the boys of Seoul a feminine but not effeminate appearance, and foreign visitors frequently remark upon the boldness of the pretty tom-boy girls with whom they have been flirting.

MEN IN HORSE-HAIR HATS, SEOUL 1901

Korea is indeed the land of hats, and every hat has its significance. But whence comes that curious cone of horsehair, so delicate, so inconvenient, and so picturesque! Once upon a time—for the story goes back a long way, to the days of feudal strife, of clashing clans—a very wise king of the time hit upon a plan to tame his quarrelsome lords and princes and place a check upon conspiracies. "If men cannot put their heads together, they cannot conspire," said this king; "therefore, my lords, you must wear hats so big that you will have to shout at each other." He prescribed the size and shape of hats for all his subjects, and made the constant wearing of the hat obligatory. The removal of it was regarded as an act of treason; injury to the hat brought deep disgrace upon the wearer. Times changed, and the Korean hat began its evolution, and finally the fantastic flytraps of today emerged triumphant in their elegance and comfort, with which are still combined some of the essential bigness and breakability.

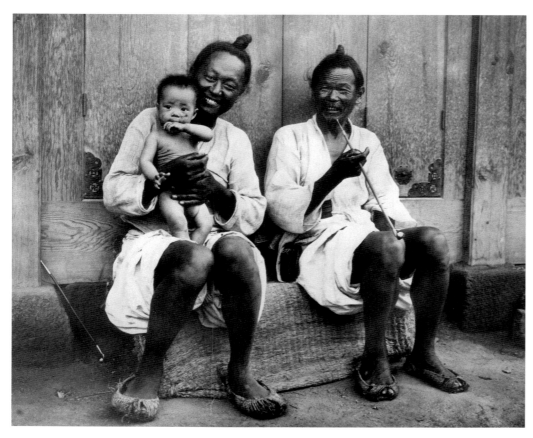

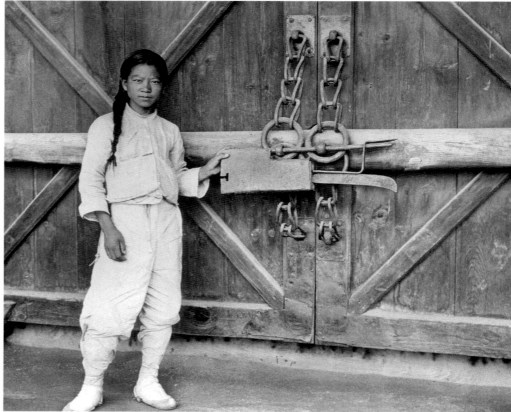

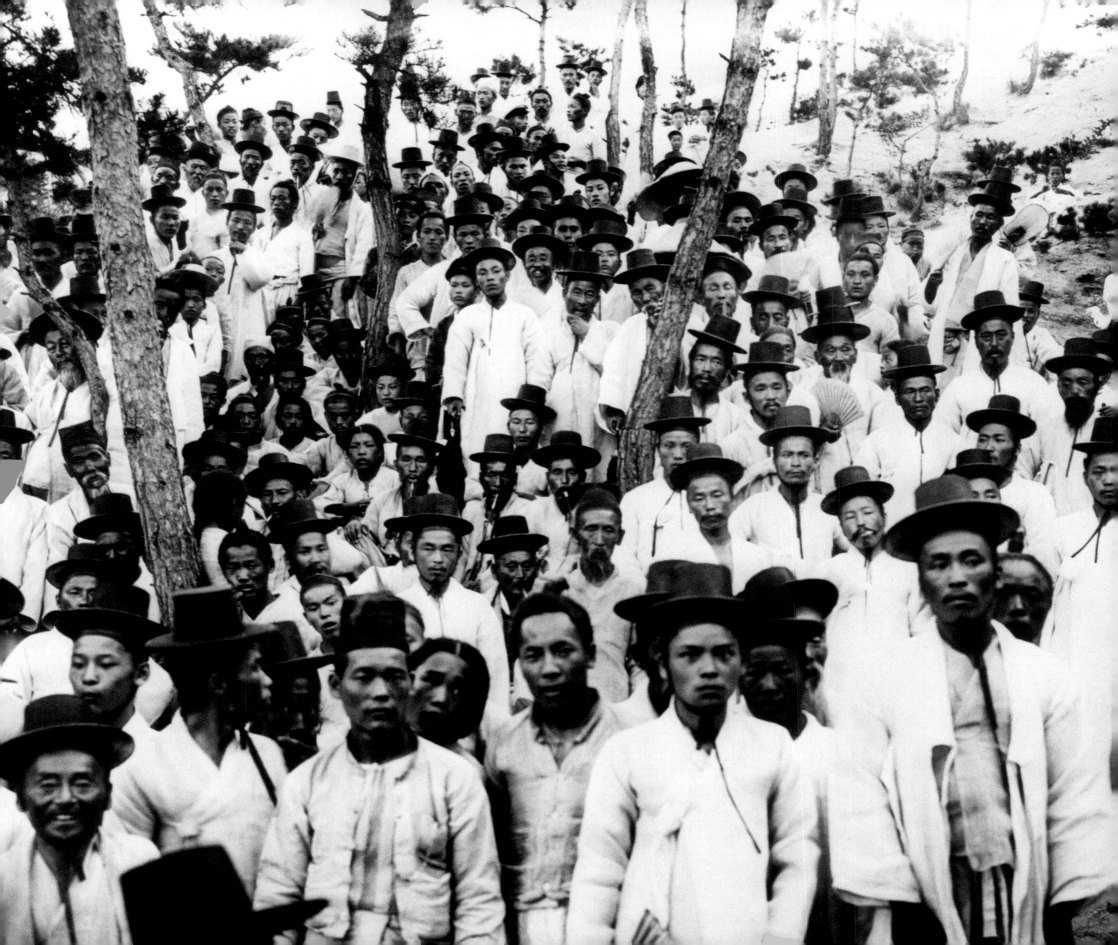

THE MAGIC OF MEXICO

The summer of 1891 found me touring with Grandmother as one of the earliest Grafton Excursions. J. L. Stoddard too did Mexico that year and again I had the opportunity of studying the technique with which he handled a topic with which I was freshly familiar.

Stoddard was disappointed in the Mexico of 1891 but I was not; the color and quaintness made up for the lack of the classic associations of the Continental countries Stoddard loved.

Speaking Spanish, I could leave our tourist party and do a little sightseeing on my own. But life with the members of the land cruise had its attractions. The entire party was received by President Porfirio Díaz. I shook hands with the Dictator and understood the brief and friendly speech he had prepared for the occasion. He looked indeed like the Master of Mexico which he then was.

Later in Guadalajara we had another interesting experience. Ours was the first solid Pullman train that ever entered Guadalajara station. The local folk had never seen even a single Pullman car. So great was the popular curiosity that Manager Grafton arranged for the train to be inspected by several hundred of the leading families. My grandmother was appointed hostess and, seated in our Drawing Room, received the distinguished citizens who were presented to her by the official interpreter. The delight of our visitors was great as they watched the Pullman porters making up the beds and the cooks and waiters preparing and serving refreshments in the first dining car that ever came to town.

I made pictures in Mexico, this time on the new flexible celluloid film, forerunner of the wonderful Eastman product of today. These pictures I never used upon the screen, perhaps because they did not seem quite good enough, perhaps because I was too busy trying to find my place in life, little dreaming that my place was to be at the corner of a platform, talking about pictures projected on a canvas screen. [1953]

LEFT **THE CATHEDRAL ON THE ZÓCALO, MEXICO CITY, 1921**

"Viva Mexico" has been the cry of thousands of returning tourists who have at last discovered just what they have been looking for—a foreign land rich in the color and quaintness of the Old World but situated right in the heart of the New World between our own United States of North America and our sister republics of the Southern Continent. Mexico now has everything the traveler demands.

RIGHT **YOUNG BURTON HOLMES (FAR RIGHT) AND MEMBERS OF THE GRAFTON TOUR GROUP, MEXICO CITY, 1891**

The Grafton slogan was: "Thirty days from Chicago to Chicago via all interesting points in the Mexican Republic with a solid Pullman train as your hotel."

THE HEART OF THE MOORISH EMPIRE

ABOVE BURTON HOLMES IN MOROCCO, 1894
On horseback, with our guide atop a donkey, we covered many sandy miles. For eleven days we ambled slowly on, covering never more than eighteen miles a day. For eleven nights we slept under canvas beside a little stream or near one of the rare clumps of six or seven trees which our guide, Haj, referred to as a "forest." Sometimes we found ourselves within hail of a city, village or Bedouin camp, whose male denizens would timidly approach and sit in a circle round our camp, observing the strange ways and manners of the pale-faced infidels.

Morocco was no place for the tourist in 1894. It was then, as it had been for centuries, an independent empire, closed to the infidel, without roads, hotels, or Christian comforts, and haughtily regardless of the outer world. Few were the travelers who had ventured far beyond the gates of civilized Tangier. Many were the obstacles raised to guard the sanctity and secrecy of the most fanatically religious country of North Africa.

Nelson Barnes, my traveling companion, and I left the ship at Algiers resolved to see North Africa in our own way, in leisurely fashion, taking time and taking pictures. It was for us a glorious adventure—Algeria, the Kabyle mountains, Biskra and a long slow drive with the *"courier des postes"* to Tougourt far across the Sahara sands.

One thinks of Morocco as a rough desert country. We found it a smiling, rolling plain, green with the freshness of the month of May, and carpeted with the wild flowers of spring. It was unmarred by road or railway, or by those hideosities of our civilization, wire fences, telegraph poles and billboards. It offered a broad and lovely landscape just as Allah had made it.

In Morocco, there is no beaten track—the traveler who would penetrate to the mysterious dying cities of the interior may do so only with the sanction of the Moorish Government. He must travel under military escort, providing himself with all things necessary for the journey: men and animals, tents and provisions. By night his camp is pitched near to some Arab *douar*, and guarded until morning by groups of sleepless tribesmen. By day his caravan makes its way over endless fields of purple poppies and white marguerites, slowly advancing toward the desired goal—toward Fez, whose streets have seldom been profaned by the feet of unbelievers.

Our first day in Fez was spent in seeking a place in which to lay our heads. First to the palace of the Basha or Governor of the Capital, to present our official letter from Tangier and ask the necessary permission to remain within the walls. His Excellency kept us waiting in the courtyard for several hours, then deigned to designate a house in a remote part of the city as our residence. For it, no charge was to be made; we were guests of the city, unhonored guests, who might be asked to leave town at the pleasure of the Basha. A guest cannot refuse to move on when his host says, "Go!"

Keeping house in Fez was, up to 1894, an experience enjoyed by very, very few "Christian Dogs." That epithet was applied to us many times in the course of our ten-day sojourn

RIGHT "FANTASIA" IN THE MOROCCAN DESERT, 1894
The son of the old Sultan was expected to arrive the next day. I rode forth with the tribesmen and sheiks shortly after sunrise to meet the Prince's splendid caravan. I was the sole white man in all that mounted Moslem multitude that spread itself across the horizon. It was a never-to-be-forgotten day— a day of peril for a solitary infidel, but so rich in pictorial possibilities that I had no time to think of danger. There is nothing better calculated to take one's mind off ugly possibilities than to view those possibilities through the tiny finder of a camera. Danger came towards me in the form of charging cavaliers doing their "fantasias," firing their gorgeous flintlocks—happily not at me, but into the air.
A fantasia is an exhibition of Arabian horsemanship, a sort of glorified cavalry-charge, a spectacular maneuver, the favorite amusement of the Moorish cavalier, the exercise in which the horseman takes most pleasure and most pride.

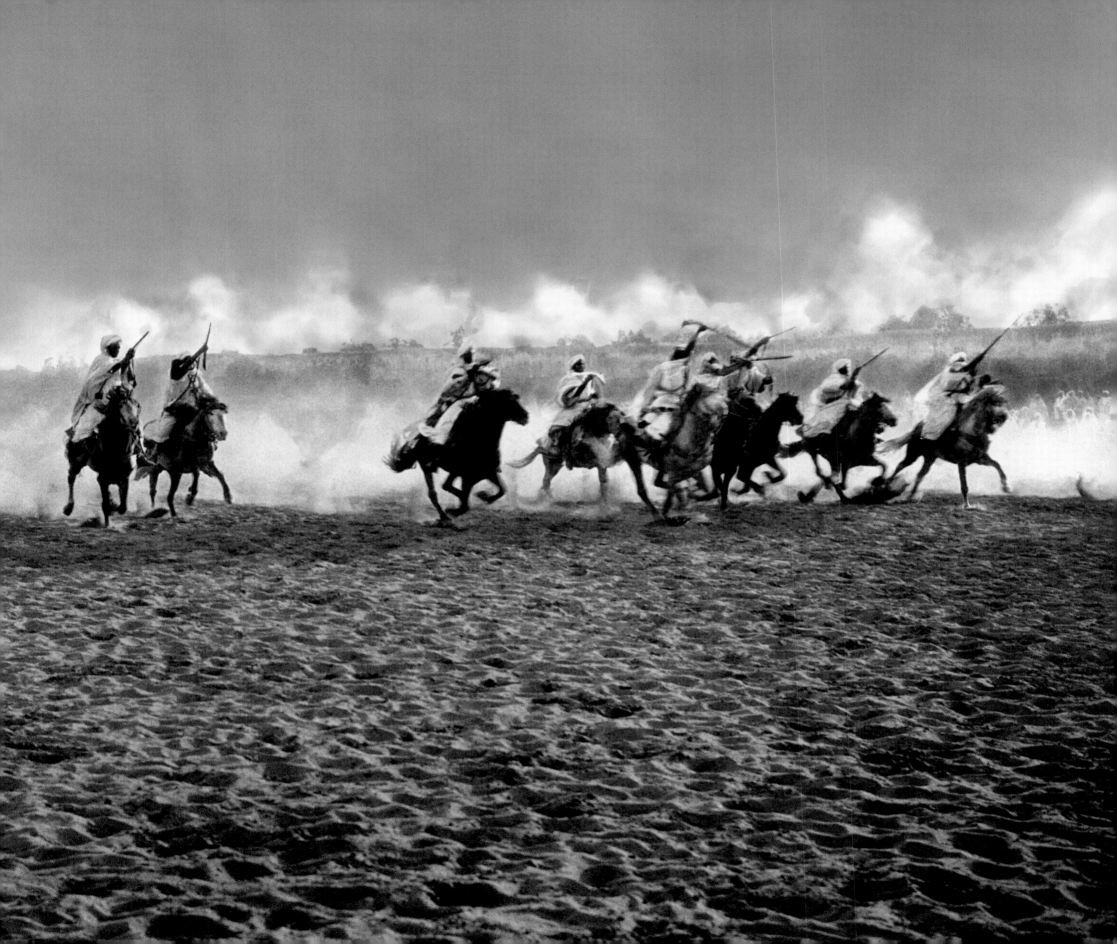

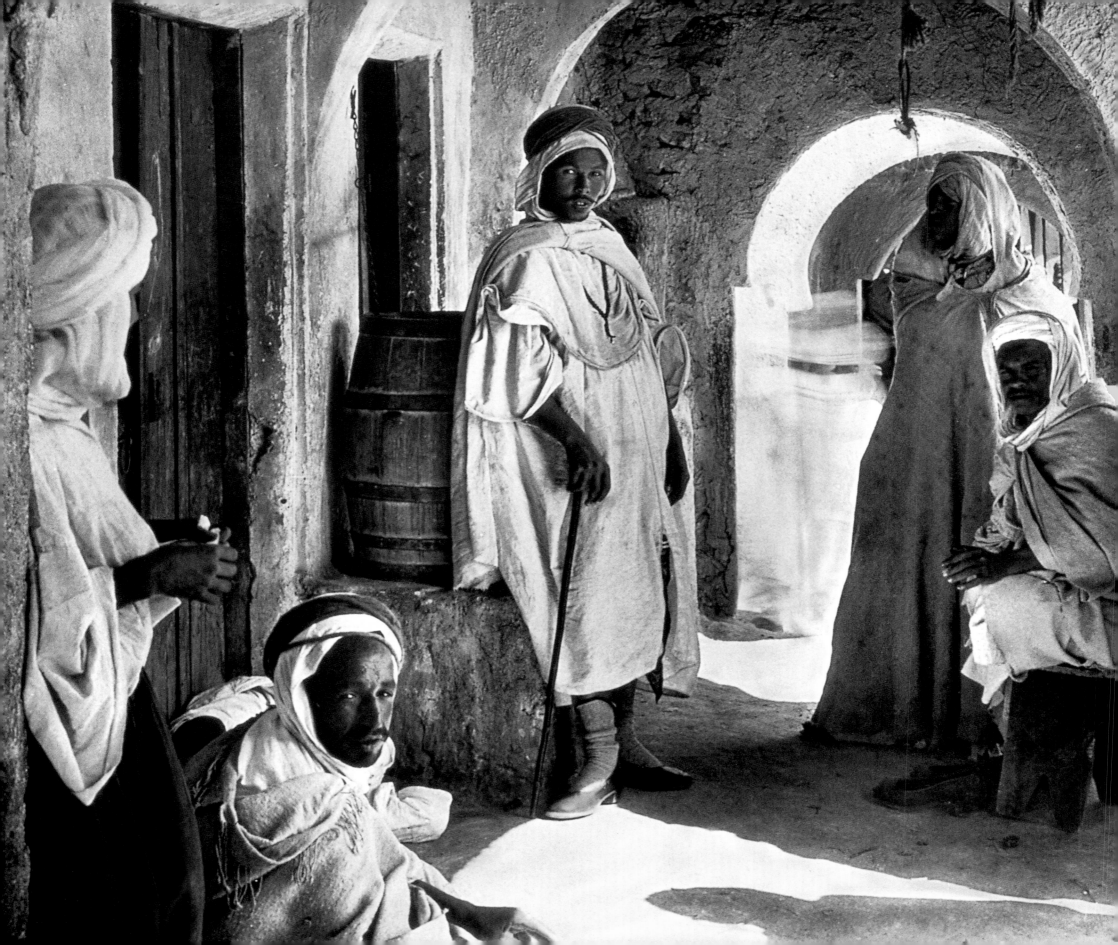

LEFT **IN A FEZ ALLEY, 1894**

To photograph in the streets of Fez is difficult to the verge of impossibility, as picture-taking is prohibited. Even though this difficulty may be overcome by cunning, the very streets conspire with the people to foil the eager camerist. Street life in Fez is vividly suggestive of subterranean existence. There is a dark cellar-like coolness, which, combined with the ghostly stride and costume of the inhabitants, gives us the impression of being in the catacombs among resuscitated men in their shrouds.

Our faithful guide Haj, rascal that he is, knowing that I care more for snap-shots than for introductions, always arranges when he meets a friend or relative to detain him in conversation, in the best illuminated portion of the street, thus giving us invaluable opportunities for secret portraiture. Then after he has heard the "click!" that comes from what appears to be an innocent brown paper parcel under my right arm, Haj, with many complimentary phrases, presents us to the visitor, introducing us as men of great distinction from America.

RIGHT **BURTON HOLMES, FEZ, 1894**

I wore a flowing burnoose over my riding togs and was thus less conspicuous in the street life of Fez.

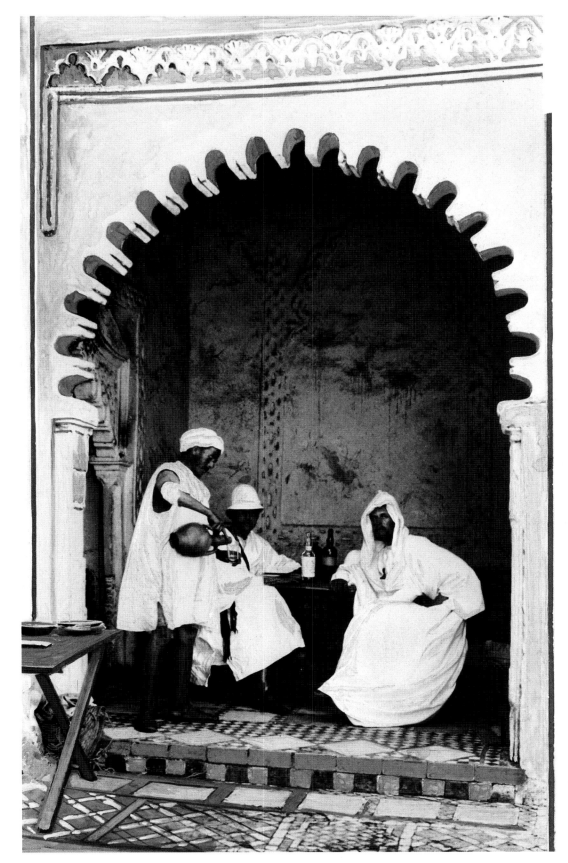

in the holy city. As we passed through the streets, we thought at first that an epidemic of coughs and colds was raging in all parts of town. There was intermittent coughing and a barrage of expectoration all along our route. This, we learned, was the customary chorus of welcome that greeted unbelievers. Our infidel presence was supposed to pollute the atmosphere of Islam. Men cleared their throats and spat at the sight of Christian Dogs—we two inoffensive but unwelcome visitors being

the dogs. We pretended not to understand and not to resent it. It was a novel experience; we rather enjoyed being the objects of so much picturesque contempt.

There was real adventure in our Moroccan journey, though we did not seek it or take it seriously when it touched us. We were shot at as we caravanned away from the sacred city of the Shareef of Wazzan. We thought that a little party was out hunting birds and did not suspect that the game they

were after was in the form of Christian Dogs. The hunters were bad shots; the bullets whizzed above our heads and, ignorant and unafraid, we calmly rode away. *[1894]*

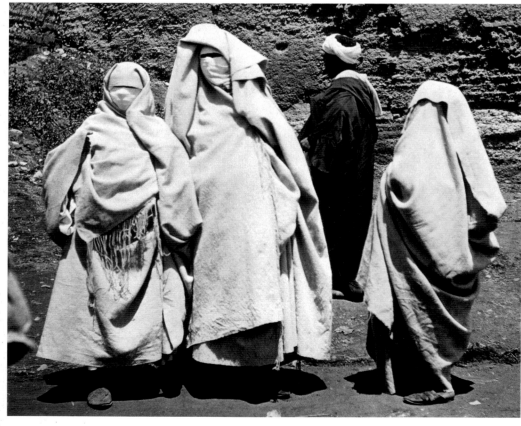

LEFT **VEILED WOMEN IN PUBLIC, FEZ, 1894**
These women frankly halted as we passed, turned their pretty faces toward us and gazed smilingly at the arriving travelers. We must admit, however, that they had the advantage of us; we were compelled to take for granted both the prettiness and smiles, and it was pleasanter to do so; moreover, there was nothing else to do. Still, the features of her who paused on the left, as vaguely molded by the masking *haik*, were not of Grecian purity. She would have charmed us more had she not drawn her veil so tight. On the right an older woman was more discreet; like the wise Katisha she believed that it is not alone in the face that beauty is to be sought, so she sparingly displayed her charms, revealing only a left heel which people may have come many miles to see. The fair one in the middle bares her face in a most immodest fashion: through an opening at least three quarters of an inch in width two pretty eyes of black are flaming.

RIGHT **VEILED WOMEN INDOORS, FEZ, 1894**
But as for the ladies we encountered—bless their souls!— their womanly curiosity proved stronger than religious prejudice. Indeed, it may be set down as an almost invariable rule that wider the opening 'twixt veil and *haik*, the prettier the eyes that flash between.

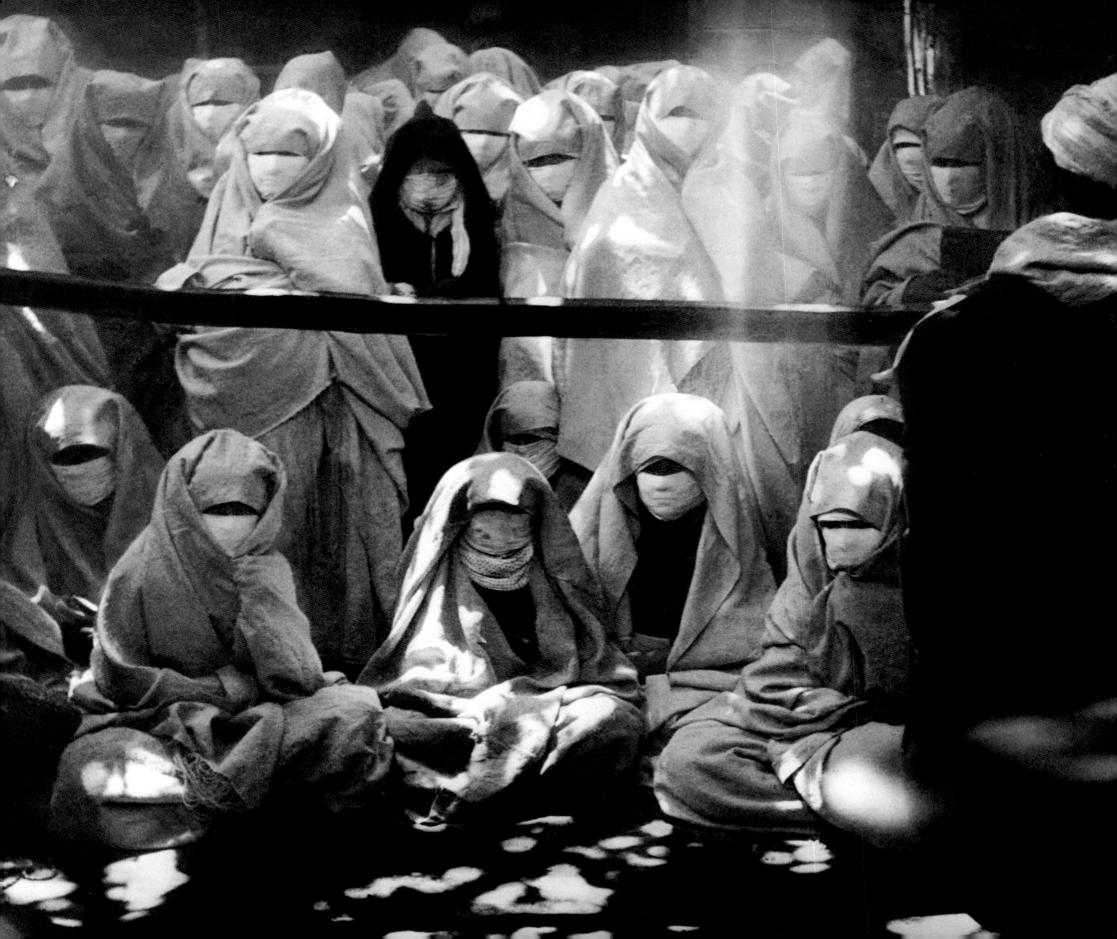

TOWARD THE MIDNIGHT SUN

To tell of Norway, one should speak a language all of form and color, light and shade, and speak it with the accent of the eternal silences that brood on mountain-tops and in the bottom of the sea. The summer of my Norway tour seems to me now, as I recall it, like a long, magnificent dream of the impossible, a splendid scenic nightmare filled with an endless succession of sensations as overpowering and unforgettable as the scenes that inspired them were stupendously impressive. Nature herself has set us an example of extravagance unapproached anywhere on the earth.

In Norway, ice, the elder brother of the liquid element, has performed miracles, of which the testimonies are the fjords, those terrible gashes in the breast of the Scandinavian peninsula—gashes that are deeper than the ocean and are cleft in mountains, the slopes of which descend from the line of perpetual snows to meet in the depths of submarine gorges more than four thousand feet below the level of the sea. Could we drain those rock-bound fjords, Norway would present a spectacle of unspeakable sublimity; but Norway, even as it is to-day—its grandeur half concealed by the black waters that lie heavily between the somber cliffs—is one of the most marvelous and most inspiring scenic regions of the world.

The scenery of Norway is almost without equal in the world. There is apparently no end of Norway's scenic wealth; the land is literally crowded with scenery; the inhabitants of some regions find but a narrow foothold between the mountains and the invading channels of sea. Although Norwegians at home are comparatively poor—less than three per cent of them being persons of independent means—all are independent in spirit, all are self-supporting, there is no visible misery, there are no paupers and no tramps, and there is no child labor. Every citizen has a vote; the franchise has been extended to women, and in several Norwegian cities women sit to-day in the municipal councils. [1909]

LEFT **HAMMERFEST, THE MIDNIGHT SUN'S METROPOLIS, 1909**

More than two months of darkness is the annual fate of Hammerfest. But for seventy-seven days, from the 13th of May until the 29th of July, the sun swings around the town, rising and falling slightly, but never going out of sight at all, save when it hides behind a hill or house.

This picture of Hammerfest was made long after night, or what is called night here, had fallen. But day and night are terms that have become meaningless; the sun never sinks far enough below the horizon to make much difference in the illumination of the scenes past which we glide as in an endless, sleepless dream.

Four hours' sleep each night is more than any of us cared to take. For three days and nights I was practically a stranger to my bunk, remaining dressed all night, snatching a little rest in the lounging rooms upon the upper deck. Every hour brings its incident of interest or its striking vision of sublimity. We have allowed our watches to run down, as useless. Therefore I cannot say what time it was when we approached the little city which of all the cities on earth lies nearest the pole. I think, however, that it was early in the morning that we glided into the harbor of Hammerfest, the midnight sun metropolis, a city of about twenty-five hundred souls.

Later from a neighboring height, we look down on the almost land-locked harbor, where fishing ships have settled like a flock of gulls on the blue surface of the waters, their white sails spread to catch and hold the light that is so generously shed upon this region by the long summer days, as if in compensation for the sunless days of the past winter.

RIGHT **THE SEAPORT TOWN OF AALESUND, 1909**

Norway is a land of cleanliness even if modern plumbing is not yet in evidence in the small towns and villages. The traveler is always sure to find decent rooms, good wholesome food, a cheery welcome, and the services of an honest host in towns like this seaport town, Aalesund.

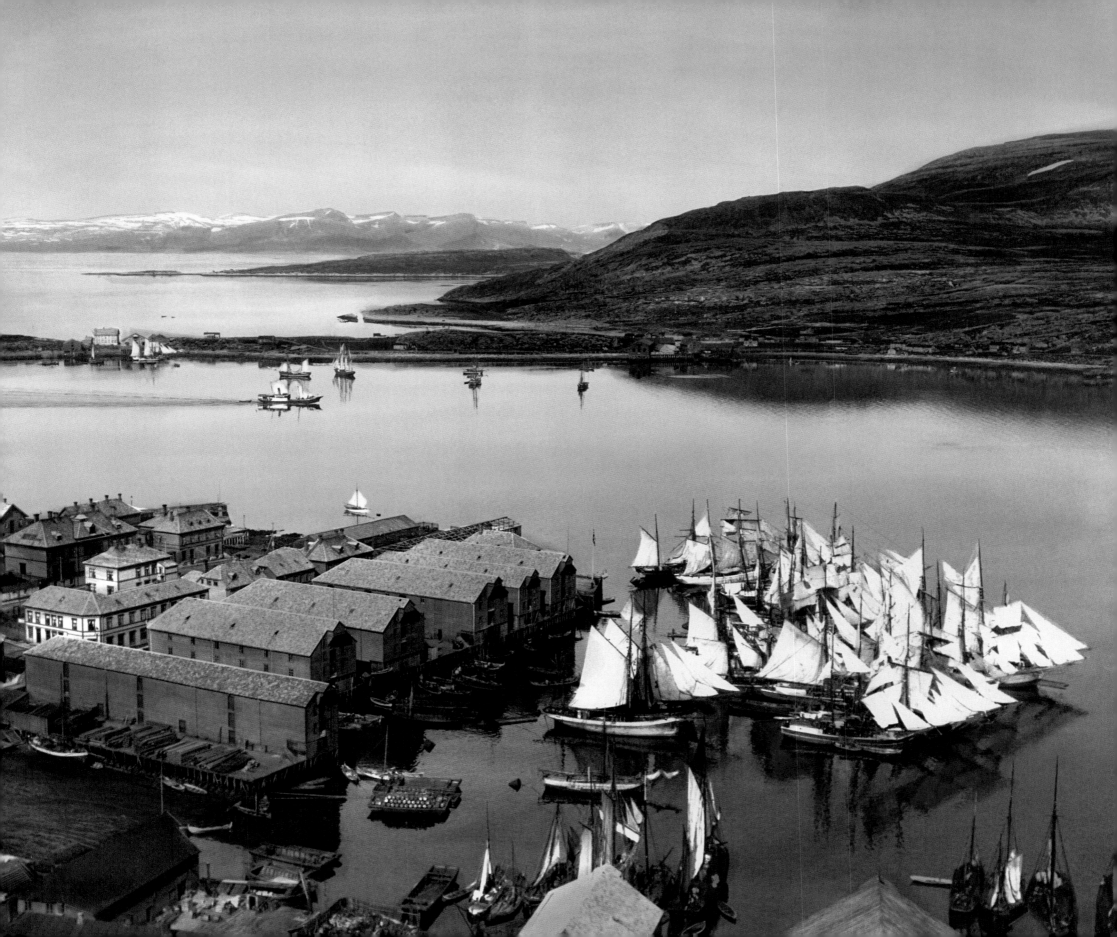

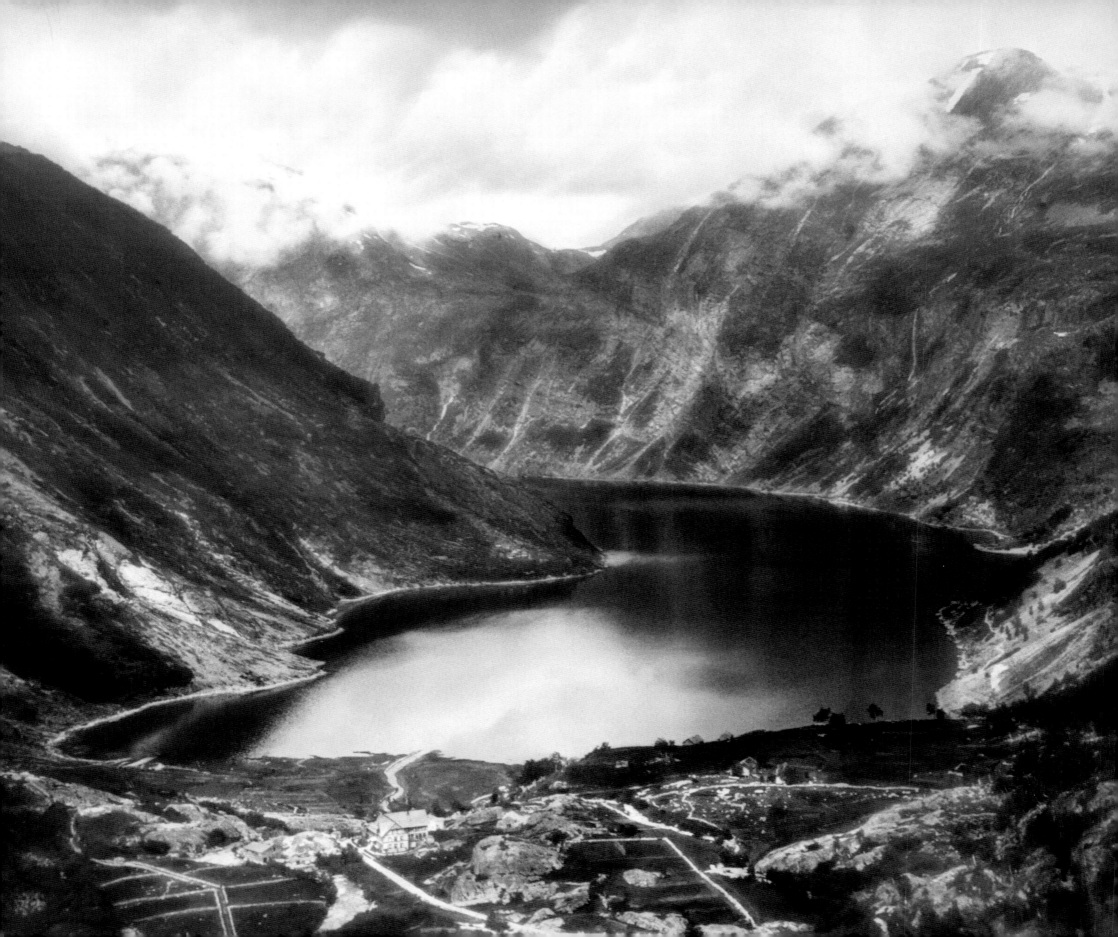

THE TITANIC GORGE OF GEIRANGER FJORD, 1909

LEFT

We made a long twilight ride, down the twisted coils of one of the grandest roads in all the world, a road that leads us down to the Geiranger Fjord, a titanic gorge, filled halfway to the brink with the waters of the wide Atlantic.

Far below lies a lake-like fragment of the sea, deep, dark, eternally quiescent, and yet a living member of the mighty ocean, for it is in reality the tip of a long finger of the sea, crooked round a rocky headland, as if to feel the pulse of this cold Scandinavian land, so recently released from the icy grip of the glaciers that have now receded upland from the fjords, leaving that little patch of fertile, level earth where pygmy man may play at keeping house in the rude gaards [small villages] of Merok.

THE "FAST SKYDS STATION," 1909

BELOW

In the course of a long mountain journey from fjord to fjord, we spent an hour on the shores of the Djupvand, a repellent little lake, half frozen even in the mid-summer, where we found shelter in a comfortable tourist hut established and supported by the state government for the security and comfort of the traveler. It is a "Fast Skyds Station"—that is to say, a post where a fixed or "fast" number of post horses must be kept and where the owner must provide immediate change of horses on pain of having fines imposed for all delays exceeding fifteen minutes.

The ponies are admirable little brutes, well fed, well groomed, and rarely overworked, for the kind-hearted driver always walks up the ascents, even when the rise is so gradual that a spirit-level would be required to detect it; and when a steeper grade is reached, if you do not get out and walk yourself, you must be prepared to meet the reproachful glance of the indignant driver. Had I to be born into the animal kingdom in the course of future transmigrations, I should pray that my soul might manifest itself in the form of a petty pony here among these people who are merciful; and they are as honest with the stranger as they are kindly to their beasts, and they hold their honest services so cheap.

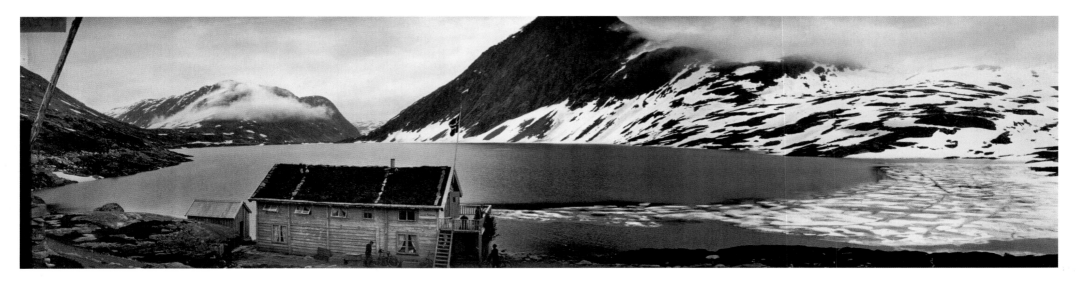

**DWELLERS OF THE NORWEGIAN NORDLAND,
THE WANDERING LAPPS, 1909**

Among the dwellers in the Norwegian Nordland there are
to-day some twenty-thousand little people of an alien race,
the Lapps, wanderers, yet ever wandering over the same
desolate no-man's land that lies between the habitable
regions of Norway and north Sweden. Reindeer rearing is
the favorite occupation of the Lapps, who in the summer
pitch their camps near the little Nordland ports to profit
by the passing of the tourist.

The reindeer supplies all their needs: the milk yields butter
and cheese; the fermented whey makes a strong intoxicant;
the flesh the staple food; the skins are used for making
tents, blankets, coats and trousers. The antlers are fash-
ioned into household utensils, the intestines into gloves,
and the tendons are used in place of thread. The same use-
ful creature serves as a beast of burden; in fact, the Lapps
are compelled to maintain a reindeer posting system, like
the pony skyds system of the south.

MIDNIGHT AT THE NORTH CAPE, 1909

Only one out of four North Cape excursion parties sees
the Midnight Sun, but as a famous traveler declares, "I have
never met anybody who has gone to the North Cape with-
out seeing the Midnight Sun. General absolution is granted
to tourists who lie about it to other travelers and to the
folks at home." But of this general absolution, I refuse my
share and flatly state that while our little company of wan-
derers stood or sat there at the world's end whither we had
come to see the midnight sun, we did not see it and yet we
did half-see it; for at least one-half of the golden disk was
visible by midnight.

Although the supreme moment to enjoy the thrill of which
we had traveled so many miles came a few minutes after
midnight when that kindly compromise-making cannon
did at last speak its innocent untruth announcing a belated
midnight with its boom just as the full disk of the golden sun
revealed itself to us between two long dense bands of glori-
ously golden clouds.

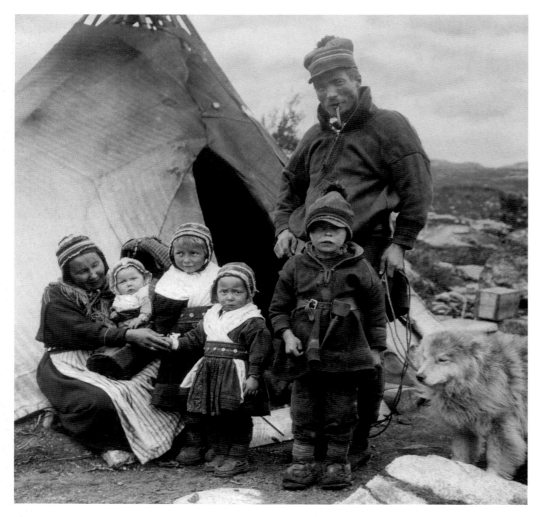

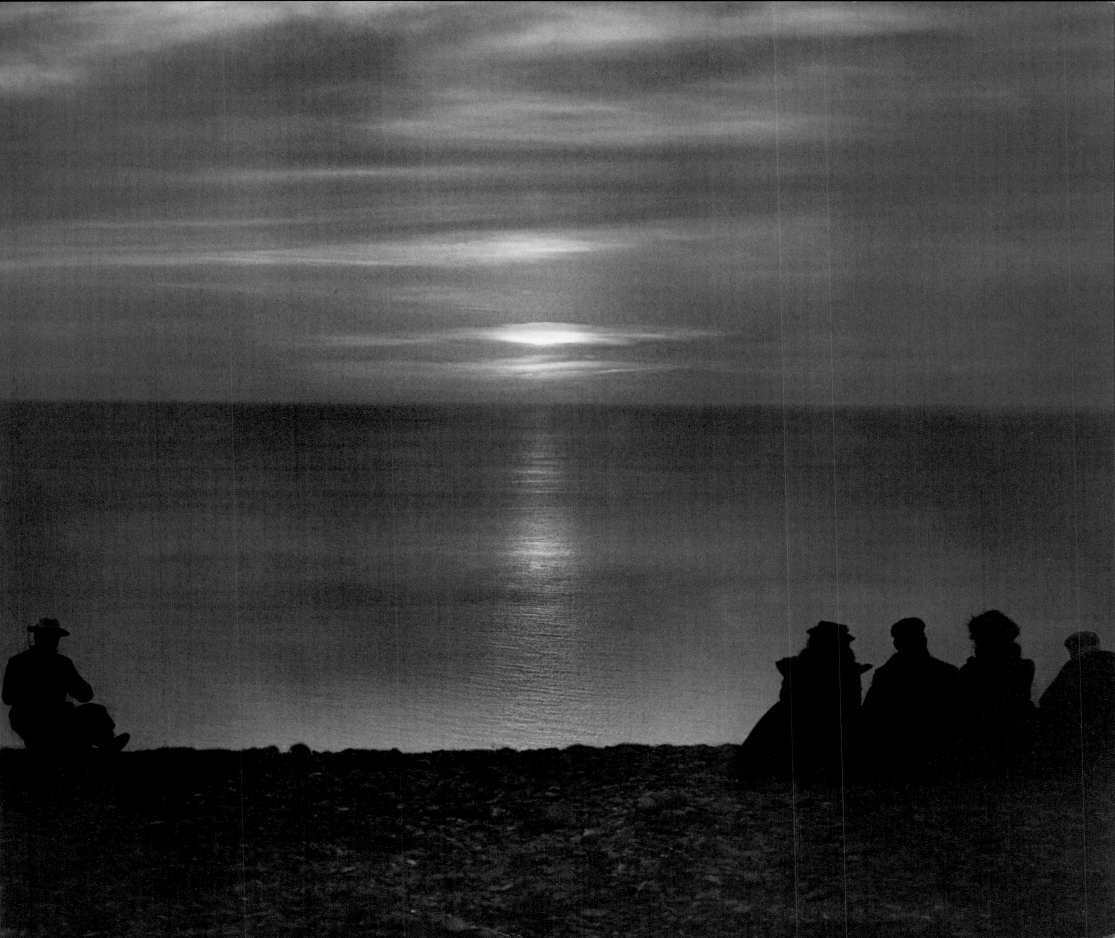

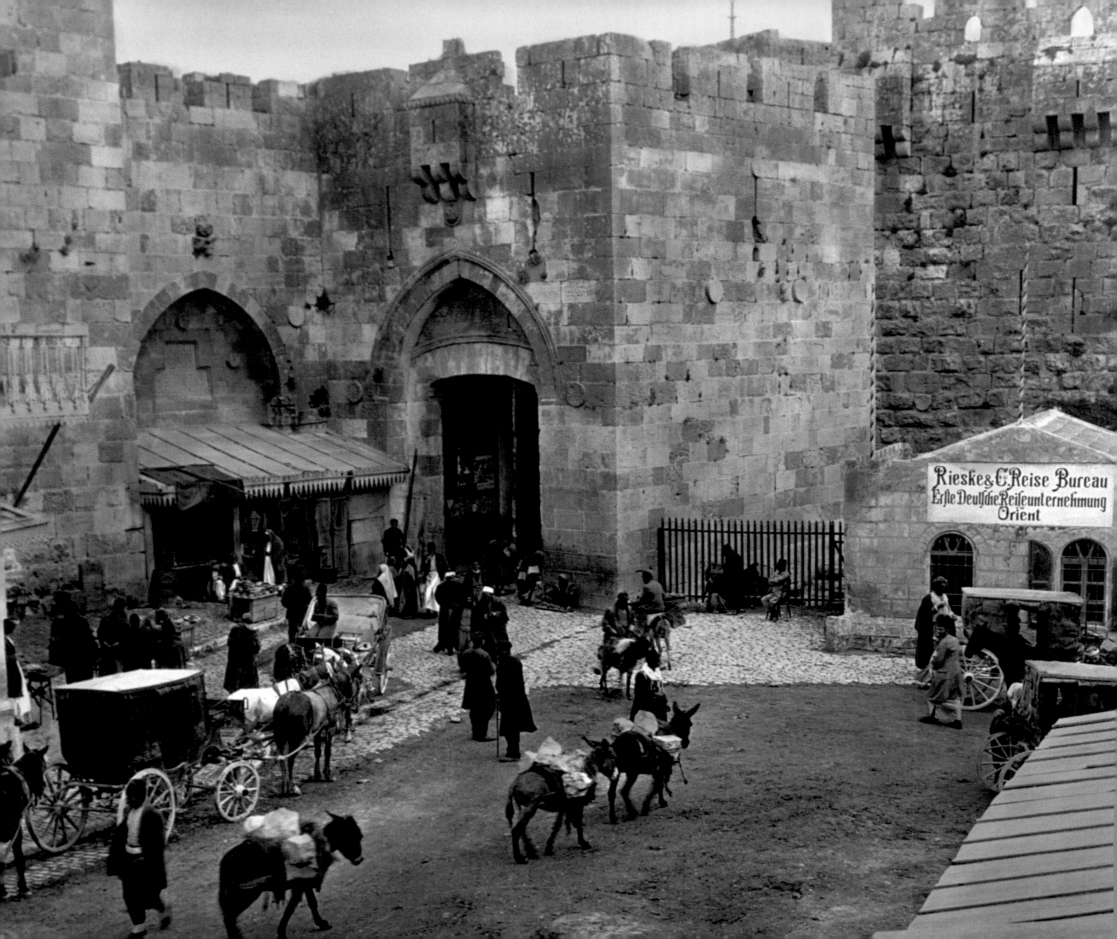

JERUSALEM: THE HOLY CITY OF THREE FAITHS

priz
wal
bul
ov

mi
Je
C

ded, it has been the
fallen many times, its
people slain or exiled:
ruins of the older city

anquish Zion's deter-
werless to wipe out
eternal verities, in the
l, that nothing of time

or circumstance can suppress. War and Man have been compelled to recognize the indestructibility, the everlastingness of the Jews and Jerusalem, that old gray city on a hill, whose "light cannot be hid."

Many religions are represented in Jerusalem: Greek and Russian Orthodox, Roman Catholic, Armenian, Coptic, Ethiopian and Assyrian and Muslim, each recognized by his traditional dress and hat. All the clergymen appear to know each other and speak with much cordiality. *[1920]*

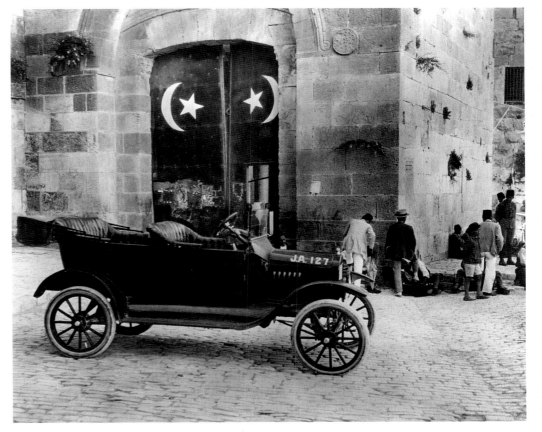

1920
fensive wall built by
6th century, the city of
rough several different
he Jaffa Gate is one of
eads to David Street and
Street of the Chain.

A BLIZZARD IN JERUSALEM, 1920
Jerusalem had a blizzard in February1920, the first one
in two thousand years. It put the city to sleep. Snow itself
is not entirely unknown, Jerusalem has experienced a few
rare gentle flurries in the past. But a real snowstorm, this
was new, something astounding and alarming. A few struc-
tures collapsed under the unaccustomed weight of snow.
Frightened folk shut themselves indoors as the life of the
city came to an absolute stand- still. But Jerusalem recov-
ered from its chilly panic, and one of the many memorable
and miraculous things that have happened in Jerusalem in
modern times passed into history.

RIGHT **ORTHODOX JEWS, JERUSALEM, 1920**
Curly locks affected by the strictly Orthodox Jews
of Jerusalem.

CONSTRUCTION OF THE PANAMA CANAL

A tale that must be told again. The popularity of the *Panama Travelogue* presented last season was overwhelming. To satisfy the ever-increasing demand for seats the management arranged for repetition after repetition in all the cities visited by me, but *Panama* continued to turn hundreds away until the very end.

It was in Philadelphia that we broke an all-time record with our lecture on *The Panama Canal*. This was presented in 1912 and 1913, while the great ditch was being dug and all Americans were eager to know more about it. The lecture and the pictures seemed to answer all the questions then seething in the public mind, "How does a ship get up hill—and down?" "What is a lock canal?" The old Academy of Music

seats thirty-one hundred persons. We gave *The Panama Canal* twelve times to overflowing houses, not a vacant seat; orchestra pit, fourth tier proscenium boxes (with only a plunging, cross-eyed view of the screen) and all permissible standing room sold out twelve times in the same season. Not only in Philadelphia but all over the United States the story of the canal drew enormous houses. I wish the Government would start digging another Isthmian Canal! *[1914]*

The Panama Canal was originally a glimmer in the eye of Spanish King Charles V, who sought to create a waterway through Central America to expedite the transport of riches from his western South American territories in the 16th century. But it was not until nearly 300 years later that Frenchman Ferdinand Marie de Lesseps, who had completed Egypt's revolutionary Suez Canal in 1870, revived the idea and secured the financing to start construction. After a series of technical and financial disasters, including the deaths of thousands of workers from continual landslides and mosquito-borne diseases, the project was taken over by the United States government from 1904–14. It would be the country's greatest financial investment to date, costing $375 million. The impact on trade would be immense, cutting the travel time of ships from San Francisco to New York to a third. Equally marvelous to Burton Holmes's audience was the construction itself and the system of great locks, which would lift passing ships through the canal.

LEFT **SPANISH WORKERS ON THE PANAMA CANAL, 1912**
Behind all the machines, that do man's bidding with a million times a man's power, are over forty thousand working men of many nationalities. Here is a group of Spaniards; but you will find in Panama men of all races and all nations, doing the world's work well.

RIGHT **BLASTING THROUGH THE ROCK, 1912**
The task of cutting South America adrift there at the narrow isthmus by means of which it hangs to our own continent has been almost completed—a few months more and our great sister continent will be an independent island.

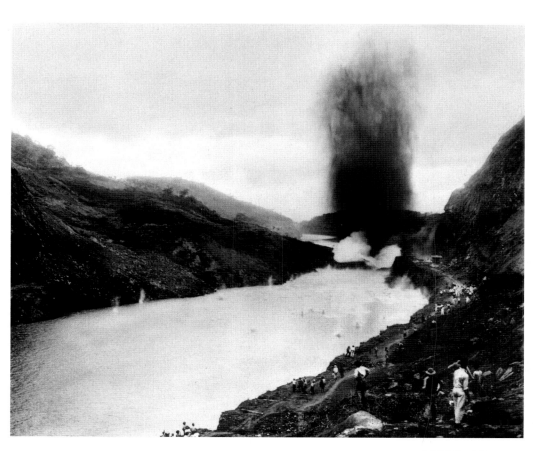

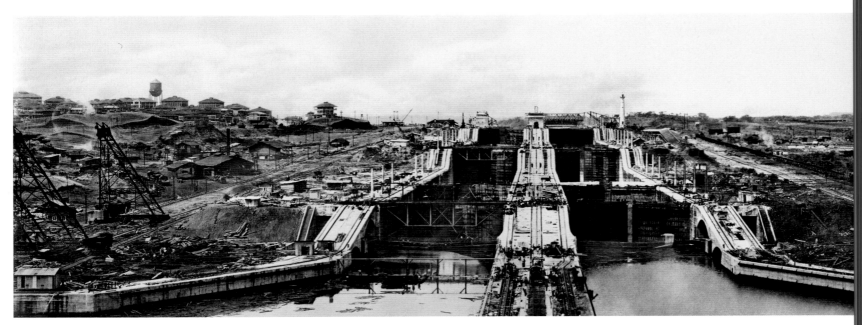

RIGHT VIEW OF THE LOCK
Just thinking about t
vague idea of the en
the daring, and the w

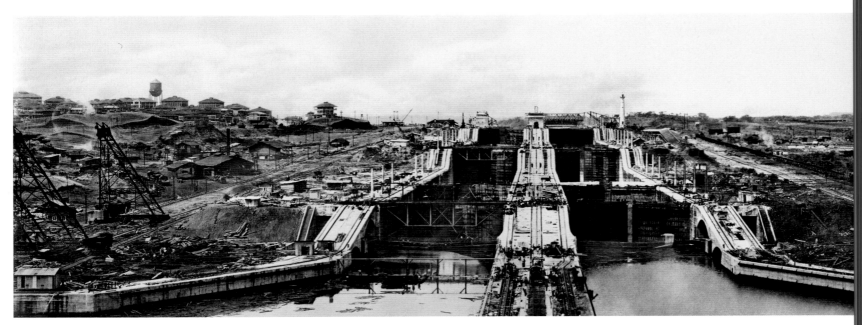

ABOVE PANORAMIC VIEW OF THE WHOLE CONSTRUCTION SITE, 1912
The United States is now completing a great task. A few months more and the Isthmian Canal will be an accomplished fact. It is fitting on the eve of the realization of the greatest engineering dream of modern times, to study the ways and means by which this magnificent dream has been made to come true ... give a clear conception of the vastness and intricacy of the undertaking.

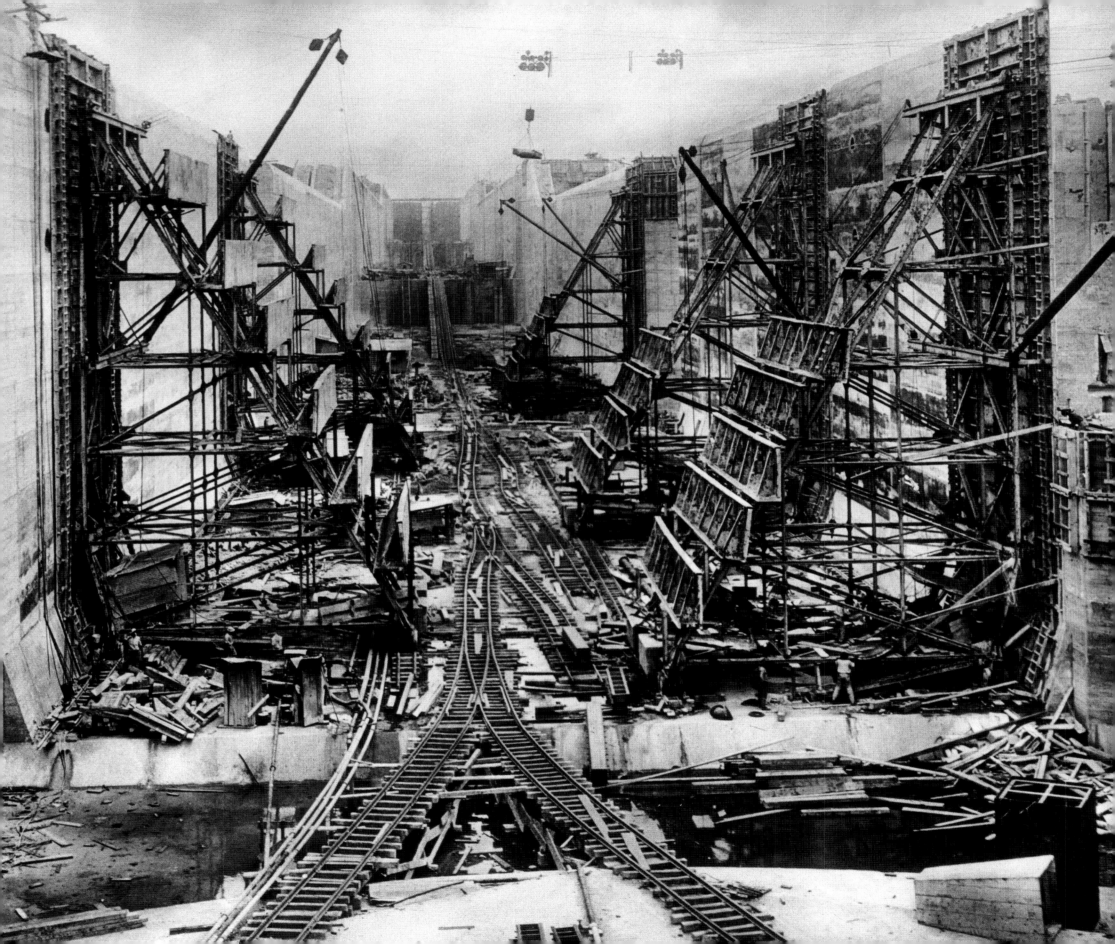

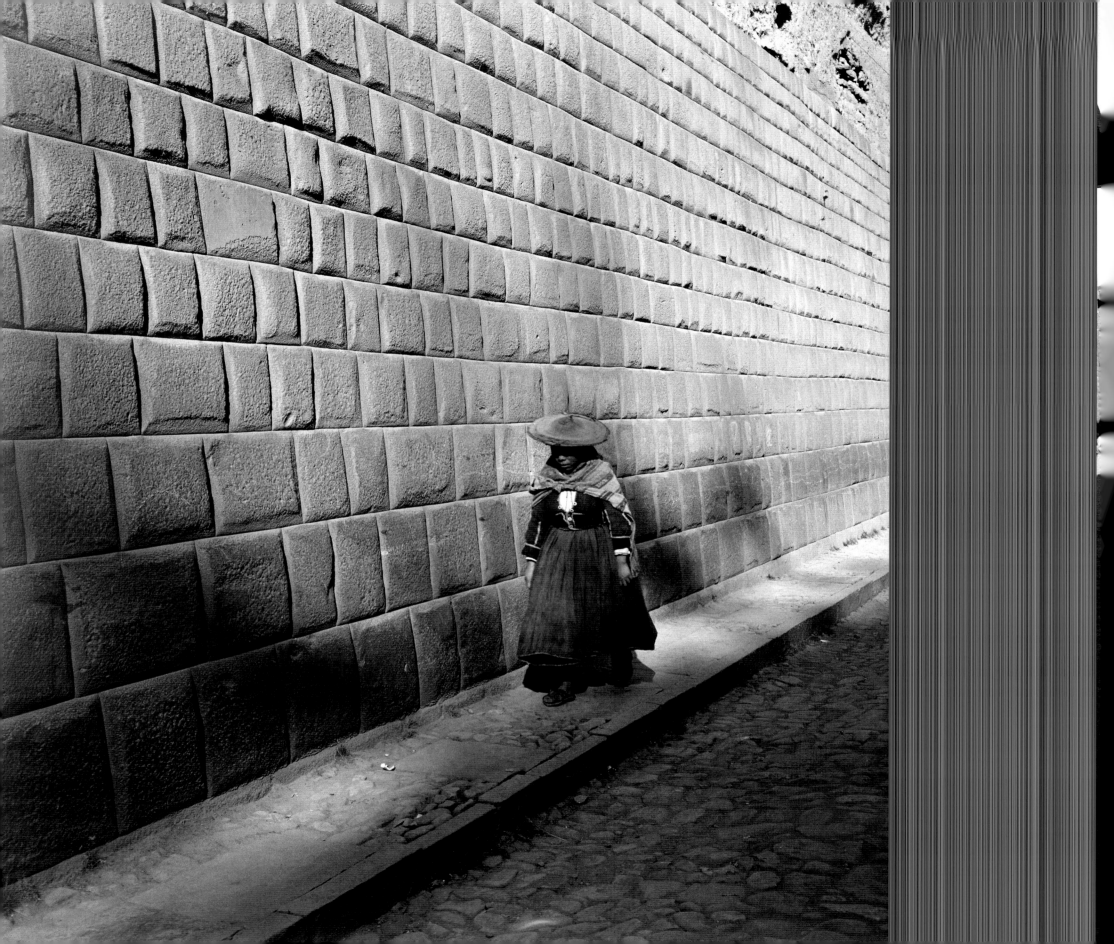

PERU
OVER THE ANDES

It's an awful blow to the Yankee's pride to visit South America. He has regarded it in his ignorance as a land of yellow fever and revolutions. Arriving there, a revolution is inevitable in the mind of the self-styled "American" of North America. He finds that the term *America* embraces about twice as much territory—and about twenty times as many nations—as he imagined.

The Andes hold second place among the mountain ranges of the world—the first place among the ranges of our hemisphere. Our first impression of the Andes is a gentle, distant, friendly one. On closer inspection the scenery is magnificently monotonous: bare, cruel mountains; bare, cruel valleys; everything on a scale so vast that nothing really impresses. Everything oppresses the spirit of the traveler. He yearns for the gentle grandeur of the Alps, the beautiful variety of Switzerland, the pretty terrors of the Austrian Tyrol.

The Andes are not lovable; they are grim, hideous, hateful piles of sterile rock—gorgeous in coloring, and yet unlovely to the eye. Only the more distant higher peaks are snowclad, but even they seem poorly clad in white mantles that are sadly worn and frayed. We look in vain for the unbroken, snowy surfaces that give, even in summer, so pure a beauty to the peaks of Switzerland. *[1935]*

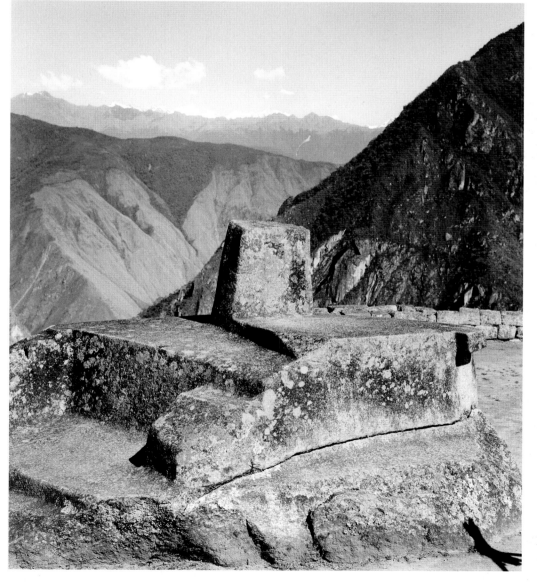

LEFT **NATIVE WOMAN, CALLEJÓN LORETO, CUZCO, 1935**
The high walls of Cuzco were built by Viracocha, an Inca ruler of the fifteenth century.
Callejón Loreto, a side street which runs off the Plaza de Armas, has many fine examples of the intricate Incan stonework still standing among the predominant colonial architecture.

RIGHT **THE SUN DIAL AT MACHU PICCHU, ANDES MOUNTAINS, 1935**
The walls and ruins of Machu Picchu sum up the enigma of the Incas: how and whence they came to be constructed. Fragments—caught in an ancient wisp of time, rarified but not forgotten.

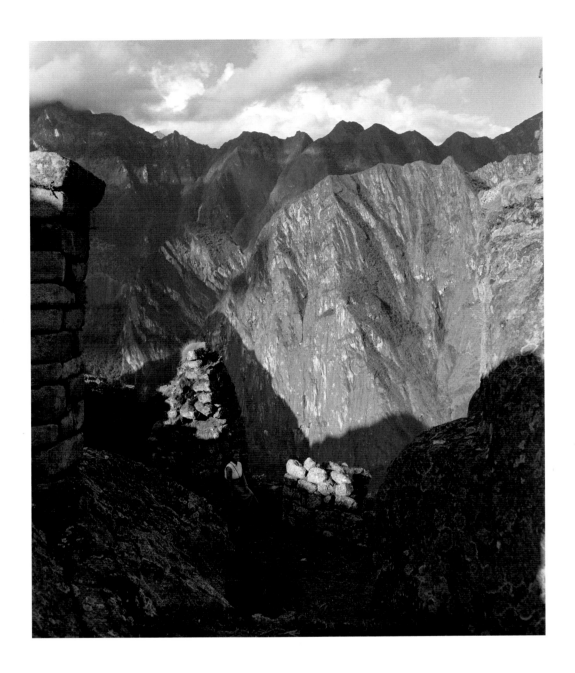

LEFT **THE VIEW FROM M...
MOUNTAINS, 1935**

RIGHT **THE TEMPLE OF TH...
OF HUAYNA PICCHU...
MOUNTAINS, 1935**

*The lost city of Mach...
attention in 1911 by ...
III. He and a small gro...
pre-Columbian ruin q...
ing in Peru's Andes M...
Valley.*

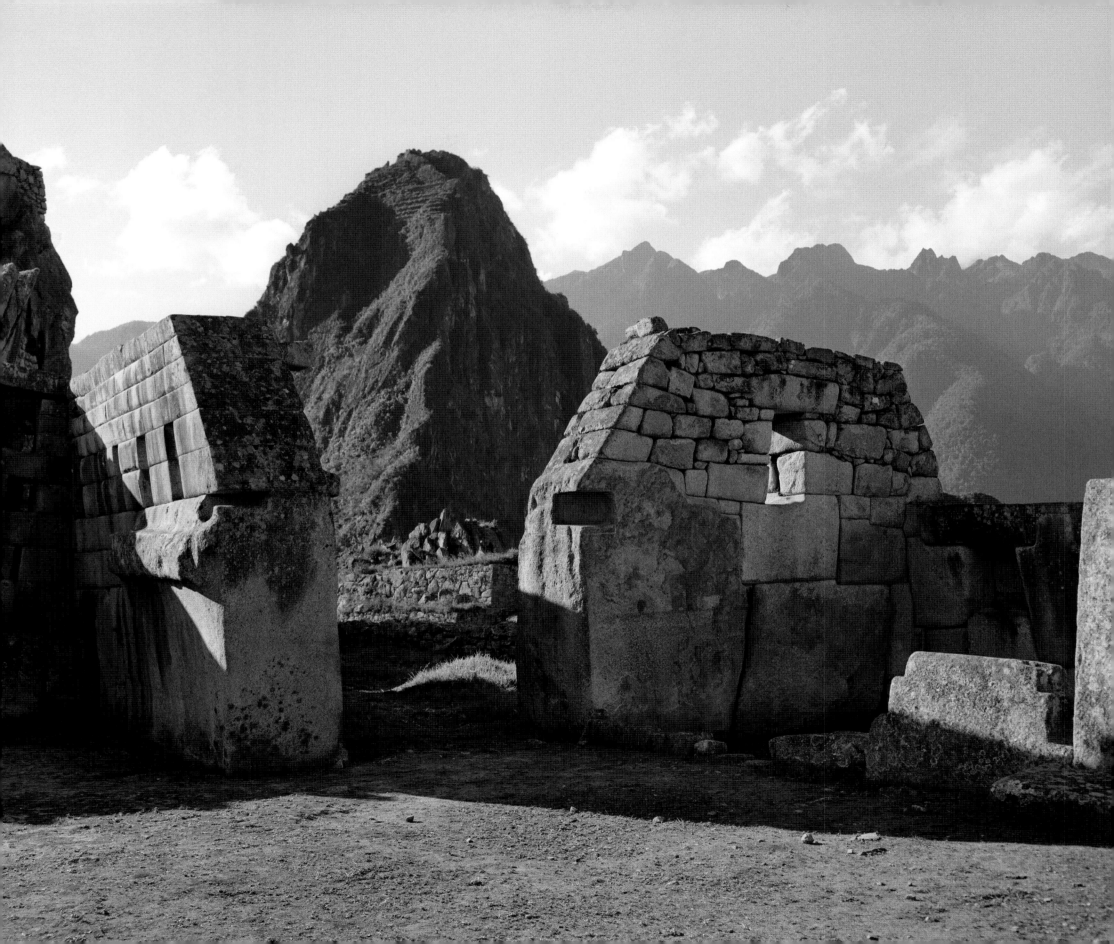

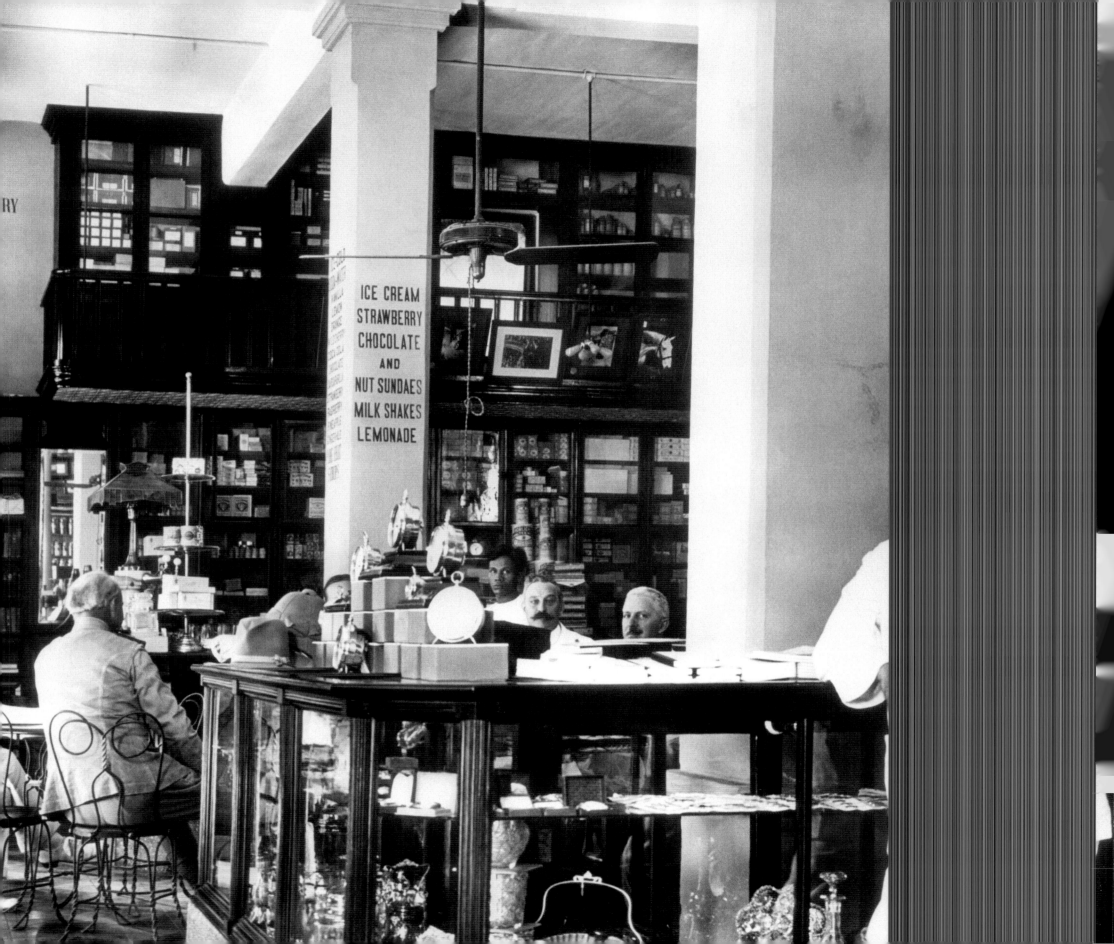

THE PHILIPPINES
THE THRIVING FAR EASTERN ARCHIPELAGO

In 1899, America was looking with anxious interest toward the Philippines. Admiral Dewey, his work accomplished, had left Manila; General Otis, as Military Governor, was in command; the Filipinos under Aguinaldo were successfully defending themselves, and all the American forces were confined to the immediate surroundings of Manila and to a thin wedge of country bordering the railway that leads northward from the capital. This being the situation, it would appear that little inducement was offered to the traveler to direct his steps toward the Far Eastern archipelago that fate had assigned to Uncle Sam. But Manila itself was accessible, and the situation, political and military, presented picturesque aspects that appealed even to the globe-trotter intent only upon what is called in the East, "Look-See." *[1899]*

It takes three days to cross the China Sea from Hongkong to Manila. On my 1913 voyage our steamer is the famous *Esmeralda*, grown old in this service. Our traveling companions are white folk, black folk, brown folk, yellow folk, and sundry other individuals variously "complected."

The voyage begins gaily enough; a lovely night, big tables spread on deck, all hands hungry. Once outside the harbor the winds begin to howl and the sea rises. Diners one by one forsake the tables and retire to bunks that are so stuffy that those who are not already bedded down have to be crammed into sleeping-places on the upper deck. I slept upon a pile of life-rafts, my companions in cots and long-chairs of bamboo. The first day out was the hottest and wettest I have ever lived through; shower after shower of tropic fury came at half-hourly succession and each one stayed with us for a full hour, so, as it were, the showers overlapped. Thus we accumulated downpours until the decks ran deep, and the canvas awning leaked copious streams. A miserable, sticky, lazy, hopeless day!

LEFT **GENERAL STORE OWNER, MANILA, 1913**
The business world of Manila, in which several transplanted American merchants are conspicuous parts, is centered in five or six squares of modern stores and offices. When walking in these streets, the traveler can easily imagine himself in the business district of a small American town; he sees familiar articles exposed for sale, reads signs that he has read before, meets people like the people whom he knows at home.
To add to our feelings of comfort, we find drugstores offering sizzling soda-water, and fountains where soft ice-cream and soapy frothy drinks are doled out by familiar-looking clerks. There is a "hot time" in Manila from 11 A.M. to 4 P.M., and this accounts for the immediate success achieved by the American ice-cream soda-water fountains now operating in the Philippines. "What if there is no milk or cream to be had?" The so-called "ice-cream" here has a least one virtue—it is cold; and what if the fountain frequently fails to fizz and the syrups sour early in the day? There is a grateful reminder of home in the familiar printed signs concerning shakes and phosphates that relieve even the most homesick of our fellows.

RIGHT **THE MORO CHIEFTAIN DIKI-DIKI AND BURTON HOLMES, 1913**
The Moros are believed to be of Malayan descent and one of the world's few remaining Pygmy peoples, characterized by their unusually short stature. The Moros openly defied the Americans in 1898, when these fierce Mohammedan fighters battled the American troops. The Moro are by nature and tradition an independent and dauntless people, and the land they have occupied for centuries is sacred to them.
We visited one of the Moro settlements of Mindanao, where we met and talked with the Datu (chieftain) Diki-Diki, a skilled and able village leader, who received us with a cheerful, gentlemanly demeanor offering us the full hospitality of his people.

The second day is fair and calm, a rare day in these troubled waters. Few of us have energy enough to dress; we open and shut unread books, and after a day of utter idleness closed by a gorgeous sunset, after a glimpse of the peaks of Northern Luzon, we again make our beds on the deck—men, women, and children in pajamas and kimonos—and sleep like patients in a hospital ward. Terrific rain and thunder-storms break the monotony of the night; we wrap ourselves in macintoshes, roll up our bedding and sit upon it to keep it dry until the awning ceases to leak; then we lie down again until another downpour forces us to repeat the operation. And when we finally awake at 5 A.M., we discover that we have passed the island of Corregidor—that we are already in Manila Bay. There in the distance the long low line of the Filipino capital is cut against the misty morning sky. The Bay is vast, and it is only on the clearest days that Manila Bay appears to be a landlocked sheet of water; it usually resembles the open sea, and frequently the rough waves make the resemblance unpleasantly remarkable. All hands are eager to put ashore after our three-day adventure at sea. [1913]

In 1899, the first motion picture camera ever seen in Japan, China and the Philippines, was brought in by Burton Holmes to film travelogues on each country. He was the first filmmaker to film the Aquinaldo Insurrection and the Battles of Baliuag and San Fernando in the Philippines. Holmes later met and filmed U. S. Admiral Dewey in Hong Kong following his victory in the Battle of Manila. In 1913, he returned for a second visit to see what had been accomplished in the islands for the Filipino people in the fifteen years of the American occupation.

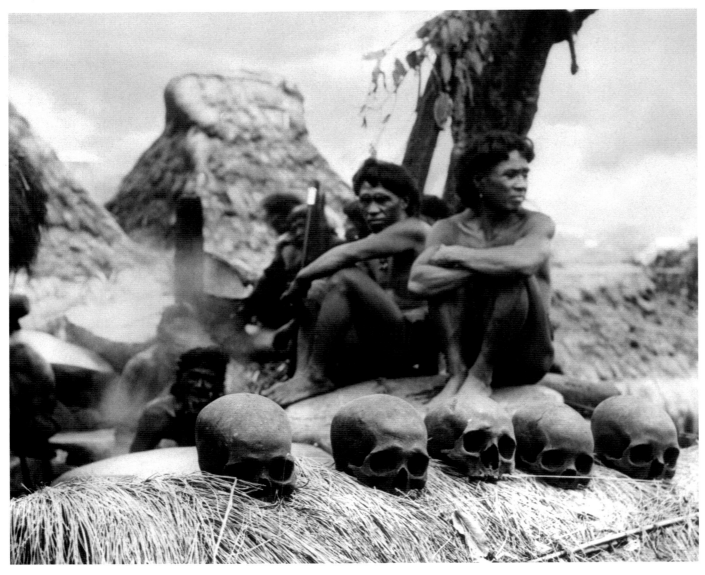

LEFT **THE IGOROT, BONT**
We toured the lovely
culture and civilizatio
tly as one tours Engla
friends and followed
gadores—former head
over superb mountai
A difficult six-day trek
jungle terrain brough
home of the Igorot, a
The old men of Bont
of their youthful prow
so to speak, the Natio
taken in a dispute onl
by the Mayor of the t
I found a new world f
and as safe as Switzer

RIGHT **THE IGOROT CONS**
At the Provincial Gov
by the Governor, who
to show us what a spl
from these superb na
dialect and orders the
and very little else! Th
belt (and sometimes,
beautiful, bronze Bor
ped to have their pict
clad.

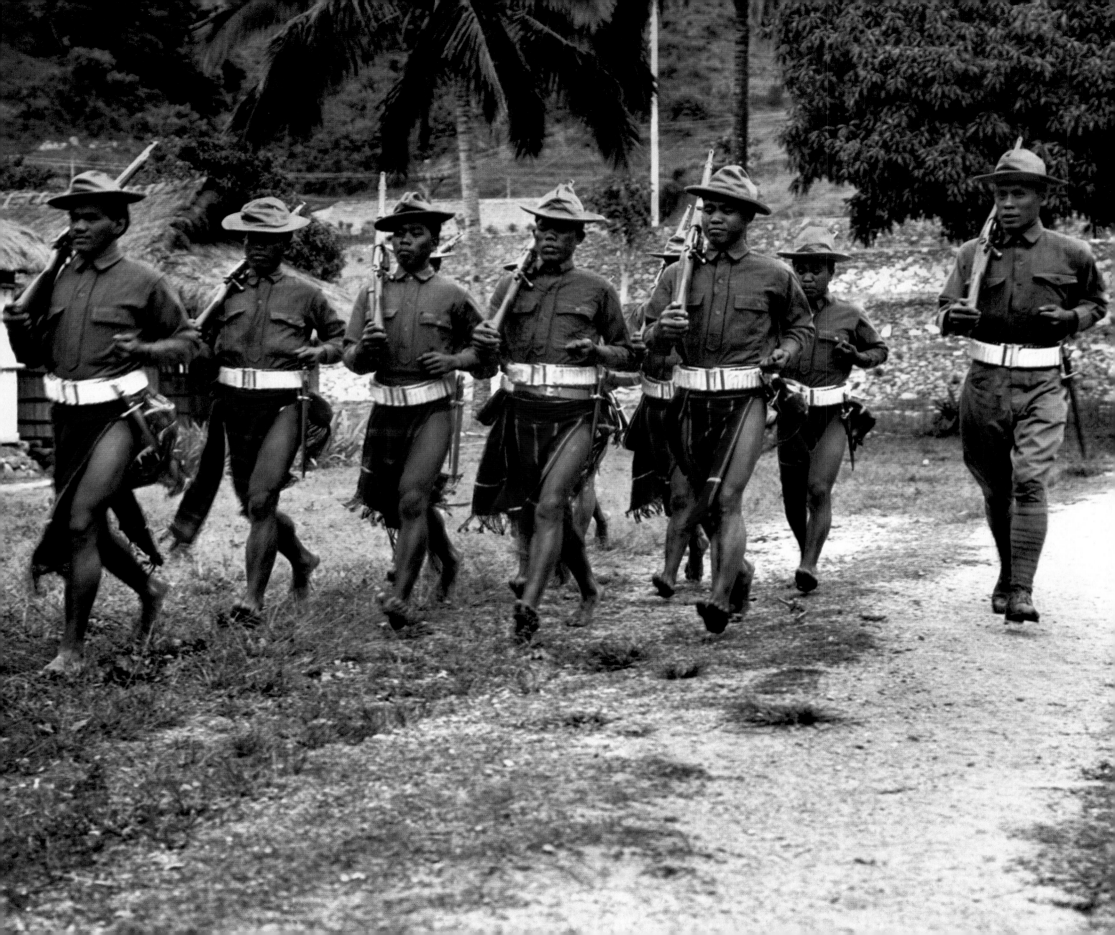

PORTUGAL
NATION OF GREAT SEAFARERS AND EXPLORERS

Portugal was once the foremost nation of the world. As a back-ground for the romantic story of her brief age of glory, there is one of the loveliest lands of Europe, studded with architectural monuments, almost unrivalled in magnificence. After a sojourn in splendid Lisbon, the capital, attending thrilling bull fights, and witnessing imposing religious ceremonial processions, the traveler wends his way northward through scenes of beauty, visiting verdurous Cintra with its castle-crowned heights, the superb monasteries of Mafra, Alcobaca and Batalha—the "Battle Abbey" of King John I, one of the most beautiful buildings in the world—the quaint interior towns like Thornar, with its stronghold of the Knights of Christ, and the old town of Coimbra, which was once capital of the kingdom, with its souvenirs of Inez de Castro, whose story is one of the most tragically romantic of all history— Bussaco's field of blood and mountain grove of beauty, the scene of Wellington's great victory—the holy hill of Braga and the busy port of Oporto, whence passing through the *"paiz do vinho,"* the "land of wine" he bids a reluctant *"adeus"* to Portugal in the wild gorges that lead out toward Spain.

The motion pictur[...] ness, scenes of street li[...] Christi processions and t[...] ular bull fights of Portug[...] ship of the *cavalheros*, th[...] reckless daring of the *m*[...] caught up by the horns of[...] lor panoramas reveal the[...] Oporto. *[From Burton H[...] Gibraltar to the North C[...]*

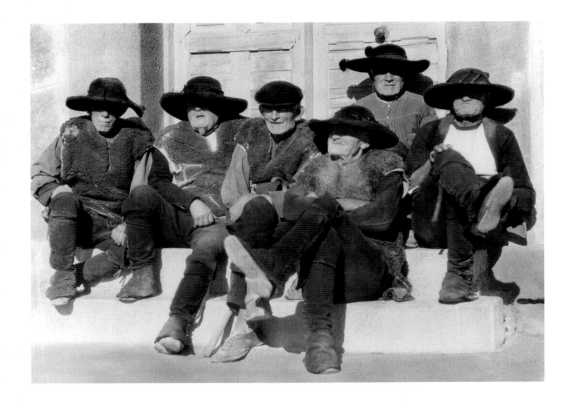

LEFT **WINE MERCHANTS[...]** **MADEIRA, 1902**

RIGHT **PRAÇA DO ROSSIO,[...]**
One of the main squa[...]
the 1755 earthquake[...]
of the square is the 1[...]
and a statue of Pedr[...]
of Portugal—tops the[...]

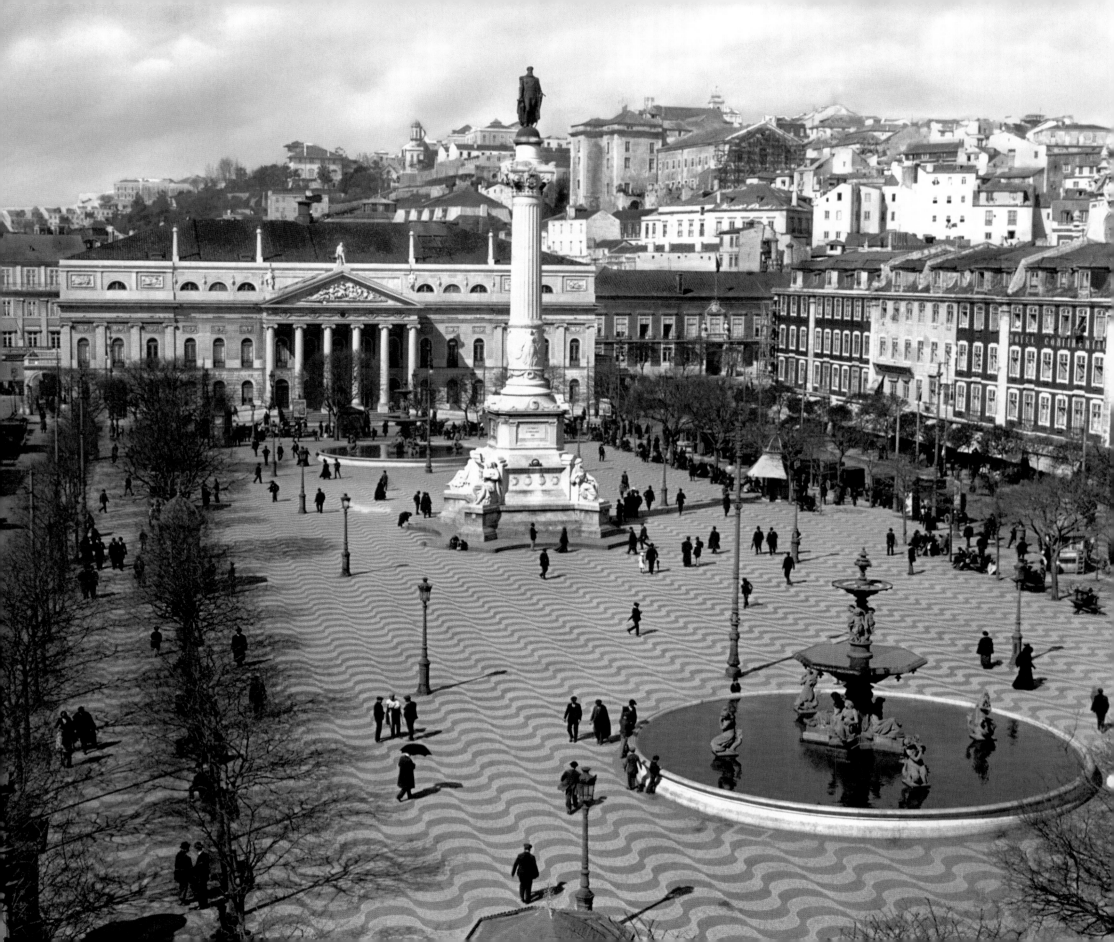

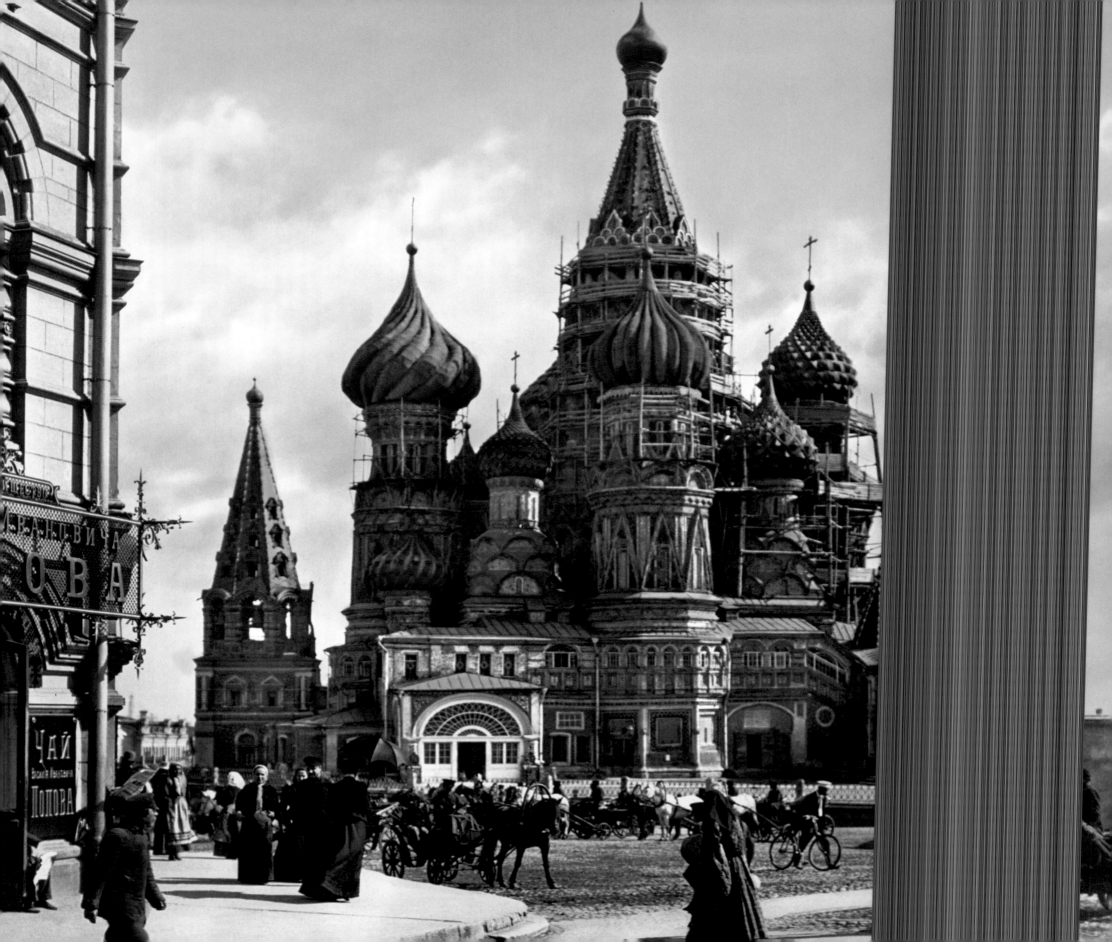

RUSSIA
COLSSUS OF THE NORTH

The dawn of the twentieth century finds Russia one of the most conspicuous figures among contemporary nations. The world, amazed by the achievements of Russian diplomacy in Europe and of Russian enterprise in Siberia, is asking what the Muscovite will next attempt. Russia invariably replies, with courteous and modest words, that she is planning no surprise, and has in view no ends save the welfare of her people and the preservation of universal peace.

She announces no policy, she never says that she intends to do a given thing; she does not speak until she can make known her attitude with the triumphant phrase, "The thing is done." The rest of Europe never learns what Russia has accomplished until it is too late for the undoing of her prodigious achievements.

Russia can no longer remain an unfamiliar land. The searchlights of investigation— historical, political, and scientific—have been turned upon her mighty empire, revealing its conditions and its possibilities, showing the world what Russia is. To our searchlight—the photographic, focused upon the picturesque—is left the overwhelming but delightful task of showing you what Russia *looks like* at the present day.

Russia, that "dread Colossus of the North," has been for many years the most imposing figure among modern nations. Today, although threatened with defeat—a colossal defeat as befits a colossal nation—Russia still looms imposing in the minds of men, and the world is asking how and why Russia in her might and hugeness now finds herself seemingly helpless. There is no surer way to find an answer than to visit

Russia—to study Russian life in the broad avenues of imperial St. Petersburg, in the icon-studded streets of holy Moscow—in the simple home of Tolstoi and in the dark hovels of the ignorant ex-serfs—in the subjugated provinces of the Pole and the Finn and in the splendid domain of Siberia, won from the wilderness by the untiring Slav.

Russia is usually regarded as the home of semi-savages; glazed over with a veneer of polish, through which the barbaric Tatar is instantly attainable by the finger-nails of those who dare to scratch the Russian. But nowhere in all the world have I found the police so unfailingly polite, or the people more considerate and courteous to the foreigner. I do not speak without experience. I took seven hundred photographs in Moscow—I had seven hundred interviews with policemen.

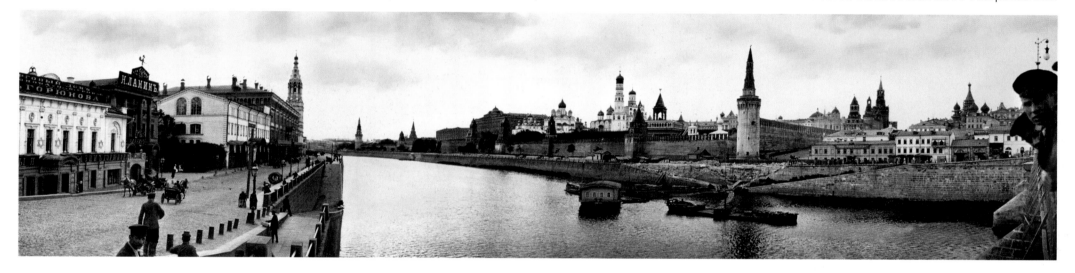

ABOVE **VIEW OF THE MOSCVA RIVER AND THE KREMLIN, MOSCOW, 1901**

LEFT **ST. BASIL'S CATHEDRAL, MOSCOW, 1901**
One more reminder of an architecture that is now no more is the unspeakably fantastic Church of St. Basil's, honoring a mendicant monk of the 16th century, said to be as crazy as the design of his marvelous memorial. Description falters, words lose color, and phrases utterly fail to frame this structural monstrosity, so monstrous in its ugliness that it is positively beautiful. It's true that every civilization in every epoch has produced its characteristic pile. In the Church of St. Basil's are distinctly typified the civilization of the early

Moscovite and the fearful reign of Ivan the Terrible, the Nero of the Slavonic race. Just as Ivan's Imperial torturer brought his victims to an ecstasy of agony so intense that they knew not whether they were suffering pain or pleasure, so this creation of his architect tortures our eyes, until we exclaim in one and the same breath, "How hideous!" "How beautiful!" and know not which expression voices our true feeling. We know not whether to praise or to blame Czar Ivan, who put out the eyes of the unhappy designer of this church lest he should build another like it.

Each one began with a salute, a courteous demand to see my permit papers; then a careful perusal of the permits, an apology, and a farewell salute. I did my best to get arrested, knowing that such a happy mishap would delight my managers at home, for it would result in much gratuitous publicity.

Moscow is even older than the Empire. She is indeed the mother city of the Russians. The history of Moscow until the founding of St. Petersburg is the history of Russia. The old and the new capitals are strikingly dissimilar. St. Petersburg, with a population of one million three hundred thousand, is an artificial product, forced into being by the imperious will of one astounding man—the man whose name it bears, Peter the Great.

No foreigner can look at Moscow without deep emotion; and as for Russian peasants, when they approach this sacred city of the empire, and see its gilded turrets gleam like golden helmets in the sun, they often fall upon their knees and weep for joy, moved to an ecstasy of religious feeling.

To enter Russia is popularly regarded as something of a feat, as difficult as the passing of a camel through the eye of a needle; but in our case, we—the camel—properly ballasted with passports, slipped through the needle's eye at the frontier town of Alexandrovo with astonishing ease and celerity. Before we had been two minutes in Russia, popular fallacies began to fade so fast that we were tempted to turn back lest we should lack, in this misunderstood country, sufficient

material for the traditiona
from the traveler. We arri
express-train from Berli
metropolis of Poland.

At Alexandrovo the
ly because passports ar
because the gauge of the
made wider than the c
Napoleon of the future wl
to St. Petersburg by rail. E
wait until all passports ha
whose papers are not in
hie themselves towa

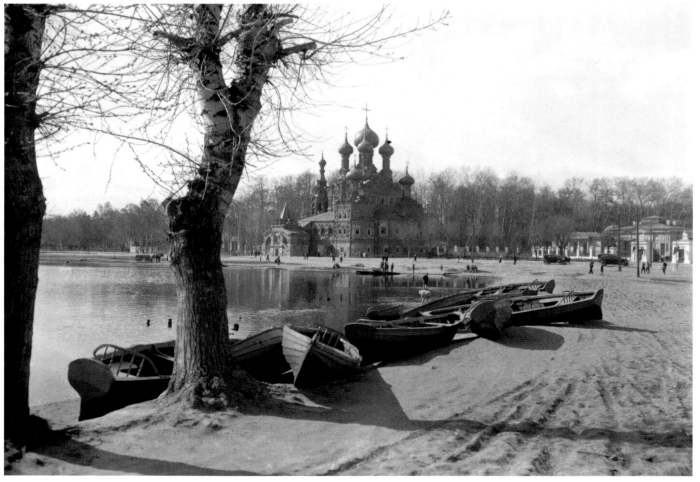

LEFT **TRINITY CHURCH, (
OUTSIDE MOSCOW**
We drive out into the
Moscow to visit the
Ostankino. The pala
decorations designe
mer mistress of Osta
serf, an actress whos
to the foreign tongue
Everything about the
rate, but we were as
player and that the t
her for the entertain
Imperial guests were
supported. The pala
gardens, is now the
the neighboring cap

RIGHT **THE TSAR'S BELL,**
The Tsar's Bell, the h
bell was cast in 173
two years later, befc
tion cracked off a fr
robbed the mighty
been today—one of
world. That fragme
it is worn glossy by
everyday caress it
the attraction of thi
to every touch an a
life of all the million
terious way passed
a sentient, respons

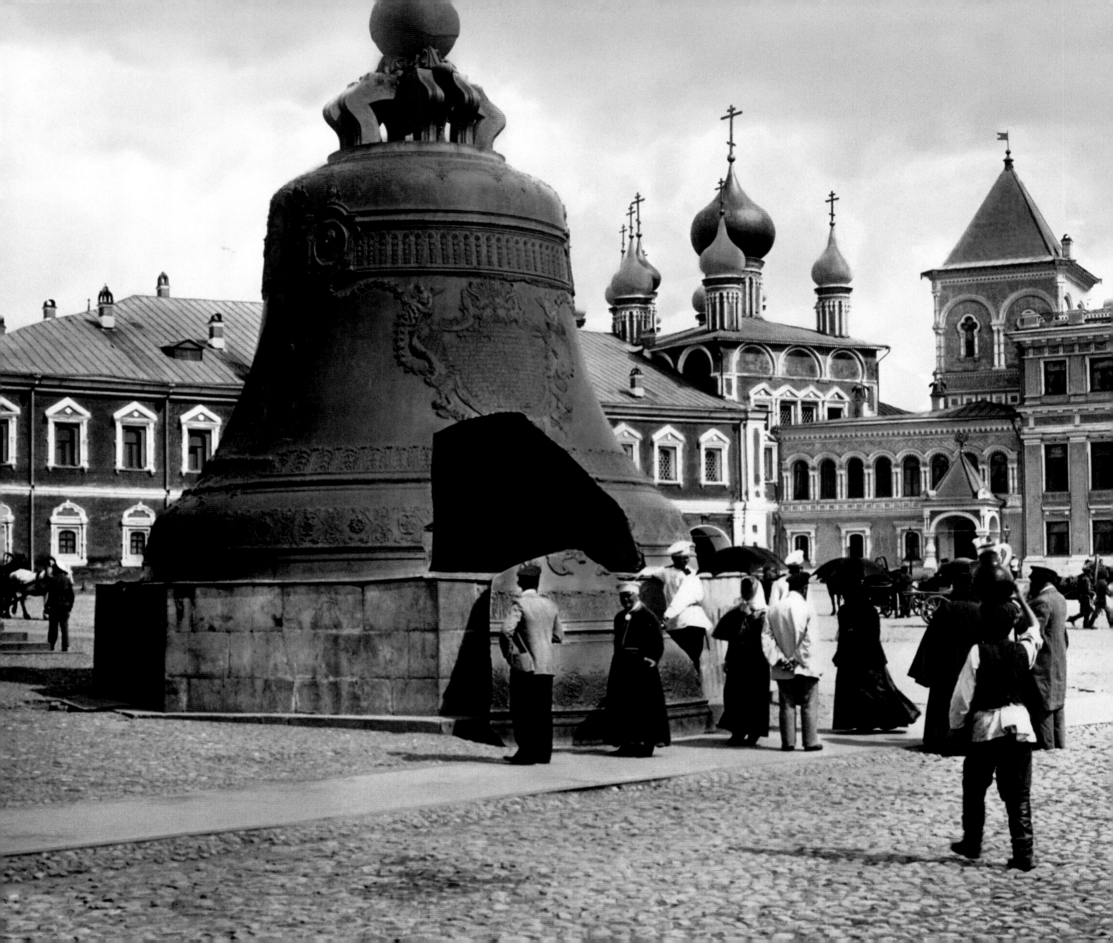

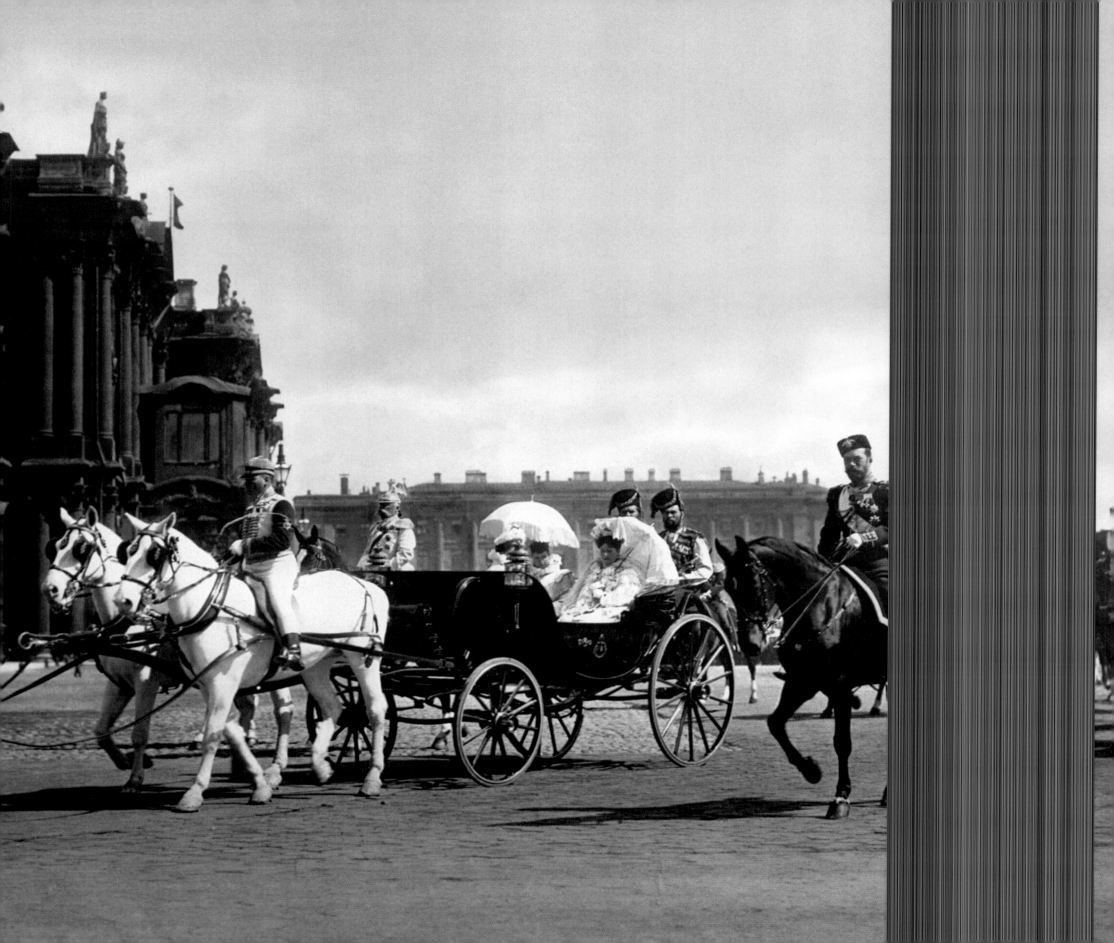

a dozen people are refused admission; among them an old woman who is pleading with an officer, vainly reading to him a telegram from her daughter, who is dying in a town not far across the line. The officer was inexorable but as courteous to her, in his refusal, as he was to us when we presented our crisp new passports from America. Four trunks of photographic material are carefully examined by the customs-guards, while the officer, intensely interested in our outfit, discusses with us the respective merits of our various instruments, and then passes the whole formidable array without opening any of the sealed boxes of plates or mysterious tin cans containing more than a mile and a half of motion-picture film.

An hour later we are speeding across the cultivated plains of Poland en route for Warsaw, whence we proceed a few days later to St. Petersburg by rail. We arrived, unloaded our baggage, proceeded like experienced travelers to St. Petersburg's best hotel, but we are caught by the burst of glory that attended the going down of the sun. We lingered far into the night—the night according to our watches only, for darkness never came at all; the sunset glow crept slowly northward, that was all, until somewhere, just below the bright horizon, the sunset glow was transmuted in the caldrons of the deep into the gold of sunrise. Meantime, the silvern moon stole timidly behind the clouds, and finally the blush of the retiring day was changed, there, in the north, into the flush of the new day, the dawn of which gilds for us the domes and spires of St. Petersburg. *[1901]*

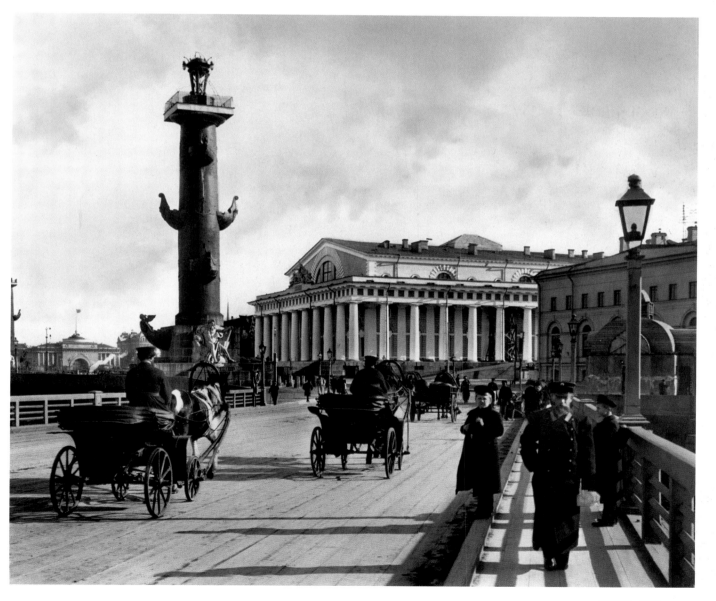

LEFT **THE TSAR AND TSARINA, ST. PETERSBURG, 1901**
A mighty host of dignitaries and royal figures awaits the coming of the Tsar, who is now riding from the Winter Palace beside the carriage in which sit his wife, and his mother, and his sister: the Empress Marie Feodorovna; the Empress-Dowager, widow of Alexander III, sister to the Queen, Alexandra; and the Grand-Duchess Olga Alexandrovna, daughter of Alexander. Meantime the multitude on the field of the review is warned of the Imperial approach by the thundering cheers which roll along the quays and avenues as the Imperial family advances. Because of our permit, which we frequently flash, signed by His Excellency General Kleghels, Grand Master of the Metropolitan Police, we are far in advance of the first rank of spectators when the carriage of the Empresses moves slowly down the nearer wall of troops. His Majesty the Tsar rides at the left, two paces in advance; his simple uniform just visible to us over the backs of the white horses. Meantime we seize the golden moments to make a motion-picture record of the passing of an Emperor, two Empresses, and an Imperial escort.

RIGHT **ON VASILIEVSKY ISLAND, ST. PETERSBURG, 1901**
The elegant old pile, The Bourse, erected in 1805 to house the stock exchange, sits on a spit of land on Vasilievsky Island. The most picturesque features of the place are the Rostal Columns, actually lighthouses, with their odd-looking nautical ornamentation, built during the reign of Peter the Great.

Burton Holmes visited the Trans-Siberian Pavilion at the Paris Exposition in 1900, where he was intrigued by the simulation of scenery one would see through a train window on the actual Trans-Siberian run. He impulsively purchased a ticket and Russia became his next destination. Holmes's cameras revealed the actual aspects of unfamiliar Russia and the vast territories of Siberia in a forty-two day journey across Russia, nine of which he spent on the Trans-Siberian Railway.

On 19th of June, 1901, we begin our nine days' journey toward the Rising Sun. For three days we roll on across the somber lands of eastern Russia, where there is little to relieve the sad monotony save the crossing of several rivers and glimpses of big ragged cities on the Volga. We are impressed by the thought that for nine days the endless panorama of Siberia is to unroll itself to us as we stand gazing from the windows of our car. I say "stand" gazing because that is what we did all day and day after day in the confined space of the narrow corridor of our sleeping-car.

Departures are announced by the ringing of a big bell at the station. We soon learn not to be startled by the first ring, for it means merely that it is time to begin to think about beginning to commence to get ready to prepare to go. By and by comes another clap or two, just to remind us that the bell

has rung before. Then finally, after we have stepped aboard at the polite personal request of the numerous employees, a final ultimate and authoritative clang announces that something is really going to happen by and by.

Sure enough, after a shrill blast from the whistle of the station-master, a toot from the horn of the switchman, and a squeak from the locomotive, the Trans-Siberian Flyer does move at last and before long there is nothing in sight except distance, bisected by the straight and seemingly endless line of the track.

On the ninth evening we roll into the great Siberian city of Irkutsk—metropolis of northern Asia. We are on time to the minute; but this is not remarkable, for the schedule is so arranged that if the brakes were not in working order, even these leisurely, inexperienced trains would have difficulty in avoiding premature arrivals. We have covered roughly three thousand miles—between Moscow and Irkutsk—in nine days, at an average speed of about fifteen miles an hour.

Russia is always striving for effect, and here in Irkutsk we get the same impression as in St. Petersburg, of a city built to order—designed to impress the observer. The same "stone" walls of stucco, the same "marble" pillars of staff, the wide streets and the endless avenues, still unpaved and

insistently suggestive of th
formed a part. Space is the
The Russians have been pr
cities. The Orthodox Cath
needs of a city four times t
critical tourist must not f
future quadruple its popul

We board another t
uing our journey to Lake E
arrive in Stryetensk on th
terminal in 1901. Our tri
Shilka River to the Amur
banks to Khabarovsk. Bef
the tide of travel was still f
soon discover, it is not fl
and a water-famine on th
the shallow Shilka, horse
result of the shallowness,
steamer had left the da
friends who had not linge
to make sure of the of
chances on catching it, a

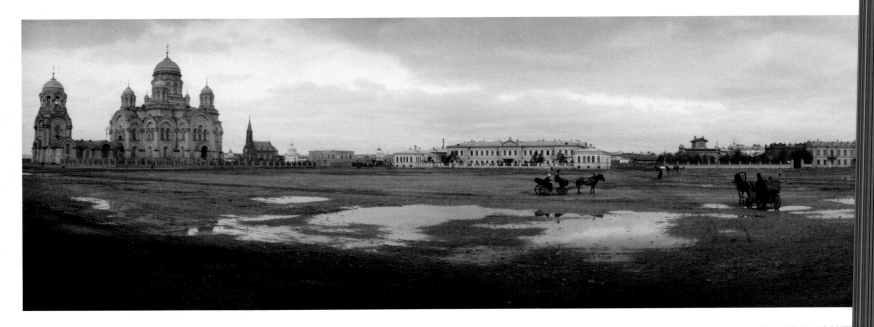

ABOVE **PANORAMIC VIEW
OF IRKUTSK, SIBE**

RIGHT **THE RUSSIAN OR**

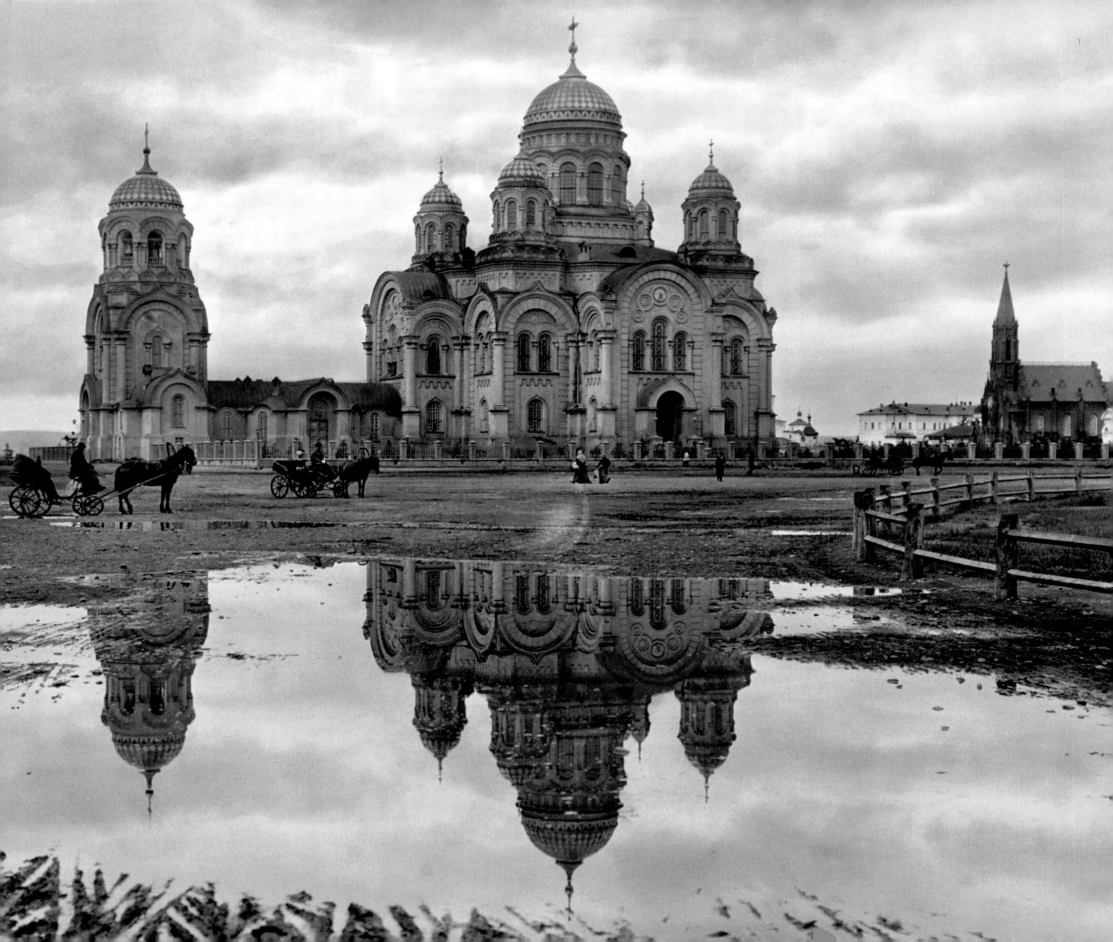

On his last trip to Moscow in 1934, Holmes went on to write:

"It won't be long now before we see the golden domes of Moscow," I say to my friend as we pass what looks like a suburban station. But the golden domes do not appear. Instead all I see are the tops of smoking chimneys and the ugly, endless walls of factories and flats. We might be coming into Manchester or Pittsburgh. What has become of the colorful oriental capital of ancient Muscovy? What has become of lots of things that used to be in Russia? My impressions of thirty-three years ago have already begun to revise themselves.

The train pulls into a big, busy station. Before my belongings have been touched by any porter, a tall, spare, tired-looking man inquires in English, "Are you traveling Intourist?" He takes charge of me and my baggage, and I follow him to the exit, where he stows me and my belongings into a brand new Lincoln touring car. At my request, my German companion, who is to sp[...]me, is also taken under t[...]crowded streets we whi[...]drawn carts, and on all t[...]cession. From curbs t[...]crowded. "Why all these[...]there to be a special de[...]these are just people on[...]

ABOVE A RURAL STOP O[...]

RIGHT CROSSING THE S[...]

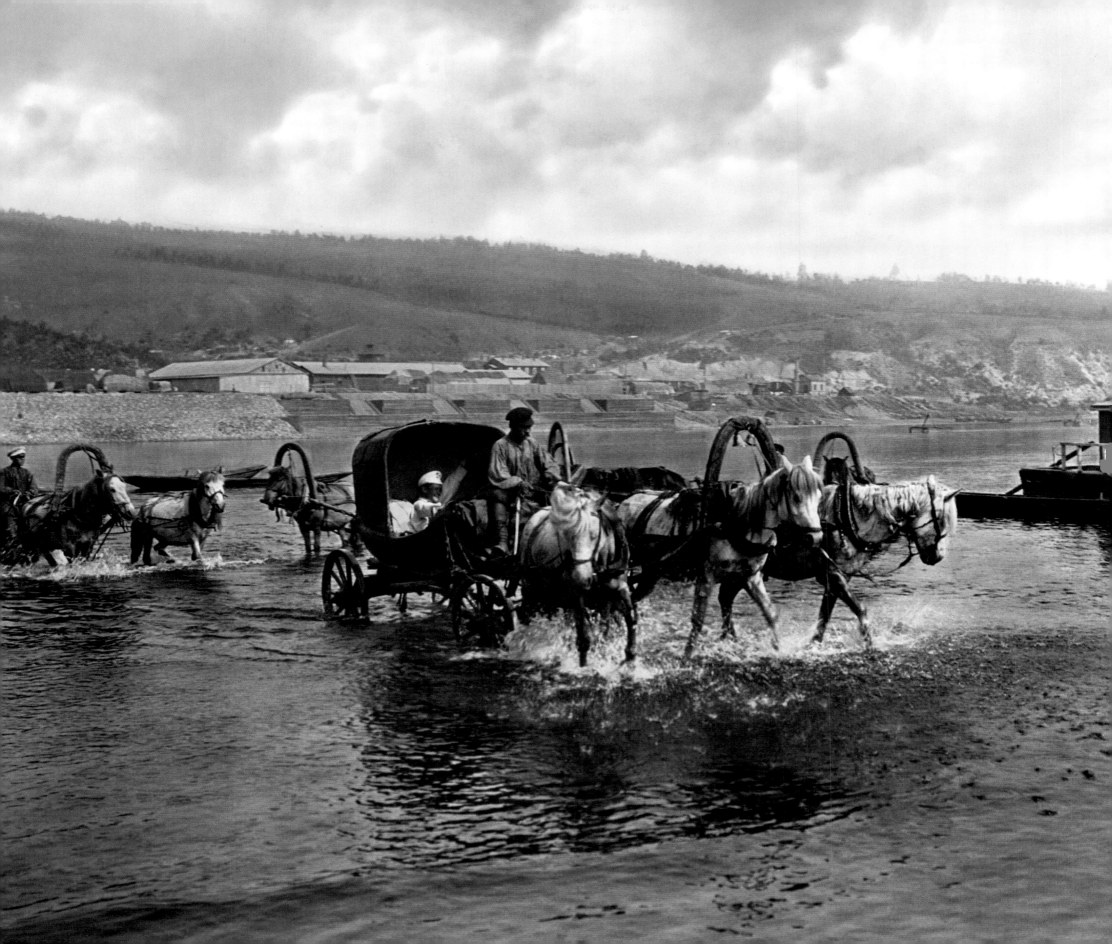

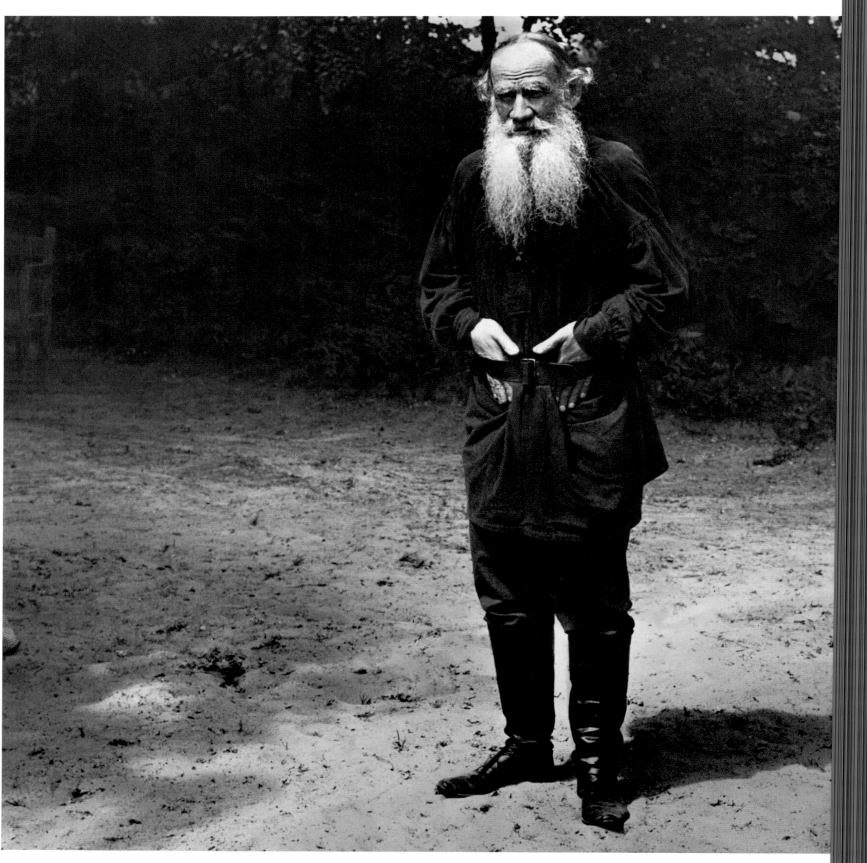

COUNT LEO TOLSTOI AT YASNAYA POLYANA, 1901

Tolstoi speaks English fluently, but with an accent that suggests the speech of famed Shakespearean actor, Henry Irving, with an added Gallic twist. He talks upon a dozen subjects with equal interest, enthusiasm, and, above all, originality. There should be no law; no man should have the right to judge or to condemn another; absolute freedom of the individual is the only thing that will redeem the world. Christ was a great teacher, nothing more. This was the sum and substance of his views as expressed to us in June, 1901. But Tolstoi both claims and exercises the right to revise opinions, and proclaims from time to time a new and always startling attitude toward the truths and contentions in the great area of philosophic thought.

We breakfasted with him on the veranda, a large and loving family gathered around the samovar; the two dainty grandchildren relieved with a note of youth and hope and freshness the almost sad impression produced upon us by the atmosphere of neglect and tumbledownness permeating not only the peasant village, but even the house and private grounds of the estate, of which the Russian title, "Yasnaya Polyana," means the Bright Plain, or the Illuminated Field. Even if we cannot sympathize with the almost fatalistic philosophy of a return to nature—a philosophy that would let all things return to seed, we are not blind to the brightness that illuminates Yasnaya Polyana, for it is the brightness of a mighty mind, an intellectual luminosity that has lighted for all time the dark path trodden by oppressed humanity.

The great Russian author poses for a still camera shot. He has never seen a motion picture camera, and he is unaware he is being filmed. So he patiently keeps talking and posing, perhaps thinking to himself that these Americans must be incredibly incompetent photographers to be taking so long to make a simple photograph. Note: Holmes used the alternate spelling to the more familiar, Leo Tolstoy.

IN THE VILLAGE OUTSIDE COUNT TOLSTOI'S ESTATE, YASNAYA POLYANA, 1901

We drive through the adjacent village, peopled by the folk whose fathers were the serfs of the Tolstoi estate. A deformed woman and a big strapping mujik are persistent in their demands for money, and servile in their thanks upon receiving it. As we gaze about us, we strive in vain to reconcile the altruistic theories of the master and the existent conditions in this village at his gates. Rank misery pervades the filthy and disgusting village—no better and no worse than villages in other parts of Russia.

RIGHT **THE BOLSHOI THEATER, MOSCOW, 1934**
I enjoyed a feast of beauty at the classic Bolshoi ballet the-
ater. Two tickets for the evening performance of the Bolshoi
Theater have been assigned me—one for the blonde young
woman who had been my guide and interpreter throughout
the morning. For these seats I was charged about four dol-
lars and a half apiece. They were good seats—where I like
them for a ballet, right down in the front row.
The Bolshoi auditorium is one of the most grandiosely pleas-
ing in the world. It looks a little bit run down at present but

the effect of the ens
curve one above the
orchestra to roof. Th
seat in every box is f
in many boxes. In so
the house is occupie
your place with the a
then you make your
ishment, there are v

BELOW **MAY DAY CELEBRATIONS, MOSCOW, 1934**
These two handsomely uniformed flute-playing youngsters
were privileged to be included in the May Day celebration.
It was an honor for the boys and a source of pride for their
families to be among the chosen few to play in the band
during the activities honoring May Day, a day of tribute to
the Tireless Workers of the Soviet Union.

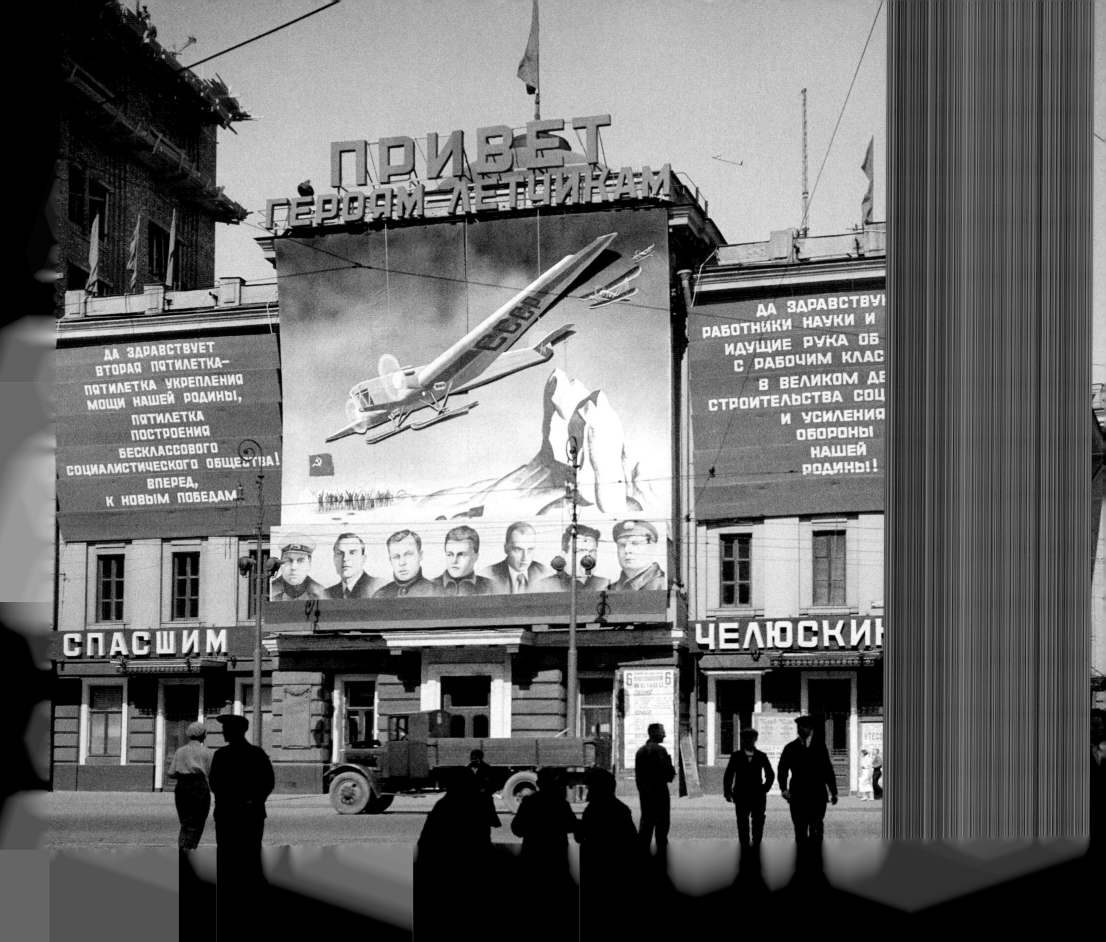

**THE HOUSE OF TRADE UNIONS, FORMERLY
THE NOBLES' CLUB, MOSCOW, 1934**

*The House of Trade Unions, near Red Square, was covered
in signs congratulating the pilots who saved crewmembers
aboard the icebreaker Cheluskin, which was crushed by ice
during a polar expedition in 1934. A film called Cheluskin
was released later that year, popularizing the heroic rescue.*

BELOW **PREPARATIONS FOR THE MAY DAY PARADE,
MOSCOW, 1934**

All Moscow looks like one vast red flag on the last day
of April. The May Day decorations are completed and in
place. They are astonishing. Along the front of the unfin-
ished fourteen-story hotel has been erected the most un-
believable decoration of all. The effect is that of a red flag,
ten stories high and perhaps two hundred feet long, almost
completely masking the wide façade of the high structure.
Upon the flag appear gigantic portrait heads: that of Lenin is
fully nine stories high; that of Stalin, a little less enormous;
those of the fourteen other leaders of the Communist Party
range from one to three stories in heights. As a political por-
trait gallery, this surpasses in sheer magnitude anything of
the kind I have ever seen.

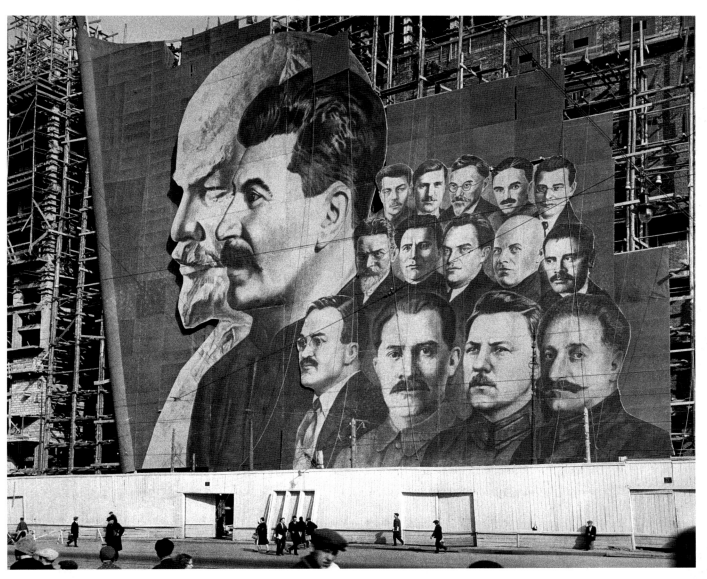

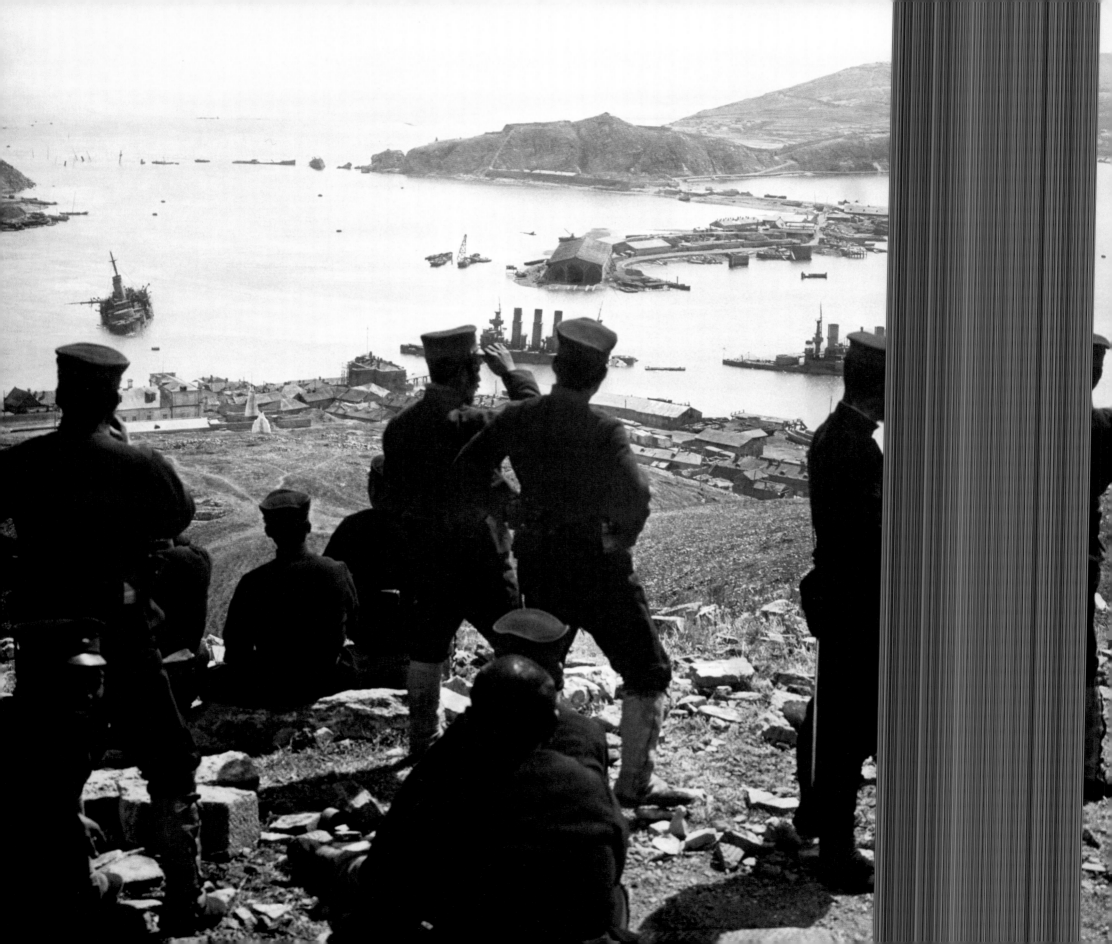

In 1905, Holmes wanted to do a lecture on the Russo-Japanese War to show the devastation at Port Arthur, Manchuria, in the great siege of the Russian stronghold by the Japanese. He asked two veteran war photographers/correspondents, James Ricalton and Joseph Rosenthal, for their permission to build a lecture around their war pictures, as he had great respect for both men and for the dangerous work they were doing covering the explosive, destructive war halfway across the world. He gave them full credit in the lecture and in the program materials, and although he did not take these photos, they are considered an important part of the Burton Holmes Collection.

I want to present to you as vividly as possible the best pictures of the Russo-Japanese conflict obtained by the few able, daring men who occupied dangerous points of vantage at the front, in the capacity of war-correspondents,

bioscopist or photographer: James Ricalton, war-photographer, loved and admired by Asiatic officers as well as the little correspondent colony of which he formed a part. All called him "Dear old Ricalton," for he is more than sixty years of age, yet he it was who made the major part of the war pictures you see, the risky ones, the ticklish snapshots at the snapping shells, and the tragic studies of the men under fire in the fatal trenches. Richard Barry calls Ricalton, "one of the world's obscure great men..." He has carried his Stereoscopic camera, for Underwood and Underwood, through many campaigns. He has never in his long life resorted to that easy, tempting practice of faking war pictures. His explosions and conflagrations were not made in the darkroom with a smudge of India ink upon the negative. His negatives, you have my word of honor, tell no photographic lies."

Joseph Rosenthal spent two years at the seat of war,

operating the Urban Bioscope, working ofttimes under fire, exposed to the same dangers as Ricalton. The photos are honest, truthful and real.

This destructive war developed out of colonial rivalries between Russia and Japan. Russia had penetrated Korea and Manchuria (spheres of influence claimed by Japan) and had hardened the intrusion by refusing to negotiate.

Japan laid siege on Port Arthur, bottling up the Russian battleships in the harbor. By 1905, the Japanese had captured the port, scattered the Russians at Mukden, and obliterated the Russian fleet at Tsushima. President Theodore Roosevelt mediated a truce between the warring nations. The conflict proved such a debacle for Russia that the demoralized armed forces mutinied, leading to the abortive Revolution of 1905. *[1905]*

LEFT **JAPANESE OFFICERS WATCHING THE SINKING OF RUSSIAN FLEET, PORT ARTHUR, MANCHURIA, 1905**
Japanese activity against Port Arthur was practically continuous for ten months and twenty days. The siege proper, after the taking of the outer series of defenses, lasted four months and nineteen days. His Excellency General Count Maresuke Nogi: conqueror of the strongest fortress ever reared by man, successful director of the most marvelous military operations in the history of war, the executive

genius of the siege who carried into effect with masterly ability the seemingly impossible designs framed by another genius, General Kodama.

BELOW LEFT AND RIGHT **TWO VIEWS OF THE RUSSIAN FLEET SUNK AT PORT ARTHUR, 1905**
All of the ships have been riddled, first, horizontally by shells from Togo's fleet, then vertically, raked up and down, from bridge to bunker, from deck to keel, by the shells from the

big guns concealed three miles away behind the hills, unseen but not inaudible, and feared, as man always fears that which he cannot see and against which there is absolutely no defense.

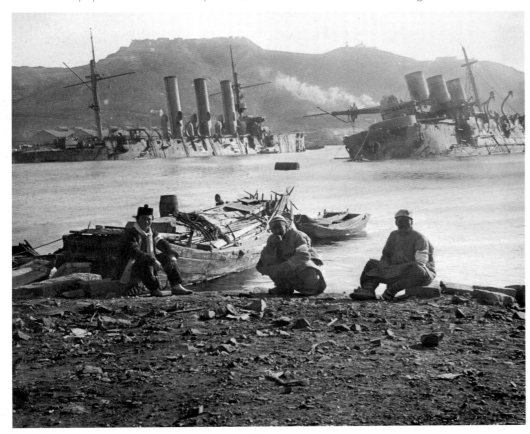

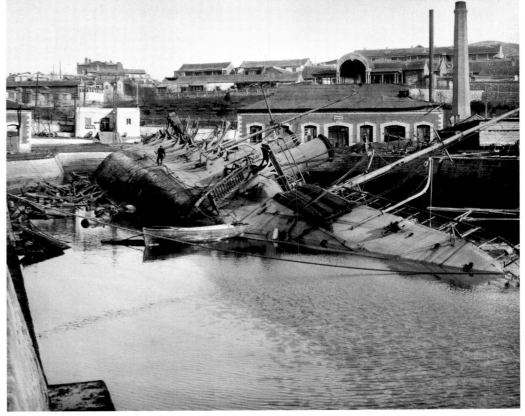

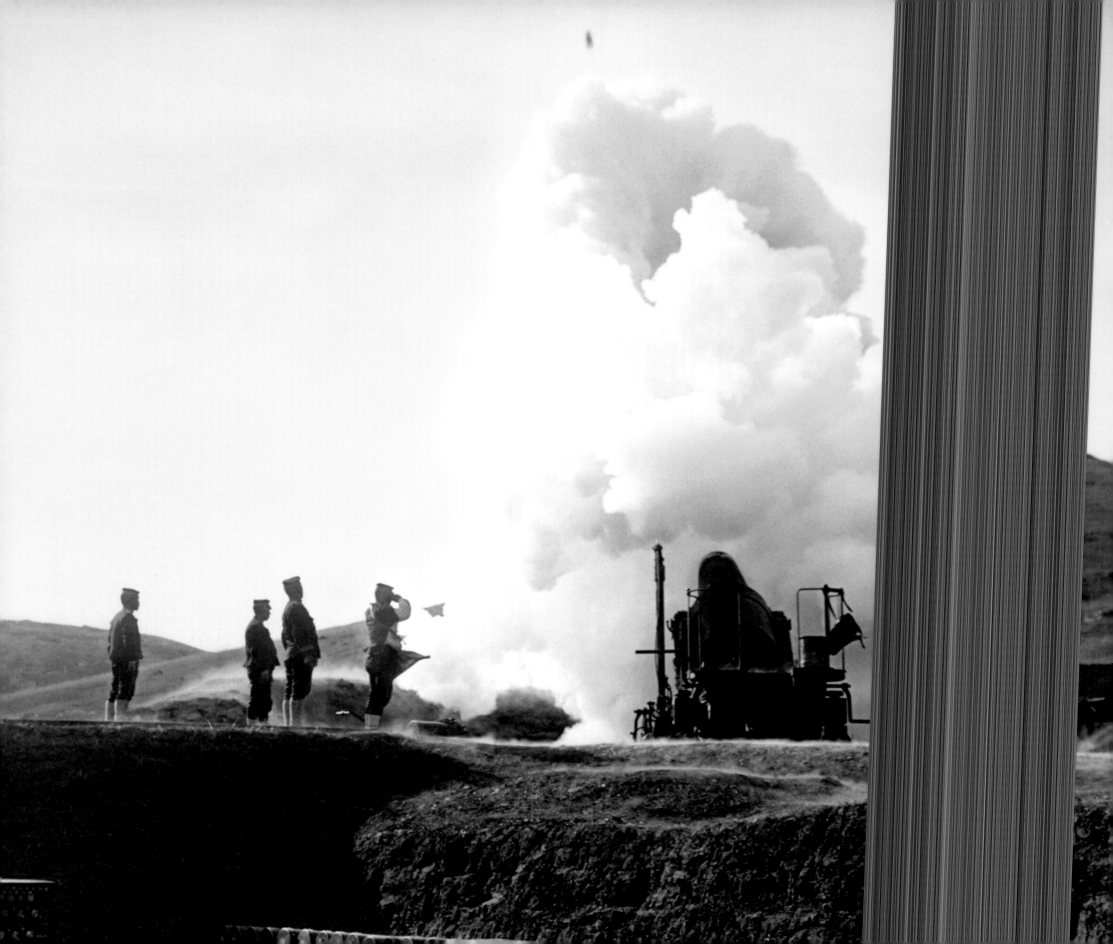

**LEFT ONE OF THE JAPANESE OSAKA BABIES FIRING
A SHELL, PORT ARTHUR, 1905**

These guns weighed seventeen tons each; their mouths
were eleven inches wide; the shells that they spit forth
weighed five hundred pounds each, as much as three strong
men. The roads, or rather the open country over which these
great guns had to be hauled was soft and rough, and there
was not a square rod of well-placed rocky ground to serve as
natural foundation. The thing appeared impossible, yet it
was done; perfectly sound foundations made of the best
cement, put in at the right spot, by the engineers of the
Mikado, ofttimes working under Russian fire.

**BELOW JAPANESE BIG GUNS, ONE OF THE OSAKA BABIES
ON ITS TRAVERSING PLATFORM, PORT ARTHUR, 1905**

The ready word was given and eight hundred men sprang
to their ropes and, tugging in the grandest tug-of-war that
soldiers ever pulled, those men brought the great guns of
Osaka, called "The Osaka Babies," to their playground,
muffling the squealing of the axles, lightening the toil with
that peculiar rhythm that makes concerted labor easy.
Thus were the Osaka Babies, so obstinate in their immov-
ability, wheeled out of their railway carriages and coaxed
across country to play their awful game, each in charge of
a thousand nurses, their thousand faces lighted by a thou-
sand willing smiles; smiles that mocked at this Herculean
labor and defied whizzing, whirring Russian shells that now
and then arched overhead.

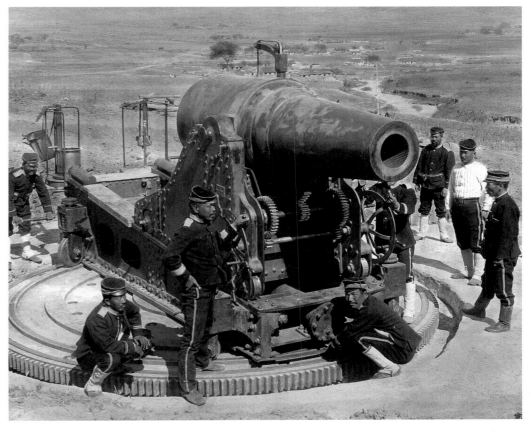

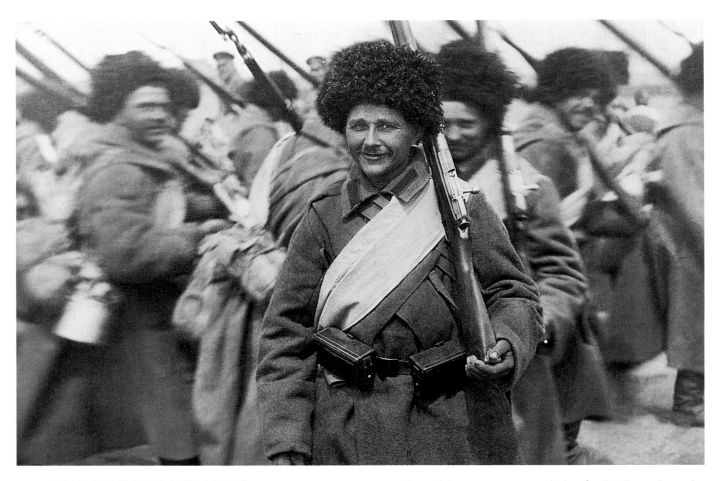

ABOVE **COSSACK SOLDIERS, PORT ARTHUR, 1905**
The Cossack soldier wears a fur cap or helmet, a jacket, rather new dark trousers, and a wide leather strap serves for a belt, to which he attaches his cartridge box, meal bag and field glasses, with his carbine casually slung over his shoulder.

The Russian Cossacks would lose one or two men every day and there were many such days for the Cossacks; and finally it reached a number past counting. Correspondents covering the war reported that the Russians fought with courage and endurance, despite the horror and inhumanity of the war going on around them. After the war was over, the Russian government claimed that not one single man abandoned his carbine or saber.

RIGHT **GENERAL NOG...**
CELEBRATING ...
PORT ARTHUR, ...
Brains played th...
Russians proved...
rage when not d...
in possessing ma...
chessboard that...
and firmly moun...

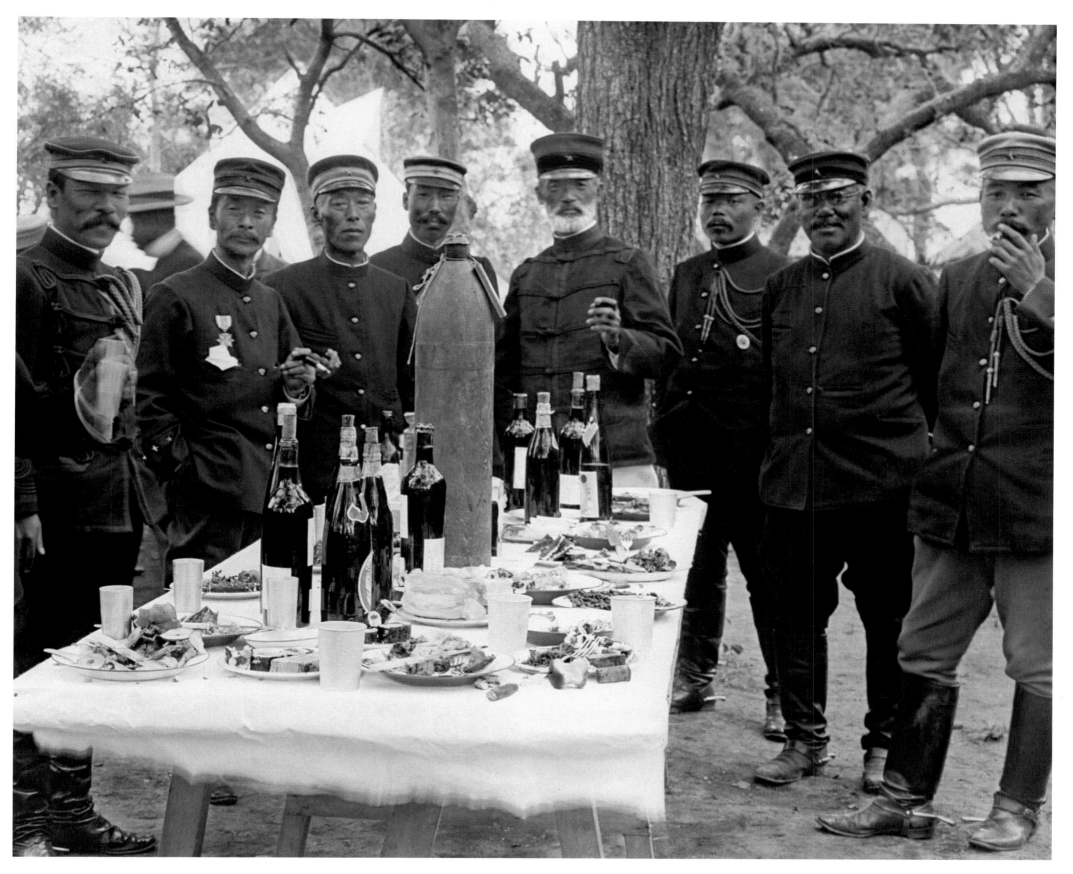

JAPANESE SOLDIERS IN THE TRENCHES, PORT ARTHUR, 1905

There were seven grand assaults; the failure of the first with its terrible loss of life, a list of killed and wounded twenty-five thousand long, taught General Nogi that he could not charge into Port Arthur's forts. He would have to dig his way in, his men would have to lay aside their rifles and take up the weapons that ultimately won the citadel: the pick, the spade, and the straw basket in which each night the fresh earth was carried the whole length of the trench and dumped out at the rear, for it would never do to heap it up along the rim and have the Russian gunners discover the precise whereabouts of the invisible attacking forces.

A RUSSIAN FIELD FU **PORT ARTHUR, 1905**

All this work was don of Russian forts. Was done under condition was it done without c this time; bullets and that which they were ded have been carrie some days by dozens days of those imposs finally the days when when even the woun contested slopes, so rain of lead.

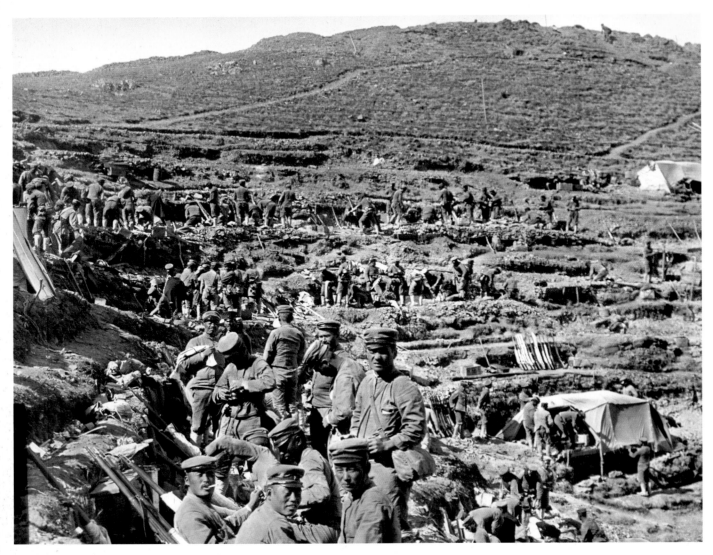

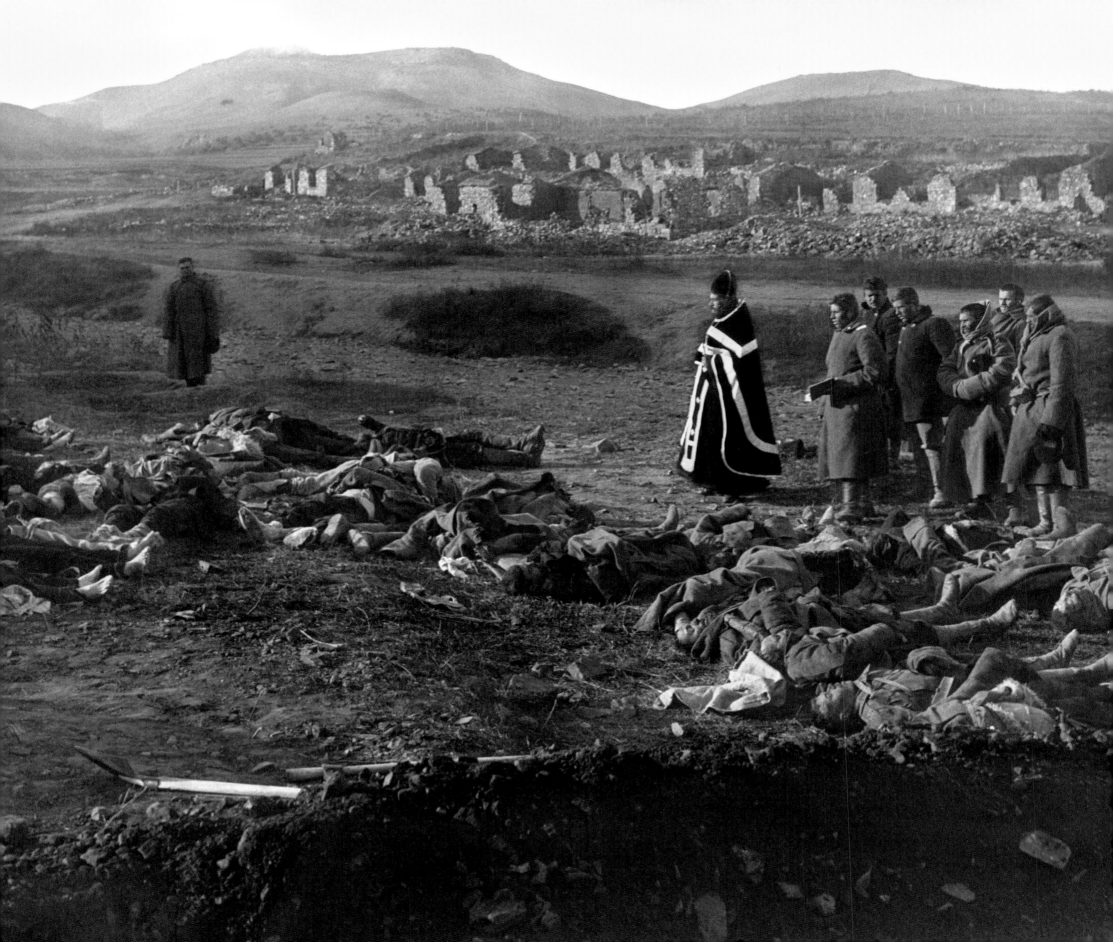

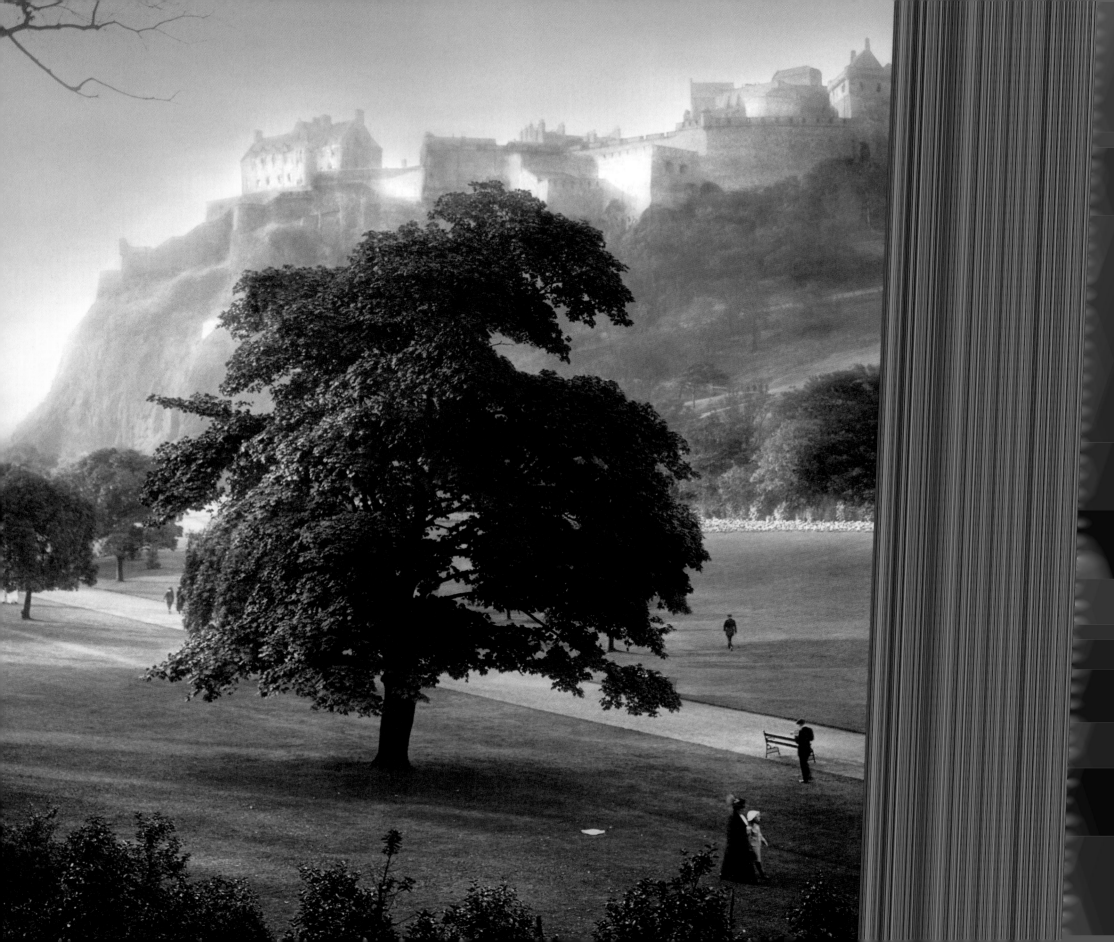

SCOTLAND
WHERE POETS AND THINKERS DWELL

The conspicuous part which Scotland has played on the great stage of human activities is manifestly out of all proportion to the area of Scotland and the number of her sons. That a people numerically far less considerable than the population of London have left so deep an impression on the world's history, religion, literature, and industry inspires an admiring and a sympathetic interest in the homeland of that people.

Every year thousands of eager travelers throng to its historic sights, shrines, literary landmarks, and the industrial centers of Scotland. To leave England and cross the border into Scotland is like coming out of a carefully kept park into the really wide-open country. In England the traveler feels the charm of studiously finished scenery, as he motors along the perfect roads between the accurately clipped hedges, beyond which lies the sleek and well-groomed landscape, dotted with model villages or dominated by the towers of great cathedrals. In Scotland he feels the charm of a land not yet completely tamed by man, a land of ruder aspect, wider vistas, freer air.

Edinburgh Castle was built upon the easily defended summit of the Castle Rock where some early chieftain of some barbarous, prehistoric clan must have reared the first crude stockade under the protection of which his people built the mud and fagot hovels of the village to which the centuries later Edwin, King of the invading Northumbrians, gave the name of "Edwin's Burg"—whence the name of "Edinburgh" of to-day. [1914]

Young Burton Holmes visited Edinburgh in 1886, an early stop on his first abbreviated grand tour of Europe. Hosted by his grandmother Burton and accompanied by his mother, Scotland was one of their first stops: "As a boy Edinburgh thrilled me. I nearly quarreled with Grandma because she had allotted only two days to what was, to me, the most wonderful city I had ever seen." Holmes had not yet been to Paris.

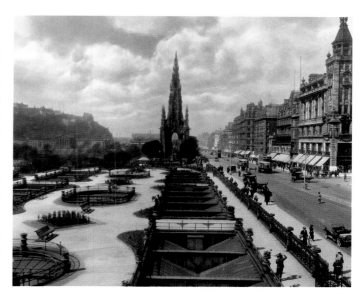

ABOVE PRINCES STREET, EDINBURGH, 1914

It is a pleasing and certainly not an unprofitable occupation for the traveler to sit at his hotel window, on Princes Street, and watch the lingering twilight of the north climb up Castle Rock, and finally, leave it in the care of Night, as it has done, day after day, so many million times since a caprice of Nature placed it there.

The Gothic spire in the background is Scott's Monument, Edinburgh's tribute to pure literary genius in Sir Walter Scott. It is superbly placed; to right and left stretch long and lovely gardens gay with flowers—while from his seat beneath the graceful Gothic spire, Sir Walter looks down upon the animated panorama of Princes Street—that prince of streets, and proudest of all Edinburgh's thoroughfares.

It is one of the most characterful avenues in the world. As a business street it is one-sided, "It is but one-half a street!" exclaimed a jealous citizen of Glasgow. Commerce, it is true, claims but one side of Princes Street; beauty and grandeur claim the other—the beauty of the Princes Gardens and the grandeur of the classic Grecian structure of the Royal Institution with its capitalized Doric colonnades.

LEFT EDINBURGH CASTLE AND WEST PRINCES GARDENS, 1886

Edinburgh Castle looms high above the old town and the new. It is surely one of the great sights of the world, one of those things that stamp themselves forever in the memory of every traveler. It is superb from every point of view, rising like some citadel of medieval romance in lonely, frowning isolation.

One of Burton Holmes's first travel photos, captured while in Edinburgh on his first grand tour of Europe.

BEYOND "CHANG"

They say that there is nothing new under the sun. This may be true, but the traveler always finds cause to doubt it—especially if his wanderings lie under the tropic sun. A longer stay—in these neighboring lands of lightheartedness, brings to a restful, satisfying close the most picturesque itinerary in the whole realm of travel. Siam is a unique country with its own sophisticated culture and civilization, its own ancient art and architecture, its own romantic legends and heroic history. Alone among the countries of Southeast Asia, Thailand never came under European colonial domination—a fact in which the Thai take great pride.

That marvelous film called *Chang* has put Siam on the popular map. But it illustrated only life in the jungle—I now complete the picture with a well-rounded Travelogue that tells of Siamese art and architecture, history and industry, customs and singularities—Modern Siam is one of the great show places of the changing East.

Released in 1927, the same year that Holmes presented his lecture "The Land of Chang," this fictional documentary by Merian C. Cooper and Ernest B. Schoedsack was about a tribesman who accidentally catches a baby chang (Siamese for elephant). Shot on location, the film featured *animal footage spectac… Award nomination for … award presented only at… later in 1929. The direc… buster film King Kong (… nature, Burton Holmes … which the Western wor… temples and the people… that cemented his reput… who could go anywhere… of a genuinely warm wel…*

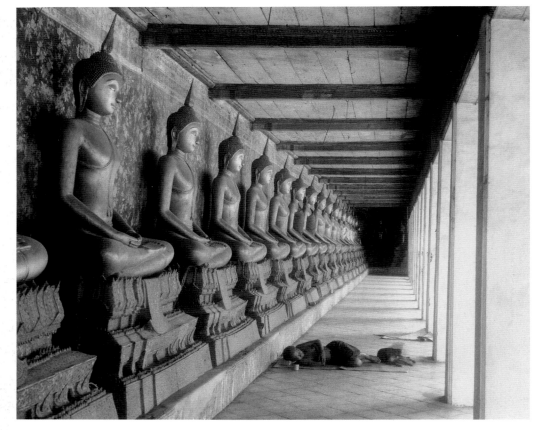

LEFT **GOLDEN BUDDH…**
A glittering compa…
into eternity; assist…
feet.

RIGHT **KING RAMA VI, R…**
*The King of Siam, …
in modern times, fr…
in England, and w…
died at the age of …*

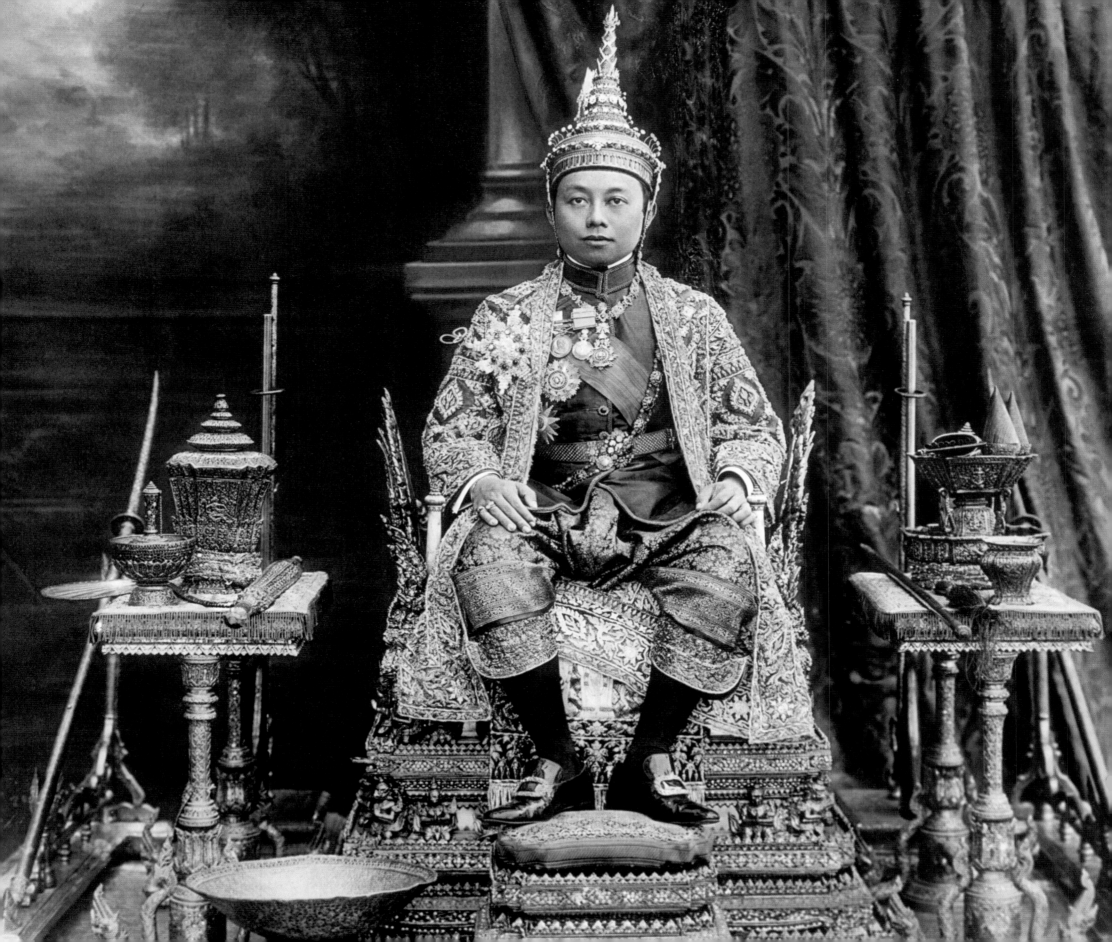

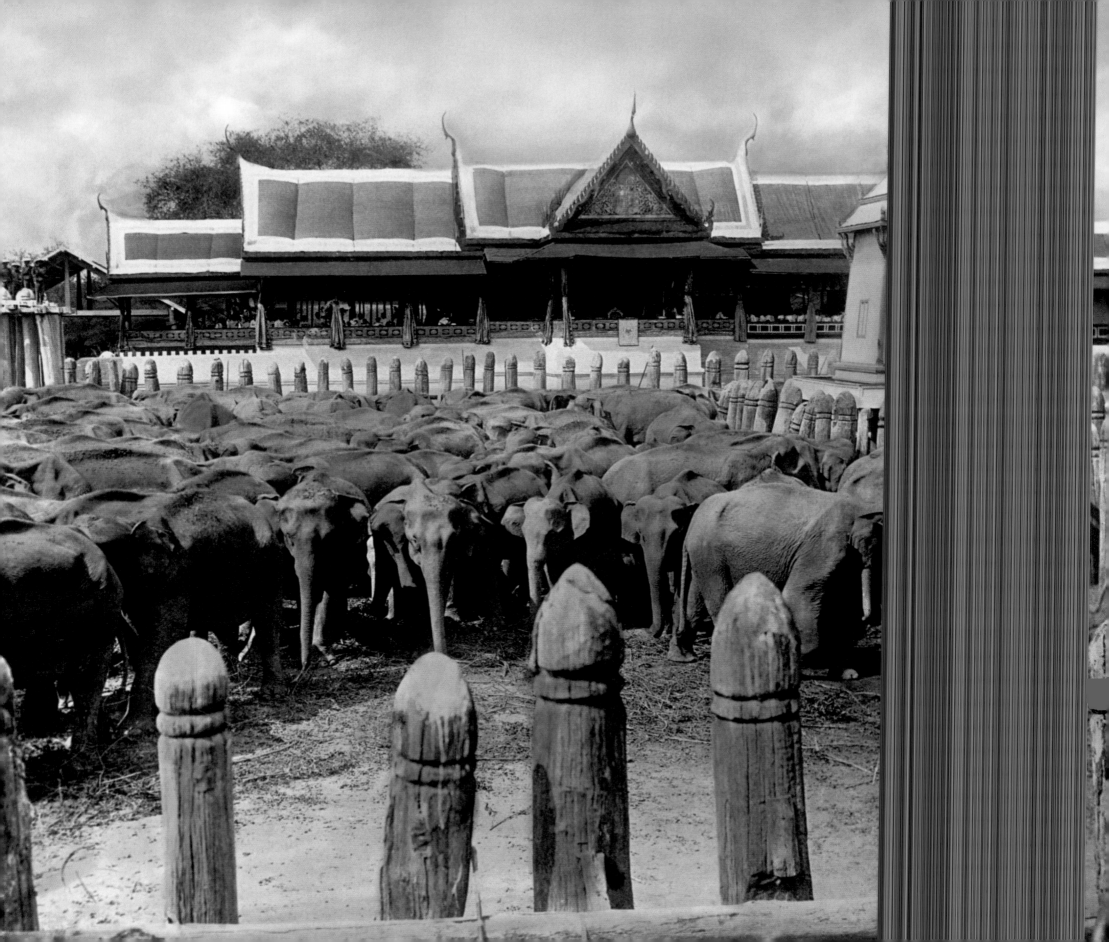

LEFT **THE ELEPHANT COMPOUND,
THE ROYAL PALACE, BANGKOK, 1925**
A huge herd of Imperial elephants roam the Royal Palace
compound in Bangkok.

RIGHT **WAT PHRA KAEO, BANGKOK, 1925**
The entrance to Wat Phra Kaeo, the Temple of the Emerald
Buddha, is the holiest shrine in Thailand; its portals have
been guarded for centuries by two huge, ornate gargoyles.
It is easy for me to understand why Buddhism has swept
through such a large part of the Orient. But I am content to
be Buddhist merely in my admiration for the beautiful and
curious artistic creations inspired by the cult of the Indian
Prince and Sage, who opened to humanity the vision of the
"Perfect Way" that would lead to complete enlightenment.

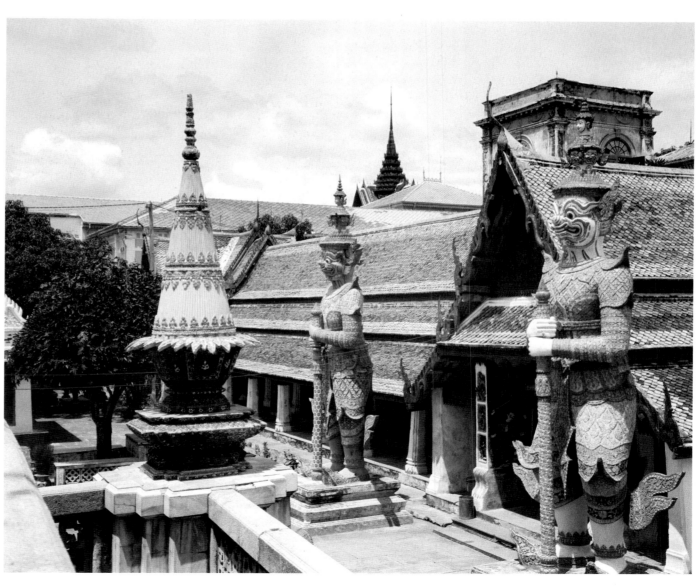

LEFT **ANCIENT RUIN**
Lop Buri, an imp
tains Khmer and

BELOW LEFT **TWO BUDDHIST MONKS, BANGKOK, 1925**
For Thai Buddhists the ritual of giving morning alms to monks is a daily opportunity to gain spiritual merit.

BELOW RIGHT **PHRA PRANG SAM YOT, ANCIENT TEMPLE RUINS, LOP BURI, 1925**
In the Ruins at Lop Buri stand the Hindu temple towers of the Phra Prang Sam Yot with its three towers signifying the Hindu Trinity. The former Hindu shrine was converted to a Buddhist temple under the reign of King Narai.

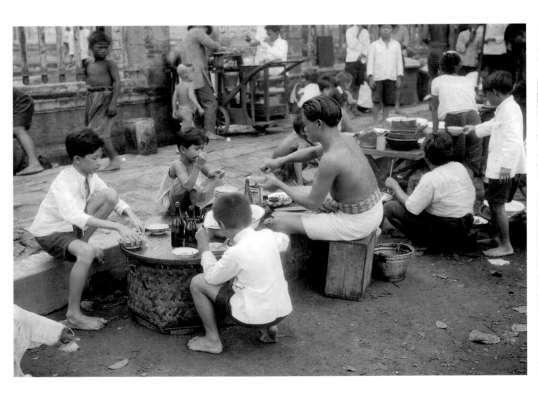

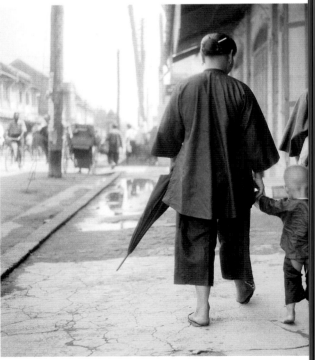

ABOVE **STREET SCENES, B.**

RIGHT **CHICKEN VENDOR**

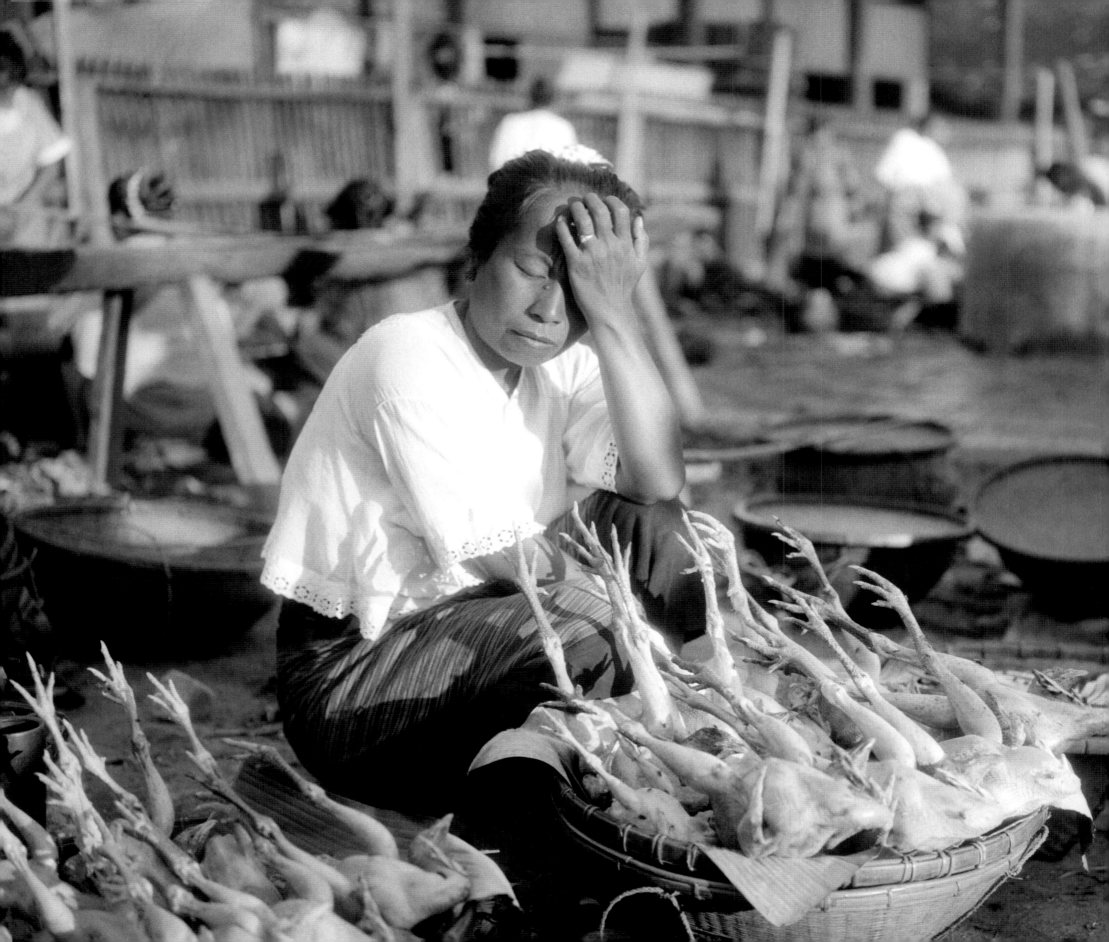

SOUTH AFRICA/RHODESIA
THE LAST FRONTIER

For many years, *Who's Who* had said, "Burton Holmes, traveler and lecturer, has traveled everywhere but South Africa." So, I decided to find a country audiences would like to hear about, and, at the same time, wipe out the line about never visiting South Africa. I sailed in May, and as soon as I reached Cape Town, I cabled *Who's Who*: "Lafayette, I am here." *[1937]*

Some of us wish to know only the place we call home. Some most desire only peace and quietude. Not so with me.

Give me the hurried crunching of wheels on roads of steel, the swift purr of resilient tires on the highways of far countries, the soul-stirring hum of tireless propeller-blades as they fend the ether of the skyways, shrinking the weary miles of yesterday to the mere paces of to-day. Give me, too, the throb of mighty engines in great ships and the dizzying revolutions of the whirring turbines that devour distances at sea. Give me, some day, those silent *individual wings* with which Science will surely endow us earthly angels—wings that will

make us indeed masters of Space and, in degree, masters of Time itself. Give me a different place each day. Give me the stinging tonic of contrast and the exhilarating contact of the exotic and the unexpected. And for a destination, give me only such a one as I shall have earned and shall deserve. None other! *[1939]*

LEFT **ZULU TAXI, DURBAN, SOUTH AFRICA, 1937**
The Zulu Taxi, a strange ritual fabricated entirely for tourist eyes.
Note that the sign on the side of the cab reads "Europeans Only."

PAGES 294–95 **VICTORIA FALLS FROM THE AIR, RHODESIA, 1937**
Much bigger than Niagara Falls, Victoria Falls are situated on the Zambezi river on the border between Zambia and Zimbabwe, formerly North and South Rhodesia. The local name is Mosi-oa-Tunya, meaning "smoke that thunders." Missionary and explorer David Livingstone renamed the falls in 1855 after Queen Victoria.

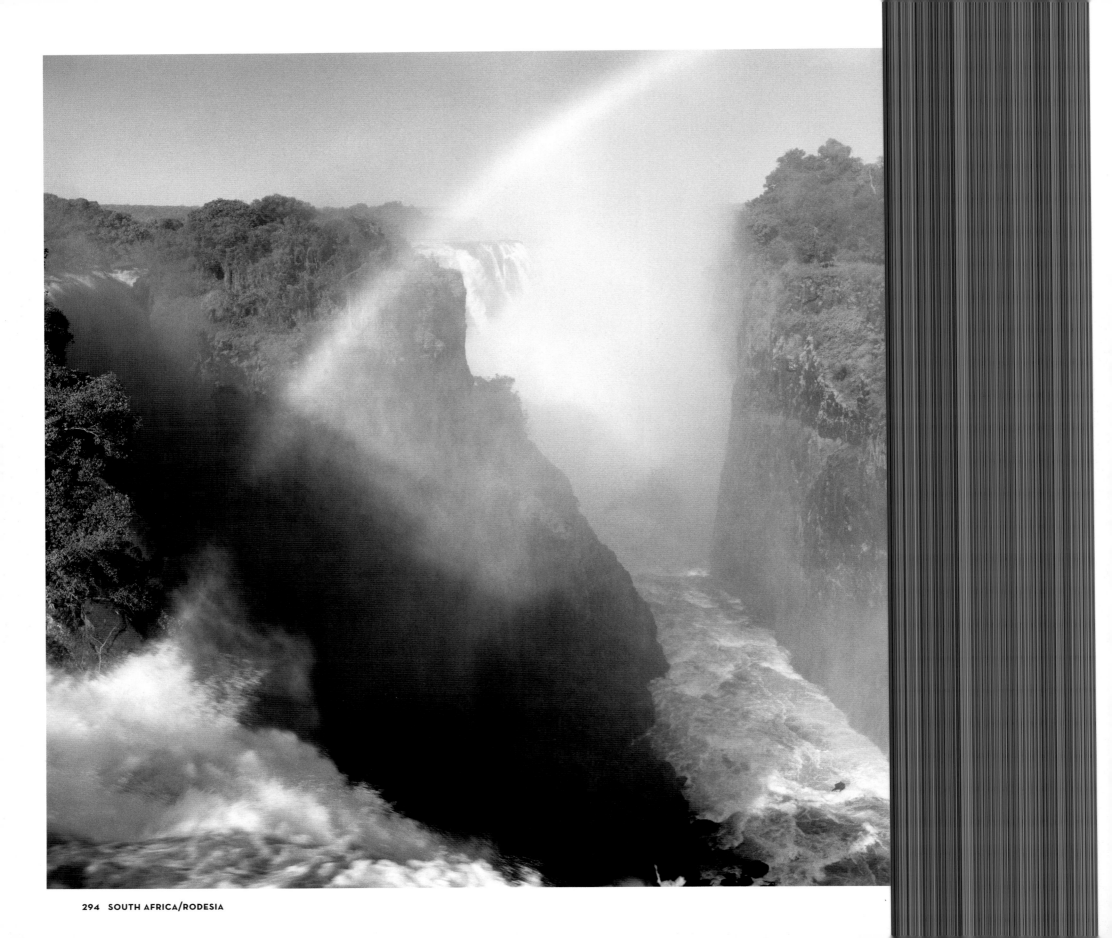

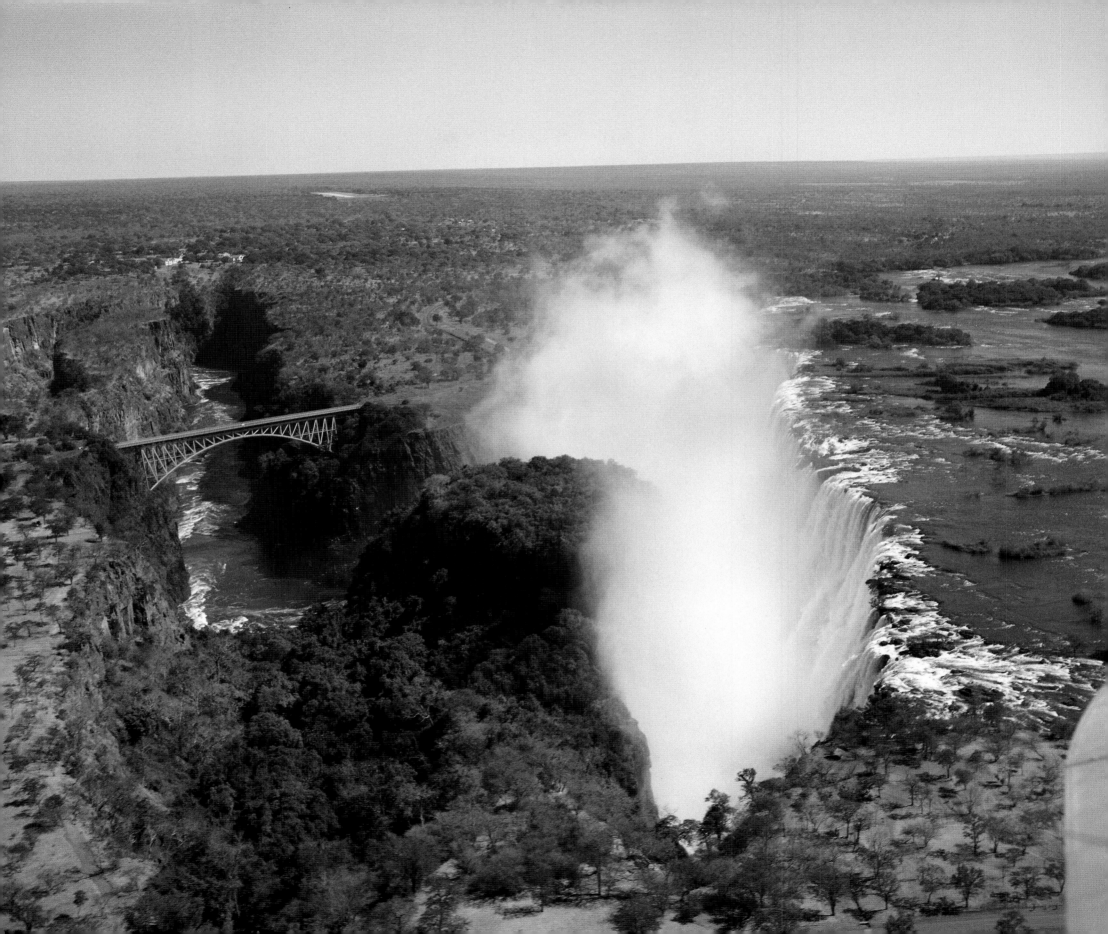

SPAIN
THE HIDALGO AND THE DON

It is a remarkable fact that Spain, the proud land under whose flag the first ships sailed across the broad Atlantic to our shores, now lies almost untouched by the great tide of travel from America. Spain dared and did the most to transform the mysterious western ocean from a place of vague terrors into a mighty highway for the commerce of two worlds, and yet her seaports now play no important part as termini for transatlantic steamship lines, nor is it possible to reach them save by circuitous voyages or in inferior ships.

One of the main currents of trade and travel reaches Europe through the ports of England, France, and Germany; the other flows through the Gibraltar Straits and rolls on toward the Orient. The traveler who would visit Spain must enter therefore by a French or British doorway; he must either cross a Pyrenean border from the south of France, or, landing at Gibraltar, braving the stare of British guns, enter the lovely province of Andalusia with the music of "God Save the King" echoing in his ears.

My first impression of the Hidalgo and the Don was the never-to-be-forgotten vision of Gibraltar arising from the deep. Though dimly seen in the first flash of dawn, the rock at once impresses us as a thing to be feared, respected and admired. Of that mighty chain of fortresses by means by which England binds her Oriental conquests firmly to her island throne, Gibraltar is the grandest link. Slowly, almost respectfully, our ship approaches the place of anchorage.

This town of about 20,000 is the port through which the ocean traveler enters southern Spain. The Rock, as the English proudly term Gibraltar, guards the entrance way to the Mediterranean and the lands beyond, and in ancient time was one of the two rocks known as the pillars of Hercules. The town has a motley population of Spaniards, Italians and Jews, beside a garrison of five thousand English soldiers.

We decide to take a few hours to visit the lower galleries of the fortress. From that point on the visitor must proceed on foot. Cameras must be left at the guard house.

These remarkable galler[...]
the different owners of t[...]
aperture made for the ca[...]
by shrubs and vines, wor[...]
lower rock can be obtain[...]
galleries are old. The mo[...]
fare are higher up and no[...]

Leaving Gibraltar t[...]
ciras, Spain, where the S[...]
he boards the train for i[...]
amongst which should be[...]
perched and beautifully [...]
shine; Seville with its wor[...]
Tower, its Plaza de Toros, [...]
witnessed in certain seas[...]
oriental splendor and it[...]
Alhambra.

LEFT **PLAZA DE TOROS, S[...]**
It was in Seville that I[...]
said I to myself. But a[...]
the *corrida* on the se[...]
seat near the royal b[...]
just to see the young[...]
the bloody scenes in[...]
cruel and gory aspec[...]
ment, find peculiar p[...]
of the *toreros, bande*[...]
was up early to get a[...]

RIGHT **PLAZA DE TOROS, T[...]**
"Death in the Aftern[...]
attention no matter h[...]
no brief for the bull fi[...]
barbarous performan[...]
cession, I defy you n[...]
like olives: you don't l[...]
decent sentiment wh[...]
da, it's ten to one you[...]
alluring about even a[...]
sure even though you[...]

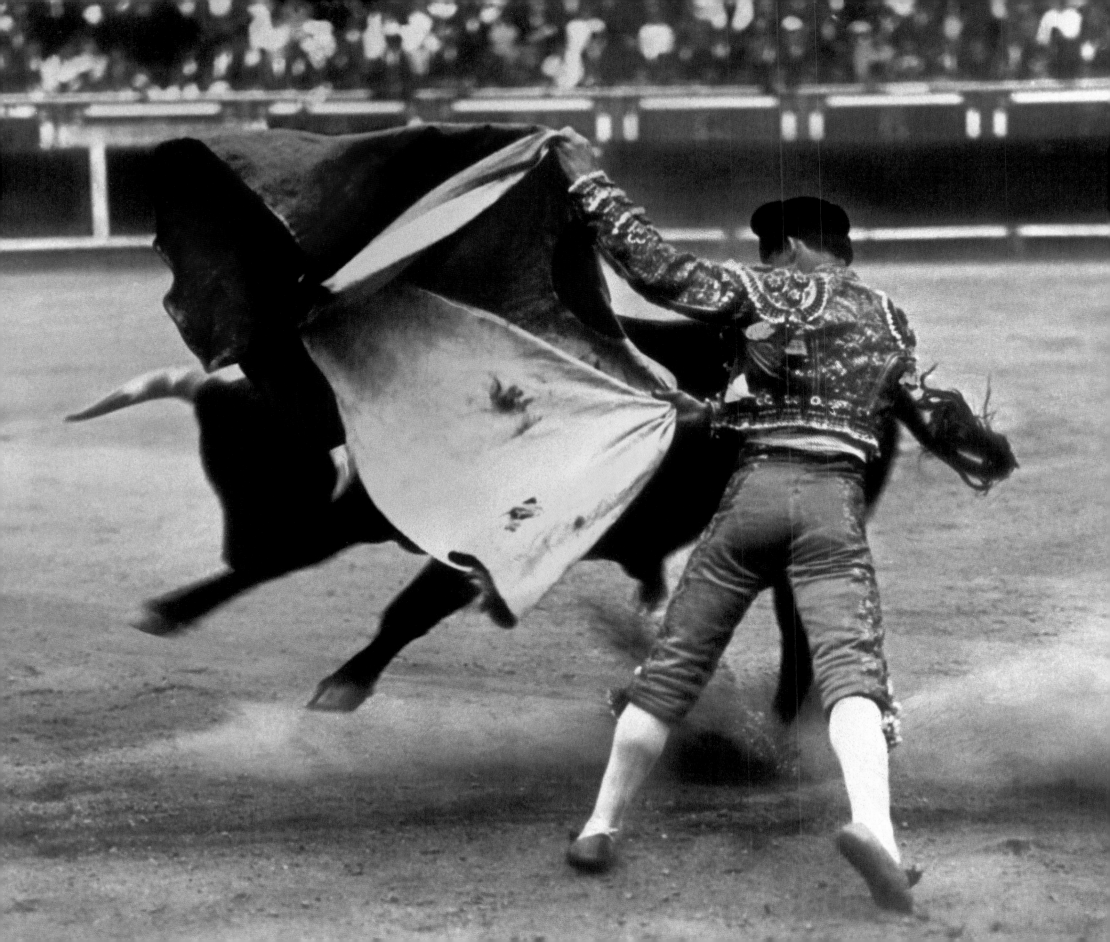

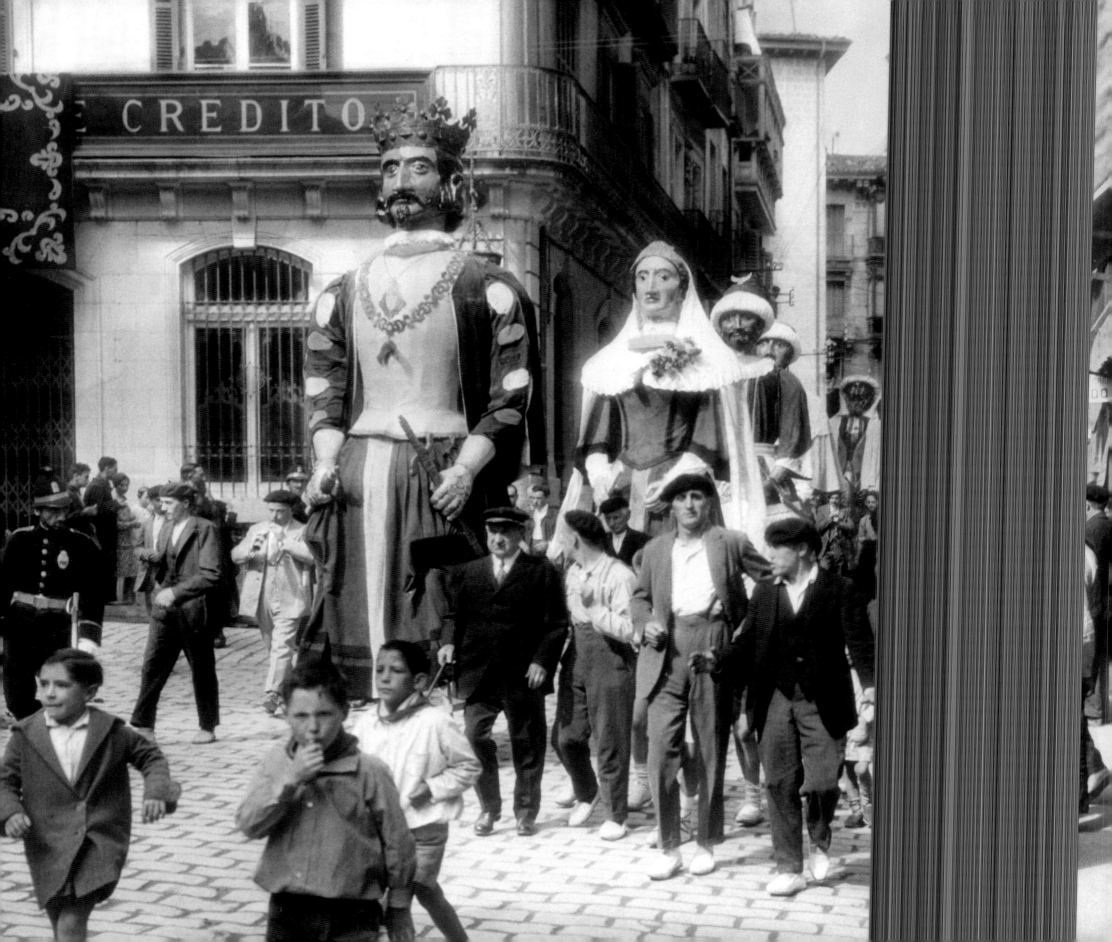

There was in those days another national sport in Spain—a nocturnal sport. But my first contact with it came by day. In a first-class railway compartment I occupied one of the eight seats. I felt a feverish sensation; I was hot under the collar. Presently my *vis-à-vis,* a Spanish gentleman, leaned forward, plucked something from my neck and tossed it out the window saying, "Permit me to quit you of an evil thing." I was grateful but embarrassed. The other passengers, amused, shrank away from me as far as space permitted. I tried to explain that I had come direct from the best and cleanest hotel in the last town. This did not seem to reassure them. However, it was with pleasure that presently I leaned forward and said to one of them, "Permit me in turn to quit

you of an evil thing." By this time we were all feverish. Standing up, we examined the seats on which we had been sitting. The cushions were alive with "evil things." We staged a massacre and flung the corpses from the windows. Then when the fray was over, desirous of warning future travelers, we unscrewed from the walls the little frames that held notices to passengers like, "Dangerous to lean out," and "Smoking prohibited." These we reversed and replaced after printing clearly on the back of each, *"Atencion—Hay millones de chinches en este compartimento"*—"Attention! There are millions of bed bugs in this compartment."

But for me, the worst was still to come. In Valladolid I lodged in the best hotel—God save the mark! At midnight I

rang for the maid and requested a change of room. Leaving my luggage where it was, my feverish carcass was put to bed elsewhere. At 1 A. M. I again demanded another room. At 2 A. M. I rang again. The maid, her patience exhausted, inquired why I wished to move from room to room. When I explained, she seemed astonished. "But, *Señor,* you ought to know, they are in *all* our rooms. *This* is the season!" There was a train at 3 A. M. I took it, after retrieving my belongings left in the first infested room that I had occupied, where in my bed lay a caballero, or at any rate a native guest, a late arrival, snoring serenely, unbothered by the chinches. He knew it was the season. Things are better now and there are clean hotels in Spain for fussy travelers. *[1928]*

LEFT **THE PARADE OF THE GIANTS, FESTIVAL OF SAN FERMIN, PAMPLONA, 1928**

The people of Pamplona have been honoring their patron saint, San Fermin, for centuries with a nine-day festival in July. To the stranger, it offers a unique attraction: it gives him in a few days a clearer idea of the Spanish people than he could gain by months of formal study.

BELOW **THE RUNNING OF THE BULLS, PAMPLONA, 1928**

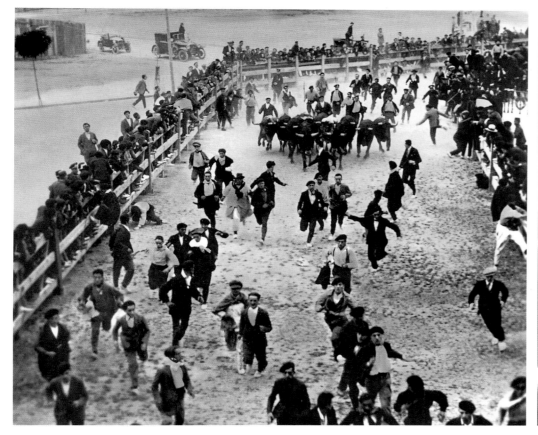

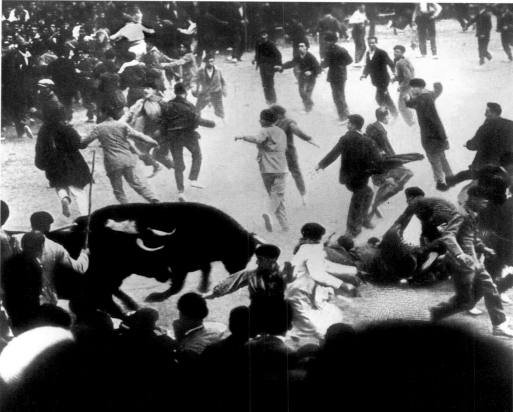

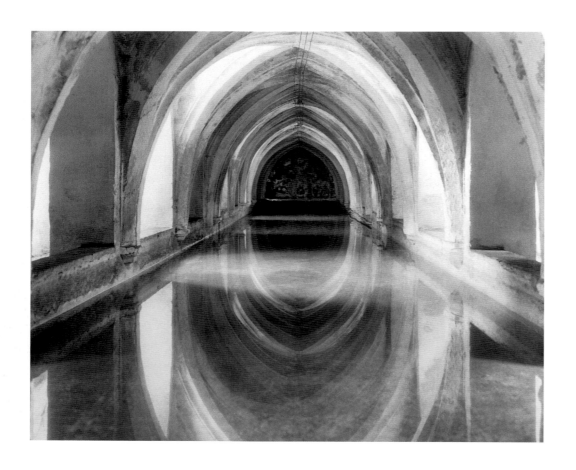

LEFT **UNIDENTIFIED M**

RIGHT **FOREST VIEW, 19**
In the quick transi
to the seclusion o
nity of Nature. In t
we may repose ou

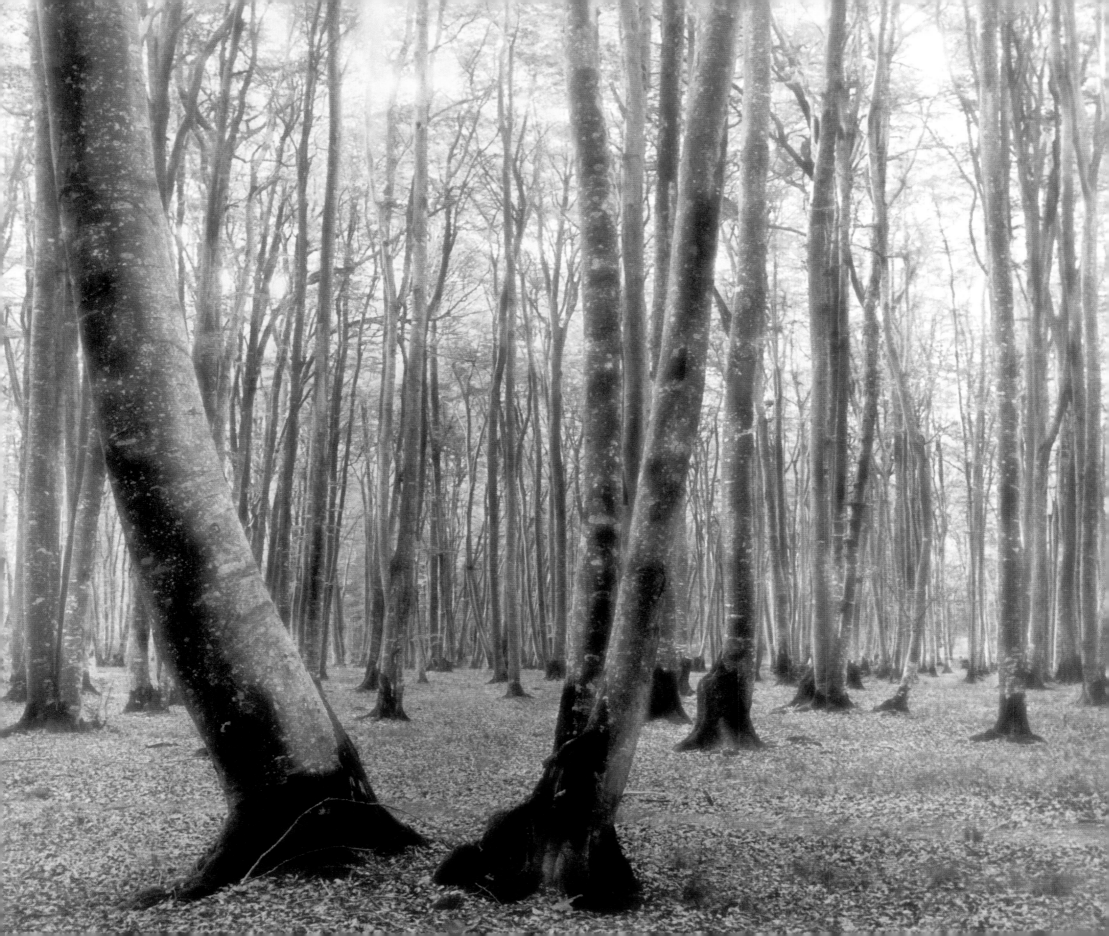

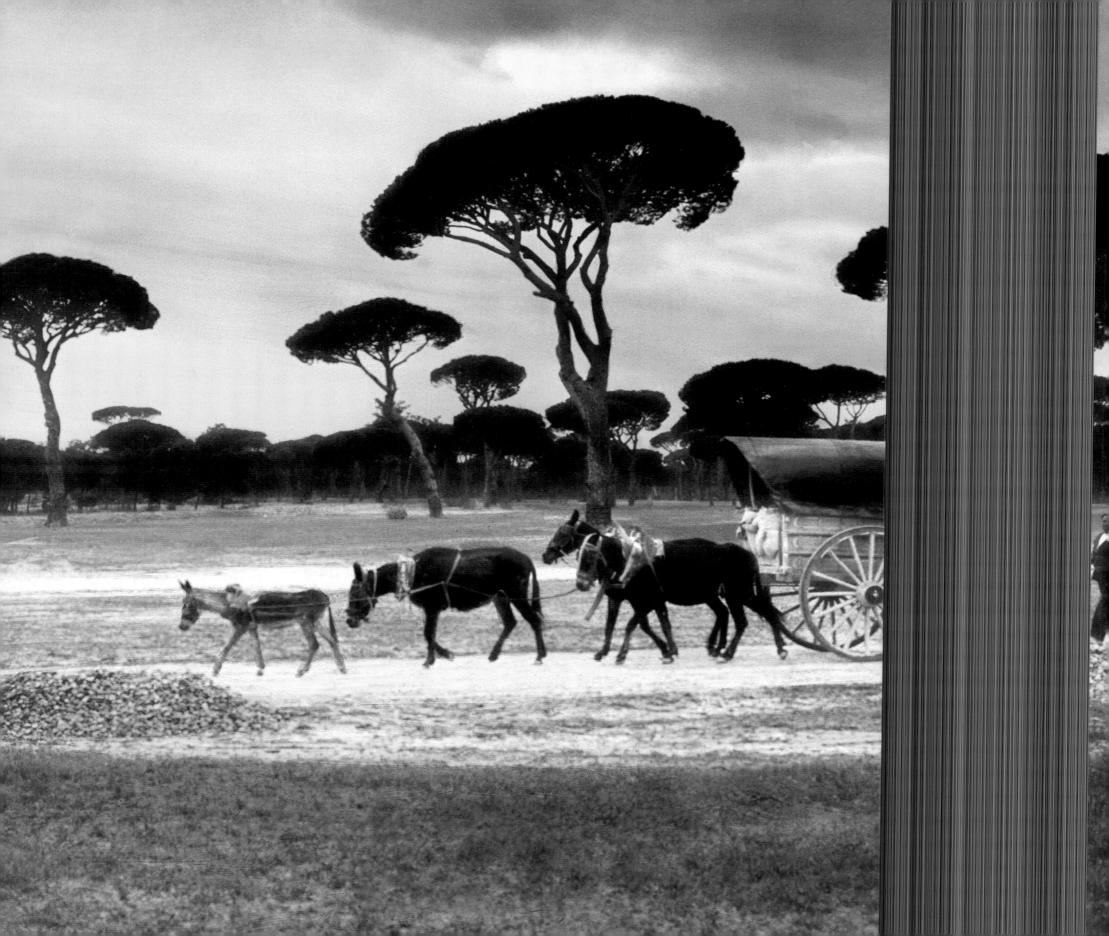

A PASTORAL SCENE, 1928

I recall a little side excursion which I undertook one after-
noon with my old guide and his group of small lazy donkeys.
We crossed a dry landscape, dotted with trees that seem
sculpted by human hands; naked trunks blossoming into
umbrella-like canopies, which we passed heading to a
deserted hermitage on yonder range of hills.

CHARLIE CHAPLIN POSTER, SALAMANCA, 1928

Bill-boards can either be a nuisance, or highly informative.
In Seville, at frequent intervals, we find corners of buildings
upon which notices tell us plainly all we wish to know about
the local bullfights, theaters, and movies. Then, once you
start to look for them, you will find on almost every corner
ads for Hollywood films, a much be-postered institution.

BELOW LEFT **ANDRE DE LA VARRE AND A GYPSY DANCER, SEVILLE, 1928**

The word *gypsy* brings to mind an image of mysterious women with flashing eyes in long, colorful costumes—we encountered that very image while visiting Seville. For our travelogue on Spain, our cameraman, Andre de la Varre, filmed a lively performance of flamenco by this talented dancer. She explained the intricacies of flamenco and said it had taken her many hours of practice to perfect her technique, especially the expert footwork.

BELOW RIGHT **A SEÑORITA, SEVIL**
Such a vision of beau
ple—black hair; such
and velvety; so grace

RIGHT **STREET SCENE, MA**

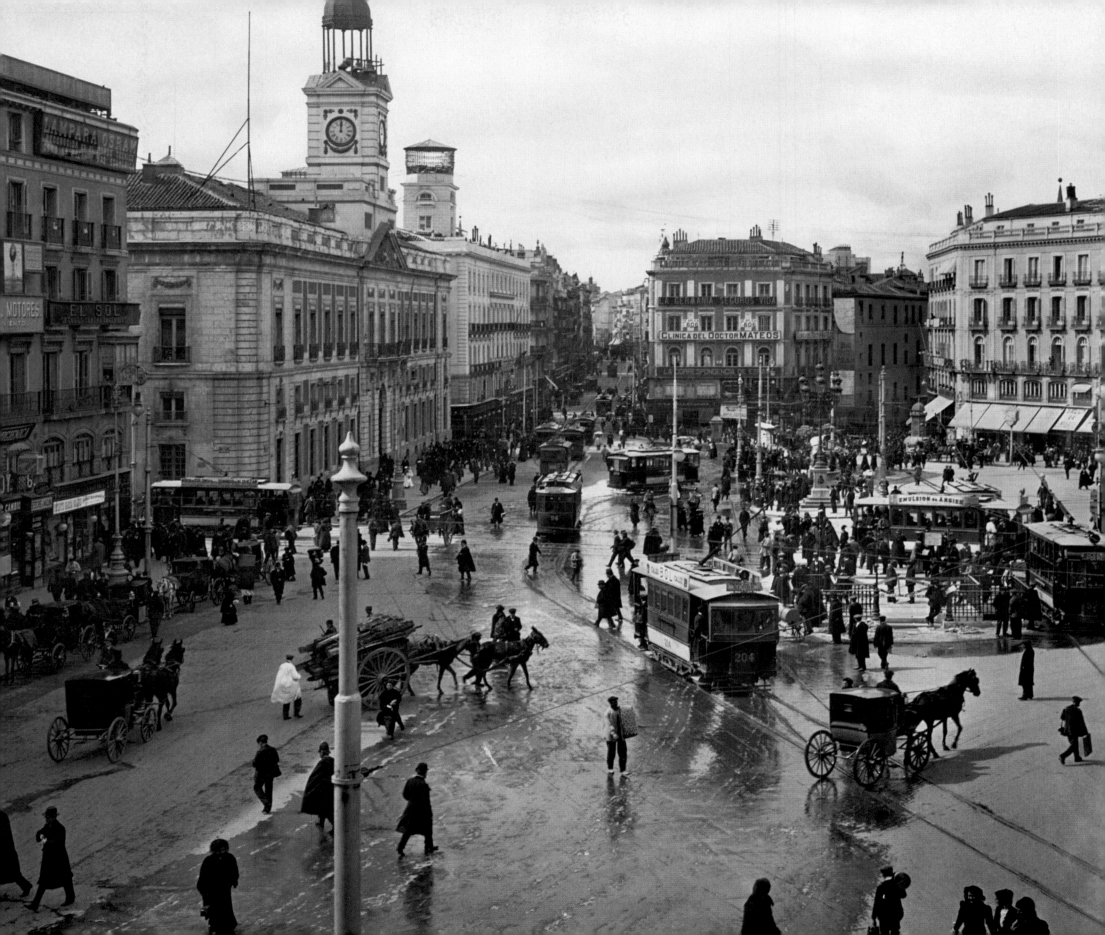

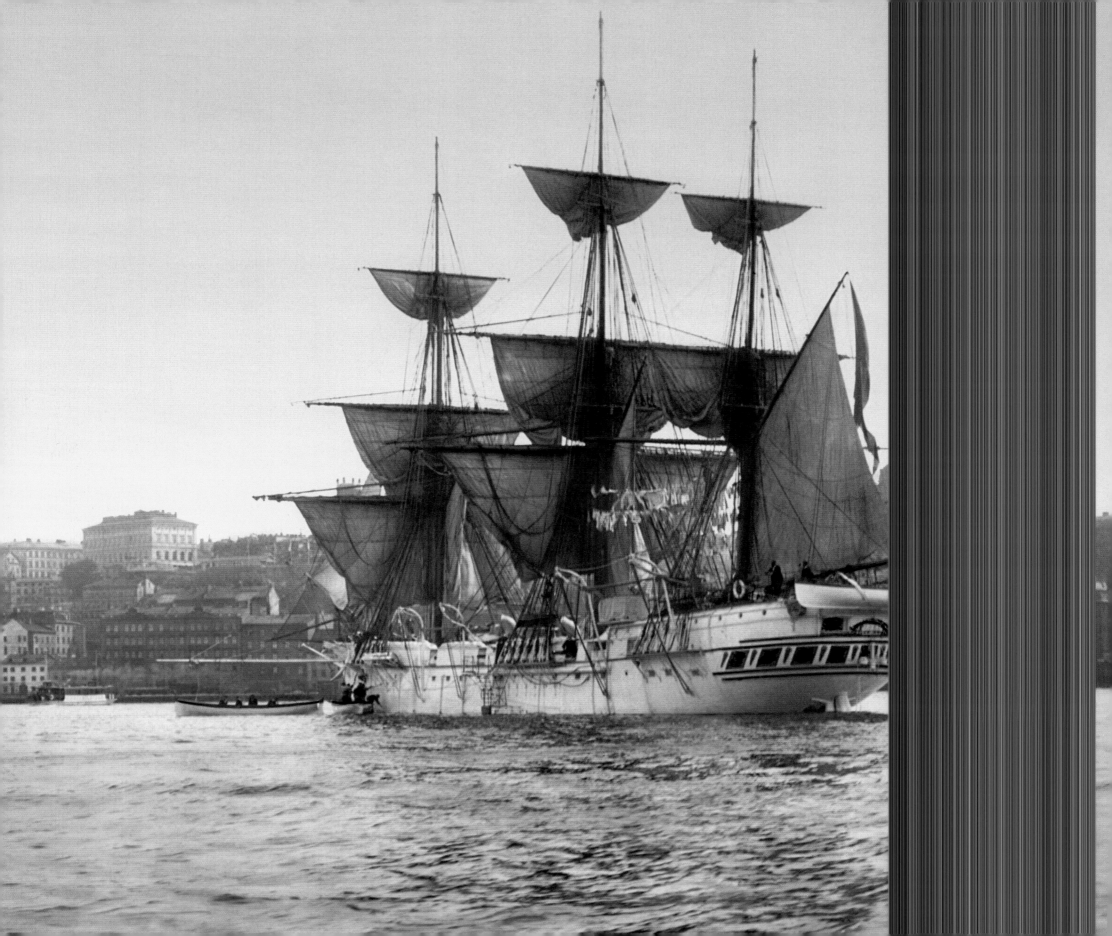

SWEDEN
LAND OF THE VIKINGS

Glance at a map of Sweden and you will see that there is as much blue water there upon the map as there is land, for Sweden, like its neighboring country, Finland, is internally a vast fresh-water archipelago, high above sea level.

To travel overland by water across Sweden reminds me of those impossible dreams which come to every one of us—dreams in which we are accomplishing all sorts of curious things without the slightest sense of incongruity. We are navigating country roads in ocean steamers, plucking flowers from the waves of shrubbery that break against the sides of our ship, or promenading on a moving deck in the shade of forest trees.

Certain phases of this waking dream bear the stamp of naturalness, for now and then we sweep out from the forest-bordered channels upon the bosom of lovely lakes, some of which are large enough for us to lose sight of the land in crossing them. How any traveler can be content to go by rail is quite inconceivable.

The proverb that "God made the country and man made the town" holds good in Sweden, where both the towns and the country are particularly well made. There is nothing especially ornate about a Swedish city; there is nothing frivolously pretty about the Swedish landscape. Both town and country bear the stamp of enduring worth and frank simplicity. I have made the statement that Sweden is more like the United States than any other of the European countries. This requires a word of explanation. I mean that, in general outlines, the Swedish country-side bears a remarkable similarity to many of the most commonplace and prosperous regions in our eastern states. We find the same indifferent roads, the same rail fences, telegraph poles and railway crossings; the general aspect of the fields and farms is similar, and the rural architecture is not sufficiently unlike that of our own country to injure the illusion of a Scandinavian New England or a Central New York State. Save that the Little Red Schoolhouse crops out here too numerously, for the walls of nearly every farmhouse have usurped the warm tone which we have associated with the outside of the country school. *[1902]*

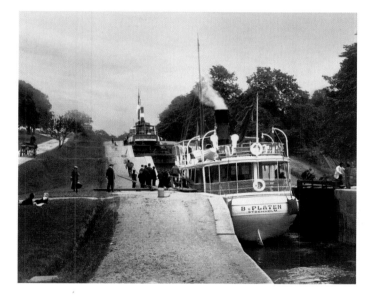

LEFT **A SAILING SHIP, 1902**
An old proverb assures us that when God divided the waters from the land He forgot all about Sweden, and this accounts for the inextricable tangle of lakes and landscapes, rivers and ridges, for the watery lanes leading across green meadows, and for the mirrory paths that wind through the woods, bringing sea-going ships even into the hillside grooves, making the snorting of the marine donkey-engine as familiar to the farmer as the braying of his farmyard donkey.

RIGHT **A CANAL STEAMER, TROLLHÄTTAN, 1902**
Our watery journey begins at Trollhättan where we board the canal steamer, which has been steaming along between the fields from Gothenburg to overtake us at the entrance to the locks below the town. It is always interesting to watch a steamboat go up hill, but these canal boats are such practiced stair climbers that the low hills appear to offer no obstacles to their upward course. Into the lower lock the thick-set rotund little ship thrusts her short body; then as the lower gates are closed, sluices above are opened and the water of the second basin gushes into the first, raising the level of its waters and with it the ship, until the water in both locks stands at the same level. Then the next pair of gates is opened and the boat advances into the second lock which, closed in turn, receives part of the water from the next higher lock, through which our ascending boat will pass in its onward and upward course, that brings it ultimately to the level of the lake-like channel at the top of the long stairway up which it has come steadily and silently, rising no less than one hundred and forty-five feet from the level of the sea to that of an inland lake.

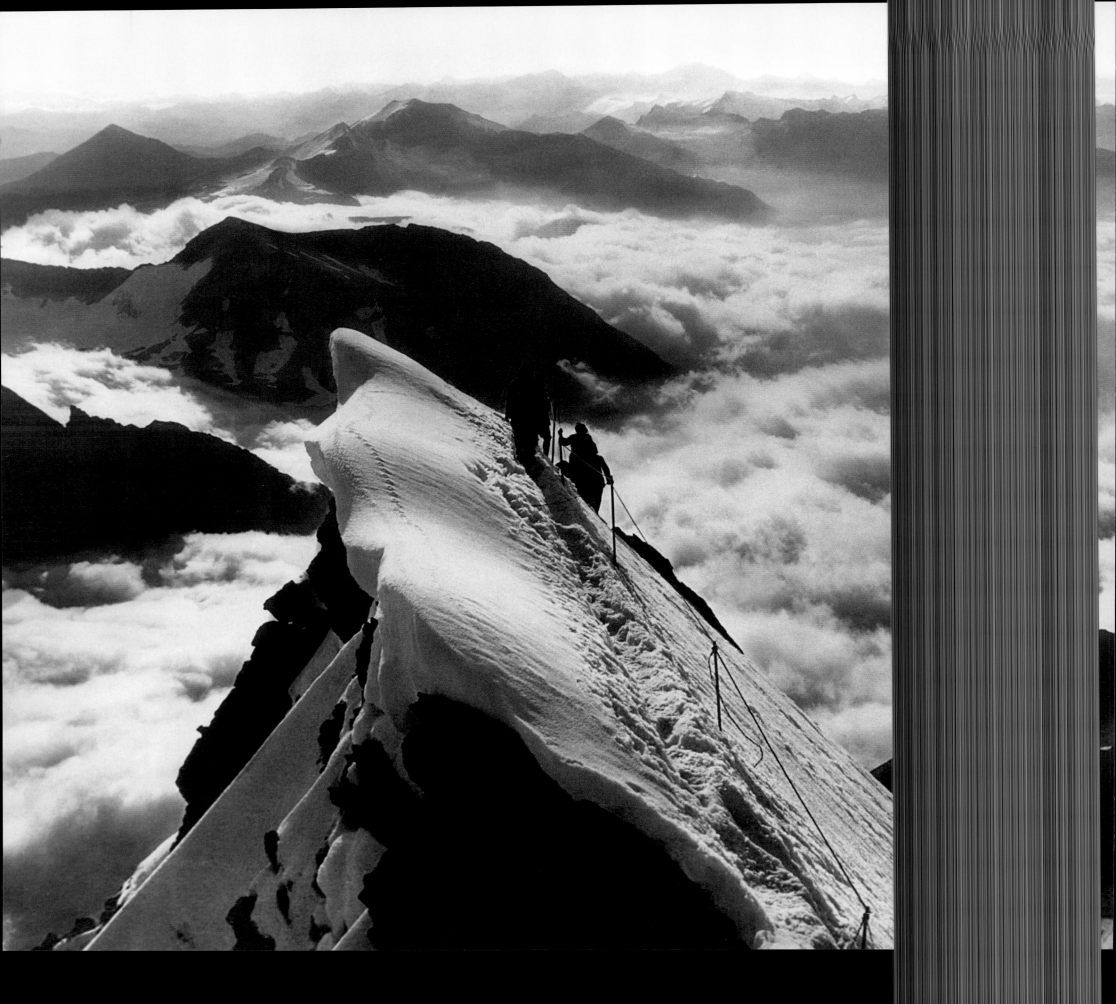

SWITZERLAND
AMIDST ALPINE GRANDEUR

Everybody is interested in Switzerland. No other country in Europe offers a richer return to the traveler for his time and effort. To revisit Switzerland is for the old to renew one's youth; while for the young it is to gain a life-long sense of the inspiring grandeurs of the wonder-world.

The traveler goes to Switzerland chiefly to look at mountains; the Swiss Alps are as effectively displayed as the treasures in a well-arranged museum. But the mountains are not the only things in Switzerland. There are the towns and cities and the people, those admirable Swiss people, who have made their land in many respects the model country of the world.

Although Switzerland may be the playground of Europe, it is not the playground of the Swiss. It is their workshop, where they toil at many industries, and practice many useful arts of which the outside world knows little. We know only that they make music-boxes, cheese, and watches; and that they are the best hotel-keepers in the world. But to say that they are a nation of hotel-keepers is to make poor return for all the comforts and courtesies we owe to those who have been our hosts in Switzerland. The traveler has cause in many lands to thank the Swiss, who have made the management of hotels an art, and sent forth missionaries to practice and to teach that art in the lands of the outer barbarians.

The climax of a European tour is usually reached in Switzerland, where grandeur, beauty, quaintness and comfort are so effectively and happily combined. To the active traveler the Alps offer a perpetual challenge; to the lover of Nature, a perpetual lure. To the seeker after peace of mind the Swiss lakes and valleys offer an ideal refuge from the cares that weigh upon a worrying world. *[1932]*

LEFT **MOUNTAIN CLIMBERS, THE JUNGFRAU, 1904**
The Jungfrau was first climbed about a hundred years ago. It is now climbed every year and every year the Jungfrau claims her victims. The very day I came, two men died there amid the snows. They were skilled climbers, but they were not able to cope with storm and chance—those evil geniuses of every mountaineer. Alpine climbers are not made; like fools they must be born with a contempt for those perils that the wise man in his wisdom would not seek.

RIGHT **BIPLANE FLYING OVER THE ALPS, 1924**
The Alps are the most self-assertive mountains in the world, the most astonishing in outline, the most savage in form, the coldest, cruelest peaks that Nature ever fashioned in her favorite rock-garden. But, in the presence of great mountains we grasp, as we have never grasped before, the meaning of three words that mean so much to every man who thinks—Beauty, Infinity, Eternity.

BELOW **ALPINE SKIER, 1924**

Mountains are the grandest manifestation of mere matter of which we are able to conceive. The vastness of the desert and of the sea eludes our faculty of measurement, but a mountain, rearing itself against the sky, seems to reveal itself to us in all its hugeness. We feel that we can measure it, that we know where it begins and where it ends, that we have grasped its size and shape. Therefore, we like to look at mountains, and most of all, as a sport, we love to ski down mountains. There is a satisfying completeness in the vision. As we commune, the mountain seems to tell us all its secrets. Yet we know that mountains are hedged about with mystery, that they reveal themselves only to those who pay for them with a long lifetime of devotion.

RIGHT **SUNSET, SWISS ALPS, 1904**

We stand at the center of snow peaks for a perfect panoramic view, for look where you will, Alpine grandeur fills the eye. As the night approaches, at last only the very summits of the grander peaks are touched by the sun's rays—the faint, soft, pinkish rays that still strain feebly over the western wall, of which the shadow creeps relentlessly up the slopes and which we are gazing, until it puts out the rosy fires that burn there upon the crest, one last, faint last rosy glimmer on the supreme peak of Switzerland; then all grows gray and colorless. The day is done; the night has come—the glorious Alpine night, clean and transparent, but thick with mystery and dense with the beauty of the ultimate silences—the silences that sing aloud to every human soul.

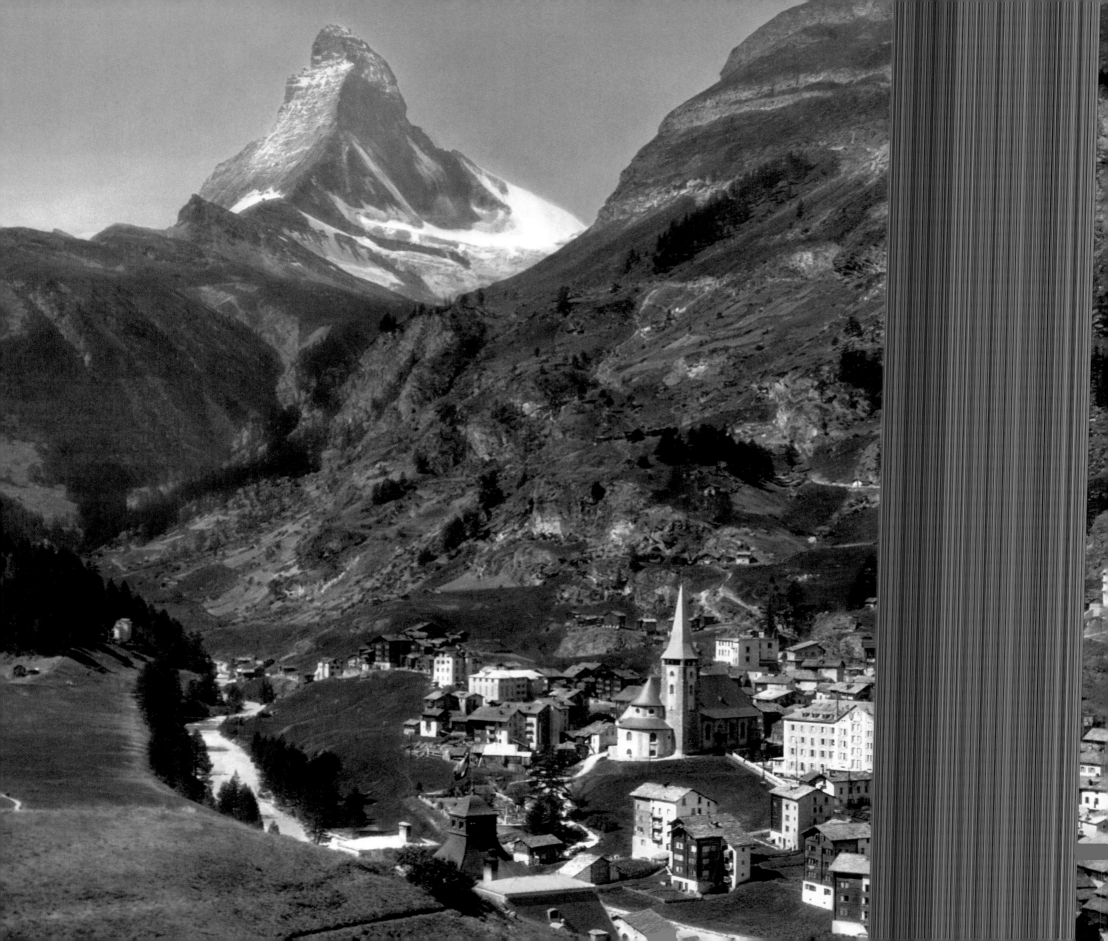

LEFT **THE MATTERHORN, ZERMATT, 1904**

No traveler feels that he has quite reached the heart of Switzerland until he finds himself at Zermatt. The town is always full of climbers—the ice-axe is the ordinary walking stick, and everybody wears spiked shoes with great hats adorned with edelweiss, a coil of rope and rucksack. The magnet that draws most people to Zermatt, I need not name. I need not even point it out. It is there, you cannot miss it—it is everywhere.

To the north yawns the valley of Zermatt, up out of which we have come. In early morning that abyss is often filled with floating masses of white vapor, morning mists lie lightly in the deep, narrow depression, which then appears like a Norwegian fjord, filled with the flood of some sea of pure white eiderdown. That sea of fluffy clouds is beautiful to look at from above. From Zermatt village, in the valley far below, it is not beautiful. When tourists there in the bottom of the valley wake and look out from their hotel windows to see what sort of weather they have for their excursions, they scowl and lose their tempers, for to them, roofed in by this great, misty canopy, the weather appears shocking—the sky is overcast for them, impossible there in Zermatt, while here 5,000 feet above, we bathe in glorious floods of morning light under a cloudless sky.

BELOW **MOUNTAIN PASS, SWISS ALPS, 1924**

In the Alps the traveler revels in a glorious unspoiled Alpine paradise endowed with perfect roads, attractive inns and trails that give access to the very heart of Switzerland.

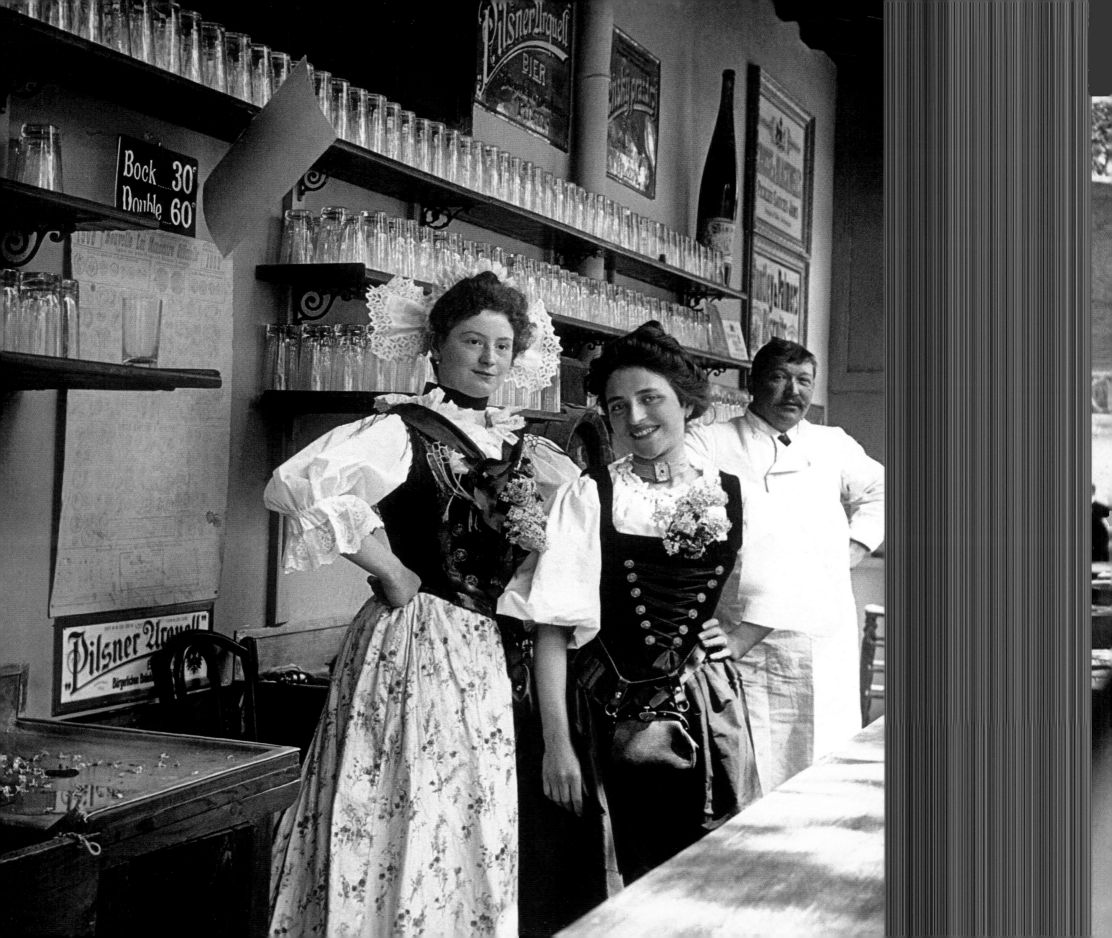

LEFT **BARMAIDS, ALPINE INN, 1904**
There are many luxurious hotels and inns offering the best of everything Swiss, staffed by friendly folk who are totally devoted to the travelers' ease and comfort. It is quite astonishing to find so much metropolitan luxury so near the edge of the icy wilderness of the high Alps.

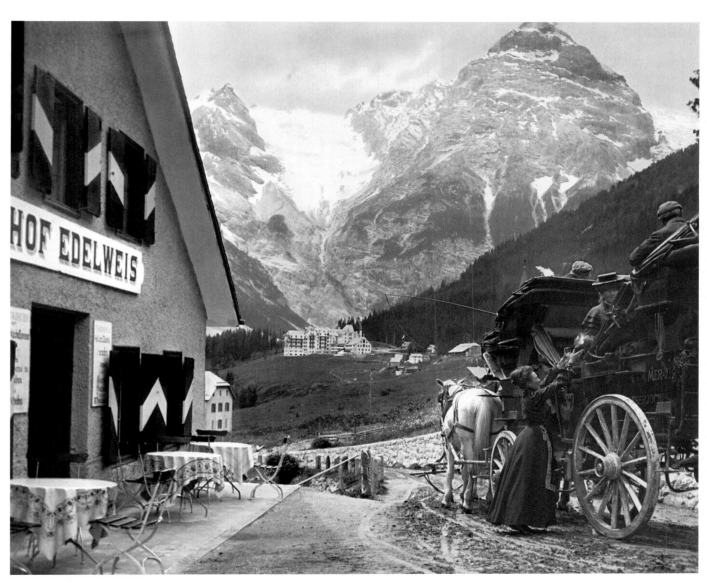

ABOVE **AN ALPINE INN, SWISS ALPS, 1904**
Many of the windows of this inn look out upon one of the most beautiful views in Switzerland—a simple view, but grandly, gloriously simple: a flat foreground of green, two gentle hills, one rocky cliff, and a great snow-clad peak. Other windows command splendid views of the surrounding mountains or of the lovely valleys that lead away. Many a tourist does his mountaining from these windows, with the assistance of field-glasses and a refreshing cup of tea. Fault-finding critics—and it is not a critic's duty to find fault— declares that the charm of Switzerland has been killed by comfort, like the proverbial cat. But as an enterprising native said to me—one who had made a fortune in the hotel business, and had built himself a splendid hotel containing every modern comfort: "You foreigners are so unreasonable. You come to our village and complain that it affords no comfort to those who would gladly come to enjoy the lovely scenery roundabout. We borrow money and build for you a magnificent hotel, and then you say, 'The mercenary Swiss are ruining their country and killing all its charm.'"

RIGHT **THE FÊTE DES VIGNERONS, VEVEY, 1905**

The Fête des Vignerons is the vintners' thanksgiving cele-
bration. During the Fête, Vevey's streets are alive with gods
and goddesses, the fauns and nymphs, satyrs and bacchan-
tes of mythology. A stranger dropping into town, not know-
ing that a festival was on, would imagine himself enjoying a
delightful classic nightmare.

But what we see in the streets is nothing compared with
the great spectacle presented in the arena of the huge
amphitheater in the presence of audiences of thirteen
thousand persons. More than eighteen hundred characters
appear in the colossal production. The orchestra is made
up of three symphony orchestras and two military bands.
The music is good music; it has the dignity and genuineness
of the native folk song, with a beauty and poetic grace that
one would not expect to find in a mere peasant festival.

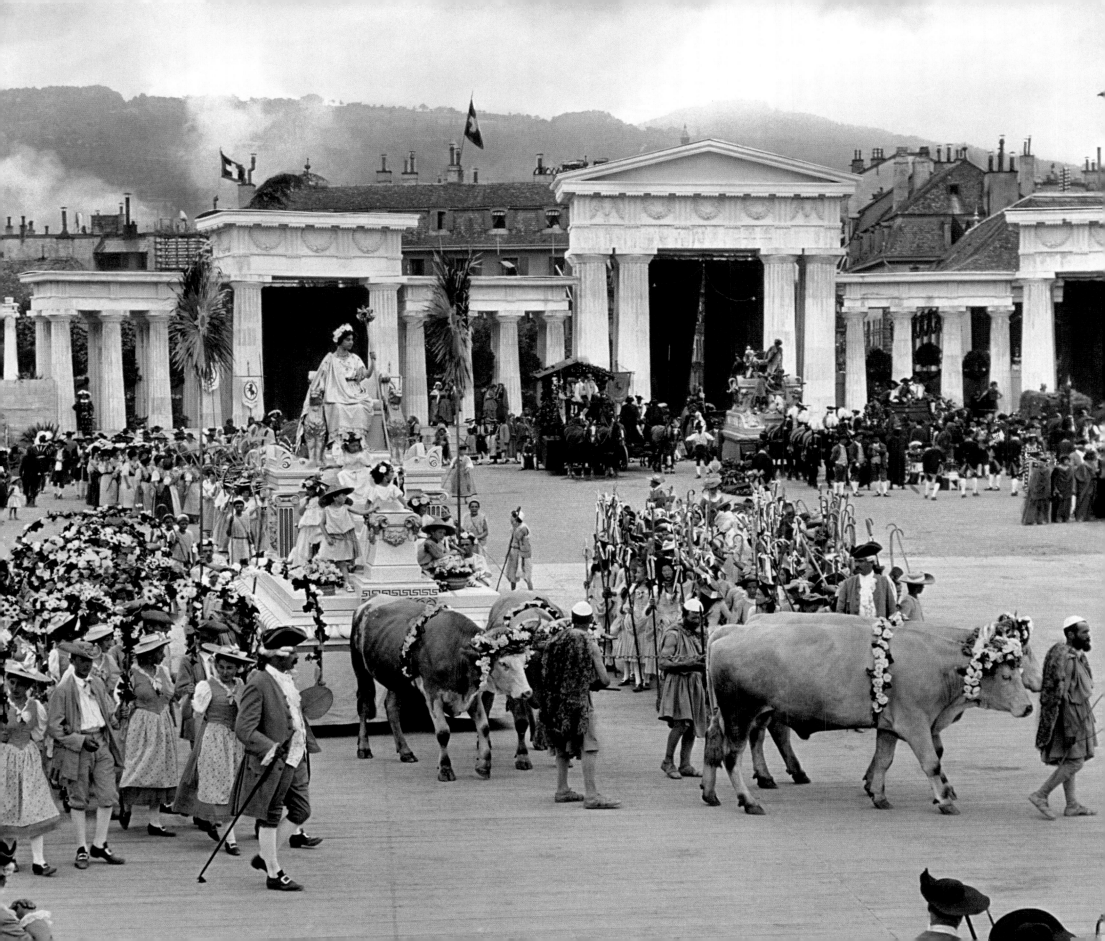

ALONG THE BARBARY COAST TO TU

The fascinating cities of the coast of Barbary are comparatively unfamiliar to the globe-trotter. A hundred years ago a visit to the Barbary Coast was an experience not to be desired by voyagers from Christian lands, who then came not as tourists with cameras and guidebooks but as prisoners or slaves in manacles and chains.

Cities white in outward seeming but black in rascality and crime then graced and at the same time disgraced the smiling southern shore of the Mediterranean Sea. The various states of Barbary, Morocco, Tunis, Tripoli, and Algeria, ruled by lawless potentates, then exacted tribute from other governments both great and small. The Corsair fleets of

infamous memory then threatened the maritime commerce of the world, respecting only the ships that sailed under the flags of tribute-paying nations.

Travelers are just awakening to the fact that on the northern shore of Africa and within easy access of the Continent there awaits them a land full of surprises—of unsuspected treasures of the strange and picturesque—an Occidental Orient.

The most direct route to the Barbary Coast is that followed by the steamers of the German Mediterranean service, sailing from a New Jersey town the name of which is dear to globe-trotters, for Hoboken lies at the great gate-way

to the world of travel. the Azores, a smile fr Gibraltar as we pass th the Mediterranean and sunny welcome from Al

One part of Tu might be in a lesser city the peculiar costumes Tunis wear not only th well. So many women the attention of the tou

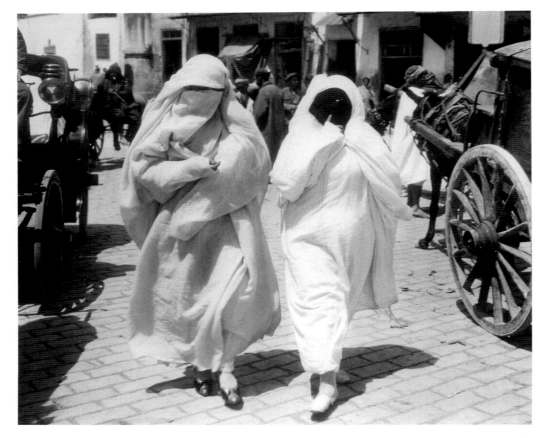

LEFT STREET SCENE I

RIGHT HOUSES AT MAT

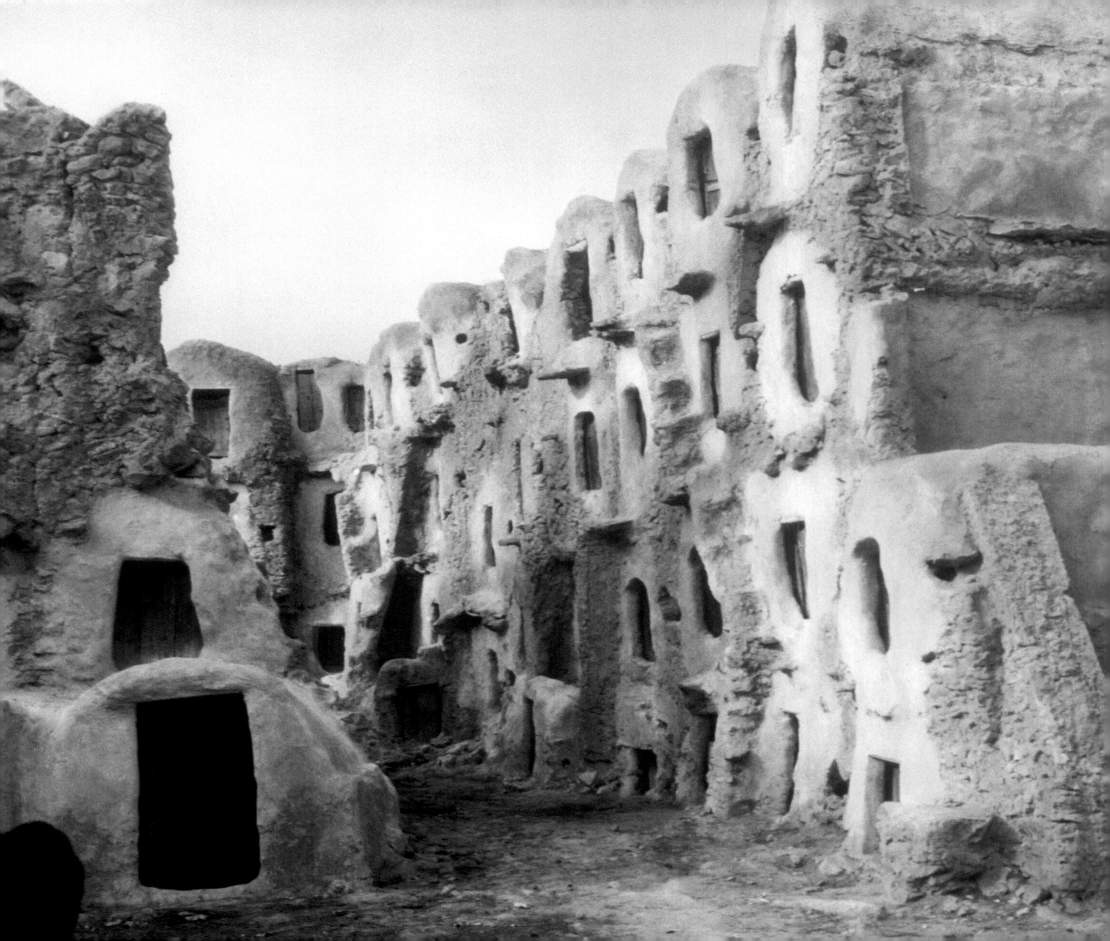

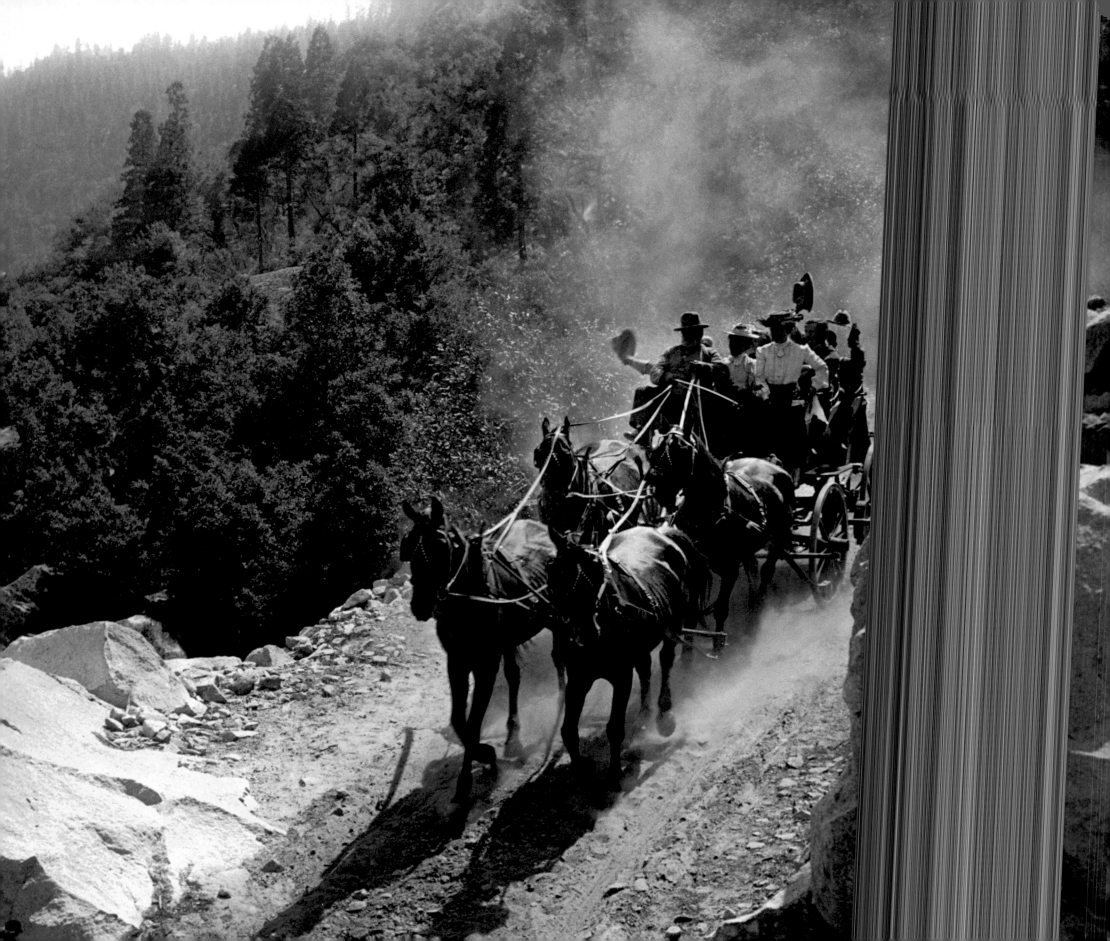

"MY COUNTRY, 'TIS OF THEE!"

Seeing America is strenuous work.

To see it all is out of the question. The acme of sublimity in natural scenery is reached in Arizona. The world is not aware that this is true, nor do I hope to prove that it is true except to those who, with an interest aroused by words that are inadequate and pictures that fall far short of the reality, shall someday undertake the marvelous journey that glorified for me the summer of 1898.

When I first visited the Grand Cañon [sic] in Arizona, it was inaccessible to the multitude, known to very few and had been viewed only by the Indian, the explorer, the prospector and an occasional enterprising traveler.

The traveler usually enters the Grand Cañon by a first-class wagon road from Flagstaff, seventy-five miles to the Grand Cañon at Grandview. The road is open for travel in spring, summer and fall, and the trip takes two days each way by wagon. Supplies, camp outfits and teams are procurable in Flagstaff. Camping trips with pack and saddle animals, or with wagon and saddle animals, are organized, completely equipped and placed in charge of experienced guides. Horse trips over any of the Cañon trails into the Cañon are permitted only in the company of a guide. This rule is merely a matter of precaution.

The arrival of our party at Flagstaff, Arizona, the starting-point for the stage ride (to the Cañon), with cameras and chronomatographs [an early term for a movie camera], almost a mile of film, and rather more than two hundred weight of plates, causes the citizens to smile and murmur to themselves, "Here come another group of sanguine photographers, doomed to disaster and defeat."

Flagstaff has been very aptly described as a nice little town with nothing Puritanical about it; nor is it hypocritical. For barefaced honest badness, all on the surface, commend me to this frank and open town of Flagstaff. We first pass three saloons, then a restaurant, a newsstand, and a barbershop, and then another group of drinking-halls, and there are no screen doors to hide the bars. No; gambling is not winked at by the municipality, it is boldly smiled upon, and flourishes like a green bay-tree upon a score of green baize tables. Even the smoking-room of our hotel nightly resounds to the click of the ivory chips along with the chink of silver dollars; but in the glorious, healthful atmosphere of Arizona much of the abjectness of these pitiable pursuits is lost.

LEFT **TOURING BY STAGECOACH, ARIZONA, 1898**

A dash downgrade is thrilling exciting; our four horses swing us at a spanking pace around curves and past a score of splendid points of view. We worry that all the shaking and violent rocking will damage our film equipment or break the glass plates, but we had to sit tight—this was part of the adventure.

RIGHT **LUNCH DEEP IN A CAÑON, GRAND CAÑON, ARIZONA, 1898**

But as we look around us, we can scarcely realize that we are six thousand feet below the level of the surrounding land. The effect of being in a cañon is here completely lost. The Titanic walls have shrunk backward and also downward behind the minor buttes and palisades, and we look in vain for the outer limits of the gulf. The true skyline of the cañon is not visible, though here and there some isolated promontory-tip projects into the ether, like a dot left to mark the place where once the huge escarpment stood.

Our thirst assuaged by draughts of water that is almost mud, filtered between the teeth, we first unpack the animals, indulge in a rude picnic beneath a meager cottonwood, and then, during a long, hot afternoon, we wander round about the camp, scaling low cliffs, in an endeavor to reach some stirring point of view.

Accompanied by his entourage that included Oscar B. Depue, Holmes visited northern Arizona in 1898 and 1899. They made the first movies taken in Arizona of such subjects as the Hopi Snake Dance and Captain John Hance leading tourist groups into the Grand Cañon. While visiting the Navajos, Holmes and Depue staged a chase scene where a young white woman from Denver, "Rattlesnake Jack," challenges the braves to catch her when she steals the chief's horse.

Hopi Land, also known as Moki Land, in Arizona is the home of the strangest of our fellow-countrymen. Moki Land is unique; it is a changeless corner of our land of perpetual change. The Mokis are a pueblo people, differing from other tribes of the southwest in language, customs, and religion. They dwell in seven villages, each set like an acropolis upon a barren rock, high above the barren, boundless sands of the Arizona desert.

How long they have lived there in the sunshine, no man knows. The Spaniards found them there in 1541, living and praying and performing their religious ceremonies, just as they had lived and prayed and worshipped for uncounted centuries.

The name *Moki*, which we now erroneously apply to this little nation, means literally "dead people," and was originally a term of derision given by the warlike Apaches and Navajos to these peaceful farmers and home-builders. Ask one of the boys whom we find playing in the Plaza of Walpi what he is, and he will say that he belongs to the "hop," or "good people," for Hopi is the original name by which these pueblo-builders call the[mselves]

LEFT **LEAD GUIDE ON T**

RIGHT **YOSEMITE, CALIF**

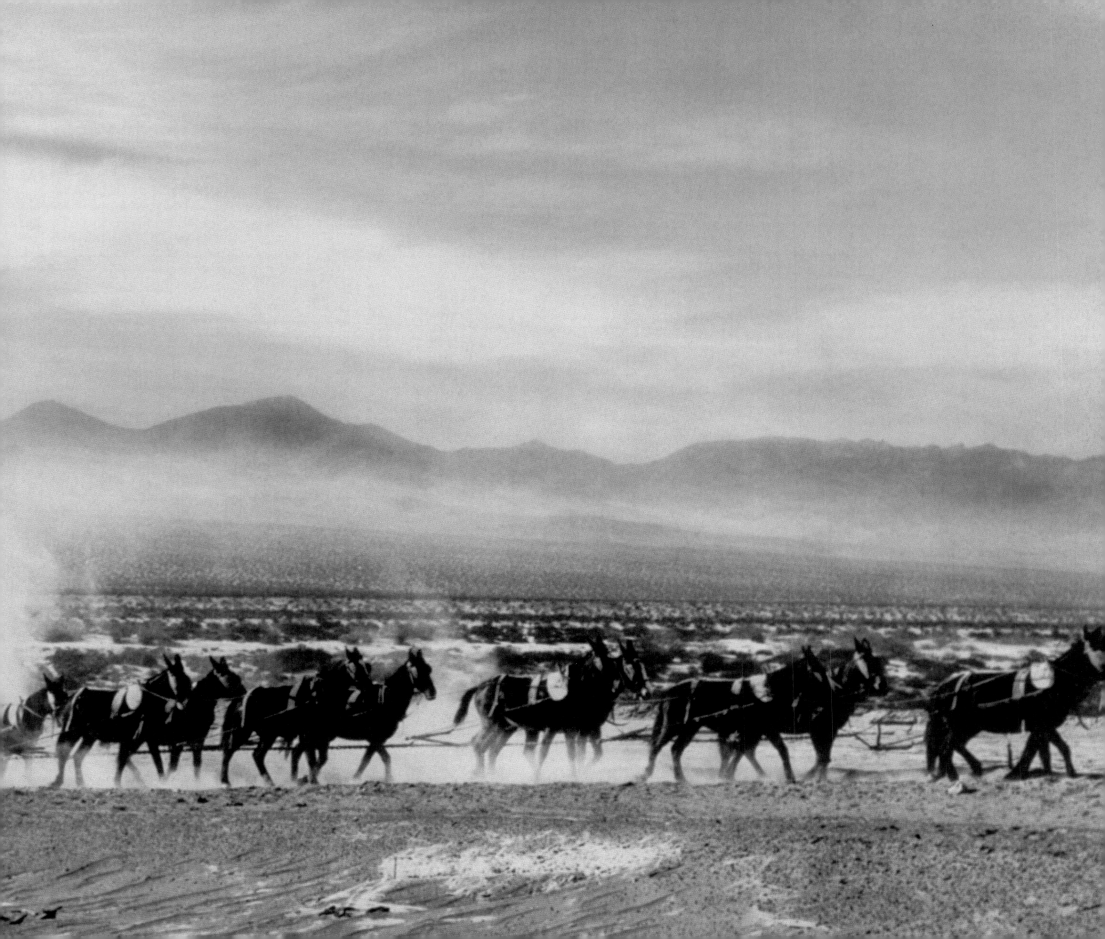

that copious rains may fall, and that bounteous crops of corn and beans and melons may grow up out of the desert sands.

The Snake Dance of 1898 was performed in August at Oraibi. Though Oraibi is the largest town of Moki Land, it is at the same time the one least in touch with the white man's civilization. In 1898, however, at least forty white visitors toiled up the trail and roamed through the broad street of the big village, peeping into Hopi houses, frightening the timid children, and affording a new subject of conversation for the elders, who so rarely see a white stranger.

The final invocation begins; this is a symbolic ceremony, not a dance. The Antelope and Snake Fraternities begin a low peculiar chant, swaying their bodies, waving their feather wands, pointing them to the ground. The humming chant is almost wordless; it represents the sighing of the winds, the rushing of the storm-clouds, while the accompanying rattles play an obligato as of thunder. There is in it all a mystery and dignity which cannot be described.

As the ceremony continues, you will see some of the priests take snakes of various kinds from the kisi; then, holding the neck between the teeth and the body in the hands, dance slowly round and round, followed by other priests whose duty is to aid the carrier in case of need, and to gather up the wriggling snakes and prevent their escape after they have been dropped to the ground. One by one, the snakes, about sixty in number, many of them venomous rattlers, are carried round the plaza. Meantime, women with baskets of cornmeal assemble near at hand. A priest draws with the

sacred meal a circle on
snakes are hurled, formin
instant, the dancers paus
plunging their arms into t
reptiles as the hand will
zied bearers with the g
down the steep trails t
dark and somber, for the
have scattered, lost in th

When half an hou
empty, the snakes, mess
its of the underworld, h
bearing the petitions of
We do not know why th

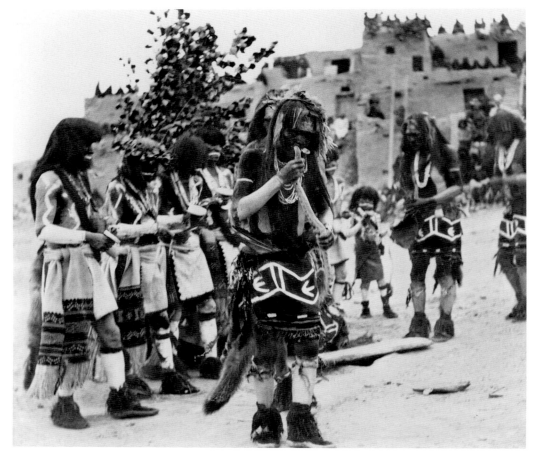

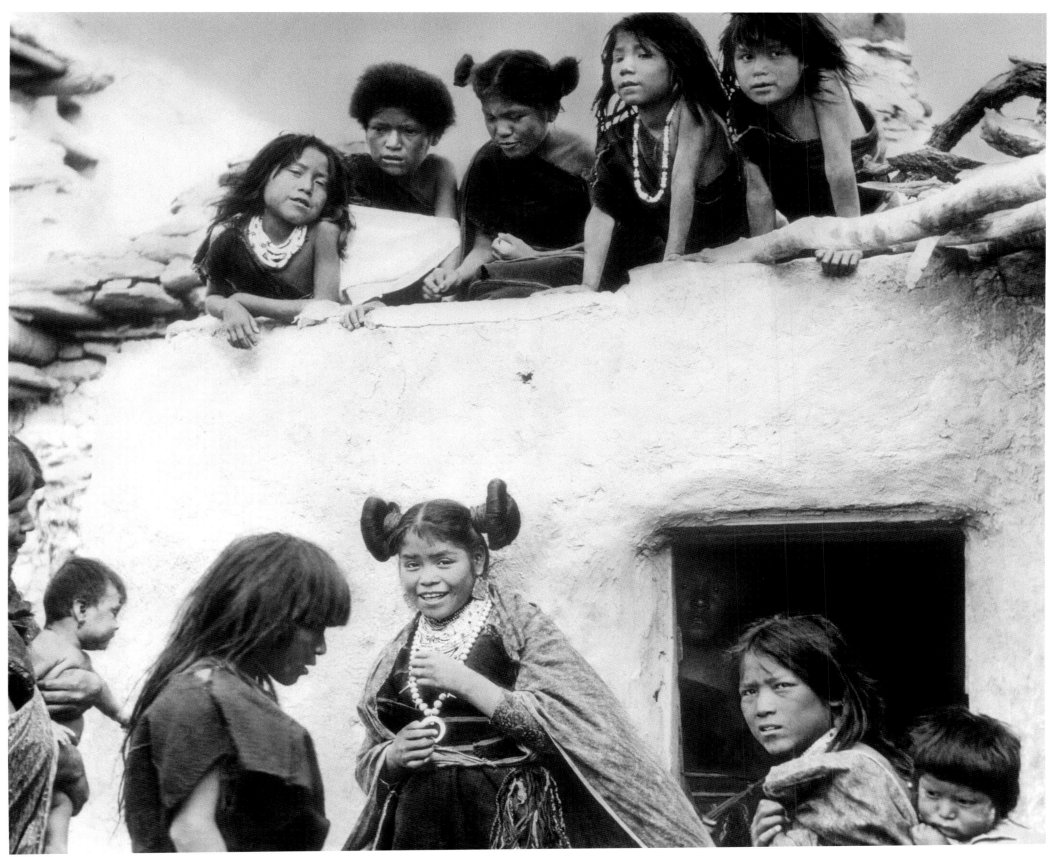

ABOVE AND RIGHT **NAVAJO PORTRAITS, ARIZONA, CA. 1907**
While probably colored under the instruction of Holmes,
these portraits were given to him by another photographer.

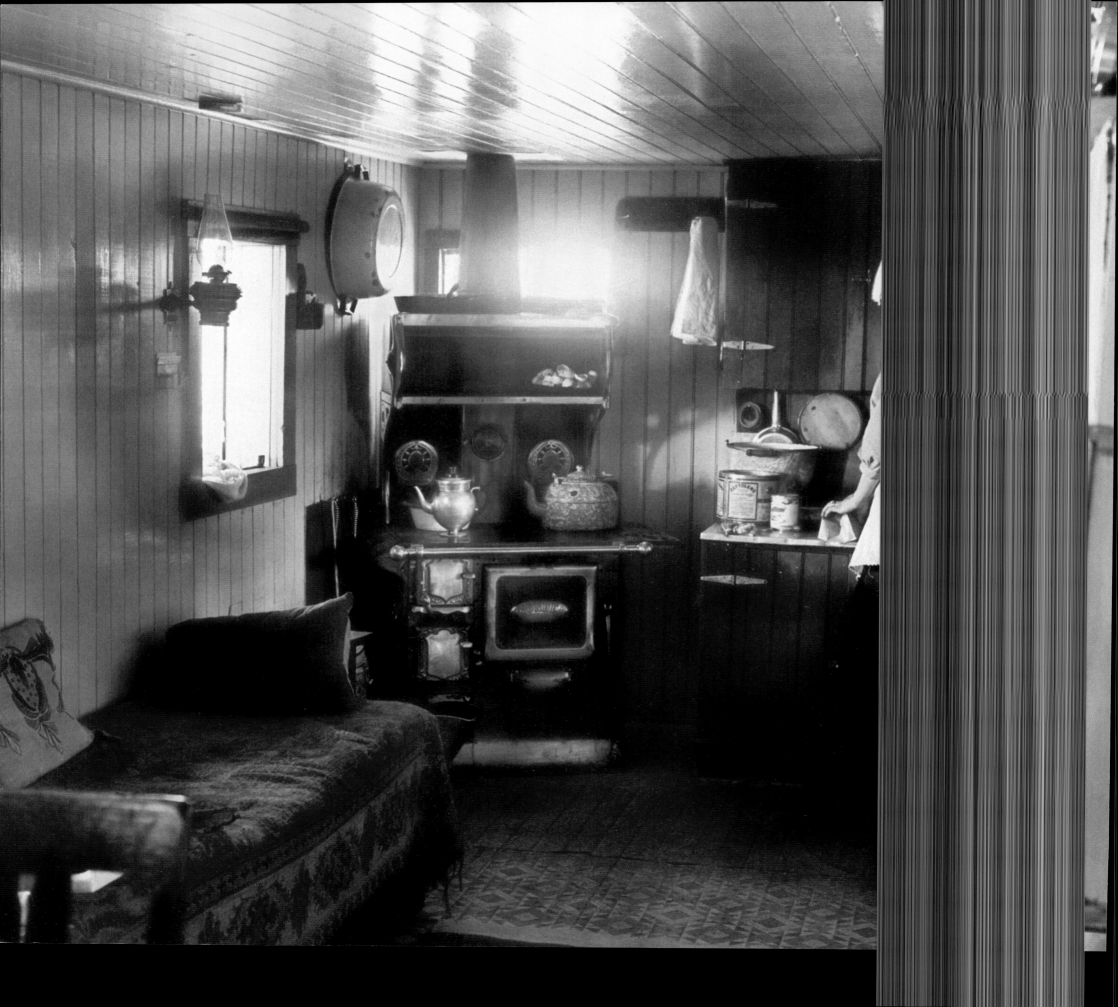

the rattlesnake or how they render its dreaded fangs innocuous; the secret of immunity remains a Hopi secret, jealously guarded by the successive generations of the brotherhoods.

It is an incontrovertible fact that the Hopi prayers are usually far more efficacious in bringing rains than are the prayers of the average country clergymen. But on the day following the invocation, there burst over the villages a terrific thunder-storm. The north heavens were as black as night, fierce lightning flashed, and the rain descended, as if entire lakes had been snatched up by the grateful Rain Gods, wrapped in black vapors, and dispatched to Hopi Land to answer to the prayers of the Good People. Yet the downpour fell only upon the Hopi mesas and upon their fields. *[1898]*

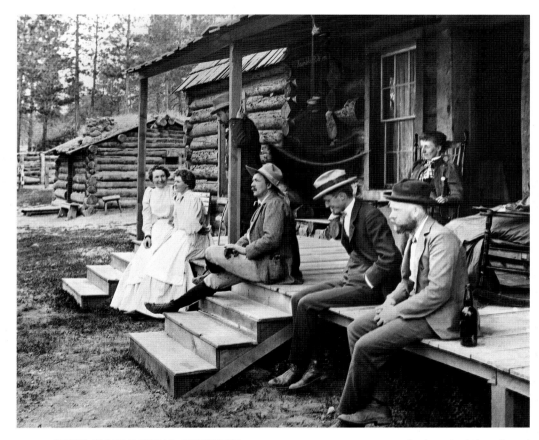

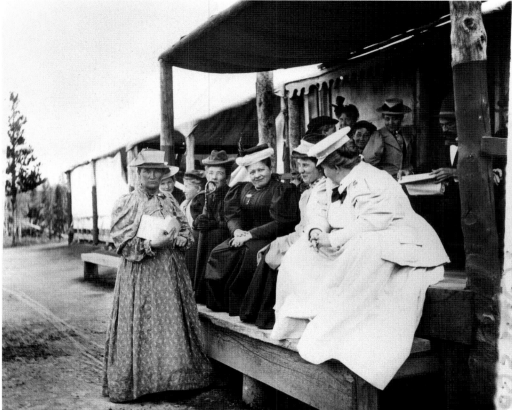

LEFT **AT HOME IN A BOXCAR, OUT WEST, 1915**
A resourceful mother fashioned a small but comfortable home for her family from an abandoned boxcar.

ABOVE LEFT **TOURISTS OUTSIDE LARRY MATTHEWS'S CANVAS PALACE, YELLOWSTONE PARK, 1896**
What traveler does not remember Larry Matthews and his Canvas Palace? Who can forget his cheery welcome when, lifting the ladies from the coach, he cries: "Glad to see you! Walk right upstairs—or would ye rather take the elevator?" We never know what we are eating at Larry's busy table d'hôte. He never gives us time to think about the food. He is able to make the people laugh so much and eat so little that the company should meet all his demands for an increase

of salary. And then if one looks wistfully upon the butter or the sauce, he quickly reassures you with the declaration that "there's no extra charge for flies and dust—always on the bill-of-fare—a standing order." This joke, like the dish referred to, is "a standing order"; but although we lunched four times at Larry's, we seldom caught him putting old cylinders in his phonograph of fun.

ABOVE RIGHT **THE FAMOUS "CALAMITY JANE" AT YELLOWSTONE PARK, 1896**
It was at Larry's that we met the original, Simon-pure "Calamity Jane" who twenty years ago was famous as a woman-scout, and served our generals faithfully in many of the Indian wars.

American frontierswoman Martha Jane Cannary (on the left, in the calico dress and straw hat), better known as Calamity Jane, was a colorful and much mythologized figure of the Old West. She gained fame as an Indian scout during the 1870; a woman who could ride a horse and shoot a rifle better than most men. Independent and unconventional, she authored her own legend as a hard-drinking, tough-talking cowgirl. During her life, she supported herself in many ways, as a dance hall hostess, cook, laundress and devoted nurse, but her toughest battles were fought with the bottle—most likely the cause of her early death.

BELOW LEFT THE EDGE OF CHINATOWN, SAN FRANCISCO, CALIFORNIA, 1915

BELOW RIGHT THE VIEW DOWN CALIFORNIA STREET, SAN FRANCISCO, 1915

RIGHT MARKET STREET, SAN FRANCISCO, 1915
San Francisco's main commercial corridor shows no sign of the devastating earthquake of 1906, which destroyed the city and leveled many buildings throughout the city.

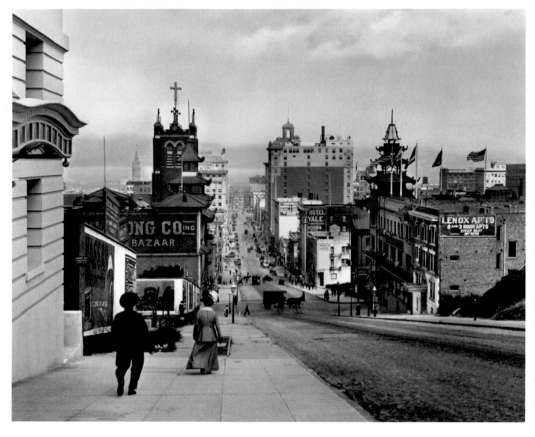

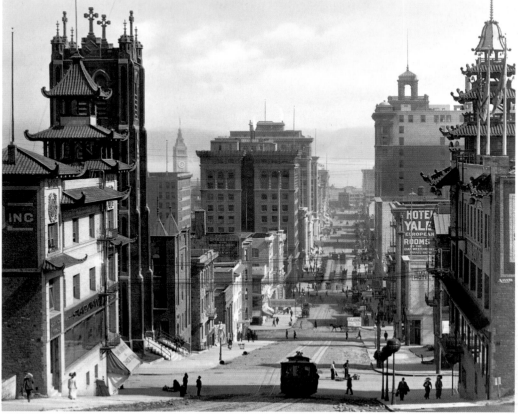

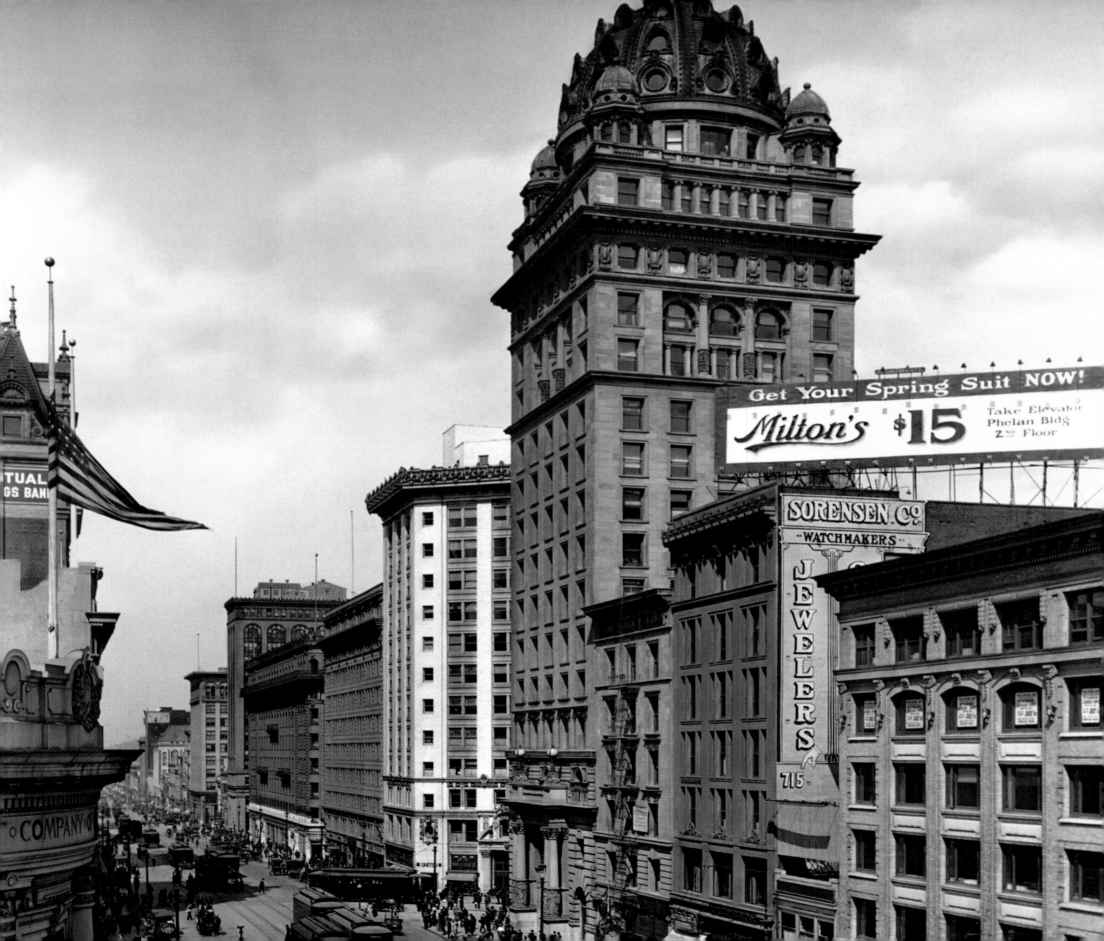

BELOW
LEFT

SEATTLE, WASHINGTON, 1934

BELOW
AND
RIGHT

SING FAT CO., CHINATOWN, SAN FRANCISCO, 1934
*Located at the southwest corner of California Street and
Grant Avenue, and in business since 1866, Sing Fat Co.
billed itself as the city's "leading Oriental bazaar." The
photo on the right is taken from nearly the same angle as the
image gracing the store's ubiquitous promotional postcard.*

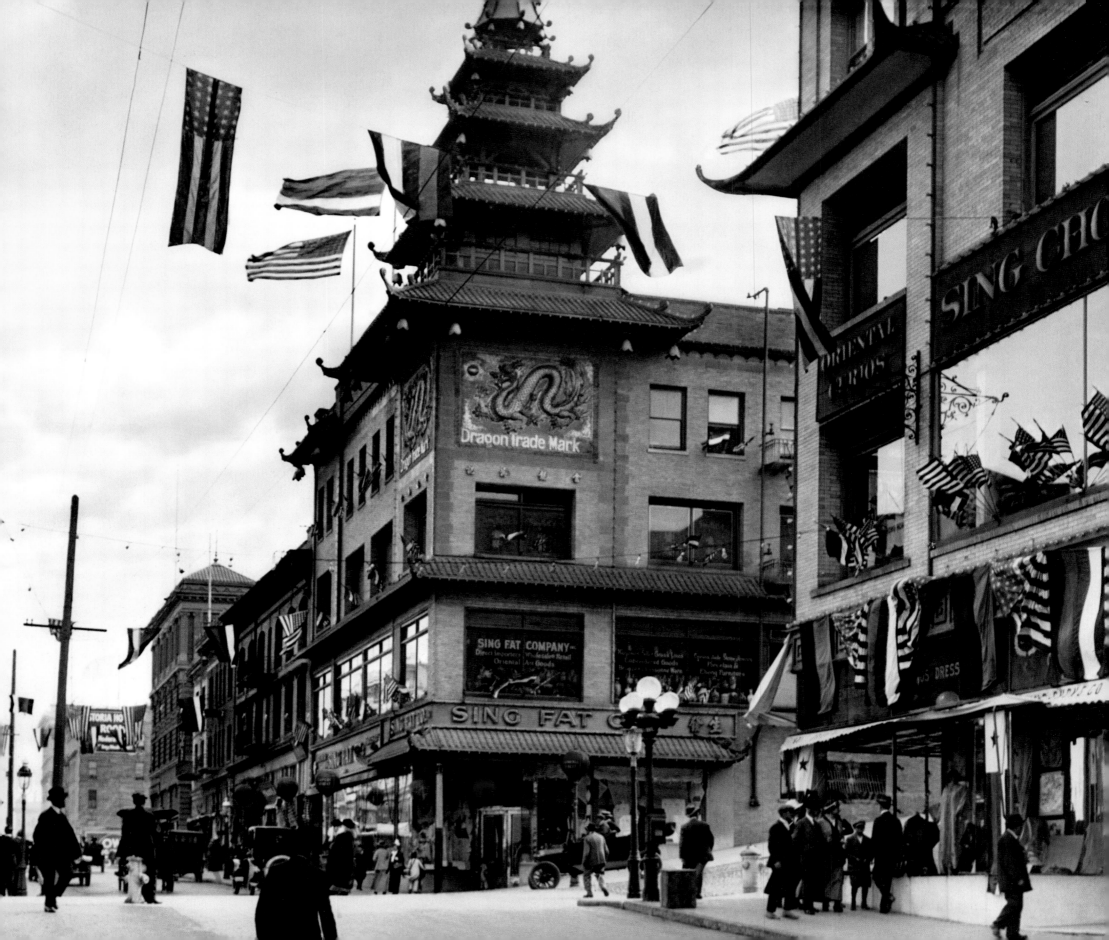

Long years ago in the piney depths of the Yellowstone National Park I met a lone wanderer touring through that Northwestern wonderland with two ponies, one for himself and one for his pack. He had no tent, only a sleeping-bag, and his camp kitchen was rudimentary and extremely portable. He could mobilize in a minute. He had been on the move for many months and intended to keep on the move until he had seen all there was to see between his home town in the middle West and his Ultima Thule—the Golden Gate. His expenses averaged just 50 cents a day. He sized up my comparatively elaborate outfit and inquired, "Are you travelin', or just goin' somewhere?" I did not know just how to answer him.

Do we ever really *travel* in America? We do travel in Europe, in Asia, in Africa—but is it not true that in our own country we are usually "just goin' somewhere"—more often than not going to the same place we went to last year and the year before? In the course of our goings to and fro at home few of us ever get that delightful sense of being *otherwhere*, that fascinating "foreign feel" that lends so much of charm to travel abroad—in the older world of Europe or the East. Yet this travel thrill born of strangeness and difference and novelty, or inspired by the historical associations of some place or scene, is to be had in our own country if we will "go abroad at home" in the same spirit in which we go abroad—abroad. [1916]

Someone once said of California "it is our Italy." California is more than that. It is not only our Italy with its sunshine and flowers, its volcanoes and vineyards; it is our Riviera too, with its blue skies, its rocky cliffs, its plutocratic villas looking down upon an azure sea and its costly caravansaries for the homeless rich. It is our Egypt, with its reclaimed deserts; a carefree "Bohemia" lives again in California's colossal groves. It is our Spain, with its old churches, silent cloisters and crumbling epoch-marking missions, its liquid Castilian place-names, its *barrancos* and *arroyos*. California is to-day more Spanish than it has been since it became American. [1915]

LEFT **MOBILE GILMORE OIL BOILER, LOS ANGELES, CALIFORNIA, 1931**
A mobile advertising novelty on the streets of Los Angeles: "Some day you will own a horseless carriage. Our gasoline will run it."

RIGHT **OIL DERRICKS AT LONG BEACH, CALIFORNIA, 1931**

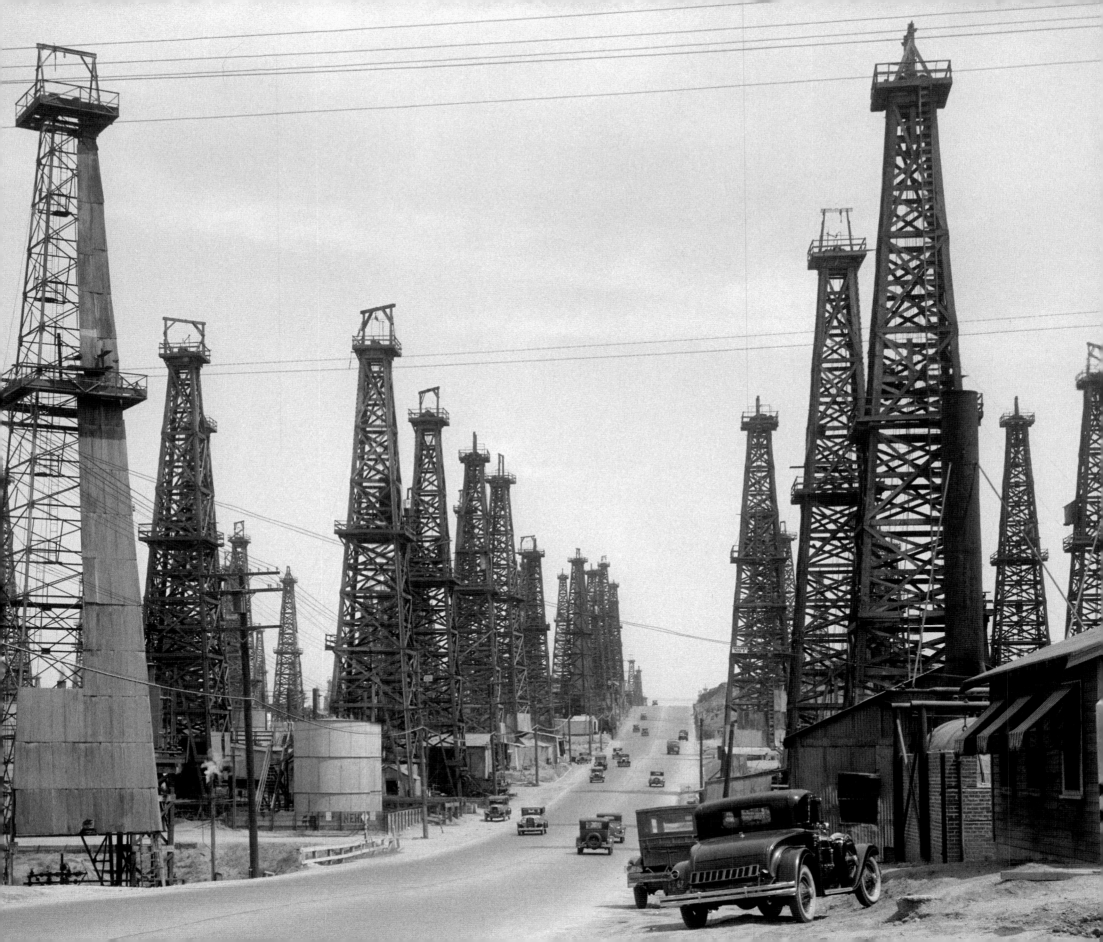

BELOW **THE SANTA MONICA PIER, CALIFORNIA, 1931**
*Extending over the Pacific Ocean, a carousel and roller
coaster join the La Monica ballroom (site of numerous
dance marathons) on the Santa Monica pier.*

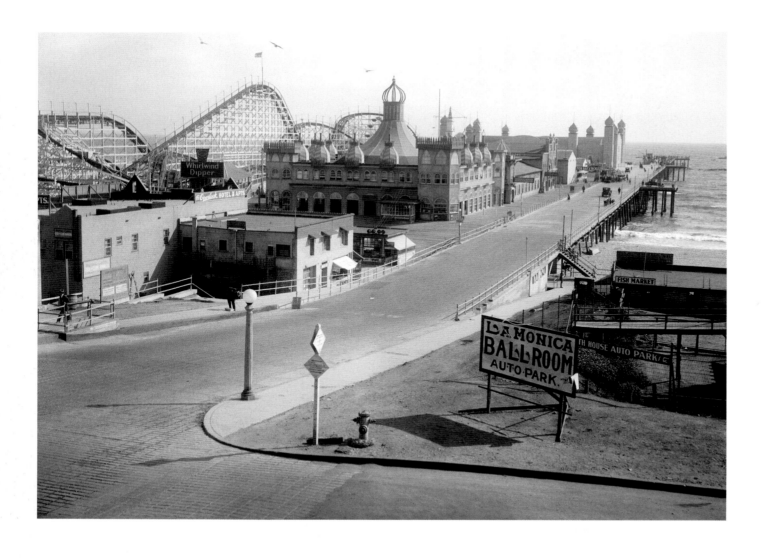

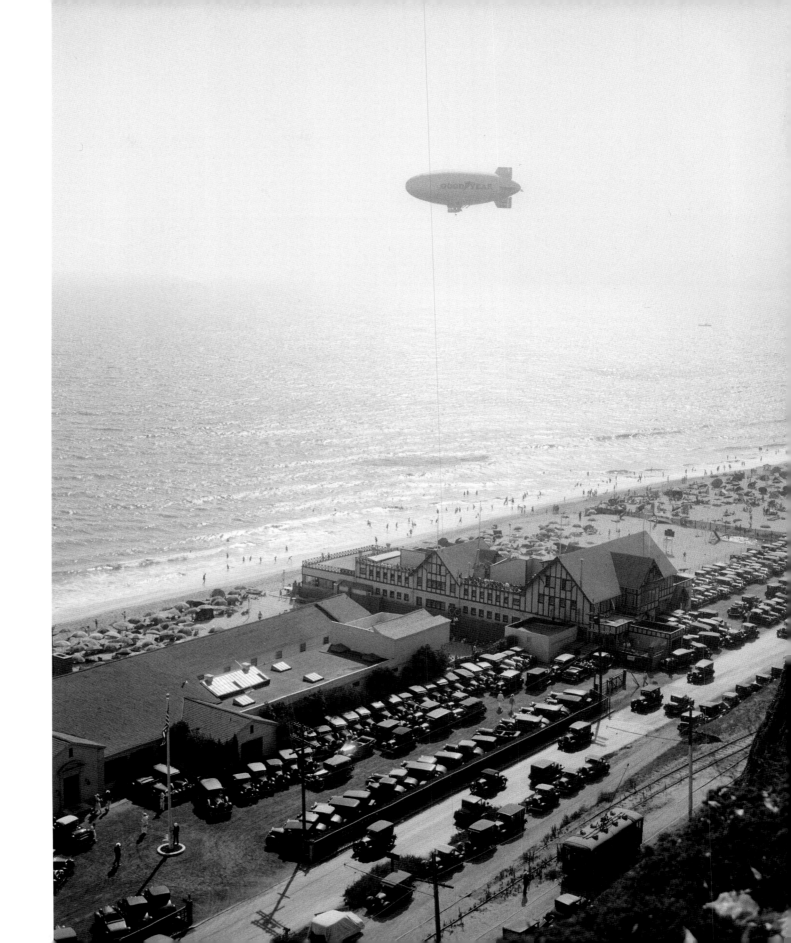

RIGHT SANTA MONICA BEACH, 1931

LEFT **WILSHIRE LINKS MINIATURE GOLF COURSE, BEVERLY HILLS, CALIFORNIA, 1931**
Mary Pickford was an investor in this fanciful miniature golf course at the intersection of Wilshire Boulevard and La Cienega.

RIGHT **TWIN BARRELS DRIVE-IN, BEVERLY BOULEVARD, LOS ANGELES, CALIFORNIA, 1931**
Carhops serve a meal at one of the many examples of mimetic architecture that dotted the Southern California landscape.

BEN-HUR CAFÉ, HOLLYWOOD, 1931

TOED INN, SANTA MONICA CAÑON, CALIFORNIA, 1931
Vulnerable to California's unpredictable weather, the Toed Inn was destroyed by a flash flood in 1938, pushing the stucco amphibian out to sea.

KONE INN ICE CREAM STAND, EAGLE ROCK, CALIFORNIA, 1931

RIGHT THE BULLDOG CAFÉ, LOS ANGELES, 1931

BELOW
LEFT
**ENTRANCE TO PARAMOUNT STUDIOS,
HOLLYWOOD, 1931**
*Through the gates of Paramount Studios, one of
Hollywood's most recognizable icons, passed Cinema-
land's most famous stars.*

BELOW
RIGHT
**GUARD GATE, UNITED STUDIOS,
HOLLYWOOD, 1931**

RIGHT
**ON THE SET OF *STREET SCENE*, GOLDWYN STUDIOS,
HOLLYWOOD, 1931**
*The film Street Scene, directed by King Vidor, was based
on the Elmer Rice play and filmed entirely on this one set.*

Hollywood is filled with fantasy, from a fabulous premiere, like that of *Hell's Angels* at Grauman's Chinese Theatre, to one of the new miniature golf courses that have become such a craze, to anything-but-ordinary-looking sandwich shops, and drive-ins with their complements of "carhop" waitresses whose good looks proclaim them to be would-be "movie stars."

The world knows Hollywood only by name—and by reputation. Pictures made in Hollywood have delighted—or distressed—the multitudes of many lands, but Hollywood itself has never yet been honestly presented on the screen. I have been at work behind the scenes and among the stars in the Movie Capital and have produced a truthful, beautiful and amusing picture-record of what Hollywood is really like. It is one of the most interesting places in the world of to-day. [1931]

A burgeoning new medium, Hollywood feature films appeared to be the travelogues' greatest threat. But, Holmes, always a little ahead of the crowd, contracted with Paramount Studios to produce weekly releases of his travel tours. From 1915 to 1921, he filmed and narrated 312 travel "shorts" resulting in six years of unbroken weekly travelogues being shown in Paramount theaters across the country. The popular "shorts" publicized his lecture tours as well and his audiences grew even larger. In 1923, as an air travel pioneer flying in primitive aircraft between France and Morocco, Burton Holmes produced the first motion picture glamorizing air travel, entitled Mediterranean Sky Cruisings.

Holmes always said if he ever decided to settle down it would be either in New York or Hollywood; either in the roaring metropolis or in the Peter Pan suburb of Los Angeles, where he found the climate and the atmosphere of hopeful make-believe alluring. He had visited Los Angeles for years as part of his tours, and because of his work with Paramount, he had many professional contacts and friends. In 1930, Burton and his wife Margaret purchased a second home high above Hollywood, which he named "Topside."

Hollywood royals Douglas Fairbanks and Mary Pickford were regular guests at Topside, as were actresses, Jean Harlow, Pola Negri and the exotic Dolores del Rio. Many weekends were spent at the San Simeon ranch of newspaper magnate William Randolf Hearst and actress Marion Davies; and studio heads Sam Goldwyn and Jack Warner always had their doors open to Holmes. In spite of his connections, Holmes always maintained a sense of humor about the glamorous life he was leading, and once quipped to a friend: "You know, one of these days someone will say, 'Strike the set!' and this whole town will fall down."

LEFT DOLORES DEL RIO AT HOME, HOLLYWOOD, 1931
Surrounded by Art Deco sophistication, film star Dolores del Rio poses in the home designed by her husband, MGM set decorator Cedric Gibbons.

RIGHT HOLLYWOOD ROYALTY MARY PICKFORD AND DOUGLAS FAIRBANKS IN THEIR FAMED PICKFAIR MANSION, BEVERLY HILLS, 1931

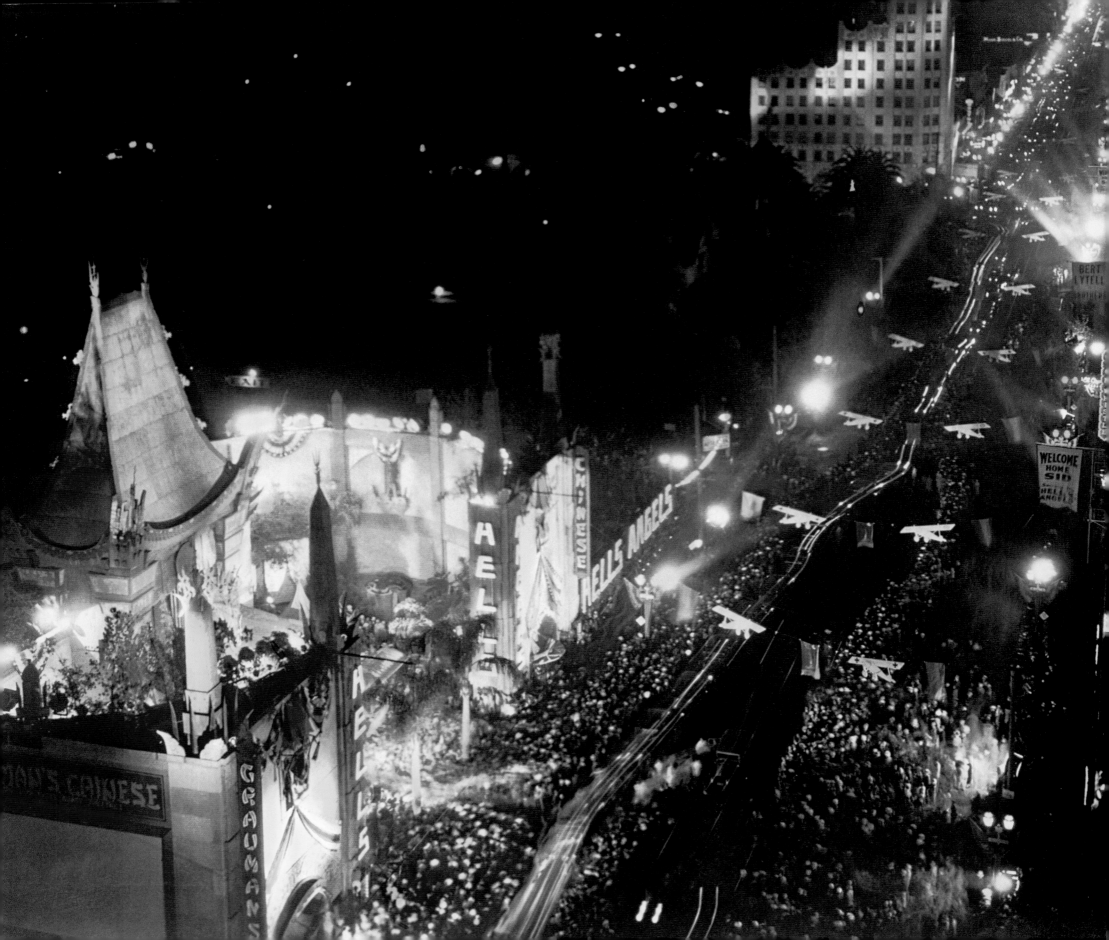

LEFT **PREMIERE OF** *HELL'S ANGELS,* **GRAUMAN'S CHINESE THEATRE, HOLLYWOOD,** 1931

An invention of theater impresario Sid Grauman, the movie premiere reached spectacular proportions with the launch of the Howard Hughes production of Hell's Angels starring Jean Harlow.

BELOW **DOUGLAS FAIRBANKS' AND MARY PICKFORD'S HAND- AND FOOTPRINTS, OUTSIDE GRAUMAN'S CHINESE THEATRE, HOLLYWOOD,** 1931

In 1930, Holmes made the film, The Real Hollywood with a "million-dollar" cast of volunteers, including Fairbanks and Pickford, del Rio, Harlow, Edward Everett Horton, Negri, Laura La Plante, and Charles Ruggles. The film proved to be popular with his Travelogue audiences. Hollywood, 1931 gave Holmes a chance to tell of his brief glory as a movie star doing talking "travel shorts" for MGM in English, and flawless French, Spanish, and Italian.

For his role as one of the world's earliest filmmakers and a pioneer in the documentary field, Holmes received a star for cinematography on Hollywood Boulevard's Walk of Fame.

Travelers who have never traveled in the land which owes so much to Jefferson tell us that there is no variety in the United States—that one town is very like another—hopelessly American, monotonously prosperous and hideously unpicturesque. Such a critic has never been to the town of Taos or to the ancient metropolis of Acoma. Both of these wonder places are in our Southwestern wonderland—New Mexico. Both are Indian pueblos—yet each is unique. Taos represents the highest type of piled-up communal dwelling; Acoma approaches the acme of picturesquesness in situation and surroundings. Taos was touched by the old Santa Fe trail, which meandered far from its indicated path to bring its thirsty pioneers into the Taos Valley, because there water was to be found—fresh running water—and trees, big

beautiful green trees that gave a grateful shade and created there in the burning highlands of the great Southwest a sense of security, of civilization and of home. Taos, even to the white stranger, still seems a home-like place, despite its strangeness and its remoteness from the beaten tracks of travel. To reach Taos we did 90 long, tough miles by motor overland from Santa Fe. We slept—not in the pueblo—but at the newer white man's town of Taos, four miles away. There we found a small community of Spanish-speaking Americanos—and a little colony of English-speaking artists—for there Couse and Philips and Sharp and other painters have installed their studios within the walls of old-time Mexican conventos.

Surprising and agreeable it is to find so far away and in so strange a land, a little corner of the art-world and an

LEFT **CENTRAL ARCH, PAN-PACIFIC EXPO, SAN FRANCISCO, 1915**
The Panama-Pacific Exposition was held to celebrate the completion of the Panama Canal. It was also an opportunity to showcase San Francisco's recovery from the 1906 earthquake.

RIGHT **ILLUMINATED TOWER OF JEWELS, PAN-PACIFIC EXPO, SAN FRANCISCO, 1915**
No one has been disappointed in the Panama-Pacific Exposition. It excels all former Expositions in its artistic beauty, its impressive grandeur, its colorful charm, and to coin a phrase, its classic novelty. There is a thrill in the thought that all the wonder and beauty of this Exposition are really only a spontaneous manifestation of the world's admiration for the works of those great soldiers of progress and all the humble workers to whose genius and energy we owe the Panama Canal.

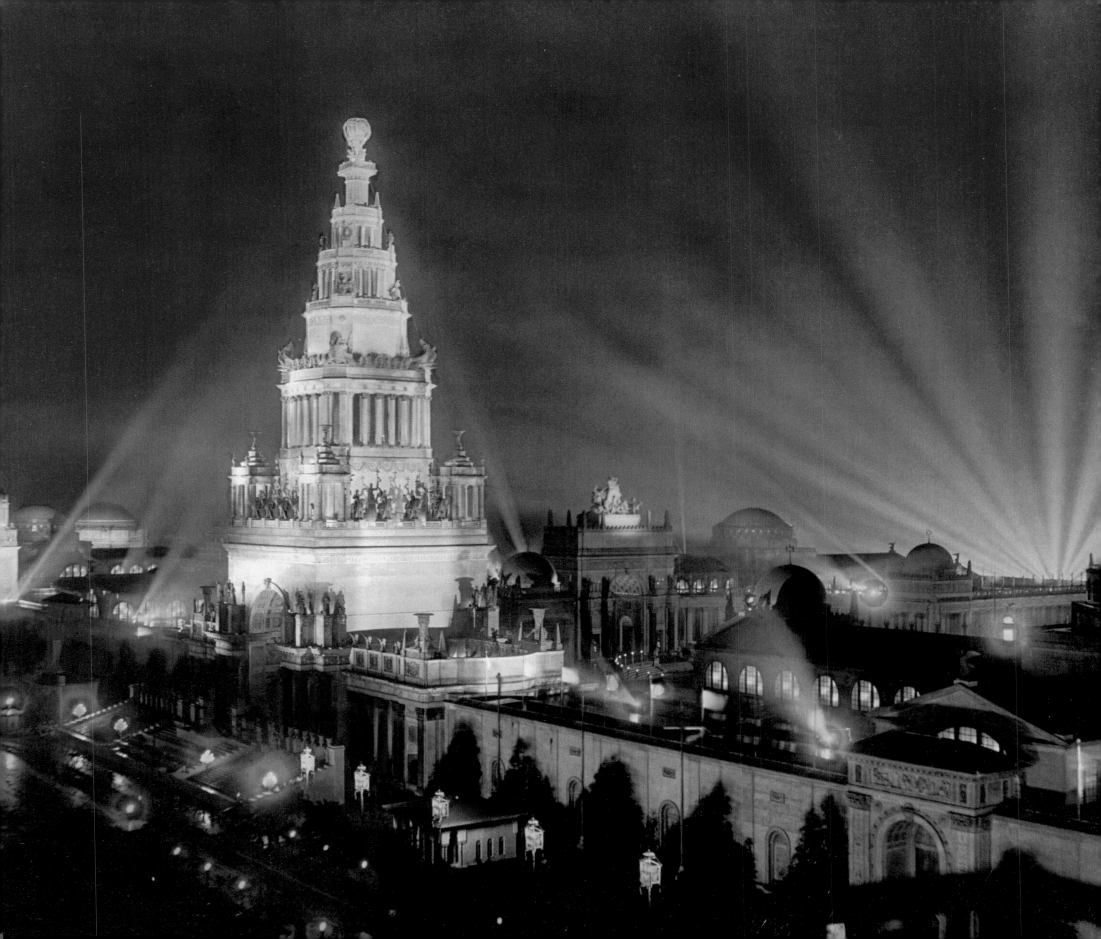

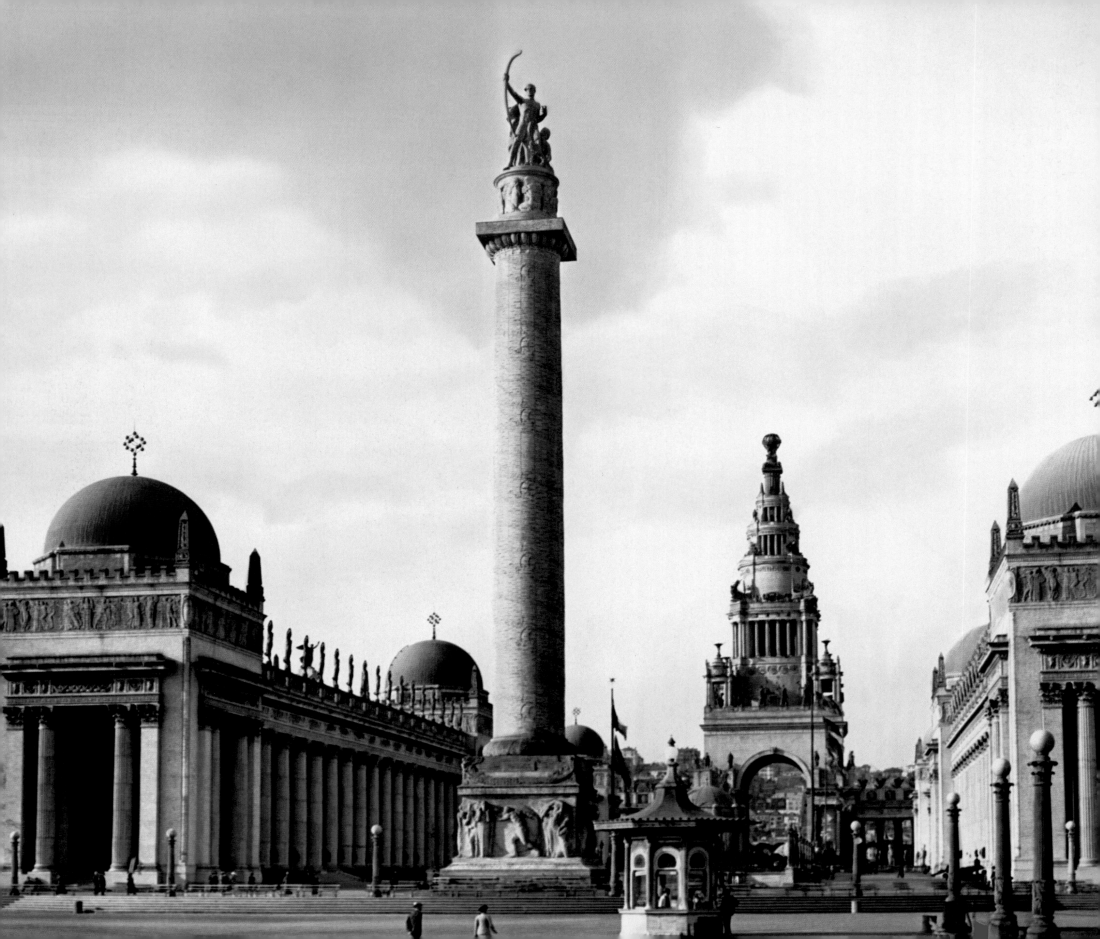

atmosphere that savors of both the Rue Boissonade and West Sixty-seventh Street. But the models are not such as haunt the studios of Paris and New York; they are the superbly natural sons and daughters of the Taos tribe, who come tempted by the white man's gold and made confident and tractable by the white man's tact and kindliness—to pose in those adobe studios whence come so many and such truthful canvases, reflecting the life and customs of the very oldest really American families of the United States. Taos was Taos when New York was nameless and Chicago non-existent.

The world admits that our United States is rich in scenic splendor. Supreme among earth's spectacles of grandeur is the unspeakably sublime Grand Cañon of the Colorado.

Supreme beauty is the valley of valleys that we call Yosemite. The wonders of the Yellowstone are without rivals in the world. The hugest trees that nature ever nursed lift their millennium-crowned heads in California's great forests. There is in California an almost unknown, untraveled Alpine region, rivaling in beauty and grandeur the most famed regions of Switzerland. We have been told all this hundreds of times but we do not heed. We continue "just goin' somewhere," we do not practice the art of travel in America; we do not try to go "abroad at home."

A quarter of a century of travel has shown me the wonders of nearly all the world. The spell of foreign travel has always been upon me—the impelling motive of my life and work—and yet now that I have realized a tardy determination

to "See America *at Last*" I know that were all other lands to perish, or like Atlantis sink into the sea, the traveler who seeks the inspiration of beauty and grandeur, of romance and antiquity, need no in any way despair, for he would find within the borders of our own United States an exhaustless wealth of charm and wonder—ample compensation for his lost lands of delight. *[1916]*

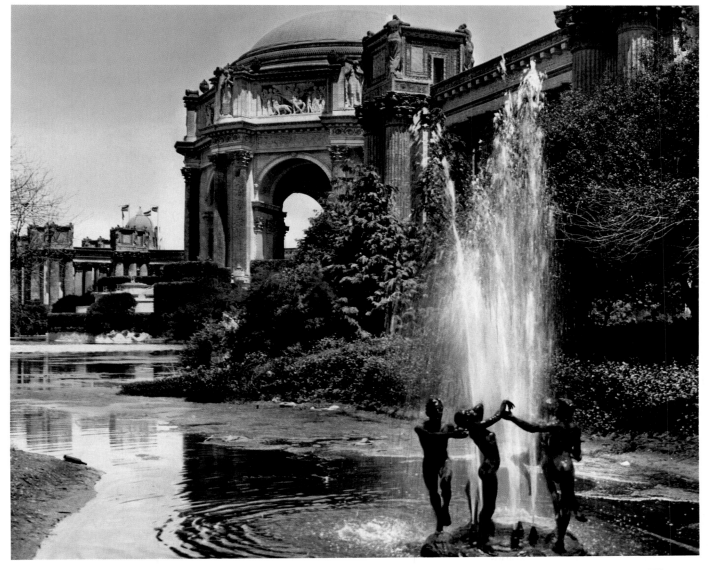

LEFT **GENERAL VIEW, PAN-PACIFIC EXPO, SAN FRANCISCO, 1915**
Exposition visitors were surrounded by a small city built of plaster, most of which was demolished at the close of the fair.

RIGHT **THE PALACE OF FINE ARTS, PAN-PACIFIC EXPO, SAN FRANCISCO, 1915**
One of the few structures to be retained once the exposition ended, the Palace of Fine Arts defined the Beaux Arts style.

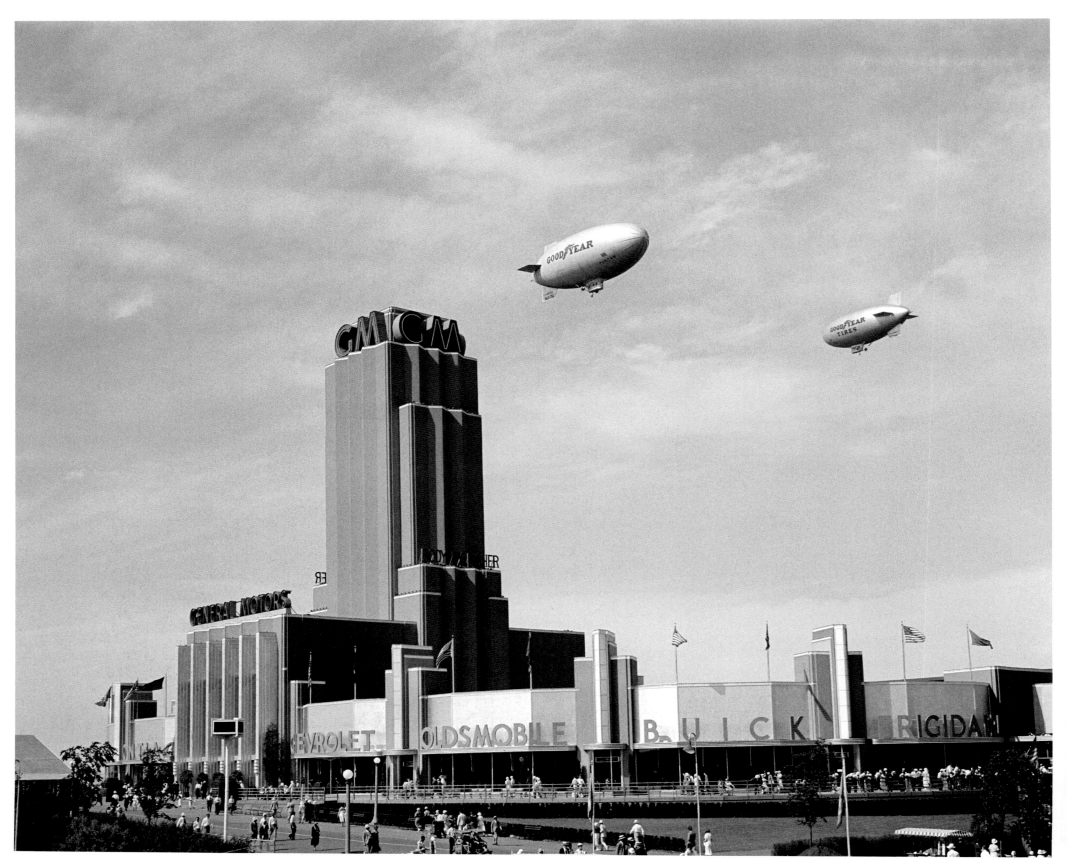

CENTURY OF PROGRESS EXPOSITION, CHICAGO, ILLINOIS, 1933
The General Motors Exhibit building with two Goodyear blimps floating overhead. The National Broadcasting Corporation (NBC) contracted with Holmes to spend this summer in Chicago delivering his impressions of the Expo via radio broadcasts for the network.

VANDERBILT MANSION, NEW YORK CITY, CA. 1910
The Vanderbilt family filled up the residential portion of Fifth Avenue, beginning at 50th Street and Fifth Avenue, by building a parade of elegant mansions.

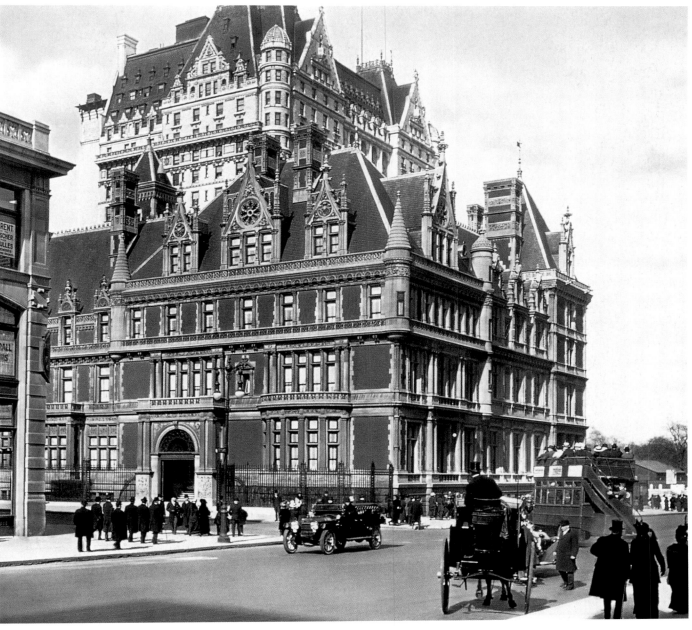

BELOW LEFT **NEW YORK CITY WELCOMES THE FRENCH LINE'S** ***NORMANDIE*** **ON HER MAIDEN VOYAGE, 1935.**
Crowned the "Queen of the Seas," the Normandie arrived from Le Havre, France, on June 3, with 1261 passengers on board supported by 1276 crew members. An airplane flying a welcoming banner passes over one of the huge funnels of the elegant Normandie as the ship approaches New York harbor.

BELOW RIGHT **DECKSIDE ON THE *NORMANDIE*, OUTSIDE NEW YORK HARBOR, 1935**

RIGHT **THE *NORMANDIE* DOCKING, NEW YORK HARBOR, 1935**

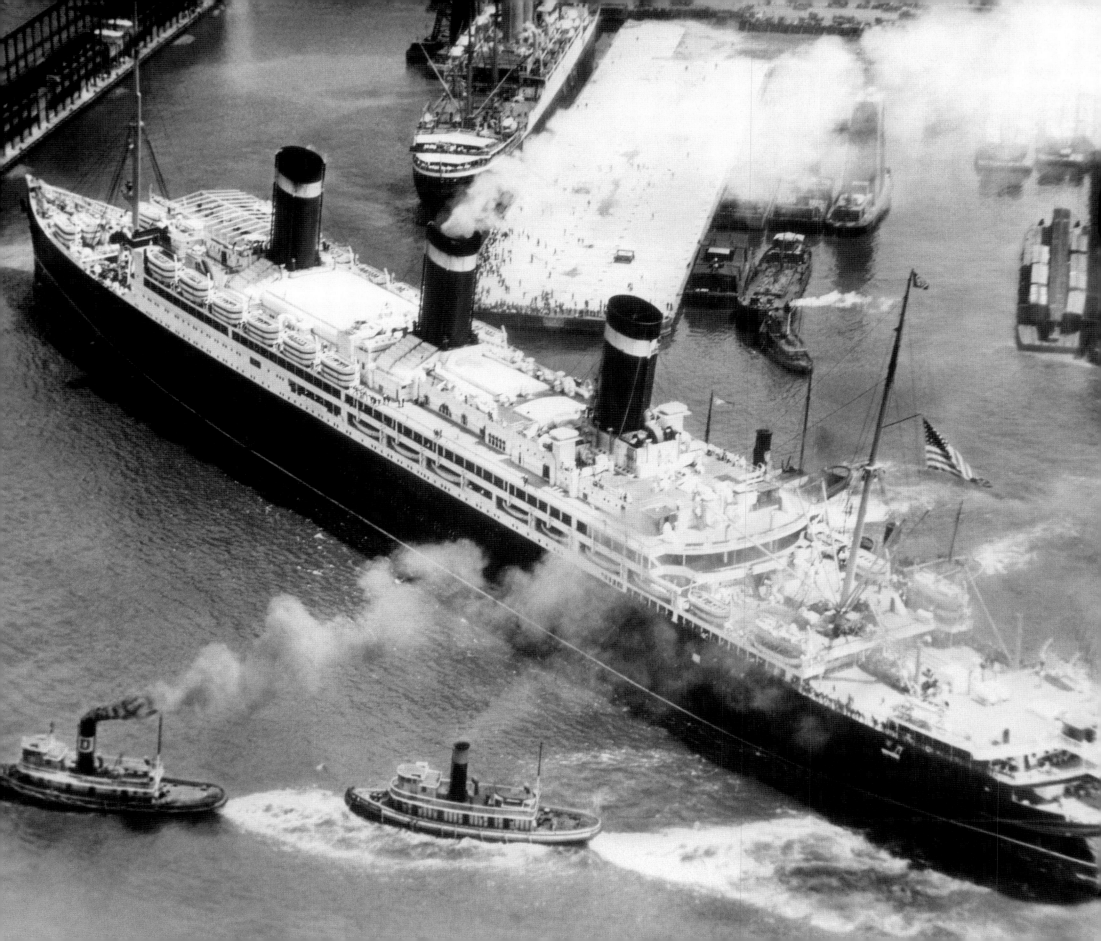

BAND AND CROWD AWAITING THE ARRIVAL OF THE *NORMANDIE*, PIER 88, NEW YORK CITY, 1935

THE VIEW LOOKING SOUTH AND ACROSS CENTRAL PARK FROM NIRVANA, BURTON HOLMES'S NEW YORK CITY APARTMENT, 1940

I was once an enthusiastic collector of things Japanese—beautiful, exquisite things that gave me boundless pleasure. My home in New York City became a treasure house of the worthwhile creations of an artistic Oriental race. In due time, my collection was as complete as my means permitted and had been installed in a manner that seemed to me ideal. I reveled in the serenity and beauty of the home I had created, which I called my Nirvana.

But the fourteenth floor windows of my New York Nirvana commanded a panorama of the greatest city of our modern, materialistic, militant, ambitious world, with all its fascinating problems, duties, liabilities and possibilities. I was content to live in my "ivory tower," surrounded by the gilded glories of a cult that was not mine and at the same time play my small but congenial part in the great comedy-drama of the modern, living world of men.

My beloved material Nirvana, high above Central Park, has passed out of my busy life. Its gorgeous trappings became a burden after I had reached my allotted span of three score years and ten. At that age, a man should simplify his life and shuffle off the strangling coils of things that have become too much a part of him. So, gladly did I relinquish my Nirvana,

with its pantheon of golden images, its lacquered walls, its coffered ceilings. Away it went for cash—happily to an appreciative purchaser! *[1951]*

A few years after this photo was taken, Holmes sold his entire Asian artifacts collection at Nirvana to Robert Ripley, of Ripley's Believe It or Not! fame.

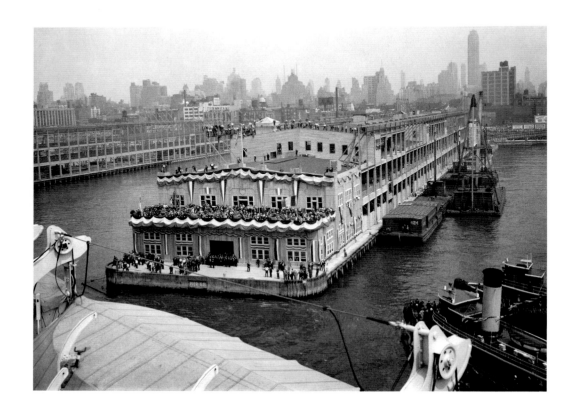

AFTERWORD

In closing, dear friends, I would like to say I could never write an inspiring success story. Some years ago the magazine called *Success* asked me to do an article. I told the Editor that my story would not be a story he would care to print. I explained to him that I had never buckled down to work, had never done the things I should have done, had never tried very hard to reach any particular goal, had always done about as I pleased and had followed my own inclinations rather than the admonitions of my elders and the advice of my teachers.

I should be glad, of course, to have more years and more comradeship with this dear planet, that I might know the good Earth better than I do—find out all her secret places, speak all her tongues, taste all her pleasures. But the long tale of this traveler is done, and I am content.

—*Burton Holmes*

RIGHT **BURTON HOLMES, HOLLYWOOD, CA. 1930**
While Holmes and two friends were walking along Hollywood Boulevard, Burton spied an empty plinth on the street corner. With a mischievous wink, Holmes jumped up onto the pedestal, turned the brim of his hat upward, and with hand over heart struck this Napoleonic pose for the amusement of his companions.

TIME LINE: THE FAR-FLUNG JOURNEYS OF BURTON HOLMES

Over his lifetime Burton Holmes traveled to every continent and nearly every country on the planet, shooting over 30,000 photographs and nearly 500,000 feet of film. The highlights of his life's journey follow.

1870 Burton Holmes was born in Chicago, Illinois, a year before the Great Chicago Fire.

1883 Holmes purchased his first camera with his life savings of ten dollars.

1886 Holmes accompanied his grandmother, Ann Burton, and his mother, Virginia, to Europe for a short grand tour. A second, more extensive tour of the continent would follow in 1890.

1889 Holmes toured Mexico with Grandmother Burton on one of the earliest Grafton Pullman Train Excursions.

1891 Holmes prepared his first show of travel photos from unique Kodak negatives for the monthly meeting of the Chicago Camera Club. The reception was enthusiastic enough for him to seriously consider making his hobby his profession.

1892 A visit to Japan inspired his first professional lecture series in Chicago in 1893.

1894 Accompanied by boyhood friend Nelson Barnes, Holmes went to Algeria, Tunisia and Morocco, making a caravan journey of forty days through the independent and roadless empire of the Moorish sultan.

1895 Holmes and companions cycled from Paris along the Riviera into Italy, and then over to Corsica, bringing the first bicycles ever seen on the island of Napoleon.

1896 Holmes was in Athens as Greece revived the ancient Olympic Games. He also visited the monasteries of Thessaly, toured the Peloponnesus by pony caravan with English novelist E.F. Benson, and cruised up the Adriatic, making all the Dalmatian ports. After a long sojourn in Venice, he topped off the year with a visit to the recently opened Yellowstone Park.

1897 John L. Stoddard, king of the glass lantern lecture Circuit, retired, and recommended to his regular performance venues that they book Holmes as their new travel lecturer. With friend Frederick Stearns of Detroit and cameraman Oscar Depue, Holmes toured through Sicily, and then on bicycles set out from Naples for Paris. They reached Paris by train and proceeded to London for the Jubilee of Queen Victoria. That summer, Holmes and Depue bought their first motion-picture camera—a French 60mm Gamont, with which they made one of the earliest travel films ever produced.

1898 Holmes and Depue, with their new motion-picture outfit, visited the Grand Canyon and the Native American Hopi villages of Arizona by stagecoach and pack horse, and made the first films ever taken there. Then on to Hawaii, their ship bringing to Honolulu the first news of U.S. annexation—there was no cable or radio yet to deliver the message.

1899 Holmes set out for the Philippines, en route visiting Canton and meeting Admiral Dewey in Hong Kong. He experienced battle conditions for the first time during the Philippine-American conflict. That year he personally cranked the first motion-picture camera ever brought to Korea, Japan, China or the Philippines.

1900 The Paris Exposition of 1900 and the Passion Play in Oberammergau, Germany provided material for the season.

1901 Holmes found "A New Way Around the World" across Russia and Asia—on the Trans-Siberian Railway, while

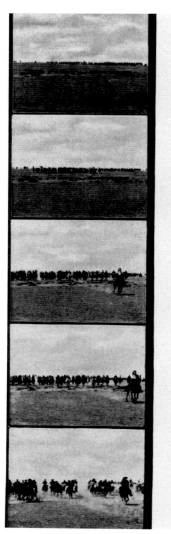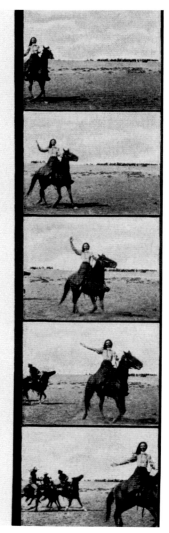

the track was still being laid. It was a forty-two-day journey filled with many uncertainties.

1904 Holmes had related his North American treks to an American audience the year before. Now he presented Yosemite, Yellowstone Park, the Grand Canyon, the North American Hopi Villages, Alaska, the Klondike, and the Yukon in a premiere London lecture performance at Queen's Hall. The word *travelogue* was invented this year to set Holmes's performances apart from the pack.

1905 Holmes delivered a lecture on the Russo-Japanese War and the sinking of the Russian fleet at Port Arthur, Manchuria, using photographs made by veteran war correspondents Joseph Rosenthal and James Ricalton.

1906 Condensing his lecture schedule, Holmes was free to

LEFT **EARLY FILM STRIP, NAVAJO BRAVES AND "RATTLESNAKE JACK," ARIZONA, 1898**
Holmes and Depue visited northern Arizona in 1898 and 1899, where they made the first movies taken in Arizona of such subjects as the Hopi Snake Dance and scenes of the Grand Canyon. While visiting the Navajos, the company staged a chase scene wherein a young white woman from Denver named "Rattlesnake Jack" steals the chief's horse. Holmes returned to the desert the following year to screen the film and several others for 500 members of the Navajo tribe. It was the first time they had seen moving pictures, and according to Holmes, they were enthralled by the canvas screen, which was "minutely examined by the nonplused Navajos who fingered it and rubbed their cheeks against it, as if to detect some sign of life or of sorcery in the white fabric.

realize his dream of a winter visit to Egypt and the Nile. In April occurred the greatest eruption of Vesuvius in our time; Holmes and Depue were the only movie men on the spot. They also took in the second Olympiad in Athens.

1909 In August, he saw flying machines aloft for the first time at the first-ever aviation tournament, at Rheims, France.

1910 Holmes moved from his hometown of Chicago to New York City's Upper West Side. Ten years later he purchased the duplex apartment he named Nirvana.

1911 Spain and Portugal again and South America for the first time—Rio, Buenos Aires, the Iguassú Cataracts and over the Andes to Chile by train.

1912 A cruise to the West Indies and on to the Panama Canal, then under construction, which would provide material for his most popular show to date. This was followed by a summer visit to India and Burma, where the temperature reached 110 degrees Fahrenheit.

1914 Holmes married Margaret Oliver, his wife of nearly forty years, and they took their first journey together that summer, motoring through Great Britain and Ireland. The pleasure cruise ended with a voyage home on a second-class refugee ship to Montreal, Canada. The First World War had begun.

1915 The world at war, Holmes stayed Stateside, touring the Southern states and the Panama-Pacific International Exposition in San Francisco.

THE DREAM THEATRE, DAWSON CITY, THE YUKON, CANADA, 1916
Even living as Far North as the Yukon Territory, local patrons of the Dream Theatre could enjoy a Hollywood movie, and a weekly Burton Holmes travel film short featuring an exotic port of call.

BURTON HOLMES IN FLIGHT GEAR, TOULOUSE, FRANCE, 1923
The *Travelogues* went "up in the air" for the first time in 1923 when Holmes took his first flight, joined by Mrs. Holmes. They rode in a tiny open cockpit squatting on air mail sacks, from Toulouse to Rabat, flying over water and dangerous rebel-held Moroccan deserts.

1917 Seven months of strenuous travel took Holmes through New Zealand, Tasmania, Australia, Fiji, China, Japan and Alaska.

1918 Holmes was "With the Yanks" in France and Italy, in uniform as a war correspondent, filming for the military and for his own *Travelogues*. The following year he visited the battlefields of France and Belgium and toured the German Rhineland, then under Allied occupation.

1920 With the war over, Holmes trekked to Constantinople, Jerusalem and Northern Italy.

1922 Returning to the Far East, Holmes toured Lafcadio Hearn's Japan with Hearn's son, Kazuo Koizumi. Then over to Shanghai, Soochow, Hangchow, Nanking, Hankow and up the fearsome Yangtze Gorge to Chungking and other cities of inner China.

1923 The *Travelogues* went airborne for the first time when Holmes filmed *Mediterranean Sky-Cruisings*. Scenes included his risky first flight in a tiny open cockpit, squatting on mail sacks, from Toulouse, France to Rabat, Morocco.

1925 Holmes returns to Asia, exploring Angkor Wat, Indo-China and Siam.

1927 Like many others that year, Holmes became an American in Paris. He also toured Austria with Baron Popper de Podhragy and the Baroness, who as Maria Jeritza was the reigning soprano of the Metropolitan Opera.

1929 The *Travelogues* enjoyed one of their best seasons, featuring London, France, the Mediterranean and Venice, playing everywhere to capacity audiences.

1930 Separate journeys took Holmes to two divergent spectacles: the Passion Play at Oberammergau, Germany, and the coronation of Haile Selassie I in Ethiopia. For the latter, Holmes had to go from Djibouti to Addis Ababa as a stowaway on the special train of the Duke of Gloucester. He also made Hollywood his second home, purchasing a home in the hills he named Topside.

1931 Holmes made the feature-length film, The Real Hollywood, with a cast that included many of the top stars of the day. In *Hollywood, 1931* Holmes told of his brief glory as a movie star doing talking "travel shorts" for MGM in English, French, Spanish and Italian.

1933 The Century of Progress Exposition kept Holmes in Chicago for the summer, broadcasting his impressions five times weekly over the NBC network.

1934 He returned to Soviet Russia to see what a third of a century had done to the Russia he had known in 1901.

1935 A short journey to Normandy and Brittany, and homeward on the maiden voyage of the super ship of the French Line, the *Normandie*. Then a twenty-thousand-mile flying tour around South America, touching down in Mexico, Guatemala and nearly all the South American republics.

1937 Challenged by a short biography of him in *Who's Who*, which claimed that Holmes had "traveled everywhere but South Africa," he finally made the voyage there. He then flew from the Belgian Congo to Madagascar and toured Italy by motorcar—with a side trip to Tripoli by flying boat.

1940 With the advent of World War II, Holmes focused his attention on the United States, taking train tours and motoring jaunts around his own country to savor its particular beauties.

1941 -52 The years rolled on, and the miles rolled up by the millions. But each winter season found him back on stage presenting his *Travelogues* in person, invariably before sell-out audiences.

1952 Holmes retired from the public platform.

1958 Holmes died peacefully at home in Hollywood. Burton Holmes, the consummate gentleman, intrepid traveler and celebrated showman, remained an American legend in his own lifetime.

ABOUT THE COLLECTION

THE PHOTOGRAPHS

In 1975, while making plans to open my own photo agency in Los Angeles, a family friend, Curt Matson, invited my husband, Brooks, and me to the old Burton Holmes building on Sunset Boulevard in West Hollywood to see an extensive collection of old photographs and glass lantern slides. The thought of an unknown collection that wasn't already in a photo archive intrigued me. As Curt had promised, the photographs were spectacular—1890 Paris, 1895 London, 1901 China, the world displayed on a light box! As we sifted through stack after stack of beautiful historical images, I knew I had my hands on a treasure trove.

The caretaking associates, who had worked closely with Burton Holmes for many years before his death in 1958, were responsible for the photographs and had rarely allowed anyone to view the images. Our mutual friend and my background as a photo editor allowed for an unprecedented trust just as the associates had come to the conclusion that the collection needed to be formally organized. I offered my services as private archivist and they accepted gratefully, as it was quite an undertaking.

The Burton Holmes Collection began in 1976 as a labor of love. Brooks and I sifted through hundreds of images, indexed and searched for exact dates and caption materials to create a photo library collection. We culled from stacks of tin boxes filled with perfect and deteriorating nitrate negatives, as well as many safety negatives in excellent condition. We made color negatives from the glass lantern slides, and printed contacts and made prints of a wide array of never-before-printed negatives. Late in 1977, *The Man Who Photographed the World: Burton Holmes 1892-1938* was published by Harry N. Abrams, NY.

While working on my book about the Burton Holmes

Travelogues, I discovered that Holmes had left thousands of feet of documentary film footage dating from the early days of cinema, 1897 to the 1930s. That opened a whole new chapter in the legacy of Burton Holmes and my continued involvement.

PRESERVATION

In 1978, documentary filmmakers Bill Cartwright Sr. and Scott N. Garen and I catalogued approximately 350 cans of films kept in the film vault in the Burton Holmes offices in West Hollywood. The intention was to prepare the way to make a documentary film about the life and early cinematic contributions of this remarkable man.

It was evident then that some of the footage was deteriorating, so we wasted no time in working through three hot summer months to document all we could. When we completed the work, the associates informed us that they had changed their minds about allowing a documentary to be made about Holmes, and decided they wanted to do it themselves since they knew Holmes best. Time passed, and we went our separate ways. In 1983, we learned that Burton Holmes International had dissolved as a company after the untimely death of the last Holmes associate. The entire contents of the building—film vault, photographs, negatives, antique cameras and other memorabilia—had vanished. For the next twenty years, we Holmes supporters, film historians and national institutions searched in vain for the lost film.

Then, in 2004, through a series of coincidences and the Internet, I received an email from building owner, Jay Turner, offering me 200 cans of the Holmes *Travelogue* films found in an abandoned storage unit on his property in Los Angeles. Turner had known the Holmes associates as a child and knew what he had found when he opened the locked unit. Filmmakers Bill Cartwright Sr. and Bruce Nolte retrieved the

films and stored them until we could assess the contents. We compiled a new film log while searching for preservation funding. While some of the films were lost to time and chemical reaction, the remainder, about 85,000 feet of one of the world's great documentary film collections, needed to be rescued.

The restoration and future preservation of the film requires an enormous effort and the services and dedication of a major American film archive. In June 2005, I donated the entire film collection to the Motion Picture Department of the George Eastman House International Museum of Photography and Film in Rochester, New York.

Film Curator Dr. Patrick Loughney and his staff are committed to preserving this historically important film collection and to advancing wider public knowledge of the legacy of Burton Holmes. What remains of the lifework of photographer and pioneering cinematographer Burton Holmes, America's premier traveler, will be saved for posterity.

—*Genoa Caldwell, Archivist*

ABOVE **SOME OF THE 200 BURTON HOLMES FILM CANISTERS, RECOVERED IN 2004**
Because of the age of the recovered film, opening any film can, large or small, elicited a surprise. Either we found early nitrate and safety film perfectly clean and sound, or gellied, warped, white frosted reels with the "vinegar syndrome" odor of disintegration. The saddest sight of all had to be the cans of early film of Paris, Russia and Japan, filled with brittle and broken sections and sometimes piles of rusty dust.

P 368 **LECTURE PROGRAM COVER FOR THE 1931-32 SEASON**

BIBLIOGRAPHY
ACKNOWLEDGEMENTS
CREDITS & IMPRINT

BIBLIOGRAPHY

Caldwell, Genoa, ed. *Burton Holmes: The Man Who Photographed the World 1892–1938.* Introduction by Irving Wallace: "Everybody's Rover Boy." New York: Harry N. Abrams, 1978.

Holmes, Burton. "America—The Land for Tourists, How to See America," *Leslie's Weekly,* May 11, 1916.

Holmes, Burton. *Burton Holmes Travelogues, Volumes 1–14.* Chicago and New York: The Travelogue Bureau, 1919–1922.

Holmes, Burton. *The World Is Mine.* Culver City, CA: Murray and Gee, 1953.

Montgomery, Patrick. Travel Film Archive, including Burton Holmes Lecture Programs (1904–1936) and Holmes family photographs. New York.

Stoddard, Lothrop. *Burton Holmes and the Travelogue.* Los Angeles: Burton Holmes, Inc., 1939.

ACKNOWLEDGEMENTS

I'd like to express my thanks to friends who have helped and encouraged me in my work with The Burton Holmes Collection over the past thirty years: Curt and Erica Matson, who led me to Burton Holmes; Brooks Caldwell, partner in the initial archiving of the photographs and extraordinary friend; Lauren Bates, adviser and ardent Holmes supporter; and Dr. Pat Freeman, for hours of helpful historical research. Also to other friends who lent support in special ways, especially Yukiko Launois, Gail Treischman, Susan DiFusco Reed, Deana Paulson, the Goeppeles and Rachel Dawn.

Professional assistance with the Burton Holmes photographs and with the 2003–04 film recovery required great generosity of spirit, gifts of time, resources, and expertise. Heartfelt thanks to Jay Turner, Bill Cartwright Sr., Bruce Nolte, Robert M. Tamiso, Patrick Montgomery, and Michael Ward. Finally, to curator, Patrick Loughney and his staff at the George Eastman House Museum of Photography and Film who are making the preservation of the Burton Holmes travel film legacy a reality.

To my friends at Taschen: Jim Heimann, who promised me a great book and delivered; Nina Wiener, a most talented and invaluable editor with a genius for bringing out the best in others; and Benedikt Taschen, for sharing my vision of Burton Holmes, his images and words, and for the creation of a lasting tribute to the incomparable Burton Holmes. Additional thanks go to Doug Adrianson, Colin Harding, Anna Skinner, and Andrea Richards for their meticulous proofreading and fact-checking work.

IMPRINT

Front cover: Giza, Egypt, 1906
Back cover: Paris, ca. 1878 (Photographer unidentified)
Fly title: Lecture Program Cover, 1936
Frontispiece: *Travelogues* Bus Ad, London, 1904
Endpaper: Lecture Program Cover, 1931–32

All images are from the Burton Holmes Historical Collection unless otherwise noted. Patrick Montgomery: 1, 6, 9, 11, 12, 16; Bruce Nolte: 366; Redpath Chautauqua Bureau, University of Iowa Libraries, Iowa City, Iowa: p. 368. Foreword © Lowell Thomas 1958.

To stay informed about upcoming TASCHEN titles, please request our magazine at www.taschen.com/magazine or write to TASCHEN, Hohenzollernring 53, D-50672 Cologne, Germany, contact@taschen.com, fax: +49–221–254 919. We will be happy to send you a free copy of our magazine.

© 2006 TASCHEN GmbH
Hohenzollernring 53, D-50672 Köln
www.taschen.com

Director and producer: Benedikt Taschen, Cologne
Acquiring editor: Jim Heimann, Los Angeles
Editor/Project management: Nina Wiener, Los Angeles, and Florian Kobler, Cologne
Design: Sense/Net, Andy Disl and Birgit Reber, Cologne
Production: Thomas Grell, Cologne
Collaboration: Morgan Slade and Amy Francis, Los Angeles

Printed in Italy
ISBN-13: 978-3-8228-4815-9
ISBN-10: 3-8228-4815-8

BURTON HOLMES

LOOKS AT THE WORLD FROM MANY ANGLES
AND FINDS IT WELL WORTH YOUR ATTENTION